History and Process
Printmaking

History and Process
Printmaking

Donald Saff/Deli Sacilotto
University of South Florida

WADSWORTH

THOMSON LEARNING

Australia • Canada • Mexico • Singapore • Spain
United Kingdom • United States

WADSWORTH
THOMSON LEARNING

Editor: Rita Gilbert
Picture Editor: Joan Curtis
Project Editor: Elisa Adams
Manuscript Editors: Elisa Adams, Eric Zafran
Project Assistants: Barbara Curialle, Polly
 Myhrum. Hope Davis Rost

Production Manager: Robert de Villeneuve
Illustrators: Abe Markson, Jim Bolles
Designer: Marlene Rothkin Vine
Associate Designer: Karen Salsgiver
Cover Design: Karen Salsgiver
Cover Printer: Lehigh Press, Inc.

Printed in the United States of America
1 2 3 4 5 6 7 20 19

For more information about our products,
contact us at:
**Thomson Learning Academic Resource
Center
1-800-423-0563**
For permission to use material from this text,
contact us by:
Phone: 1-800-730-2214
Fax: 1-800-730-2215
Web: http://www.thomsonrights.com

**Library of Congress Cataloging-in-Publication
Data**
Saff, Donald, 1937—
Printmaking: history and process.
Bibliography: p. 422.
I. Prints—Technique. 1. Sacilotto, Deli, joint
author.
II. Title.
NE850.S23 760′ x 2′8 76-54995
ISBN: 0-03-085663-9

Asia
Thomson Learning
60 Albert Street, #15-01
Albert Complex
Singapore 189969

Australia
Nelson Thomson Learning
102 Dodds Street
South Melbourne, Victoria 3205
Australia

Canada
Nelson Thomson Learning
1120 Birchmount Road
Toronto, Ontario M1K 5G4
Canada

Europe/Middle East/Africa
Thomson Learning
Berkshire House
168-173 High Holborn
London WC1 V7AA
United Kingdom

Latin America
Thomson Learning
Seneca, 53
Colonia Polanco
11560 Mexico D.F.
Mexico

Spain
Paraninfo Thomson Learning
Calle/Magallanes, 25
28015 Madrid, Spain

For Diane, Ruth,
Jeff, Mia, and Stephen

Preface

We have written *Printmaking: History and Process* in an attempt to bring together the most complete, accurate, and up-to-date information about all the various printmaking techniques. This book is planned for students of printmaking at the college or university level, as well as for the general reader who wishes to explore the challenging medium of multiples. It will also serve as a basic resource book for the professional printmaker.

In preparing the text we have assumed that a large portion of our audience will have had no previous experience or knowledge of printmaking methods. Therefore, all directions for the procedures described have been written for the layman. Every process stage is illustrated by detailed, step-by-step photographs or drawings in order to clarify the instructions. At the same time, however, we did not restrict ourselves to basic, introductory techniques. We have tried rather to build a progression from the standard to the sophisticated, ending with innovative forms and methods as current as the on-press date of this book. We hope that the book will become a storehouse of information for the printmaker at every level. No one could possibly keep in mind all the details of every print process. Indeed, since the manuscript for this book has been assembled—from our own material and the contributions of many others—we ourselves have begun to use it as a reference source.

The core of *Printmaking* is in the chapters devoted to the traditional four process categories: relief, intaglio, lithography, and serigraphy. Here will be found detailed instructions for making a woodcut, an engraving, an etching, a mezzotint, a lithograph, a silkscreen print, and countless other variations and combinations. Each chapter lists all the materials and equipment needed for that medium, then proceeds logically from the preparation of the plate or "master" to the printing of the image. Wherever possible we have explored the chemical and physical phenomena that relate to specific techniques, in the belief that understanding will aid the artist.

Throughout history artists have been inspired by—and fascinated with—the work of their predecessors. Because prints are reproduced less often than paintings (and partly because of our own unabashed love of historical prints), we have prefaced each technical chapter with a brief, fully illustrated history of that medium. We believe that a knowledge of prints dating back many centuries can give the artist of today a sense of continuity with the past, a sense of growth and development in a field that has changed tremendously in the 20th century. In addition to this, many printmakers will wish to explore special techniques perfected by a particular artist—techniques that may have been temporarily misplaced in the backwaters of the art.

Although the four categories listed above are traditional, some prints today defy classification and even blur the definition of a print. They may combine many different methods to produce a single print or employ materials and techniques that would have startled a Dürer or Rembrandt. In order to do full justice to these innovative works, we have prepared a chapter devoted to "Expanded and Applied Techniques." Many new processes are presented for the first time, having never before appeared in a book. Among these are the lithoaquatint developed by Deli Sacilotto and the Kwik Proof litho registration method introduced by Charles Ringness. There are also a number of variations on standard methods, including the blueprinting and brown sepiaprinting technique as practiced by Paul Clinton, and the litho air deletion process perfected by Julio Juristo.

Paper is the classic support for a print, and printmakers often develop a special infatuation with fine papers. We have included a final chapter for those who, like us, find beauty and sensuous delight in a sheet of handmade paper. The chapter includes a brief history of paper, a list of papers suitable for printmaking, methods of making paper, and a discussion of the proper ways to curate prints.

The Appendices in *Printmaking* are provided for those who need specialized information. These include an explanation of the chemistry of etching; a description of the method for steel facing plates; and a full treatment of the presses used for printmaking. Readers interested in investigating the voluminous literature of prints will find many sources in the Bibliography. A Glossary defines terms used in the text and others particular to printmaking.

In preparing the photographic illustrations for *Printmaking*, we have been especially fortunate. Prominent artists and ateliers across the United States and Canada have made their prints and facilities available to us. Photographs of "works in progress" are just that—important editions actually being printed, rather than demonstration plates quickly fabricated in the studio for the sake of the book. Some of the most acclaimed artists of the 1970s have generously contributed their advice, details of their methods, and photographs of their work. With this great resource available to us, we made the decision not to include any of our own prints or those of our students. The finished book contains nearly 700 illustrations, 40 of them in full color. We think that these represent the supreme achievement of printmaking from its origins to the present.

Many people feel that printmaking is the quintessential medium of the latter 20th century. Certainly few prominent artists have been able to resist the temptation to explore this endlessly flexible form. And, in a time when paintings and sculpture have soared in price to stratospheric levels, the print offers to the person of modest means an opportunity to own and cherish an original work of art. For both the

artist and the collector, then, printmaking is very much the medium of today—and of tomorrow.

Acknowledgments

We feel extremely fortunate in having had the contributions of a vast number of people in preparing *Printmaking: History and Process*. Actually, the list of those who have helped us in various ways would be almost as long as the book itself. We do, however, want to express our special thanks to the following: to Dr. Edwin Ziegfeld, who initially suggested the idea for the book; to Kathryn Clark of Twinrocker Handmade Paper, Willard McCracken, Charles Ringness, Norman Lassiter, Alan Eaker, Richard Upton of Skidmore College, Albert Christ-Janer of Pratt Institute Manhattan Center, and John L. Ihle of San Francisco State College—all of whom read and criticized portions of the manuscript. We are indebted for technical assistance to Drs. Paul Whitson and Graham Solomon for the material on the chemistry of etching; to Joseph Alexander for the photo etching process; to Maurice Sanchez for demonstrating techniques at Petersburg Press; and to Joseph Petruzelli for information about offset printing.

Our particular thanks go to Sidney Felsen and Stanley Grinstein for giving us access to Gemini G.E.L. and to the Gemini photo archive; to Kathryn Clark for providing photographs of the Twinrocker Paper Mill; to Alan Eaker for technical assistance and photographs from Pyramid Arts, Ltd.; to Theo Wujcik for technical advice and permission to photograph his works in progress; to Adolph Rischner and Addie Rischner for permission to photograph works at Styria Studios; to Kathan Brown for technical information and permission to photograph works at Crown Point Press; to John Koller and Kathy Koller for technical information and photographs at the H.M.P. papermill; to Mark Stock for technical information and the opportunity to photograph his lithographic work; to Paul Clinton, who prepared the paper mold and test stone for litho; to Seong Moy for providing photographs and allowing us to photograph him at work; to Noburu Sawai for photographs of his work in progress; to Ansei Uchima for information about his adaptation of the Japanese woodcut technique and for allowing us to photograph his work in progress; to Charles Cardinale of Fine Creations, Inc., for allowing us to photograph work in progress; and to Will Barnet for providing photographs of his recent work. Phyllis Prinz of Pace Editions has been extremely generous in supplying photographs and general information.

Among the people who helped us with the monumental task of completing the photographic series, we would like to express our gratitude to Alex Mirzaoff, Dieter Grund, Michelle Juristo, Patrick Lindhardt, Irv Saff, and Rose Saff. The typing of manuscript through many drafts was done by Barbara Cox, Loretta Saff, Mike Copeland, and Brenda Woodard; we are most appreciative of their endurance in the face of reams of paper.

A special note of thanks must go to Jim Dine, Robert Rauschenberg, and James Rosenquist for allowing us to photograph them at work, as well as for providing the inspiration that made us aim for the highest level of aesthetic excellence.

The staff at Holt, Rinehart and Winston have been supportive throughout the project. Our editor, Rita Gilbert, oversaw the entire project, alternately encouraging and chastising us as seemed appro-

priate. Without her expertise, persistence, and patience the book would never have come to fruition. We must give special acknowledgment to Joan Curtis, our picture editor, who tracked down elusive illustrations with the zeal of a detective and often singlehandedly prevented the whole fragile network of a book-in-progress from falling apart. Elisa Adams edited most of the manuscript and controlled its extremely complicated production, while Barbara Curialle and Polly Myhrum kept track of endless production details. We are grateful to Marlene Rothkin Vine for the book's elegant, functional design, which brings order to a complex subject; and to Karen Salsgiver for her intelligent and attractive page-by-page layout.

Last, and most important, we must thank the people who sustained us through the seemingly endless months of completing this text. To our wives and children, then, goes the only gift that can compensate for the ordeal they have seen us through—the book itself.

Tampa, Florida Donald Saff
New York City Deli Sacilotto
August 1977

Contents

History and Process
Printmaking

Introduction

The definition of the print, like that of any other art medium, is in a constant state of evolution. It can be molded to the social and aesthetic needs of a given society and to the individual expression of a particular artist.

Unlike other art forms, which often could be viewed only on a limited basis, early prints found their way to a larger audience. The visual and social impact of these works became a potent mass media force. Prints were often utilitarian, educational tools in the form of religious images, book illustrations, playing cards, maps, and commemoratives of important historic events. As other types of printing and communication developed, the hand printmaking processes became more exclusive, attracting artists by the richness and variety inherent in the various techniques. Collectors of art began to place a premium on high-quality prints as artists used the prints creatively. The originality with which the plate, block, or stone was conceived carried over into the multiple impressions that were considered "original" works.

An important characteristic of the print, therefore, is its identity as a *multiple*. While an artist could certainly create just one impression from a block or plate, the usual practice is for an *edition* of many prints to be struck. For some people this casts doubt on the designation of the print as an original work of art. However, the criteria for originality in a print have the weight of long tradition to support them: a design conceived by the artist for this medium, printed under the supervision of the artist, and meeting standards of excellence established by the artist. Actually, multiples have existed in sculpture as well for centuries. The bronze-cast sculpture made from a mold can be duplicated several times, but each cast is considered an original sculpture.

It is now common practice to limit the edition size and to number and sign the prints. With some tech-niques, where the plate is soft or the image subject to deterioration, as in drypoint, it is appropriate to number the prints in sequence as they are pulled. The earlier impressions are the sharpest and thus the most valuable. However, with today's more durable surfaces and especially with steel facing applied to metal plates, diminishing clarity is less of a problem.

This potential for extremely high print runs raises a number of questions—questions that have not yet been satisfactorily answered. In the early days of printmaking, edition size was governed by the durability of the plate. When the image would no longer print clearly, printing was halted. In fact, some of Rembrandt's plates were actually printed long after the metal face had worn down, so that considerable detail was lost in the later impressions. The print-maker and dealer of today, presented with a plate capable of sustaining many thousands of identical impressions, must somehow decide when to stop. Obviously, the major consideration in this choice is financial. There is a natural temptation to print huge editions and therefore sell enormous quantities of any given print. On the other hand, the value of each individual print decreases as the size of the edition increases. A print from an edition of ten or twenty would be worth far more money than one from an edition of five thousand. Large editions, moreover, often bear the stigma of "commercialism." As technology continues to advance the mechanical possibilities of printmaking, these questions may be difficult to resolve.

Innovations in 20th-century printmaking have to some extent confused the issue of what *physically* constitutes a print. The traditional idea of a print is a flat inked image on paper. But many prints today have three-dimensional objects or areas incorporated in them, and some are actual freestanding three-dimensional pieces. Also, a number of processes involve no

ink at all. In addition, artists who have used commercial reproduction techniques in making limited editions have blurred definitions even further. In this instance, the deciding factor must be the artist's intent. If an existing work of art such as a painting is transposed by photographic or other means into a printmaking medium simply to be reproduced, then the reproductions cannot be considered original prints. If, however, an artist employs an existing image on the master plate or block with the intention of making an edition of prints, the resulting works can be considered original. Ultimately, each work must be evaluated without preconceptions regarding technique or other extra-aesthetic constraints. Rigid definitions no longer apply.

Printmaking in the last quarter of the 20th century is a dynamic and rapidly changing art form. Works incorporating many different media are common, and some pieces seem to defy classification altogether. Nevertheless, most prints still fall generally into one of the four major traditional categories of printmaking.

Relief prints result from a *raised* printing surface. In other words, the portion of the block or plate meant to take the ink is raised, while the nonprinting areas are cut away below the surface. The most common form of relief printing is the *woodcut*. In this method an image is drawn on a wood block, and then the nonimage areas are cut away with sharp tools. The remaining, raised areas are inked, paper is laid on the block, and then the back of the paper is rubbed to pick up the inked image. Variations of the relief process include linoleum block printing (*linocut*) and *wood engraving*.

In *intaglio* printing, the image areas are *depressed* below the surface of the plate. Lines are incised into a metal plate or some other surface, either with a sharp tool or with acids. When the printer rolls ink onto the plate, these lines hold the ink, after which the surface is wiped clean. Paper forced into the depressed lines with a press picks up the image. Intaglio techniques include *engraving, etching, drypoint, mezzotint,* and *aquatint.*

Lithography is a *planographic* process, which means that the printing surface is flat, neither raised nor depressed. In this case, printing depends upon a chemical reaction—the mutual antipathy of grease and water. Images drawn in greasy crayon on a lithographic stone or metal plate attract the ink, while the undrawn areas are treated so as to repel it. Printing is done on a lithographic press.

Serigraphy, also known as *silkscreen* or *screen printing,* is an adaptation of the basic stencil-making technique. Image areas are drawn on a fabric mesh, usually silk or nylon, and the nonimage areas are made nonporous. A squeegee pulled across the screen forces ink through the image areas and onto the printing paper directly underneath.

Because the range of techniques is so vast, the art of printmaking offers a medium for almost every purpose. Beyond the aesthetic pleasure that a beautiful image can provide, many artists and printers find that the satisfaction of pulling a finished print from a well-executed plate, block, or stone is its own reward.

part one
Relief

1 The History of Relief

Few inventions in the history of civilization have played such a key role in the evolution of thought as the development of printed images. The cultural impact of printing was without parallel until our own age of computers, photography, and mass communications. The earliest printed images were relief prints—the best known method being the woodcut.

Relief printing takes its name from the fact that the printing surface is *raised* above its background. In wood block printing, for example, background areas that are *not* meant to print are carved away, leaving the image areas of the print in relief. Ink is applied to this raised surface, and the image is transferred to paper.

Carved reliefs capable of making an impression predate actual printing by many centuries. There were wooden stamps in Egypt, brick seals in Babylonia, and clay seals in Rome. Among other purposes, stamps were used for branding animals and criminals, in the latter case to indicate the particular crime committed. However, the idea of using carved reliefs to print multiple images on surfaces such as paper originated in China.

Seals carved from various substances had been common in China from earliest times, but one crucial invention set the Chinese apart from other cultures—the technique of papermaking. According to legend, paper was invented in A.D. 105. The availability of this material opened up a whole new world. For the first time the images on seals—as well as those on stamped wall tiles and stone reliefs—could be transferred to a suitable surface by a simple process.

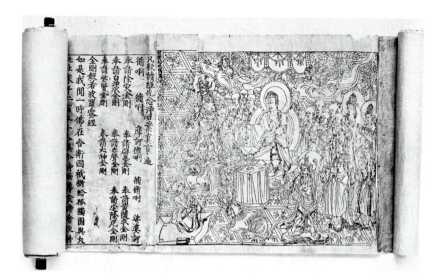

Dampened paper, placed over a stone slab and brushed vigorously to mold itself into the interstices of the stone, was rubbed on the top surface with a flat pad of ink. This process yielded an image of white characters on an inked background.

Out of this technique of rubbing stone or tile must have come the idea for printing as we now know it. However, it was the introduction and spread of Buddhism from India that gave impetus to this development. Buddhism, like Christianity and Judaism, uses the written word to promote, protect, and reveal its essential truths. The Buddha specifically instructed his followers about the value of transcribing and disseminating these truths in the form of standard texts, or *sutras*. Printing on paper offered a way to mass-produce, in scroll form, the sacred words and images. The method used was that which in the West would come to be known as *block book printing*. The text and the images of Buddhist deities were all cut in relief on the same block of wood. This block was then coated with a water-base ink, and paper was pressed against the surface, after which the paper with its printed impression was lifted off. One of the earliest known Chinese woodcuts—text and image—is the 17-foot long *Diamond Sutra* of A.D. 868, discovered in a walled-up cave by Sir Aurel Stein in 1907 (Fig. 1). The assured style and beauty of the design captures the effect of calligraphic brush work, suggesting that the woodcut in China must have already undergone a long period of maturation. It was to be many centuries before western woodcuts attained this level of sophistication and artistry.

Early Relief Prints in Europe

Among the first surviving records of European wood-block printing is a fragment of a block depicting a Crucifixion. This block, known as the *Bois Protat,* has

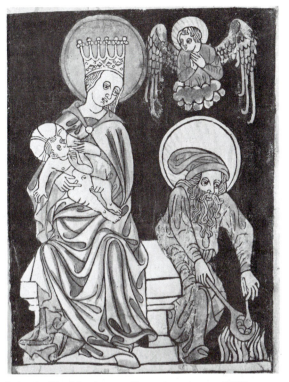

been dated about 1380, and it probably was intended
for printing on cloth. As can be seen in modern im-
pressions taken from the block (Fig. 2), it has a bold,
outline style suitable for textile decoration. The size
of the total block to which this fragment belongs
would have been too large for paper milled at that
time. It was not until about 1400 that paper was
available in sufficient quantity to be employed for the
printing of religious and secular images. At that time
the style and methods used previously for the textile
designs (Fig. 3) were adapted to paper.

The center for woodcut printing in the 15th cen-
tury was Germany. Of the rare surviving prints from
this era, one of the earliest and most beautiful is the
Rest on the Flight into Egypt (Fig. 4). Like the *Bois
Protat*, this woodcut has simple forms composed by
thick outlines; a heavy black ink is employed, and
there is no shading. The drapery folds, however, are
indicated by gracefully swelling loops. Hand coloring
effectively heightens the clear woodcut design.

The next phase of woodcut development is indi-
cated in one of the earliest dated prints, a *St. Christo-
pher* of 1423 (Fig. 5). Here the drawing style has be-
come more angular, and a thinner brown ink was
used for printing. Cut parallel lines form a rudimen-
tary shading. Coloring was done by hand or stencil.

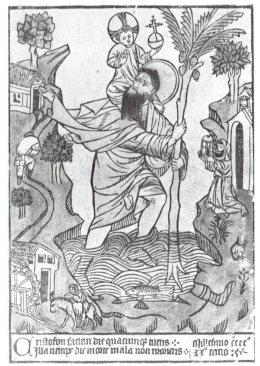

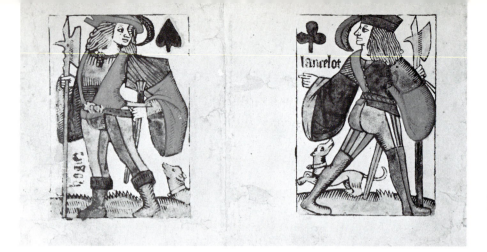

6. *Valet of Spades, Hogier* and *Valet of Clubs, Lancelot.* French. c. 1540. Hand-colored woodcut playing cards. Cincinnati Art Museum (John Onwake Playing Card Collection).

These early religious prints reveal one of the chief functions of the woodcut—that of providing multiple, accessible, sacred images. Religion played a central role in 15th-century life, and for the most part it was a religion marked by symbolism and superstition. The upper classes could afford painted altarpieces and illuminated manuscripts; for those of modest means, the printed woodcut offered a readily available icon to which they could address their prayers. In an era marked by rampant plagues and war, the sacred image acted as a charm for warding off evil and death. More-over, pilgrims to the holy shrines of medieval Europe found woodcut prints to be inexpensive and easily transportable souvenirs of their religious journeys.

Prints were also used to simulate illuminated manuscripts and textiles. Paste prints, which served this purpose, were impressions from dotted-manner blocks pressed into a doughlike paste spread on a sheet of paper. These prints are rare, since the hardened paste became brittle in time and began to disintegrate. There are now only about 200 extant examples of paste prints, most of which were exe-

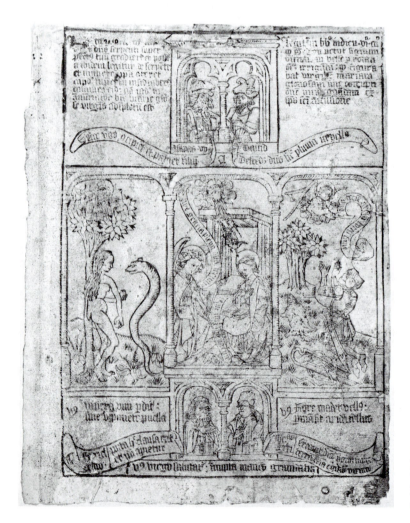

7. *The Annunciation,* from *Biblia Pauperum.* Netherlandish. 1465 or earlier. Woodcut. Metropolitan Museum of Art, New York (bequest of James Clark Maguire, 1931).

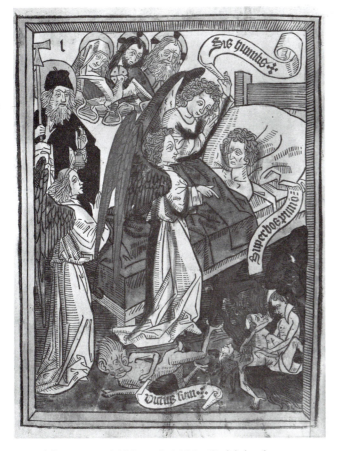

cuted between 1450 and 1470. Gold leaf, precious stones, bits of cloth, and other decorative materials were sometimes embedded in the prints, using glue.

But printing served not only as an aid to spiritual fulfillment. It could also contribute to pleasurable secular functions, among which the most prominent was card playing. Card games became popular in Europe among all classes of society in the mid-1300s, and by the early 1400s there was a mass market for the new, cheaply printed cards (Fig. 6).

Block Books

A special adaptation of the woodcut technique was its use in illustrated books. In the early 15th century, before the invention of movable type, both text and illustrations were cut into the same block, hence the name *block book*. The best known of these books is probably the *Biblia Pauperum*, or "Bible of the Poor" (Fig. 7). The woodcut images in this book feature illustrations of New Testament episodes, together with the Old Testament subjects that prefigured them and portraits of the prophets who had foretold them. These productions offered an intelligible, basic account of biblical stories, which could be understood by the predominantly illiterate populace of the time. Probably of Netherlandish origin, the *Biblia Pauperum* has a clear, forthright style.

above left: 8. *Ars Moriendi.* Netherlandish. c. 1466.
Page from block book, $8\frac{1}{2} \times 6\frac{1}{8}''$.
Kupferstichkabinett,
Staatliche Museen, Berlin.

above right: 9. *Jonah and the Whale,*
from *Speculum Humanae Salvationis.*
German. 1473. Woodcut.
Metropolitan Museum of Art, New York
(Harris Brisbane Dick Fund, 1923).

After the *Biblia Pauperum,* the most widespread block book was the *Ars Moriendi* or *Art of Dying,* which deals with the struggle between angelic and devilish forces for the soul of a dying man. Here again a Netherlandish master of great skill must have been responsible for the designs (Fig. 8). They reveal much sensitivity and sophistication in their use of shading to create effects of color, in the rendering of perspective, and in the dramatic interplay of the characters.

Book Illustration

A book much discussed by those who theorize about the origin of movable type is the *Speculum Humanae Salvationis,* or *Mirror of Man's Salvation.* This work was one of the first to combine printing from type with wood block images. In a later edition (Fig. 9), Günther Zanier of Augsburg had guild cutters produce blocks that were type-measure width. Unlike the

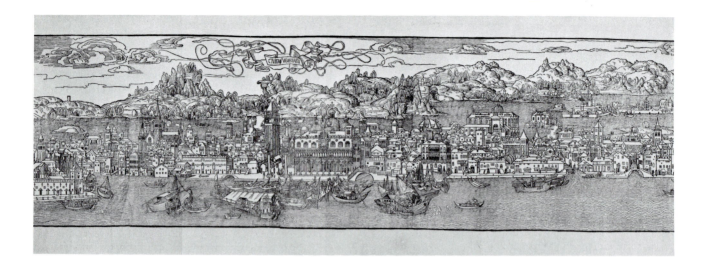

above: 10. **Erhard Reuwich.** *Venice,* detail
from *Sanctae Peregrinationes* by Bernhard von Breydenbach.
1486. Woodcut.
Metropolitan Museum of Art, New York (Rogers Fund, 1919).

below: 11. *Poliphilus Before Queen Eleuterylida,* from
Hypnerotomachia Poliphili. Italian. 1499. Woodcut.
Metropolitan Museum of Art, New York
(gift of J. Pierpont Morgan, 1923).

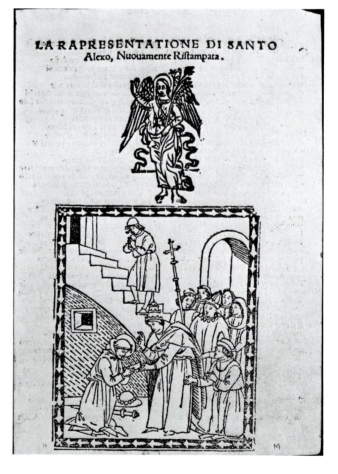

above: 12. *Miracle Play* from *Libro di Rapresentationi.*
Italian. c. 1490. Woodcut.
Metropolitan Museum of Art, New York
(Harris Brisbane Dick Fund).

early *Speculum* and the publications of Albrecht Pfister (which had burnish-printed blocks and press-printed type, Zanier's productions printed type and block simultaneously. Using movable type, he was able to change the typeface to suit various needs and preferences.

With the development of movable type in the mid-15th century, book illustration entered a new phase, for the image was freed from its direct tie to the text and could assume a new and larger format. One of the most impressive examples of this is a series of woodcuts by the Dutch-born artist Erhard Reuwich, illustrating his account of a journey he made in the company of the Dean of Mainz, Bernhard von Breydenbach, to the Holy Land in 1485. Published in

Mainz the following year, Reuwich's *Sanctae Peregrinationes* (Fig. 10) not only depicts the exotic peoples seen during the voyage, but also contains some of the first accurately drawn cityscapes. One of the travelers' stops was Venice, and to capture its panoramic vastness, Reuwich created the first foldout plate. Consisting of several woodblocks, this plate is nearly 5 feet long. Its sheer size and ornamental patterning alone stand as a great achievement, but the careful cutting and detailed observation add still further to this remarkable work.

Woodcutting in Italy

It may seem strange that a Northern artist should have been the one to make this great woodcut image of an Italian city, but in fact the Italians themselves did not really develop a style of woodcutting until the end of the 15th century. Reflecting the innovative developments of the Italian Renaissance, the southern style was one of exquisite lightness and openness. The most beautiful examples occur in a book published by Aldus Manutius in Venice in 1499, the *Hypnerotomachia Poliphili* (Fig. 11). This complex allegorical work is memorable chiefly for the woodcuts, which combine pure outlines and areas of solid black ink to create striking designs. The careful proportions of the figures and classically accurate perspective are in striking contrast to the many cramped, angular works produced at the same time in Germany.

In Florence the woodcut technique was adopted for innumerable small pamphlets having both religious and secular subjects. Possibly the most distinctive are those found in editions of popular plays known as *rapresentationi* (Fig. 12). Each illustration is surrounded by a decorative border. The emphasis on linear design recalls the style of such leading contemporary Florentine painters as Botticelli, but the rather simplistic patterning introduced by the wood block cutters endows the prints with an appealing naïveté.

Dotted Metalcuts

The metalcut or dotted print (*manière criblée*) emerged during the second half of the 15th century. To produce an image on a metal plate—usually of lead, pewter, or copper—the artisan used instruments more typical of the armorer's or goldsmith's shop. The plate was worked in such a way that it could be printed in the manner of a woodcut. Planes and surfaces were cut, punched, or stamped to produce an extremely decorative effect (Figs. 13, 196). Many extant metalcuts are highly expressive, but the technique remained arduous and stylistically limited. Thus it is not surprising that few examples can be found dating later than 1500.

Europe—the 15th and 16th Centuries

Albrecht Dürer

It was the painter and printmaker Albrecht Dürer who, with a production of more than 250 graphic works, raised the woodcut to the level of fine art. Born in the cultivated and prosperous city of Nuremberg, Dürer was first trained by his father in the art of goldsmithing and in 1486 entered the workshop of the city's leading artist, Michael Wolgemut. Here the young Dürer learned the fundamentals not only of painting, but also of printmaking and book publishing, for Wolgemut was responsible for the design and printing of several major works. The most important of these was the *Nuremberg Chronicle*, a history of the world from the time of the creation, which was illustrated with more than six hundred individual woodcuts (Fig. 14). Although the *Chronicle* was published after Dürer's departure, it is fairly certain that he was involved in this massive project. The woodcuts by

13. Master of Cologne Arms (?). *Christ and the Woman of Samaria.* c. 1450. Metalcut (crible print), 7 x 4½″. Stattliche Graphische Sammlung, Munich.

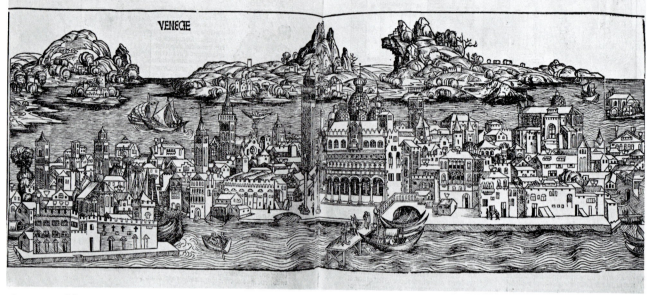

VENECIE

above: 14. *Venice.*
Illustration from *Nuremberg Chronicle*
by Hartmann Schedel.
1493. Woodcut.
Metropolitan Museum of Art, New York.

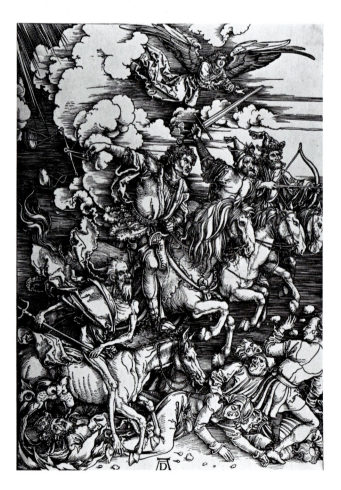

Wolgemut and his shop, often large, full-page scenes, display a crude, crowded Gothic structure. Great originality marks the rendering of textures and illusionistic settings. Dürer would later develop these very features in his own woodcuts.

After completing his brief apprenticeship in Wolgemut's shop, Dürer set out on a period of travel and study, from 1490 to 1494. He journeyed to Colmar to meet and work with the master engraver Martin Schongauer (Figs. 137, 138), but the older artist had died before his arrival. Dürer had to content himself with secondhand information from Schongauer's goldsmith brothers, who in turn sent him on to the city of Basel. There in 1492 he executed his first major woodcut.

After returning briefly to Nuremberg, Dürer again departed, this time traveling to Italy, where direct knowledge of the classicism preoccupying the Italian Renaissance masters created an impression that would influence the artist throughout his career. The results of this new approach are evident in Dürer's first major woodcut series, the fifteen prints illustrating the revelations of St. John the evangelist,

15. Albrecht Dürer.
The Four Horsemen of the Apocalypse,
from the *Apocalypse* series. c. 1497–98.
Woodcut, 15½ x 11″. British Museum, London.

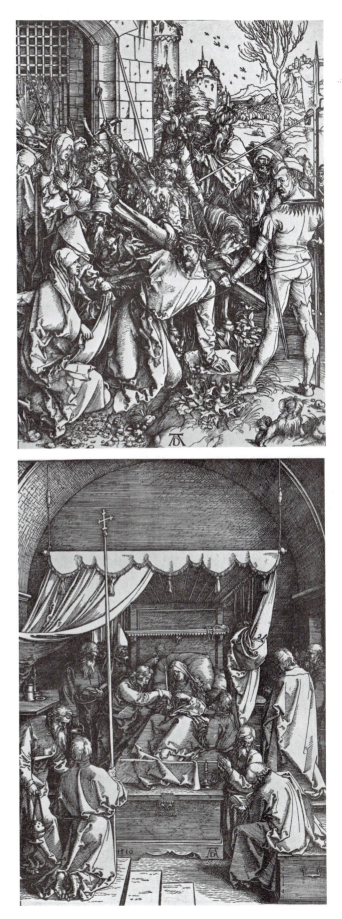

known as the *Apocalypse.* Like most of Dürer's wood
blocks, these works were cut by guild artisans known
as *Formschneiders.* The most famous block, *The Four
Horsemen of the Apocalypse* (Fig. 15), demonstrates a
new monumental quality combined with an unprece-
dented sense of movement and energy. The horse-
men—Famine, Death, War, and Pestilence—seem to
fly through a wind-whipped space on their horses,
trampling all of humanity. With remarkable skill
Dürer captures the sense of this visionary moment
through the most precise representation of details.
He achieves this not only through complex textures
of linear patterns, but also by an even more revolu-
tionary development—a variable-thickness line that
swells and tapers. The latter effect is much more eas-
ily obtainable in drawing or engraving. Dürer's pride
in his accomplishment is marked by the introduction
and prominent display of the distinctive monogram
that would henceforth appear on all his works.

During his long career Dürer made six different
versions of the Passion of Christ. The so-called *Great
Passion* series was completed in 1510, but most of the
prints date from the period 1497 to 1499, roughly the
same time the artist was at work on the *Apocalypse.*
Christ Bearing the Cross (Fig. 16) represents a splendid
example of this production. Like *The Four Horsemen*
this print has a dynamic composition, with strong
opposing diagonals crisscrossing the field. There is
here, too, an explicit scene of violence, in the
flagellation of Christ. However, in contrast to the
apocalyptic doom of total chaos, *Christ Bearing the
Cross* is a scene of pathos, largely because of the mas-
terful expressiveness with which Dürer has drawn
the faces of the onlookers—Veronica, Simon the Cy-
renian, St. John—as well as of Christ himself.

This same expressiveness assumed even greater
depth in the *Life of the Virgin,* another of Dürer's
major series. Many of these prints, such as the *Death
of the Virgin* done in 1510 (Fig. 17), are intimate genre
scenes, their quiet and composure a direct contrast to
the energy of the *Apocalypse* and *Passion* series. Care-
fully rendered architectural settings demonstrate
Dürer's advanced studies in Renaissance perspective.
The fine, linear drawing style emphasizes the flow of
draperies, the molding of volumes, and at the same
time creates an elegant decorative effect.

17. **Albrecht Dürer.** *Death of the Virgin,*
from the *Life of the Virgin* series.
1510. Woodcut.
Albertina Graphische Sammlung, Vienna.

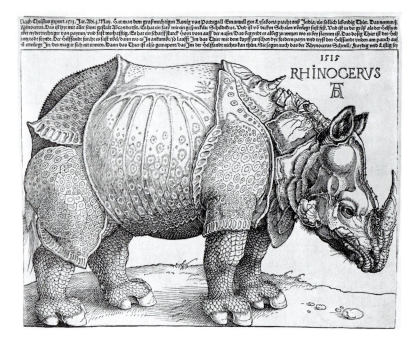

18. Albrecht Dürer.
Rhinoceros. 1515.
Woodcut, 8⅜ x 11⅝".
Metropolitan Museum of Art, New York
(gift of Harry G. Friedman, 1959).

One of the most amusing of Dürer's woodcuts is the exotic and imaginary *Rhinoceros* (Fig. 18). The artist never actually saw this beast, which had been sent in 1515 from India to Lisbon as a gift from the Sultan of Cambay to Emmanuel I, King of Portugal.

Dürer worked from a description sent from Portugal to Nuremberg, the text of which appears at the top of the print. Following this, he created a fantastic, armor-plated, scaly creature, whose massive bulk fills the entire space of the block. Dürer seems to have abandoned himself completely to a delight in sheer decorative surface detail.

A striking aspect of Dürer's career is that his talent was recognized immediately by his contemporaries—an unusual occurrence at that time. He was deeply involved in the most important religious and political developments of his age. Dürer became an adherent of the Protestant reformer Martin Luther, and many of his religious works, such as *The Last Supper* (Fig. 19), reflect Luther's teaching in their directness and simplicity.

Beginning in 1512, Dürer was employed by the Hapsburg Emperor Maximilian to work on a number of propagandistic projects. Among the grandest of these was an immense woodcut image of a triumphal arch to commemorate the Emperor's ancestry and pay homage to his own accomplishments (Fig. 20). Many artists worked on the project, but Dürer was the overall supervisor and designer. Completed in 1517, the arch consists of 192 blocks and measures slightly over 10 feet high and 9 feet wide. It is necessary to examine the work in detail to appreciate Dürer's ingenuity in conceiving endless ornamental patterns with which to decorate this fantastic structure.

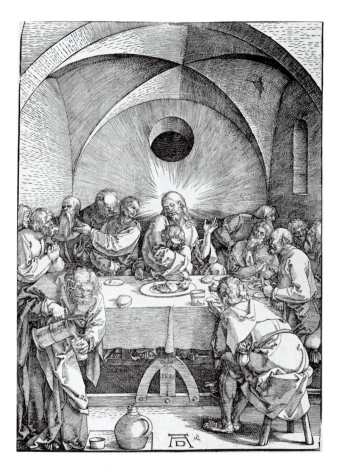

19. Albrecht Dürer. *The Last Supper,*
from the *Great Passion* series.
1510. Woodcut.
Metropolitan Museum of Art, New York (Rogers Fund, 1922).

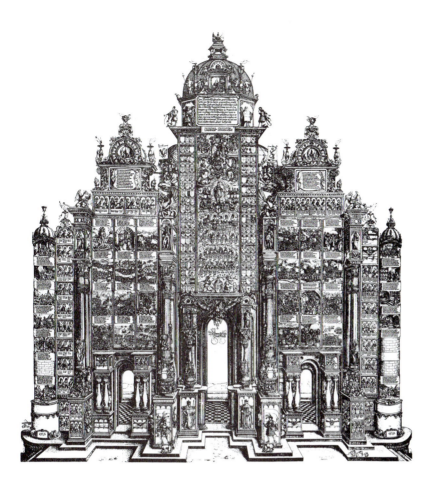

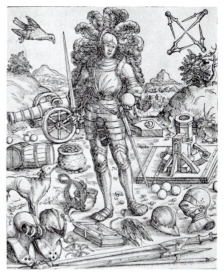

20. **Albrecht Dürer** (and others).
Triumphal Arch (left), and a detail *(above)*.
1515-17. Woodcut made from 192 blocks,
10′ × 9′4″. New York Public Library
(Astor, Lenox, and Tilden Foundations).

below: 21. **Albrecht Dürer.**
Triumph of Maximilian I, detail.
1518. Woodcut.
Metropolitan Museum of Art, New York
(gift of Junius S. Morgan, 1919).

Even more grandiose in conception was the *Triumph of Maximilian I*, an allegorical procession for which Dürer was commissioned to execute the triumphal car containing the Emperor (Fig. 21). This work, planned in 1512, was brought to an end by the death of Maximilian in 1519, but it was eventually issued as a sheet 60 yards long including the contributions of many artists. Dürer's portion shows the Emperor riding in state surrounded by the figures of the Virtues, who offer him wreaths. The driver, Rea-

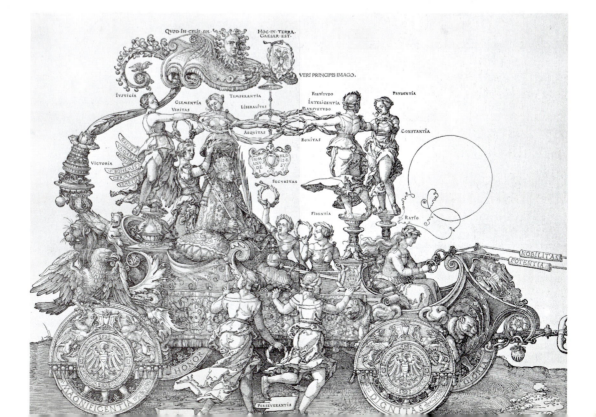

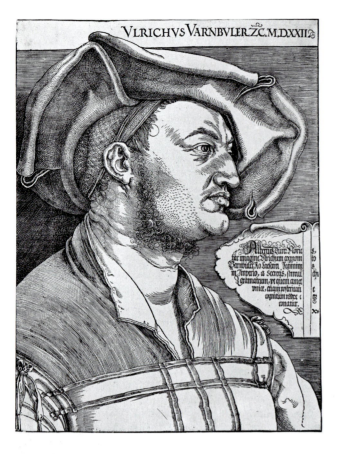

son, holds the reins of Power and Nobility, while the wheels of the car are Magnificence, Dignity, Honor, and Glory. As in the *Arch*, Dürer gave full expression to his elaborate, decorative style.

A similar impressive quality marks Dürer's portrait woodcuts. The portrait of his friend Ulrich Varnbüler (Fig. 22) makes use of an imposing profile view to give a sense of concentration and dignity to the otherwise fleshy figure. Through the simplest of means the artist has captured an astonishing variety of textures, from the heavy cloth of the beret to the prickly hair of the beard.

After Maximilian's death Dürer turned to other pursuits, directing his attention to scientific studies of the principles of measurement and proportion. The woodcuts he made to illustrate his treatises depict the various mechanical aids available to assist artists in drawing accurately. Once again Dürer's own clarity of design and total mastery of the woodcut make it possible to present the careful and accurate procedure necessary for turning visual aspects of the real world into a convincing art of illusion.

Dürer's art, particularly his perfection of the woodcut technique, dominated northern Europe in the early part of the 16th century, but there were many others who made valuable individual statements.

above: 22. Albrecht Dürer.
Ulrich Varnbüler. 1522.
Woodcut.
Metropolitan Museum of Art, New York
(Avery Fund, 1919).

right: 23. Hans Burgkmair.
Johann Paumgärtner. 1512.
Chiaroscuro woodcut, 11¾ x 9½".
Kupferstichkabinett,
Staatliche Museen, Berlin.

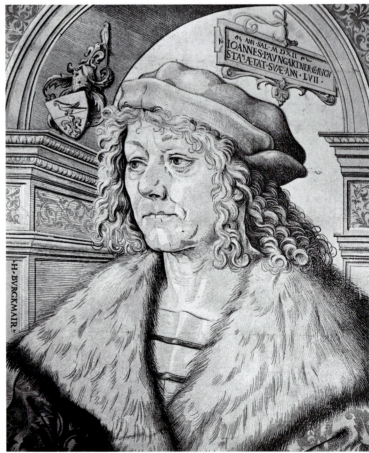

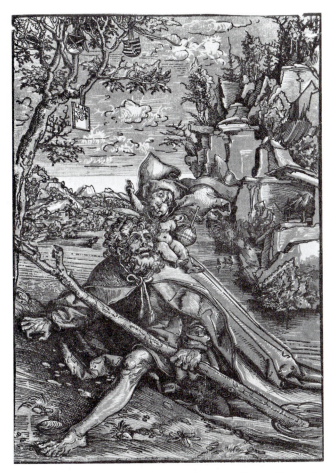

above **24. Lucas Cranach.**
St. Christopher. 1509. Chiaroscuro woodcut
with added color, 11 x 7⅝″.
Metropolitan Museum of Art, New York
(Purchase, Joseph Pulitzer Bequest, 1917).

right: **25. Urs Graf.**
Soldiers and Death. 1524.
Woodcut, 8 x 4⅝″.
Kupferstichkabinett,
Staatliche Museen, Berlin.

Dürer's Contemporaries

Dürer's woodcuts were, for the most part, traditional black-and-white images; other artists experimented with color and with different methods of printing from wood blocks. In the rich German banking city of Augsburg lived the artist Hans Burgkmair who, besides contributing to several of Maximilian's projects, also worked at perfecting the process of printing color, or *chiaroscuro,* woodcuts. Burgkmair used a multiple-block technique to obtain the rich chiaroscuro effect in his portrait of *Johann Paumgärtner* (Fig. 23). The figure of Paumgärtner is set in a Renaissance architectural background based on Italian prototypes. This device would later appear in the work of other artists, notably Hans Holbein the Younger.

Another artist who developed the chiaroscuro technique was Lucas Cranach, who became court

painter to the Elector of Bavaria in Wittenberg. Cranach was even more deeply involved with Luther and the Protestant Reformation than was Dürer; in both paintings and prints he produced a number of stirring religious images (Fig. 24). Although his woodcuts were much influenced in style by the work of Dürer, the cutting is less refined. Cranach's prints depend more on the chiaroscuro provided by a second plate for their rich effect, rather than on fineness of detail. In the *St. Christopher* a tablet hanging on the tree shows Cranach's device—a winged serpent—which later became his coat of arms.

The Swiss soldier and artist Urs Graf also experimented with technique, especially with a type of white line engraving. He is best known, however, for depictions of his favorite subject—the elaborately dressed soldiers of the period. The conventional woodcut *Soldiers and Death* (Fig. 25) shows two such stalwarts, overdressed and equipped to the point of

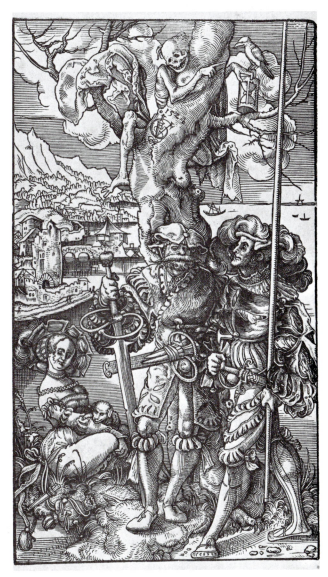

ting not merely as a classical reference, as some of his predecessors had done, but as a real space in which action takes place. The crowding of figures in the lower half of the print heightens the drama.

Like Burgkmair and Cranach, Altdorfer made a number of chiaroscuro woodcuts. *The Beautiful Virgin of Ratisbon* (Pl. 1, opposite), an extraordinarily well-printed multiple-block image, reminds one of a formal altarpiece. Here the architecture is purely decorative, a device for framing the Madonna and child.

Aspects of Dürer's style combine with an emotional, sometimes macabre mysticism in the work of Hans Baldung Grien. Trained in Dürer's workshop, Baldung turned his master's forceful drawing style and interest in perspective to quite different ends. His portrait of *Luther as a Monk* (Fig. 27) shows the reformer not as a worldly leader but as a humble, pious man struck by divine inspiration. The ethereal light of the Holy Ghost radiates behind Luther's head. There is an overall quality of softness in the print, which lacks solid blacks or restraining outlines.

26. Albrecht Altdorfer.
Death of the Virgin, from the *Passion* series.
c. 1515. Woodcut, $2\frac{7}{8}$ x $1\frac{7}{8}$".
National Gallery of Art, Washington, D.C.
(Rosenwald Collection).

27. Hans Baldung Grien.
Luther as a Monk. 1521.
Woodcut, 6 x $4\frac{1}{2}$".
Kupferstichkabinett,
Staatliche Museen,
Berlin.

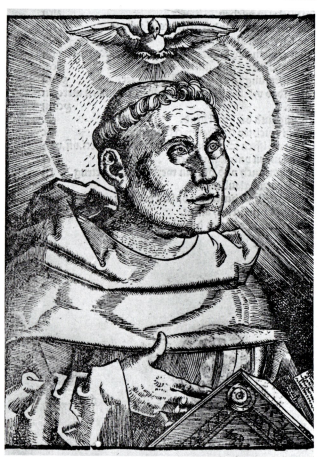

ludicrousness. Juxtaposed against them is the macabre figure of Death perched in the tree. Sudden and often violent death was a frequent enough occurrence in that time to make it a preoccupation of the people. Death images abound in the art of 16th-century northern Europe.

Among the most important of Dürer's successors was Albrecht Altdorfer, a native of Regensburg. Altdorfer was the son of an engraver, and, unlike most of his contemporaries who emphasized the woodcut, the artist made a number of etchings and engravings. Even his woodcut style seems closer, in some respects, to an intaglio effect, as a scene from the *Passion* series illustrates (Fig. 26). Altdorfer used an exceptional amount of cross-hatching to create tone, with the result that his prints show rich patterns of gray without any strong blacks. Elements of his compositional style can also be seen from the *Death of the Virgin* print. Altdorfer employs the architectural set-

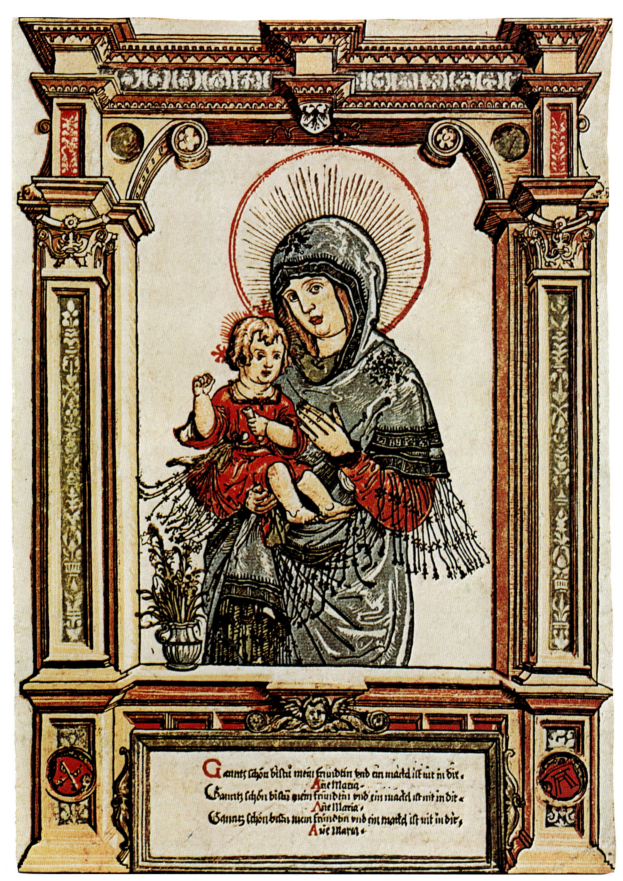

Plate 1. Albrecht Altdorfer. *The Beautiful Virgin of Ratisbon.* c. 1519. Color woodcut, 13⅜ × 9⅝″.
National Gallery of Art, Washington, D.C. (Rosenwald Collection).

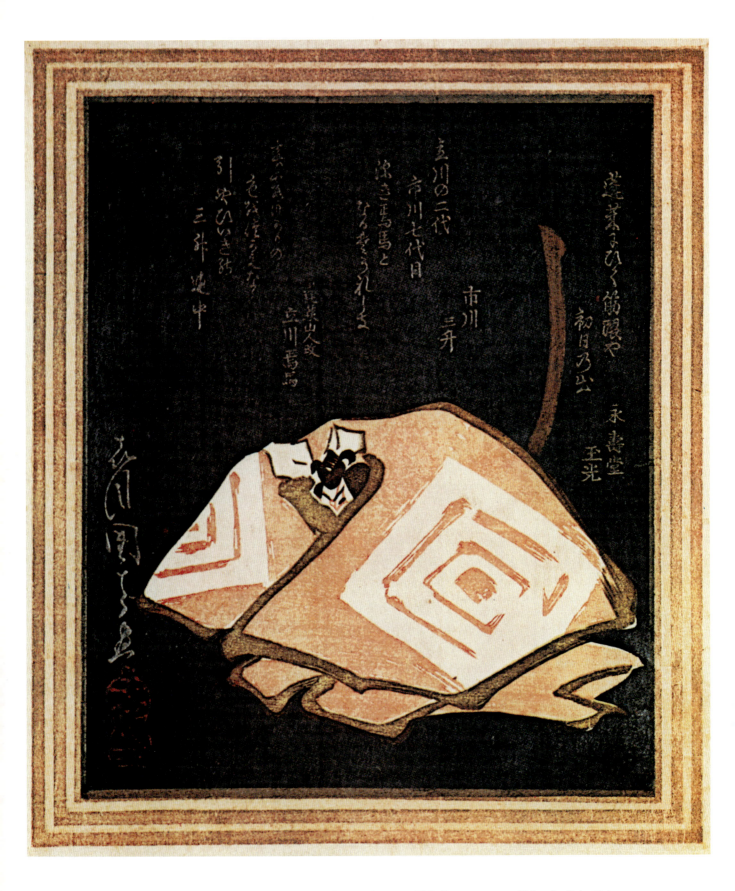

Plate 2. Danjuro VII. *Danjuro (?) in a Shibaraku Role.* 19th century.
Color woodcut with mica and brass powder applied, surinomo, 8 × 7″.
Metropolitan Museum of Art, New York (Rogers Fund, 1922).

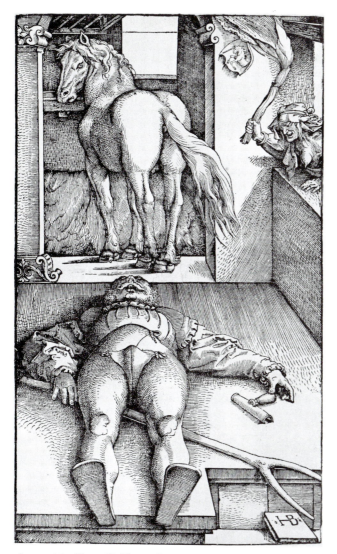

also made a number of excellent woodcuts, of which *Jezebel and Ahab* (Fig. 29) provides a splendid example. This work sets the Biblical story of Jezebel in a typical Dutch genre interior rather than a contemporary setting—an unusual approach for that time. The style is more painterly than Dürer's, with a multitude of hatched and cross-hatched lines ending in hooked or tapered points. This linear complexity endows the print with a rich tonal quality.

The last in the great line of German Renaissance masters is Hans Holbein. Although often remembered primarily as the court painter for Henry VIII of England, Holbein had previously established himself as one of the leading woodcut designers of the time. While working in Basel he created his most important set of woodcuts, the *Dance of Death,* published in 1538 (Fig. 30).

The story of the *Dance of Death,* or *Danse Macabre,* originated in the 13th century. The "dance" as a concept probably evolved from a processional play utilized by the church to teach morality. Its theme was

below: **29. Lucas van Leyden.**
Jezebel and Ahab. 1517–18.
Woodcut, 9½ x 6¾".
Metropolitan Museum of Art, New York
(Rogers Fund, 1922).

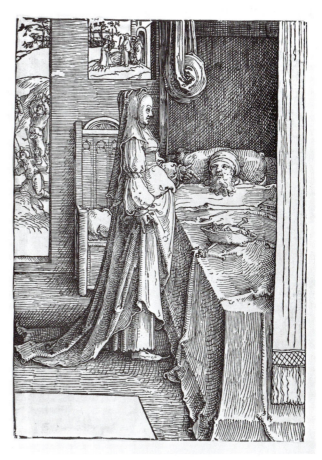

above: **28. Hans Baldung Grien.**
The Bewitched Groom. 1544.
Woodcut, 13½ x 7⅞".
Kupferstichkabinett,
Staatliche Museen, Berlin.

Most famous of Baldung's woodcuts is *The Bewitched Groom* (Fig. 28), which displays his fascination with witchcraft and magic. Under a spell cast by the burning torch the witch holds, the groom has fallen into a deep trance, leaving the great horse in his care free to escape. The interplay among the three figures is extremely powerful; the atmosphere seems filled with energies and fears of all kinds. Baldung's debt to Dürer is particularly clear in this woodcut. The horse is based on a prototype of the master's, while the stunning foreshortening employed for the groom shows how well Baldung had learned his figure work from Dürer.

Lucas van Leyden is considered by many to be the "Dürer of the Low Countries." While as a printmaker Lucas is better known for his engravings (Fig. 147), he

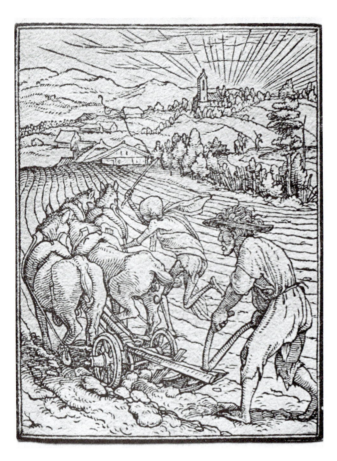

30. Hans Holbein the Younger.
The Husbandman, from the *Dance of Death*.
1538. Woodcut.
Metropolitan Museum of Art, New York
(Rogers Fund, 1919).

large blocks, and they avoid laborious techniques. Dürer, who approached the process more as a facsimile device, made little effort to alter his drawing technique to accommodate the limitations of the block cutter. Holbein, on the other hand, simplified the work of his cutter, Hans Lutzelburger, by finding the most direct means of obtaining delicate, expressive lines. As in all great works, technique is subjugated to expression and content.

The original drawings for the *Dance of Death* were made in 1526 in Basel, and a number of blocks were printed before publication of the entire work in 1538. By 1563 thirteen editions existed, in Latin, French, and Italian. After that date, many editions were made from new blocks and from engravings in metal—all of which were technically inferior to the earlier work of Lutzelburger.

Holbein's interpretation is filled with personal expression quite unlike the earlier work of other artists on the same subject. Possibly because of his extensive portrait work, the artist was able to bring his subjects emotionally close to the viewer. As we look at the works, it becomes apparent that each line is an assertion and that each subject describes Holbein's intractable attitude toward religion and immortality. Death's triumph is viewed as a step toward the new spiritual life, yet it is final and sorrowful. Death serves the King, accompanies the Queen with her ladies to an open grave, runs off with the mitre and crozier of an abbot, and steals the attention from a preacher by standing behind him with a more dread sermon. A nun turns to her lover as Death, behind her back, snuffs out a candle. He runs alongside the horses of a plowman and tugs at the shirt of a peddler.

Death the leveler, and the people confronted by him encompassed all ranks and stations, from the emperor to the fool. Death appears as a skeleton, but the skeletons may also be afterimages, posthumous reflections of each of the figures described. Throughout the Middle Ages and early Renaissance, many artists explored this fascinating theme; none, however, brought to it as masterful a treatment as Holbein.

Holbein's *Dance of Death* displays the consummate use of the traditional woodcut method. The prints are small, especially in comparison to Dürer's

31. Hans Holbein the Younger. Letters A, B, and C from the *Alphabet of Death*. c. 1525. Woodcut, each 1″ square. Metropolitan Museum of Art, New York (gift of Robert Hartshorne).

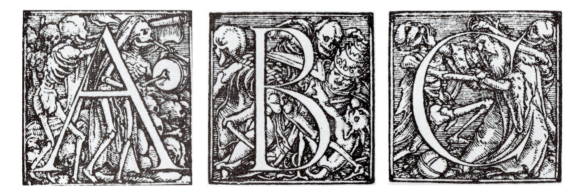

corum, TOMVS Primus. 21

Plantago Rubea.

Rot Wegerich.

All told, the *Dance of Death* reveals the full power of Holbein's draughtsmanship, as it evolved from his designs for silver and gold plate. He retained the jewellike quality in his work whether the image was large or small; similarly, he retained the sense of mass in his figures whether in a full-scale portrait or in the 2½-inch format of the *Dance of Death*.

Preliminary studies for the *Dance of Death* can be seen in Holbein's series, the *Alphabet of Death* (Fig. 31), probably also cut by Lützelburger. This alphabet has 24 letters, the I and J as well as the V and U being interchangeable. The prints, each about 1 inch square, show Roman letters against a background that portrays Death in the form of a skeleton victimizing all sorts of people—from the Pope to the money-changer. From A to Z the woodcuts depict impudent Death with great clarity—all this never interfering with the readability of the initial.

Our discussion of 16th-century Northern prints would not be complete without some mention of book illustration. A shining example of this production is the *Herbarum Vivae Eicones* (*Living Figures of Plants*) (Fig. 32), published in Strasbourg in 1530. The *Herbarum* resulted from a collaboration between the physician Otto Brunfels and the artist Hans Weiditz. In most earlier and contemporary herbals, the illustrations were drawn from memory or from verbal descriptions. By contrast, the images in the *Herbarum Vivae Eicones* were drawn, as the name implies, directly from life and with apparently careful observation, as testified by the occasional torn leaves and other natural defects. The drawing style is simple and graceful; hatched lines delineate the shadows under leaves and around roots. The *Herbarum* fulfilled the needs of botanical science and of the general public.

French and Italian Masters

During the 15th and 16th centuries artists in Germany and the Low Countries were the undisputed masters of relief printing. Nevertheless, a number of French and Italian artists adapted the techniques.

Geoffrey Tory, who worked in Paris, was influential in introducing the Italian Renaissance style of drawing to France. A book of metalcuts, *Champfleury*, published in Paris in 1529, included discussions of the French language, Italian humanistic ideas, and examples of the proportions of Roman letters as related to the human body (Fig. 33). Tory is perhaps best known, however, for having been granted a descriptive copyright to protect his designs from plagiarism.

In Italy the great painter Titian was among the earliest in a long line of artists who realized the po-

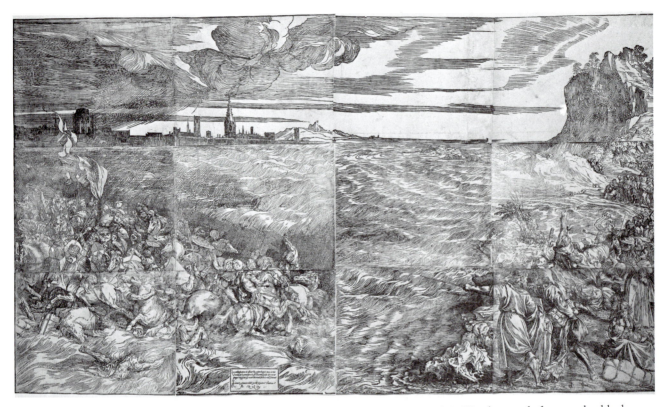

34. Titian (cut by Domenico dalle Greche). *Pharaoh's Army Drowned in the Red Sea.* 1549. Woodcut made from twelve blocks, 15¾ x 22″. Metropolitan Museum of Art, New York (Harris Brisbane Dick Fund, 1927).

tential of the printed medium for making multiple copies of his works. Eventually, woodcuts based on his designs became monumental projects, independent of painted sources. The largest of these, consisting of twelve blocks, is *Pharaoh's Army Drowned in the Red Sea* (Fig. 34). Cut by an artisan known as Domenico dalle Greche, this vast work manages to preserve the sweep and grandeur of Titian's composition. Much of the image shows the sea itself, but it is a sea writhing and glowing with energy, reflecting his lifetime spent in the watery city of Venice.

One of the more impressive aspects of Italian woodcutting from this period is its stylistic variety. While Titian worked his designs for traditional block cutting, another Venetian, Giuseppe Scolari, perfected a white-line technique that expanded the methods used by Graf. In *The Man of Sorrows* (Fig. 35) it is the swirl of the white line over the arm and drapery that defines the form, not the customary black line. The drapery background is cut as one would cut an intaglio plate, and the crown of thorns is striking for its stark whiteness. This work anticipates the line engraving technique.

35. Giuseppe Scolari.
The Man of Sorrows. c. 1580.
Woodcut.
Metropolitan Museum of Art, New York
(Elisha Whittelsey Fund, 1953).

36. Hendrik Goltzius. *Arkadische Landschaft.* 16th century.
Chiaroscuro woodcut, 7⅛ x 10″. Rijksprentenkabinet, Rijksmuseum, Amsterdam.

17th- and 18th-Century Relief Prints

In the 17th century engraving and etching became the dominant printmaking methods (see Chap. 3). Nevertheless, a few individual artists of great merit, primarily in the Lowlands, continued to make important woodcut works.

Northern Masters

A virtuoso master of engraving, Hendrik Goltzius of Haarlem also produced some outstanding woodcuts. Goltzius combined the ideas gleaned from a period of study in Italy with his native northern manner to forge a uniquely powerful style. His woodcut landscapes (Fig. 36) have a fluid line and strength of contour that recall relief works by Titian and his followers. Goltzius was also among those most interested in the chiaroscuro woodcut. He designed many using a strong black block to offset the paler colors.

In the circle of artists around Rembrandt (who, as we shall see, concentrated solely on intaglio techniques, Chap. 3) only one turned to woodcut as a means of expression. This was Jan Lievens, who worked with the great master during his early Leiden period. Lievens later moved to Antwerp and began to cut woodcut portraits of a strikingly individual and modern look (Fig. 37). Concentrated areas of black

37. Jan Lievens.
Man in Armchair. 16th century.
Woodcut, 6⅞ x 5½″.
Rijksprentenkabinet, Rijksmuseum, Amsterdam.

left: 38. Illustration from
*The History of Sir Richard Whittington,
Thrice Lord Mayor of London.*
English. 18th century. Woodcut, 3″ square.
British Library, London.

below: 39. **Thomas Bewick.**
The Tawny Owl, from *History of British Birds.*
1804. Wood engraving.
Metropolitan Museum of Art, New York
(Harris Brisbane Dick Fund, 1931).

line not only capture the character of the sitter but also effectively suggest the various textures of cloth, skin, and chair. The imagery is direct and powerful—obviously not the product of an artisan cutter interpreting the artist's drawing, but rather the work of an artist cutting his own block.

Chapbooks

A very special category of woodcut prints from the 18th century are the illustrations from chapbooks—inexpensive little books sold by itinerant peddlers to the general public. Containing simple tales and ballads, these books were illustrated by untutored artists employing primitive, crude techniques (Fig. 38). Many histories of printmaking do not consider them at all; undeniably the quality of the drawing is coarse. Still, the chapbooks have a direct, forthright quality comparable to that of folk art and to the naïveté of concept found in works by 20th-century "primitive" painters. While outside the mainstream of art prints, they are a very direct form of visual communication.

19th-Century Relief Prints— Europe and the United States

As must be obvious from the brevity of the preceding section, the woodcut fell into a period of decline after the 16th century. Its main function became the illustration of popular books and magazines, and only gradually was the expressive power of the medium rediscovered. One can get a capsule view of the decline and revival of the woodcut by tracing its history in England.

A more refined and improved method of illustrating books began with Thomas Bewick of Newcastle. Trained as a copperplate engraver, Bewick found

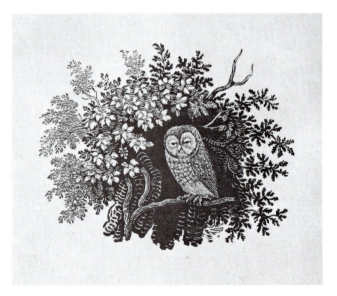

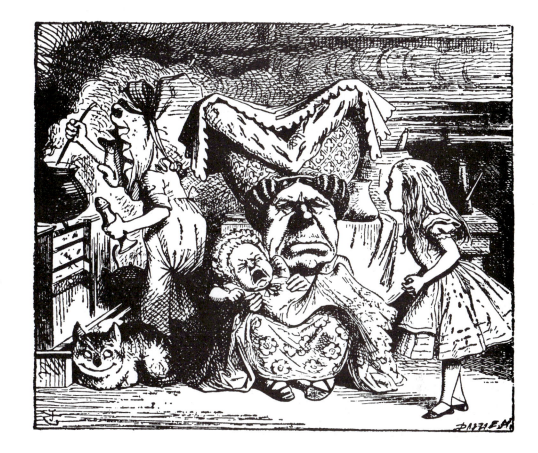

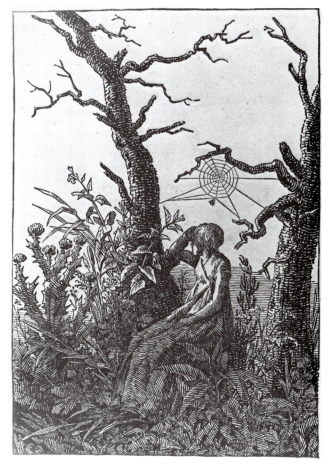

that by using his metal cutting tools on the end grain of one of the hardest woods—boxwood—he could incise white-line images of the most delicate and precise quality (Fig. 39). Another advantage of this technique was that the hard wood, combined with improved printing processes, would yield many more impressions than soft metal plates.

Perhaps the most famous English illustrator of the 19th century was John Tenniel. A cartoonist by trade, Tenniel is best remembered now as the illustrator of Lewis Carroll's *Alice's Adventures in Wonderland* (Fig. 40). So appropriate were his designs that the author often recast his words to match them. Tenniel's classic illustrations are still cherished in facsimile editions of *Alice*.

In Germany the Romantic movement and style that spread through Europe in the early and mid-19th century found its expression in relief prints as well. The painter of soaring mountain landscapes and quiescent spiritual dawns, Caspar David Friedrich, produced designs for several woodcuts, which were executed by his brother. In *The Spider Web* (Fig. 41) the

Schnupdiwup! Da wird nach oben
Schon ein Huhn herauf gehoben;

42. Wilhelm Busch.
Illustration from *Max und Moritz*,
1865. Wood engraving.
(Munich: Braun and Schneider).

greater appeal than the stark photographs taken by Matthew Brady of the same subject.

Thomas Nast, a staff artist for *Harper's Weekly*, elevated the political cartoon to the status of an art form (Fig. 44). With his incisive caricatures and exquisite drawing style Nast attempted to capture the sympathies of his readership for the social reform he so passionately desired.

The relief book illustration was doomed almost from the moment it achieved its highest standard of excellence. While in the 1860s Brady's pictures of the Civil War were still too "real" for most people, within a very few years the photograph would completely supplant the print as an illustrative medium. The focus of relief prints then shifted almost exclusively to artistic expression, and a major stimulus for this development was the introduction of Japanese prints to the Western world.

Japanese Woodcuts

When Commodore Perry opened Japan to the West in 1854, a great stream of artistic inspiration was released. Most of this took the form of distinctive color woodcuts known as *ukiyo-e,* or "pictures of the transient world of everyday life." The Japanese woodcuts had a profound effect on Western artists, especially the group working in Paris in the late 19th century, so it is well to examine them in detail.

The stimulus for the Japanese production of woodcuts may have come from China. In the years between 1679 and 1701 in China there appeared a manual or encyclopedia on the technique of painting entitled *The Mustard-Seed Garden*. This book was illustrated with many delicate woodcuts in both color and black and white, in the styles of various artists. Imported to Japan, *The Mustard-Seed Garden* definitely served as a catalyst to local development in advanced printing methods.

The *ukiyo-e* style was based on the pleasures of everyday life. Its subject matter was vogue: the newest robes, hairdos, daily pleasures, and kabuki theater. Depictions of actors in particular roles were especially common (Pl. 2, p. 22). Early *ukiyo-e* were printed in black-and-white, but between 1743 and 1765 the technique of color printing from multiple blocks evolved.

The first great artist to develop this method was Suzuki Harunobu. Taking advantage of a new invention called the *kento* (see p. 63), a registration device, Harunobu produced marvelously sensitive poly-

woman's averted face, the bare trees, and the spiky plants—all silhouetted against a white background—create a mood of romantic gloom and melancholy.

Friedrich's countryman Wilhelm Busch developed his ideas in quite a different direction. With his amusingly captioned drawings of two bad little boys—Max and Moritz (Fig. 42)—Busch in effect developed the forerunner of the modern comic strip. His style had a great influence on popular illustration art in Europe and later in the United States.

Relief prints for book and magazine illustration reached their zenith in the United States in the mid- and late-19th century. Two artists in particular were so widely reproduced that they exerted considerable influence on the political and social awareness of the time. Winslow Homer, whose wood-engraved illustrations appeared in *Harper's Weekly* and other magazines, captured the spirit of 19th-century American values. His beautifully drawn and somewhat romanticized scenes of the Civil War (Fig. 43) had far

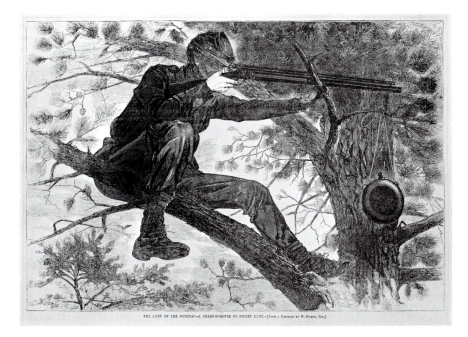

43. Winslow Homer.
*The Army of the Potomac:
A Sharpshooter on Picket Duty.*
Wood engraving, 13¾ x 20⅛".
From *Harper's Weekly,*
November 15, 1862.
Whitney Museum of American Art,
New York.

chrome works known as "brocade pictures." The flowing style of his designs was perfectly suited to the renderings of languorous aristocratic ladies and girls, who were his chief subjects (Fig. 102). Harunobu further embellished these prints with *gauffrage* or blind embossing—stamping the impression of an uninked woodblock onto the paper for a relief surface.

With the development of the multiblock technique, the division of labor in woodcut production became pronounced and standardized. It was the artist who made a line drawing in black and white on thin paper. This work was then glued to a block facedown by the cutter, who cut the key block and took

several impressions to give to the artist for hand coloring. Each color was then cut on a separate block. From these was made the approved edition of the print that bore the artist's name. (Details of the *ukiyo-e* technique are given on pages 53 to 68.) Sometimes mica, or colored powders, would be added to the surface for even richer effects (Pl. 2). Mass-produced in this way, the prints were relatively inexpensive and immensely popular.

One of the most popular *ukiyo-e* artists was Kitagawa Utamaro, who produced more than a thousand works. Utamaro devoted considerable attention to the female figure (Fig. 82). In *The Fickle Type* (Fig.

44. Thomas Nast.
The Power of the Press.
Wood engraving.
From *Harper's Weekly,* May 9, 1874.
New York Public Library
(Astor, Lenox
and Tilden Foundations).

45) one can see the assurance of his line, as the robe cascades in sweeping curves. Each form is placed carefully to contribute to the overall balance of the work. This woodcut deliberately gives the impression of a candid image, with the woman half turning away, the robe slipping off her shoulder, and the interrupted gesture of her hands.

Utamaro's contemporary, Chobunsai Eishi, also concentrated on the female figure. In his depiction of *Komurasaki of Kodatama-ya* (Fig. 46) there is a wonderful treatment of the volumes, folds, and curves of traditional Japanese costume. The interplay between body and voluminous clothing is a fascination of much Japanese art.

In the 19th century the *ukiyo-e* depiction of figures and actors passed into a decadent stage, and works by the two leading masters—Hokusai and Hiroshige—were preoccupied mainly with various aspects of landscape and the natural world. Katsushika Hokusai so devoted his long life to art that in later years he often signed himself "the man mad about painting." Hokusai was, as his innumerable views of Mount Fuji show, a tireless observer of nature in all its guises and seasons. In his famous *Great Wave of Kanagawa* (Fig. 47) the volcano is all but obscured by the powerful sweep of the sea caught in a moment of peak action.

Ando Hiroshige was in many ways the last master of the great tradition. For a period in his life he was a river inspector, and this occupation gave him both the time and the opportunity to study the landscape scene around the great waterways of Japan. His woodcuts (Fig. 48) show human figures reduced to a minuscule scale; great areas of sky and water dominate. Hiroshige captured in a new and original fashion the atmospheric effects of the elements. His softening of edges and use of the wood grain contrasts with Hokusai's more precise, sharp-edged view. Both artists were to be of decisive influence when Japanese woodcut prints burst into the European art scene in the late 19th century.

below left: 45. Kitagawa Utamaro.
The Fickle Type, from the
Ten Physiognomies of Women series. c. 1793.
Woodcut with mica background, 14 x 9⅞".
British Museum, London.

below right: 46. Chobunsai Eishi.
Komurasaki of Kodatama-ya, from the
Greenhouse Beauties as the Six Poets series. c. 1795.
Woodcut, 15¼ x 10¼".
Art Institute of Chicago
(Clarence Buckingham Collection).

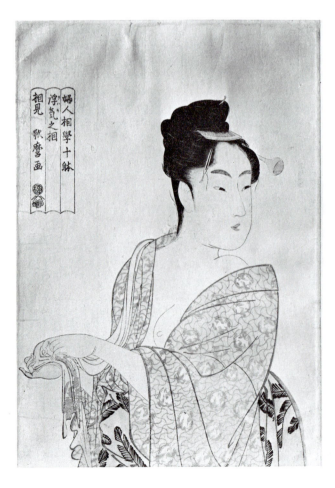

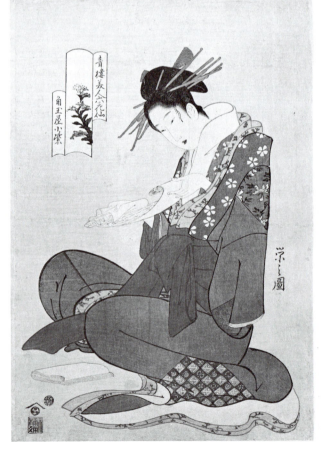

47. Katsushika Hokusai. *The Great Wave of Kanagawa.* c. 1823–29. Color woodcut, 10 x 15″. Metropolitan Museum of Art, New York (Howard Mansfield Collection, Rogers Fund, 1936).

Europe and the United States after 1890

The Japanese Influence

During the years following Perry's trip to Japan, works of art began to flow westward; at first, though, the influx consisted mainly of decorative objects. In 1856 the French artist Felix Bracquemond accidentally discovered a copy of Hokusai's book *Manga* in his printer's shop. The book had been used to pack porcelain. Eventually acquiring a copy for himself, Bracquemond introduced the prints to many artists working in Paris. Within a few years, the craze for Japanese woodcuts had spread among collectors, scholars, and artists, and by 1890 an exhibition at the Ecole des Beaux-Arts contained more than a thousand examples of the Japanese printmaker's art.

Few of the artists who collected and admired the *ukiyo-e* woodcuts had any desire to make prints them-

48. Ando Hiroshige.
Fishing Boats Returning to Yabase,
from *Eight Views of Biwa.* c. 1830–35.
Color woodcut, 9⅛ x 14″.
Brooklyn Museum, New York
(Frank L. Babbott Fund).

History of Relief **33**

49. Paul Gauguin. *Te Atua* (*The Gods*). 1891–93.
Woodcut printed in black and red, 8⅛ x 14⅛″. Art Institute of Chicago.

selves. Many were painters who took from the wood-cuts elements of style, composition, or subject matter that would be useful in their own work: flat pictorial space, angles of vision, abstract patterns, cropped images, lyrical line, flattened colors, calligraphy, theatricality, shortened perspective, economy of form, atmospheric effects, preoccupation with nature, and compelling human emotions. However, two artists in particular, whose overall production was influenced by *ukiyo-e*, actually made a number of woodcuts. These were Paul Gauguin and Edvard Munch.

When Gauguin returned to Paris in 1893, after his first sojourn in Tahiti, he published a number of large woodcuts based on exotic themes developed in the South Pacific, and done in the context of familiarity with *ukiyo-e* (Figs. 49, 56). Having practiced his technique by carving crude wood sculptures, he literally attacked the planks pieced together from smaller wood blocks. The action of the knife cutting into wood becomes part of the imagery. This rough quality was abetted by Gauguin's method of using sandpaper to achieve variations in tone and a needle for the fine white lines. His deliberate primitivism in these depictions of native life exploits the black and white contrasts of the woodcut to suggest the intense mysticism and symbolism underlying his work.

Following in Gauguin's footsteps, the Norwegian artist Edvard Munch also combined an interest in the woodcut texture with a knowledge of Japanese prints to express his highly personal imagery. A clear example of this mixture can be seen in *The Kiss* (Fig. 50). Here the grain of the wood block has been permitted to dominate the surface of the print, thus contribut-

ing to the mood of the work, while the composition of the figures is reminiscent of Japanese prints.

Munch is also notable for his experimentation with multicolor woodcuts (Pl. 7, p. 75). The method he devised replaced the old one of overprintings from different color blocks. Instead of this procedure,

50. Edvard Munch.
The Kiss. 1902.
Color woodcut, 18⅜ x 18⁵⁄₁₆″.
Museum of Modern Art, New York
(gift of Abby Aldrich Rockefeller).

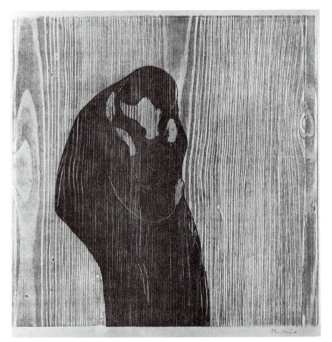

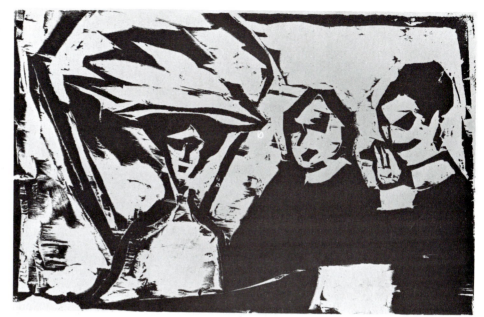

51. Ernst Ludwig Kirchner. *Three Figures.* 1909.
Woodcut. Albertina Graphische Sammlung, Vienna.

Munch cut out various sections of the block, inked them separately, and then reassembled the block.

Later Western Prints

Possibly the greatest revival of woodcutting took place in Germany at the beginning of the 20th century. Consciously imitating the old Gothic tradition of simple, directly cut images, a number of artists, aptly labeled Expressionists, produced works of great, often frightening, immediacy. Of those who formed a group called *Die Brücke* ("The Bridge") in Dresden

Ernst Ludwig Kirchner and Emil Nolde were outstanding. Their styles were quite different, however.

In a work such as *Three Figures* (Fig. 51) Kirchner displays the immense vitality of his method, swiftly gouging out large sections of the wood to produce harsh black-and-white contrasts. It is likely that the cutting was done with no preliminary drawing on the block, to retain the immediacy of the expression.

Nolde was a more somber, more mystically inclined artist. In the woodcut known as *Fishing Boat* (Fig. 52) we see the same bold cutting and stark con-

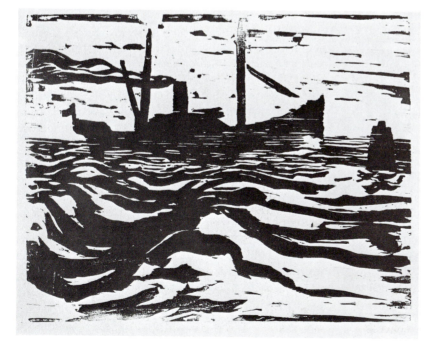

52. Emile Nolde.
Fischdampfer (Fishing Boat). 1910.
Woodcut, 11¾ x 15⅜".
Nolde-Museum,
Seebüll, West Germany.

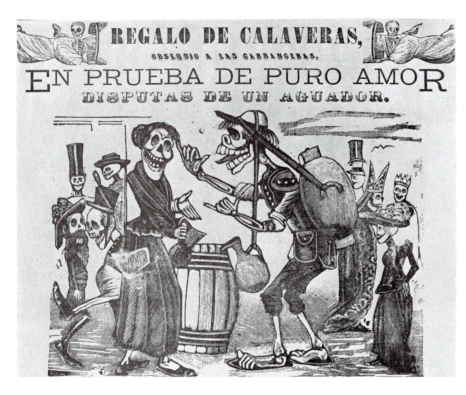

REGALO DE CALAVERAS,
OBSEQUIO A LAS GARBANCERAS.

EN PRUEBA DE PURO AMOR
DISPUTAS DE UN AGUADOR.

53. Guadalupe Posada.
*Regalo de Calaveras,
En Prueba de Puro Amor*, detail.
20th century. Metalcut.
Metropolitan Museum of Art, New York
(Whittelsey Fund).

trasts, yet there is a sense of control in the definite horizontals of the water line and clouds. The boat in the distance is haunting and mysterious, with some of the elusive quality of a dream image.

As with so many other aspects of 20th-century art, it was Pablo Picasso who gave a new impetus to the art of relief printing. In fact, finding the strictures of wood not at all to his liking, Picasso abandoned the old material in favor of a more modern substance— linoleum. Picasso began his linoleum cuts in 1939, but they reached their greatest height of technical splendor in the late 1950s and 1960s, with complex multicolor works such as *Bust of a Woman after Cranach the Younger* (Pl. 8, p. 76).

The Cranach study was printed by a conventional multiblock system. However, Picasso also developed a unique method for multicolor linocuts, as in Figure 129. Here the formidable task of achieving many colors was accomplished by a continual cutting of the linoleum block during the printing. The elimination process continued, building overlays of ink until the work was complete. The resultant image seems to glow with brilliant life and hue.

The role of relief printing as a medium of propaganda and satire did not die with Thomas Nast. One notable artist who carried the tradition into the 20th century was the Mexican Guadalupe Posada. Posada began his career as a lithographer but later turned to metal relief prints produced by drawing on metal with a resist and also by engraving on soft type-metal blocks with multiple-point gravers. In this form his

remarkable talent and cryptic humor were given free rein. His *Regalo de Calaveras* (Fig. 53) resembles an ominous (yet amusing) modern-day *danse macabre*.

Contemporary Artists

It would not be inaccurate to say that relief printing has never entirely recovered from the decline it experienced after the 16th century. Contemporary artists have tended to concentrate on lithography, intaglio, and silk screen methods. Nevertheless, there are exceptions to this trend, and a few printmakers have made substantial developments in the art of relief. Leonard Baskin has applied classical western cutting techniques to vividly modern imagery (Fig. 54). Helen Frankenthaler achieves a fluid textural effect in muted colors (Pl. 4, p. 56). Carol Summers bleeds his ink through the fibers of the paper to yield a rich, bold surface (Pl. 3, p. 55). Jim Dine created a *Bathrobe* by combining woodcut with a lithographic outline (Pl. 6, p. 58). Employing Munch's technique, he cut three rough plywood blocks into twelve separate sections. The surface was inked with a litho roller so that it would retain the rich wood texture.

In the mid-20th century artists in many fields have reexplored older techniques and applied them to a modern idiom. There is every likelihood that this approach will be applied to relief printing processes, and that age-old techniques will be combined with a contemporary aesthetic and technology to make a new statement.

2 Relief Techniques

Relief printing is perhaps the most direct of the four major printmaking processes. Its primary characteristic is the raised printing surface of the block, which can be created in any of several ways: by cutting the background away (as in a woodcut or a linocut), by carving the image into the block and leaving the background standing (as in a wood engraving), or by adding objects to a flat surface (as in metal relief).

Wood engraving was used widely for reproduction throughout the 19th century, and its creative possibilities continue to be explored. The image-making method resembles intaglio engraving, but printing is done in the same manner as for woodcut.

Many people associate relief printing with the stark, intense imagery of Edvard Munch (Pl. 7, p. 75) or with the stylized prints of Japan (Pl. 2, p. 22), both of which tend to exploit the natural characteristics of wood grain. Some contemporary prints also feature this special wood quality (Fig. 54). Others, such as Roy Lichtenstein's *Modern Head #1* (Fig. 55), depend upon geometric and patterned shapes independent of the wood's textured surface.

A few contemporary printmakers, including Carol Summers and Helen Frankenthaler (Pls. 3, 4, pp. 55, 56), have developed special techniques to make the relief process uniquely their own, building up broad, free-flowing areas of color and shape with the flexibility of painting or silk-screen printing. There are few limits to the visual effects possible with adaptations of relief printing.

Basic Woodcut Techniques

The technique of wood block cutting is one of the oldest and simplest forms of printmaking. From its early origins in China (see Chap. 1, p. 7), it spread throughout the Orient and into Europe, where by the mid-1400s it had become a popular form for the printing and mass distribution of religious and informative imagery of all kinds. Nowhere, however, has the art of wood block printing achieved the degree of aesthetic and technical perfection that it reached in Japan during the height of the *ukiyo-e* period (Fig. 82).

In its simplest form, the woodcut is made on the plank side of the wood, with the grain running lengthwise. After all the background areas have been cut away, the image remains on the surface wood. The surface is inked, the paper placed on top, and the back of it is rubbed with a spoon or other burnisher to make the impression, or print.

The degree of fineness and detail is determined not only by the skill of the cutter, but also by the quality and type of wood available. Through the long history of the woodcut, many different types of wood in different parts of the world have been used successfully for making prints. The character of the wood itself varies tremendously, not only from one kind of tree to another, but also among trees of the same kind grown in different locations. Most blocks for woodcutting are rather narrow, and they are often glued together at the edges for large-format prints.

Since the cutting takes place on the grained or plank side of the wood, the coarseness and direction of the grain are major considerations. The use of wild cherry wood by the *ukiyo-e* artists was important to the quality of the results they achieved. This wood is extremely hard and fine-grained, so that intricate cut-

left: **54. Leonard Baskin.** *Passover.*
c. 1960. Woodcut, printed in black,
image 19⅝ x 14⁵⁄₁₆″.
Museum of Modern Art, New York
(gift of Mr. and Mrs. Albert A. List).

below: **55. Roy Lichtenstein.** *Modern Head # 1.*
1970. Four-color woodcut, 24 x 19″.
Courtesy Gemini G.E.L., Los Angeles.

below: **56. Paul Gauguin.** *Te Atua.*
After 1895. Woodcut, 9⅝ x 8¾″.
Art Institute of Chicago
(gift of the Print and Drawing Club).

ting can be done both with and against the grain. In softer woods such as pine or fir, the grain is more pronounced. While it is less able to hold fine detail, soft wood is easier to cut. Thus, the wood itself can influence the flow and curve of the linear cutting patterns. In some woodcuts produced in the West, the grain of the wood is strongly in evidence, as is cutting that favors the grain direction. The works of Edvard Munch and Paul Gauguin in particular show the textural influence of the wood (Fig. 56).

57. Maurice Denis.
Illustration for *Sagesse* by Paul Verlaine.
1889. Woodcut, 4 x 1¾".
Rutgers University Fine Arts Collection,
New Brunswick, N.J.

In making a woodcut, the artist has a natural inclination to cut in straight rather than curved lines, and to cut with the grain, rather than against it (Fig. 57). This gives the image a certain angularity and directional movement, enabling the woodcut to be used for direct and powerful effects. Each block of wood also possesses certain characteristics, defects, or imperfections that, at times, can work to great advantage for the artist. The following tools and equipment will be useful for the woodcut technique:

☐ wood blocks of various sizes and textures
☐ wire brush
☐ woodcut knife
☐ C-shaped gouges
☐ U-shaped gouges
☐ V-shaped gouges
☐ India stone
☐ Arkansas stone
☐ carborundum stone
☐ kerosene
☐ light machine oil
☐ electric or hand-operated grinding wheel
☐ India ink
☐ brushes
☐ felt-tip pens
☐ sandpaper
☐ conté pencils
☐ charcoal
☐ tracing paper
☐ wheat paste or wallpaper paste
☐ bench hook
☐ glue
☐ modeling paste
☐ proofing papers
☐ printing papers
☐ woodcut inks (in different colors, if desired)
☐ rollers of varying widths

☐ inking slab
☐ sponges
☐ burnisher, such as a spoon or traditional Japanese baren
☐ registration device for color or edition printing
☐ sheets of Mylar or acetate

Materials for Woodcutting

As a rule, the harder the wood, the more detail it is capable of holding. The following soft and hard woods are the ones most frequently used for the woodcut technique.

Hard Woods

Both maple and birch are extremely hard woods and difficult to cut, but they justify the effort if fine detail is needed. Boards are available in differing widths, usually in a standard ³/₄-inch thickness. Because of the hardness of the wood, tools need frequent sharpening during the cutting.

Fruit Woods The woods from the cherry, pear, or apple trees are some of the finest for woodcutting. They are hard and even-grained and will hold exquisite detail. Fruit woods tend to be expensive, however, and difficult to obtain.

Other Hard Woods Of the many other hard woods, beech is the most even-grained, and excellent for fine detail. Walnut is often too expensive. Oak, while extremely hard, has an objectionable open grain. The softer mahogany cuts reasonably well but splinters easily. It performs in large areas of color, although some mahogany can have a very porous, textured surface.

Soft Woods

Pine Throughout Northern Europe, Asia, and North America, one of the most abundant species of tree is the pine. It is an old and very widely used material for woodcutting.

Pine varies tremendously in evenness of grain, ease of cutting, and tendency to splinter. Sugar pine, grown on the East Coast of the United States, is one of the superior varieties of pine in North America for woodcut purposes. Firm and even-grained, it can be cut both with and against the grain. Good detail is possible with sharp tools and careful cutting, and despite its softness when compared to cherry or maple,

pine is capable of producing thousands of prints from a single block.

Some pine has a strong grain pattern and much difference in hardness between the dark and light rings of the wood. The grain often shows in the final print, and in many cases it can be exaggerated for textural effects.

Poplar Poplar has excellent qualities for woodcut. The grain tends to be smooth and even. Poplar holds detail well when cut both with and against the grain. It can be worked easily, does not warp readily, and is strong and resilient.

Poplar is often used for furniture, and an old chest of drawers can yield many beautiful wood block surfaces. Boards only ³/₈ or ¹/₂ inch thick can still make excellent surfaces for cutting. Old drawing boards made from many laminated pieces of poplar are also excellent, for they offer two sides that can be made into a large-format woodcut.

Basswood A drawing board made of basswood (as many drawing boards are) provides an excellent and handy surface for a woodcut. Basswood, or linden wood as it is known in Europe, is very similar to poplar in cutting qualities and ability to hold detail.

Plywood By the nature of its formation, plywood is never quite as good for detail as a solid piece of wood. Each layer of wood in the plywood is cut and glued in a way different from its structure on the trunk of a tree. Certain kinds of plywood, however, prove invaluable for large woodcuts and solid areas. Some types, such as plywood made from basswood or birch, will hold a surprising amount of detail. The most common, fir plywood, has a strong grain and splinters easily. It can produce strong wood grain textures when scrubbed with a wire brush.

above: 58. The natural texture of the wood block often can be used to advantage in the image.

below: 59. The basic woodcut tools.

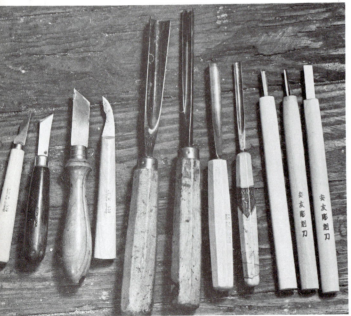

Other Sources of Wood

Woods for cutting or for textural effects can be found in a variety of places. Driftwood picked up at the beach or lake shore can yield exquisite textural nuances in a print, as can weathered lumber from an empty lot or an old house. Discarded furniture, table tops, shelves, and drawers all become excellent sources of woodcut materials. The inquisitive mind must search out the materials from the many sources all around us.

Textural Use of the Wood

Most soft woods have a grain that can be emphasized for use in color areas or for an entire background texture. Pine, fir, spruce, cedar, and redwood all have a definite grain, which the artist can bring out by rubbing with a wire brush. Rubbing removes softer parts of the wood and leaves the harder parts slightly raised. In printing, a hard roller will pick up more of the surface texture than a soft roller, and a thin layer of ink more than a heavy one.

Knots and circles in the wood are often unavoidable. They can be circumvented with selective placement of the image, or worked into a print, sometimes with great advantage (Fig. 58).

Tools

During the centuries when woodcuts have been made, the technique of cutting and the tools employed have remained simple. In both Western and Oriental techniques, the knife serves for all the basic cutting of the image, and various forms of gouges or chisels for the clearing operations (Fig. 59).

The kinds of effects, textural or otherwise, used in contemporary relief printing frequently go beyond

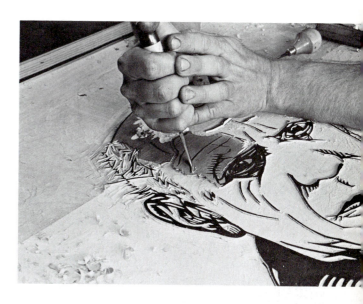

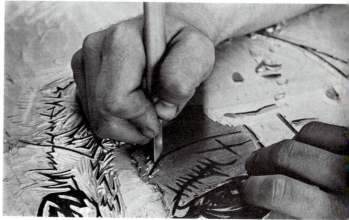

the traditional approach. Any depression made into the surface of the block will produce a white mark as the surface is rolled with ink; thus, the artist has limitless means for creating images. If wire screening, for example, is hammered into the surface of a piece of wood, this texture then becomes a printing surface capable of yielding as many consistent impressions as a block cut with a knife. The total range of image-making possibilities is determined by the materials on hand and the ingenuity of the artist in relating the technique to his or her personal imagery and intent.

The Woodcut Knife

The knife is the most important tool of the woodcut artist. It should be comfortable to hold, have a rigid, high-quality carbon steel blade, and be of the right shape and length to suit one's cutting needs. Because a number of shapes and styles are made, it is important to select one that has the right feel and can be manipulated with ease.

The cutting edge of the knife blade makes a 45-degree angle with the top edge. One side of the blade is flat, and the other is faceted to the cutting edge. This structure allows each flat surface to be honed easily on the Arkansas stone, so that a sharp edge and point can be maintained. Many woodcut artists prefer to have a larger, heavier knife for most of the basic cutting and a smaller one for detail.

The woodcutter grasps the knife firmly, with the fingers and thumb in a stabbing position so the blade faces downward (Fig. 60). The knife is never held in a completely vertical position, but always at an angle of about 60 degrees. Almost all the cutting is done in a direction toward the cutter. The first $\frac{1}{4}$ inch of the blade, measuring from the point, does most of the cutting. Using the knife in the basic position will seem awkward at first, but once familiarity with it is acquired, it will prove the least tiring position. It allows great flexibility in manipulating the tool for straight linear work, curved lines, and fine, detailed cutting. The beginner may find it more comfortable, when cutting detail, to hold the knife like a pencil, rather than in the basic holding position (Fig. 61). There are no rigid rules in this respect, and whatever method gives the desired results should be used.

Deep cutting is not necessary, and the finer the detail that is cut, the less depth is required. Rarely is it necessary to cut deeper than $\frac{1}{8}$ inch for any area done with the knife. It is a good idea to keep all the lines cut with the knife at a constant depth. This facilitates the clearing operation and prevents parts of the work from being broken or lifted by the gouge.

Gouges

Gouges are used for clearing the wood between the image areas. The C-shaped gouges are the most versatile. They shave the wood gradually and are easier to sharpen than U-shaped gouges.

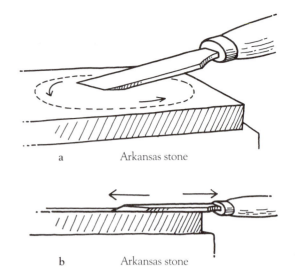

a Arkansas stone

b Arkansas stone

63. Sharpening the woodcut knife.

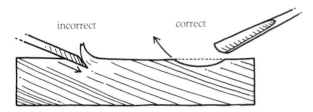

62. Gouging with the grain digs into the wood
in one direction and lifts the wood
cleanly in the other.

Gouging is done as much as possible in the direction of the grain of the wood (Fig. 62), usually the direction in which the gouge lifts the wood cleanly from the surface without having a tendency to dig into it.

The woodcutter will need several gouges of various sizes. A small C- or U-shaped gouge is useful for clearing close to image areas, where control is imperative so as not to damage the cut linear work. For clearing larger areas of the block, a larger C-shaped gouge works best.

A V-shaped gouge is a very useful tool. If sharpened to the proper angle it will cut efficiently both with and across the grain. The blade must be ground so that the edges cut into the wood at an angle. Each of the cutting facets should be kept very sharp and honed frequently during the cutting.

Sharpening Stones

The stones most useful for sharpening woodcut tools are rectangular or round India stones with a coarse side and a fine side, and carborundum stones. These stones are intended for medium to fine grinding of the tool edges. They must be lubricated with a light machine oil or kerosene. For a final sharpening, a soft or hard Arkansas stone is one of the best materials for producing a keen edge. This stone is quarried naturally and varies in color from white through mottled

gray to black. The white stone is slightly softer, the black harder. Both serve for fine honing of edges, with a little light machine oil or kerosene. Olive oil and linseed oil should be avoided, for they will eventually oxidize and dry, clogging the stone.

A stone can be cleaned occasionally with acetone or lacquer thinner to remove loose particles of metal or stone from the surface and thereby improve the cutting quality.

Sharpening the Tools

The cutting knife is the easiest tool to sharpen, because of its flat cutting surfaces; the U-shaped gouge is the most difficult.

A new knife may have to be ground first on a medium India or carborundum stone, with final touching up on an Arkansas stone. To sharpen the knife, hone the side first. This will rarely, if ever, need

64. Sharpening the U- or C-shaped gouge (above) and the V-shaped gouge (below).

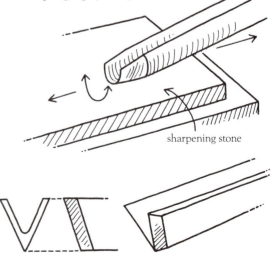

sharpening stone

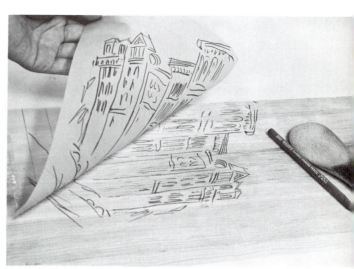

resharpening. Next, hone the faceted edge on the India stone, then on the Arkansas stone (Fig. 63). The tool must not be rocked while it is being sharpened, and the facet must stay flat against the stone as it is honed back and forth. To remove a burr on the edge, it can be stropped on a piece of oiled leather.

If the tip of the knife is accidentally broken, or a dent made in the cutting edge of a gouge, the tool may have to be reground to the proper shape on an electric or hand-operated grinding wheel. When this is being done, grind for brief periods at a time, so as not to overheat the tool and cause the metal to lose its temper or hardness. Dip the blade frequently into a cup of cold water to keep the metal cool.

When sharpening the curved gouges, you must maintain the angle of the faceted edge, while at the same time drawing the tool back and forth to trace a narrow ellipse and rocking it from side to side (Fig. 64). Final honing is done on the Arkansas stone.

For gouges, a number of manufacturers offer stones with grooves for sharpening the outer edges of the tool. These require a light machine oil or kerosene just as does the flat stone. For a light honing of the inside edge of the gouge, a rounded circular stone or the rounded edge of a small flat stone will remove any slight burr and polish the edge.

Placing the Image on the Block for Cutting

The approach to image-making on the block will differ greatly, depending on the natural proclivities of the artist, and his or her manner of working. The image may be worked out carefully beforehand and traced to the block, or the drawing can be made directly on the block and altered as the cutting proceeds. A few artists work in such a way that the image is developed in the cutting, and no guidelines—except for those defined in the mind—are used on the block.

left: **65.** Drawing the image directly on the wood block.

right: **66.** Transferring an image to the block with tracing paper. At right is a Japanese rice spoon.

Direct Drawing Method

The simplest and most direct manner of putting an image on the block is by drawing directly on the wood with a brush and India ink or poster color, or with a felt-tipped marker or other drawing material (Fig. 65). The use of a Japanese brush and India ink produces a thick-and-thin line quality that complements the character of cutting on wood, as a pencil line, for example, does not. When drawing directly on the block, keep in mind the fact that the print will always be a mirror image of the one drawn on the block. If you need to correct the drawing before cutting, you can work the surface with a sponge and water or rub it lightly with sandpaper. This will not remove all of the image, but it will allow you to see the second drawing distinctly.

Transfer Method

An image for a woodcut can also be drawn on paper and transferred onto the block with tracing paper (Fig. 66). The drawing can be made with carbon, charcoal, or conté pencils, then placed face down on the block and rubbed to offset the drawing. It will be reversed, so that after cutting it will print the same way as the initial drawing. To avoid smudging the transfer, spray it with fixative. Working over the transferred drawing with a brush and India ink will make it possible to visualize the total image much more clearly than with a thin line drawing alone.

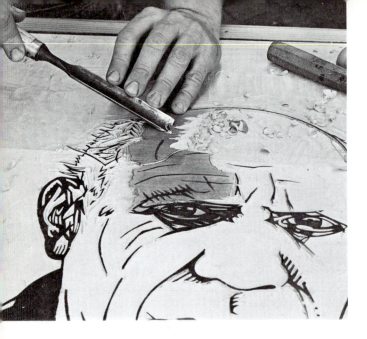

67. Clearing away nonimage areas of the block. Note the position of the fingers. The block has been stained with a light watercolor so that the cut areas can be seen readily.

Pasting the Drawing to the Block

Many woodcut artists use a variation of the Japanese *ukiyo-e* method of pasting the key drawing onto the block. The basic principles are the same, although the materials may differ.

The drawing is made on a thin Oriental or translucent paper. Mending tissue, Troya 90, and a thin tracing paper or vellum are suitable. This paper is placed over the initial drawing, and a careful tracing is made to the exact size of the block with India ink or a felt-tip marker. Next, a thin, even layer of wheat paste or wallpaper paste (about the consistency of porridge) should be smoothed onto the block. Then the paper is placed face-down on the block and quickly pressed flat with the hand, sometimes with a sheet of newsprint as protection on top (Fig. 84). The paper is so thin that the image will show through to the other side to serve as a cutting guide.

After the block dries, the excess paper can be trimmed from the edges and the cutting can begin. Because the drawing was placed *face-down* on the block, the final printed image will be the same as the original drawing.

Cutting the Block

Once a part is cut away, it is difficult to replace. It is therefore a good idea to underwork the block, and to take proofs at various stages during the cutting. Cut less than initially intended in both the cutting and the clearing operations. In this way, much of the freshness of the direct cutting remains in evidence, and textures left by the gouges are still on the surface. Later, after a proof has been pulled, the image can be progressively refined and selective clearing continued. Do not pull a proof too soon, however, or uncut portions of the block will become covered with ink

and the image on the surface may be obliterated, making it difficult to continue cutting.

First cut both sides of all the lines drawn on the block, using the woodcut knife. This should be done slowly and carefully. Then, with the gouges, clear away the areas of the block between the lines, digging deeper into the wood in the larger, open areas (Fig. 67). More detailed parts of the image should be left rather shallow, since deep cutting weakens the small pieces of wood left on the surface and increases the chances of their being chipped away accidentally.

The block should be turned to any angle that permits ease in cutting a particular line. Since all of the basic knife cutting is done toward the cutter, the cutting of both sides of a line may necessitate having the block face first one direction, then another.

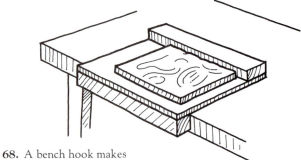

68. A bench hook makes a convenient device for holding the block in position during the cutting.

It is most important that the block be held firmly on the table top, so that it does not slip while areas are being cut or cleared with the gouge. If stops made from pieces of wood cannot be nailed directly to the table top, then it is best to make a separate cutting board or bench hook on which the block can be placed and positioned at different angles while it is being cut (Fig. 68). A single bench hook is made from

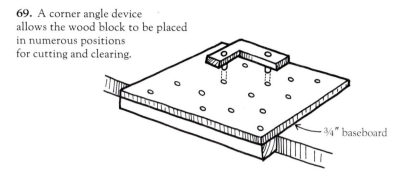

69. A corner angle device allows the wood block to be placed in numerous positions for cutting and clearing.

¾" baseboard

any thin plywood or other board, with lips on opposite ends. One lip is held against the table top and the other acts as a stop for the block.

Another useful device can be made from ¾-inch plywood in which a number of holes have been drilled (Fig. 69). A small piece of wood or plywood is cut into a 90-degree angle, and short dowels are glued in the holes, protruding about ½ inch. The holes drilled on the ¾-inch plywood base should be the same distance apart as the pegs. Fitting the pegs into different holes allows the angle to be changed, thus permitting the block to be placed in numerous position for cutting and clearing operations. The holes should be drilled into the block in as many places as needed to move the block in a variety of convenient cutting positions.

Repairs to the Block

When you are working against the grain, it is highly probable that a piece of the image may be chipped away accidentally. The piece should be replaced immediately before it becomes lost among all the rest of the chips lying about. A little glue dabbed on the spot will make the repair permanent. If the chip is lost, acrylic modeling paste or plastic wood can be used to build up the area, which is afterwards smoothed out with sandpaper and recut.

Minor indentations and bruises in the wood can often be corrected by wetting the spot with water. This swells the wood, bringing it close to its original state. Indentations that do not come back with this method can be repaired by filling in the area with some modeling paste or gesso, smoothing out the surface with an ink knife, and finally sanding it until it is perfectly level with the block. The area can be cut afterwards with the knife or gouges in the usual manner and will accept cutting as the wood does.

When a small part of a line has been chipped accidentally, it can be corrected by making a narrow V-shaped cut and wedging a thin sliver of wood into it. The top part is then sawed off flush with the surface and sanded. If a large area is to be repaired or altered, another piece of wood can be inlaid into the block and recut (Figs. 70, 114).

70. To correct or repair an area on the block, insert a small wedge of wood (a), trim it down to the height of the block (b), and recut (c).

In all cases, these repairs to the block should be made while the wood is dry. When it is wet later, the wood will tighten the wedge or inlay without the necessity of an adhesive, making the repair more or less permanent.

Lowering an Edge

The woodcut is generally characterized by sharp, crisp edges and distinct outlines. It is possible, however, to fade out edges or create a variation in tone by a slight change in the surface elevation or angle of the image. In this technique, the edges of a raised line can be burnished so that the surface is slightly rounded rather than flat. This will create a printed line that is fuzzy at the edges. Similarly, an area can be lowered slightly by shaving the wood minutely with the edge of the knife. Less ink from the roller will be deposited on that area than on the rest of the image surface, thereby printing a lighter, or gradated, tone.

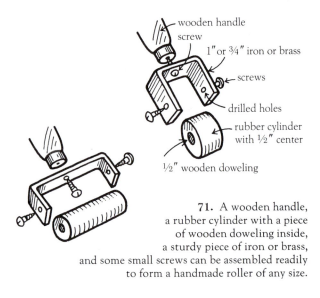

wooden handle
screw
1″ or ¾″ iron or brass
screws
drilled holes
rubber cylinder
with ½″ center
½″ wooden doweling

71. A wooden handle,
a rubber cylinder with a piece
of wooden doweling inside,
a sturdy piece of iron or brass,
and some small screws can be assembled readily
to form a handmade roller of any size.

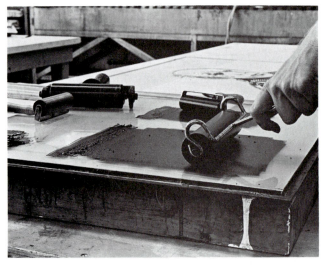

72. Spreading the ink with the roller.

Printing

Paper

The importance of the paper in the appearance of the final print cannot be overemphasized. Many commercial offset papers can be used for block printing, although they are hard-surfaced. They produce better results if they are dampened slightly, or printed with heavy pressure on an etching press or Albion-type press. Oriental papers in combination with oil-based inks do not necessarily have to be sized or dampened. Traditional Japanese papers such as Moriki, Sekishu, hosho, and mulberry take the oil-based inks beautifully into the fibers and are excellent for color printing, as well as for black and white. A domestic rice paper called Troya is inexpensive and has a consistently good surface and fine printing qualities. It yellows somewhat with age, however.

Inks for Woodcut

The inks used for woodcuts are of two types: *oil-based* and *water-based*. Most of the woodcuts made in the West have been printed with oil-based inks, whose composition resembles typographic or letterpress ink made of pigment and an oil vehicle. The ink applied to the block in the Japanese technique is water-based, with rice paste acting as both binder and vehicle for the pigment.

The inks for relief printing should be dense, heavy-bodied, and finely ground. They should also be *short*, have little tack, and be relatively stiff so that they print sharply and lift cleanly from the block onto the paper. Too soft an ink will squeeze over the edges, filling in detail and creating irregular lines.

Inks made specifically for letterpress printing, such as IPI inks, are available in tubes as well as cans and make excellent all-purpose woodcut inks. The tube inks are a convenient answer to the problems of ink drying in the can or bits of dried ink getting mixed up in the liquid ink. The IPI inks come in a complete range of colors, as well as a transparent white for making overlays of color. There is also an "anti-tack" compound that reduces the stickiness of the ink and allows it to release easily from the block. The "anti-tack" compound can be added to lithographic inks to make them workable for woodcut. Another way of modifying a litho ink for woodcut is to add some raw linseed oil and either magnesium carbonate or alumina in small quantities.

Rollers

For the printing of early European wood blocks, the ink was applied to the block in vertical strokes with a padded leather dabber having a firm, flat inking surface. The ink was necessarily stiff, and the dabber could not be allowed to contact any area below the surface of the block. This slow but effective method did not change until the roller was introduced in the early 19th century.

The roller is important for good inking of the block. It should be neither too hard nor too soft. If the roller is too soft, the ink has a tendency to squeeze out over the edges and create a buildup on the edge of the block. If it is too hard, the roller will not ink evenly.

The best rollers are the medium-hard variety made of composition rubber or plastic, although for fine detail a firmer roller is necessary. For large areas of color, a softer roller will be fine. Polyurethane plastic and polyvinyl chloride rollers are almost indestructible. They perform well in the workshop or for student use, can be cleaned with most solvents, and will give long years of service. Gelatin rollers, if firm, will work for printing woodcuts, but they are deli-

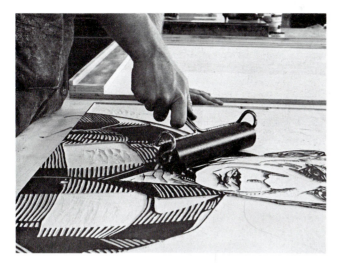

73. Inking the block.

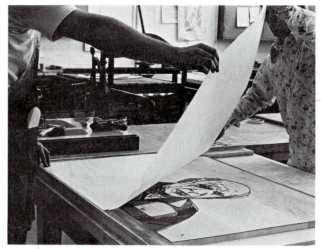

74. Registering the paper on the inked block.

cate, can be dented, and are easily affected by heat and moisture.

A number of different-sized rollers should be available, both for inking a variety of blocks and for use in color printing. Rollers varying from about ½ inch to 8 inches in width will cover most printing needs. Several in each size will often be required for color printing.

Although rollers can be purchased cheaply, they are easy to make from readily obtainable materials (Fig. 71).

Printing the Block

A well-printed woodcut reveals all the fine detail of the cutting, as well as the subtle variations in the edges and surfaces of the block. Careful printing requires time and effort. The most common printing error is to overload the surface of the block with ink. This, of course, makes it very easy to develop a strong, solid color in the image with almost no rubbing, but the print becomes so heavily charged with ink that all advantages of detail and quality of impression are lost. If you expend a little extra effort in the rubbing, and roll just a thin film of ink onto the block, the image will retain its character.

To print, spread a little ink on the inking slab and work it back and forth with the roller at different angles until a thin, even film is laid out (Fig. 72). Next, check the block and remove any loose bits of wood from the cutting. If paper was pasted down as a guide for the cutting, it should now be removed and the block rubbed gently with a sponge and water until all the dried paste is gone. Try not to wet the block too much, and let it dry before printing.

Roll the ink onto the surface of the block (Fig. 73). If ink appears on gouged areas of the block, it can be eliminated by cutting the block deeper in those areas, by choosing a harder roller, or by following a different pattern of rolling on the ink.

When the ink on the block seems evenly distributed over the image, lay a piece of paper over it (Fig. 74), and rub the back of the paper with a burnisher—either the traditional Japanese baren, a spoon, or some other device (Fig. 75). Most of the rubbing will follow the grain of the wood or the lines of the image, or both. After carefully rubbing all areas of the image, pull the paper gently from the block (Fig. 76).

A Japanese bamboo rice spoon, with the ends and sides slightly squared, makes an excellent burnishing tool for applying pressure on the back of the paper. With the flat bottom surface of the spoon, large areas

75. Rubbing the paper with a Japanese rice spoon.

76. Pulling the print.

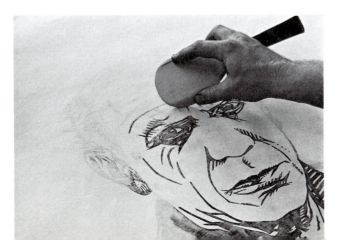

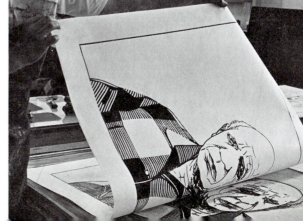

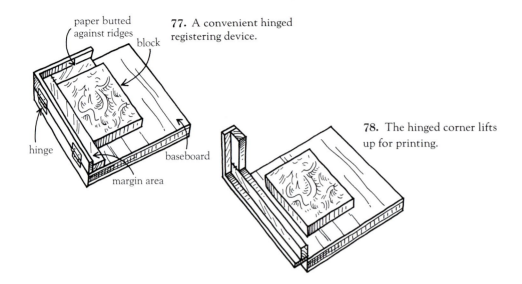

paper butted against ridges
block
77. A convenient hinged registering device.
hinge
baseboard
margin area
78. The hinged corner lifts up for printing.

can be covered; the side or end of the spoon brings up the fine detail in delicately carved areas. An Oriental paper will show from the back of the print how the ink takes to the surface and when it has been rubbed enough. The amount of pressure will help to determine both the tone and the sharpness of the printing. A sharper, more detailed impression results from a thin inking and heavy rubbing, rather than from a heavy inking and light rubbing.

If the impression, even with much pressure, is still too light because of insufficient ink, the paper can be lifted, a portion at a time, and the block re-inked. The other part of the paper must be held firmly so that it does not shift while this is being done.

Variety of Impression in Hand Printing

Because more pressure applied to the back of the paper will produce a darker impression, a difference in pressure can yield a difference in tonality. A *kiss impression* results when the paper is first put onto the inked block and rubbed lightly with the hand. The paper picks up an even-textured, light tone that can be controlled for an edition if necessary. Other parts of the block can be rubbed with the spoon or baren for a darker printing.

Besides the baren and Japanese rice spoon, many other objects will serve for applying pressure to the back of the paper. Wooden drawer pulls, ordinary wooden spoons, or separate small pieces of hard wood, carved and sanded, are all effective.

Registering the Paper to the Block

For printing editions, whether in a single color or many colors, the print should appear on each sheet of paper in the same place. A simple but effective registering device can be made in the following way.

Make a 90-degree corner angle from two thin pieces of wood. Inside this, fit another 90-degree corner angle of wood of the same thickness as your woodcut. The width of the margin around the image will be the same as the width of this inner angle. (Wider margins can be achieved by adding to the width of the angle.) Set this double corner on top of a baseboard somewhat larger than the woodcut, aligning the top and side edges. Attach the corner and the baseboard with hinges that will allow the corner to be lifted out of the way (Fig. 77). When you are ready to print, place the inked woodcut on the base board, fitting it tightly into the inner corner angle. Set the paper over the block so that its edges are flush with the outer corner angle. Lift the hinged corner out of the way (Fig. 78), holding the paper carefully in place, and print as usual.

This is one of the most accurate systems for registering both black-and-white and color prints. For color prints, however, it is important that each block be cut to the same size, and that the image be positioned correctly on each block.

Printing a Warped Block

Printing a warped block with most etching presses will cause splitting of the wood. If a block has warped only in one direction, however, it can be run safely through the press with the curvature of the block following the curvature of the upper cylinder (Fig. 79).

Color Printing

Until the Japanese *ukiyo-e* artists began their prolific use of color, the woodcut was primarily a black-and-white medium, except for *chiaroscuro* woodcuts of 17th-century Italy. There are now many techniques

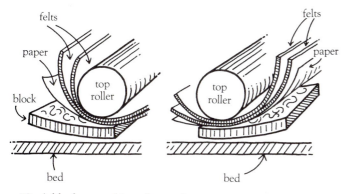

79. A block warped in only one direction can be printed on an etching press.

for printing in color, but the one most frequently used is the traditional key-block method perfected by the Japanese. This process requires the cutting of a separate block for each color to be printed, except when areas of color are far enough apart to be cut and inked on the same block. Careful registration of each block on the paper is always necessary.

The approach to color is highly subjective. The artist may work with a tightly drawn image as the key, or each color block may be considerably more independent in relation to the total image. Transparent tones of color, printed over other colors, open up new avenues of artistic expression. The beginner should approach these with care, so as not to allow technical effects and complexities to overshadow the personal imagery.

Planning the Color Print

Even in woodcuts with the most unrestrained handling of color, there must be an established relationship among the individual color blocks, to allow for accurate registration of the printed colors (Pl. 5, p.

57; Pls. 9–14, pp. 77, 78). The use of blocks cut to the same size is the first important step in this direction. Do not overlook the fact that both sides of a block can be cut, making a four-color print possible with only two blocks.

Printing each color on transparent Mylar or acetate, and placing one over the other, will provide an excellent means of visualizing the work as it progresses. Registration is important; the Mylar or acetate should be cut to the same size as the paper to be used in making the print and registered in the same way. The hinged device shown in Figures 77 and 78 will provide an accurate means of color registration.

There are two principal methods of working out color areas on separate blocks—the *tracing paper method* and the *transfer color method*.

Tracing Paper Method For the tracing paper method, make a tracing of the key image, and transfer it onto each separate block surface. Using the original drawing as a guide, fill in color areas with poster color or ink, and cut the wood blocks separately. Once most of the basic cutting is completed, the blocks can be proofed individually or progressively.

Transfer Color Method The transfer method proceeds as follows. Once the first block has been cut, make an impression of it. While the ink is still wet, transfer it to the second block. In this way it is possible to see the exact placement of the image on the next block. The image of one or more of the cut blocks can be transferred to each subsequent block as required, using the same technique.

To transfer the image of the first block, use the registering device to pull the impression onto Mylar, or tracing paper (Fig. 80). Remove the block, and place the next block into the corner of the registering device. Place the inked impression over it, and trans-

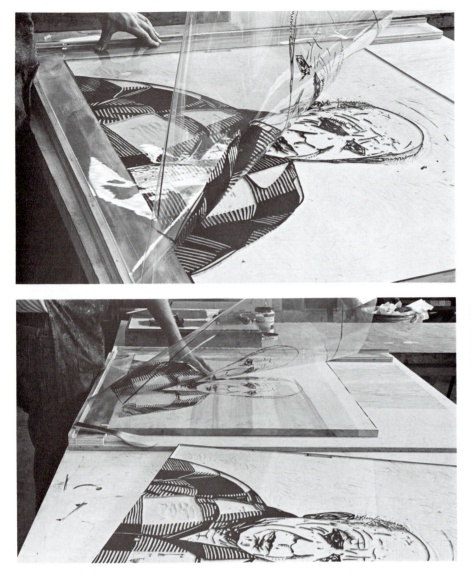

above: 80. An impression being pulled from the key block on Mylar.

left: 81. The inked Mylar is registered onto a new block. The key block is in the foreground.

fer by rubbing (Fig. 81). The fresh ink transferred to the block can be dusted with some talc to prevent getting it over everything during the cutting. This method of making color prints allows for very tight registration.

Trap

If two different colors are to butt up against each other, there should be a slight *trapping* of the colors. Trap is a term describing the slight overlap of two edges, so as not to leave a white line between. It allows for some tolerance in the registration of colors.

The amount of trap necessary will depend on the overall size of the paper and the care with which it is registered. The larger the paper, the more it can be affected by humidity, which expands or contracts it slightly. On a small block, which might measure about 8 by 10 inches, the amount of trap will be very small—$\frac{1}{32}$ inch or less—while on a larger print the trap could be as much as $\frac{1}{8}$ inch. The trap is more apparent with transparent colors than with opaque ones. It is best to leave more trap during the first cutting and to refine slowly the amount of overlap in subsequent cuttings, as proofs are pulled. This lessens the chance of cutting too much of the image away.

The Classic Japanese Woodcut Technique (Ukiyo-e)

The technique used in making color woodcuts during the *ukiyo-e* period is a highly skilled and specialized process. It is difficult to overestimate the technical achievement of this era, or the aesthetic one (Fig. 82). Certainly, the power of the evocative line, the uniqueness of composition, and the magnificent use of color did not go unheeded when *ukiyo-e* prints were first introduced into Europe in the mid-1800s. The influence of these woodcuts transformed the styles of many leading artists of the day—including Edgar Degas, James Abbott McNeill Whistler, and especially Paul Gauguin—and expanded the perimeters of Western art (Fig. 56). Ukiyo-e is still used in parts of the world for making prints both traditional and modern in concept.

The classic Japanese method of working involves two people—the artist and the cutter. The artist makes a key drawing with brush and ink, and pastes it down on a block. To produce the key block, the cutter carves the wood and the key drawing simultaneously. The drawing remains in relief as areas around each brush stroke are cut away. All the detailed carving is done with a knife; a number of different gouges and chisels serve for clearing other unwanted areas. The work is quite intricate, calling for great skill as well as manual control and dexterity.

Once the key block has been made, including registration guides cut into a corner and side of the block, black and white impressions are made from the block. These are returned to the artist, who indicates on each sheet the different colors and their positions. The sheets are then pasted down on separate blocks for each color, and the blocks are cut.

For the printing, a basic rice paste is mixed with color pigment directly on the block with a special brush. The printing paper is then placed on top and hand-rubbed with a baren. The pressure applied with the baren makes the impression.

In addition to wood blocks, proofing papers and printing papers, the following items are required for the *ukiyo-e* technique:

☐ *hosho* paper for key drawing
☐ traditional Japanese baren
☐ rice flour
☐ minogami paper for key impressions
☐ cutting knife
☐ flat scrapers
☐ general clearing chisel and flat chisel
☐ gouges

☐ saw
☐ rough, medium, and smooth whetstones
☐ mallet
☐ alum
☐ dry animal glue (gelatin)
☐ horsehair brushes and wide Japanese brushes
☐ ground pigments (black and other colors)
☐ strip of sharkskin stretched to a board

A glossary of Japanese words describing the *ukiyo-e* techniques and materials appears at the end of this section.

82. Kitagawa Utamaro. *Fujin Tomari kyaku no Zu (Six Women Preparing for Bed Under a Mosquito Net).* c. 1806. Woodcut, 14⅜ x 29⅝". Prints Division, New York Public Library (Astor, Lenox and Tilden Foundations).

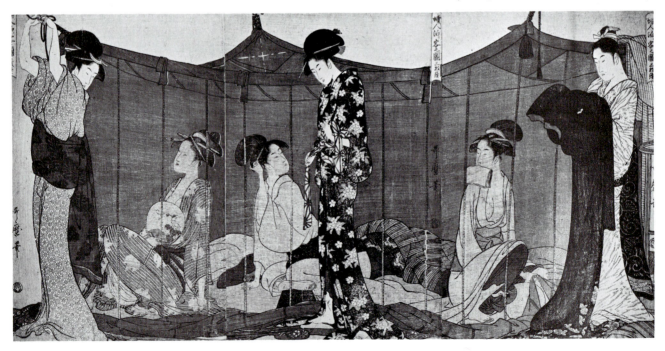

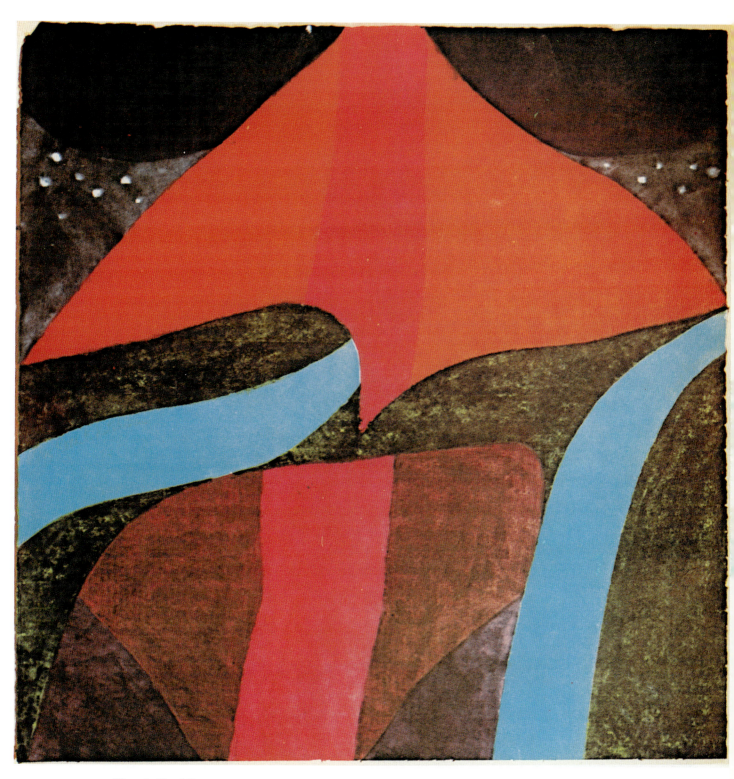

Plate 3. Carol Summers.
Road to Ketchikan. 1976.
Color woodcut, 37″ square.
Courtesy Associated American Artists, New York.

Plate 4. Helen Frankenthaler. *Savage Breeze.* 1974.
Color woodcut using eight blocks, 31¼ × 27″.
Courtesy Universal Limited Art Editions, West Islip, N.Y.

Plate 5. Ansei Uchima. *Space Landscape B.* 1971–76.
Color woodcut, 30 × 20½″. Courtesy the artist.

Plate 6. Jim Dine. *Bathrobe.* 1975. Thirteen-color woodcut and lithograph, 36 × 24″.
Courtesy Graphicstudio, University of South Florida, Tampa.

right: 83. The key drawing, or *hanshita*,
for a print by Noboru Sawai.

below: 84. Rubbing the fibers from the back
of the key drawing pasted on the block.

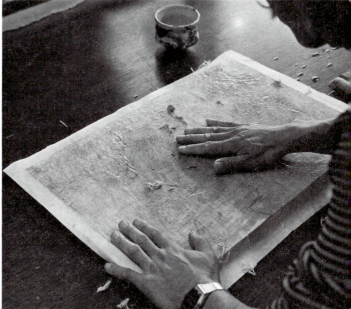

The Key Drawing (Hanshita)

The key drawing is the most important element in the production of the color print (Fig. 83), for it acts as the basis for the key block. In addition to the drawing itself, the artist will indicate with thin, fine brush lines where areas of color are to be placed. These fine lines are used only for the positioning of color areas on the blocks and are cut away for the final printing.

The paper used for making the key drawing is thin and quite smooth, and is made from plant fibers. Before being transferred to the block, the paper must be sized and rubbed with a baren to flatten and stretch the fibers.

Pasting the Key Drawing onto the Block

The key drawing must be pasted onto the block in less than 10 seconds, to prevent wrinkling or deformation of the paper as it comes into contact with the paste. The paste is prepared with rice flour and water, in the manner described on page 64, but reducing the amount of water by one-third to create a slightly heavier mixture. Thus the proportions are:

50.0 grams refined rice flour (about $1\frac{3}{4}$ ounces)
0.23 liters of water (about $\frac{1}{2}$ pint)

Wheat paste and wallpaper paste also work well. The paste should be smooth and neither stiff nor runny. A quantity of paste is put onto the block and spread evenly over the surface with the palm of the hand, then dabbed to produce a slightly rough surface. In this way, the key drawing can be positioned carefully on the block and adjusted before absorbing the paste fully into the fibers.

Once positioned, the paper is rubbed lightly with the hand, beginning in the center and working to the outer edges. This rubbing should be done gradually so as not to tear or distort the paper. The paper should then be allowed to dry for a few minutes, after which the back is rubbed lightly with the fingers. This step rolls some of the paper fibers from the surface and makes the drawing more visible (Fig. 84).

Cutting the Key Block

The operation of cutting the key block requires great skill. Each brush stroke of the original drawing is refined and perfected, and all roughness and irregularity is smoothed out in the cutting process. The most difficult and delicate carving—that of the face and hands in figure work—would traditionally be left to the master cutter, while the less detailed work was undertaken by apprentices.

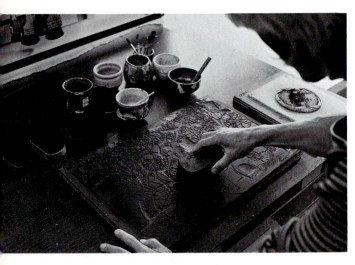

85. Preparing the cut block for the first impression.

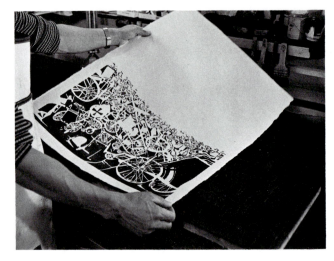

86. The key block impression.

The Key Block Impressions (Kyogo)

A number of impressions must be taken from the key block in order to prepare the color wood blocks (Figs. 85, 86). Minogami paper is ideal. It is lightly sized and rubbed with the baren to stretch the paper and allow for close registration.

To make the impressions, the cutter first brushes black ink on the block—including the registration guides—then places the paper on top and rubs it with a baren or rice spoon. One print for each color block is pulled. The artist then indicates on each impression the portions that are to be cut for each color. If two areas, each a different color, are separated by an inch or more, they can be placed on a single block. The cutter defines the edges of each color area on the impressions with vermillion ink, which contrasts sharply with the black lines and remains clearly visible. The ink is brushed on lightly and with little water so as not to wrinkle or distort the paper.

The prints, which include the registration guides, are then pasted onto separate blocks, in the same procedure as that used for pasting the key drawing onto the key block. Once dry, the blocks and registration guides will be ready for cutting and proofing in color.

Wood Selection and Preparation

Wood suitable for *ukiyo-e* must have an exceptionally fine and even grain. It should be solid, well-seasoned, and without texture or imperfections. The white portions of the wood in the center and the outer edges of the trunk are discarded (Fig. 87).

A fine piece of wood should allow delicate lines to be cut in any direction on the block. It must be hard, yet slightly absorbent, to retain some of the water-based pigment. A block with a straight grain is preferable to one with an irregular grain. Japanese wild

cherry wood has proven ideal. Fine woods in the United States include cherry, pear, birch, or birch veneer plywood. (Plywood does not hold fine detail.)

For the key drawing in which considerable detail is to be cut, a harder, close-grained piece of cherry is best. Blocks suitable for this purpose are heavier and usually deep red in color. A block intended for a flat area of color may be softer, but it should be free of imperfections in the grain. The heavier the deposit of color in the print, the softer the block that can be used, because the absorbency of the wood will hold more pigment.

A block is capable of withstanding thousands of impressions without change. In spite of this, many *ukiyo-e* prints were pulled in editions numbering only a few hundred.

87. A cross-section of a piece of wood, showing the parts that are suitable for the *ukiyo-e* technique.

Tools

Ukiyo-e requires only a few simple tools (Fig. 88). They are a knife, several chisels, a small saw, a mallet, scrapers, gouges, and one or two whetstones.

The method of making the tools follows the ancient traditions of the Japanese swordsmith. Steel—welded to iron for support and strength—is used for the cutting edge.

The Cutting Knife (To) The main cutting knife is the most important tool because it serves for cutting

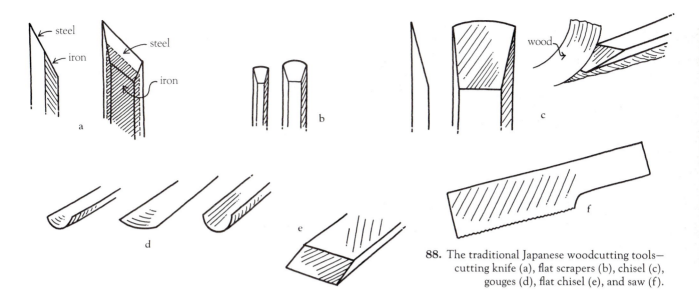

88. The traditional Japanese woodcutting tools—cutting knife (a), flat scrapers (b), chisel (c), gouges (d), flat chisel (e), and saw (f).

all the major lines on the block. The handle, usually of ebony or cherry wood, measures about 3 inches long, tapering to a smaller diameter at one end. The blade is inserted at the thinner end and held tightly with a brass ring.

The cutting blade of the knife is ground at about a 45-degree angle and faceted from the iron side to the steel cutting edge.

Flat Scrapers (Aisuki) The scrapers are flat tools shaped like chisels but with slightly curved cutting edges. They vary in width from about $\frac{1}{16}$ inch to a little over $\frac{1}{4}$ inch. The handle, made of bamboo or hardwood, is held between the thumb and forefinger. This tool clears away unwanted parts of the block.

The General Clearing Chisel (Soainomi) The general clearing chisel is broad and flat with a slightly curved cutting edge. Its function is the clearing of large spaces. A heavy, sturdy construction enables it to be used with a mallet.

The Flat Chisel (Kentonomi) Another chisel is flat and square-ended. Its primary function is to cut the square and rectangular registration marks on the side and corner of the block.

Gouges (Marunomi) The gouges clear the wood close to the grooves cut by the knife. Around larger areas, they help to circumscribe the space before clearing with the flat scrapers and chisels.

The Saw (Sashiki-nokogiri) When an extra piece of wood is wedged into the block in order to correct a part chipped in error, the saw removes excess wood from the surface. The traditional saw is about $3\frac{1}{2}$ inches long, with approximately 140 teeth. A fine-toothed hack saw blade will serve the same purpose.

Sharpening the Tools

Three kinds of whetstones are needed to sharpen the tools: rough, medium, and smooth. Each stone must be wet with water before the tool is ground.

To sharpen the knife, whet the flat sides of the blade first on the rough stone, then on the medium stone until they are absolutely smooth. Next, hone the facet of the cutting edge in the same manner, keeping it flat against the stone. When the flat side and faceted edge are smooth and the edge sharp, they can be honed to a polish on the finest stone. A few final strokes of the cutting edge at an angle somewhat less than that of the facet will give more strength to the point and prevent its breaking. (For extremely fine cutting, the last step is omitted in order to retain the greatest possible sharpness.)

Follow the same procedure when sharpening the chisels. A slight rocking motion is necessary when honing these tools, to allow for the curvature of the cutting edges.

The curved gouges are sharpened on a special whetstone with several grooves of different sizes. After the stone has been wet with water, the outside edges of the gouges can be sharpened by a forward and backward motion in the appropriate groove. The inside edge of the tool is honed by a whetstone shaped like a small, round stick.

All tools, when not in use, should be oiled and kept in a dry place to prevent rusting. With good care, they can last for many years.

Cutting the Blocks

All the cutting consists of two primary operations: the cutting of all the line work with the knife, and the clearing operation, performed with the gouges and the chisels, and sometimes with the aid of a mallet.

a b

Use of the Basic Knife

The basic knife does all the image cutting on the block, from the finest details—such as delicate facial features—to bold, sweeping lines. Proper handling of this important tool will greatly enhance its effectiveness, and ultimately the appearance of the finished print.

Grasp the handle of the knife firmly with all four fingers, and place the thumb on the top end. Cutting always moves in the direction of the cutter, with the blade and cutting edge always visible (Fig. 89). The thumb on top serves to regulate the pressure and depth of the cut. As the right hand cuts the lines, a finger or thumb of the left hand is placed on the side of the blade to help steady the cutting and prevent slippage during the cutting of delicate areas.

Pressure on the cutting point of the knife should be constant, so that the depth of the cut (about $\frac{1}{16}$ inch) is uniform. The first line cut in each image area is the important one, for it refines the lines of the key drawing. It is always made so that the knife handle is tilted toward the line. As a line is being cut, therefore, the point of the knife angles down *away* from the line on either side, forming a pyramid of wood under the line. Because it is difficult to see where the first cut has been made, only a small area at a time should be cut. The second cut should be made following the first but at a different angle so that a thin wedge of wood is removed from the edge of the image. The knife should never be used straight up and down or in such a way as to undercut the drawing (Fig. 90).

The block is placed against a ridge of the cutting table and held firmly while the cutting progresses. The block can be turned to different positions, so that the cutter is always working at a comfortable angle. The cutter completes one whole area—including fine details—before going on to another.

Use of the Gouges and Chisels

Clearing with gouges and chisels is done only after all the linear cutting is completed, for otherwise uncut areas would be chipped away during the process of clearing.

Large areas to be cleared are first circumscribed carefully with the smaller gouges. Then the large clearing chisel and mallet are used to clear away the wood in between (Fig. 91). In using a tool with a

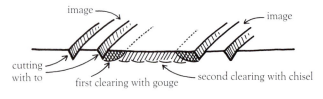

91. The smaller gouges clear areas close to the image; areas in between are cleared by the chisel.

mallet, it is important to watch the cutting edge and not the end of the tool being hit with the mallet. The greater the area being cleared, the greater the depth of the cutting must be, for otherwise the paper might

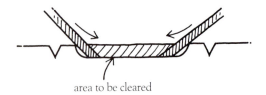

area to be cleared

92. The chisel should be angled away from the lines cut with the knife.

dip down and become stained by pigment on the surface. Insofar as possible, clearing should be done *with* the grain of the wood rather than against it. The chisels should always be pushed away from the lines cut with the knife (Fig. 92).

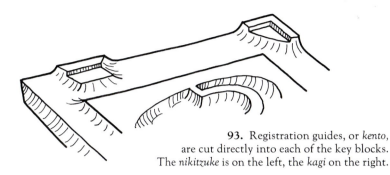

93. Registration guides, or *kento*, are cut directly into each of the key blocks. The *nikitzuke* is on the left, the *kagi* on the right.

Registration Guides (Kento)

In the *ukiyo-e* technique, the registration guides are cut into each printing block (Fig. 93). One guide is cut in a corner in the shape of a right angle; the other is placed about three-quarters of the way down the side of the block. Each block must be considerably larger than the image in order to accommodate the registration guides and leave room for the margins of the print. The square-ended flat chisel is used for the cutting and adjusting of the registration guides.

The Printing Paper

Of the hundreds of Japanese papers available, the type best suited to the *ukiyo-e* technique is *hosho*, a strong, long-fibered paper made of *kozo* fiber. It is available in a standard size measuring 20 by $14\frac{1}{4}$ inches, usually trimmed in half (to measure 10 by $14\frac{1}{4}$ inches) for most *ukiyo-e* prints. The deckle or rough edge is trimmed off to facilitate registration. *Hosho* paper is generally unsized, but for printing with rice paste pigments it should be sized in order to remain flat and maintain good registration.

Sizing

All paper used for making the key block color impressions and the final prints should be sized. Sizing strengthens the paper by constricting the fibers, and preventing the pigment and paste from being absorbed too readily. The size is prepared with:

1 gallon water
8 ounces dry animal glue (gelatin)
3 to 4 ounces alum

The glue is placed in a large pan of cool water and allowed to soften. This may take several hours. It is then heated until all the glue is dissolved, at which point the alum can be added and dissolved in turn.

A very broad, flat brush made from Chinese sheep hair is used to size the paper. Place the paper on a large, flat board, and brush the sizing over the paper, quickly at first, then more slowly to equalize the deposit of sizing over the entire sheet. If a single application of sizing proves insufficient, apply a second coat to the other side of the paper in the same manner. This can be done while the first coat is still damp or after it has dried. Hang each sheet to dry.

Preparation of the Paper for Printing

The sized paper must be dampened before printing, so that the moisture from the paste and pigment will not cause the paper to wrinkle or expand. The dampness must be kept as uniform as possible throughout the entire printing process, which must be done quickly and methodically.

Every second sheet of paper is dampened with a long, flat brush and clean water. The paper is then placed in an even pile, alternating moist and dry sheets. A few drops of formaldehyde can be added to the dampening water to discourage the formation of mildew in the paper. The paper should be left for at least 24 hours to allow the moisture to permeate the fibers evenly. To organize the paper for printing, arrange the sheets on a board covered with some unsized, dampened *hosho* or blotting paper.

After the paper has been arranged, the pile is covered with a heavy dampened sheet of cardboard or damp blotter, with a sheet of plastic on top. It is then left overnight for the next day's printing. During the printing, if the paper begins to dry at the edges, water can be applied with a clean brush. The relative humidity of the atmosphere will greatly influence the printing and the way the paper retains moisture.

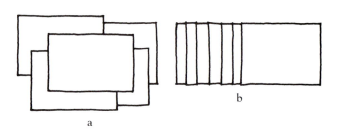
a
b

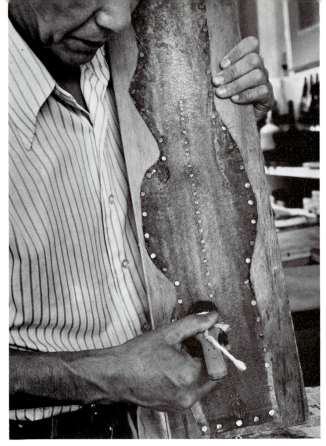

above: 94. Two traditional systems for arranging the dampened printing paper— *otosu* (a) and *hawasu* (b).

right: 95. Ansei Uchima conditioning a brush on a strip of sharkskin.

For arranging the paper after printing, there are two traditional systems in Japan. In one method, four sheets are arranged in a staggered fashion with the fifth sheet placed in the center. In another method, the dampened paper is laid out by overlapping each sheet from the left to the right until the end of the board is reached. Then another layer is placed on top of this in the same arrangement. Both methods are shown in Figure 94.

Ink

Pigment

A considerable number of powdered pigments are available, such as earth colors, dyes, metallic pigments, and oxides. A pigment suitable for the *uikyo-e* technique should be finely ground, mix readily with water, and be easily accepted by the fibers of the paper. Some colors are likely to fade with time, particularly transparent reds and purples.

The pigment is ground in a mortar and pestle with a little water. A thorough grinding creates uniformity in the color and eliminates blotches in the printing. Good-quality watercolors and gouache can also be used for *ukiyo-e* printing.

Chinese *sumi* ink, made from lampblack or the soot produced by burning fresh pine needles, is the black most commonly used. It is mixed with glue and sold in slab form, and must be dissolved in a little water before being mixed with the paste on the block.

Paste

The paste gives body to the pigment, binds the particles of pigment together, and makes the pigment adhere to the fibers of the paper. It also ensures the uniform dispersion of the coloring matter and its application on the block. The consistency of the paste must be thick enough to provide adhesion of the paper to the block during printing, so that the paper does not shift. It must not be too heavy, however, or it will stick to the surface and not lift easily.

The paste is made in the following manner, from:

50.0 grams refined rice flour (about $1\frac{3}{4}$ ounces)
0.34 liters of water (about $\frac{3}{4}$ pint)

Place some of the water in a pan, and slowly stir in the rice flour. Do not add all the water at once. Make a paste with the mixture, and stir until it is of a smooth and even consistency. Gradually add the remaining water and place over a medium heat until the mixture becomes translucent. If it comes to a boil, remove immediately from the heat. (A double boiler can be used without danger of overheating the mixture.) Allow the paste to cool.

The consistency of the paste for proper mixing with the pigment must be tested by trial and error. In general, the paste should be fluid enough to be poured from one container to another, yet cling in small globs to the brush. If it is too heavy, a few drops of water can be sprinkled on top of the block as the pigment is being mixed. The final test is the sharpness and completeness of the impression itself and the way it adheres to the paper.

Brushes (for Pigment and Paste)

Brushes are made in a variety of sizes to accommodate image areas of different sizes on the wood blocks.

Separate brushes are kept for pigment and for paste. Bristles for these brushes are made from horsehair set into a wood or bamboo handle. The end of the hair must be fine and soft, and it is conditioned by rubbing on a piece of sharkskin with water (Fig. 95). This softens and splits the ends, making the application of the paste and pigment uniform. A large brush can require several hours of treatment on the sharkskin before it is ready for use.

Applying the Pigment and Paste to the Block

The pigment and water mixture and the paste are kept in separate bowls, each with its own brush. The size of the brush will depend on the size of the area to be covered.

The mixing of the pigment and paste always takes place on the block itself and never in the bowl. Place some pigment on the block with the bamboo brush, and set a small quantity of paste next to it with the paste brush. Then mix the two together, using a circular motion over the appropriate image area. If the strokes of the brush follow the grain, most of the pigment particles will be swept away. For this reason, a final stroking of the brush across the grain is always performed in order to even out the color.

Printing

Registering the Paper

After the color has been applied, the paper is immediately registered on the block, first to the corner guide, then to the side guide. Care must be taken to hold the paper off the image while this is being done (Fig. 96). After the paper is aligned with the registration points, it is allowed to fall onto the block and is rubbed with the baren.

The Baren

The baren is a small circular pad for applying pressure to the back of the paper in printing. It consists of three parts: a flat spiral of cord, the backing disc, and a wrapping of bamboo sheathing.

White bamboo sheathing is used to make the spiral cord. The sheathing is dampened, then twisted and woven together to produce a cord that may have four, eight, or sixteen strands. This produces variation in the number of points that come in contact with the surface of the paper. If the spiral cord is made from four-stranded cord, the contact points will be smaller and closer together and therefore ideal for printing fine detail. A baren with eight strands is generally used for color, and one with sixteen strands for printing large solid areas where a heavy deposit of ink has been applied.

On top of the spiral cord a circular piece of backing is fitted. This is made from many layers of paper that are pasted together and lacquered. It has a narrow lip that holds the spiral cord. Because it is slightly

96. Aligning the printing paper with the registration guides.

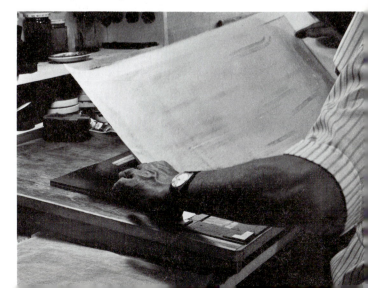

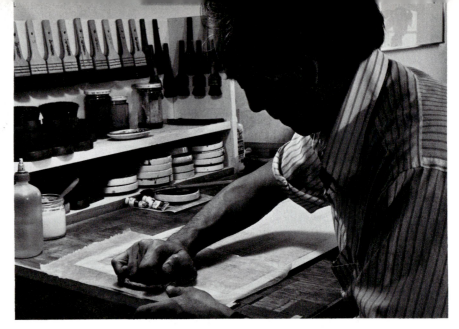

convex, the backing provides a little more pressure in the middle area than at the edges (Fig. 97).

Wrapped around the spiral cord and the lacquered disc is a sheet of white bamboo sheathing. This is the part of the baren that touches the paper directly, covering a strip about 4 inches wide. Its flat surface bridges the gap between one raised surface and another, so the paper is not pushed below the surface to pick up any of the color.

During the printing, the bamboo sheathing is turned slightly, so that the position of the pressure points made by the cord is altered, and the bamboo sheathing does not wear out prematurely. When it does wear out, it is replaced.

The baren is gripped with the four fingers around the cord and the thumb over it (Fig. 98). Pressure should be exerted from the shoulder, and not just from the wrist.

The pattern of rubbing will change somewhat, depending on the image area, but the first rubbing is always light and follows the image in circular motions to secure the paper. A small amount of oil of cloves is then rubbed on the baren and the excess removed with some cotton. This is followed by the application of heavier pressure on the image area, with the baren tracing zig-zag motions. Sometimes, in order to protect the back of the printing paper from wear, a smooth backing sheet will be placed on top.

Gradations

A special printing technique is often used for horizon, sea, or sky areas, in which the intensity of color is gradated. The gradation can be short or spread over a wide area (Pl. 5, p. 57). To accomplish this, the block is first dampened with some water and a rag. Then the brush is moved back and forth, and the pigments are worked gradually into the area (Figs. 99, 100). Occa-

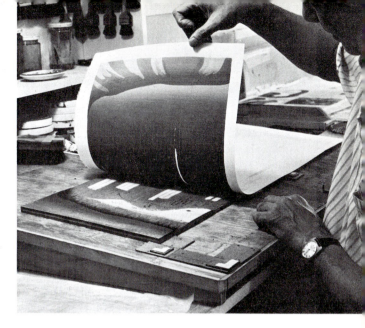

below: **99.** Ansei Uchima applies pigment
for a gradated area of the print,
using a small bamboo brush.

bottom: **100.** The pigment is worked
into the area with a larger brush.

right: **101.** Pulling the gradated print.

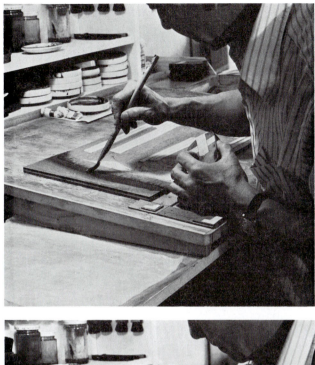

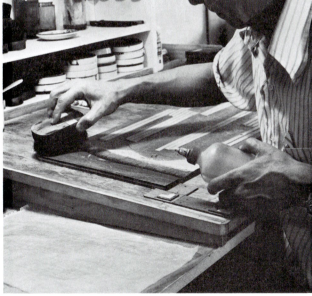

Embossing and Other Effects

The Japanese woodcut artist Suzuki Harunobu (1725–1770) often used the technique of embossing fine lines for the outlines and features of women's faces (Fig. 102). For this effect, a heavy pressure is used on the uninked lines with a soft baren and a smooth backing sheet.

A number of other effects have been used by *ukiyo-e* printers. A common technique is to sprinkle finely-ground mica onto an area on which some glue has been stenciled. Occasionally, gold, silver, or copper powder was used in the same way.

102. Suzuki Harunobu.
*Geisha Masquerading as Dharma
Crossing the Sea on a Reed,* detail.
1766. Color woodcut.
Philadelphia Museum of Art
(gift of Mrs. Emile Geyelin
in memory of Anne Hampton Barnes).

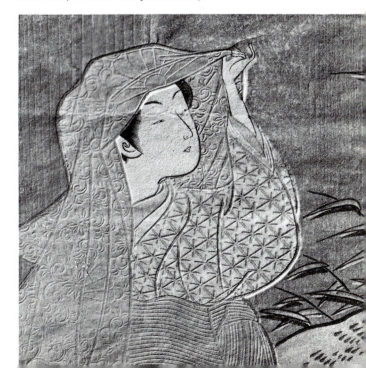

sionally more than one brush is used, each with a different concentration of pigment. Each brush is manipulated in the same manner—from side to side, slowly blending the shades of color into one another. Different colors can be blended in the same technique to achieve very subtle transitions. The print is pulled in the usual way (Fig. 101).

Glossary of Japanese Names

Listed below are the traditional Japanese names for some of the techniques and tools mentioned in this section.

aisuki flat scrapers used in cutting the blocks.

arato rough whetstone.

ategami backing sheet to protect the printing paper when it is rubbed with the baren.

bokoju ("*sumi* juice") Chinese black *sumi* ink dissolved in water.

chudo medium whetstone.

dobori ("cutter of the body") apprentice cutter, responsible for the less detailed work on the block.

dosa size for strengthening printing paper, made from water, *sansembon*, and alum.

dosabake brush made from Chinese sheep hair, for applying *dosa*.

hanshita key drawing from which the key block is made.

hawasu method of arranging sheets of dampened printing paper by overlapping each sheet from left to right.

hinemori paste added to pigment on the block to produce ink, made from water and refined rice flour. A heavier mixture of *hinemori* is also used for pasting the *hanshita* to the block.

hosho paper made from *kozo* bark; the best paper for the *ukiyo-e* technique.

kagi ("key") corner registration guide, shaped like a right angle.

kashirabori ("cutter of the head") master cutter, responsible for the most difficult and delicate carving such as the face and hands in figure work. An apprenticeship of at least ten years was usually necessary to attain this rank.

kento the kagi and nikitzuke, or registration guides cut in each block.

kentonomi flat chisel for cutting the *kento*.

kozo long, inner-bark mulberry fibers.

kyogo impressions made from the key block and used in making individual color blocks.

marunomi gouges for clearing wood on the block.

masaban standard size of *hosho* paper (20 x 14½ inches).

mimi-tsuki ("with ears") deckle or rough edge on printing paper, usually trimmed to obtain closer registration.

minoban *hosho* paper trimmed to 10 x 14½ inches (half of the *masaban*); the usual size for *ukiyo-e* prints.

minogami paper used for making the *kyogo*.

mitzumata short and fine mulberry fibers.

mizubake long, flat brush for dampening printing paper with water.

mundabori ("extra carving") fine lines indicating color areas on the *hanshita*.

nikitzuke registration guide placed on the side of the block, about three-quarters of the way down from the *kagi*.

otosu method of arranging sheets of dampened printing paper by laying four sheets down in staggered fashion with the fifth in the center.

sansembon animal glue, an ingredient of *dosa*.

sashiki-nokogiri saw used for removing excess wood from the surface of the block.

shiageto smooth whetstone.

soainomi general clearing chisel.

sutebori second cut made with the *to*. This removes a thin wedge of wood from the edge of the image.

to basic cutting knife and the most important tool.

ukiyo-e classic period of Japanese woodcutting, from the first half of the 17th century to the middle of the 19th century.

yamazakura wild cherry tree. Its wood is ideal for the *ukiyo-e* technique.

Wood Engraving

Wood engraving is done on the end grain of the wood, as opposed to the plank side associated with the woodcut (Fig. 103). Blocks for wood engraving are available "type-high" (about .918 inch thick), which allows them to be printed in a proofing press that accepts hand-set type used in normal letterpress printing.

During the 1800s wood engraving was an art practiced throughout the world for the illustration of magazines, catalogues, books, and newspapers (Figs. 104, 105). By the mid-1850s, while photography was still in its infancy, a way was found to put photographic images onto the end grain of the wood. These were then translated into line by engraving, in the regular manner for printing in relief. The wood engraver in the latter part of the 19th century was an important person in all the letterpress printing done at that time.

Often a newspaper or journal would need blocks for the next day's edition. As a result, images were transferred onto a composite unit of several individual blocks, and each block would be given to a separate engraver. After cutting, the pieces were put back together again for printing. The important aspect of wood block engravings was that they could be printed *simultaneously* with the type, because the heights of the block and the type were identical, and both were printed in the same relief technique. This greatly speeded the production of early periodicals, enabling many of them to reach mass audiences.

Many of the same tools used for engraving on metal also serve for wood engraving. The major difference is that wood engraving is primarily a "white line" approach to relief printing; that is, the graver

103. The end grain of the block of wood (the top side in this drawing) is the side used for wood engraving.

makes a thin, fine gouge in the wood that remains white as the surface takes ink. The image is created by a number of different tools that produce lines of various widths or engrave several parallel lines simultaneously on the block.

104. **Winslow Homer.** *Christmas Belles.*
1869. Wood engraving, 9 x 13¾".
From *Harper's Weekly*, January 2, 1869.
Whitney Museum of American Art, New York.

The tools necessary for wood engraving are:

□ angle tint tools
□ elliptical tint tools
□ multiple tint tools
□ flat gravers
□ round gravers or scorpers
□ square burins
□ lozenge burins

In addition, the wood engraver will need sharpening stones, a sharpening jig, a small sandbag or leather pad, a slab of white magnesia, and a magnifying glass (optional). Proofing and printing papers, inks, and rollers are also necessary.

Materials for Wood Engraving

The finest wood currently available for engraving is South American boxwood. Because the best boxwood is cut from the trunks of trees only 5 or 6 inches in diameter, a block for wood engraving usually consists of a number of smaller pieces fitted together. Standard-size blocks range from 2 inches square to 10 inches by 12 inches, although blocks as

large as 15 inches by 24 inches can be made to order. All blocks are sold by the square inch; some are of a higher quality than others.

Although it does not produce the same degree of sharpness as boxwood, maple is still capable of yielding extremely fine results. Many wood engravers have been able to make their own blocks from maple or birch available locally. The wood is sliced on a power saw and pieced together to make larger blocks suitable for an engraved work to be printed by hand. If the block is to be type-high for use in a proof press or with type, the planing and sanding of the block must be done with precision and accuracy.

Tools

There are several kinds of cutting tools necessary in wood engraving: the tint tools used for most of the cutting, and the various gravers or burins used for the clearing. The tools come in a range of sizes to produce lines of differing widths.

All the tools are held in essentially the same way—the fingers grasping the side of the graver, the thumb on the opposite side close to the cutting edge

105. A fresh print being
pulled from a 19th-century
boxwood engraving block.

106. Holding an engraving tool.
The sandbag allows the wood block
to be turned easily during the cutting.

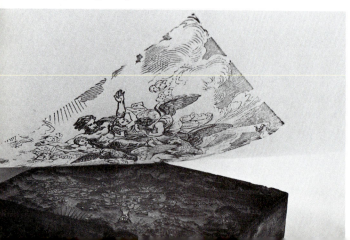

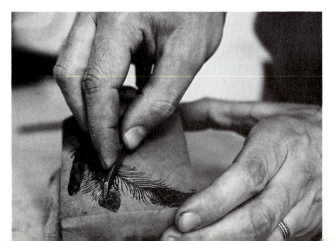

108. Angle tint tools
and their typical line characteristics (a);
elliptical tint tools
and their typical line characteristics (b).

109. Multiple tint tools
and their line characteristics.

(Fig. 106). The thumb in this position acts as a guide and helps steady the cutting. The wooden handle is fitted into the palm of the hand.

Angle Tint Tools The angle tint tools are flat on the sides, tapering to a cutting edge that is slightly flat at the point (Fig. 107). This produces a line of even width. Depending on the tool, the line produced can

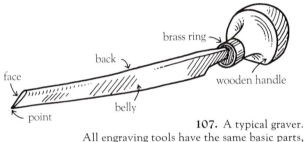

107. A typical graver.
All engraving tools have the same basic parts,
but the shapes of the faces differ.

vary from a knife-edge fineness to a line about $\frac{1}{16}$ inch wide. The tools are numbered from 1, the finest, to 12, the heaviest.

Elliptical Tint Tools The teardrop-shaped elliptical tint tool has a sharp point capable of producing lines that vary from thick to thin (Fig. 108). As the tool digs deeper into the wood, the width of the line increases.

Multiple Tint Tools A series of parallel lines can be made in a single stroke with the multiple tint tool (Fig. 109). The number of lines per inch varies from about twenty or thirty to over a hundred. The most popular sizes for wood engraving, however, produce fifty to seventy-five lines per inch. This tool is used for tonal work, cross-hatching (engraving sets of close intersecting lines), and shading.

Flat Gravers and Round Gravers For removing wood from larger areas of the block, the flat graver or chisel is used (Fig. 110). The round graver, or scorper, can be used to produce wide lines on the block, although its main purpose is to gouge out areas close to the image, where careful control is necessary.

Square Burins and Lozenge Burins The square and lozenge burins are the most popular tools for all types of engraving, on both metal and wood (Fig. 111). Because of its shape, the lozenge burin produces

above: **110.** Round gravers (a)
and flat gravers (b).

right: **111.** The square burin (a)
and the lozenge-shaped burin (b)
with their typical line characteristics.

a finer and deeper line than the square burin, but it is not as easily manipulated in engraving curved and swirling lines.

Sharpening the Tools Most of the tools for wood engraving are sharpened in an identical manner, using a sharpening stone and a little oil. Care must be taken to maintain the cutting edges of the face flat against the stone without rocking the tool. Many tools can be honed on a sharpening jig (Fig. 217).

Placing the Image on the Block

Direct Drawing Method

The first consideration in making the drawing on the block is that most printing techniques will produce a mirror image of the final print.

The block can be drawn on directly with India ink, charcoal, or pencil. An image can also be traced onto a block that has first been coated with a thin film of opaque white watercolor or acrylic. A common practice is to cover the entire block with India ink, and make a white or red chalk drawing or tracing on the surface. This enables the artist to see the work clearly while cutting, and it also gives a good idea of how the finished image will look. A gray ground on the block allows black carbon pencil and other black drawing materials to be seen clearly.

Photo-Image Method

Photographic images on the wood were employed by wood engravers prior to the advent of halftone reproduction methods. The photographic image was used as a guide for the engraving, which was subsequently reproduced in line, stipple, or another engraving technique.

A photographic emulsion from Sanders Wood Engraving Company can be used on a block that has first been sealed with a thin coat of acrylic gesso. Excess emulsion on the surface is blotted up so that only a thin film is left. A negative containing the image to be printed is then placed on top of the block and covered with a piece of glass. Exposure can be made with an arc lamp or sunlamp that has rays high in ultraviolet light. This operation can be done in subdued room light; a darkroom is not required.

The exposure alone will bring up the image on the block, but to make it permanent, a small amount of photographic fixer (*hypo*) should be applied, then washed from the surface. The photographic image can now be used as a guide for the cutting. Some other emulsions (both contact and projection speed) that are suitable for wood engraving blocks are available from Rockland-Colloid Corporation. These emulsions must be used in a darkroom.

Cutting the Block

Until you gain experience in manipulating the tools, proceed slowly in cutting the block. You can cut the block all at once, or one section at a time. A sandbag or leather pad under the block will greatly aid fluidity of movement and will also facilitate turning the block for curved or circular lines (Fig. 106). The *block* is always rotated, never the tool.

As the cutting is underway, a slab of white magnesia can be rubbed onto the surface of the block. This fills the cut lines of the engraved portions with white powder, simulating the appearance of the final print.

Large magnifying glasses are invaluable for cutting fine detail. These are available on stands, so that they can be placed over the work. A magnifying visor that fits over the head is also excellent for this pur-

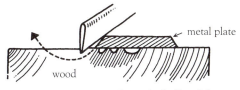

112. Protect cut areas from the belly of the graver with a brass or copper plate.

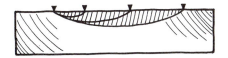

above: 113. Large nonimage areas can be cleared to a greater depth than smaller areas can.

below: 114. Small areas of the image can be repaired by inserting a square or round plug into a hole drilled or chiseled in the block.

pose. Some visors can be fitted with lenses of different degrees of magnification. Adequate lighting must be available for good engraving. The source should be behind the shoulder, or at the side, bouncing light away from the eyes and eliminating glare.

When cutting or gouging is done close to other lines, there is a danger of the belly of the graver denting other work. To prevent this, place a brass or copper plate about $\frac{1}{16}$ inch thick and with a beveled edge over the completed work. Then lever the graver against the metal, rather than against the wood itself (Fig. 112).

When a large area is to be cleared, the depth to which the wood should be gouged is proportional to the size of the area (Fig. 113). The wider the area, the deeper the gouging must be.

For repairing a small area, make a square or round hole partially through the block, and plug with a dowel of the same wood (Fig. 114). Saw the plug close to the surface, sand, and engrave.

Printing

In Thomas Bewick's time (1753–1828), stiff ink was applied to the wood engraving with a leather dabber. This technique was later replaced by the use of the roller.

Because of the detail in wood engraving, the roller should not be too soft, or it will have a tendency to push ink over the edges of the engraved lines. A roller of composition rubber, plastic, or gelatin is best. The ink must be heavy, intense, and thinly applied. Too soft or too heavy an ink will squeeze over the edge, thickening the image and filling in detail.

A wide variety of papers can be used for printing. Smooth, thin papers are generally associated with wood engraving, because they produce sharp, crisp images typical of the magazine and book illustrations of the late 1800s. Mold-made and handmade papers for limited editions will yield beautiful prints if the paper is slightly dampened in advance. A letterpress effect, with the inked surface slightly indented, can be achieved in this way. The printing itself can be accomplished in two ways: by rubbing the back of the paper by hand with a burnisher, or by using a press.

Press Printing

Several types of presses can be adapted for printing wood engravings as well as woodcuts. If the wood engraving block is type-high, it can be printed on a

Vandercook press or platen press designed to accommodate blocks of this exact height (Figs. 115, 116). These presses are often equipped with automatic inking devices but will not accept warped blocks. Blocks lower than type height can be shimmed up with paper until the proper height is reached.

Both lithographic hand presses and etching presses can be adapted to print woodcuts and wood engravings. On a lithographic press, the block is surrounded by other blocks of the same height. The scraper bar of the press must start and stop off the surface of the block, and beyond the size of the printing paper on either end. The engraved block can be either fitted into the opening after it is inked or inked while in position on the pressbed. Once in position, the block is covered with the printing paper, a thin sheet of mat board, oak tag, or other heavy paper, and the greased tympan. Only a light to medium pressure is needed to make a good impression from wood.

On an etching press, the upper cylinder is first raised above the height of the block. The inked block is placed in the center of the pressbed with the printing paper on top. This is covered with a thin mat board or one or two sheets of heavy-weight printing paper, and a thin blanket of felt or rubber. The pressure, which should be light, is adjusted so that the roller will come onto the block and off again without difficulty. Heavy pressure is unnecessary and could damage the block. To prevent slippage, hold the papers and blanket on the block as it begins to roll under the press.

left: 115. The type-high wood engraving shown in Figure 106 was printed on a Vandercook press.

right: 116. The completed wood engraving.

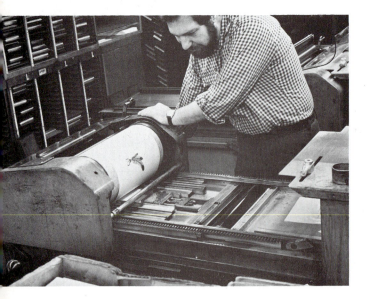

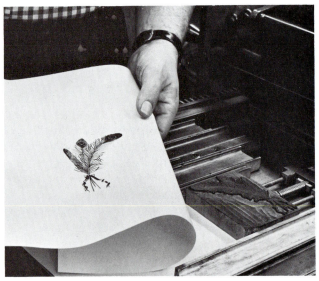

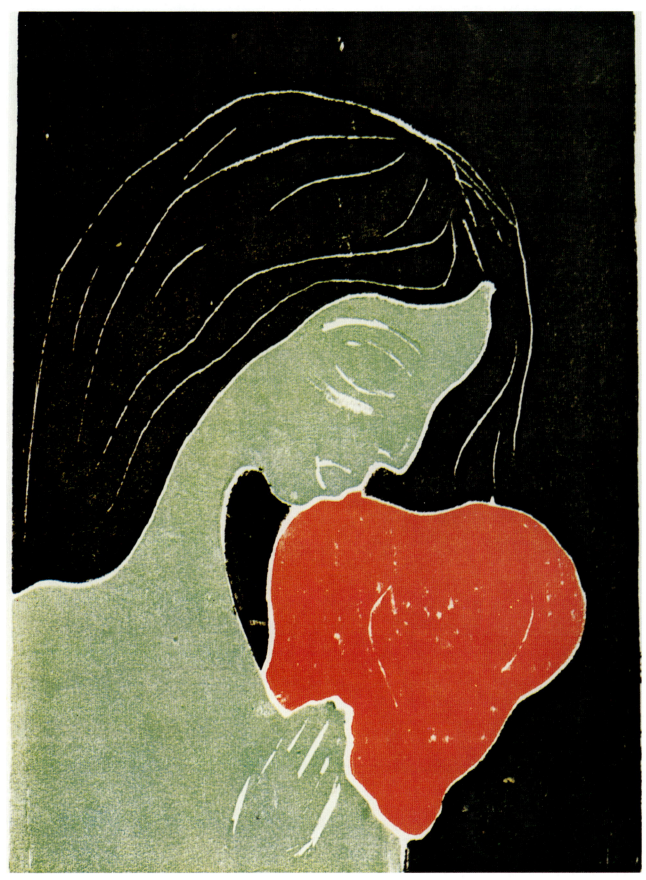

Plate 7. Edvard Munch. *The Heart.* 1899.
Color woodcut, 9⅞ × 7¼″. Munch-Museet, Oslo.

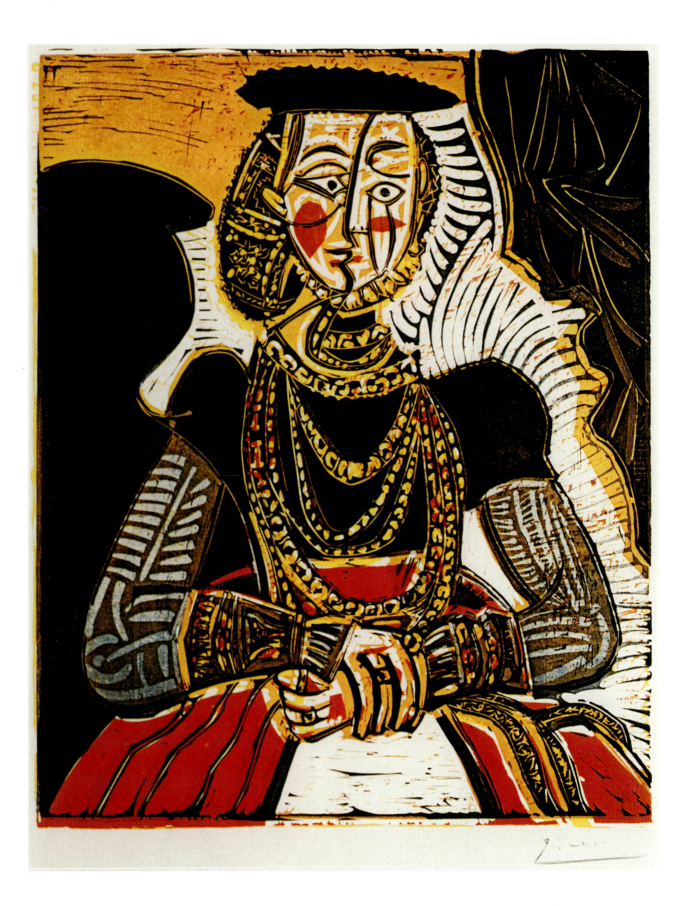

Plate 8. Pablo Picasso. *Bust of a Woman after Cranach the Younger.* 1958.
Color linocut, 25¼ × 21⅛″.
Courtesy Fischer Fine Art Ltd., London.

Plate 9. A proof taken from the first, two-color block for Seong Moy's cardboard relief *"555" - #2.*

with a

Plate 11. A proof of the third block printed separately shows the five color areas that were inked on the block.

Pla

Plate 13. This proof shows all the previous stages printed together. One more block was inked and printed to complete the image. (See Plate 14, p. 78.)

Plate 14. Seong Moy. "555" - #2. Cardboard relief print, 22¾" × 32". Courtesy the artist.

Other Approaches to the Relief Print

For most of the techniques described below, the artist will need much of the same equipment and tools listed on page 40.

Cut Block Prints

A single wood block can be cut with a jigsaw into any number of curved shapes, which are then inked with different colors, reassembled, and printed (Figs. 117–120 and Pl. 6, p. 58). Edvard Munch employed this technique in many of his wood block prints, in a way that gave his images unique drama and power (Pl. 7, p. 75). The white line that often appears between the shapes is typical of this method, and can sometimes be emphasized for a special effect.

This pieced approach to cutting the block can be applied to most other relief processes as well. Plastic and Masonite plates can be cut into pieces; so can cardboard or metal relief plates. This is often a simple and expedient way to print several colors at one time.

below left: 117. To pull a print of the color woodcut by Jim Dine shown in Plate 6 (p. 58), the cut pieces of wood are first inked separately.

below: 118. The nonimage area of the block is positioned on an etching press.

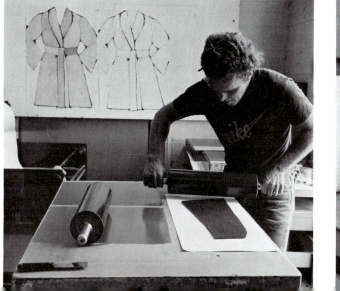

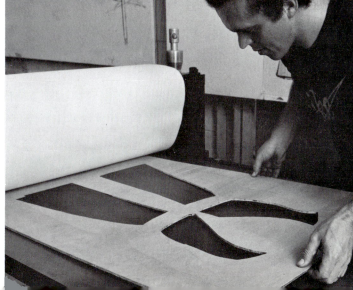

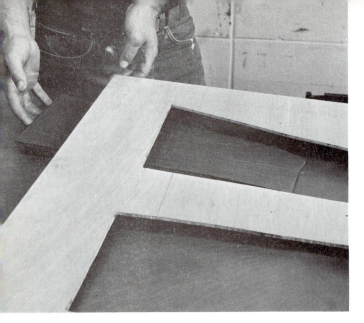

119. The cut and inked blocks are replaced.

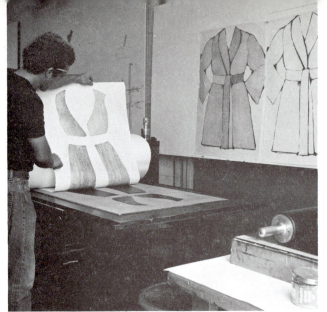

120. A proof of the first block is pulled. (See Pl. 6, p. 58).

Prints Made from Small Blocks and Found Objects

Small pieces of textured wood, found objects, and separate small blocks can be incorporated into larger prints for some very interesting effects (Fig. 121). Cut a piece of cardboard the same size as the full-size block to be printed. Glue the smaller piece to be inked onto the cardboard in the correct position, and allow it to dry. The cardboard can now be registered like a separate block (see p. 50), and is ready to be inked and printed. Pieces higher than the sides of the registration guide can be printed by adding some stripping to raise the level of the guide.

Stamped Prints

It often happens that only a small accent of color is needed on a particular print. Instead of attaching a small piece of wood to a separate block or cardboard, it may be easier to make a little stamp that can be inked separately and printed directly over the larger image (Fig. 122). Commercial rubber stamps (precut or cut by hand), small wood blocks, art gum erasers, pink pearl erasers, and other small, firm objects are excellent. Regular woodcut inks can be rolled onto the stamp, or it can be inked on a commercial stamp pad for variety of color and impression. The image can be repeated as many times as desired.

121. Detail from a print by Seong Moy shows texture produced by weatherbeaten plywood.

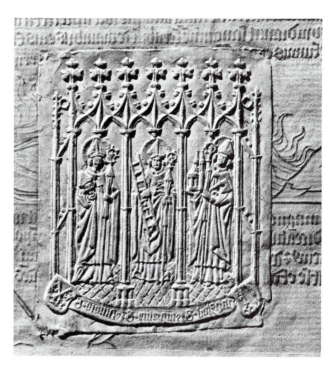

below: **122.** A small stamp can be printed once or repeated several times.

right: **123.** *Patron Saints of Ratisbon: St. Denis, St. Emmeram, and St. Wolfgang.* German, 1460-70. Woodcut (seal print). Metropolitan Museum of Art, New York (gift of J. Pierpont Morgan, 1917).

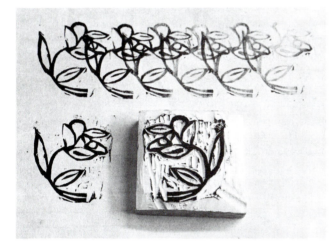

below: **124. William Blake.** *The Tyger,* from *Songs of Experience.* 1794. Relief etching printed as a woodcut, $4\frac{5}{8}$ x $2\frac{5}{8}$". Metropolitan Museum of Art, New York (Rogers Fund, 1917).

Embossed Prints

Embossing, sometimes called *blind embossing* or *gauffrage,* has been used since the 15th century (Fig. 123). Deep embossing can be made on a print by applying pressure. An etching press will accomplish this easily, but it is also possible to emboss by hand. A heavy, dampened paper should be used, such as Murillo or Arches Cover. Arrange the paper on the block, and rub the back of it to reveal the entire image on the block. Then, with a bamboo spoon or other burnisher, push the paper against the edges of the carving and increase the depth of the embossing, working slowly to allow the fibers of the paper to stretch.

Metal Relief Prints

Around the turn of the 19th century, William Blake developed a technique in which an etching ground was used to draw directly on a copper plate. The printing image remained in relief when the rest of the plate was etched in acid (Fig. 124). Metal relief print-

125. Various textures produced on a plaster relief cast.

ing plates can be made for handprinting in the same way, using a commercial photo resist and a photographic line or halftone negative. For maximum detail in printing, work with a medium-hard roller and a thin film of dense ink.

Plaster Relief Prints

For making plaster relief prints, the printing plate is cast in plaster and worked with various tools, both while it is still wet and after it has dried. Gypsum casting plaster, commonly called plaster of Paris, is most often used, although other kinds of fine plaster or plaster mixtures can be made to work successfully. Marble dust and an acrylic medium, for example, form a tough casting material that can be cut, gouged, scratched, and engraved with excellent results for

126. Pouring plaster into the wooden frame. A piece of fiberglass is used to reinforce the cast; the plaster is smoothed with a stick.

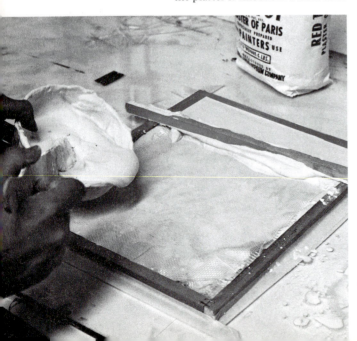

both relief and intaglio printing. Calcium carbonate and acrylic medium or glue, dental plaster, and even potter's clay can all produce a cast printing surface capable of holding considerable texture and detail (Fig. 125).

Glass, Plexiglas, and Formica all make excellent base sheets when surrounded by a frame of wooden strips to hold in the plaster as it is being poured. To make sure the plaster or acrylic mixture will release easily from the base, spray the entire base with a coating of silicone.

With the base and frame on a level surface, pour out enough plaster to fill the frame about halfway to the top. Set a piece of plastic screen, wire screen, burlap, or other strong, porous material on top, and pour in the remaining plaster (Fig. 126). The screen or fabric enmeshed in the plaster will give strength to the hardened slab. When the plaster has set, the wood can be removed and the slab separated from the base.

India ink rubbed over the surface will allow the image to be seen more clearly during cutting. For printing, an oil-based ink is best. If the surface of the slab is too absorbent, it can be sealed with shellac, acrylic medium, or varnish. This also facilitates cleaning (with kerosene or paint thinner) and allows the artist to change colors. Printing is done in the same manner as for an ordinary woodcut.

Linoleum Prints

Linoleum is made with powdered cork, rosin, and linseed oil, with a burlap backing. Because of its relative softness and the ease with which it can be cut, it has long been popular with school children as an inexpensive and simple material for the making of relief prints. In the hands of an artist such as Picasso, however, linoleum can be transformed into a medium of infinite creative value (Pl. 8, p. 76).

128. A detail of a typically cut linoleum print.

The U-shaped gouge is the most practical tool for cutting linoleum, and it is often used exclusively for the creation of the entire image. At least three gouges of different sizes, varying from ⅛ inch to ⅜ inch, will be needed. A wider, C-shaped gouge can be used for clearing larger areas.

It is a good idea to mount the linoleum on a piece of wood or plywood before cutting. Simply spread some glue over the wood, place the burlap side of the linoleum down on it, and put a heavy weight on top. The edges can be trimmed after the glue has dried. To remove any imperfections in the linoleum and smooth out its pebbly surface, sand it lightly.

Textures can be made in the surface of the linoleum with a knife or other tool (Fig. 127). When clearing the unwanted areas, make the initial gouging shallow, so that the ridges left by the blade will pick

127. Because of its softness, linoleum is easy to cut in any direction.

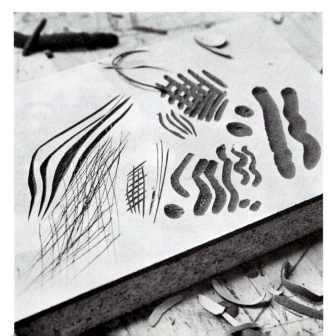

up ink. This technique leaves an interesting textural effect between the raised areas and produces an active surface characteristic of the linoleum print (Fig. 128). By gouging more deeply into these areas, you can eliminate textures produced by the tool. It is wise, however, to minimize cutting and make progressive proofs, in order to take advantage of desirable textures in the wood.

Printing the linoleum block by hand follows the same procedure as making other types of relief prints. Because of the consistency of the linoleum, it will also print with excellent results on an etching press (see Chap. 4, pp. 160–164). The block can be used with dampened paper to create inkless intaglios or embossed prints. If the blocks are type-high and absolutely smooth, they can be printed in a Vandercook press or an Albion-type press. In some cases, a lithographic press will even work if enough space is left on all sides of the image to accommodate the scraper bar and provide support as it moves through the press.

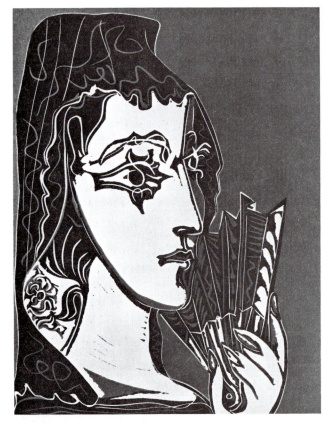

129. **Pablo Picasso.** *Head of a Woman.* 1962. Reduction woodcut printed in beige, brown, and black, 14 x 10¾". Albertina Graphische Sammlung, Vienna.

printed with yellow at this time. Next, the areas that are to remain yellow are cut from the block, and the areas that are left are printed with the second color, such as red. The block is reduced with each cutting, and the entire edition is printed each time. Because the colors will print over each other, it is best to work from light to dark.

Carol Summers' Solvent Technique

An unusual printing technique is used by Carol Summers. After cutting the blocks for *Road to Ketchikan* (Pl. 3, p. 55), he printed the mountain with pink ink on the back of the paper, in the relief manner. The rest of the colors, including a deep red for the mountain, were printed by laying the paper over the uninked blocks and rolling the ink directly onto the paper. The print was sprayed with mineral spirits, which dissolved the inks and slightly blurred the edges of the shapes.

Cardboard Relief Prints

The following materials are needed for making cardboard relief prints:

- single– and double–weight smooth white or cream-colored mat board
- Masonite or chipboard panels
- sharp mat knife, X-acto knife, or woodcut knife
- double-faced masking tape
- modeling paste
- acrylic medium (gloss or mat)
- spray lacquer (lacquer hair spray)
- inks, rollers, solvents

Reduction Block Prints

The reduction block method is a means of creating different images on the same block by a process of elimination (Fig. 129). Because each cutting alters the printing image, the artist must have a clear idea in mind of the steps needed to produce the final print and must plan the cutting accordingly.

If there will be any white in the image, these areas are cut from the block first, and the remaining areas are printed in the lightest color to be used, such as yellow. The entire edition of prints must all be

An outgrowth of the basic woodcut methods, the cardboard relief system of printing utilizes readily available and inexpensive materials—mat board and other related boards—in a way that is both simple and direct. The format is not as limiting as the wood block, and the process is additive as well as subtractive. In other words, imagery can be made in relief by adding pieces to the surface as well as by cutting away. This allows infinite control and flexibility in the manipulation of the image at all stages of the creative process (Pls. 9–14, pp. 77, 78).

Construction of the Cardboard Relief Plate

The thickness of the base board and the relief image will be governed by the weight of the mat board. The height created by single-weight mat board is sufficient for most work, and will provide the strength and rigidity necessary for large editions.

For the base plate, a heavier material such as double-weight mat board or Masonite can be used for greater rigidity. This is cut to whatever the final image size is to be. The image areas are then cut from pieces of single-weight smooth mat board and arranged on top of the base plate. The shapes should always be cut in a pyramidal fashion; that is, with the side edges of each shape wider at the base than at the level of the printing surface. This gives strength to even the most delicate of lines (Fig. 130). The cut pieces are initially affixed to the base plate with double-faced masking tape, after which they can be glued for greater permanence if necessary. (A certain fluidity in the compositional arrangement is made possible, however, by keeping the double-faced tape under each shape and rearranging the printing surfaces in a variety of positions.) They are then sprayed with lacquer (lacquer hair spray is excellent) so that the printing ink will not be absorbed into the board itself. With the use of

130. Cut and glued shapes for a cardboard relief print by Seong Moy. Figures 131–133 and Plates 9–14 (pp. 77, 78) show further stages in the development of the same print.

131. Building up textures on the surface.

132. Pulling a trial proof.

modeling paste and acrylic mediums, textures can be built up lightly on the surface areas with fabrics and other materials (Fig. 131).

Pull a trial proof by inking the surface and printing as you would a normal woodcut (Fig. 132). If additions or subtractions are necessary, this is done simply by removing or adhering new shapes to the base or by recutting carefully the original shapes.

Registration

Because of the ease with which cardboard relief printing plates can be made, the process is ideal for multicolor printing. A registration device similar to that used in the normal woodcut technique (see p. 50) can be made. The baseboard for the registration device should be of a rigid material, such as Masonite or hard board (Fig. 133). This can be several inches larger all around than the largest plate to be printed. On the lower left corner, strips of mat board are glued to the surface to form a corner angle against which both the plate and paper are to be registered. This

angle could be of the same material as the printing plates and the same height.

Printing

In the printing operation, the inks, papers, and method of registering are all identical to those used in the normal woodcut technique (see pp. 48–52). Seong Moy has developed this technique into a system appropriate to many creative approaches—textural, hard-edged, and linear. He also employs a unique method of blotting the print to produce consistent and subtle tonalities. First he prints a light-colored ink containing a small amount of cobalt or manganese drier. This ink seals the surface of the printing paper (usually Torinoko). A darker transparent color is printed over the first color and is immediately blotted with clean newsprint, removing some ink from the areas where it overlaps the first color. Blotting a second or third time removes additional ink from the overprinted areas, but the areas where the second ink contacts the paper directly remain dark.

133. Registering the print.

part two
Intaglio

3 The History of Intaglio

The several processes grouped under the category of *intaglio* have in common the incision of lines or images into a surface, usually of metal. Intaglio prints result when the incised areas are filled with ink or similar substance for transfer of the image to paper. Whereas the relief processes discussed in Chapter 1 rely on a *raised* printing surface, the printing areas in the intaglio methods are *depressed* below the surface of the plate.

The vehicle for cutting into the metal or other material may be either a sharp tool (engraving, wood engraving, drypoint, mezzotint) or an acid solution (etching, aquatint). Once the plate has been cut, the depressed areas are filled with ink and the nonprinting surface wiped clean. Pressure forces the paper into the depressed areas, and the image is transferred.

15th-Century Engraving in Europe

The underlying principles of intaglio printing were known in the Middle Ages, especially to goldsmiths and armorers. However, it was not until the 15th century, when paper became more generally available, that intaglio printing emerged as a specific art medium. The goldsmith and the armorer played an integral part in medieval European culture. These artisans needed to keep records of their engraved designs, as well as to follow the development of work in progress. Thus, they transferred their images to paper. From this practice it was but a short step to considering the paper image as an end in itself.

As with woodcut, engraving in the 15th century served for two quite separate purposes—serious reli-

gious imagery and popular secular themes. In a population that was overwhelmingly illiterate, prints depicting the saints, the mysteries, and other holy scenes performed as a direct and forceful method of instruction.

One of the most popular secular outlets for the engraver's art was in the production of playing cards. As discussed in Chapter 1, playing cards offered a major form of recreation for both the aristocracy and the common people. Many of these were woodcuts (Fig. 6), but there are splendid examples of engraved playing cards from the 15th century. All told, both religious and secular ends provided the stimulus for the flowering of the engraver's art in late medieval and Renaissance Europe.

The Northern and Southern Styles

The two outstanding centers in the development of engraving were Germany and Italy, but the styles practiced in these areas were quite different. It must be remembered that the Renaissance, that most self-conscious of artistic upheavals, began in Italy and did not spread to the rest of Europe until much later. The northern artists achieved a greater technical facility, but their imagery and approach remained basically medieval in the 15th century. The Italians, however, caught up in the classical aesthetic of the Renaissance, created works characterized by both a greater degree of freedom in invention and a grandeur of design. Specific technological differences also separated the methods of the two countries. In the North artists had the advantage of the drum or roller press, which produced lines and tones of great clarity. In Italy, some prints were made by hand-burnishing, which resulted in much more uneven impressions. Our understanding of the development of engraving in Italy is somewhat complicated by the anonymity of the craftsmen. In the North the artists and the engravers were the same; both design and execution rested in the hands of one individual. In Italy, especially at first, this was not so. Perhaps the distinctions between the two regions will become clear as we discuss the earliest masters in each.

The Northern Masters

The first significant engraver in northern Europe was the anonymous artist known simply as the Master of the Playing Cards, so called because of his production of more than sixty engraved cards in various suits of flowers, birds, and animals (Fig. 134). Working in Germany from the 1430s to the 1460s, this master invented creatures that are curiously naïve, yet full of vitality. He achieved in his prints a coloration or value change through the proximity of single strokes

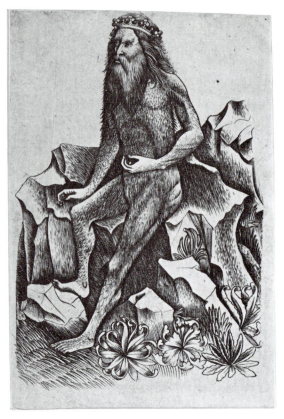

above: 134. **Master of the Playing Cards.**
King of Wild Men. c. 1435–40. Engraving, $5\frac{1}{4}$ x $3\frac{1}{2}$''.
Kupferstichkabinett, Staatliche Museen, Berlin.

below: 135. **Master E.S.** *Einsiedeln Madonna.* 1466.
Engraving, $8\frac{1}{4}$ x $4\frac{7}{8}$''.
Kupferstichkabinett, Staatliche Museen, Berlin.

at various angles. Close, often parallel lines create dark, rich areas of value. In particular, the Master of the Playing Cards used short, rather erratic lines, and their subtle effect shows his sensitivity toward nature.

During the third quarter of the 15th century the master known as "E.S.," after the way in which he signed his prints, flourished in southern Germany or Switzerland. Probably trained as a goldsmith, this artist produced a great number of prints, many of which are both monogrammed and dated. It is likely that Master E.S. observed the work of the Master of the Playing Cards, and with this advantage he perfected a clarity and directness of linear patterning (Fig. 135). Yet his technique is more than a simple compilation from previous artists. Through a combination of single strokes, parallels, cross-hatchings, dots, and flicks, E.S. managed to attain a new subtlety and wider variety of coloristic effects. The monumentality of his Gothic architectural settings is counterbalanced by the soft folds of draperies and the delicacy of foliage. The works have a serene orderliness and describe facial features with great expressiveness.

Yet another anonymous northern master is responsible for developing the important complementary technique to engraving—the *drypoint*. This was the Master of the Housebook, named for the drawings of medieval objects in a manuscript known as *The Housebook*. Because most of his prints now belong to the museum in Amsterdam, this artist is also known as the Master of the Amsterdam Cabinet.

Probably of Netherlandish origin and trained as a painter, the Housebook Master brought a quite distinct approach and personality to the art of intaglio (Fig. 136). Rejecting the crisp and rather hard-edged cutting action of the burin, he used a needle, which made a jagged rupture, instead of a deep groove, on the surface of the metal. When the plate was inked, the rough texture of the lines formed in this manner produced a rich, furry black. The loose strokes and lines tend to vitalize the compositions and allow latitude for a clear analysis of subject matter. The Housebook Master's approach to genre subjects and his power for the description of human expression set him far above his contemporary printmakers.

Among the leading Northern engravers whose identity we know is Martin Schongauer. Like Master E.S., who was probably his teacher, Schongauer was trained as a gold- and silversmith, but he also worked as a painter. It was this artist who elevated the print to a position of artistic rivalry with traditional art forms, through both the grandeur of his subjects and his ability to represent human expression. His prints bridge the gap between medieval and Renaissance aesthetic. Stylistic development of Schongauer's signature monogram enables historians to arrange his prints in a reasonably chronological order, so we can

trace his efforts to develop the purpose and form of the print.

Schongauer seems to have adapted the very monsters that enlivened the façades of Gothic cathedrals to heighten the dramatic effect in *The Temptation of Saint Anthony* (Fig. 137), a print that Michelangelo is

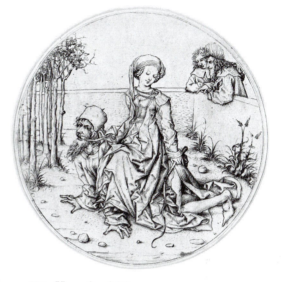

above: **136. Housebook Master.**
Aristotle and Phyllis. c. 1475–80.
Drypoint, diameter 6⅛". Rijksmuseum, Amsterdam.

below: **137. Martin Schongauer.**
The Temptation of Saint Anthony.
c. 1480–90. Engraving, 12⅜ x 9⅛".
National Gallery of Art, Washington, D.C.
(Rosenwald Collection).

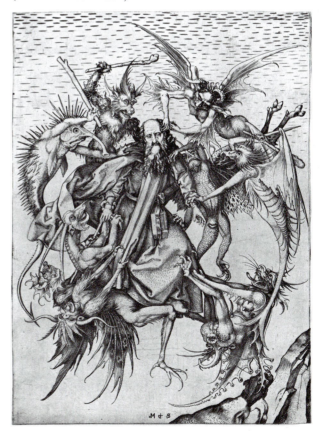

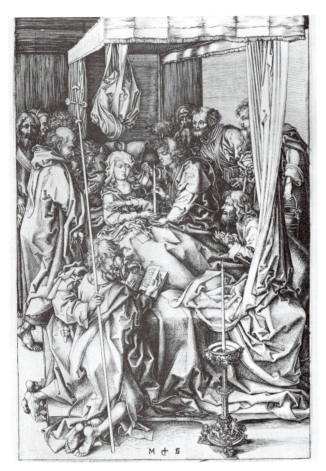

138. Martin Schongauer. *Death of the Virgin.* c. 1470–75. Engraving (first state), 10 x 7⅝″. British Museum, London.

said to have admired and copied several times. Here the artist contrasts the horrific aspects of the fantastic beasts, with their incredibly varied surfaces, against the triumphant goodness radiating from the face of the saint.

Among the most forceful of Schongauer's religious prints is the *Death of the Virgin* (Fig. 138), from the same period. The artist's superb craftsmanship is evident in such precise details as the candleholder and the twisted drapery, but again Schongauer achieves his moving effect by contrasting the agitated features of the highly individualized apostles against the calm of the dying Virgin. The tremendous influence of this work can be seen in the prints of Dürer and Rembrandt when they deal with similar subject matter (Figs. 17, 158).

The Italian Masters

The most important center of engraving in Italy in the last half of the 15th century was also the city in the forefront of the Italian Renaissance—Florence. Early Florentine engraving is often divided into two coexisting schools known as the *Fine Manner* and the *Broad Manner.*

Fine-Manner engraving seems to have developed from the silversmiths' process known as *niello.* In this technique lines were engraved into silver and then filled with an enamellike substance called *nigellum,* which, when heated, united with the metal. The surface was then polished, revealing a black design in a silver field. Niello work sometimes consisted of fine lines laid closely together, occasionally with irregular cross-hatching. This same delicate pattern can be seen in Fine-Manner engravings, of which the leading master was Maso Finiguerra.

Of the works attributed to Finiguerra, the most important are a series illustrating the so-called "children of the planets," which in effect meant depictions of the various professions thought to be influenced by the different stars and planets. The engraving that features the children of the planet *Mercury* is particularly interesting (Fig. 139). Among the many artisans who worked under this sign, the print shows an engraver busily scratching at his metal plate (lower left, just inside the building). In the *Planets* series Finiguerra used a very high horizon line and clearly made an attempt at linear perspective. The rather precious effect of the prints, with their childlike figures, refers directly to the metalsmith tradition.

The Broad-Manner engravers, no doubt influenced by the classically inspired works of the Renaissance painters and architects, sought to achieve grander pictorial schemes. Works in the Broad Manner rely on simple, broad lines with some cross-hatching done in the manner of pen drawings. The style was utilized by several anonymous artists for impressive large-scale engravings, but the acknowledged master of Broad-Manner engraving was the painter Antonio Pollaiuolo.

As Schongauer elevated the art of engraving in the North, so his contemporary Antonio Pollaiuolo introduced a new concept of expression in engraving to the South, and he did it with a single print, the work known as *The Battle of Naked Men* (Fig. 140). It has been suggested that *The Battle of Naked Men* was a *tour de force* intended by Pollaiuolo to serve as an advertisement of his own genius, compared to that of Finiguerra. Nevertheless, this engraving is among the most influential works in the history of printmaking. Scholars continue to debate the nature of the subject matter depicted; however, it is not necessary to know what specific classical story Pollaiuolo had in mind to appreciate the remarkable display of the human body in a variety of dynamic poses. Pollaiuolo was one of the first artists to seriously study human anatomy, and this print serves as a summation of his knowledge. To achieve this remarkable work the artist combined qualities of both the Fine and Broad Manners.

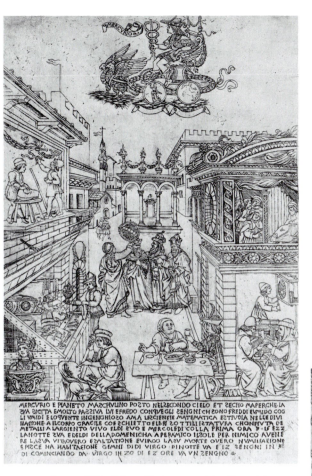

The fine shading on the tall plants that act as a backdrop to the scene recalls the approach of the niellists, but the strong outlines describing the figures and the return-stroke shading characteristic of pen work relate to the Broad Manner. In terms of its content, *The Battle of Naked Men* is significant in its serious investigation of a secular theme—a Renaissance ideal that contrasts with the predominantly religious orientation of the Middle Ages.

Outside Florence there were also several important engravers. Perhaps the greatest of these was the Mantuan artist Andrea Mantegna. Chiefly renowned as a painter, Mantegna was devoted to a study of the ancient world. In his engraving of *The Battle of the Sea Gods* (Fig. 141) we can see the influences of classical sculpture as well as of Pollaiuolo's anatomical study. But while Pollaiuolo felt compelled to cover the whole surface of the print with his rhythmic forms, Mantegna left more areas free and open, thus attaining greater strength of design.

above: 139. **Maso Finiguerra.** *The Planet Mercury.*
c. 1460–65. Engraving, 12½ x 8½".
British Museum, London.

right: 140. **Antonio Pollaiuolo.**
Battle of Naked Men. c. 1470.
Engraving, 16¼ x 24¼".
Cleveland Museum of Art (J. H. Wade Fund).

ow: 141. **Andrea Mantegna.** *Battle of the Sea Gods.* c. 1493.
Engraving, 11⅝ x 15⅝".
Metropolitan Museum of Art, New York
(Rogers Fund, 1920).

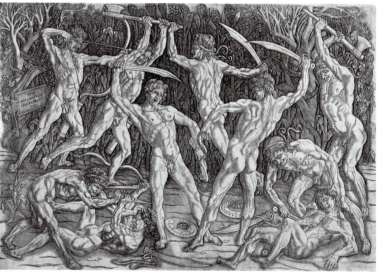

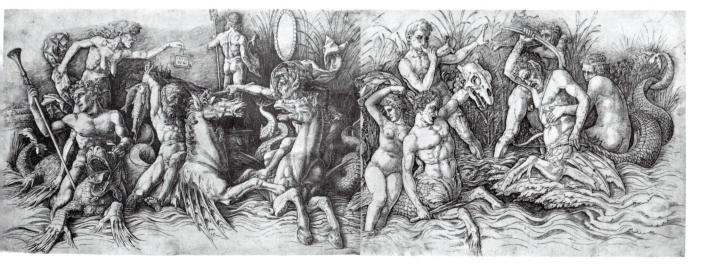

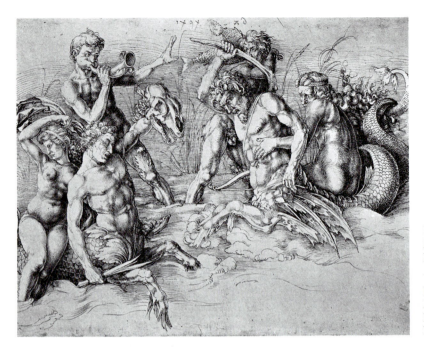

left: **142. Albrecht Dürer.**
Battle of the Sea Gods. 1494.
Pen drawing, 11⅜ x 15″.
Albertina Graphische Sammlung, Vienna.

below: **143. Albrecht Dürer.**
Knight, Death, and the Devil. 1513.
Engraving, 9⅞ x 7¾″.
British Museum, London.

Mantegna's engravings were widely distributed throughout Europe, a fact that caused his style to have great influence on other artists. This leads us directly to a consideration of the first true genius of the engraver's art—as of woodcut—for Dürer copied *The Battle of the Sea Gods* a year after Mantegna published it.

16th-Century Intaglio Printing

Albrecht Dürer

The advancements in the art of representation, the study of proportion and perspective made by the Italians in the 15th century, bore their greatest fruit in the works of the German artist Albrecht Dürer. We have already seen how Dürer raised woodcut from a crude workshop craft to a fine art, and he did much the same with engraving and drypoint. In the northern tradition Dürer had been trained as a goldsmith. His early engravings reveal the crispness of design and use of ornamental forms that characterize that mode. Yet at the same time, even early works demonstrate his extraordinary technical facility and wonderful sensitivity.

In 1594 Dürer made a pen drawing after Mantegna's *Battle of the Sea Gods* (Fig. 142), and it is interesting to compare the two works. Clearly Dürer intended this exercise as an instructional device for himself, yet he did not simply make a mechanical copy of the engraving. Many subtle alterations pinpoint the differences between Dürer's and Mantegna's styles, between northern and southern aesthetic—and, of course, between the media of pen

and engraving. Most obviously, Dürer has simplified the background and foreground details, so that the figures stand in clearer relief. The musculature of the figures, particularly the god at the far right, has been much more strongly modeled by Dürer; thus the

forms seem rounder and fuller while at the same time having softer contours. Even more telling are the expressions on the faces, which in Dürer's version take on a northern intensity. Finally, Dürer's careful shading gives the pen drawing greater contrasts in value—more "color"—than the engraving.

above: 144. **Albrecht Dürer.** *St. Jerome in His Study.* 1514. Engraving, 9¾ x 7½″. British Museum, London.

below: 145. **Albrecht Dürer.** *The Cannon.* 1518. Etching, 8⅝ x 12⅝″. National Gallery of Art, Washington, D.C. (Rosenwald Collection).

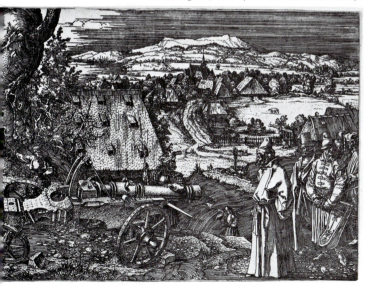

Northern currents also played their role in Dürer's development. Martin Schongauer had a profound effect on his work, as did the Housebook Master. Dürer was a friend and correspondent of the leading thinkers of his day, so it is no surprise to discover that his works are invested with complex meanings beyond anything ever attempted by his predecessors. Unlike his practice with woodblocks, Dürer cut his own intaglio work, but his prints transcend technique; versatility remains subservient to idea.

The engraving *Knight, Death, and the Devil* (Fig. 143) is a symbolic representation of the Christian faith. The good knight moves unconquerable through a forest of knurled trees, curled snakes, composite monsters, and dripping flesh, paying heed neither to the skeletal figure of death nor to the devil figure borrowed from Schongauer. He adheres to Erasmus' famous mandate, "Look not behind thee." The forceful effect of this print is enhanced by an infinite number of cross-hatching and dot combinations, as well as variations of stroke (accomplished both by rotating the plate against the burin and by securing the plate and moving the burin).

By comparison to the active knight, Dürer's image of *St. Jerome in His Study* (Fig. 144) represents the contemplative, thinking man. A serene calm pervades the saint's cosy room, which is flooded with sunlight and guarded by the sleeping lion. The interior of the room is drawn in strict linear perspective, and again details are provided by a multitude of intricate line and stroke combinations.

At about the same time when Dürer engraved the *St. Jerome*, he was also investigating a newer medium—etching. Compared to engraving, etching is a very free process—unencumbered by awkward tools and physical limitations. The engraver's burin must not only describe a line but fashion its depth as well; by contrast the etcher's needle is passed gently over the ground of the plate, exposing the metal with gestures similar to those of pencil or pen drawing. Variations in line depth are accomplished through the chemical process of acid reacting against metal when the plate is eaten (from the German *aetzung*, the derivation of the term "etching").

Dürer's most elaborate etching, *The Cannon* (Fig. 145), shows how the artist fostered this freedom of the line, for it is much more open and spontaneous than most of his engravings. However, possibly because he could not achieve the fine detail of engraving and because the iron etching plates tended to corrode rapidly, Dürer did not pursue the medium very far. This was to be undertaken by his successors.

In later life Dürer turned increasingly to portraits, bringing to them a sensitivity that allowed for penetration below the skin level to reveal the personalities

of his subjects. An infinity of vigorous lines lends vitality to the engraved portrait of his imposing friend *Willibald Pirckheimer* (Fig. 146). Dürer has omitted all surrounding details to focus upon the nature of the subject—monumental, dignified, yet warm and human. It was this ability to reveal the nature of his sitters through physical characteristics that set Dürer apart from his predecessors. This gift would not really be equaled in the print medium until a century and a half later, with Rembrandt.

Dürer's Contemporaries

Dürer's art made a significant impact on the Dutch painter and engraver Lucas van Leyden. Through contact with Dürer, Lucas changed his style from one of subtle modeling to a cross-hatching system. He also conceived the idea of combining two techniques—engraving and etching—on the same copper plate, with the stronger lines engraved, the more delicate ones etched. This method not only saved time, but it achieved an appealing silvery richness of tone, even more delicate than that of Dürer. Lucas could also execute engravings of rather monumental stature, such as *Christ Presented to the People* (Fig. 147), in which the Biblical story is conceived in the homey terms of a miracle play presented in a town square.

Italian artists were also investigating the new etching techniques. Francesco Mazzuoli, known as Parmigiano after his native city of Parma, had experimented with alchemy, and this may have led to his becoming the first Italian practitioner of etching. His use of the medium was quite different from that of northern etchers, with their shallowness of etched depth, casual variations in cross-hatched shading patterns, and penlike freedom. This freedom, combined with Parmigiano's erratic contrasts of light and dark areas, produces a flickering result that is particularly effective in works such as *The Entombment* (Fig. 148).

Reproductive Engraving

So far we have been discussing engraving and etching primarily as independent artistic media. But by the late 15th century their potential for making multiple reproductions of other works of art, especially paintings, had already been tapped. For such work, a mastery of cutting and copying proved more important than creative imagination. Perhaps the greatest expo-

above: **146. Albrecht Dürer.**
Willibald Pirckheimer. 1524.
Engraving, 7¼ x 4½".
British Museum, London.

right: **147. Lucas van Leyden.**
Christ Presented to the People.
1510. Engraving, 11¼ x 17¾".
Kupferstichkabinett,
Staatliche Museen, Berlin.

nent of reproductive engraving was the Italian Marcantonio Raimondi. Trained in Bologna, Marcantonio made a number of deceptive copies after prints by Dürer and Lucas van Leyden, much to the dismay of the northern artists. However, his most profound impact on the history of art came from his association in Rome with the great painter Raphael. Raphael presided over a large shop with many assistants, but to perpetuate the works he and his shop produced in fresco, ink, and oil, he needed the talents of Marcantonio. While such reproductive engravings (Fig. 149) perhaps marked the beginning of the debasement of intaglio techniques, in a sense they reflected the earliest role of prints—the dissemination of information. Reproductive engravings played an important catalytic role in spreading the images and achievements of the Italian Renaissance throughout Europe, so that even an artist like Rembrandt, who never traveled, could later become familiar with them and make use of them.

Goltzius and the Line Engraving

In northern Europe during the 16th century, reproductive engraving was employed increasingly for both book illustration and mapmaking. The perfector of this technique and perhaps the last great engraver was Hendrik Goltzius. Born in Haarlem, Goltzius received artistic training in Rome and then returned to his native city to develop the method known as line engraving. Goltzius' command of the burin was such that he did not have to rely as heavily on patterns of cross-hatching to achieve his tonal variations. Instead, he dug deeply into the plate and cut remarkably long lines that swell and diminish in breadth. Such lines were ideally suited to the then-popular Mannerist mode of composition, as seen in the magnificently strutting posture of Goltzius' *Standard Bearer*

above: 148. Parmigiano (Francesco Mazzuoli).
The Entombment. Etching. 16th century.
Metropolitan Museum of Art, New York
(Harris Brisbane Dick Fund, 1927).

below: 149. Marcantonio Raimondi.
The Judgment of Paris. 1527–1534.
Engraving, $11\frac{5}{8}$ x $17\frac{1}{4}$".
Metropolitan Museum of Art, New York
(Rogers Fund, 1919).

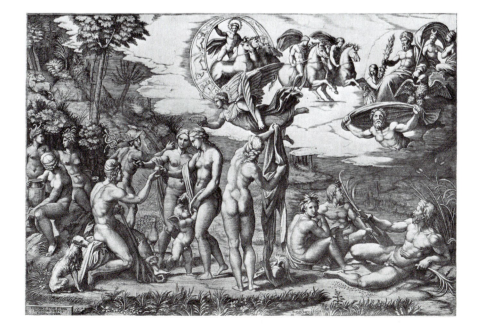

(Fig. 150). Here the huge expanse of the unfurled banner is captured by a careful mixing and spacing of lines of varying thickness combined with dots and flicks. The metallic brilliance of such works was to remain the ideal of engraving for centuries to come.

17th-Century Engraving and Etching
The French Masters

The potential of the line engraving technique popularized by Goltzius was most fully realized in France, where it became standardized through the work of several generations of specialists. One of the most versatile was Claude Mellan. Mellan relied almost solely on the curving and swelling of his line to create form; he rarely employed flicks or patterns of crosshatched lines to create tone. For example, Mellan's *La Sainte Face* (Fig. 151) is constructed in one continuous unbroken spiral line radiating outward from the tip of Christ's nose. While we can admire the virtuosity of this graphic *tour de force*, we must also note that the work is somewhat lacking in expressive content.

A much more sensitive master of the line engraving was Robert Nanteuil. Working for the court of Louis XIV, Nanteuil produced handsome portrait engravings that flattered his aristocratic and despotic patrons while at the same time capturing their highly individual features (Fig. 152). The faces, subtly modeled through the patterning of short, delicate strokes, are usually set against a regularized screenlike background and surrounded by a cartouche, so that the sitter seems to observe the spectator from a mirror.

While engravings honoring the monarchy flourished in Paris, a quite different school, employing

above: 150. Hendrik Goltzius.
Standard Bearer. 1587. Engraving, 11⅜ x 7⅝″.
British Museum, London.

below left: 151. Claude Mellan.
La Sainte Face (Suclarium of St. Veronica).
1649. Engraving, 17⅛ x 12⅝″.
Philadelphia Museum of Art (Charles M. Lea Collection).

below right: 152. Robert Nanteuil.
Portrait of J. B. Colbert. 1668.
Engraving. Bibliothèque Nationale, Paris.

right: 153. Jacques Callot.
The Fair at Impruneta.
1620. Etching.
Metropolitan Museum of Art,
New York (Harris Brisbane
Dick Fund, 1917).

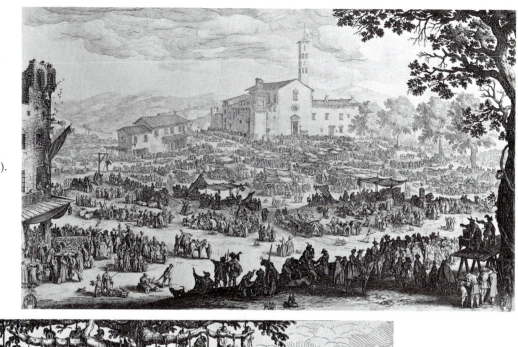

below: 154. Jacques Callot.
Hanging, from
The Miseries of War
(Paris: 1633). Etching.
Metropolitan Museum of Art,
New York (Rogers Fund, 1922).

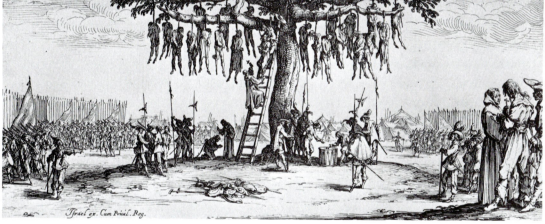

etching, developed in the province of Lorraine and specifically in the city of Nancy. By far the most distinguished practitioner of this school was Jacques Callot, who spent his early years engraving in Italy. In the course of his relatively short career, he created more than 1400 etchings and engravings, and his technical and aesthetic achievements have few equals.

Like the older masters, Callot secured his early education through apprenticeship to a goldsmith. He became familiar with the works of many northern artists, especially those of Martin Schongauer (Figs. 137, 138). For about ten years Callot lived in Florence, where he studied engraving. He began to experiment with etching under the patronage of the Medici family. In 1620 he produced one of his first masterpieces, *The Fair at Impruneta* (Fig. 153). Never before had the scope of an etching been so vast or its structure so detailed. More than 1100 human figures, as well as an immense quantity of animals, are shown engaged in a seemingly infinite number of activities,

and yet the whole is organized harmoniously in a wide-angle panoramic view. To achieve this remarkable work, Callot introduced two major changes in etching technique. First, in place of the conventional waxy etching ground—which was susceptible to false biting and uneven printing—he substituted the harder, more uniform varnish employed by lutemakers. Then, for drawing his lines into this surface, he abandoned the traditional pointed needle in favor of the *échoppe* (Fig. 232), a steel cylinder with its end cut off at an angle. The resultant rounded, slanted point could be manipulated in such a way that a thin quill-like line could broaden into a full one that mimicked engraving. This tool was ideal for the modeling of the multitude of figures Callot drew.

When Callot returned to his native Nancy in about 1621, he found the region ravaged by the Wars of Religion. His response to the widespread suffering was a series of etchings, *The Miseries of War* (Fig. 154), that with an impartial clarity of thought chronicle the

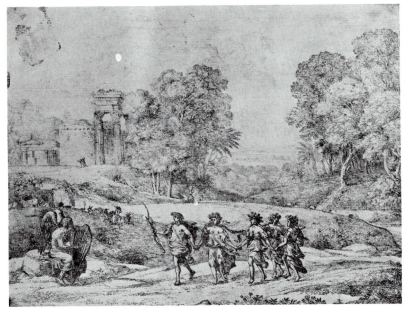

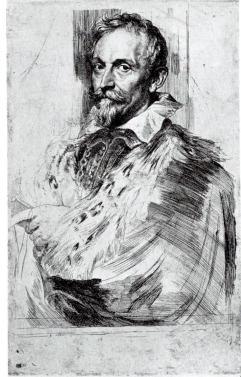

above: 155. **Claude Lorrain.** *Apollo Leading the Dance of the Seasons.* 1662.
Etching, $7\frac{1}{4}$ x $9\frac{15}{16}$". Metropolitan Museum of Art, New York
(Harris Brisbane Dick Fund, 1927).

right: 156. **Anthony van Dyck.** *Portrait of Jan van den Wouwer,* from *Iconography.*
1641. Etching and copperplate engraving, 10 x $5\frac{7}{8}$". Rijksmuseum, Amsterdam.

ruthless brutality and heedless actions of war. Not until Goya was there to be another artist capable of transforming such horrific scenes into universal appeals for humanity.

Callot's technique—although not his subject matter—influenced another artist from Lorraine. Claude Gellée, who is generally called Claude Lorrain after his native region, spent most of his life working as a landscape painter in Rome. In his etchings (Fig. 155) as well as his paintings he sought to capture the evocative, atmospheric moods of the Italian country and seaside. Following Callot's example he gave his plates multiple bitings in the acid to obtain the varying degrees of depth. In addition, Claude would scrape and burnish their surfaces to increase the misty effect.

Etching and Engraving in the North—Flanders and Holland

The use of engraving and etching for reproductive purposes was readily adopted by the leading 17th-century artists of Flanders. Peter Paul Rubens established his workshop early in the century at Antwerp, and through his long and productive career he employed a number of artisans to produce in almost assembly-line fashion a steady stream of prints after his exuberant Baroque paintings, drawings, and designs for large decorative schemes.

Rubens' younger contemporary and associate Anthony van Dyck achieved his greatest renown as court portraitist to the English king James I. But apparently as early in his career as 1626 he realized that there was a market for printed images of famous men, and he began to make drawings and sketches of the well-known artists with whom he was acquainted. From these drawings he then made a group of about fifteen etchings on copper (Fig. 156). The few impressions pulled of these etchings are among the gems of the art. They exhibit a technical perfection; sparse lines together with dots produce a draughtsmanly suggestion of modeling. The prints have a spontaneous unfinished look combined with an eloquent aristocratic grandeur that is unique. After Van Dyck finished with them, the plates were turned over to a team of professional engravers who reworked and standardized the images. In 1641 a suite of 84 prints, known as *Iconography,* was published under the master's name. This suite included the original fifteen prints, plus other engravings based on his drawings. Four years later an expanded version of more than one hundred portrait plates was published.

Etching in 17th-century Holland was to be dominated by the mighty figure of Rembrandt, but even before he came to prominence there were several highly respected artists who worked in the medium. Among these, the most daring experimenter with the etching technique during the early 17th century was the Dutch landscape painter Hercules Seghers. In an apparent attempt to create a kind of printed painting, Seghers was the first to tint his paper, or in some cases

linen, with an ink that was different in color from the printing ink. This bicolored work would then be further enhanced by the addition of subtle hand coloring. Seghers also experimented with different types of grounds to produce textures that would be in some cases granular and in others syrupy. The resultant landscapes (Pl. 15, p. 111) are often bleak, hallucinatory vistas of great power, in which the thick lines forming the rocky structures actually seem to be eroding before our very eyes. We can well understand why these etchings had such a lasting effect on Rembrandt and his art.

Rembrandt

Beyond any doubt, the consummate etcher of all time was Rembrandt. No enthusiasm could possibly overstate the sheer force implicit in his visual conceptions. However much he labored over his plates, the ultimate result remains a sketch in the best sense of that word: a direct artistic expression unencumbered by superficial ''finish.''

Although he is known primarily as a painter, Rembrandt's massive oeuvre includes more than three hundred prints, mainly etchings and drypoints. Born the son of a miller in the town of Leyden, Rembrandt began experimenting with the medium of etching while still in his twenties. He concentrated at first on simple images, sketching portraits of himself, the members of his family, and various anonymous peasants and beggars (Fig. 157). These works served the artist as a means of studying, in an almost theatrical manner, a wide variety of expressions and types. They have about them a vitality that is as much the result of the artist's technique as it is of his enthusiasm, for Rembrandt frequently used spikes or nails instead of the traditional etching needle, to make his jagged, rapid lines.

In 1631 Rembrandt moved to Amsterdam, the leading art center of Holland, and by this time he was already a master of the etching medium. His new environment brought exposure to the outstanding artistic movements of the 17th-century—the dramatic use of light and shade developed by the Italian painter Caravaggio and his northern followers, as well as the dynamic, sensuous, muscular forms of the Flemish painter Rubens. In a series of religious etchings that Rembrandt began to produce at this time we can perceive that he has assimilated the effects of these earlier masters, but he also reveals his own deep spirituality and profound humanity (Fig. 158).

During the late 1640s and early 1650s, as his popularity decreased and personal troubles multiplied, Rembrandt turned more and more to nature for solace, and this resulted in a series of remarkable landscape etchings. One of the most notable is the so-

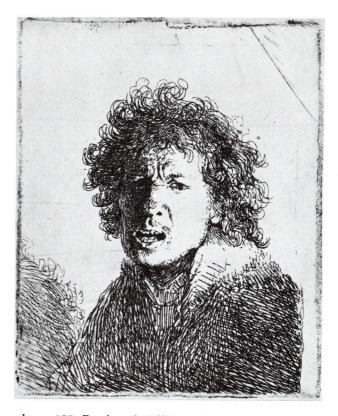

above: 157. **Rembrandt.** *Self-Portrait by Candlelight.* 1630. Etching. Staatliche Museen, East Berlin.

below: 158. **Rembrandt.** *Death of the Virgin.* 1639. Etching (third state), $16\frac{3}{8}$ x $12\frac{5}{8}$''. British Museum, London.

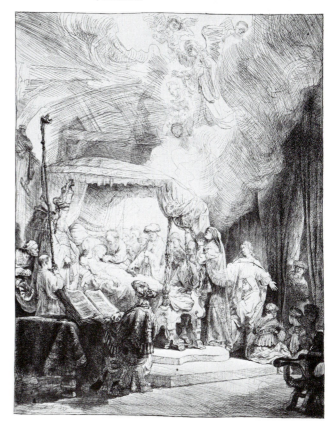

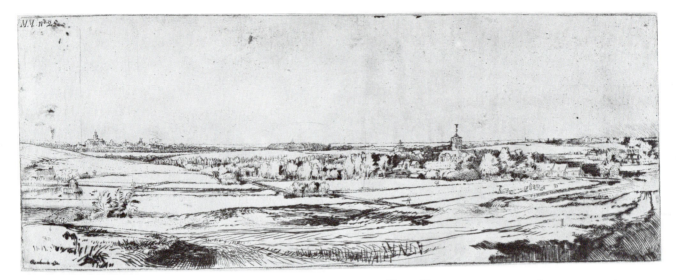

above: 159. **Rembrandt.** *Goldweighers' Field.* 1651. Etching and drypoint, 4¾ x 12⅞″. Pierpont Morgan Library, New York.

below: 160. **Rembrandt.** *Faust in His Study Watching a Magic Disc.* 1652. Etching and drypoint, 8⅜ x 6⅜″. Rijskmuseum, Amsterdam.

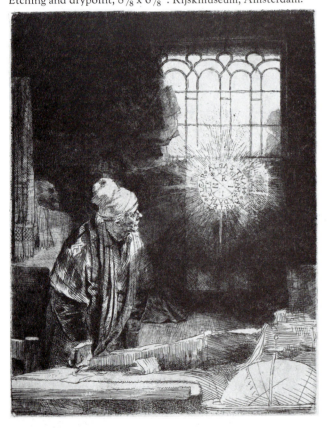

and atmosphere, almost as if the artist had captured and frozen the blowing of the wind.

Even during his own lifetime Rembrandt's prints became collector's items, and he seems to have purposely experimented with different effects of ink, paper, and wiping to please this lucrative market. Long after his death his plates continued to be recut and reprinted, placing in circulation many inferior impressions. To really appreciate Rembrandt's genius, however, it is necessary to examine the works in their early states, when they reflect exactly the careful effect he sought to achieve. In the print known as *Faust in His Study Watching a Magic Disc* (Fig. 160), of about 1652, Rembrandt powerfully combines etching and drypoint. The rich, dark ink left on the plate here conveys the mysterious, gloomy depth of the scholar's crowded room, while the ragged drypoint burr on Faust's robe veils him in this eerie atmosphere. However, the three concentric circles of the magic disc glowing brilliantly at the window have been highlighted by the artist's technique of cleanly wiping the plate in that one spot only, so that he seems to capture a sense of sudden illumination of genius that is both intellectual and visual.

Rembrandt's experiments with his prints also provide one of the best means for seeing the process of artistic creation in action. Through the successive states he executed of some of his most important works, we can observe his extraordinarily agile mind and facile hand exploring various alternatives in the search for a perfect solution. For example, *Clement de Jonghe,* which also combines etching and drypoint, shows a notable development of the sitter's character between the first and the fourth states (Figs. 161, 162). In the early state Rembrandt let shallow cutting and a relatively dull ink surface depict a somewhat

called *Goldweighers' Field* (Fig. 159) of 1651. With the low horizon of the Dutch countryside serving to separate land and sky, the scene appears to have an almost overwhelming breadth of scale. This is accomplished simply, however, by the many active flicks of the etching or drypoint needle, which can completely describe a tree, a building, or a stretch of land with only the slightest twist of the line. The patches of rich, black drypoint burr convey a sense of movement

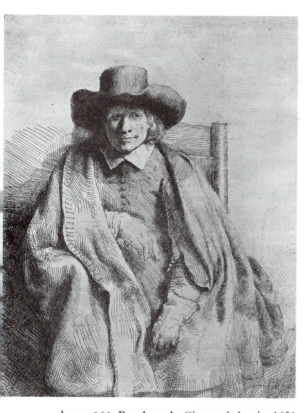

reticent individual. However, as the states progress, the image becomes richer and darker, the texture of the shadow and line pattern more elaborate; accessory decorative details—like the arched top—are added, but most importantly de Jonghe becomes, through the subtle use of shading and change of expression, a far more accessible person.

No other artist has ever brought such profundity of feeling to an interpretation of religious subjects as did Rembrandt. One of the most impressive of the religious prints is the etching and drypoint *Christ Presented to the People* (Figs. 163, 164). Here, too, the succession of states allows us to see how he achieved his

above: **161. Rembrandt.** *Clement de Jonghe.* 1651. Etching (first state), $8\frac{1}{4}$ x $6\frac{3}{8}$″. British Museum, London.
below: **162. Rembrandt.** *Clement de Jonghe.* 1651. Etching, drypoint, and burin (fourth state), $8\frac{1}{4}$ x $6\frac{3}{8}$″. British Museum, London.

below: **163. Rembrandt.** *Christ Presented to the People (Ecce Homo).* 1655. Etching (first state). Metropolitan Museum of Art, New York (gift of Felix M. Warburg and family, 1941).
bottom: **164. Rembrandt.** *Christ Presented to the People (Ecce Homo).* 1655. Etching (last state). British Museum, London.

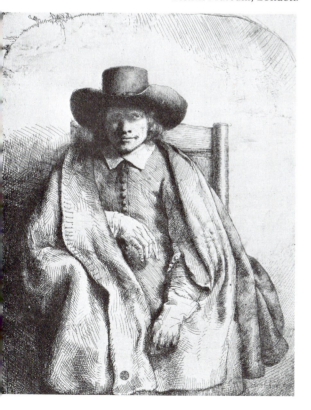

above: 165. **Prince Rupert.**
The Standard-Bearer. 1658. Mezzotint.
Metropolitan Museum of Art, New York
(Harris Brisbane Dick Fund, 1933).

below: 166. **Peter Pelham.**
Cotton Mather. 1727.
Mezzotint, 11⅞ x 9¾".

effects. In the early state a swarm of people appears before the plain wall of the high platform upon which stands the bound figure of Jesus. There is no doubt that this crowd scene, with its diversity of gesture and brilliance of drawing, is a masterpiece, but Rembrandt obviously felt that the mass of people distracted the viewer's attention from the drama of Christ's fate. Therefore, he burnished out this whole section and replaced it with a sculptured figure flanked by two arches. The large, dark voids serve to draw the eye immediately into the center of the scene and make the drama of the presentation more emphatic and more poignant. It is not surprising that contemporary and later Dutch artists were completely overshadowed by Rembrandt's genius.

The Development of Mezzotint

An amateur printmaker named Ludwig von Siegen is credited with the invention of the mezzotint or "half tone" process, which was to offer new means of achieving textural effects and prove especially useful in the reproduction of paintings. Von Seigen's method was given legitimacy when it was taken up and refined by another distinguished amateur, Prince Rupert of the Palatinate. It was the latter who perfected the mezzotint tool known today as a *roulette* but called in the 17th-century an "engine." This was a spike-toothed small wheel which, when applied to the surface of a plate, produced an area of closely packed dotlike abrasions. When the surface was inked and printed, it yielded a uniform fuzzy black ground, which could be toned down by burnishing. Von Siegen had employed this method for only limited effects of texture in restricted areas, but Rupert, a more accomplished artist, used it for a soft continuous overall tone (Fig. 165). He preferred to work from white to black, making minimal use of the scraper and burnisher. The rather irregular teeth of his roulette often produced a certain apparent roughness in the dot pattern. Rupert is particularly important in the proselytizing role he played. As son of Frederick V of Bohemia and nephew of Charles I of England, he moved freely through the courts of Europe, thus gaining access to artists all over the Continent. His frequent contacts with the royal court in England no doubt accelerated the reception the mezzotint process enjoyed there.

The roughness that characterized Rupert's prints was eliminated by the invention of an improved mezzotint tool—the *rocker.* Introduced by Abraham Blooteling, the rocker allowed for more regular surfaces and the attainment of a wider range of shadings. It was by far the fastest means for a printmaker to achieve a uniform black. Both Prince Rupert and Blooteling worked in England, where the mezzotint

became so popular that it was frequently referred to as "the English manner." In the person of Peter Pelham it was even exported to the New World. Pelham's portrait of *Cotton Mather* (Fig. 166) is undoubtedly the first mezzotint produced in America.

18th-Century Intaglio Printing

Italian Printmakers

Four artists dominated Italian printmaking of the 18th-century—the Tiepolos, Canaletto, and Piranesi. Giovanni Battista Tiepolo is best known for his wonderful airy, large-scale frescoes that decorate churches and palaces throughout Italy, Germany, and Spain. But the elder Tiepolo also etched some 25 copper plates. Like his frescoes, these prints are of an ex-

tremely inventive nature, full of great delicacy and much active empty space (Fig. 167). The technique is direct, with a minimum of cross-hatching. This manner was continued by his son, Giovanni Domenico, who is best remembered for an ingenious series of 27 etchings each depicting a moment of the Holy Family's *Flight Into Egypt* (Fig. 168). Not only is each scene marvelously varied, but all reveal a rare blending of figures into atmospheric renderings of a landscape.

Also primarily concerned with the representation of light and color was the Venetian-born artist Antonio Canale, known as Canaletto. Although originally trained as a painter of stage settings, Canaletto soon turned to view painting and produced both paintings and etchings of scenes in his native city (Fig. 169). These works were purchased mainly by English visitors to Venice. Canaletto's etchings, however, do not

above: 167. Giovanni Battista Tiepolo.
Six Persons Watching a Snake.
18th century. Etching, plate 9 x 6^{15}/$_{16}$".
Metropolitan Museum of Art, New York
(gift of Dr. Vanhorne Norrie, 1917).

above right: 168. Giovanni Domenico Tiepolo.
Flight Into Egypt. 1753. Etching, 7^1/$_4$ x 9^1/$_2$".
Bibliothèque Nationale, Paris.

right: 169. Canaletto (Antonio Canale).
Alle Porte del Dolo. 18th century.
Etching, 11^3/$_4$ x 17".
Staatliche Graphische Sammlung, Munich.

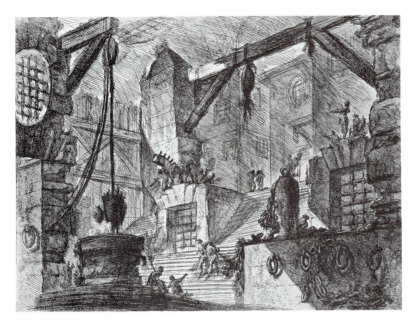

left: **170. Giovanni Battista Piranesi.**
Carceri. c. 1750. Etching (first state), plate 16¼ x 22″.
National Gallery of Art, Washington, D.C.
(Rosenwald Collection).

below: **171. William Hogarth.**
The Harlot's Progress. 1732.
Engraving, 11⅞ x 14⅝″.
British Museum, London.

bottom: **172. Thomas Rowlandson.**
Sudden Squall in Hyde Park. 1791. Etching.
Metropolitan Museum of Art, New York
(Elisha Whittelsey Fund, 1959).

merely record specific sites. Through their use of long, thin, almost vibrating lines we sense the mood of the city—its moist atmosphere and the reflections of the brilliant sunlight upon the canals.

By far the most dedicated Italian printmaker of the 18th century was Giovanni Battista Piranesi. Like Canaletto, Piranesi had been trained as a designer of architectural settings for the theater, but he also had some background in engineering, and this factor turned his very individual etching skills to the treatment of unique subjects. He was fascinated by the ruins of ancient Rome and produced many large etchings depicting them with archaeological fidelity. But Piranesi is best known for the fanciful visionary constructions he invented. Possibly his most astounding works in this vein are the series of fourteen etchings of imaginary prisons, the *Carceri* (Fig. 170). Seen from a low vantage point, these huge, multilevel interiors are built of mammoth stones and filled with large chains, wheels, walkways, and other forms. Strong contrasts of light and dark, achieved through the texture of vivid, often roughly bitten lines, create an overwhelming sense of confinement. The figures inhabiting this gigantic world are reduced to insignificant, almost abstract shapes.

English Printmakers

In Georgian England, there flourished a native school rooted in middle-class taste and satiric humor, the leading proponent of which—in the visual arts—was William Hogarth. A native Londoner, Hogarth began his career as an engraver of silver and had to teach himself the fundamentals of drawing and painting. By 1720 he was producing engraved book illustrations.

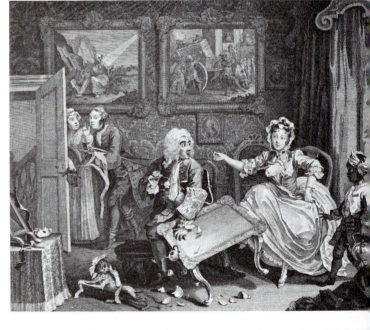

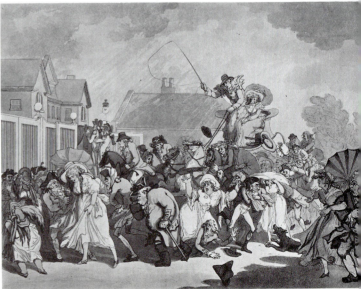

His most famous paintings are the three series that detail, in rather bawdy terms, the mannered social customs of the day and the wages of sin: *The Rake's Progress, The Harlot's Progress,* and *Mariage à la Mode.* Each moves from a beginning of relative innocence through increasing dissipation to utter ruin. Hogarth found that the engraved copies he made after these paintings (Fig. 171) were far more lucrative than the originals. Often, he did the preliminary work on his plate by etching and then worked over this with the burin. Because of their wide dispersion, these copyrighted engravings established the artist's fame. Today, their moralizing tone seems a bit heavy-handed, but they still delight us with their detailed and mocking observation of middle-class life in 18th-century England.

Hogarth's countryman Thomas Rowlandson was far less the prude and a far greater draughtsman. Rowlandson, who trained in France, developed a facile, graceful manner of etching that he could turn to either biting satire or lewd eroticism. In order to produce a greater number of prints, Rowlandson found it expedient to etch only the preliminary design, leaving the coloring to professional "washers." Rowlandson's witty, ribald caricatures demonstrate a spirited outlook on the part of the artist. *Sudden Squall* (Fig. 172), for example, depicts all manner of English character types—the old and the young, the thin and the fat, the peacock and the fop—all overreacting to an oncoming storm. The prints sold very well, bringing huge success to the artist.

James Gillray could really be considered a political cartoonist; like Hogarth, he began his career as a silver plate engraver. Gillray seldom worked from previously executed drawings or paintings, and his style is purely that of printmaking. When they can be found without color, his prints are seen to be exquisitely drawn and unbridled in their incisiveness. *Frying Sprats* and *Toasting Muffins* (Fig. 173) poke fun at King George III and his Queen. This overstated mockery of royalty had great appeal for the bourgeoisie.

A striking contrast to Rowlandson (and to all other English artists) is offered by his close contemporary, William Blake. Blake was a mystical poet of genius, who devised his own orginal method and style of printing. There is in his work a consistent effort to unite the natural with the supernatural, the real with the imagined, the soul with the body.

From his early study of medieval tomb sculptures, Blake derived a Gothic, sinuous line. This he combined with huge, muscular human forms taken from the study of Michelangelo. He augmented the traditional engraving techniques with a printing and coloring process the specifics of which are still a matter of speculation. The resultant amalgam gives his engravings illustrating *The Book of Job* and *The Inferno*

below: **173. James Gillray.**
Frying Sprats and *Toasting Muffins.* 1791.
Etching and aquatint, each $7\frac{5}{8}$ x $5\frac{3}{4}$".
British Museum, London.

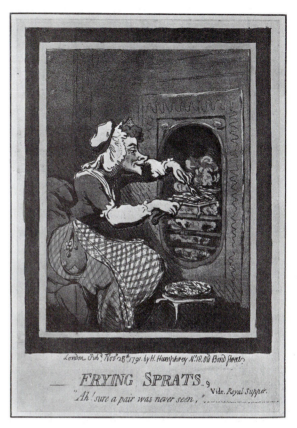

174. William Blake.
The Whirlwind of Lovers,
illustration for
The Inferno, Canto V.
1824–27. Engraving.
Metropolitan Museum of Art, New York
(Rogers Fund, 1917).

(Fig. 174) a powerful sweeping and visionary quality that has remained unique.

Even more extraordinary are Blake's illustrations for his own writings, in which text and image combine to form what the artist called "illuminated books." His method, which he claimed had been imparted to him in dreams by the spirit of his dead brother, reversed the traditional intaglio technique. Blake made his plates into a relief, the whites being etched more deeply. In order to avoid the necessity of etching the words backwards, he seems to have devised a process whereby the words were written in an acid-resistant medium on paper and then transferred to the surface of the plate, probably by rolling the paper onto it with a heated roller. The sticky medium would adhere to the plate, and the paper could then be soaked away. In the same medium the artist would then add his illustrations directly to the copper plate with either pen or brush.

Blake printed every edition of his work to order on his own hand press. To achieve even more remarkable effects—effects that often give his pages the look of medieval illuminated manuscripts—he would print with various colored inks and then hand touch each print with watercolor and sometimes even gold (Pl. 16, p. 112). Thus, no two prints from the same plate are ever quite identical.

Blake's efforts met with little success during his lifetime. Not until the late 19th century, after nearly all his original plates had been destroyed, was his truly astounding ability recognized.

Spain and Goya

The eccentric genius of Blake had no parallel in England nor in any other country save one, and that exception was Spain, a nation which until the 18th century had produced no significant printmaker. But in Blake's contemporary, Francisco de Goya y Lucientes, we find the southern counterpart to the Englishman's inspired individuality.

Goya began his career as a designer of tapestries and a painter of charming rococo scenes. In the early 1770s he journeyed to Rome and there undoubtedly saw the work of Piranesi. His first etchings also reveal the influence of G. B. Tiepolo, who had spent the last years of his life in Madrid.

In 1787 Goya became an official court painter for the Spanish royal family. This position gave him the opportunity to study the magnificent royal art collections, and he issued a series of etchings after the great 17th-century painter, Diego Velázquez. In his privileged situation Goya also could witness firsthand the venality and corruption of the Spanish monarchy, government, and clergy, whose style of living contrasted so markedly with the widespread poverty among most of the population. This insight, combined with the suffering of an illness that rendered him almost totally deaf, found its outlet in a remarkable series known as *Los Caprichos* (Figs. 175, 176).

Carefully veiling the meaning of his attacks on superstition and corruption under ambiguous titles, Goya created some of the most devastating political satire ever penned. He was greatly aided by the dark and ominous settings he had learned to construct from studying the etchings of Piranesi. But certainly Goya's greatest achievement was the innovation of using aquatint as an expressive medium, rather than just as a technical trick. Some of the *Caprichos* are in fact executed totally in aquatint of differing tones. The whites, though simply achieved by stopping out, create an amazing sense of volume and weight. In

these prints the delicate softness of the aquatint medium contrasts sharply with the powerful subject.

During the years when Spain was at war with the French armies of Napoleon, Goya traveled from Madrid to Zaragoza—a site of fierce resistance—and back, witnessing many horrible events. These formed the basis for another great set of etchings, the so-called *Desastres de la Guerra* (*Disasters of War*), which were not fully published until after the artist's death. With unflinching realism these prints depict the atrocities of warfare (Fig. 177). Because metal was scarce, Goya had to reuse old plates, so that the texture of the

above left: 175. Francisco Goya.
Asta su Abuelo, from
Los Caprichos. 1796–98.
Etching and aquatint.
Metropolitan Museum of Art,
New York
(gift of M. Knoedler & Co., 1918).

above right: 176. Francisco Goya.
La Vieja Dama y sus Galanes
(*Old Woman and Her Gallants*),
additional illustration from
Los Caprichos. 1796–98.
Etching and aquatint, 8⅝ x 6″.
Bibliothèque Nationale, Paris.

right: 177. Francisco Goya.
Tampoco (*Nor These*), from
Desastres de la Guerra.
c. 1820. Etching, 5⅜ x 7½″.
Metropolitan Museum of Art,
New York (Schiff Fund, 1922).

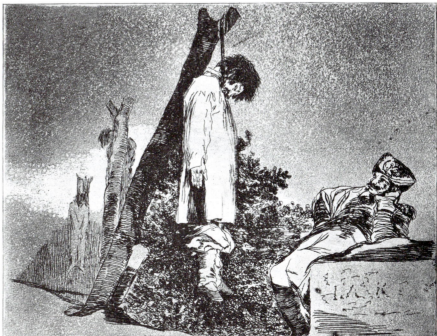

prints in this series is much rougher. He relied more on etching and drypoint, instead of aquatint, to achieve the brutal intensity he sought. In his lifetime Goya was abused, suppressed, and finally exiled. Only after his death and the coming to power of a new regime was his great genius understood.

19th-Century Intaglio

The Barbizon School

An important aspect of French 19th-century art was the development of landscape painting, and during the mid-century period a major center for landscapists was the town of Barbizon near the forest of Fontainebleau. Among the artists who visited there the greatest was probably Jean-Baptiste-Camille Corot. Late in his career Corot turned to printmaking. To achieve the quality he desired in landscape images, he often worked in an unusual semiphotographic process called *cliché verre* (Fig. 178). In this technique a piece of glass, rather than a metal plate, is coated and has the design scraped into it. The glass is then placed on photosensitive paper that darkens along the opened lines when exposed to light. By these means Corot could capture the shimmering atmosphere and tonalities of natural light and give his prints a painterly texture. *Cliché verre* is not a true intaglio technique, however. Along with Corot, other artists such as Jean-François Millet and Théodore Rousseau produced a number of conventional etchings typical of the pastoral Barbizon style.

French Impressionists and American Expatriates

In 19th-century France the most outstanding printmaker was the Impressionist painter Edgar Degas. His early training gave him a sound knowledge of past traditions, especially in the works of Rembrandt, but no artist was more aware of modern techniques—including photography—than Degas.

Degas' career in printmaking was marked by ceaseless experimentation and a search for perfection. His aquatint *At the Louvre: Mary Cassatt* (Fig. 179) went through nearly twenty states until it satisfied the artist's vision of strength and abstraction. The mixture of mottled and smooth textures in the print reminds one of Degas' favorite drawing medium—pastel. In terms of design, the strongly silhouetted back view was an element that Degas borrowed from Japanese woodblock prints, which became increasingly popular in Paris at this time (see p. 30).

Even bolder was Degas' use of the monotype, a process, invented in the 17th century, by which the image is drawn directly on the plate with printer's

Plate 15. Hercules Seghers. *Landscape*. 17th century. Color etching, 5 × 7″. British Museum, London.

The text within the illustration reads:

*Then the Divine hand found the two Limits, Satan and Adam,
In Albions bosom: for in every Human bosom those Limits stand.
And the Divine voice came from the Furnaces, as multitudes without
Number! the voices of the innumerable multitudes of Eternity.
And the appearance of a Man was seen in the Furnaces;
Saving those who have sinned from the punishment of the Law,
(In pity of the punisher whose state is eternal death,)
And keeping them from Sin by the mild counsels of his love.*

*Albion goes to Eternal Death: In Me all Eternity,
Must pass thro' condemnation, and awake beyond the Grave!
No individual can keep these Laws, for they are death
To every energy of man, and forbid the springs of life;
Albion hath entered the State Satan! Be permanent O State!
And be thou for ever accursed! that Albion may arise again:
And be thou created into a State! I go forth to Create
States: to deliver Individuals evermore! Amen.*

So spoke the voice from the Furnaces, descending into Non-Entity

Plate 16. William Blake. *The Creation of Eve,* from *Jerusalem: The Emanation of the Giant Albion.* 1804–20.
Facsimile published by Trianon Press. Beinecke Rare Book and Manuscript Library, Yale University, New Haven, Conn.

112

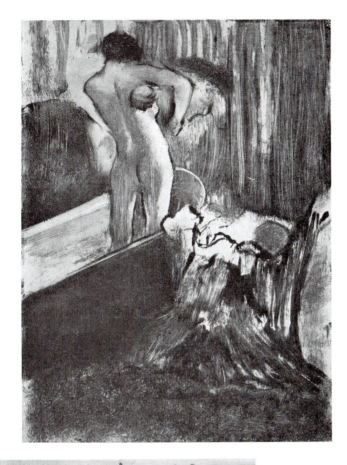

ink. The plate is then run through the press like an etching. Degas obviously enjoyed the freedom and immediacy of direct drawing, as well as the control permitted by printing the plates on his own press. He would even print a second paler impression to be strengthened by watercolor or pastel applied by hand. The monotypes of Degas include both light, airy colored landscapes and dark, ominous interiors filled with abstract figures and shapes (Fig. 180).

Prominent among Degas' followers was his friend and the subject of his aquatint, Mary Cassatt. Born in Philadelphia, Cassatt arrived in Paris to study art at the age of 21 and soon became a member of the Impressionist group. Her study of Japanese woodblocks led her to adopt, to a greater extent than Degas, their ornamental patterns and odd angles of view. The content of Cassatt's various etchings and aquatints (Fig. 181) is almost totally devoted to delicate and poignant observation of women and children engaged in everyday domestic activities.

Also American by birth and trained in Paris was James Abbott McNeill Whistler. Whistler, who eventually settled in London, devoted as much time and concern to his prints as he did to his paintings. He delighted in representing scenes of English life along the river Thames. A work such as *Black Lion Wharf* (Fig. 182) shows Whistler's keen eye for the picturesque. The combination of etching and drypoint to suggest color, light, and shade, as well as the freedom of the rendering in the foreground, recalls

above left: 180. Edgar Degas. *The Bath.* c. 1880.
Monotype, $8\frac{3}{8}$ x $6\frac{7}{16}$″.
Royal Museum of Fine Arts, Copenhagen.

left: 181. Mary Cassatt. *The Letter.* 1891.
Etching and aquatint, $13\frac{5}{8}$ x $8\frac{15}{16}$″.
Philadelphia Museum of Art (Louis E. Stern Collection).

below: 182. James Abbott McNeill Whistler.
Black Lion Wharf. 1859. Etching, $5\frac{7}{8}$ x $8\frac{7}{8}$″.
Metropolitan Museum of Art, New York
(Harris Brisbane Dick Fund, 1923).

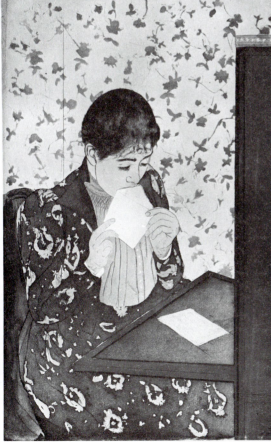

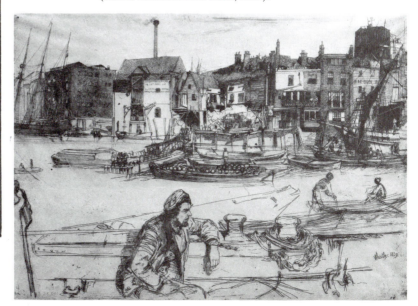

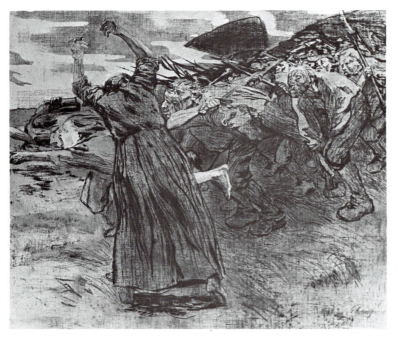

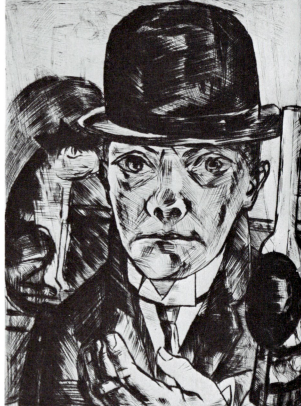

Rembrandt. Like Degas, Whistler was a tireless experimenter with prints. He was among the first to use the process of steel facing, whereby the surface of a plate is strengthened through the electrolytic adhesion of a thin layer of iron to the copper. This device allowed a great many more impressions than usual.

20th-Century Intaglio in Europe

The adaption of the graphic arts to social comment developed most significantly in Germany and most profoundly in the work of Käthe Kollwitz. Kollwitz' works convey a universal appeal against the horrors of oppression, war, and hunger. She not only mastered the technical aspects of etching, soft-ground, and aquatint but also developed a truly remarkable compositional sense. Her series illustrating the Peasant Wars, such as the mixed-technique work *Outbreak* (Fig. 183), evokes rage and dramatic dynamism.

Max Beckmann was certainly one of the most intense representatives of the direct manner cultivated by the German Expressionist movement, although he was not formally allied with the group. It was after the First World War that Beckmann's works, especially his etchings and drypoints, took on the violence and strident angularity that have come to be associated with his style. In his many self-portraits (Fig. 184) Beckmann exploited to the full the harsh contrast between short, violent drypoint lines and areas of deep black burr. It is almost as though the face has been formed by stripping off a layer of outer skin to reveal the anxiety-ridden being underneath.

The great breakthrough of 20th-century art was the realization that so-called visual reality need not limit the artist's perceptions. Rather, the mind could penetrate beyond mere surfaces and create a new abstract reality. The small group of artists centered in Paris at the beginning of the century who gave most concrete form to this idea were the Cubists. Led by Picasso, they experimented with showing multiple viewpoints combined in one image or breaking an object or person into multifaceted units. In their struggle with form the Cubists found the media of drypoint and etching to be well suited to their ends. One artist who for a time came under the sway of the Cubists was Jacques Villon. Villon adopted the Cubist idiom for a series of impressive drypoint portraits done in 1913 (Fig. 194). A later etching of his brother Marcel Duchamp (Fig. 185), is a study in formal abstraction. The body is reduced to a series of intersecting shapes and planes. Any sense of coldness, however, is counteracted by the rich—almost coloristic—effect of the luminous etched line.

The attempt to liberate color from its traditional constraints was the concern of another group of French artists, whose bold and sometimes violent use of colors earned them the name *Fauves*, or wild beasts. Far and away the most prominent member of this school was Henri Matisse. Throughout his long career Matisse periodically turned to the simple black and white of the printed image as a respite from his struggles with color. Characteristic of Matisse' etched works are a series of prints done in 1932 as illustrations for the poems of Mallarmé. The portrait of Baudelaire (Fig. 186) fills a whole plate with a few simple lines of the utmost purity, etched with the hard point of a sapphire. By these extremely economical means the artist manages to convey a vivid insight into the spiritual and troubled mind of the poet.

Picasso

Beyond a doubt the most important artist of the 20th century has been the Spanish-born Pablo Ruiz y Picasso. Picasso was not only a great painter and sculptor but a dedicated and experimental printmaker. During the course of his long life he executed nearly 2000 prints. Picasso began making prints in Paris in the early years of the century, and his first graphic masterpiece was *The Frugal Repast* of 1904 (Fig. 187).

above: 185. Jacques Villon. *Marcel Duchamp.* 1953.
Etching, 12¹¹⁄₁₆ x 9¹¹⁄₁₆″.
Museum of Modern Art, New York (gift of Louis Carré).

below: 186. Henri Matisse. *Charles Baudelaire.*
Illustration for "Le Tombeau de Charles Baudelaire"
from *Poésies* by Stéphane Mallarmé. 1930–32.
Etching, 13 x 9¾″. Museum of Modern Art, New York.

187. Pablo Picasso.
The Frugal Repast. 1904.
Etching, 18¼ x 14¾″.
Metropolitan Museum of Art, New York
(Harris Brisbane Dick Fund, 1923).

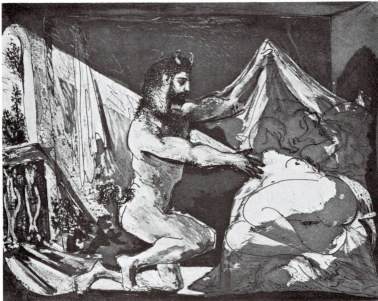

left: 188. **Pablo Picasso.** *Faun and Sleeping Woman.* 1936. Etching and aquatint, 12⁷⁄₁₆ x 16⁷⁄₁₆".
Museum of Modern Art, New York.

below: 189. **John Marin.**
Brooklyn Bridge No. 6 (Swaying). 1913. Etching, 10³⁄₄ x 8⁷⁄₈".
Museum of Modern Art, New York (Edward M. M. Warburg Fund).

bottom: 190. **Edward Hopper.**
Night Shadows. 1921. Etching, 6⁷⁄₈ x 8".
Library of Congress, Washington, D.C. (Pennell Fund).

As with other of his works done during this time, the artist's Blue Period, the subjects are poor people, sentimentally drawn. Their attenuated figures and mannered poses suggest Picasso's knowledge of works by El Greco. Picasso's easy mastery of the print medium is seen in the marvelous use of cross-hatched lines to build up areas of shadow that serve to give the work its moody, atmospheric effect.

After passing through his Cubist period, Picasso struck on a pure, classical style of monumental simple forms. His etchings from this time recall the works of Matisse. In turn, this simple linear style gave way to a more varied and complex approach. The series of prints from 1936, known after their publisher as the *Vollard Suite,* are among Picasso's most powerful printed works. *Faun and Sleeping Woman* (Fig. 188), for example, is a striking mixture of etching and aquatint which conveys at the same time a variety of textures and the force of emotions.

Intaglio in the United States

At the beginning of the 20th century the most important influence on American printmakers was the expatriate Whistler. Even such artists as John Marin, who were to become distinctive masters in their own right, went through a Whistleresque phase. But the veiled manner and delicate tracery of much of Whistler's work was soon found to be in conflict with the bold, surging new life found in the American "melting pot." Thus, when Marin returned from his training period in Paris in 1911 and settled in New York, he quickly adopted a strong, almost expressionistic style that sought to capture the exuberance and dynamism of the cityscape. His series of etchings

depicting the Brooklyn Bridge (Fig. 189) has a freedom of abstraction that rivals that of the Cubists and simultaneously captures the American pride in technological achievement.

Another image of America is conveyed in the etchings of Edward Hopper. Hopper began his career as a commercial artist, but by the late teens and early twenties he had begun to develop a personal style as a painter. Most of his etchings, meticulously executed by the artist himself, were done between 1915 and 1923. Hopper's prints emphasize the aimless and lonely existence of isolated individuals in both the large cities and the country. A work such as *Night Shadows* (Fig. 190) has a surprisingly strong emotional impact for such a simple design. Hopper had adopted a high viewpoint and then contrasted deeply bitten blacks in the shadows with cleanly wiped highlights to produce an eerie, almost fearful effect.

During the late 1920s Stanley William Hayter, an English printmaker working in Paris, established an experimental graphics workshop called Atelier 17. The effect of this workshop was profound on artists like Chagall, Picasso, Miró, and others. In 1940 Atelier 17 moved to New York and was housed at the New School for Social Research. The avowed purposes of Hayter and other printmakers who surrounded the shop were to explore graphics for contemporary creative expression and to enlarge the technical potential of printmaking to suit the new ways in which visual imagery was moving. Just as painters and sculptors had redefined the boundaries of their art, so too did printmakers begin to seek appropriate means by which to accommodate the 20th-century idiom.

Hayter's group added to the historical definition of intaglio by experimenting with color printing, relief whites, and printing in plaster. In addition, they explored soft-ground etching to increase the tactility of textural surfaces, and they combined more traditional techniques, such as the simultaneous printing from the relief surface and the intaglio surface. Outside Atelier 17 this experimentation in prints continued through the efforts of Gabor Peterdi and Mauricio Lasansky, both of whom were affected deeply by Hayter's activities.

Lithography and silkscreen techniques inspired contemporary American artists in the sixties, but the seventies have brought a new interest in intaglio processes. This can be seen in the quality of draughtsmanship and technical virtuosity in works by Johns, Rosenquist, Rauschenberg, and Dine. The range and flexibility of the medium is such that it can accommodate a diversity of styles. In Chuck Close' mezzotint of *Keith* (Fig. 191) Crown Point Press photomechanically etched a large surface to create the minute dots necessary for a mezzotint. Close then divided the

above: **191. Chuck Close.** *Keith.* 1972. Mezzotint, 4'4" x 3'6". Courtesy Parasol Press, New York.

below: **192. Jim Dine.** *Saw.* 1976. Etching and aquatint, $32\frac{7}{16}$ x $22\frac{5}{8}$". Courtesy Pyramid Arts, Ltd., Tampa, Fla.

surface into a grid of small squares and reproduced with the use of a scraper a similarly divided photograph. Jim Dine's *Saw* (Fig. 192) was created with line etching and mordant painted on an aquatint. These and the works reproduced in the following chapter demonstrate that intaglio printing is very much alive in the last quarter of the 20th century.

4 Intaglio Techniques

Intaglio prints have always been considered one of the elite forms of graphic art. The precise nature of the etched or engraved line, the richness and tactility of the printed surface, and the ability of the medium to amplify the intention of the artist—all these give to the intaglio processes a unique and unmistakable identity.

The word *intaglio* comes from the Italian and means to engrave or cut into. In intaglio printing, an impression is made by pushing the paper into inked depressions and recesses in a metal plate. These depressions and recesses are created by acid (in etching and aquatint), by a burin or graver (in line and stipple engraving), or by direct scratching and scoring on the metal (in drypoint). Contemporary printing terminology broadens the term *intaglio print* to include works—such as collagraphs and epoxy prints—made by additive techniques but printed in the intaglio fashion.

An intaglio print is made in several operations. First, a short, soft ink is applied to the surface of the etched or engraved plate and rubbed into all recessed and incised areas. The surface ink is then removed, leaving the ink deposited in all the crevices. Paper—softened by being dampened with water—is placed on the plate. Considerable pressure is applied with the aid of an etching press and felt blankets, forcing the paper into the recessed areas to pick up the ink.

The quality of the printed line can vary greatly, depending on the image-making method that was used. It can be sharp and crisp, soft and crayonlike, or smooth and almost velvety.

Intaglio
Print
Characteristics

Types of Intaglio Prints	Metal Plates for Intaglio
Drypoint	Copper
Engraving	Zinc
Mezzotint	Brass
Etching	Aluminum and Magnesium
Aquatint	Steel

The many techniques for making intaglio plates can be divided into two basic categories—etching techniques that employ acids, and engraving techniques dependent on sharp tools. Drypoint, line engraving, stipple engraving, criblé, and mezzotint are all engraving methods; etching techniques include hard-ground etching, soft-ground etching, aquatint and its many variations.

The basic techniques of both engraving and etching have changed very little from the methods that were practiced in Rembrandt's time. Many variations have developed for grounds, etches, and procedures, but, with the exception of photoetching, most of the formulas for intaglio plate-making have remained essentially the same.

Types of Intaglio Prints

Drypoint　Drypoint produces a characteristically soft, heavy line (Fig. 193). As the hard point of the needle is scratched across the plate in creating the image, it displaces metal, thus raising a burr. The incised groove and burr, however, are very fragile. Because of wear from the friction of inking, wiping, and printing, the plate will yield no more than ten to twenty good impressions unless it is steel faced.

Engraving　The engraved line, exemplified by any good banknote, is characterized by sharp and infi-

193. Jacques Villon.
Portrait of a Young Woman, detail.
1913. Drypoint printed in black.
Museum of Modern Art, New York
(gift in memory of Peter H. Deitsch).

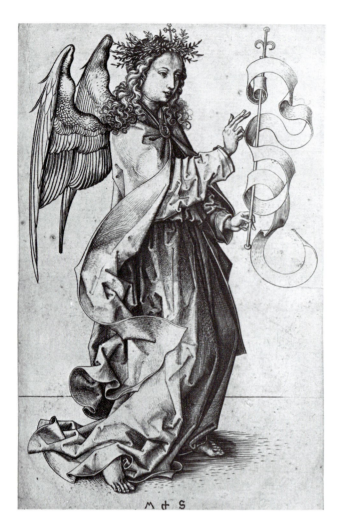

nitely crisp detail. Lines are often smooth and flowing—thinner where the engraving tool cuts less of the surface metal, swelling to heavier and wider lines where the tool is pushed deeper into the metal (Fig. 194). Tonalities are achieved by engraving parallel lines close together (*hatching*), by making parallel lines that intersect at various angles (*cross-hatching*), or by many closely spaced fine dots (*stippling*). Some engraving is often employed on etched plates to intensify, correct, or alter the lines after the etching has been completed.

An engraved copper plate can yield several hundred good impressions. Steel is capable of holding the finest detail (Fig. 195); because it is much harder than copper, it can produce thousands of impressions from a single plate. In the late 19th century, steel-plate engraving was a popular technique for better-quality book illustrations. Today the process is almost entirely limited to the printing of currency and stamps.

The historical technique of criblé is related to engraving (Fig. 196). In criblé images are created by hammering indentations in a plate with a variety of shaped punches. The technique began in wood block

printing and was later used for metal plates as well, often incorporating normal engraving techniques. One rarely sees criblé work today. However, since any depression in a metal plate will retain ink, the contemporary printmaker may want to explore its possibilities for special effects and variations. The chasing and repoussé punches used by metalworkers would be among the possible tools for making indentations in a metal plate to obtain the effect of a criblé print.

Mezzotint Although the origin of the mezzotint technique is not entirely known, in 18th- and 19th-century England the process—sometimes called *manière noire* or "the black method"—reached a zenith of technical perfection and popularity. Because of its ability to capture the most subtle nuances of tone and value from rich, velvety blacks to glowing highlights, mezzotint was used primarily for reproducing other works of art. Ironically, these prints are now prized as collectors' items, and some of the mezzotint draughtsmen have become as famous as the "fine artists" whose work they copied.

196. Master of the Aachen Madonna.
Saint Jerome in His Study.
1460-70. Criblé, 7 x 4¾".
National Gallery of Art, Washington, D.C.
(Rosenwald Collection).
This relief print employs methods
useful in the intaglio process.

The making of a mezzotint plate involves several steps, the first of which is to roughen the entire plate with the aid of a mezzotint rocker. In this state, the plate would print a solid black. Tones are then burnished and scraped into the plate, working from black to middle values to highlights (Fig. 197). As a reverse technique, with the image developed from dark to light, mezzotint is unique among the intaglio image-making processes.

Etching An etched line does not have the smooth, crisp quality of an engraved line. It is usually sharply

197. Mario Avati.
Il Est 3 Heures, Madame. 1969.
Color mezzotint, 9½ x 12".
Courtesy Associated
American Artists, Inc., New York.

defined, but slightly irregular due to the action of the acid biting into the metal plate (Fig. 198).

There is a characteristic freedom of line in soft-ground etching (Fig. 199) as opposed to hard-ground etching, because the softer ground offers less resistance to the drawing instrument. For this reason, soft-ground etching is often referred to as *crayon manner* or *pencil manner*. Even more typical of the soft-ground technique are the textural effects achieved by pressing fabrics or other materials into the ground.

below: 198. **Giorgio Morandi.** *Still Life.*
1956. Etching, 8 x 7¾".
Collection Emiliano Sorini,
Maywood, N.J.

above: 199. **William Strang.**
Frontispiece from *Etching, Engraving and the Other Methods of Printing Pictures* by Hans W. Singer and William Strang (London: Kegan Paul, Trench, Trubner and Co. Ltd., 1897).
This image was produced by the soft-ground etching technique, shown in Figure 234.

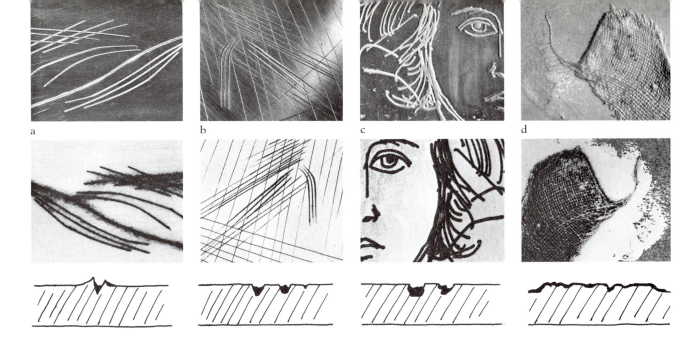

200. Drypoint (a), engraving (b),
etching (c), and collagraph (d).
Each column shows a plate close-up,
detail of a print, and plate cross-section.

Aquatint Aquatint is a method of etching tonal areas into a metal plate (Pl. 17, p. 145). The name derives from the Latin *aquafortis*, indicating nitric acid (literally, "strong water"), and the Italian *tinto*, meaning tone. This technique is often used in conjunction with linear etching or engraving. The texture of an aquatint plate can be coarse or very fine. Intaglio characteristics are shown in Figure 200.

Metal Plates for Intaglio

Copper Copper plates are ideal for all intaglio techniques and can be purchased in several forms. Photoengraver's copper, usually 16 or 18 gauge, comes with an acid-proof backing and is polished to a mirror finish. Uncoated copper, often available by the pound from metal suppliers, is cheaper and has the advantage of providing two usable surfaces. It may have to be burnished or polished before use.

Most available metal is made into sheets by a rolling process that arranges the random copper molecules in a longitudinal pattern. This copper has a tendency to be soft; hardened copper is available at a higher cost. Early engravers used to hammer each sheet of copper to harden it; this made the molecular structure identical in all directions. Copper plates can be readily steel faced, which greatly increases the number of potential prints. Steel facing is a process that places a microscopically thin layer of iron on the metal by electrodeposition. This supports the fine detail and burr and is necessary to achieve a consistent edition of fifty or more prints. The technique for steel facing is described in Appendix B.

Zinc Zinc is usually cheaper than copper. It does not hold fine detail as well as copper, because it is softer and has a coarser structure. Zinc is not as good as copper for fine line engraving, since the tools have a tendency to dig into the surface too readily. A drypoint on zinc yields far fewer impressions than a copper one. For most etching, however, zinc will perform almost as well as copper, especially for heavy textural biting. A very malleable metal, zinc can be reworked easily by scraping, burnishing, or polishing. Steel facing on zinc presents problems, because the metal must first be faced with copper, and this double facing will result in loss of some detail.

Brass Brass has many of the same etching and engraving capabilities as copper. An alloy of copper and zinc, it is harder than either and similar in price to copper.

Aluminum and Magnesium Aluminum and magnesium are soft and produce few impressions. Fine etched detail is difficult to obtain on an aluminum plate, because the acid bites in a coarse and irregular manner. Magnesium etches more cleanly, but the plate does not endure as well as zinc or copper. Both metals are difficult to engrave, because the tool digs in too readily.

Steel Soft steel, despite its name, is harder than any of the other metals mentioned. In terms of durability it may be the most desirable material, since it yields very large editions. For engraving, steel holds exquisitely fine linear detail, cross-hatching, and stipple. It etches with a coarser bite than copper. Drypoint is possible, but it requires considerably more effort to create a burr than on any of the other metals. Steel rusts very easily, so it must always be coated with a thin film of oil or etching ground when stored.

The Intaglio Plate

Preparing the Metal Plate

Cutting Sheets of metal for intaglio printing must generally be cut into smaller, usable pieces. A draw tool gouges a thin channel in the metal so that it can be bent cleanly and broken at the score line (Fig. 201). If it is kept sharp, this tool will cut plates quickly with only a few strokes. A sheet of paper should be placed on top of the metal just to the cut line to protect the surface from scratches. When the metal has been scored about two-thirds of the way through, it can be moved to the table edge and bent, so that it breaks at the score line. A drypoint tool can substitute for the draw tool, although it necessitates repeated scoring.

Metal shears operated by foot pressure or a hand lever cut the metal quickly and accurately in a single stroke (Fig. 202). Used shears can sometimes be found at auctions or printing supply houses and are a worthwhile investment for the workshop.

Beveling The first step in preparing a new plate for drypoint or engraving is to file down rough edges and

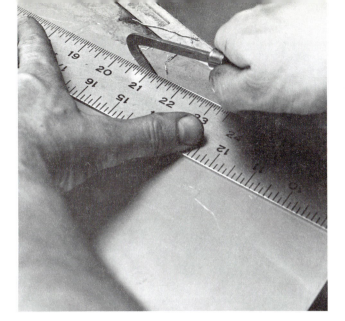

201. Cutting the metal plate with a draw tool.

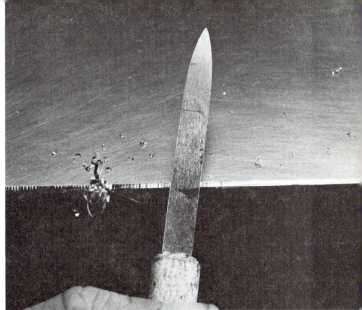

203. Beveling the edges of the plate with a scraper.

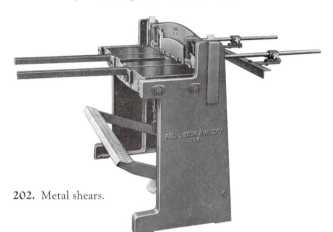

202. Metal shears.

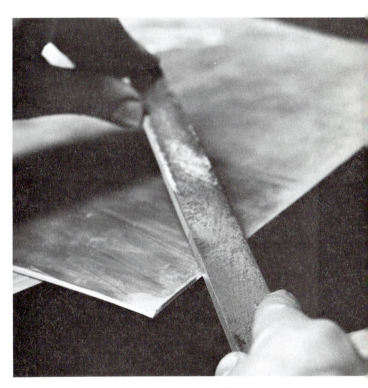

204. Beveling the edges of the plate with a file.

205. Use steel wool to remove file marks from the edge of the plate.

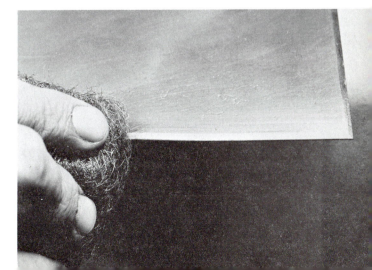

sharp corners with a scraper or file, so that the plate can be handled safely (Figs. 203, 204). For etching, however, many artists prefer to bevel the plate afterwards. At this point the filing and polishing will also remove any roughness caused by the acid biting the edge of the plate.

Whether the bevel is to be faceted or rounded and whether the corners are to be square or slightly rounded are matters of personal preference. Sometimes the imagery of the print will determine this choice. In any event, it is important to remove all sharpness from the edges of the plate before it is printed, for otherwise the paper and the press blankets may be irreparably cut. After beveling the edges, smooth them with steel wool to remove file marks (Fig. 205).

Cleaning New metal is usually protected by a thin film of oil to prevent oxidation. The oil should be cleaned from the plate to allow proper adhesion of the ground for etching or aquatint. Simply rub the plate with ammonia water and some whiting or with commercial metal cleaner. This action degreases the metal and has a slight abrasive effect. When water

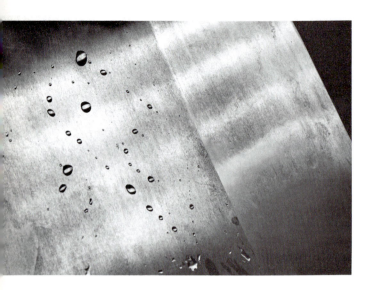

206. Water beads up on the left side of this plate, showing that it requires further cleaning. The right side is clean.

flows on the surface in a thin, unbroken film without beading, the plate is completely free of grease or wax.

The plate is now ready to be polished for drypoint or line engraving, or to be used directly for etching. Once clean, the plate should be handled carefully to avoid fingerprints (Fig. 206).

Polishing All intaglio plates are polished at one stage or another, depending upon the technique. With drypoint, the polishing must be done before the plate is worked, because polishing afterward would remove or damage the burr. Plates for line engraving are also polished before drawing. This allows better visibility of the tiniest scratch and provides a smooth, clean surface for working. Etched or engraved plates most often are polished (or repolished) with a charcoal block after the image has been created in order to ensure an even printing surface (Fig. 207).

The plate can be hand-polished with jeweler's rouge and a soft cloth (crocus cloth) or with fine emery (No. 4/00). Liquid metal polish also works well on almost any metal. With the aid of a little jeweler's rouge, an electric grinder or drill fitted with cotton buffing wheels brings the surface to a high polish.

207. Polishing the plate with a charcoal block.

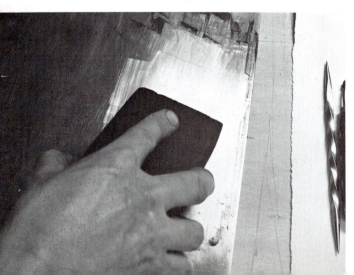

Basic Equipment

Certain tools and materials are essential to any intaglio workshop. The *scraper* and the *burnisher* play a role in every intaglio process. Other supplies are necessary to the maintenance of these and other tools. The following list outlines the supplies that are general to intaglio printing. More specialized equipment will be listed under specific techniques.

- □ scraper
- □ burnisher
- □ grinding wheel (electric or hand-powered)
- □ India oil stone, with coarse and fine sides
- □ Arkansas stone, soft and hard
- □ snakestone (also called water-of-Ayr stone or Scotch stone)
- □ light machine oil or kerosene
- □ emery paper (Nos. 4/0, 4/00, 4/000, 4/0000)
- □ crocus cloth
- □ putz pomade
- □ jeweler's rouge—powder or stick
- □ fine steel wool
- □ metal cleaner (commercial household)
- □ charcoal blocks
- □ soft cotton rags and pieces of felt (cut from an old discarded etching blanket)
- □ English chalk whiting
- □ alcohol, turpentine, and benzine

Scraper The scraper (Fig. 208) serves several purposes. It removes the burr from engraved lines, shaves off surface metal in making corrections on the plate, and—along with the burnisher—builds middle tones and highlights in the mezzotint technique. It can also be used to bevel the plate. The scraper is made of hardened steel, with a three-faceted shaft coming to a sharp point. When the tool is new, these facets show

208. The burnisher (left) and the scraper (right). Note the masking tape wound around the shaft of the scraper.

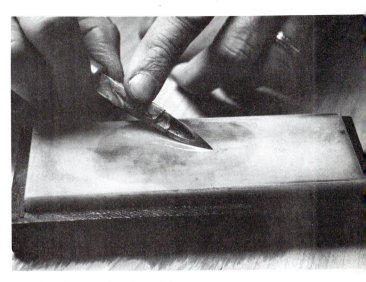

209. Touching up the edges of the scraper on an Arkansas stone.

the grinding lines produced in its manufacture, at right angles to the axis of the tool. The facets must be ground on an oilstone (with a little kerosene) to remove all traces of the grinding lines before the tool can be used. The edges can then be touched up with an Arkansas stone (again with kerosene) to remove any roughness or nicks that would scratch the surface of the plate (Fig. 209). For better control when using the tool, cover about $1\frac{1}{2}$ inches of the metal shaft next to the handle with some masking tape, wound around several times. This enables you to hold the scraper closer to the cutting end.

The curved cutting end of the scraper should always be coated with a thin film of oil to prevent rusting. When not in use, it can be inserted into a wax ball or piece of cork to protect the edges.

Burnisher The metal shaft of the burnisher is round or elliptical in cross section, and comes to a blunt point at the end. Some burnishers curve near the tip. This tool should be kept polished and coated with a thin film of oil. If spots, oxidation, or nicks appear on the surface, they can be removed by polishing with 4/00 emery and finally with crocus cloth.

The burnisher polishes small areas of a plate, pushes down the metal, and smooths out any rough-

ness on the surface. In the mezzotint technique, it can do most of the tonal work by smoothing the areas roughened by the mezzotint tools.

Using an Old Plate

If an unused plate has been lying about for some time, it is likely to be nicked, scratched, and covered with fingerprints or moisture stains that have oxidized on the plate. Unless these areas are deeply pitted, they can be smoothed out quickly with a large charcoal block and some light machine oil or olive oil. The plate can then be polished if necessary.

Restoring an old plate that has been previously printed is a more difficult task, although it can be economically advantageous. Fine scratches are the easiest to remove. Put a little machine oil on the plate, and rub and press it with the burnisher until the scratches are smoothed out (Fig. 210). The bur-

210. Fine scratches on the plate can be smoothed down with the burnisher.

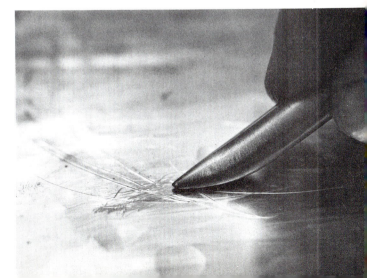

211. The scraper shaves down the metal
to remove irregularities.
A Scotch stone can be seen at the right.

nisher also tends to polish the plate, creating a differ-ence in the final print between the polished areas and the unpolished ones. Although this difference is sometimes produced deliberately to achieve a certain effect, for even tonalities the entire plate should be polished with jeweler's rouge or whiting and ammo-nia. Lightly etched lines, pitting, and other irregular-ities can be removed by using the scraper to shave down the metal (Fig. 211). After this treatment, hone the plate with a large piece of snakestone and some water. This is very effective for planing down a small area or an entire plate surface.

If a deeply bitten line or spot is removed by scrap-ing and burnishing, the indentation left on the plate can make it difficult to print successfully. A method called *repoussage* can be used to hammer out the plate from the back and flatten the surface. With calipers, find the exact place to hammer (Fig. 212). Hammer gradually and lightly, being careful not to overdo it (Fig. 213). Check the results with the calipers.

Drypoint

In terms of materials and execution, drypoint is one of the most direct and straightforward of the intaglio techniques (Fig. 193). All that is required for making a drypoint engraving—other than a metal plate—is a drypoint needle. Copper would be the preferred ma-terial for the plate, because it is soft and fine-grained, but the other materials described above can also be used. Copper plates can be steel-faced to give them the capacity for printing larger editions (see Appen-dix B for steel-facing technique).

The Drypoint Needle

The needle for drypoint should be of hardened steel and strong enough to withstand considerable pres-sure at its point without breaking. A diamond-tipped or sapphire-tipped needle is an ideal instrument, for it will last indefinitely and never need sharpening.

212. Find the spot that needs to be hammered by using
calipers. The calipers shown here were homemade.

213. Hammer gently and carefully
from the back.

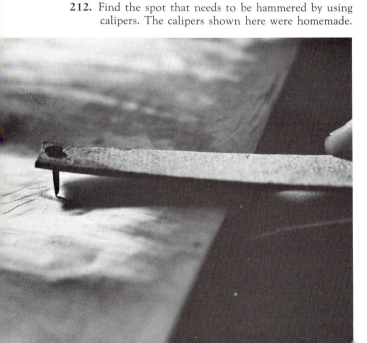

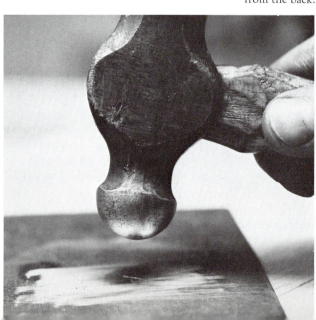

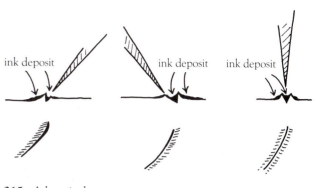

215. A burr is thrown up
on either or both sides of the line,
depending on the angle of the drypoint needle.

The needle is held in much the same manner as a drawing pencil (Fig. 214). There is no standard or ideal position. Each printmaker should find the one that feels most comfortable and is most effective. On a polished plate the finest scratches will print. The image can be built up slowly, with gradually increasing pressure as the drawing takes form. The angle at which the needle is held determines the nature of the burr (Fig. 215). Inclining the needle to one side of the line will produce a burr that is greater on the opposite side of the line. This, of course, affects the printed line. A line with a burr on one side prints fuzzily on the burr side and more sharply on the other. Too acute an angle, however, will raise a very fragile burr capable of withstanding only a few impressions. If a burr is raised equally on either side of the line by holding the needle almost vertically, the printed line will be dark at the center and have velvety edges. The greater the pressure of the needle, the deeper the line that is cut and the higher the burr.

As the work progresses, ink the plate and wipe the surface clean with a cloth, just as if you were about to print. This will show how the image is taking ink and help visualize the final work, without actually printing. The ink can then be removed with solvent so work can continue. Corrections are relatively simple. If a line is too heavy, the burr can be removed with the scraper or flattened with the burnisher. Fine scratches are removed by burnishing. Lines are intensified by repeated scoring, and tonal areas built up by cross-hatching or stippling.

Drypoint Engraving

In drypoint engraving, the image is made on the plate as for an ordinary drypoint, but before printing all the burr is removed from the plate with the scraper. This leaves only the grooves to hold the ink. There is no

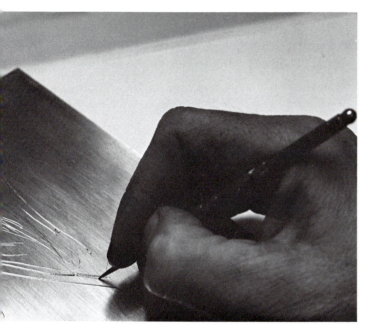

214. Find a comfortable position
in which to hold the drypoint needle.

However, these needles are expensive. Their cost is justified only when a great amount of drypoint work is planned. Good drypoint needles can be made from hardened dentist's tools ground to a sharp point. Engineer's scribers or carbide-tipped points, available at most hardware stores, also make good drypoint tools. Fine etching needles should not be used for drypoint, for they will invariably break under pressure.

The point of the needle should be round in cross section, without flat sides or facets. Facets would have a tendency to angle the needle's path and will remove metal rather than turning up a burr. The point's taper should be sufficiently acute to ensure a fine point, yet not so delicate that it breaks.

way to judge the strength of the line until the burr has been removed, so the depth of the graving must be determined by trial and error until experience is gained in the process. The plate can be reworked many times in order to build up the required strength; the first attempts may be disappointingly weak.

After the burr has been removed, give the plate a final smoothing with snakestone and water, then polish it with a piece of charcoal and light oil. Extremely fine emery cloth (4/0) wrapped around a wooden block also works well for smoothing out the plate, and crocus cloth—used in the same manner—does the final polishing.

Line Engraving

Line engraving, perhaps the oldest of the intaglio techniques, produces a smooth and crisp line on the plate (Fig. 194). The tools for line engraving are the same as those for wood engraving (see p. 70). In addition to the basic list on page 126, the following equipment will be needed:

- burins—square-shaped and lozenge-shaped
- elliptical tint tools
- multiple tint tools (optional)
- scorper (optional)
- carbon paper
- pen or hard pencil
- nitric or acetic acid
- gum arabic
- etching needle

The Burin and Related Tools

The shaft of the engraving burin is made of straight, highly tempered steel, curving upward as it enters a wooden handle. The cutting end of the tool is faceted at an angle of about 45 degrees to the main shaft. All the cutting edges of the burin must be kept true and sharp in order to cut clean lines. The shaft is held at a very shallow angle to the surface of the plate, with the wooden handle snugly in the palm of the hand. Burins can be fitted with longer or shorter handles to suit personal preferences, but if the tool extends too far from the hand, control over the cutting end will be lessened. As the cutting proceeds, metal will be gouged from the plate leaving a slight burr. This can be removed at intervals with a scraper.

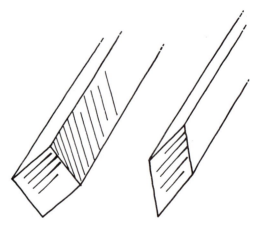

216. The square-shaped burin (left) and the lozenge-shaped or diamond-shaped burin (right), the most popular engraving tools.

The two main types of burin are the square-shaped burin, preferred for cutting curved and swirling lines, and the lozenge-shaped burin, for finer and deeper lines (Fig. 216). Because they sharpen easily and take a fine edge, these are the most popular tools for engraving. However, others are sometimes re-

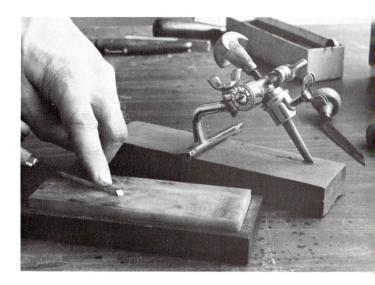

217. Honing the facets of the burin shaft. A sharpening jig is at the right.

quired (Fig. 108). Elliptical tint tools are designed so that each will produce a particular line width, from heavy to extremely fine. They can yield a deeply engraved line that is capable of great stability in extended runs.

The scorper and the multiple-tint line engraver (Figs. 109, 110) may have some limited use for metal engraving. The scorper can reach and remove areas of metal that are inaccessible to other tools, while the multiple-tint line engraver produces a series of closely spaced parallel lines (hatchings) of varying widths. However, these tools serve more often for wood engraving (see Chap. 2).

Sharpening the Burin The new burin comes with a machined end that must invariably be sharpened before use. The first step in sharpening the burin is to "true up" the belly or undersurface of the burin shaft. Place each facet in turn on a fine oil stone with some kerosene or light machine oil and hone it back and forth on the stone (Fig. 217). Once the bottom surfaces are true, they will remain so, often for the life of the burin. The angled facet of the cutting end is sharpened next. Place this flat on the oil stone, and move it back and forth against the stone without any rocking motion. The two bottom edges are the most important, since these are the cutting edges; they can be finished up with a fine Arkansas stone, removing any burr. During the course of engraving, it will be necessary to hone these facets again, so they remain sharp enough to give the best results.

Drawing on the Plate

It must always be remembered that the engraved image will be reversed upon printing, so this should be taken into consideration in planning the drawing. A preliminary drawing can be made on the polished plate in several ways. One of the simplest procedures is to draw on the plate with carbon paper and a hard pencil or ballpoint pen. Due to the slightly greasy nature of the carbon paper, the fine lines traced on the plate will act as a mild acid resist. The plate can then be immersed momentarily in a weak nitric or acetic acid solution. When the plate has been cleaned with alcohol or benzine, the traced lines appear shiny on the dulled background. This surface will not affect the engraved image.

Another method is to clean the plate with ammonia and water so that no grease remains on the surface. Next, apply a thin layer of gum arabic to the surface, and allow it to dry. The drawing can now be made directly onto the plate with a pencil or traced with carbon paper. Fine scratches can be made in the gum coating with a sharp point, then filled with etching ink as a guide. To prevent the scratches from printing later, remove them after the engraving is completed with a sheet of 4/0 emery or crocus cloth wrapped around a flat wooden block. A thin layer of cloth or felt between the emery and the wood will give better contact with the surface. This slightly abrasive polishing action removes the fine scratches but does not affect the deeper engraved lines.

Engraving the Plate

Fluidity and expressiveness in engraving techniques are difficult to develop and require considerable experience. It is a good idea to purchase a small, thin, inexpensive copper plate for practicing both the engraving and the printing techniques. Rehearse using the burin until you find the most comfortable position for holding it. Practice flowing contours and curves, swelling and tapering lines. Once you have achieved a certain confidence in the results, you are ready to begin on a new plate.

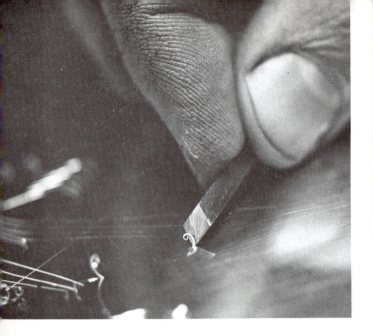

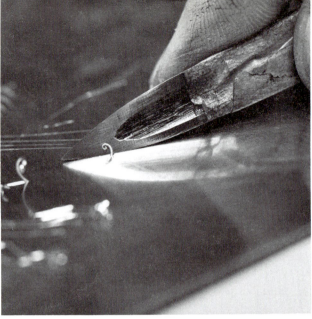

above left: **218.** Hold the burin low on the plate. Here, a pigtail of metal is left on the plate surface.

above right: **219.** The pigtail, or burr, can be trimmed away with the flat edge of the scraper.

below: **220. Dora Raab, after Rembrandt.** *Lady with Fan,* detail. Steel engraving c. 1890 Collection Deli Sacilotto.

The burin should be held low on the plate and guided with firm pressure (Fig. 218). To increase the depth of the line, raise the handle end of the burin slightly and apply more pressure. For curved or cir-cular lines, rest the plate on a leather pad or sandbag so that it can be turned slowly while the burin re-mains in a fixed position. This seems very awkward at first, but with practice it provides a means for engrav-ing smooth, flowing curves with ease.

The way you begin and end each stroke is impor-tant. Keep the burin almost parallel with the surface, and begin lightly with a shallow line. Lines can be reengraved later if necessary. The line can terminate abruptly or be tapered by lifting the burin slowly from the metal. Where a line stops abruptly, a high curl of metal (*pigtail*) is left projecting from the plate. Fine burrs can be removed with a snakestone and water; to remove heavier ones, put a flat scraper edge on the plate and trim the raised part even with the plate surface (Fig. 219). The slight burr left by the burin in normal engraving is also removed with the scraper in a similar way at intervals during the en-graving process. In removing the burr, use a light, gentle action to prevent scraping any of the sur-rounding metal.

During the centuries when line engraving flour-ished, a considerable number of variations for pro-ducing tonal effects were devised. Hatchings can produce a full range of values depending on their closeness and depth (Fig. 220). These lines are some-times alternated with a series of short strokes, dots, or broken lines to provide variety to the surface. Cross-hatching yields deep and rich surfaces. Lines can be overlapped a number of times or interspersed with engraved dots. By using the point of the burin one can flick out dots of metal to create a subtle tonal image—a method known as *stipple engraving* (Fig. 221). Some of the most elaborate and difficult techniques

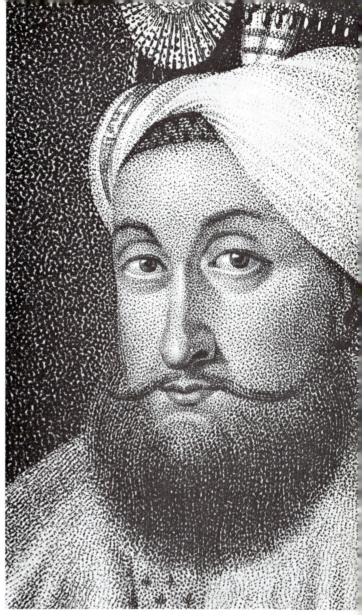

involve the use of parallel lines that curve and swell, creating many nuances in tone for portraits and other figurative work.

Mezzotint

The mezzotint technique (or *manière noire*) is a negative process—that is, one in which the image is developed from dark to light (Fig. 197). Beyond the basic intaglio equipment, this technique requires:

- □ mezzotint rockers in various sizes
- □ mezzotint roulettes of various textures (hatching, dot, random-pattern)
- □ carborundum grit (optional)
- □ small lithographic stone or glass muller (optional)

First, the entire plate is roughened with a mezzotint rocker so that it would print a solid velvety black (Fig. 222). Light tones are then worked into the plate with the aid of the burnisher and the scraper. The more an area is burnished or scraped, the lighter it becomes.

The Mezzotint Rocker

The traditional tool for applying the mezzotint ground to the plate, the mezzotint rocker is shaped like a wide, heavy chisel with a curved and serrated cutting edge. As the edge is rocked back and forth on the plate, the teeth cast up a rough burr.

Rockers are made in many sizes, the coarsest having approximately 28 teeth to the inch and the finest more than one hundred. The cutting edge is usually about 2½ inches long, but tools of 1-inch and ½-inch widths can be made on special order. Small rockers are ideal for making corrections or working around detailed forms. In combination with etched linear work or drypoint, they can greatly increase the tonal range of an image.

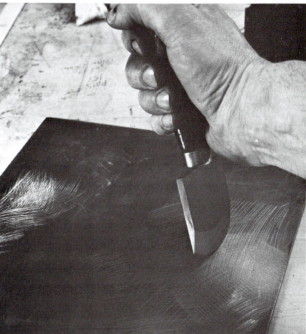

223. The directions of the strokes
for laying the mezzotint ground.

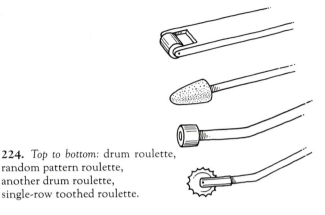

224. *Top to bottom:* drum roulette,
random pattern roulette,
another drum roulette,
single-row toothed roulette.

To make the mezzotint ground, grasp the rocker firmly by the handle, with the serrated side facing away from the body and tilted about 20 degrees in that direction. Move the rocker from side to side on the plate so that the rows of dots proceed in a close, zig-zag movement forward. Begin working on the side of the plate closest to you and move to the opposite end. Repeat several times if necessary.

The general pattern for producing the traditional deep-black ground should be followed closely. The ground is applied first in a horizontal direction. Next, the rocker is moved vertically, then along a 45-degree angle, then a 22½-degree angle, and so on, splitting the angle each time until the ground is satisfactorily laid. Lines in at least eight different directions are usually required (Fig. 223).

Keep the pressure of the rocker consistent to produce an evenly textured ground. A forty-line or fifty-line rocker will produce a rough ground that is easier to apply evenly. Rockers with a ruling of one hundred or higher will necessitate considerably more work to put down an even ground. A little light machine oil applied from time to time to the edge of the rocker will make the cutting easier.

When applying the mezzotint ground with the rocker, some artists prefer to avoid areas of the image that are to be white or very light in tonality. In effect, then, these areas are worked from light to dark in the normal intaglio manner.

Mezzotint Roulettes

The mezzotint roulette is a small, textured wheel on a metal shaft attached to a handle (Fig. 224). Several different types are available, and the number of teeth per inch varies from 35 to more than one hundred. As its name implies, the single-row toothed roulette produces a single row of dots on the plate. The hatch-ing roulette creates a series of closely spaced lines and a cross-hatching effect when worked at right angles. The drum roulette is the most common type. It is made from hardened carbon steel, with a series of regularly spaced teeth. The greater the pressure that is applied and the more a plate is worked over, the darker will be the tone produced. Because most roulettes have a regular dot or linear pattern that some artists feel is rather mechanical in appearance, a random-pattern roulette has been introduced that builds up tones with a potentially more varied effect. Figure 225 shows two different types of mezzotint grounds.

The burr raised with the mezzotint rocker or roulette will withstand somewhat more wear than a drypoint, even though the techniques are related. The mezzotint burr is pushed up from the surface by vertical pressure—as opposed to the scratching motion of the sharp drypoint needle—so it is generally lower and not as fragile. Nevertheless, the mezzotint plate should be steel-faced if possible soon after a final proof is made, so that nothing will be lost in the subsequent edition. A steel-faced plate can easily yield an edition of several hundred impressions.

Carborundum Mezzotint Ground

A good, quick way of producing a mezzotint ground is to use carborundum (silicon carbide) grit. The coarseness or fineness of the roughened surface is controlled by the quality of the carborundum grit. Carborundum is available in grades from 80 (coarse) to 220 or finer.

To make a carborundum ground for mezzotint, sprinkle some water and carborundum on the plate. Using a very small lithographic stone or glass muller, grind the carborundum into the surface. When the plate has been made rough and grainy, it is ready to be burnished and scraped for middle and bright tones.

above: 225. Two very different grounds made with drum roulettes Nos. 150 and 45.

right: 226. Theo Wujcik. *Jim Dine.* 1976. Stipple etching, $16\frac{7}{8} \times 20\frac{7}{8}''$. Courtesy Pyramid Arts Ltd., Tampa, Fla.

A commercial sand-blaster or an air brush with a sand-blasting tip can also be used with carborundum to roughen the plate.

Etching

The term "etching" describes those intaglio techniques in which the grooves are made in the plate by acid (Figs. 198, 199), as opposed to engraving techniques in which they are made by hand with a needle or burin. As noted in Chapter 3, etching developed much later than engraving and was almost immediately recognized to have manifest economic and creative possibilities.

For etching, the metal plate is first coated with an acid-resistant substance called a ground. The ground is then drawn upon with an etching needle, which exposes the metal wherever the point breaks through the ground. Variations in tone are produced by hatching, cross-hatching, or by stippling through the etching ground with a drypoint needle and various mezzotint tools (Fig. 226). Next, the plate is set in an acid bath, so that the drawn areas exposed by the needle are etched or "eaten" into. The length of time in the acid and the strength of the solution determine both the width and the depth of the line. Finally, the remaining ground is removed with solvent and the plate prepared for printing.

Depending on whether a hard or a soft ground is to be used for etching, some or all of the following equipment will be required, in addition to the basic intaglio materials.

- etching needle
- *échoppe*
- chisel points (optional)
- hot plate
- mortar and pestle
- leather roller or dabber
- brushes—wide to fine
- asphaltum (lump bitumen or powdered asphalt)
- liquid asphaltum (gilsonite)
- beeswax (yellow or white)
- lump rosin
- carbon paper
- tallow or cup grease
- methyl violet dye (optional)

The Hard Ground

A good hard ground should adhere firmly to the surface of the plate in a thin layer, be completely resistant to the mordant (biting) action of the acid for prolonged periods, and hold fine linear work without chipping or flaking from the surface. Hard grounds can be purchased in solid or liquid form. If you expect to use a great deal, you will find it preferable, and certainly less expensive, to make your own. A good basic hard ground in solid form can be made from the following materials:

2 ounces asphaltum (lump bitumen, or powdered Egyptian or Syrian asphalt)
2 ounces yellow or white beeswax
1 ounce clear lump rosin, pulverized with a mortar and pestle

Melt the beeswax first over a low heat. Gradually add the asphaltum, then the rosin. Stir until thoroughly mixed. If the ground is too hard, it can be varied by reducing the amount of rosin or increasing the amount of beeswax. A convenient way to store this mixture is to form it into small balls, about 2 inches in diameter. Pour a quantity of the hot ground into a bucket of cool water. As the ground cools and begins to harden, it can be formed into small balls under water.

A liquid hard ground can be made by dissolving the ball ground in benzine or paint thinner; the quantity of solvent will control the viscosity of the liquid.

The ingredients for making a liquid hard ground are as follows:

16 ounces liquid asphaltum (often called gilsonite, and available in hardware stores as an acid-resistant paint)
4 ounces yellow or white beeswax
6 ounces benzine or paint thinner

The beeswax, if cut into small pieces, will dissolve slowly in the asphaltum-benzine or paint thinner mixture over a period of a few days. Heating the mixture in a double boiler arrangement speeds the process. All the ingredients are flammable, so care must be taken to avoid contact with an open flame or high heat source.

Sherwin-Williams makes a liquid asphaltum varnish containing 43 percent blown asphalt, gilsonite, and resin, and 57 percent mineral spirits (naphtha). When mixed with an equal amount of lacquer thinner, it produces a tacky, workable surface in 10 minutes and a hard surface in 30 minutes. This extraordinary ground remains flexible yet durable, and is also an excellent ground for lift-ground work when one part of asphaltum is mixed with three parts of thin-

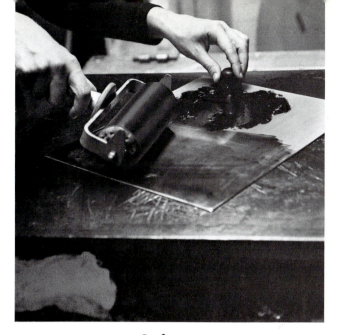

left: **227.** Spreading melted hard ball ground over the etching plate with a roller.

below left: **228.** Construction of a dabber.

below: **229.** Brush liquid hard ground across the plate, beginning at the top.

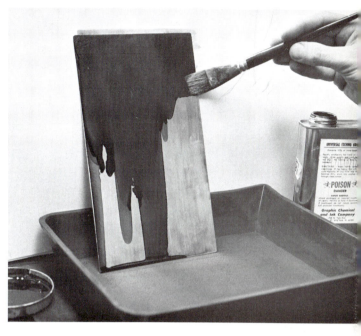

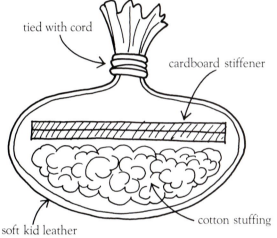

tied with cord

cardboard stiffener

cotton stuffing

soft kid leather

ner. Thinning with turpentine works well but triples the drying time. Most of the commercially prepared hard grounds, both ball and liquid types, are excellent. Some use chloroform, ether, or benzol as the solvent and should be used in a well-ventilated place to avoid inhalation of the vapors. These solvents are extremely fast-drying.

Applying Hard Ball Ground The plate must be free of all grease or oil for good adhesion of the hard ball ground. It need not be polished, however.

Put the metal face-up on a hot plate, and heat it evenly. When the metal has heated, set the hard ball ground upon it and move the ball around on the plate until it begins to melt and spread. When approximately one-third of the plate has been covered thickly from the melting ball, there should be enough ground on the plate to make a thin layer over the entire surface. At this point the ball can be removed and, with the aid of a leather roller or dabber, the melted ground can be spread evenly across the whole plate (Fig. 227).

Special rollers covered with heavy but smooth leather serve well for any size plate. The roller should be moved across the plate until it becomes slightly warm itself, for only when this occurs will it be able to smooth the ground adequately. Gelatin rollers should not be used, although some types of composition rollers will work. A dabber also serves to distribute the ground on the plate. This tool can be made from soft kid leather or some fine, soft, lint-free cloth drawn over cotton or other stuffing and pulled together at the top. A round disk of cardboard or other material is added as a stiffener, with the whole assembled as in Figure 228. To use the dabber, melt the ground and then with quick, short dabs, spread it over the surface.

If at any time the ground should begin to smoke and burn, the plate is much too hot. Reduce the heat immediately. When the entire coating is a medium-dark, even, tan color, remove it from the heat and allow it to cool. If the first amount proved insufficient to cover the plate, the plate can be reheated and more ground melted onto the surface.

Applying Liquid Hard Ground For the liquid hard ground, again be sure the plate is clean and free of grease. To apply the ground, prop the plate up at a sharp angle and brush the ground on with a soft, wide brush. Start at the top of the plate and brush across it, back and forth, as if you were applying a wash in watercolor (Fig. 229). Some artists rub the ground on

the surface with a lint-free soft rag or paper, and then immediately proceed to treat the surface in the above method. This assures better bonding of the ground to the plate. The applied ground should be medium brown in color. If it is black or nearly black, it is probably too thick. If it is a light tan, it may not withstand repeated or strong etching and will be more susceptible to false biting. *False biting* is a term that describes a random, unplanned mordant action on the plate where the acid has broken through accidentally. Usually, it is characterized by multiple pinholes scattered over the plate. If this action is discovered

early enough in the etching, the plate can be dried and regrounded. However, if the false biting takes place in a detailed area, it may be difficult or impossible to correct. Some artists deliberately make use of false biting for special effects, in which case they will intentionally lay a very thin ground.

Heating the plate after the liquid hard ground has been applied will help soften and even out the coating. Always allow the plate to cool before etching.

Smoking the Ground In order to make the hard ground darker so that the exposed metal will be seen

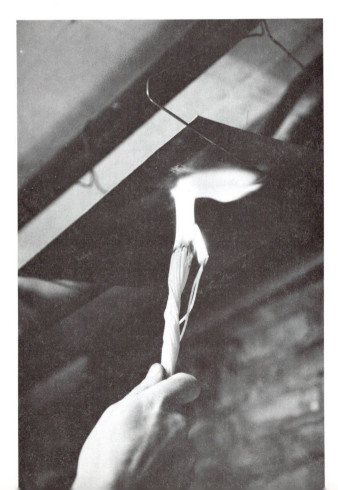

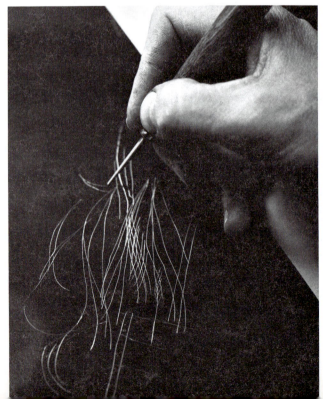

left: 230. Wax tapers can be used to smoke the etching ground.

below: 231. The ground is removed from image areas by means of needling.

232. Various uses of the *échoppe* are shown in this illustration from *De la Manière de Graver à l'Eau Forte et au Burin, et de la Gravure en Manière Noire* by Abraham Bosse, 1758. Collection Donald Saff.

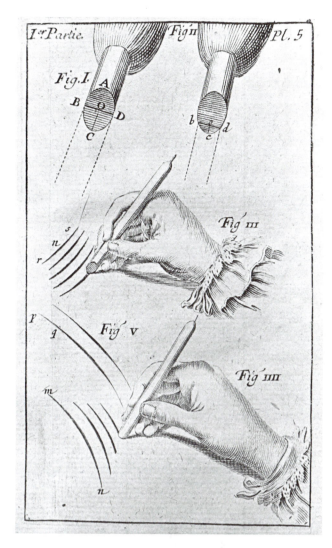

more easily, it is common practice to *smoke the ground.* The plate is held upside down with a hand vise or wire hangers and smoked with a candle flame—or better, with wax tapers. The flame is moved back and forth over the grounded surface, which turns it black (Fig. 230). As the flame touches the surface, the ground will appear shiny. The wick must not touch the plate for this will disturb the ground. As the carbon mixes with the ground, it hardens it slightly.

Tracing the Image on the Plate The manner of drawing on the plate will depend upon the results the artist desires. A preliminary drawing may not be necessary, and in this case you can begin working directly on the ground with the etching needle. For images that require precision, a tracing of some sort should be made on the ground. Black or white carbon paper yields good results when placed face-down on the ground and traced from the back with a pencil. Red conté or white chalk on a thin paper also works well.

Working into the Hard Ground *Needling* the ground exposes the metal so that the acid can etch the line (Fig. 231). The etching needle is one of the simplest tools available for this purpose. It can be purchased inexpensively or made from an ordinary sewing needle set into a wooden handle. Needles improvised from a variety of other sources perform quite well if they are light and properly sharpened. When a point is faceted or too sharp, it can scratch the plate and raise a burr or remove metal unnecessarily, causing uneven biting and irregularities in the line. A slightly rounded tip will glide better over the metal surface and permit freedom of movement. The needle should be used with light but sufficient pressure—just enough to scratch through the ground and expose the metal underneath. A point that is too dull or is used with insufficient pressure will not break

completely through the ground, with the result that some areas will bite and some will not.

Many etchers employ a variety of points to produce lines of varying thicknesses. The *échoppe* point (Fig. 232), developed by Jacques Callot in the 17th century, can produce lines that swell and thin in the manner of engraved work. Small chisel-like tools can also be improvised to produce calligraphic effects. These specialty tools are designed to create differences in the line quality with a single biting in acid.

Most important, however, is the fact that the longer a line is etched in the acid, the deeper and wider it becomes. With this in mind, you can vary the strength of individual lines and areas throughout the plate by progressively *stopping out* with stop-out varnish (see p. 141) or liquid ground. In this method, the entire drawing is first completed on the plate. The lightest lines are stopped out after a brief time in the etching bath. Then, in successive stages, the other lines are covered until the stopping out is completed. The darkest lines will be those that have been left in the bath for the longest period of time.

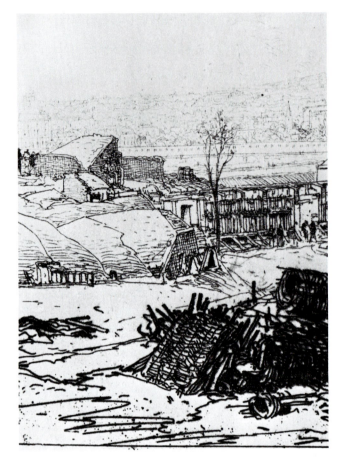

233. **Maxime Lalanne.** *Siege of Paris*, detail. 1870–71. Etching. Collection Deli Sacilotto. The great range of line quality between foreground and background in this image was controlled by the length of time each line was exposed in the acid bath.

A good brush with a fine point is necessary to stop out fine detail. The consistency of the ground must also be controlled so that when the brush is applied to the plate, *crawling* or unevenness of the ground does not occur. A good method is to dip the brush into some solvent, then rub it on a ball of hard ground until it dissolves sufficiently to be used as a clean, sharp stop-out on the plate.

Another technique for producing line variation by successive biting is to draw only a part of the image at a time (Fig. 233). The darkest lines are drawn in the ground first and etched in the acid. Then the plate is removed from the bath and other areas drawn in. The last lines drawn will produce the lightest lines, while those drawn first will be darker, having etched longest. No stop-out is necessary with this process, except to touch up false biting as it may occur. Some artists can successfully draw on the plate at intervals while it remains in the acid.

The Soft Ground

A soft etching ground remains pliable on the surface of the metal, allowing greater fluidity in the drawing. Objects and textured materials can also be pressed into the surface to produce tonal variations. A basic soft ground can be made by adding tallow or another greasy material to the hard ground in the following proportions:

1 part tallow (also petroleum jelly, shortening, or cup grease)

3 parts hard ground (see p. 136)

This mixture is applied to the plate in the same manner as the hard ground, with the dabber or the roller. It must be thinly and evenly applied, the final ground being medium brown in color. The plate can then be heated slightly to soften and even the surface.

Adding tallow to the prepared liquid hard ground, in the proportion one part tallow (or other grease) to two parts ground, yields a good liquid soft ground. If the ingredients are heated slightly, they will produce a better mixture.

Even after the soft ground sets on the plate it should be handled with great care, since anything that touches its surface can mark the plate. Fingerprints on the edges of the plate are a particularly common problem; if not too serious, they can be touched up before the etching takes place.

The traditional soft-ground technique is sometimes called the *crayon* or *pencil manner*, because it simulates—often very accurately—a pencil or crayon drawing on paper. Place a thin sheet of paper over the ground, and draw on it with a soft or medium pencil. A bridge of some sort over the plate will prevent it from being ruined by the pressure of the hand. The pressure of the pencil causes the soft ground to adhere to the back of the paper. As the paper is removed, it picks up the ground wherever the pencil

above: 234. The soft etching ground
lifts easily from the plate
wherever the paper was pressed into it by a pencil.

right: 235. Jim Dine. *A Nurse.*
1976. Detail of Figure 259.

strokes have pressed upon it (Fig. 234). The fibrous texture of the paper, the relative hardness of the pencil, and the degree of pressure exerted all influence the amount of ground picked up. Where the ground has been lifted, the metal is exposed and ready to be etched by the acid.

For direct drawing into the soft ground, a pointed hardwood pencil can serve in place of the etching needle. This allows greater freedom in drawing. If a metal point is preferred, it should be slightly rounded at the end so as not to scratch the plate. Should the drawing prove unsatisfactory, the plate can simply be regrounded and begun again.

Textured material pressed into the soft ground produces many different effects, depending on the nature of the material (Fig. 235). A textured cloth such as nylon netting or tarlatan, for example, can be cut to various shapes or even folded onto the surface. With several sheets of tissue or other thin paper placed on top, the plate can be run through the press quite safely with light to medium pressure, depending on the material and the softness of the ground. Some objects or materials can be pressed by hand into the surface, or rubbed onto the ground in the manner of a woodcut print. The soft ground presents infinite possibilities for creating textures. Fascinating effects can be achieved with great ease, but their use should be considered subservient to the content of the work.

Stop-Out Varnishes Stop-out varnish is brushed onto etching plates to stop the action of the acid. Commercial stop-out varnishes, usually made from rosin and alcohol, protect well and dry very quickly. To be effective, a varnish should be neither too thick nor too thin, and it should be capable of being brushed over small areas without spreading to adjacent lines. The stop-out varnish is also used to protect the edges and back of a plate, unless some other acid-resistant coating has been applied. Transparent stop-out varnish is excellent for successive-stage biting on the plate, since it allows each successive bite to be compared. A basic formula for transparent stop-out varnish is:

1 part clear lump rosin
3 parts alcohol

A little methyl violet dye added to the mixture will allow it to be seen more readily on the plate without obscuring the etched grooves.

Most stop-out varnishes are brittle, and once applied, they cannot be worked. A hard ground used as a stop-out varnish will allow additional work to be done over it, but it dries more slowly than the alcohol-rosin solution.

Aquatint

The effect of aquatint is to produce solid areas of tone (Pl. 17, p. 145). In the absence of any special treat-

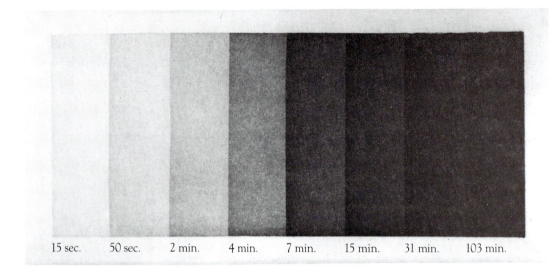

| 15 sec. | 50 sec. | 2 min. | 4 min. | 7 min. | 15 min. | 31 min. | 103 min. |

236. A print made from
the aquatint test plate shown in Figure 237.
The range of aquatint bites was produced
by a saturated ferric chloride
and hydrochloric acid (15%) solution at 70°F.

ment, when a plate is exposed to the acid bath, a large smooth area on the plate will simply be etched to a lower level without producing any appreciable tonal change between that level and the surface of the plate. To retain ink and print a tonal value, the area must be pitted to a greater or lesser degree by the aquatint process (Figs. 236, 237).

Aquatint uses much of the basic equipment for the general etching process. Depending upon the particular aquatint variation to be employed, some of the following materials may also be required:

☐ rosin (lump)
☐ mineral spirits
☐ lacquer thinner
☐ dust bag or dust box
☐ nitric acid
☐ sandpaper (or garnet paper or emery cloth)
☐ India ink
☐ sugar (or honey)
☐ soap
☐ alcohol
☐ ethylene glycol
☐ gum arabic
☐ black tempera color

Before the etching takes place, particles of rosin or asphaltum powder are dusted on a clean plate and heated until they melt, adhering to the metal surface. The acid bites into the plate around each acid-resistant particle, roughening the surface so that it will hold the ink (Fig. 238). The longer the plate remains in the bath, the darker will be the tone it produces.

Both asphaltum and rosin produce good aquatint grounds. The best rosin is the clear, hard lump variety, ground in a mortar and pestle before use. This melts at about 250°F, a considerably lower temperature than asphaltum. The transparency of rosin

237. A close-up of the plate from which Figure 236 was made.

METRIC 1 2 3 4 5 6

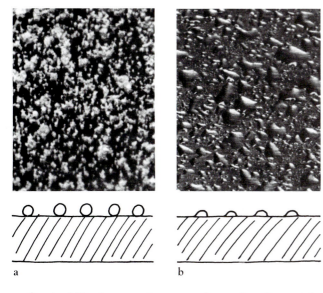
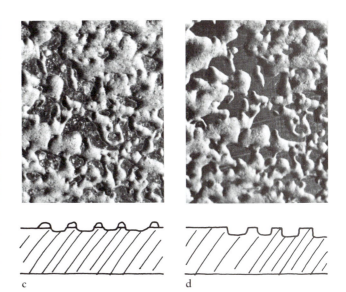

a b c d

makes it difficult to read accurately on the plate without careful examination under a magnifying glass. Rosin is dissolved with alcohol.

The best varieties of asphaltum powder are Egyptian or Syrian in origin. These melt at about 500°F. Because of its dark color, asphaltum can be seen more easily on the plate than rosin. Asphaltum dissolves in turpentine, mineral spirits, or lacquer thinner.

Applying the Aquatint Ground

The rosin or asphaltum is placed on the plate either by hand with a dust bag, or by means of a device called a dust box.

The dust bag method allows greater variety of concentration and particle size on different parts of the plate. Put the powder in a bag made of several layers of muslin, silk, or nylon. The fineness of the mesh fabric and the number of layers will determine the size and number of particles that filter through to the plate. Separate bags can be made for use with different sized particles. Tie the dust bag tightly at the top with string or an elastic band. Make sure the plate is very clean and has not the slightest trace of grease or fingerprints, and place it, face-up, in an area of the room that is free from drafts. Shake or tap the dust bag *lightly* over the plate (Fig. 239). Watch the plate carefully as the powder filters downward and settles on it. Ideally, the spaces between the particles should be roughly the size of the particles themselves. If they are too close together, the particles will fuse when heated, thus defeating the purpose of the technique. Careful examination of the surface with a magnifying glass will help determine the evenness and distribution of the particles.

Another excellent method for using the dust bag is to hold the plate face-up in one hand and the dust bag in the other, keeping them apart. Shake the dust

above: 238. Rosin particles on the plate (a), particles melting on the heated plate (b), the plate after immersion in acid (c), and the bitten plate washed of rosin (d). The diagrams show the plate in cross-section.

below: 239. Applying aquatint ground to a metal plate by means of a dust bag.

above: **240.** The dust box provides another way of applying the aquatint ground. This photo was taken at Crown Point Press, Oakland, Calif.

below: **241.** When the aquatint ground has been applied, heat the plate until each particle becomes shiny and transparent.

bag at arm's length, high in the air. A second or two later, when the coarsest particles have fallen to the floor, move the plate under the falling dust to catch the finer particles. This technique allows excellent control over the fineness of the ground. Needless to say, it too must be used where there are no drafts, and where dust on the floor can be swept up easily.

The dust box can be small or very large, depending on the size of the plates to be dusted. Most boxes have an open-mesh wire shelf in the lower third of the interior. This holds the plate face-up, with space around it on all sides (Fig. 240). Before inserting the plate, stir the powder in the bottom of the box for a second or two with an electric fan or bellows. Next, open the door, put the plate in position, and reclose the door. The plate can be placed on a slightly larger sheet of plywood. This will help achieve even distribution of particles along the edge of the plate. As the dust filters downward, it settles on the plate in a very even layer. From this point, the period of time that elapses governs the density of the particles deposited on the plate. The usual time is 1 to 1½ minutes; be careful not to leave the plate in the box for too long. Now remove the plate carefully and examine it. Again, as with the dust bag methods, all drafts should be eliminated or avoided, and the plate should be kept level so that the particles are not disturbed. The plate is now ready for the next step.

After dusting, heat the plate on a hot plate to about 250°F (or higher for asphaltum). As the powder melts on the surface, each particle becomes shiny and almost transparent (Fig. 241). When this has occurred over the entire plate, remove it from the heat with gloves, and allow it to cool. Meanwhile, examine the plate with a magnifying glass. If the particles are close but still separated, the aquatint will be good. If they are too sparse, the operation can be repeated. An overheated plate or too heavy a dusting will cause the

Plate 17. Robert Motherwell. *"Red" 8-11, from A La Pintura.* 1968-72. Aquatint, 26 × 39″.
Courtesy Universal Limited Art Editions, West Islip, N.Y.

Plate 18. Claes Oldenburg. *Floating Three-Way Plug.* 1976.
Etching and aquatint, image 42 × 32¼″. Courtesy Multiples, Inc., New York.

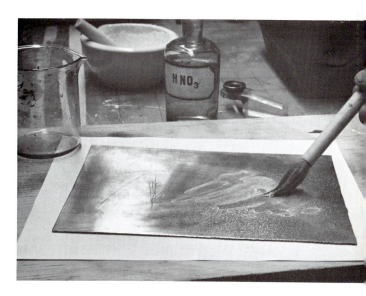

242. The spit-biting technique can produce subtle, cloudlike effects.

particles to fuse together and ruin the effect. You must dissolve the aquatint ground and begin again. The finished plate, with etching ground covering the areas that are to remain unbitten, is then put into the acid bath to be etched.

Other Aquatint Techniques

Paint Spray Aquatint Spray enamel or lacquer performs well as an aquatint ground. Each dot of paint sprayed on the plate becomes an acid resist, so that the acid bites only *around* the adhered particles. Varied biting is possible by alternately spraying and etching a number of times. With controlled biting times, this method can yield very subtle aquatints. Graduated biting is much easier to accomplish with the spray method than with other techniques.

Flower-of-Sulphur Aquatint Olive oil and sulphur powder serve as the ground in the flower-of-sulphur technique. Olive oil is first brushed onto the plate in areas where aquatinting is desired. The sulphur powder is then sprinkled into the oil and allowed to sit for several hours or overnight. The sulphur has a mild oxidizing effect on the metal, pitting it slightly and producing subtle tones. These tones are very fragile, however, and may not last more than a dozen or so impressions.

Spit-Biting In the spit-biting technique, the plate is first covered with a fine aquatint rosin ground and heated until the ground adheres. Next, a brush that has been wet with saliva is used to pick up pure acid and brush it onto the plate. The saliva breaks the surface tension, allowing the acid to go on freely without crawling on the surface. In place of saliva, a little ethylene glycol or Kodak Photo-Flo solution can be used with the acid. Acid mixed with gum arabic

can also be used. The strength of the resultant tones depends on the length of time the acid remains on the plate. As the brush moves the solution around the surface, a varied biting takes place. Thus, because the acid bites more in one place than another, the artist can achieve subtle, gradated, cloudlike effects (Fig. 242).

Concentrated nitric acid is preferred for this technique, since it bites faster than other acids, but it must be handled carefully. *At no time should the brush containing acid be touched to the mouth.* A relatively cheap brush is the best choice for this method, since the acid will slowly destroy the bristles. A soft brush with polyester bristles and an aluminum or plastic ferrule is considerably more durable.

Ferric Chloride Aquatint Damp ferric chloride crystals can be brushed on a copper plate directly or over an aquatint ground (Fig. 192). The plate can then be placed in sunlight for a few hours. Fisher's I-89 purified, anhydrous, sublime ferric chloride is preferable to lump ferric chloride.

Sandpaper Aquatint Another good way of obtaining aquatint tones is by means of sandpaper, garnet paper, or emery cloth. There are two basic methods. In the first, the sandpaper is laid face-down directly on the polished plate and then the plate is run through the press under considerable pressure. If desired, the sandpaper can be cut into shapes so that tone will be created in prescribed areas. Each granular part of the sandpaper pits the surface of the metal. The strength of the tone will depend upon the amount of pressure applied and the number of times the plate is run through the press. More subtle tones and finer results are achieved by running the plate and paper through several times, changing the position of the sandpaper each time.

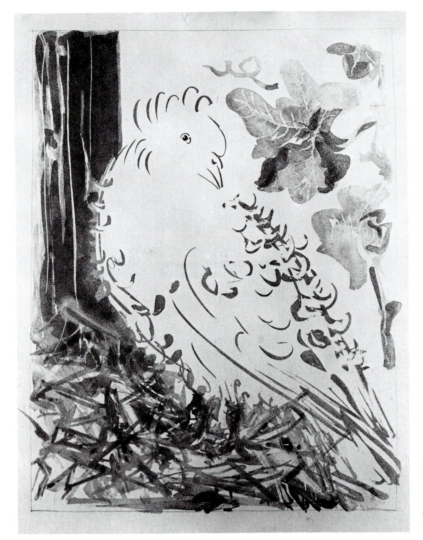

243. Pablo Picasso. *Le Pigeon.*
From *Histoire Naturelle* by Buffon
(Paris: Martin Fabriani, 1942).
Lift-ground aquatint, 12½ x 8½".
Grunwald Center for the Graphic Arts,
University of California, Los Angeles.

The second method employs a plate to which a thin layer of hard ground has been applied. In this version, the sandpaper is simply placed face-down on the grounded plate, and a light pressure is applied to the back. Pressure may come from a run through the press or simply from rubbing the back of the paper with a burnisher or spoon. Wherever the sandpaper breaks through the ground, the acid will attack the metal. Tone in this instance is controlled by the length of time the plate remains in the bath and the strength of the acid.

Sand-Blast Aquatint The sand-blast method also works well for creating areas of tone on a metallic plate. Rubber cement painted on the surface acts as a stop-out in those areas of the plate where no tone is desired. Either sand or carborundum is then blasted onto the surface with a sandblaster or an air brush equipped with a basting tip. The abrasive particles bounce off the rubber cement but produce tone in the open areas of the plate.

Lift-Ground Aquatint

Lift-ground aquatint, also known as *sugar-lift*, is a reversal of the usual aquatint process. In the normal procedure, the whites are varnished out and the artist works from light to dark. In lift-ground, however, the line or area created by the pen or brush stroke is the part of the plate that will eventually print. The drawing is done with a water-soluble sugar solution, and the plate is covered with liquid hard ground. When the plate is submerged in water, the sugar solution dissolves and lifts the ground, exposing the image area. The plate is then aquatinted before printing. The great advantage of lift-ground is that it allows the freedom and spontaneity of pen and brush drawing to be recorded faithfully on the plate (Fig. 243). Most artists use lift-ground in combination with normal aquatint methods.

There are a number of sugar-lift formulas. One of the most common is a simple mixture of one part sugar to one part India ink, with a small amount of

below: 244. As the lift ground dissolves, it exposes the image areas of the plate.

bottom: 245. A safe and practical area for working with acids should be equipped with a vented hood to draw dangerous fumes outside.

soap or ethylene glycol as a wetting agent to break the surface tension and allow better adhesion to the plate. The sugar can be pulverized in a mortar and pestle to make it dissolve faster, or honey can be substituted. If the mixture proves too thick, it can be diluted with a little water to brushing consistency. Another formula is made from one part gum arabic solution, one part black tempera color, and a small amount of soap.

Once the solution has been penned or brushed onto the plate, it should be allowed to dry for about fifteen minutes or longer, depending on the thickness of the coating. When it feels sticky to the touch, it is ready for the next step—applying a liquid hard ground (see p. 137). The liquid hard ground should be as thin as possible, yet still heavy enough to protect the plate where it comes in contact with the acid. If the ground is too heavily applied, it will not lift in the water. It is better to apply the ground thinly at first and touch up the plate later to prevent false biting.

When the ground has dried, let the plate sit in a tray of warm water for at least $\frac{1}{2}$ hour, or until the lift-ground begins to dissolve and expose parts of the plate (Fig. 244). This action can be helped along by gentle rubbing with some soft cotton wool in the image areas. Once all of the positive image has lifted completely, dry the plate and dust rosin on the surface for the aquatint. (Asphaltum powder should not be used, since the high temperature needed to melt it would destroy the hard ground.) For fine aquatints, adhere the rosin to the plate before applying the lift ground and hard ground.

Working with Acids

In every print workshop a special area should be set aside where acids are stored and the actual biting of the plates occurs (Fig. 245). Some general precautions

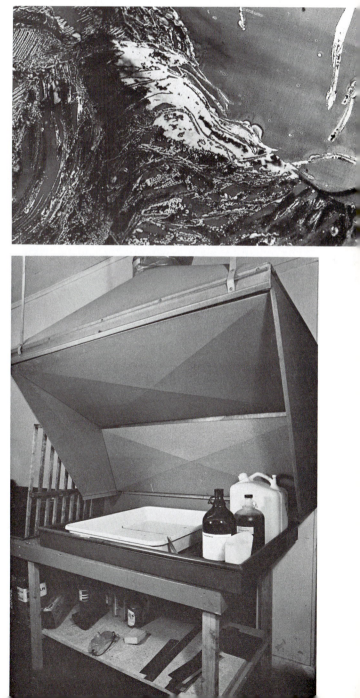

must always be observed when working with acids. Everyone who works in the general vicinity of the acids should be informed about how to handle them.

All acids should be stored in locked cabinets on a low, easy-to-reach shelf—that is, never above waist level. Use acid-resistant plastic or glass containers, carefully labeled with the date, type of acid, degree of dilution, and kind of metal for which they are intended. Fumes from most acids are dangerous and should always be avoided. Acids should be used only in a well-ventilated area, preferably close to or under a vented hood that draws the fumes outside. Running water should be on hand. If any acid is spilled on the clothes or the skin, flush *immediately* with water, then cover with baking soda or ammonia water to neutralize the remaining acid. When mixing acid and water, always *pour the acid into the water*, never the reverse. Pouring water into acid generates considerable heat that could burst the container. Although the hands can safely come in contact with weak acid solutions for brief periods, it is better to wear polyurethane gloves when working with any acid. If you form the habit of working with bare hands, it may be easy to forget to protect yourself from stronger solutions.

The basic strength of any acid can be varied according to the results desired. A line bitten slowly in a weak acid will be much sharper than one bitten for a short time in strong acid. For this reason, a weaker acid is preferred for finely detailed etching and aquatints, since it bites more cleanly and has less of a lifting action on the ground. A stronger acid produces a faster, deeper bite suitable for heavily textured areas and coarsely drawn work.

An acid bath can be used several times for the same type of metal, but separate baths must be made for each metal. If, for example, a solution that has been used previously for copper is mistakenly applied to zinc, an electrolytic action will take place in the acid that causes the etching ground to be lifted from the plate. Careful labeling will eliminate such accidents. However, color can also serve as a clue to the type of metal that was submerged in the acid. For example, nitric acid turns a brilliant blue-green after etching copper or brass, and a cloudy gray after etching zinc. The Dutch mordant used with copper turns a bright green. (For chemical formulas, see Appendix C on the chemistry of etching.)

The mordants most commonly used for etching copper, zinc, steel, and other metal plates are nitric acid, ferric chloride, and the Dutch mordant.

The Dutch Mordant One of the classic baths for etching copper is the Dutch mordant, a mixture of water, hydrochloric acid, and potassium chlorate first used in the mid-19th century. It creates a sharply defined line that etches almost straight down, with a minimum of lateral cutting. The Dutch mordant is accurate, predictable, and slow-working, offering good control over the depth of bite. It is well-suited for aquatinting because it produces an infinite range of tonalities without breaking down the ground or aquatint particles. The usual formula for this acid bath is:

water	880 grams (45 ounces, or 88 parts)
hydrochloric acid	100 grams (5 ounces, or 10 parts)
potassium chlorate	20 grams (1 ounce, or 2 parts)

The potassium chlorate can be mixed with some water until the crystals dissolve. This solution should then be poured into the hydrochloric acid and water. The solution should be mixed only in a well-ventilated place or under an exhaust hood. After mixing, it must be allowed to stand outdoors or under a ventilating hood for five to ten minutes before being

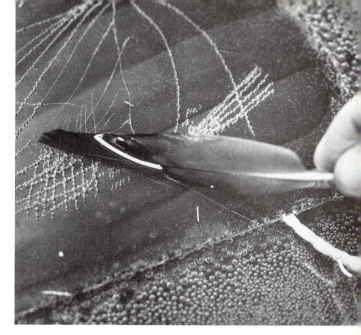

246. Bubbles created by the action of nitric acid can be swept away gently with a feather.

stored, in order to allow for the escape of the chlorine gas that forms.

For a stronger solution, the quantities of hydrochloric acid and potassium chlorate can be doubled, while holding the water constant. Additional small amounts of hydrochloric acid will bolster the strength of a solution that has etched several plates. When the acid turns a very dark green and a considerable amount of sediment becomes apparent, it is time to discard the solution and prepare another.

Ferric Chloride (Iron Perchloride) An excellent salt bath when used with copper, ferric chloride (or iron perchloride) gives a clean, sharp bite similar to that produced by the Dutch mordant. It is safe to use, because it is not very strong, produces no fumes, and has no serious effect on the skin. Nevertheless, cleanliness is important. The solution, even in small amounts, should *never* be ingested, for it could lead to a serious imbalance in the body's metabolism.

The main disadvantage of ferric chloride is that it tends to form deposits of iron oxide in the etched lines, slowing down the etching process and making it difficult to judge the depth of the bite by appearance alone. Plates are therefore most often etched in this salt upside-down on wax balls, cork, or pieces of wood, to allow the iron oxide to fall to the bottom of the bath. Ideally, the plate should be raised at least $\frac{1}{4}$ inch—and preferably more—from the tray bottom. If hydrochloric acid (10-percent solution) is added to ferric chloride, the plate can be etched face-up. The plate may occasionally have to be dipped into a 20-percent acetic acid bath to remove any residue. Ferric chloride can be purchased in a saturated liquid solution and either diluted with water or used full strength.

With ferric chloride, in some situations, the *density* of the solution may become important. A device

known as the Baumé hydrometer exists to measure specific gravity, and this can be found in many print workshops. As purchased in saturated form, the ferric chloride solution would measure about 45 degrees Baumé. Dilution with water reduces the density of the fluid.

Dry crystals are also available; these can be made into a saturated solution by diluting with $1\frac{1}{2}$ pints of water for each pound of crystals. This in turn can be diluted with an additional quart of water for the etching bath, to attain a reading of about 25 to 30 degrees Baumé. Purified, anhydrous, sublime ferric chloride, made by Fisher Chemicals, is easier to mix and use than lump ferric chloride.

Nitric Acid Nitric acid is a strong, colorless liquid that attacks metals and organic tissues with equally devastating effects. It is never used in pure form but always diluted with water. The fumes of this acid are also highly corrosive and should never be inhaled. Some etchers pour more nitric acid into the etching tray while the plate is being bitten in order to expedite the process; this should be done only with the utmost caution. Nitric acid releases a gas while etching metal, leaving tiny bubbles on the surface of the plate. The bubbles should be swept away gently with a feather without disturbing the etching ground (Fig. 246), since the bubbles would cause the acid to bite unevenly, thus distorting the image.

The line quality produced by nitric acid on zinc or copper is not as good as that produced by either the Dutch mordant or ferric chloride. Nitric acid also has more of a tendency to undercut the lines—that is, to etch not only downward but laterally as well. When this effect takes place on closely spaced lines—hatchings or cross-hatchings, for example—the metal surface between lines may actually be removed, an effect known as *crevé* (see p. 153).

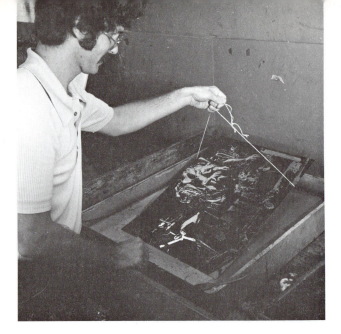

left: 247. The plate should be lowered
into the acid bath with a stick
or a piece of string, as shown here.

below: 248. A convenient method of etching,
in which the plate itself
becomes the bottom of the tray,
employs bordering wax to form the sides.
One corner is shaped to allow
the acid to be poured out later.

Etching the Plate

The most common practice in etching is to place the acid solution in a tray and then lower the plate slowly into the solution. For etching small plates, a number of inexpensive acid trays can be purchased or improvised. Any acid-resistant material will do—glass baking dishes, porcelain pans, plastic or stainless steel trays, or plastic photographic trays. Large plates present a problem, because oversize trays can be very expensive and difficult to find. Most etchers make their own large trays to save the great expense of having them custom-made.

Wooden trays covered with several coats of asphaltum paint, epoxy resin, or polyester resin will perform quite well if they are tightly made and well-sealed on all surfaces. An excellent temporary large tray can be improvised from a wooden frame clamped or nailed to a table top and draped with a heavy sheet of plastic, into which the acid is poured.

Excellent etching trays are made of fiberglass resin and cloth. The fiberglass is completely acid- and waterproof. Such trays cost only a fraction of custom polyurethane or nylon ones.

Before placing the plate into the acid bath, make sure that the edges and back of the plate are well-protected with stop-out to prevent them from being bitten. If the plate has an acid-resistant coating, the back will not need to be covered. Make a note of the time. Pour the acid solution into the tray carefully, and lower the plate slowly without splashing the acid. Lower first one side of the plate, then the other, using either a string or a stick of wood (Fig. 247). If you use a piece of string, it should be made of polyester or some other acid-resistant material, and the ends should be left dangling over the sides of the tray. This enables you to lift the plate out of the acid easily. When using a wooden stick to lower the plate, it is a

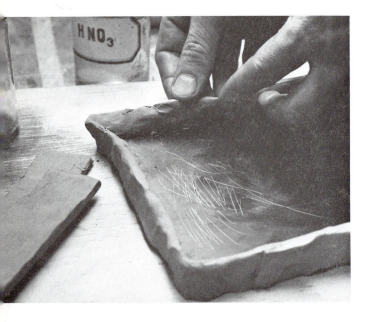

Nitric acid reacts much more slowly on copper than on zinc. For this reason, the concentration of acid to water must be greater for copper.

Various types of work will demand different strengths of nitric acid. The following table suggests some proportions of acid and water for strong biting, average biting, and slow biting.

Nitric Acid Baths

Metal		Strong Solution	Average Solution	Weak Solution
copper	nitric acid	1 part	1 part	1 part
	water	2 parts	3 parts	5 parts
zinc	nitric acid	1 part	1 part	1 part
	water	4–5 parts	10 parts	15–20 parts
soft steel	nitric acid	1 part	1 part	1 part
	water	3 parts	6 parts	8–10 parts

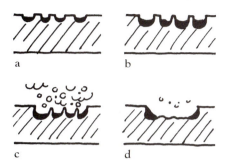

249. *Crevé* develops when etched lines are too close together or when the acid is too strong.

a b

c d

good idea to put something under it, such as some small wax balls. These keep the plate off the bottom of the tray so that you can slip the stick under one side of the plate to lift it out.

A method of etching without using trays has been in existence for centuries. This utilizes a soft, pliable wax called *bordering wax* to make a sealed wall around the plate so that the acid can be poured inside. Warmed beeswax also works well. The plate itself, set on a flat table top, becomes the bottom of the tray, since the wax adheres to the edge and is built up all around. The wax should be from 1 to 2 inches high, with a lip made at the corner of the plate to facilitate pouring the acid afterwards (Fig. 248).

Acids react faster when warm than when cold, and they weaken after repeated use. Because of these characteristics, a certain lack of control over etching results is unavoidable. It is necessary to judge the depth of the etching as it progresses, either by washing the plate off and inspecting it with a magnifying glass, or by probing the grooves gently with a fine metal point. A visual examination of the washed plate will be the most reliable indicator for fine work.

After the first bite, check the back and sides of the plate again to see if any scratches have caused unwanted etching. Apply stop-out over any spots if necessary. Sometimes the acid-resistant coating is thinly applied, and with rough handling or reworking the back may become scratched. To eliminate continual stopping out, cut a piece of plastic adhesive paper (such as Contact paper) to the size of the plate and fix it to the back. To make sure it adheres well on the surface, run the plate through the press once or twice. This will give good protection in the acid.

Crevé *Crevé* is a hazard in etching closely drawn linear work or cross-hatching, as well as in aquatinting. While the acid bites into the drawn area, it may

undercut just enough to etch out the delicate interstices of the lines or dots, leaving a flat, etched space. This problem is caused most often by the lines being drawn too close together or the acid being too strong or ebullient. Where *crevé* has occurred, the area would be cleaned of ink during the printing operation along with the surface of the plate and thus would not print. A little ink will remain on the side of the area, causing the typical dark edges of the *crevé* to show (Fig. 249). To correct the *crevé* the space must be made to hold ink, either by engraving any lines or dots left in the area or by regrounding the plate and etching additional lines farther apart.

Corrections and Alterations on the Plate

A plate is rarely made that does not need to be corrected or altered in some way. The techniques used are practically the same as those for salvaging an old pitted or used plate. Very fine shallow lines—whether bitten by acid, engraved, or made with the drypoint tool—can be removed easily by burnishing with a drop or two of machine oil. The pressure from the burnisher will close up the lines. To remove more deeply etched or engraved lines, it is necessary first to shave down the metal gradually with the scraper, then finish with the burnisher and a little oil. Once scraping and burnishing have been completed, the plate can be smoothed out still further, first with snakestone and water, then with charcoal and oil. Finally, it can be polished with crocus paper, jeweler's rouge or Putz Pomade.

If the correction of a spot or area on the plate has left a depression that would affect the printing, the *repoussage* technique mentioned on page 128 should be used to hammer it out.

When the plate has been etched or engraved to your satisfaction, the image is ready to print.

Intaglio
Printing
Techniques

Familiarity with the kinds and qualities of etching inks, the methods for inking and wiping the plate, and the quality of the paper on which the plate is printed are all prerequisites for exploring the potential of the intaglio medium. The novice seldom realizes to what extent variations in the printing technique and ink formulation can affect the appearance of the print. Even the simplest image can be greatly enhanced by a good choice of paper and careful printing. Ignorance of these details can mean the failure of the final work. Experiment with several types of ink and different methods of wiping the plate. No doubt, most plates will require considerable reworking before they reach a state of completion, and *state proofs* can be made after each change on the plate. There is no accurate way of judging the final image, however, until it is printed on good paper.

Few students can afford to have their work printed professionally, but a visit to a professional workshop—if it can be arranged—will provide valuable insights into working conditions and practices.

Paper

The nature of the paper is an important element of the finished print. The paper must be of a quality that will allow it to be dampened for printing without falling apart, and it must pick up the finest detail on the plate. Rag papers—either handmade or mold-made—are traditional for intaglio printing. They have longer fibers than the cheaper wood-pulp papers, as well as low sizing content. Good-quality paper is made of recycled or new cotton fibers. Most of the cotton for these papers is supplied by cotton mills in the form of pure cotton fiber or the end cuttings of cotton fabric. (Although still in use, the term "rag paper" has become inaccurate, since the supply of used cotton rags has all but disappeared.)

Many excellent European and American papers are available. The following list offers a brief general guide to fine-quality rag papers.

- ☐ American Etching
- ☐ Arches—text or cover stock
- ☐ Copper Plate Deluxe
- ☐ German Etching
- ☐ Italia
- ☐ Lenox 100
- ☐ Murillo
- ☐ Rives—Lightweight, Heavyweight, BFK (cover)
- ☐ Strathmore Etching
- ☐ J. Barcham Green

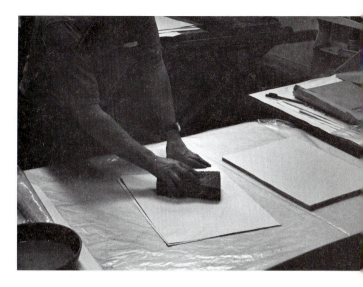

above: 250. Dampening sheets
of printing paper with a sponge.

below: 251. Paper can also be dampened
by being immersed in a large tub or vat.

A more detailed description of these papers will be found in the chapter on papers (Chap. 10, p. 371), including their characteristic colors and textures and available sizes.

Many commercial papers, including drawing papers and cover stocks, can be used for proofing. Some excellent ones that are readily available include Alexandra, Beckett cover, Hammermill cover, and Tweedweave cover.

Dampening the Paper

For all intaglio work the paper must be dampened to soften the fibers and allow it to be pressed into the grooves of the plate to pick up ink. Some papers can be dampened and printed almost immediately; others—such as heavy watercolor papers—need to be soaked for several hours. Paper can be dampened either by sponging or by dipping. The choice will depend on how many sheets are to be dampened and how readily the particular paper accepts water.

When dampening paper with a sponge, wipe each side of the sheet and place the sheets in an even pile (Fig. 250). Some papers need only be sponged on one side. A heavy-weight paper will need considerably more water than a thinner one. Wrap the stack in plastic, and put a flat piece of plywood or other flat surface over it with a weight on top. Take care not to crease or fold the plastic heavily on the top or bottom of the pile, for this will crease the paper. The weight on top of the pile helps the paper distend evenly and equalizes the amount of water in the stack.

Another excellent way of dampening the paper, particularly when many sheets are needed, is to soak it in water. Fill a large tray with clean water. (A sink or even a bathtub can be used if necessary.) Place about twenty sheets of the paper in the water, one at a time, pushing them underneath to ensure that they

are entirely covered (Fig. 251). This should take only about a minute. Gather the sheets together and lift them out all at once, grasping them by one corner. Hold them above the basin and let all the excess water drip out. Put them aside on a sheet of plastic and

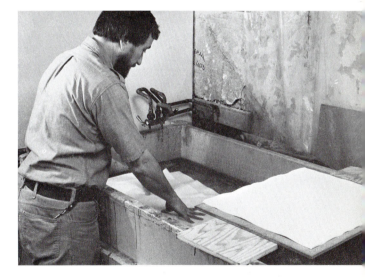

repeat the process with additional sheets. The amount of water in the paper is controlled by the length of time the paper remains in the tray, as well as by the water temperature. If the water is cold, less of it will be absorbed, if the paper is removed promptly. Warm water is absorbed much faster.

Some waterleaf papers—such as German Etching, Dutch Copper Plate, Crisbrook and others—absorb

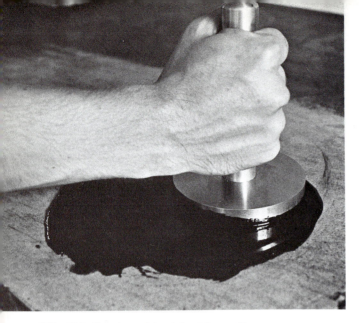

252. Grinding the etching ink with a muller.

water like a blotter, because they contain no sizing. They cannot be dampened by dipping or by sponging. Water must be sprayed or dabbed on every second or third sheet of this kind of paper. A weight placed on top of the pile of sheets will equalize the amount of water that seeps through.

If the paper has too much moisture when it is time to print, its surface will glisten with water. Blotters can help to absorb the excess moisture. Paper in perfect condition for printing is soft and extremely pliable, with a mat surface.

When printing large editions, it is best to dampen the paper the night before, so that the moisture will be distributed evenly throughout the fibers and yield more consistent results. Some heavy watercolor papers need to be soaked for many hours to soften the heavy gelatin sizing.

Prepare only enough paper for two or three days' work. If the paper is left dampened for too long a time, mildew can begin to grow, causing irreparable stains in the paper. A few drops of formaldehyde in the water will help to deter the growth of mildew. Carbolic acid, sometimes used for this purpose, changes the neutral acid content of most papers and causes yellowing, so it should be avoided.

Intaglio Inks

A good ink for intaglio printing will be short and buttery in consistency, heavily pigmented for richness and permanency, and neither too coarsely nor too finely ground. It will lift easily from the surface of the plate. There are two main ingredients in an etching ink: the ground *pigment*, which is the coloring matter, and the *vehicle*, which is usually burnt plate oil. If the ground pigment is too fine, the ink will be stringy and difficult to wipe from the plate; if it is too coarsely ground, the ink will have an abrasive effect

on the metal, hastening its wear. This abrasive effect is more pronounced with earth color pigments, such as sienas, umbers, and ochres. Burnt plate oil is made by heating and igniting basic raw linseed oil. The lighter and more volatile oils are burned off. The longer it is burnt, the more viscous the oil becomes.

Excellent inks are manufactured by the F. Weber Company, Graphic Chemical and Ink Company, Standard Color and Ink Company, and the Cronite Company in the United States; by Charbonnel and Lorilleux-Le Franc in France; and by L. Cornelissen & Son and T. N. Lawrence & Son in England.

Grinding your own ink is not difficult, but it does take some time. When large amounts of ink are to be used, hand-grinding can be less expensive than buying ink. Once ground, the ink will keep indefinitely; in fact, it improves with age.

The procedure for making ink is as follows. With a spatula, mix a small amount of pigment with some light burnt plate oil or raw linseed oil until it becomes a heavy paste. Grind a little of this mixture at a time by placing the ink on a glass slab and grinding it back and forth with a *muller*, or pigment-grinding tool, until it becomes very smooth in consistency (Fig. 252). The grinding breaks down the pigment, allowing each particle to be surrounded by vehicle. Although some machine-ground inks may be overly ground, it is impossible to overgrind the pigment by hand. The second grinding calls for the addition of some heavy plate oil. The final product should have a stiff, almost jellylike consistency that can be thinned later for specific printing jobs if necessary. Pigments for black ink include lampblack, ivory black, Frankfort black, and vine black. These and other pigments can be purchased in powder form from printmaking suppliers and many art-supply stores.

Whether ground by hand or purchased, an ink may need the addition of some oil to bring it to a

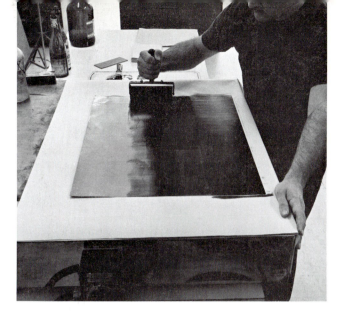

253. The plate used for Figure 259 is inked with a roller.

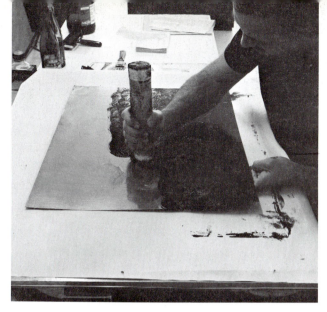

254. The same plate being inked with a rolled felt dabber.

better consistency for printing. Raw linseed oil alone slows down the drying of the ink, however, and could produce oil rings around the image as oil seeps from the ink into the paper after printing. The addition of a quantity of medium or heavy plate oil, boiled linseed oil, or Easy-Wipe compound will not only help to prevent this problem but also thin a too-thick ink. Because etching inks dry quickly, their containers must always be closed tightly. To prevent a "skin" from forming over the ink, cover it with a disc of paper inside the can.

For most printing situations, the plate and inks will perform best if kept at room temperature. However, it should be remembered that etching inks react differently at different temperatures. If the plate is warmed over a hot plate while being inked, the ink will soften slightly, making it easier to wipe. More of a plate tone will print when the plate is warm than when it is cold. In no event should the heat be more than the hand can stand, since too much heat will begin to dry the ink while it is still on the plate and cause incomplete and irregular printing.

Inking the Plate

The ink is applied to the plate with a roller, a dabber, or a card made from mat board or similar material. The procedure for making a dabber is described on page 137. The object is to cover the entire plate surface and push the ink into all the lines and crevices of the plate (Figs. 253, 254). On most intaglio plates—except deeply bitten ones—a roller will accomplish this most efficiently. Avoid excess rubbing and pressure. If the ink is too stiff, greater effort will be necessary, as will more wiping to remove the excess. This becomes a problem especially with drypoint, where the burr could be damaged by pressure. A slightly softer ink will lessen the abrasion on the plate.

Wiping the Plate

It is a good idea to have three or four pads of tarlatan ready. Most tarlatan is stiff and must first be washed and wrung out to remove most of the starch, then dried. Cut pieces about a yard square, then fold and crumple them into pads that can be held conveniently in the hand. A stiffer tarlatan is often preferred for the first wiping in order to remove more of the heavy ink. Use small circular motions, and, as the pad becomes heavy with ink, turn it inside out to expose clean parts of the fabric while wiping (Fig. 255). Next, wipe with a medium soft tarlatan. For the final wiping, use a clean, soft tarlatan and work lightly over the surface. After a day's work, the tarlatans should be unfolded and draped over a line so that the ink can dry. As they become covered with ink, the softer pads will harden and can then be used for the first wiping.

255. The plate is wiped
with a tarlatan pad.

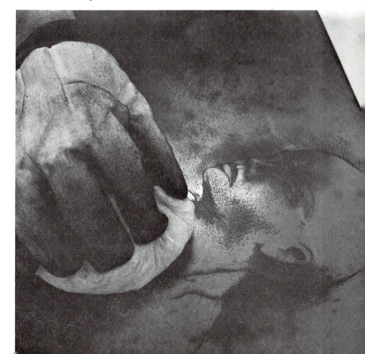

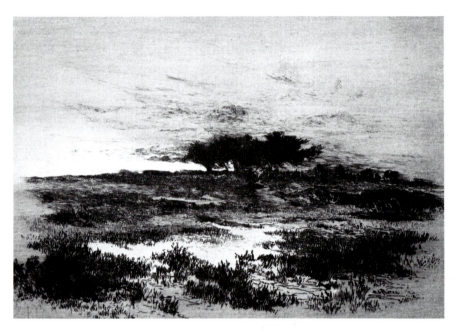

left: 256. E. Perrce. *Untitled*,
detail. Etching, late 19th century.
Collection Deli Sacilotto.
The plate tone was wiped off
in the foreground to provide highlights.

below left: 257. The plate for Figure
259 is wiped again with the palm.

below: 258. A final, optional wiping
of the inked plate with paper.

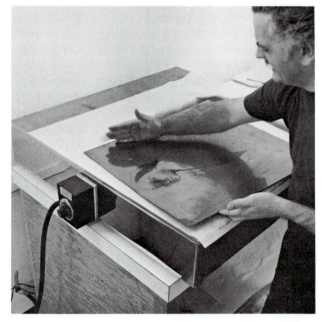

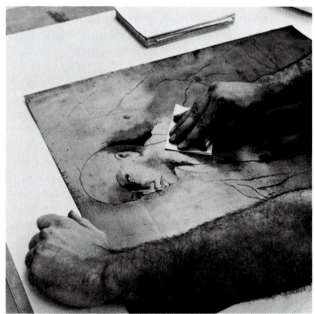

259. Jim Dine. *A Nurse.*
From *Eight Sheets
from an Undefined Novel.*
1976. Etching, 20 x 24".
Courtesy Pyramid Arts Ltd., Tampa, Fla.

Rag Wiping When a soft tarlatan cloth is used to wipe the plate lightly in the final stage just before printing, the technique is called *rag wiping.* This process leaves an overall tone on the plate, the relative darkness of which is determined by the kind and amount of ink, the polish of the plate, and the amount of wiping. *Plate tone,* a slight film of ink left on the plate after wiping, can also be accentuated by warming the plate while wiping it (Fig. 256). Drypoints are usually rag wiped rather than hand wiped. This helps to preserve the burr, as well as to retain more ink in the burr and create tonal transitions. Whistler, who preferred to print his own plates, often left considerable plate tone which varied a great deal from print to print.

Hand Wiping A final wiping of the plate can be done *a palma*—with the palm of the hand. This removes plate tone and allows the lines to be defined

sharply against the paper. Pressure should be light, and the plate wiped in quick, even strokes (Fig. 257). A buildup of ink may occur as ink is picked up on the hand. To avoid this, put a little whiting on your apron and rub your palm into it every now and then. The whiting will stick to the ink on your hand and allow additional ink to be removed from the surface. You must take care, however, not to get excess or loose powder on the hand or let any drop on the plate, where it could clog up lines and prevent them from printing.

Printers often use an alternate method of cleaning the plate with pieces of paper wiped across the surface (Fig. 258). Newsprint or pages from an old telephone book are ideal for this purpose. The paper can be wrapped around a blackboard eraser for easier use. Wiping in this manner lends a certain starkness to a one-color print (Fig. 259), and if not carefully done will remove ink from light lines. The experienced

printer, however, can get the plate as clean with the palm of the hand as with paper. Use whichever method you find easier.

Retroussage gives a soft quality like that of drypoint to etching or aquatint work. A soft cheesecloth is worked lightly across the plate or a section of the plate. The cloth drags slightly into the ink in the etched lines and deposits a little ink on the surface adjacent to the lines (Fig. 260). The *retroussage* effect is achieved on cross-hatched lines by substituting a fingertip for the cloth. By dabbing lightly with the finger in a cross-hatched area, one picks up a little ink from the lines and deposits it on the plate surface to produce a deeper tone. When done carefully, this technique can yield a consistent effect for an entire edition of prints.

The Basic Etching Press

The etching press is essential to the intaglio process. The press is mechanically simple (Fig. 261). It has two main rollers placed one above the other, with a flat metal or composition bed that travels between the rollers.

The bed is maneuvered to one end of the press and the inked plate laid face-up on it. Next, the dampened paper is set on the plate with several layers of felt blankets on top, then run through the press. The top roller compresses the felts, which in turn force the paper into the grooves on the plate. Extra moisture from the paper is absorbed by the felt blankets, creating a slight sucking action that helps to draw the ink from the etched or engraved lines. The

260. Anonymous 19th-century artist. Etching with use of *retroussage* technique, detail. Collection Deli Sacilotto.

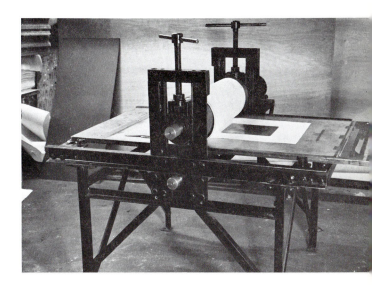

261. A custom-designed basic etching press.

press should be heavily constructed to withstand the pressures needed for good printing.

The press bed should be covered with a sheet of 22- to 24-gauge galvanized metal or ⅛-inch transparent Lexan. Lexan can serve a variety of functions, making it preferable to a metal sheet. For example, it can be scored on the underside with a grid pattern that will help in plate and paper placement; it will absorb pressure from a small plate and prevent warping of the bed; and it will keep the moisture of the printing paper from rusting the bed. A sheet of paper the same size as the printing paper can also be placed between the Lexan cover and the press bed to serve as a convenient registration device.

Blankets

The best felt blankets are made of good-quality wool, woven or pressed. Woven blankets are the most expensive but will last for years with careful use. They are made in several thicknesses and are usually preshrunk. Those most useful for the etcher are approximately ⅛ inch or ¼ inch thick. When soiled, woven blankets can be dry cleaned or washed by machine with soap and water. As they wear, the soft wool nap disappears from the surface, showing the woven understructure more clearly. Worn blankets should not be placed in direct contact with the printing paper, because the weave texture may show up in the print.

Nonwoven or pressed felt blankets are available in a great number of thicknesses and densities. These blankets are the smoothest and should be placed in direct contact with the printing paper. If they are not preshrunk, however, moisture from the dampened paper will shrink the felt. When this happens, it is best to wet and shrink the entire blanket. These blankets can be dry cleaned or washed carefully by hand. Machine-washing will pull the wool fibers apart.

At least two blankets are used in printing, and sometimes as many as four. The number and thickness of the blankets needed will generally be determined by the plate. A lightly drawn line etching, for example, could be printed adequately with two thin blankets, while a deeply bitten plate would require more or thicker blankets. The heaviest woven blankets should be put on last, closest to the top roller, with the thinner, smoother blankets closer to the paper (Fig. 262). (The latter are often called *sizing catchers*.) A thin backing paper is sometimes placed between the blankets and the printing paper. This keeps the blankets clean when a thin, porous printing paper is being used. It also prevents offsetting of the ink from dirty blankets onto the back of the print. Backing paper can diminish the cushioning effect of the blankets, however, so professional workshops usually avoid the practice.

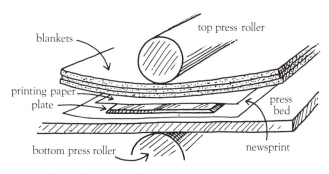

262. The usual arrangement of blankets and paper on the etching press bed.

In edition printing, moisture will build up in the blankets as it is squeezed from the paper. If allowed to go through all the blankets to the roller, it can cause rust to form. The bottom one or two blankets should therefore be changed after every twenty prints or so.

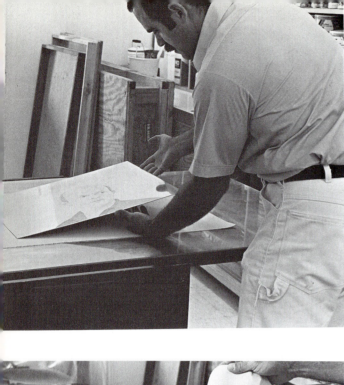

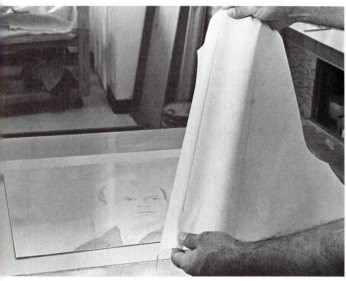

left: 263. Placing the uninked plate on the press, over a sheet of newsprint. The plate is the one used for Figure 226.

below left: 264. Checking the embossment.

Too much moisture in the blankets can also cause blurring of the image, more noticeable in fine etching or engraved linear work. Heavily sized paper will stiffen the blankets as the size builds up in the felt. As a result, the blankets will have to be washed more frequently in order to restore their softness.

Adjusting the Pressure

The amount of pressure is important and must be equal on both sides of the press. A sensitive touch is needed to adjust the pressure by hand. Pressure can be controlled by take-up screws on the sides. Some presses are equipped with micrometer adjustment dials, which are convenient but not essential. Final pressure is determined by the print quality and by judging the similarity of the embossment on all sides.

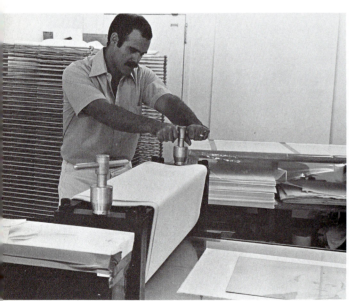

265. Adjusting the pressure.

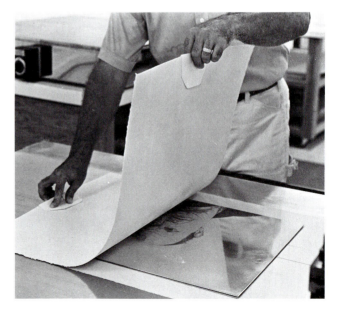

266. Paper tabs protect the damp printing paper.

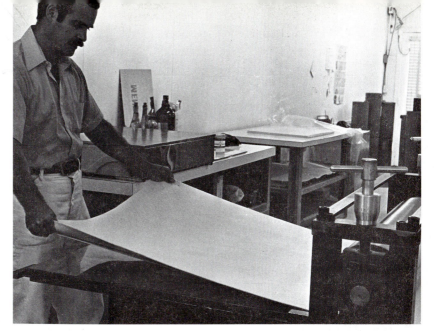

267. The blankets are stretched before printing to avoid creases and to ensure a smooth impression.

First, lower the upper roller until it touches the press bed firmly, with similar tension on both adjustment screws. Next, raise the roller about $\frac{1}{2}$ inch above the bed, making exactly the same number of turns on each side so that the roller remains parallel to the bed. Move the bed to one end of the press, and place one end of the felt blankets under the roller. Lower the roller equally on each side until you feel some resistance. The felts, which are now pressed under the roller at one end, can be lifted at the other end and draped, for the moment, over the top roller. Place a sheet of newsprint on the press bed and set the uninked plate on top (Fig. 263). Cover the plate with another sheet of newsprint, lower the felts over it, and run the plate through the press. Remove the top newsprint and check the embossment on it for evenness (Fig. 264). If the embossment is not even, pressure should be added to the side where the embossment is less defined (Fig. 265).

When you are using new blankets, the pressure will have to be increased slightly several times in the course of the run as the felt compresses.

Printing the Plate

After making sure that the edges of the plate have been wiped clean, lay the plate face-up on the press bed over a sheet of newsprint. Use some paper tabs to pick up the damp printing paper, and place it on the plate. Lower the felts onto the paper, and pull an impression (Figs. 266–268). A single run through the press is enough; running the same print through twice will cause the paper to shift slightly, often causing a blurred impression. If the plate has deeply bitten lines or areas, it will be more difficult to force the paper down into the lines to pick up ink. More pressure and/or an extra blanket will enhance the contact. It is best to print from both directions, since this

method will ensure equal stretch of the blankets and reduce the chances of the blankets creasing during printing.

Once it is printed, lift the paper slowly from the plate, holding the plate down at two corners if necessary. Use the paper tabs again so that no finger marks are made on the paper. Flip the paper over onto a blotter for examination. If all is well and no corrections are necessary, the procedures can be repeated for each subsequent print. The plate must be reinked and rewiped each time.

For printing a drypoint, pressure should be built up gradually until the image prints perfectly in all detail. This minimum setting should be held throughout the edition. Paper that is slightly dry, fibrous, or coarse will shorten the lifespan of the plate. If the plate has been steel-faced, you can exam-

268. Pulling an impression. (See Fig. 226).

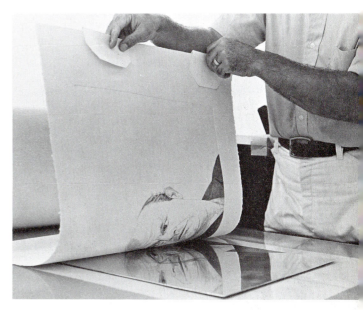

below: 269. Prints can be stacked between blotters and weighted or clamped while drying.

right: 270. Another method of drying prints is to place them in a rack to dry naturally.

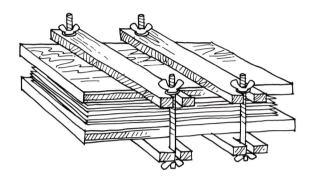

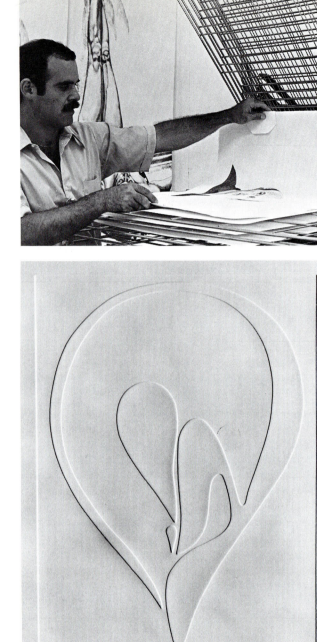

271. Jack Youngerman.
Inkless intaglio from *White Portfolio*.
1972. 36 x 27".
Courtesy Pace Editions, New York.

ine it from time to time with a magnifying glass to see if copper is beginning to show through on the ridges of the burr. In this event, the facing can be removed and the plate refaced (see Appendix B).

If a number of prints are made, place them face-up on blotters or in a rack for about fifteen or twenty minutes so that the ink has a chance to set. (Some inks may take longer.) Afterwards, the prints can be stacked with blotters between them and weighted or clamped (Fig. 269). Change the blotters every four hours or so until the prints are flattened and completely dry. This method requires a large supply of blotters, but it has the advantage of retaining the embossment of the image and plate mark while flattening the prints.

An excellent alternative method is to allow the prints to dry naturally for several days after printing. They can be either hung or racked (Fig. 270). Once the ink is thoroughly dry, the prints are redampened and placed between blotters to dry again and flatten.

The misguided practice of taping or stapling the dampened prints to a heavy board for drying removes the embossment from the plate and thus eliminates much of the tactile beauty inherent in the intaglio print. It also prevents the image from shrinking and sharpening slightly as it dries and spoils any deckled edges on the paper as the print is cut from the board. This destructive practice would be unheard of in any professional workshop.

Embossed Prints

Embossed prints—or *inkless intaglios*, as they are sometimes called—are simply prints in which a raised image is forced into the paper under pressure but, since no ink is used, the image is represented by the paper relief on the surface, rather than by contrasting tones and lines (Fig. 271). Whenever a deep relief is needed for such images, 1-inch or 2-inch-thick foam rubber blankets in addition to the regular felts will provide the extra compression needed. Inkless intaglios present a special problem in drying. Heavy pressure on the prints smooths out the embossed areas, so it is best to place each print between two or three blotters after it is pulled. The weight of the blotters alone will help keep the prints flat. To prevent the edges from drying sooner than the center of the sheet,

272. Henri Matisse.
Girl Before Aquarium.
1929. Etching, printed in black
on *chine collé* paper
laid on white wove, 5 x 7¹/₁₆".
Museum of Modern Art, New York.

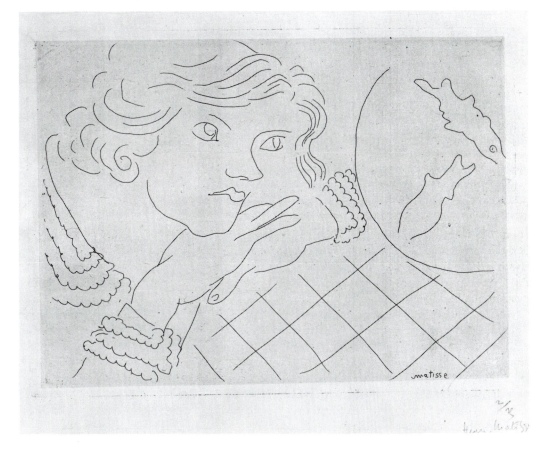

drape a piece of plastic over the prints and blotters. Change the blotters every few hours. As the prints dry, they will be able to withstand a little more pressure without losing the embossment. When they are almost dry, a light weight can be placed over the stack.

Very important to the embossed print is the choice of paper. As a rule, the heavier the paper the more embossment it will retain, and the more evenly it will lie in drying. A thin paper tears easily as it is stretched to accommodate the embossment. Both Arches Cover and Murillo will retain good medium-depth embossments. Hot-pressed and cold-pressed heavyweight watercolor papers, if properly dampened, will hold very deep embossments.

Chine Collé

In the traditional technique of *chine collé* a thin, sized Oriental paper is simultaneously printed upon and adhered to a heavier weight paper under pressure (Fig. 272). The process can be applied to both lithography and intaglio printing. As it was employed in the 1800s for quality book illustrations or individual works of art, *chine collé* was often done on the plate area, leaving the heavier paper showing in the margins. The technique is occasionally employed today for applying cut or torn shapes that become part of the image itself. Sized India paper, which could be dampened slightly and then used immediately, was

available at one time. It is now necessary to prepare your own paper for *chine collé*. This requires some effort, but it opens up enormous possibilities, with the wide assortment of imported and domestic papers available. Beautiful background tones are also possible with buff and other colored papers.

Several types of adhesive can be used. They must be stable and must not stain, yellow, or distort. Wheat paste and rice paste mixtures are excellent; so is potato starch. Cellulose glue, such as Metylan, has proved very effective when thinned and brushed onto the paper. It has a neutral pH factor (neither acidic nor alkaline)—an important consideration where permanency and stability are required.

There are two ways of applying the *chine collé*—when it is dry and when it is damp. The backing sheet must always be dampened, as in all intaglio printing. In the dry method, the *chine collé* paper is coated with the adhesive on one side, then hung up to dry. It is placed, adhesive side-up, on the inked plate, with the regular dampened paper arranged on top, and run through the press.

In the wet method, the *chine collé* paper is brushed quickly with the adhesive and placed onto the inked plate immediately; the print is made as before. This technique allows the *chine collé* paper to distend slightly before being run through the press. Since it is damp with the adhesive as it is put on the plate, it will dry at the same rate as the backing paper. It also allows the use of a slightly heavier paper than the dry method of *chine collé*.

Color Printing

A number of methods, both simple and elaborate, exist for making intaglio prints in color. Several colors can be applied to a single plate simultaneously, or to separate plates. Color intaglio printing may also be combined with lithography, screen printing, relief printing or direct stencils in a variety of ways.

Color Intaglio Inks

Color inks, made in the same manner as black ink, are available in tubes or cans from each of the ink manufacturers. French intaglio inks, called *encres taille-douce*, are also available. With certain printing methods, lithographic inks can be used. The cost of an individual color depends on the concentration and nature of the pigment used. A color containing a high percentage of cadmium pigment, for example, will be expensive, as would a similar color in oil paint. Color inks can also be made in the same manner as black ink by grinding the pigment and plate oil together by hand (see p. 156).

The wiping and inking characteristics will vary from color to color, some being stickier and more difficult to wipe than others. This is due to different rates of pigment absorption, reaction of the pigment to the plate oil, and the size of pigment particles.

Cut Plate Technique

The technique of cutting the plate into parts, inking the pieces separately, and printing them together as one unit can be used with all intaglio, relief, and collagraph plates. This method greatly simplifies the inking procedure and allows a clean separation of colors to be made from the same plate. Several procedures can be used to cut the metal plate. A hand jigsaw with a metal cutting blade is slow but effective. An electric scroll saw or band saw is a far more efficient way of cutting the metal, although it is noisy. To cut out shapes in the center of the plate, drill a small hole to accommodate the saw blade, put the blade through the hole, and cut. Cutting the plate will al-

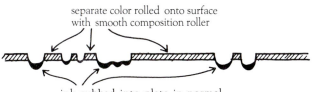

separate color rolled onto surface
with smooth composition roller

ink rubbed into plate in normal
intaglio fashion and surface wiped clean

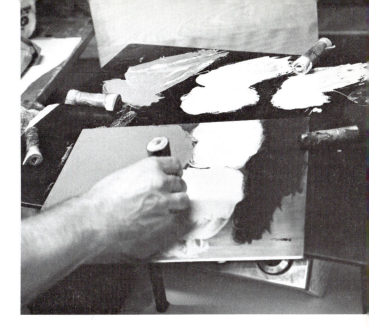

above: 273. In the surface rolling technique, one color is applied to the plate in the intaglio manner and another in the relief manner. The two colors are printed simultaneously.

right: 274. *A la poupée* dabbers are used to apply different color inks to the plate.

ways leave a slight space between the parts, which shows up as a thin white line on the print.

Surface Rolling Technique

Surface rolling is one of the simplest methods of obtaining a two-color intaglio print. In this method, the incised areas of the plate print in one color, the flat surface in another. The plate is first inked with one color and wiped. A clean wiping done either by hand or with paper will leave a better surface for the second color, which will therefore print more clearly. Then, with a roller large enough to cover the entire plate, a film of the second color is applied. This color rides on the surface, and does not penetrate the incised portions (Fig. 273). Lithographic inks are preferred for surface rolling, because they impart excellent luminosity and brilliance when inked thinly on the plate. If the lithographic inks are too thick, it may be necessary to soften them with a small amount of oil in order to prevent the paper from sticking to the tacky ink (see pp. 244–246).

Applying Various Colors to a Single Plate

One plate can be inked with several colors, instead of just one. This is done more easily if aquatint areas and linear areas are separate from one another. With a little skill the technique can be employed to blend one color into another. For each color, make separate small dabbers corresponding in size to the plate areas that are to be inked separately. Small rectangular pieces of felt or other soft cloth, tightly rolled and tied with some string, serve the purpose (Fig. 274). Because of the petite, doll-like appearance of the dabbers, this method is sometimes called *à la poupée*. (*Poupeé* is the French word for doll.) Separate pads of tarlatan are also needed for wiping each area. Each color is rubbed onto an area with the dabber, wiped with the tarlatan, and finally hand-wiped before another area is inked. The completed plate is then run through the press. To retard the drying of the colors, add some oil of cloves or lithographic ink retarder.

Multiple Plate Technique

In the multiple plate technique, a separate plate is made for each color. The plates must all be exactly the same size, with the colors registered in position. All the colors, beginning with the lightest, are printed one after another while the paper remains damp.

A key drawing is important for close registration with this method. Transfer the drawing to all the plates with carbon paper, taking care to position the image identically on each plate. Next, engrave or etch the particular color areas on the appropriate plates— such as yellow on one plate, blue on another, red on another. The tonality of each color must be considered, as must combinations of colors produced by overlapping. With just the three primary colors and black it is possible, theoretically, to achieve a complete range of colors.

Another excellent transfer procedure is as follows. Using one of the registration methods described below, pull a print of the key image, leaving the margin of the paper caught under the pressure of the roller. Register the next plate on the press, and make an offset image on the plate from the key plate impression. Carefully go over the ink lines on the plate with a drypoint needle, then remove the ink and degrease the plate. The plate is now ready for work, with the delicate drypoint lines serving as reference. Each of the other plates for the color image can be prepared in the same way.

A registration device for positioning the plate on the press bed can be made from three tabs built up on

below: 275. Tabs of masking tape
can serve as registration guides
on the press bed (a).
Another registration device
suitable for large and small plates alike
can be constructed from
two L-shaped pieces of metal (b).

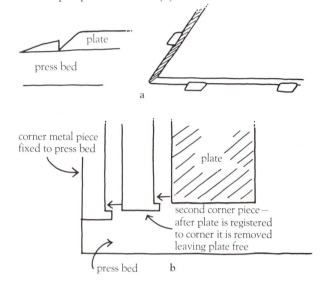

plate

press bed

a

corner metal piece
fixed to press bed

plate

second corner piece—
after plate is registered
to corner it is removed
leaving plate free

press bed b

above right: 276. The registration device shown in
Figure 275(b) is employed at Crown Point Press, Oakland,
California, to align two of the nine plates for Claes
Oldenburg's *Floating Three-Way Plug*
(see Pl. 18, p. 146).

right: 277. Two plates for the first
stage of the print are positioned.

below: 278. The partially completed work
is kept on the press with one edge under the roller,
but held out of the way so that new plates
can be positioned.

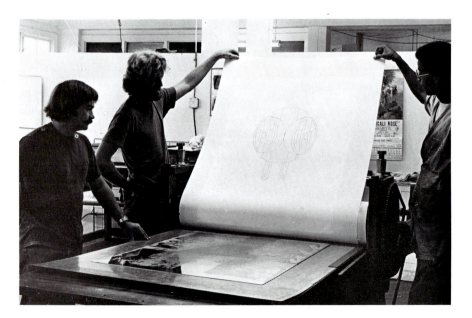

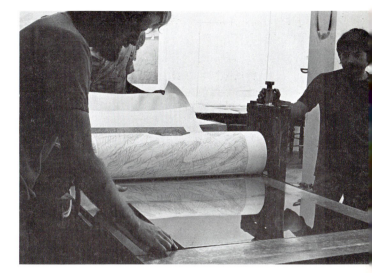

the bed with masking tape to catch two edges of the plate (Fig. 275). The tabs must be fairly low and tapered, in order not to emboss the paper. Another method uses a large aluminum or zinc lithographic plate as a base for the plates to be printed. Make three small cuts in the metal, raising it just enough to catch the corner of the plate and act as a registration guide.

A very fine registration device consists of an L-shaped plate permanently fixed to the metal or Lexan bed cover. This plate (approximately 6 inches on the long side by 1 inch by 18 gauge) should be placed along the edge of the bed cover, but far enough from the ends of the bed so that it can be used when printing from both directions. A second plate, varying in width and length according to the desired size and position of the printing plate, is fitted inside the angle of the first plate. When the printing plate has been positioned, the second plate is removed and the impression is made. A further aid in registration is the practice of catching the margin of the printing paper under the roller after each color is printed. Still another technique is to set a heavy weight—such as a bar of lead or iron wrapped with masking tape—on the margin near the edge of the paper to hold it in place while plates are being changed.

To print, run the plate with the lightest color ink through the press first. Register the next plate on the press bed, lower the paper onto it carefully, and run the second color through the press immediately. Repeat the procedure until the final color is printed (Figs. 276–280, Pl. 18, p. 146). If the printing is done with reasonable speed, the registration will be very accurate, even on fairly large plates, since the paper will not have a chance to dry and shrink. Remove the print and dry it in the usual way. The plates are then reinked in their respective colors for the next print. If some ink offsets back onto the plate during printing, the plates will have to be cleaned before reinking.

Some printers prefer to print and dry each color separately. The colors will then print on top of each other instead of mixing on the paper. The advantage of this method is that each color will print cleanly, without any offsetting of the previous color back onto the plate. It takes much longer, however, and the problem of redampening the paper so that it expands

above: 279. After another stage of printing has been completed, the paper is held back again without being removed from beneath the roller while another plate is positioned.

below: 280. Pulling a proof of the completed work. Several stages of printing involved the use of two plates at once.

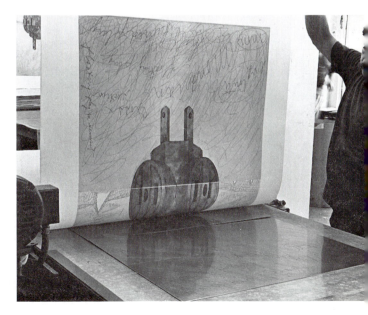

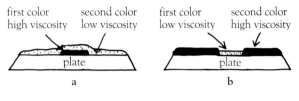

first color
high viscosity

second color
low viscosity

first color
low viscosity

second color
high viscosity

plate

plate

a

b

to the identical size each time is a major obstacle to close registration.

Multilevel Printing

A system by which several colors could be printed simultaneously was developed at Atelier 17 by Stanley William Hayter. Hayter's method depends on three conditions: the viscosity of the inks, the different levels in the surface of the plate, and the degree of hardness of the roller. The first step in the process is the making of the plate. The more defined the separation between levels on the plate, the clearer the separation of the colors will be. Collagraph plates (see p. 176) can also be used.

The first principle operating in this process is that the adhesion of one ink color rolled on over another can be controlled by varying the relative viscosities of the two inks. An ink with a high viscosity is stiff and heavy-bodied; one with a low viscosity is more liquid. If a spot of a highly viscous ink is placed on a plate and a roller with a less viscous ink is passed over it, the second color will adhere both to the plate surface and to the first color (Fig. 281). If the order is reversed, however, and a stiff ink of higher viscosity is rolled on over an ink of lower viscosity, the stiff ink will adhere only *around* the other color. The less viscous ink of the first color will be transferred back onto the roller.

Most purchased inks have a medium viscosity. To make an ink *more viscous,* add some heavy plate oil, magnesium carbonate, or aluminum stearate. To make it *less viscous,* mix it with a light plate oil or linseed oil. It is often necessary to increase the drying time of the ink when working with this method. This can be done by adding a small amount of castor oil, oil of cloves, or other nondrying oil. Test your results on a small quantity of ink first.

above: 281. Ink of low viscosity adheres to both the plate and a spot of another, more viscous ink (a), while an ink of high viscosity adheres only to the plate (b). The less viscous ink will be partially transferred back to the roller.

below: 282. A soft roller will contact the most deeply etched lines (a). A harder roller will touch only the more superficially etched areas (b).

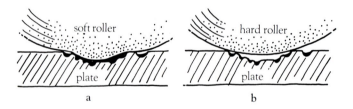

soft roller

hard roller

plate

plate

a

b

The second basic principle involves the combined effect of two elements: the plate, with differences in the elevation of its surface; and the rollers, which should be soft, medium, and hard. The rollers must be large enough to cover the entire plate surface in one pass. The hard roller will ink only the highest elevation of the plate surface, while the softer roller will reach farther down into the recesses of the plate (Fig. 282).

The first color is usually rubbed into the plate surface in the normal intaglio fashion; the plate is then wiped clean before the rollers are used. With carefully controlled conditions, each roller will contact one of three distinct levels on the plate. When color inks of different viscosities are applied on the same level of the plate, the number of possible variations can be increased greatly by the combination of two techniques. Consistent editions require patient and careful printing.

Photographic Techniques and Collagraph Processes

Photoetching

Recent improvements in the technique of photoetching have greatly advanced the use of this process in student workshops. These technical improvements have in turn increased the potential for sophistication in imagery.

When artists first began to incorporate photographic images into their work—whether in etching, lithography, or screen printing—it seemed enough simply to be able to reproduce a photograph or drawing with some degree of accuracy. Within the last decade, however, as the "language" of photographic techniques has become more familiar, the utilization of photographic images has changed from a simple reproductive process to a major means of expression.

In the photoetching technique, a light-sensitive metal plate is exposed to a piece of photographic film under ultraviolet light. The opaque areas of the film prevent exposure on corresponding areas of the plate, causing the photo resist on the plate to dissolve in the developing bath. These areas, bitten down after etching, will print the image in intaglio. Clear areas of the film, in turn, will allow the metal to be exposed to the light and the photo resist to become nonsoluble. These areas of the plate are acid-resistant after developing and will print in relief. For making relief prints, therefore, the transparency should be in negative form—that is, the background should be opaque and the image clear. For intaglio printing, the transparent film should be a positive.

The best films for creating images on metal plates are the high-contrast orthochromatic films, such as Kodalith, Dupont Ortho Litho, and Ansco Litho. Solutions needed for photoetching are:

- Kodak Photo Resist (KPR)
- Kodak Photo Resist Developer
- Kodak Photo Resist Dye (blue-purple)
- Kodak Photo Resist Thinner

All work with these chemicals should be done in very well-ventilated rooms; the fumes are highly toxic.

The other necessary equipment includes:

- spray applicator (push-button atomizer type)
- stainless-steel trays
- vacuum table
- exposure source (arc lamps, sunlamp, or photofloods)
- copper or zinc plate
- plate-cleaning solutions (ammonia and whiting)

Kodak Photo Resist (KPR) is one of the best light-sensitive resist coatings available. It readily adapts to both commercial and artistic applications. The resist is simple to apply to both copper and zinc plates, and the resultant coating has excellent chemical resistance, plus the ability to hold exact detail.

Plate Preparation

The surface of the metal plate must be scrupulously clean and free of grease or oil in order for the photo

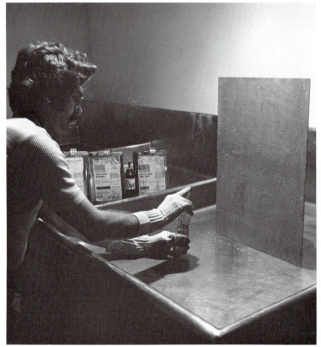

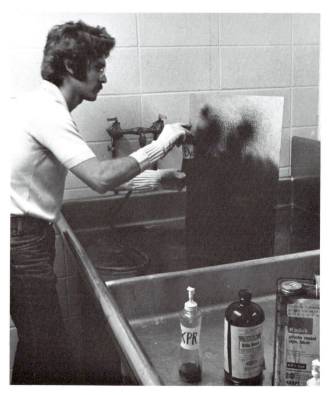

left: 283. Spraying Kodak Photo Resist over the plate in the darkroom. This plate is the title page of *Eight Sheets from an Undefined Novel* by Jim Dine.

below left: 284. Exposing the plate and the film to a carbon arc lamp.

below: 285. Spraying the exposed plate with Photo Resist Developer.

bottom: 286. Spraying Photo Resist Dye on the plate.

resist to adhere properly. Clean the plate with whiting and ammonia until water poured over the plate forms an unbroken film and does not bead. Then rinse and dry the plate, being careful not to scratch it.

The following operations should be carried out only under yellow-orange or red light darkroom conditions (a yellow bug light or a yellow fluorescent tube can be used):

1. Set the plate in a vertical position with the bottom resting in a stainless steel tray.
2. Pour or spray the Kodak Photo Resist solution (approximately one part resist to one part thinner) over the plate, beginning at the top and letting the excess flow into the tray (Fig. 283).

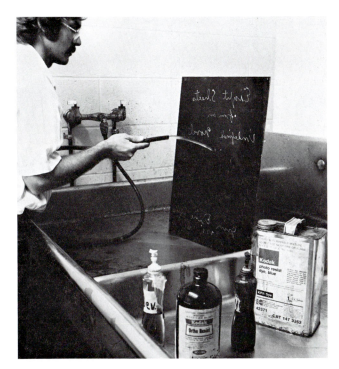

287. Rinsing the plate with water.

3. Let the plate dry flat for about 20 to 25 minutes. (Warming the plate at about 80°F for 10 or 15 minutes will improve the sensitivity of the coating, because it helps evaporate small amounts of residual solvent.)

4. Place the film transparency, emulsion side down, on the coated surface of the plate. A flat sheet of glass placed over the film or a vacuum frame will create a suction effect and ensure good contact and sharp results.

5. Expose the plate and film to a light source high in ultraviolet light, such as bright sunlight, a carbon-arc lamp, a sunlamp, or photofloods (Fig. 284). Whatever light source is used, make step exposures at first to determine the optimum exposure times for the available equipment. Photofloods, which have the least ultraviolet light, will require the longest exposure. With a single carbon arc lamp, the exposure time will be roughly between 2 and 5 minutes, depending upon output and distance. The plate must be exposed for longer periods if it has a heavy resist coating or a dull surface finish. A bright plate will reflect the light back through the resist, aiding in the polymerization of the resin.

6. Spray the exposed plate with some Photo Resist Developer, making sure the entire plate is covered (Fig. 285). Develop for ½ to 3 minutes. (Development longer than 2 minutes is almost never necessary; if the image is faulty, the defect will have been in the manner of coating or the exposure time.) The light can now be turned on. Wash the plate under cold running water.

7. Spray the plate with Photo Resist Dye to make the image visible (Fig. 286). Rinse off the excess dye with water, and dry the plate (Fig. 287). It is now ready for etching.

8. If a stronger bond of Photo Resist to plate is needed, heat the plate for 10 minutes at 250°F. (The disadvantage of this technique, however, is that it makes the resin more difficult to remove from the plate.)

As with any plate, make sure before printing that the edges are filed and smooth. The remaining coating can be left on during the proofing stage if desired, or it can be removed with lacquer thinner, Kodak Resist Stripper PR, trichloroethylene, or KPR Resist Thinner.

Photogravure

Most discussions of photogravure today revolve around the technique as it is currently practiced in commercial industry. In this application the photographic image is exposed on a sensitized copper plate through a special gravure *halftone screen*. The halftone screen breaks up solid areas of color into dots, making gray tones possible. The plate is finally etched and curled around a cylinder for rotogravure printing.

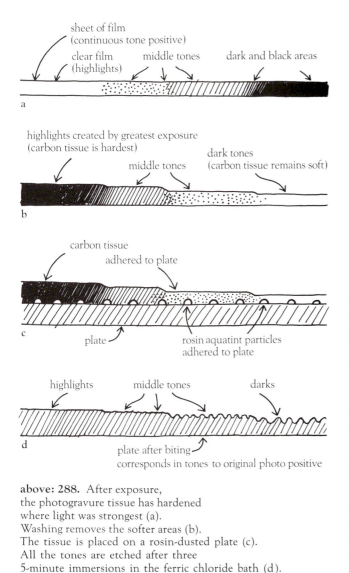

sheet of film
(continuous tone positive)

clear film
(highlights) middle tones dark and black areas

a

highlights created by greatest exposure
(carbon tissue is hardest)

middle tones

dark tones
(carbon tissue remains soft)

b

carbon tissue
adhered to plate

plate rosin aquatint particles
adhered to plate

c

highlights middle tones darks

plate after biting
corresponds in tones to original photo positive

d

above: 288. After exposure,
the photogravure tissue has hardened
where light was strongest (a).
Washing removes the softer areas (b).
The tissue is placed on a rosin-dusted plate (c).
All the tones are etched after three
5-minute immersions in the ferric chloride bath (d).

below: 289. A close-up of the plate
used for Figure 290.

Workshop versions of this process, like early methods of gravure printing, need not involve a half-tone screen. Instead, a fine rosin or asphaltum aquatint ground is dusted and heated onto the plate. Then, in a darkroom situation with yellow or red safelights, a gravure carbon tissue or film is sensitized by immersion in a 2 percent solution of potassium bichromate. After about 2 or 3 minutes in the solution, the carbon tissue is removed and placed face down on a sheet of glass, ferrotype plate, or heavy-weight smooth plastic. When the tissue is dry, it is peeled from the glass or plastic and placed in contact with a continuous-tone positive transparency. An ultraviolet light is used to radiate light through the continuous-tone positive onto the emulsion of the gravure tissue (Fig. 288). The exposure time may vary from a few minutes to more than 15 minutes, depending on the strength and distance of the light source.

After exposure, the plate is dampened slightly with water and the carbon tissue placed face down on

290. Edward S. Curtis.
Sioux Chiefs, detail.
1905. Photogravure
(entire image 11⅞ x 15¾″).

the plate. Rolling a brayer on the back of the tissue will remove air pockets and create firm adhesion. Next, the plate is immersed in a tray of warm water (about 110°F) until some carbon tissue begins to dissolve at the edges. The paper backing is removed and, with the plate still in the warm water, the surface is swabbed with soft cotton balls. The tissue corresponding to the black areas of the film will wash off completely; a more or less hardened film of emulsion will be left on the remainder, producing white and middle to dark tones. The plate is then allowed to dry and immersed in three ferric chloride baths—the first 42° Baumé, the second 36°, the third 30°. As the solution etches into the plate, the darkest areas will etch first and then gradually—as the solution breaks through the carbon tissue—the middle values will etch, working up to the highlights. At this point the plate must be watched carefully. It should be removed within seconds as the carbon tissue begins to break up in the highlight areas. The finished plate is printed by hand in the normal intaglio manner and can be touched up with the burnisher for highlights and with the roulette or rocker for deeper tones if necessary.

Photogravure is capable of immense fidelity to the tonal range of the original photograph or tonal positive. There is no halftone pattern of dots, and the aquatint ground is often invisible to the naked eye (Figs. 289, 290). This is one of the finest means of photoreproduction possible.

above: 291. In a combination of the collagraph and cut plate techniques, pieces of a Masonite plate are cut with a Cutawl machine.

left: 292. The pieces are coated with a thin layer of acrylic medium or with a mixture of acrylic medium and carborundum, which acts as a mock aquatint.

can be inked with intaglio inks in the same manner as an etching or engraving, then printed on an etching press with dampened paper. Collagraphs can also be printed as relief images. Because the various levels on the plate are so easily achieved, the multilevel printing technique mentioned above lends itself beautifully to making color collagraph prints.

The best glues to use for the collagraph are acrylic compounds, such as Aquatech, or Liquitex mediums. Acrylic modeling paste is also excellent as an adhesive, as well as for building up flat or textured surfaces. The advantage of acrylic adhesives is that they are waterproof when dry, enabling the dampened paper to come in contact with them without sticking.

Constructing the Collagraph Plate

With sandpaper or garnet paper, first bevel or cut the edges of the Masonite or mat board plate so that no sharp edges remain. The Cutawl is an excellent hand saw for cutting shapes, both large and small, into Masonite or Plexiglas plates. This electric tool moves a blade in a jigsaw motion at high speed with great flexibility (Fig. 291). With a No. 22 blade, interior shapes can be cut without having to start at the edge of the plate or drilling holes first. Cutting with the Cutawl can be done on a tabletop. A sheet of soft foam-core board or 1-inch styrofoam should be used under the plate, so as not to damage the table.

Coat the entire plate and cut pieces with a thin coat of acrylic medium (Fig. 292). Gloss medium

The Collagraph and the Metal Collage Print

Perhaps more than any other graphic process, the collagraph lends itself to producing an infinite range of textures, effects, and innovative technical approaches. Its popularity has come with the technological development of new materials such as acrylics, epoxy resins, polyesters, and a myriad of other plastics. While some artists look on the new materials as gimmicks, for others they represent endless new possibilities of freedom and flexibility.

The word collagraph is derived from the Greek *colla*, meaning "glue," and *graphos*, "to write." The process is a constructive one—objects are added to the surface of the plate—as opposed to the subtractive processes of most intaglio techniques. Pieces of cardboard, mat board, fibers, fabrics, string, and so on are glued onto a base plate of tempered Masonite or heavy cardboard, so that all the objects are in low relief on the surface. Once the glue is dry, the plate

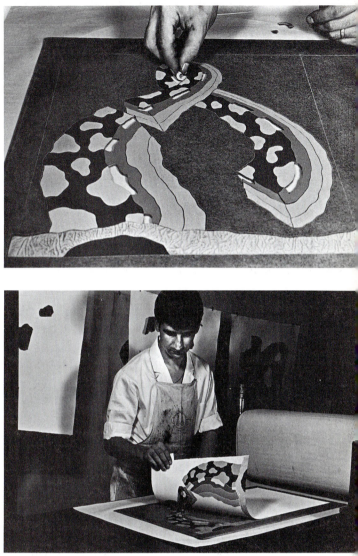

below: **293.** Textures can be introduced by gluing tissue paper to a piece of the plate with additional acrylic medium.

right: **294.** All the pieces of the collagraph plate are inked and fitted into the base plate. Note the textured piece in the foreground.

below right: **295.** A print of the collagraph being pulled.

is easier to wipe clean. This acts as a sealer and prevents warping. Brush the glue onto the surface, and arrange the pieces on it (Figs. 293–295). Once the glue has dried, another coat of the medium can be brushed over the surface. This will saturate any fabric on the plate, making it harder and more durable, allowing consistent editions of several hundred prints to be made. Elements can be added as many times as desired, although the final surface of the plate should not be more than $3/16$ to $1/4$ inch at its highest point.

Because Masonite and mat board are inexpensive compared to metal plates, a plate larger than the paper can be used, allowing the print to be made without plate marks. *Bleed prints*—in which the image area goes to the very edges of the paper—can also be achieved. Etching, engraving, and woodcut tools can cut into the dry surface of the plate for other effects.

Carborundum sprinkled onto still-wet surface areas of acrylic medium will provide an aquatint-like surface, adding considerable variations in tonal values. It can also be mixed with the acrylic medium first, and then brushed onto the plate. While still wet, the carborundum can be scraped or its shape altered by moving it about with a piece of cardboard. Different grades, from coarse (No. 80) to fine (No. 220) help to vary the effect. The carborundum should be covered with a thin coat of acrylic to ensure that the particles will not break loose in wiping or printing.

Applying the Ink

Because of the high relief and varied textures of the surface, it is necessary to ink the collagraph or metal relief differently from a regular intaglio plate. The ink is first rolled on the plate with a short-nap paint roller. Special handles for these rollers can be constructed easily; plastic cores are advantageous because they last longer and can be cut easily to different sizes. Rollers varying in width from 1 to 5 inches can be very helpful. For areas that are difficult to reach, use a blunt stencil brush. The plate must be checked carefully to make sure no areas have been missed. The excess ink can then be removed—first with pieces of cardboard, then with a fairly stiff tarlatan. Wipe next with two or three cleaner tarlatans; then hand wipe or paper wipe to clean the surface areas. The plate can be surface-rolled in one or more colors if desired. To wipe areas and edges of the plate perfectly clean, sprinkle a little talc on a soft cloth and rub with a

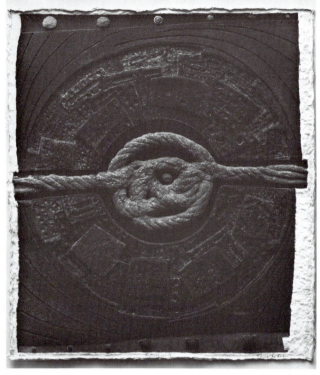

above: 296. The metal collage plate
used to produce Figure 297.

right: 297. Michael Ponce de Leon.
Entrapment. 1967.
Metal collage intaglio, 24½ x 20½″.
Courtesy the artist.

little pressure. Do not leave talc on the plate surface, however. The plate is now ready to print.

Printing

The paper for printing should be heavy enough to withstand the stretch and pull of the varied surfaces of the plate. A heavyweight watercolor paper, well-soaked with water, will produce excellent results. Other good papers are Murillo, Rives BFK, Arches cover, German Etching, and Italia. If a lightweight paper is used for proofing, a sheet of newspaper or a blotter should be placed between the paper and the blankets, to prevent any ink that might break through the paper from staining the blankets.

When the built-up area of the plate is shallow, printing can be done on an etching press with little or no change from the usual procedures. As the relief increases, it will be necessary to provide greater cushioning effect with the blankets in order to push the paper sufficiently into the surface to contact the ink. First, the inked plate is put on the pressbed over one or two sheets of clean newsprint. Then the dampened printing paper is laid on top. A foam rubber blanket about 1 inch thick is next, followed by a single, heavy felt blanket.

Start by running the plate through with light pressure. Check to see how the paper is printing by lifting a corner after it has gone through the press once. Increase the pressure slightly if necessary, and run the plate through again once or twice. Run-

ning the plate through the press several times will not blur or otherwise affect the image. On the contrary, it is sometimes preferable to follow this procedure with collagraphs, for it allows the paper to stretch in steps rather than all at once under heavy pressure.

Drying of the prints should follow the same procedure as with heavy embossed prints. Place the prints between blotters (with frequent changes of blotters) until they are almost dry; then set a light weight on top. Much of the beauty and individual character of the collagraph print comes from its varied textural and tactile surfaces. It is therefore preferable to leave a slight overall waviness in the paper than to risk the loss of the embossment by placing it under too heavy a weight.

When the printing is completed, the plate should be cleaned thoroughly with paint thinner, kerosene, lithotine, or varneline. Do not use lacquer thinner or acetone, because these will dissolve the acrylic surface. Use a brush with the solvent to get ink out of the crevices of the plate, blotting up any excess solvent with paper towels. The clean plate can then be stored.

In a metal collage plate, metal objects are soldered or welded onto a metal plate in strong relief. This technique, developed by Rolf Nesch in the 1930s, produces an immensely varied and textured surface. Michael Ponce de Leon—who utilizes many of Nesch's methods—prints his plates with hydraulic pressure on extremely heavy, custom handmade paper to create works that could almost be considered low-relief sculpture (Figs. 296, 297).

Plate 19. Henri de Toulose-Lautrec. *The Seated Clowness,* from *Elles.* 1896. Color lithograph, 20¾ × 16″.
Metropolitan Museum of Art, New York (Alfred Stieglitz Collection, 1949).

Plate 20. Pierre Auguste Renoir. *Le Chapeau Epingle.* 1898. Color lithograph, image 23⅝ × 19¼″.
Metropolitan Museum of Art, New York (Harris Brisbane Dick Fund, 1931).

180

part three
Lithography

5 The History of Lithography

Lithography is the only one among the four major graphic techniques of which the origin—and indeed the invention—are documented. Moreover, the process reached a high state of development very soon after its invention, for within a few years a range of variations had been explored, including transfer methods, direct drawing on stone, and engraving on stone. The word "lithography," derived from the Greek, means "stone writing." As compared to relief (with its raised printing surface) and intaglio (with its depressed surface), lithography is a flat-surface or *planographic* printing method, depending upon the antipathy of grease and water. The principles of lithography were accidentally discovered and then perfected in Munich in the 1790s by a young actor-playwright, Alois Senefelder (1771-1834).

Senefelder came from a family of actors. His own efforts in performing and writing were singularly un-

successful, especially from a financial point of view. In an effort to reduce the cost of publishing his plays, he began to experiment with ways of duplicating the material himself, working at first in a soft paste mold and sealing wax to produce characters in relief. Again he was frustrated by the cost of materials. Turning to a copper plate he had in his possession, he decided to write backwards on the plate, with the intention of acid-etching it in relief. For this purpose, he used a ground prepared with wax, soap, and lampblack—an important combination of ingredients that later proved central to his discovery of the lithographic process.

Writing in reverse, Senefelder found, required considerable skill. Rather than waste his one good piece of copper with his first attempt, he planned to practice the writing on a piece of Kelheim limestone he had been using for an ink slab. Having noticed the

smoothness of the worn Kelheim stone lining the streets of Munich, he found a way of polishing the stone to simulate the smoothness of a copper plate.

In a famous episode, Senefelder was at the stage in his experiments when he was about to cover a freshly polished stone with ground to practice his reverse writing, when his laundry woman made her appearance. Not having paper or ink at hand, he wrote out the laundry list on the stone with his prepared ground. Later, after he had recopied the list, it occurred to him to test the stone with nitric acid and water. To his delight he found that the acid had etched the stone and left the writing roughly defined in relief to about the thickness of a playing card.

Removing the ground, he inked up the surface with a stuffed, soft leather tampon covered with ink similar to that used for letterpress work. Because of the shallow bite, some of the ink went into the spaces between the letters as well. To solve this problem, Senefelder fashioned a new tampon with a flat, firm inking surface that would deposit ink only above the interstices of the writing. He placed a sheet of paper on the inked stone and rubbed the back of the paper as for a woodcut, thereby making an impression of this original writing. Happy at last to have found a material both readily available and inexpensive, he obtained many good prints in this manner. After further successful experiments with his relief process, Senefelder was convinced it had commercial potential. Now thoroughly engrossed with his new concern, he abandoned all ideas of acting and playwriting. The new printing process became his sole preoccupation and remained so until his death.

It must be realized that the method Senefelder had developed at this point in his experiments—

although technically "lithography" in the sense of "writing on stone"—was actually a relief process, and not the planographic method of printing that lithography would later become. It was not until about two years later, in 1798, that Senefelder's investigations led to the development of true lithography.

In essence, the process that Senefelder eventually perfected consisted of several steps. He would write or draw with greasy crayon directly on the stone. The stone was then treated with nitric acid and water, after which gum arabic was applied. Senefelder found that after he dampened the stone, the ink adhered to the design and not to the part of the stone that had absorbed water (Fig. 298). He could then pull an impression on paper against the stone.

Having invented the method, Senefelder next worked at devising an adequate mechanized press, the pole press, which prevented the paper from slipping on the stone and allowed for closer contact between the paper and the inked stone surface. In 1799 he was able to obtain in Munich an exclusive patent for his method of "chemical printing."

The Earliest Lithographs

Senefelder himself acted as ambassador for his invention. In 1800 he visited London to seek a patent in England. An associate of his there, Philipp André, had the brilliant idea of commissioning well-known artists to try the process of drawing on stone. The result was a series of lithographs known as *Specimens of Polyautography,* published between 1801 and 1807. The first artist to attempt the new technique was the American-born president of London's Royal Academy, Benjamin West. West's angel of the Resurrec-

tion (Fig. 299) reveals quite clearly the potential of the new technique. In bold strokes and cross-hatched marks like those of engraving, West has depicted the rock, the swirling clouds, and the angel whose exclamatory pose and gesture illuminate the inscription: "He is not here, for he is risen."

Back in Germany, Senefelder put his invention to new uses by commissioning the artist Johann Nepomuk Strixner to make lithographic copies of the marginal illustrations drawn by Dürer for the Prayer Book of Emperor Maximilian. The originals were traced onto thin transfer paper and then lithographed in 1808 (Fig. 300). Capturing so perfectly the delicate quill pen lines of the original, this publication made it possible for a wide audience to enjoy these works.

The relative simplicity of the new process intrigued not only professional artists but talented amateurs as well. Members of the French nobility exiled in England, such as the Duc de Montpensier, found lithography a pleasant way to spend their idle time. The duke's lithographic portrait of his sister Adélaïde d'Orléans (Fig. 301) shows a delicate grace and charm.

below: 300. **Johann Nepomuk Strixner after Dürer.**
Illustration from *Albrecht Dürers Christlich-Mythologische Handzeichnungen.* 1808. Lithograph. Metropolitan Museum of Art, New York (Harris Brisbane Dick Fund, 1948).

bottom: 301. **Duc de Montpensier.**
Adélaïde d'Orléans. 1806. Lithograph. Metropolitan Museum of Art, New York (Schiff Fund, 1922).

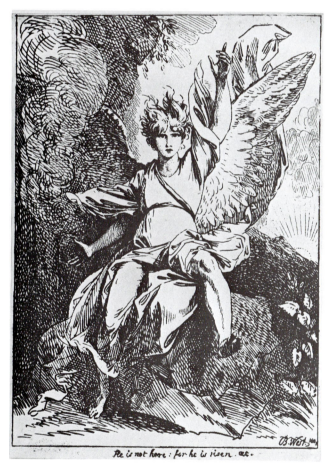

299. **Benjamin West.** *He Is Not Here: For He Is Risen.* 1801. Lithograph, 12⅞ x 8⅞". National Gallery of Art, Washington, D.C. (Rosenwald Collection).

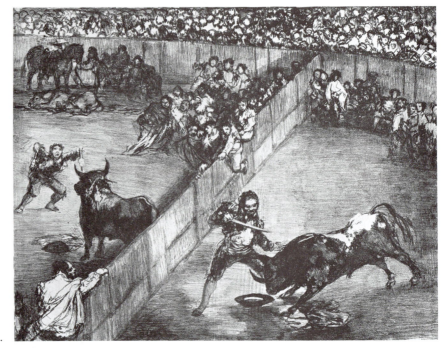

right: **302. Francisco Goya.**
Bullfight in a Divided Ring. 1825.
Lithograph, $11\frac{1}{4}$ x $15\frac{1}{4}$''.
Hispanic Society of America.

below: **303.**
Jean-Auguste-Dominique Ingres.
Odalisque. 1825. Lithograph.
New York Public Library,
Prints Division, S. P. Avery Collection
(Astor, Lenox, and Tilden Foundations).

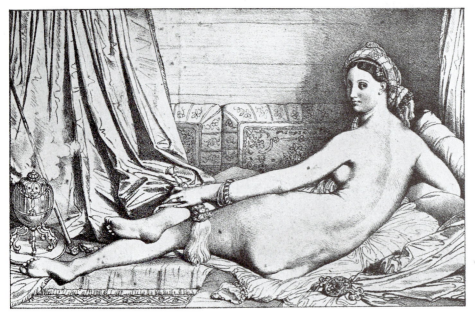

First Masters of Lithography

The lithograph was soon to become much more than a novelty for talented dilettantes. In the hands of prominent artists, it would assume the role of a major creative medium. One of the greatest technicians in France was the printer Godefroy Engelmann, who worked with most of the leading artists of the day. He developed the first "process printing," using primary colors to produce a full chromatic range. He called the resulting prints *chromo-lithographiques;* later the term "chromolithograph" was broadened to include all types of color lithography.

The first important lithographic press in England was established by the artist Charles Hullmandel in 1819. Hullmandel became interested in lithography after visits to Senefelder's Munich workshop, and upon returning home tried his own hand at the process. He published *Twenty-Four Views of Italy*, printing some of the plates himself, and incorporating the ambitious use of tint stones to produce, in his words, "...the effect of a drawing on coloured paper touched in with white." These were the first competent litho-crayon (chalk) drawings done in England and a great improvement over previous attempts by such artists as West.

New works followed, and soon Hullmandel's workshop was producing images of quality equal to any in Europe. He developed new ways of drawing on the stone, including a special cross-hatching technique with the litho-pencil to increase tonal range, and also patented a method of diluted tusche washes, which he called "lithotint." Possibly his greatest influence, however, was in persuading prominent artists to experiment with the lithographic process. Hullmandel's press remained a leading force in English lithography until the mid-19th century.

below: 304. Théodore Géricault.
Horse Being Shod. Lithograph.
Metropolitan Museum of Art, New York
(Rogers Fund, 1920).

bottom: 305. Eugène Delacroix.
Witches' Kitchen. Illustration for Goethe's *Faust.*
1828. Lithograph.
Metropolitan Museum of Art, New York
(Rogers Fund, 1917).

One of the first great artists to make use of the lithographic technique was the Spaniard Francisco Goya. A lithographic press had been opened in Madrid in 1819 by José María Cardano, and it was he who introduced the process to the 73-year-old Goya. The artist had already spent a lifetime bringing the arts of etching and aquatint to extraordinary heights (Figs. 175–177). But it was during his last years spent in exile in Bordeaux that he produced his important lithographs, four large works depicting a favorite Spanish theme—the bullfight. An outstanding example of this series is *Bullfight in a Divided Ring* (Fig. 302). The print is filled with movement and drama, the spectators a blur of faceless people huddled together. Goya's daring composition, with the sharp diagonal dividing the ring, focuses attention on the matador.

At the time when he produced the *Bulls of Bordeaux,* Goya's eyesight was failing, and he propped the stones on an easel to work them. He then moved the grease crayon rapidly over the surface to create atmosphere and movement. Foreground figures were outlined, while other areas were lightened with a scraper to build a rich contrast of tones.

In France an early experimenter with lithography was the great classicist Jean-Auguste-Dominique Ingres. His famous *Odalisque* of 1825 (Fig. 303) is consistent in style with the delicate pencil work of his many portrait drawings. The face of the odalisque is detailed with exquisite modeling, while the elegant contours of the body provide a contrast for the clearly stated volume of the head. A work such as this tested the limits of the lithographic process.

Goya's example was to have its strongest impact on artists of the Romantic movement in France, the country that would develop the greatest tradition of lithography. The first outstanding adherent of the process there was Théodore Géricault. Géricault's imaginative nature was particularly inspired by the noble qualities of the horse, and his lithograph of a *Horse Being Shod* (Fig. 304) reveals both his thorough knowledge of the animal's anatomy and his penetration into its very spirit. The smoke issuing from the shoe being applied seems to symbolize the latent power and energy of the horse, now under restraint.

The greatest of the French Romantic artists was Eugène Delacroix, who employed lithography to illustrate works by those authors who were popular with the Romantics—Shakespeare, Scott, Byron, and especially Goethe. A London production of Goethe's *Faust* inspired Delacroix to make a series of 17 lithographs (Fig. 305). These dark, frightening works possess a theatrical quality that derives partly from the subject matter, partly from the artist's invention.

Like Gericault, Delacroix was attracted to the animal world, but for him the most interesting species were the big cats, lions and tigers. A recurring theme

in his work was one of these beasts of prey attacking a helpless animal. In *Wild Horse Attacked by a Tiger* (Fig. 306) Delacroix used the crayon and scraper to depict with consummate skill the fluidity of the two creatures, the musculature of the struggling bodies, and the frenzy of the life-and-death contest.

Three other artists active in France at this time were known primarily for their landscape prints. Eugène Isabey, who worked for a time in Auvergne, made a series of lithographs of *L'Eglise St-Jean, Thiers, Auvergne* (Fig. 307). The example shown is a moody and haunting scene that typifies Isabey's masterful use of tone in the medium. To unify his tones Isabey rubbed his initial crayon drawing down with a cloth, thereby softening dark areas and creating an even tonality on the stone. He then worked back into these areas with sandpaper and a scraper, in a technique not unlike that of the *manière noire* intaglio (see p. 133). Having completed this stage, he would add detail and rich blacks with more crayon and/or wash.

Isabey exercised considerable influence on the works of Eugène Cicéri, whose *Une Rue à Quimperle* is shown in Figure 308. Cicéri's variation of the *manière noire* process was based on the use of powdered crayon. The powder would be rubbed over the entire surface of the stone and then worked with abrasives and a scraper. Cicéri's village scenes have a moody, romantic ambience similar to Isabey's landscapes.

Closer yet to the style of Isabey are the lithographs of Paul Huet (Fig. 309). Huet's theatrical lighting and romantic subject matter were abetted by the use of the scraper. A murky forest is contrasted with the sharp light on the houses and figures, while the tower on the crest of the hill is shrouded in a misty, ethereal glow.

The technical success of these landscape prints shows how quickly artists learned to exploit the full potential of the lithographic medium. However, it remained for another Frenchman, working in quite a different idiom, to make the definitive statement in lithography.

Honoré Daumier

If ever a medium and an artist were meant for each other, these were lithography and Daumier. As Dürer expressed himself most perfectly in woodcut and Rembrandt in etching, so Daumier made the lithographic print uniquely his own.

By the age of eleven Honoré-Victorin Daumier was already earning his living by making inexpensive lithographic prints for Parisian printers. The publisher-reformer Charles Philipon gave the young man his real opportunity in founding the weekly paper *La Caricature*, which increasingly printed written and visual satire upon the corrupt rule of Louis Philippe.

Daumier's first extensive series were caricatures of the reactionary deputies, and to capture perfectly their personalities he molded their features in terra cotta busts. The prints based on these busts (Fig. 310) have a sense of depth and actuality that made them doubly effective.

306. **Eugène Delacroix.**
Wild Horse Attacked by a Tiger.
1828. Lithograph.
Metropolitan Museum of Art,
New York (Rogers Fund, 1922).

below: 307. **Eugène Isabey.**
L'Eglise St.-Jean, Thiers, Auvergne.
1831. Lithograph, 22 x 16''.
Avery Library, Columbia University, New York.

bottom: 308. **Eugène Cicéri.**
Une Rue à Quimperle.
19th century. Lithograph.
Avery Library, Columbia University, New York.

above: 309. **Paul Huet.** *Tour de Mont-Perron,*
Vue des Bords de l'Allier, Auvergne. 1831. Lithograph.
Avery Library, Columbia University, New York.

below: 310. **Honoré Daumier.** *Charles de Lameth,*
from *La Caricature.* 1832. Lithograph.
Metropolitan Museum of Art, New York
(Harris Brisbane Dick Fund, 1941).

311. Honoré Daumier.
Gargantua. 1831. Lithograph.
Bibliothèque Nationale, Paris.

Becoming more ambitious and daring, Daumier began to satirize the king himself. A famous print depicts Louis Philippe as *Gargantua* (Fig. 311), a Rabelaisian glutton, pear-headed, big-bellied, and spindly-legged, perched on a toilet-seat throne. Baskets filled with gold are being carried up a ramp to the king's mouth, there to be fed to an ever-increasing appetite. Although this print did not appear in *Caricature,* the periodical did bring it to the attention of the public. Daumier was soon brought to trial and sentenced to six months in prison.

In spite of the risk, neither the artist nor the publisher Philipon were diverted from their course. Philipon established a monthly publication, *L'Association Mensuelle,* each issue of which contained an original lithograph and sold for one franc. Daumier executed some of his largest and finest lithographs for this work, including the famous *Rue Transnonain* (Fig. 312). It resulted from the artist's horror at brutal dis-

regard by the government for genuine needs of the people in a time of civil unrest. Strikes and riots had been rocking the city of Paris. In one particular incident, a battalion of antiriot forces thought they were sniped at from a building at 12 Rue Transnonain. In retaliation they entered the building and slaughtered its occupants—men, women, and children. As the episode was committed to stone by Daumier, it shows the father of a family lying dead, his child beneath him. The strong foreshortening, the sculptural modeling, and the dramatic immediacy of the scene make a strong contrast to contemporary political art. Not surprisingly, this powerful work caused a sensation, and the police seized the original stone.

In 1835 *La Caricature* was forced by the official censors to cease publication, but, undaunted, the resourceful Philipon found another outlet for his and Daumier's talents. This was a new paper, *Le Charivari,* which specialized in social rather than political

312. Honoré Daumier.
Rue Transnonain. 1834.
Lithograph, 11¼ x 17⅜".
Metropolitan Museum of Art, New York
(Rogers Fund, 1920).

190 Lithography

satire. A daily publication, *Le Charivari* consisted simply of a single folded sheet with one lithographic page and three pages of text. To meet the constant demand for material, Daumier had to develop a method of working directly on the stones, without any preliminary sketches, relying on simplified execution of broad description and bold crayon strokes. He worked for this journal on and off for the rest of his life. A typical print, showing the artist's mordant humor and empathy with people, is *A Queen Prepares for Her Great Speech* (Fig. 313). This marvelous behind-the-scenes view of the popular theater uses the cutout design of the stage set as an ideal divide between the glamorous world of the dramatic stage and that of earthy human behavior.

Appropriately enough, Daumier's last lithograph was *Monarchy Dead* (Fig. 314), in which, for the last time, the aged artist struck out at the tyranny he so detested. Like Goya, Daumier suffered from failing eyesight, and his drawing became ever broader while the strength of his inner vision increased.

Daumier was the undisputed giant among French lithographers of the period, but many others worked with him on *Le Charivari*. Notable among them was Paul Gavarni, whose real name was Sulpice Chevalier. Gavarni had an incredible facility for drawing, which allowed him to work directly on the stone without preliminary sketching. He used an expanded technique of crayon, wash, pen, and scraping, exploiting the texture of the stone to the fullest. After travels to London in 1847, Gavarni's work took a rather gloomy, contemplative turn. From this involvement came one of his most important series, a study of the philosopher-beggar *Thomas Vireloque* —a print from which is reproduced in Figure 315.

above left: 316. **Richard Parks Bonington.** *La Tour du Marché.* 1825?
Lithograph. New York Public Library, Prints Division
(Astor, Lenox, and Tilden Foundations).

below left: 317. **Thomas Shotter Boys.** *Entrance to a House.* 1841.
Chromolithograph. New York Public Library, Pennell Collection
(Astor, Lenox, and Tilden Foundations).

above: 318. **W. K. Hewitt. Nathaniel Currier, lithographer and publisher.**
Awful Conflagration of the Steam Boat Lexington
in Long Island Sound on Monday Evening January 13th 1840. 1840. Lithograph.
Museum of the City of New York (Harry T. Peters Collection).

below: 319. **Fanny Palmer. Currier & Ives, lithographers and publishers.**
American Express Train. 1864. Lithograph.
Museum of the City of New York (Harry T. Peters Collection).

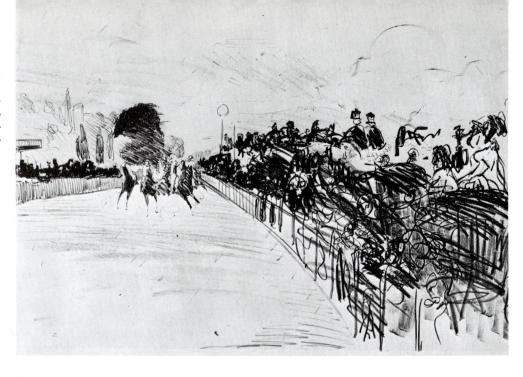

320. Edouard Manet.
The Races. 1864.
Lithograph, 14⅝ x 20½".
National Gallery of Art,
Washington, D.C.
(Rosenwald Collection).

Lithography Outside France

The Romantic movement in France had strong repercussions outside that country. One of the most influential instruments of its spread was Baron Taylor's twenty-volume *Voyages pittoresques dans l'ancienne France.* This publication, which appeared between 1820 and 1878, recorded sites and monuments throughout France. Although it was produced in Paris, many of the artists employed were English, and chief among them was Richard Parks Bonington. Bonington's picturesque prints, such as *La Tour du Marché* (Fig. 316), render the hazy sky and clouds with such delicacy of crayon work that one at first thinks the prints to be aquatints.

It was an Englishman, also, who expanded the possibilities for printed color lithography, following methods introduced by Hullmandel. Thomas Shotter Boys, a noted watercolorist, produced a series of chromolithographs entitled *Picturesque Architecture* (Fig. 317). These color prints reflected the vogue for watercolors in an England already sensitive to color in drawing. Boys used a black crayon lithograph tinted with multicolored transparent overprints from several stones. To achieve the proper blending of tones required careful registration, and the process did not for the time prove commercially successful.

Lithography crossed the Atlantic in the early 19th century and gained a modest foothold in Philadelphia in 1819 with a reproduction in *The Atlantic* magazine. One of the earliest lithographic shops established in the United States was that of Nathaniel Currier in New York in 1834. Currier specialized in depicting current events. For example, when the steamboat *Lexington* burned in Long Island Sound in January 1840, Currier sent one of his artists to very rapidly execute a view of the scene. This sketch was transferred to stone, and the printed edition was ready for sale in three days (Fig. 318). Hawked in the streets, this print graphically depicted the fire that caused the deaths of more than a hundred passengers. It certainly was not high art, but rather popular journalism in visual form.

In 1852 Currier was joined by James Merritt Ives. Henceforth, the name "Currier & Ives" became an almost universal catchphrase for colorful, decorative lithographs depicting everything from Biblical stories to life on the Mississippi. To maintain their vast production of prints, Currier and Ives needed a large staff. One of the firm's outstanding designers was the Englishwoman Fanny Palmer, whose strong compositional style can be seen in *American Express Train* (Fig. 319). Few of the Currier & Ives prints were chromolithographed; instead, they were hand colored, often with stencils, in an almost mechanical assembly-line procedure.

The Revival of Art Lithography

Manet and Degas

During the first half of the 19th century—except for the work of Daumier—graphics served mainly for book illustration or facsimile prints. Major artists seldom explored the various processes expressively. However, beginning in the 1860s nearly all the prominent French artists tried their hands at lithography, often producing works of lasting significance.

In 1862 Edouard Manet was introduced to the technique, and he employed it over the following years for a variety of purposes. *The Races* (Fig. 320), done in 1864, captures in a surprisingly abstract, calligraphic form the action of the swiftly moving event.

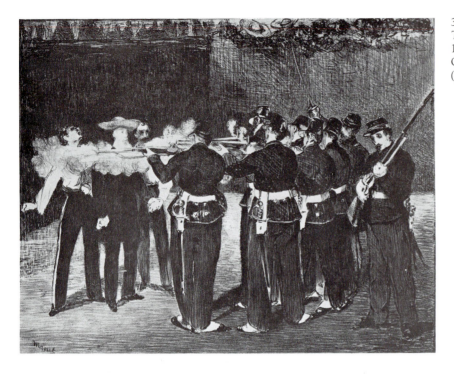

321. Edouard Manet.
The Execution of the Emperor Maximilian.
1867. Lithograph, 13⅛ x 17″.
Cleveland Museum of Art
(Dudley P. Allen Fund).

Two years later Manet took up quite a different style for *Execution of the Emperor Maximilian* (Fig. 321), which treats a sobering political subject. Here the composition is tightly organized, and the contrast of tones underscores the dramatic effects. To achieve these stark tones Manet used a sharp tool, probably an etching needle, to scratch a pattern through the crayon on the stone.

Manet could also delight in decorative, illustrative works, as revealed by *The Cats' Rendezvous* (Fig. 322), intended for a poster. The simplified contours of the animals and the flat black-and-white pattern clearly reveal the influence of Japanese *ukiyo-e* prints (see pp. 30–32).

The Japanese influence was also strongly evident in the works of Edgar Degas, who experimented with lithography as readily as he had with etching and photography (Fig. 323). Degas perfected a three-stage process for creating an image on the stone. He would first make a drawing on copper, using a greasy compound called *tusche*. He then pulled an impression from this on lithographic transfer paper, which in turn was pressed to the stone. Once the image was on the stone, Degas would work directly on it with scraper, brush, and crayon. By this method, as exemplified by *After the Bath* (Fig. 406), he retained all the directness and fluidity of painting.

The Eccentrics

In the late 19th century there were in France a few artists whose works were so individual, so intense, and often so bizarre that they can be labeled "eccen-

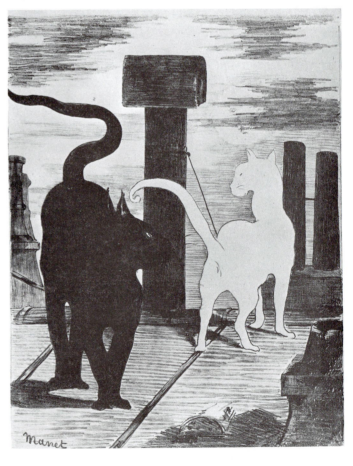

322. Edouard Manet.
The Cats' Rendezvous. 1868.
Lithograph, 17½ x 13¼″.
Museum of Fine Arts, Boston
(gift of W. G. R. Allen).

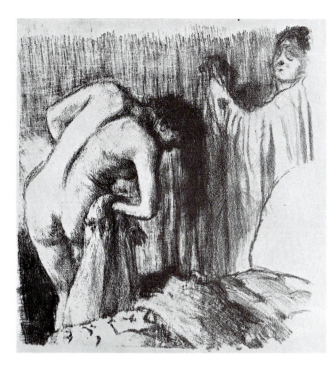

left: 323. **Edgar Degas.** *After the Bath.* c. 1890.
Lithograph, 9⅞ x 9¹/₁₆".
Cleveland Museum of Art
(gift of Capt. Charles G. King III).

below: 324. **Rodolphe Bresdin.**
The Flight into Egypt. 19th century. Lithograph, 8⅞ x 6¹⁵/₁₆".
Metropolitan Museum of Art, New York
(gift of F. H. Hirschland, 1950).

bottom: 325. **Odilon Redon.**
The Light of Day, from *Dreams.* 1891.
Lithograph, 8¼ x 6⅛". Bibliothèque Nationale, Paris.

trics"—without any connotation of linking them together. Prominent were Bresdin and Redon.

The impoverished itinerant artist Rodolphe Bresdin was fascinated by scenes set in deep forests. He often employed them for religious subjects as *The Flight into Egypt* (Fig. 324). The remarkable intricacy of this print, which is less than 9 inches high, would be very difficult to achieve on the lithographic stone. It is possible that Bresdin actually first made etchings of his fantastic subjects and then transferred them to the stone. Here the drama of the Holy Family's flight is virtually obscured by writhing, macabre forms.

Bresdin's work, although not widely appreciated at the time, had a major influence on one younger artist, Odilon Redon. Redon was among the first artists who attempted to represent the unconscious images of dreams. The lithograph, with its evocative textures and its gradations of black and white, was a means ideally suited to this end. A print called *The Light of Day* from the *Dreams* series (Fig. 325) shows the artist's typical juxtaposition of clarity and obscurity, light and dark, real and unreal.

Expatriates in Paris

The American-born artist James Abbott McNeill Whistler was a frequent visitor to Paris and a friend of Degas and Manet. Beginning in 1878, Whistler followed their lead and began working with lithography. The London printer Thomas Way had adopted a system that produced works more aptly called lithotints, in which delicate tusche washes were applied directly to the stone and then printed in subtle tonal-

ities. Whistler worked with Way, and the remarkable result of this method can be seen in *Nocturne* (Fig. 326). The flow of the ink had a delicacy that was ideal for capturing misty atmospheric effects.

Edvard Munch, who also worked in woodcut and etching, found lithography perfect for his bold, disturbing subjects. Although he learned the technique in Paris, his most famous lithograph—perhaps his most famous work of art—*The Scream,* was printed in Berlin (Fig. 327). In this print the figure, hands to head, cries out, and the reverberation of this cry is seen in the long, curved lines of sky and water as they contrast with the diagonals of the bridge. The energy of brush movement through painterly tusche application produces a curvilinear echo that can almost be heard by the viewer, but not by those on the bridge.

Munch was also capable of creating lush, sensuous works, such as the portrait of the Polish violinist *Eva Mudocci* (Fig. 328). The features of the woman's seductive face are surrounded by a mass of black, luxuriant hair, which fills the entire background and at the same time gives her a somewhat ominous air.

The Poster

The color or chromolithograph was revived in France by Jules Chéret, who printed his popular works in brilliant colors from three and later four stones (Fig. 329). These posters advertised everything from cigarettes to music hall entertainers. In them, even the lettering became an important part of the design. The tones were spread out over the surface of the stones by splattering the ink from a brush.

More elegant use of the poster was made by the Czech artist Alphonse Mucha, who also worked in Paris. Mucha's sinuous Art Nouveau forms, so ap-

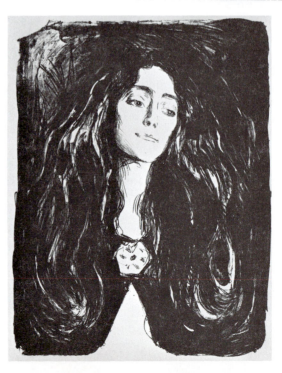

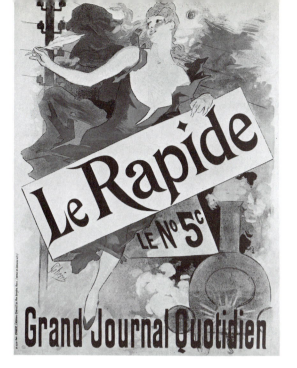

left: 329. Jules Cheret.
Poster. 1892. Color lithograph.
Metropolitan Museum of Art, New York
(gift of Mrs. Bessie Potter Vonnoh, 1941).

below: 330. Alphonse Mucha.
Poster for Sarah Bernhardt,
La Dame aux Camelias. 1896.
Color lithograph, 6'8⅜" x 2'7⅝".
Printed by F. Champenois, Paris.
Victoria & Albert Museum, London
(Crown Copyright).

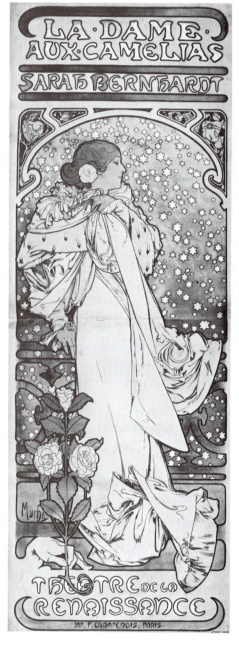

propriate for advertising the elaborate dramas of the famed Sarah Bernhardt (Fig. 330), set a standard of taste that continues to be emulated.

It was Henri de Toulouse-Lautrec, however, who developed a much more artistic form of the poster. Never before or since has this popular medium been so closely associated with one individual. Lautrec established a studio in the Montmartre section of Paris, where he became a chronicler of its exciting and sometimes sinister nightlife. Much of Lautrec's lithographic work was printed by Père Cortelle; the poster the artist designed for the publication *L'Estampe Originale* (Fig. 331) brings together his various interests in a singular way. Cortelle himself is seen in the background turning the star wheel of his hand press,

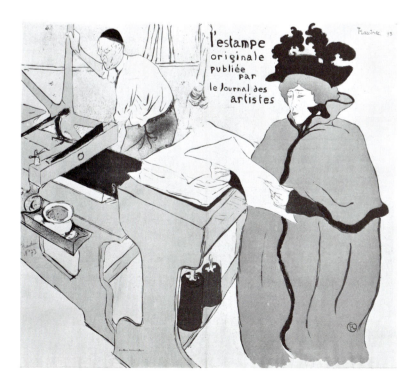

left: 331. Henri de Toulouse-Lautrec.
Cover No. 1 for *L'Estampe Originale.* 1893.
Color lithograph, 17¾ x 23¾".
Metropolitan Museum of Art, New York
(Rogers Fund, 1922).

History of Lithography **197**

while in the foreground the popular singer-comedienne Jane Avril, a good friend of Lautrec's, inspects a freshly printed impression. The flat, decorative forms of the poster, with its calligraphic style of writing, are strikingly similar to Utamaro's prints (Fig. 45).

Also no doubt inspired by Utamaro's work was one of Lautrec's greatest series of lithographs, *Elles*, published in 1896 (Pl. 19, p. 179). These prints depict, in a most intimate yet sensitive manner, the prostitutes inhabiting a Paris brothel. Lautrec combined the spray technique with an exquisite use of crayon to produce, with the greatest economy, images of truly lasting beauty.

Turn-of-the-Century French Prints

The chief publisher of lithographs in France in the late 19th century was the noted art dealer Ambroise Vollard. Vollard was able to persuade most of the leading artists of the time to execute designs for him. Two of these who took a special interest in the lithograph were Pierre Bonnard and Edouard Vuillard. Both specialized in capturing colorful, everyday scenes of Parisian life, and like Lautrec both were much influenced by the then-popular taste for Japanese prints. This influence can be seen clearly in Bonnard's four-panel lithographic *Screen*, one of the largest lithographic works of the day (Fig. 332). In the typical fashion of Japanese screens, broad areas are left empty, and only flashes of the movement and color of the horse carts and running children convey the spirit of the scene.

Vuillard's masterful series of lithographs, *Paysages et Interieurs*, was produced for Vollard in 1899. An example such as *The Avenue* (Fig. 333) shows how the artist used vigorous tusche washes to capture the activity of the bustling street scene in a manner reminiscent of Hiroshige (Fig. 48).

Vollard's expert color printer August Clot was responsible for the works by Bonnard and Vuillard. The opportunity to work with such a skilled collaborator helped Vollard to persuade even Paul Cézanne to join the move to prints. One of his favorite late themes, *The Bathers* (Fig. 334), was designed on the black key stone and then hand colored, so that Clot could make color stones to duplicate Cézanne's colors. The result is a coherent mingling of color with the powerful, simple forms.

332. Pierre Bonnard. *Screen.* 1897. Color lithograph, each panel 4'8" x 1'6¾".
Museum of Modern Art, New York (Abby Aldrich Rockefeller Fund).

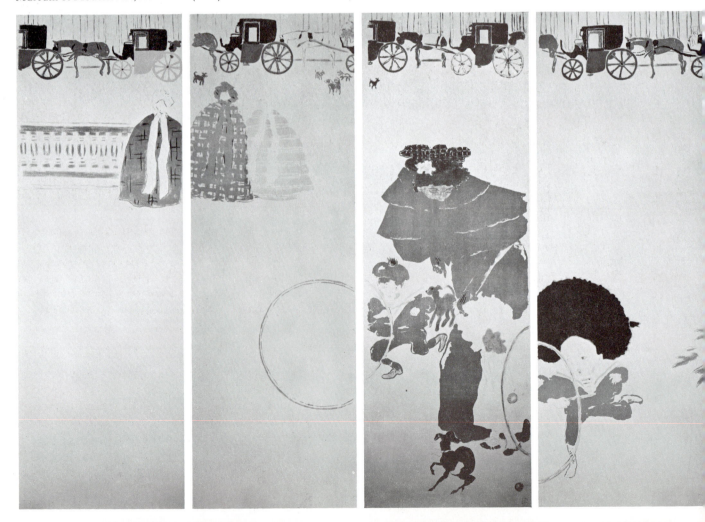

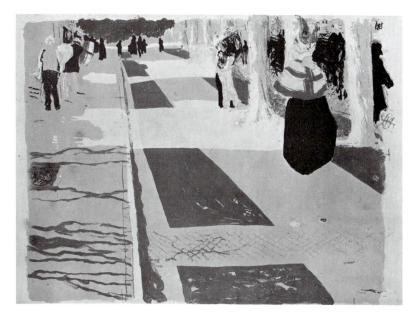

333. Edouard Vuillard.
The Avenue, from *Paysages et Interieurs.*
1899. Color lithograph.
Metropolitan Museum of Art, New York
(Harris Brisbane Dick Fund, 1925).

right: 334. Paul Cézanne.
The Bathers. 1898. Lithograph.
Philadelphia Museum of Art
(W. P. Wilstach Collection).

below: 335. Lovis Corinth.
Carl Liebknecht. c. 1919. Lithograph.
National Gallery of Art, Washington, D.C.
(Rosenwald Collection).

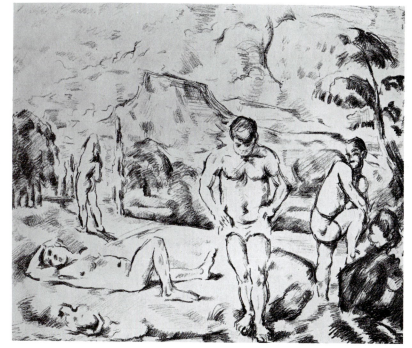

Clot also worked with Auguste Renoir, one of the leading Impressionist painters. *Le Chapeau Epingle* (Pl. 20, p. 180) was produced from eleven stones and required five years' work, using oils, pastels, and etchings as models. The two young girls, isolated in soft-focus pastels, take on a sculptural grandeur.

19th- and 20th-Century Lithography in Germany

The lithographs of both Toulouse-Lautrec and Munch were known in Germany and helped reestablish the technique there as an independent art form. Lovis Corinth, who was primarily a painter, used the process as an adjunct to his drawing (Fig. 335). Cor-

inth preferred to work only in black and white, and in crayon instead of tusche. His lithographs have a violent, spontaneous quality that prefigures the style of the German Expressionists.

The leader of the Dresden-based Expressionist group known as *Die Brücke*, Ernst Ludwig Kirchner, liked to print his own lithographs. Hence, the editions of his prints were usually small. Kirchner also developed an individual method of working, combining crayon and a wash of tusche, water, and turpentine to create bead and hairline patterns that could convey a variety of textures. His lithograph *Woman Wearing a Hat with Feathers* (Fig. 336) allows the wash to boldly describe contours of head and hat. The resemblance to works by French artists such as Bonnard and Vuillard can be explained by the fact that examples of their lithographs appeared in a German magazine in 1900.

The most lyrical of the *Die Brücke* group was Otto Mueller, who was trained as a commercial lithographer. His lithographic prints owe much to the work of Gauguin. There is a quality of pastoral primitivism in his *Three Nudes* (Fig. 337).

Works of a more refined nature were produced by the other school of German Expressionism, the *Blaue Reiter* ("Blue Rider") of Munich. Typical are those of the Swiss-born Paul Klee, who developed an imagery based on children's drawings to create seemingly whimsical subjects that embody serious and sophisticated artistic intent (Fig. 338).

The lithograph as a tool for political and social satire was practiced most effectively in post-World War I Germany by George Grosz. When transferred to stone, Grosz' brutally direct line drawings set down for all to see the grotesque figures of the military and bureaucratic corruption that was preparing the way for Naziism (Fig. 339). It is not surprising that the clear-sighted Grosz decided to emigrate to the United States in 1933.

Käthe Kollwitz was most attracted by the etching process, but she also made many lithographs during her long career. Her particular fascination throughout her life was with the self-portrait. Examples range from studies of herself as a young woman to the touching final portrait, done when the artist was in her seventies (Fig. 340). The lithographic medium here seems especially adapted to portraying a worn, haggard woman. Kollwitz' expressive manner endows the figure with a deeply moving quality.

above: 336. Ernst Ludwig Kirchner.
Woman Wearing a Hat with Feathers. 1910.
Color lithograph, 17½ x 15″.
Staatliche Graphische Sammlung, Munich.

right: 337. Otto Mueller.
Three Nudes, Two Lying in the Grass.
Lithograph, 12⅜ x 17″.
Philadelphia Museum of Art
(gift of Lessing J. Rosenwald).

below: 338. **Paul Klee.**
Tightrope Walker. 1923.
Color lithograph, 17⅛ x 10⅝″.
Museum of Modern Art, New York (anonymous gift).

above right: 339. **George Grosz.**
Exploiters of the People, from the series for
The Robbers by Friedrich von Schiller. 1922.
Lithograph. New York
Public Library, Prints Division
(Astor, Lenox, and Tilden Foundations).

right: 340. **Käthe Kollwitz.**
Self-Portrait. 1938.
Lithograph, 18¾ x 11¼″.
National Gallery of Art, Washington, D.C.
(Rosenwald Collection).

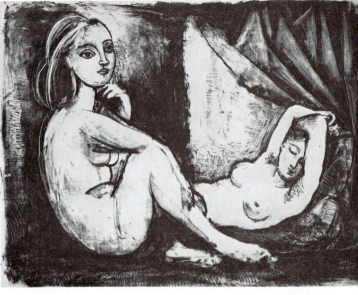

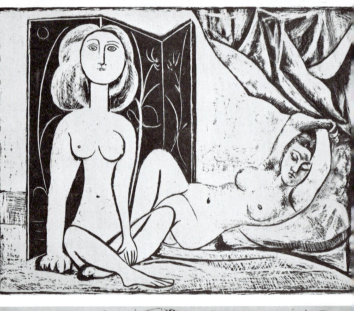

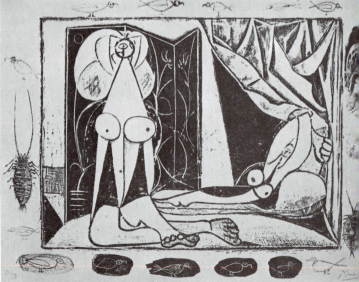

above: 341. **Henri Matisse.**
Study: A Woman's Back. 1914. Lithograph.
Metropolitan Museum of Art, New York (Rogers Fund, 1921).

right: 342. **Pablo Picasso.**
Two Nude Women. 1945. Lithographs.
Cleveland Museum of Art.
top to bottom: State III, $10\frac{1}{8}$ x $13\frac{5}{16}$" (J. H. Wade Fund).
State X, $10\frac{3}{8}$ x $14\frac{1}{16}$" (J. H. Wade Fund).
State XVIII, $12\frac{1}{2}$ x $16\frac{7}{8}$" (gift of Moselle Taylor Meals).

20th-Century Lithography

France

In 20th-century France the tendency for major artists to expand their range of expression with lithography continued unabated. Some of the most sensitive lithographs were those made by Henri Matisse. Although this artist's paintings are known for their brilliant color, many of his lithographs, particularly those in the large group of female nudes (Fig. 341), depend on simple linear purity for their remarkable effect. In other prints Matisse obtained sensuous tones by using crayon on the stone and then applying acids of various strengths, as well as pumice. Often, the drawing began with transfer paper, and the texture of the paper would be visible on the stone and in the finished print. The result has the quality of a drawing.

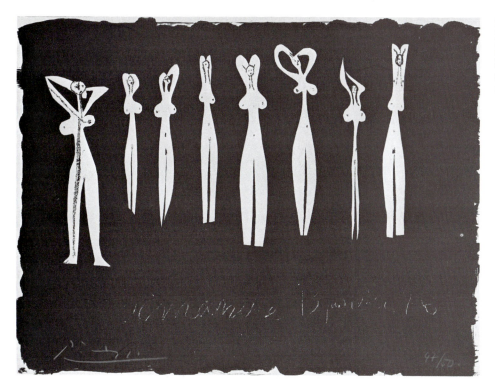

343. Pablo Picasso.
Eight Silhouettes. 1946.
Lithograph, 13 x 17".
San Francisco Museum
of Modern Art
(gift of Frank Perls).

Lithography did not play a significant part in the career of Pablo Picasso until 1945. In that year he visited the extensive Paris workshop of the Mourlot brothers, who offered him unlimited access to their facilities. Given this opportunity, Picasso allowed his graphic inventiveness free rein, as can be seen in the 18 states of *Two Nude Women,* three of which are shown in Figure 342. Most of his work from this period was done in a variety of states. However, in contrast to the refining that took place in Degas' states, Picasso metamorphosed both technique and content. A progressive removal and renewal of imagery yields a fundamentally new insight with each state. The work seems to be in the process of creation before our eyes.

A different approach can be seen in *Eight Silhouettes* (Fig. 343), done the following year. Here Picasso placed ink on transfer paper, overlaid eight cutout transfer paper figures with crayoned features, and scratched the text on the paper. This whole image was then transferred to the stone.

The Mourlot firm also invited other outstanding French artists to design lithographs for them. Georges Braque did his suite of six lithographs, *Helios,* for their studio in 1946 and 1947. Examples from it (Fig. 344) represent a moment in Braque's development when he was blending the Cubist style with an interest in Etruscan and Greek art.

Marc Chagall settled in Paris in 1922. He found lithographs, either as individual prints or as illustrations for special books, an ideal way to extend his

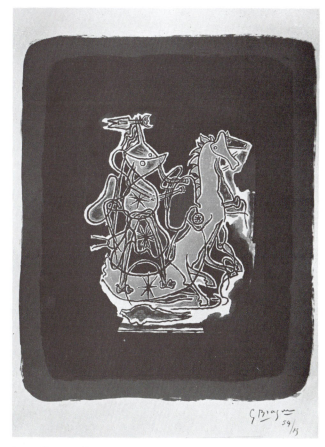

344. Georges Braque.
Helios. 1947.
Color lithograph, 20⅝ x 14⅞".
Galerie Louise Leiris, Paris.

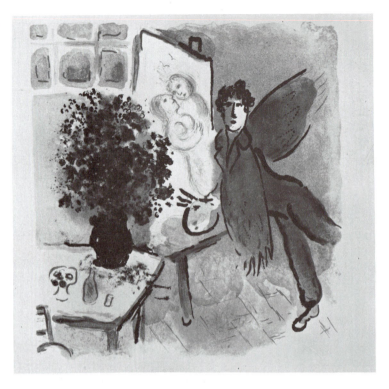

345. Marc Chagall.
The Blue Studio. 1973.
Lithograph, 16 x 14¾".
Published by Editions Maeght, Paris.

346. Joan Miró.
Acrobats in the Garden at Night. 1948.
Color lithograph, 21¾ x 16⅛".
Museum of Modern Art, New York
(gift of Abby Aldrich Rockefeller).

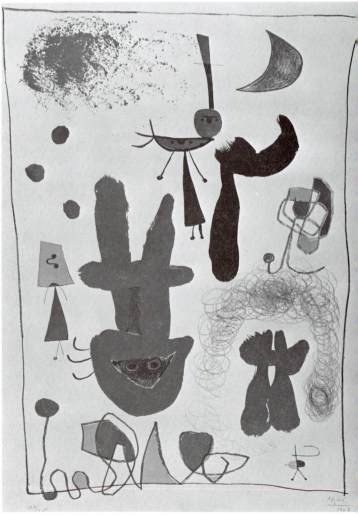

colorful, imaginative artistic world. Chagall's favorite
motifs—memories of the poor Russian village of his
birth, flying animals, flowers, the artist at work, the
Paris scene—were rendered in a painterly manner that
remained almost unchanged into the 1970s, as can be
seen in *The Blue Studio* of 1973 (Fig. 345). This work is
a virtuoso display of opaque and transparent color
washes created with tusche. The diaphanous colors
soften the structure of the studio interior and con-
trast with sharply opaque outlines. It should be noted
that Chagall seldom worked directly on the stone.
Many of his lithographs are the product of an artisan
(*chromiste*) who faithfully copied Chagall's original
drawing onto the stone or plate.

The Spaniard Joan Miró, who also worked in
Paris, used lithography to depict his uniquely deco-
rative anthropomorphic forms (Fig. 346). Miró's bril-
liant colors and shapes resemble living organisms and
have a playful charm that has placed his lithographs
among the most widely collected graphic works of
all time.

The lithographic prints of Matisse, Picasso,
Braque, Chagall, Miró, and others vitalized the tech-
nique, stimulating a proliferation of fine lithographs
in other countries, including the United States.

North America

In the Western Hemisphere lithography was to become an increasingly popular art form during the 20th century. Artists used the medium for all kinds of subjects, and it provided a fairly accurate chronicle of the varying American scene. Lithography served particularly well those regional schools that came to prominence in the 1920s and 1930s.

The Missouri-born Thomas Hart Benton is best known for his ability to capture the honest quality of hardworking, middle-class Middle America. Benton's simple genre scenes (Fig. 347) are greatly enhanced by the broad planes of black and white given by the ink on the stone.

George Bellows was a painter who thought primarily in terms of black and white. The lithograph, therefore, served him as an ideal medium. He used it effectively to represent both the refined social world of Newport and the tough, earthy one of the boxing ring, as shown by his well-known depiction of the fighters Dempsey and Firpo (Fig. 348).

347. Thomas Hart Benton.
Running Horses. 1955.
Lithograph, 12⅜ x 16⁹⁄₁₆".
Courtesy Martin Gordon
Gallery, New York.

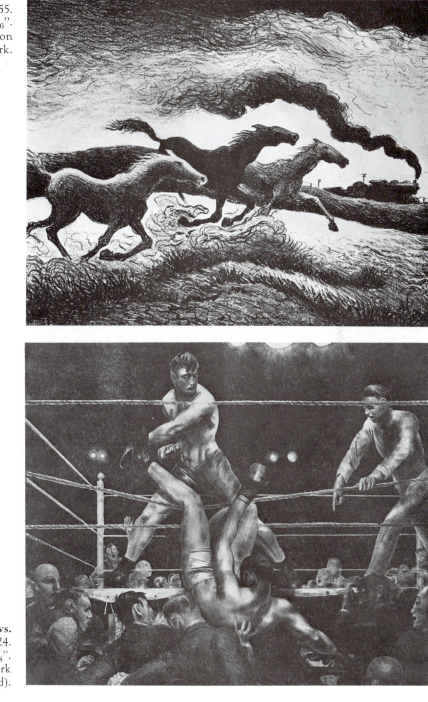

348. George Bellows.
Dempsey and Firpo. 1924.
Lithograph, 18⅛ x 22⅜".
Museum of Modern Art, New York
(Abby Aldrich Rockefeller Fund).

right: **349. Arthur B. Davies.**
Poppy. 1921. Lithograph, 10⅞ x 15¹³/₁₆″.
Courtesy Martin Gordon Gallery, New York.

below: **350. Graham Sutherland.**
Ram's Head (With Rocks and Skeletons),
from *A Bestiary.* 1965–68.
Color lithograph, 26 x 20″.
Courtesy Fischer Fine Art, Ltd., London.

Very different in spirit were the works of Arthur B. Davies (Fig. 349). Davies preferred to dwell in an imaginary world—a world of lovely elongated nudes frolicking in arcadian landscapes. To achieve his dreamlike effects, he continually varied the color and intensity of the inks.

Contemporary Lithography

The 1960s witnessed what has been referred to as a renaissance of lithography. In England Graham Sutherland continued a revival that had begun before World War II. Like Chagall, he employed transparent overlays of color washes, a technique he applied to nature forms in *A Bestiary* (Fig. 350). The print *atelier* tradition has been continued in England primarily through the activity of the Petersburg Press, Ltd. in London.

The primary focus for this new movement in lithography, however, was New York. Possibly the major influence on its growth was Tatyana Grosman, who established a center for fine lithographic printing, known as Universal Limited Art Editions, in her Long Island home in 1957. Grosman selectively invited the leading artists to learn and experiment with the process. Typical of their initial sentiments was Robert Rauschenberg's comment that it seemed strange, in the middle of the 20th century, that anyone should be "drawing on rocks." But Rauschenberg gradually came to love the process. His response to the individuality of the stone can be seen vividly in *Kitty Hawk* (Fig. 351), a very large print on eight stones done in 1974.

It is likely that no contemporary artist has explored the flexibility of the stone more than Jasper Johns, whose first project for Universal Limited Art Editions was a series representing the Arabic numerals 0 to 9. Another early work was *Coat Hanger* (Fig. 352), a simple yet richly textured image.

Much of the impulse for today's new "golden age" of lithography has come from individual workshops established around the United States. In the 1950s Bob Blackburn maintained a shop in New York where artists could spend time experimenting with

has produced both traditional and highly experimental works by Oldenburg, Stella, Johns, Rauschenberg, Albers, and others. Irwin Hollander opened a workshop in New York, which printed the lithographs of many New York-based artists. Jean Milant founded Cirrus Editions in Los Angeles, and worked mostly with West Coast artists. Some other lithography studios of importance that employed Tamarind-trained printers were the Nova Scotia Workshop, Landfall Press in Chicago, and Graphicstudio at the University of South Florida, Tampa, among others.

Some of the most innovative work in printmaking being done today is in the realm of lithography. Many artists, for example, are experimenting with commercial offset lithography methods, which have several advantages: the printed image is not reversed from the original drawing; subtle detail is picked up more effectively; large flats can be inked evenly; and the print dries more quickly. Using an offset proofing press at Universal Limited Art Editions, Jasper Johns created his painterly lithograph *Decoy* from eighteen plates and one stone (P1. 21, p. 213).

The following chapter outlines the basic lithographic techniques and a number of variations. A-typical and combined techniques are described in Chapter 9.

left: 351. Robert Rauschenberg.
Kitty Hawk. 1974. Lithograph, 6'7" x 3'4".
Courtesy Universal Limited Art Editions,
West Islip, New York.

below: 352. Jasper Johns. *Coat Hanger.* 1960.
Lithograph, 35¾ x 24¾".
Courtesy Leo Castelli Gallery, Inc., New York.

and editioning their own prints. Later, Margaret Lowengrund, with the aid of a Rockefeller Foundation Grant, opened Pratt Contemporaries, where, under the direction of skilled teachers, the entire range of printmaking was taught.

Most important in the development of fundamental technical knowledge and in the training of skilled master printers was Tamarind Lithography Workshop, established in 1960 by June Wayne with the help of a Ford Foundation grant. In recent years many artisans trained at Tamarind have gone out to work on their own, and in some cases to set up new studios. Sidney Felsen, Stanley Grinstein, and Tamarind-trained Ken Tyler began Gemini G.E.L., which

6 Lithography Techniques

The process of lithography always has been surrounded by a certain mystique, with the lithographer often thought to be something between a magician and an alchemist. Part of the fascination arises because even today, though the effects of certain chemical reactions are understood and utilized, the complexities of those reactions have yet to be fully analyzed. But to a large extent the climate of mystery was created by early workshops, who veiled their methods in secrecy. Visitors and clients never were allowed to enter the proofing or printing areas, and personnel were closely supervised. The finished lithographic print (Figs. 353, 354) must have seemed like something conjured out of the air.

Lithography differs from other printing techniques in that it depends not on differences in surface

elevation, but on the simple principle that grease and water do not mix. The lithographic stone or metal plate must be *etched*, or *processed*, to accept ink on the image areas and to reject ink and accept water everywhere else. It is this step—seemingly magical—that has been the subject of endless analysis.

In the scant two centuries since Senefelder invented the process, lithographic techniques have become established, so that it is no longer necessary to depend on word-of-mouth information or trial and error. Nevertheless, the success or failure of a lithograph still depends on the skill and awareness of the printer, who must juggle a great many variables: the reactions of different stones to the etching solution, the manner in which the drawing was made, the extent to which humidity affects the inks and the paper, even

left: 353. **Eugène Cicéri.**
Morlaix, Bretagne. 19th century.
Lithograph.
Avery Library, Columbia University, New York.

below left: 354. **Eugène Delacroix.**
Tigre Royale. 1829.
Lithograph, 12⅝ x 18".
Metropolitan Museum of Art, New York
(bequest of Susan Dwight Bliss, 1967).

below right: 355. The image areas of the etched
lithographic surface attract ink
and repel water; the nonimage areas
hold water and repel ink.

expense and rarity of the stones, however, many lithographs are now made on zinc or aluminum. The surface of either material must be roughened, or *grained,* in order to hold the drawing. The image is then drawn freely, with any one of a number of grease-based drawing materials. The entire surface receives a layer of *etch,* consisting of gum arabic and a little acid. Two chemical reactions take place—one between the etch and the drawing material, the other between the etch and the stone or metal surface. Although the stone or metal remains smooth to the touch, it has now been divided into two distinct areas—the image area, which will hold the ink, and the background area, which will hold water. To reinforce the chemical reactions that have occurred, a *second etch* is usually applied before inking. When the ink is rolled on, it adheres only to the image areas of the surface; the background areas, dampened by water, repel it (Fig. 355). Paper, either dampened or dry, is applied under pressure and picks up the image.

the temperature in the print shop, which can affect the result if it varies by only a few degrees. The most important asset for the printer, of course, is a thorough understanding of lithography's chemical basis—ideally combined with the intuition that breathes life into its application.

Limestone always has been the traditional surface for printing lithographs. Because of the increasing

Materials and Basic Chemistry

Lithographic Stones

The great majority of lithographic stones—and the finest—come from the limestone quarries near the towns of Solnhofen and Pappenheim in Bavaria (Fig. 356). When first quarried, limestone is soft and damp; it hardens upon drying in the atmosphere. The even structure and slightly porous nature of the stone make it perfectly suited to lithography, because it accepts grease and water equally well. Limestone is approximately 97 percent calcium carbonate and 2 percent silica. A mixture of alumina, iron oxide, and other substances makes up the remaining 1 percent.

Limestones are quarried in a great range of sizes (Figs. 357, 358). They vary considerably in color, hardness, and porosity. Most types are useful in lithography, but they present quite different characteristics, as described below.

White-Yellow Stones Unless they are whitish or mottled, the white-yellow stones are useful for most

techniques, especially for bold designs and those incorporating large areas of solid color. Compared to other types, they contain lower percentages of iron oxide, alumina, and silica, but a higher percentage of calcium carbonate. The soft, porous calcium carbonate allows excellent adhesion of the grease and wax from drawing materials, as well as the printing ink. The high porosity, however, creates a danger of grease spreading laterally on the stone and causing the image to spread or fill in.

Yellow-Gray and Gray Stones The greatest range of characteristics will be found in the yellow-gray and gray stones. Each is capable of producing any degree of detail, from the finest lines or crayon tone to the boldest area of color. However, because the stones differ in composition and in response to the gum arabic and acid, it is only with familiarity and experience that artists can best judge how to utilize individual stones. Most artists prefer certain stones for certain types of work, and develop a kind of rapport with the

below: 356. Workman shaping
a freshly quarried limestone
at the Solnhofen quarry, Bavaria.

above right: 357. Small litho stones
are conveniently stored
in these shelves at the Istituto Statale
in Urbino, Italy.

right: 358. Robert Rauschenberg
(center) supervises the moving
of a very large litho stone for *Waves*,
part of his *Stoned Moon* project,
at Gemini G.E.L.,
Los Angeles, in 1969.

materials that helps to produce some of the finest
examples of the lithographer's art. Occasionally, a
yellow-gray stone is found that exhibits all the char-
acteristics of the gray stones and is equally hard. As a
rule, however, the yellow stones are not as hard as the
gray and blue-gray stones.

Blue-Gray Stones Blue-gray stones are the hardest
and sometimes the most difficult stones to work. Be-
cause of their hardness, they are less absorbent, mak-
ing the grease image and the film of gum on the sur-
face equally thin and vulnerable to wear in the course
of printing. The printer must take care to maintain a
good grease base and to regum the stones frequently.
Blue-gray stones are capable of yielding exquisitely
fine detail. In the past, they were often used for bank-
notes and stock certificates, employing the stone en-
graving technique.

359. Thin lines on a litho stone are a common but minor defect.

Defects in the Stones Two types of imperfections can occur in stones—lines and small flecks of foreign matter (Fig. 359). Thin, cracklike lines cause problems occasionally, and in printing they may have a tendency to either reject or pick up ink inappropriately. Most lines, however, although they may be quite noticeable, never affect the work, even during the printing of large editions. The "cracks" are often composed of silica, which is stronger than the limestone. Unless there is an actual gap in the stone, they will not weaken its structure.

By contrast, flecks of foreign matter or tiny fossils generally do create problems, for they may break away from the stone and cause a small area to repel ink. If the stone has only a few flecks, the artist may be able to avoid them by selective placement of the image. However, if the graining process uncovers too many spots, the stone should be reserved for graining other stones or for an ink slab.

Grained Metal Plates

Zinc Plates Unlike limestone, zinc is nonporous. To enable it to retain grease and water, it must be given a "tooth." This procedure is called graining (see p. 222). The gauge of zinc varies from about .007 to .025. Heavier-gauge metal is more appropriate for hand lithography, because it lies flatter, withstands rougher handling, and can be regrained many times. For both art and commercial lithography in the United States, zinc has almost completely been replaced by aluminum.

Aluminum Plates Aluminum plates suitable for the artist's use can be obtained from commercial suppliers. Ball-grained plates with a coarse grain are generally best. The smoother, brush-grained plates are better suited for photolithography techniques. An-

odized aluminum plates, also designed for photolithography, normally yield poor results when used for hand lithography, because their surfaces resist grease adhesion, and because oxides in the anodized surface will be attacked by acids in the etch solution. But an image can be made on the anodized plate by drawing on the plate with a grease-based material, gumming the surface, and immediately replacing the greasy drawing with lacquer (see p. 277). The lacquer adheres to the metal and becomes the printing base. As with zinc, the heavier gauges of aluminum are best for lithography.

Drawing Materials

Any drawing material used in lithography must be both greasy enough to adhere to the stone and attract ink, and at the same time solid enough to remain stable in etching. In his search for the ideal material, Senefelder constantly experimented with all kinds of combinations—soaps, tallow, butter, animal fats, shellac, resins, and dozens of other substances. The following present-day formula for solid *tusche* is almost identical to Senefelder's, published in 1818:

wax	8 parts
tallow	4 parts
soap	4 parts
shellac	4 parts
lampblack	2 parts

These ingredients form the basis of all tusche and litho crayon preparations, and each one has its function. The tallow and wax are both highly acid-resistant and give the tusche or crayon its necessary grease content. Shellac, also acid-resistant, imparts hardness to the crayons. (This ingredient is omitted in the very soft crayons.) Lampblack gives color to the mixture so that the drawn image can be seen readily, and the

Plate 21. Jasper Johns. *Decoy I.* 1971. Lithograph, image $40\frac{3}{8} \times 29\frac{5}{8}''$.
Courtesy Universal Limited Art Editions, West Islip, N.Y.

360. The grease in the drawing material reacts with the stone to form a durable base for the ink.

soap emulsifies the mixture as well as containing an active greasy ingredient.

Reaction of Grease on Stone and Metal

Limestone has a natural affinity for grease. When the stone comes in contact with lithographic drawing materials, the alkaline nature of the stone reacts with the fatty acids in the grease to form an *oleomanganate of lime,* which serves as an extremely durable base for the printing ink (Fig. 360). This base is impervious to most solvents, including turpentine, kerosene, and lithotine.

Grease also has a strong hold on the roughened surface of the grained zinc or aluminum plate. Once the fatty acids in the grease have formed a bond with the metal, the grease can be removed only by using a strong degreasing agent (such as a solution of oxalic acid, or a mixture of carbolic acid and gasoline). *Regraining* the plate will also remove the grease (see p. 264).

Etch Solutions

The etch solution of gum arabic and acid plays an important role in the lithographic process—and one that is often misunderstood. Even the name "etch" is inaccurate, since little or no actual etching takes place in comparison with the surface erosion of a plate bitten in an acid bath. It would require a very strong etch solution indeed to leave the lithographic image in slight relief.

Reaction of the Etch Solution on Stone

Many experiments were made in devising formulas for etching the stone. Besides nitric acid, early lithographers often used sulphuric and hydrochloric acid in combination with gum arabic. Nitric acid, however, proved to be the most effective etch or *desensitizing* agent. The early etching procedure called for separate applications of nitric acid and gum arabic. This method was eventually discontinued in favor of etching with gum arabic and nitric acid simultaneously, in solutions of various strengths. Since the acid acts as a catalyst for the gum, a greater penetration of the surface takes place, and a tougher, more permanent bond forms when they are applied together. A thin layer of calcium nitrate forms on the stone in the following reaction:

$$CaCO_3 + 2HNO_3 \rightarrow Ca(NO_3)_2 + H_2CO_3\uparrow$$
(calcium carbonate) (nitric acid) (calcium nitrate) (carbonic gas)

The effervescence on the stone liberates carbonic gas, as indicated by the vertical arrow. Not only does the gum arabic fill the pores of the stone, but also the calcium, potassium, and magnesium salts present in the gum—along with some of the free arabic acid—unite with the stone to form an extremely tough and insoluble film. This film remains *hygroscopic* (water-retentive) and inhibits the adhesion of any greasy substance to the stone. The areas of the stone that have been acted upon by the gum and nitric acid are now desensitized and will repel the greasy lithographic ink.

Reaction of the Etch Solution on Zinc and Aluminum

The effect of the etch on zinc or aluminum is similar in some ways to its effect on stone. Gum arabic or cellulose gum is always the main ingredient of the etch. The free acid groups in some of the gum molecules assist in the formation of a film that adheres tightly to the metal. Various acids, such as phos-

phoric, chromic, gallic, and tannic, all convert more of the acid groups to carboxyl groups, thus improving the adhesion of the gum to the plate. A pH value close to 3 is considered ideal for plate etches, since all the free acid molecules are converted to carboxyl groups. Too much acid in the etch, however, will attack the metal, and instead of creating a bond with the surface it will have a mordant effect.

Reaction of Gum Arabic Etch and Acid on the Drawing

The crayon or tusche drawing on the stone or plate is soluble in water. When acid or gum arabic is spread on the drawing, however, an important reaction takes place. The acid in the gum reacts with the soap in the crayon or tusche, causing desaponification. This hardens the drawing and makes it insoluble in water. At the same time, small amounts of fatty acid are liberated from the drawing material and penetrate deeper into the stone. On zinc or aluminum, the fatty acid reacts further with the metal to form an adsorbed grease image.

Counteretch Solutions

When you wish to make changes or additions to an image after the etch solution has been applied, you must first remove all traces of etch from the stone or metal surface by *counteretching* (sometimes called *resensitizing*). On stone, counteretching removes the adsorbed gum layer, calcium nitrate, and other hygroscopic salts from the nonimage areas, thus restoring the stone in these areas to its original state. Acetic acid and water in a 5- to 7-percent solution has proved to be the most effective counteretch on stone. This solution should be applied several times, with a clean water rinse after each application. Afterwards the

stone is allowed to dry. It is a good practice to counteretch the stone after the final graining to help remove sediment lodged in the surface grain.

The same procedure applies to counteretching zinc or aluminum plates. Solutions can be made from acetic acid, hydrochloric acid, or hydrofluoric acid (see pp. 263, 264).

Other Chemicals Used in Lithography

Gum Arabic Gum arabic, also called gum acacia, is the main ingredient for etching and preparing the stone or plate for printing. It is a natural gum gathered from the acacia tree found predominantly in Arabia and the Sudan. The gum flows from the branches and trunk, and hardens into "tears" on contact with the air. The best varieties are either straw- or amber-colored. Bits of bark that might have mixed with the gum are removed easily after dissolving the gum completely in cold water, by straining the solution through a fine sieve or several layers of fine cheesecloth.

Gum arabic is an extremely complex substance containing potassium, magnesium, calcium salts, and a small amount of free arabic acid. Its reaction on the stone or plate has yet to be fully analyzed. The gum arabic adheres strongly to metal and limestone, forming a very tough, elastic, water-attracting bond called an *adsorption gum film*. This bond is difficult to remove except by counteretching. Although it swells slightly in the presence of water, it does not dissolve, but remains both *hydrophilic* (water-loving) and grease-resistant.

Cellulose Gum Cellulose gum is the sodium salt of carboxymethyl cellulose (CMC), a synthetic gum. Frequently used in etch solutions for zinc, it is less effective on stone or aluminum. Pure cellulose gum

makes an excellent etch for zinc, because it desensitizes well and adheres firmly to the metal.

Nitric Acid (HNO_3) When used in small quantities with gum arabic on limestone, nitric acid acts as a catalyst for the gum and changes the surface layer of calcium carbonate to calcium nitrate. It can also resensitize or counteretch the surface of a stone or metal plate when mixed in small quantities with water. Since it is a very strong and highly corrosive substance, nitric acid must always be handled *with extreme care.* Its toxic fumes should not be inhaled.

Phosphoric Acid (H_3PO_4) Phosphoric acid is used in most etch preparations for zinc and aluminum. A few drops can also be placed in the dampening water for the printing surface to create a mild fountain solution.

Acetic Acid (CH_3COOH) The most common acid for counteretching on stone and zinc is acetic acid. Vinegar, an impure source, contains the acid in the strength of 5 to 6 percent—a suitable concentration for most counteretch solutions. In its pure, concentrated state, the acid is called *glacial acetic acid* and is extremely corrosive and pungent.

Oxalic Acid [$(COOH)_2$ or $H_2C_2O_4$] Oxalic acid comes in a white crystalline form. When placed on a stone along with a few drops of water and rubbed with a piece of felt, it forms a glaze of calcium oxalate (CaC_2O_4). This acid destroys grease and also prevents the stone from receiving additional grease or ink. For this reason, it serves for keeping the edges of the stone clean during printing.

Gallic Acid ($C_3H_6O_5$) Some early etch solutions for zinc included gallic acid, which was extracted from gallnuts by boiling. In combination with other acids and gum arabic, it forms an effective etch for zinc.

Hydrofluoric Acid (HF) An extremely dangerous acid, hydrofluoric must be handled with the utmost care. Its fumes are corrosive and poisonous. Hydrofluoric acid is used in one of the counteretch formulas for aluminum.

Tannic Acid ($C_{76}H_{52}O_{46}$) A fluffy tan or brown powder, tannic acid is relatively mild. It serves in etch preparations for both zinc and aluminum, as well as in fountain solutions. Tannic acid also helps to strengthen the adsorbed gum film, making it more resistant to the abrasive actions in hand printing.

Carbolic Acid (C_6H_5OH) (Phenol) Carbolic acid is extremely toxic and must be handled with the greatest care. It is one of the few acids that can be absorbed through the skin. When mixed with gasoline, it will effectively remove grease from a stone or metal plate. For this purpose, the phenol and gasoline are mixed in a 1-to-1 ratio. Phenol also serves as a preservative for gum arabic.

Oleic Acid ($C_{17}H_{33}COOH$) An oily acid present in most animal fats and oils, oleic acid attacks zinc to create zinc oleate, which aids in the formation of a water-repellent image. A higher concentration of fatty acids is required for lithography on aluminum, because adsorption of the fatty acid onto the surface is comparatively slow, with less of a chemical reaction taking place.

Formaldehyde (HCHO, Formalin 37 Percent Solution) In small quantities, formaldehyde is useful for preserving gum arabic. It slows mold formation in damp printing paper, but can cause yellowing.

Preparing
the Stone
or Metal Plate

Equipment and Materials

The following equipment and materials will be needed for preparing the surface of the plate or stone and for drawing the image.

- □ levigator and/or small litho stone
- □ carborundum grit (Nos. 80, 100, 150, 220, 240; optional Nos. 180, 340)
- □ straightedge
- □ sheets of newsprint
- □ fan
- □ squeegee (optional)
- □ clean rags or paper towels
- □ cellulose sponges
- □ cheesecloth
- □ file
- □ grease-based drawing materials, such as tusche, litho crayons, autographic ink
- □ brushes, drawing pens
- □ gum arabic
- □ cellulose gum
- □ acidified cellulose gum
- □ nitric acid
- □ acetic acid
- □ red conté pencils

Graining the Stone

Graining the stone accomplishes three things: it removes any previous greasy image; it levels the stone; and it gives the surface a fresh tooth or rough texture to receive the new drawing. Graining is done by rubbing the stone with an abrasive, using either a device called a *levigator* or another stone. It is generally advisable to use the levigator for coarse graining and a stone of equal or smaller size for finer grainings.

Early lithographers used pounded glass, ground flint, and emery as abrasives for graining stones, as well as selected grades of sand, carefully sifted. Al-

though sand is still easily obtained and inexpensive, it has largely been replaced by carborundum, which comes in a variety of grit sizes. Carborundum (silica dioxide) is much harder than sand, lasts longer, and gives a sharper tooth to the stone.

Graining with the Levigator

The levigator is a round steel or cast-iron disc, 1 or 2 inches thick and 8 to 14 inches in diameter. A handle placed eccentrically on top is used to rotate the levigator. Some levigators have holes 1 or 1½ inches in diameter that go through the disc from one flat side to the other. These holes form wells that hold the grit.

To remove the old image, if any, wet the stone with water, sprinkle No. 80 or No. 100 carborundum liberally over the surface (Fig. 361), then lower the levigator gently onto the surface and grind with a circular, horizontal motion (Fig. 362). It is most important that the motion be circular and horizontal; any downward motion produces uneven pressure on the edges of the levigator that inevitably results in scratches. As the graining continues, sprinkle more water and carborundum on the stone to maintain an even layer between the stone and the levigator. Should a thick, muddy sludge form, making it difficult to turn the levigator, then the grit must be replaced. Rinse the stone and the levigator extremely well, add fresh carborundum and water, and continue graining. After a time, check the old image. If it still appears quite distinctly, more graining is necessary.

Because yellow stones are more absorbent, the grease often penetrates the surface deeply, requiring more graining in order to remove the image completely. It is also common, when graining yellow stones, to have an even older previous image make its appearance. To eliminate this danger, etch the stone once or twice between grainings with a weak solu-

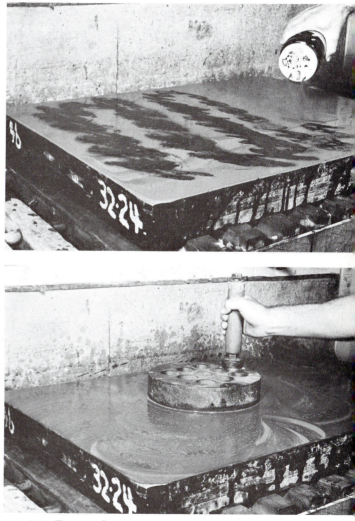

top: 361. To grain the stone, begin by sprinkling some carborundum over the dampened surface.

above: 362. Grind the carborundum with the levigator, using a circular, horizontal motion.

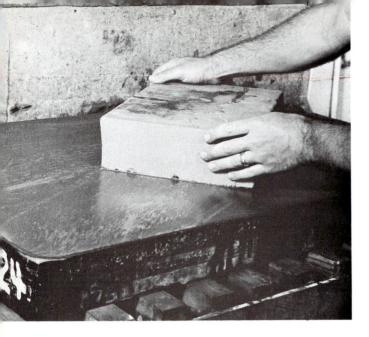

tion of nitric acid or oxalic acid and water. Nitric acid, if used, should be diluted to a 10-percent solution and must be handled with caution. Oxalic acid, on the other hand, can be mixed with water in a greater concentration. It is then poured directly on the stone. A powerful degreasing agent on both stone and metal plates, oxalic acid is very poisonous and must be handled carefully. Protective gloves should be worn.

Once the old image has been removed satisfactorily, wash the stone, the levigator, your arms, and anything else in close contact with the stone to remove the coarser grits. Remember that incomplete rinsing of the stone and levigator is a major cause of scratches. Sprinkle No. 150 or No. 180 carborundum liberally on the stone, and continue graining in the same manner as before. Again, wash the stone and the levigator thoroughly between grainings. Dry the stone, and check for level (see below), then concentrate the graining on the high spots, if any, using the same No. 150 or No. 180 carborundum until the stone is level. As many as five grainings may be necessary with coarser grits.

Final Graining with Another Stone

For more delicate graining, use No. 220 or finer carborundum grit and a smaller stone instead of the levigator. This helps to avoid scratches. Place your hands at opposite corners of the stone, and rotate the stone in a smooth, figure-eight motion without jerking or pulling it (Fig. 363). Fresh carborundum and water should be added frequently. This phase of the graining generally goes very quickly. A levigator constructed with four metal arms and wing-nut screws to hold a small stone (Fig. 364) is less likely to create scratches than the steel levigator and works well for all final grainings. The final step is to bevel the edges

of the stone with a file or electric sanding belt (Fig. 365). This prevents damage to the ink roller and the printing paper, and reduces the chance of the edge of the stone breaking. It also helps repel ink.

Checking the Level of the Stone

The level of the stone should be checked after two or three grainings with No. 150 or No. 180 carborundum. To check the level, place some strips of thin tissue or tracing paper across the dry stone at 4-inch intervals. Lay a carefully machined straightedge on top of the paper, and tug lightly on each strip (Fig.

366). Do this horizontally, vertically, and diagonally on the stone. You will discover where the high and low spots are located, because the strips will slide from under the straightedge at the low spots and stick tightly at the high spots. Mark the high spots with chalk or pencil, and concentrate the graining in these areas until the tension on the strips of paper is equal over every part of the surface. (To ensure the precision of the straightedge as a leveling device, store it in a safe place to avoid nicks, and do not use it for any other purpose.)

The most common problem encountered in graining a stone is the creation of a slight concavity; that is, the stone is higher at the edges and lower at the center when finished. In order to compensate for this defect, adjust the graining pattern to place more emphasis on the edges.

Sometimes a stone may be found to be thicker at one end than the other. Since most of the presses used in North America cannot adjust to any appreciable difference in height, this must be corrected. Check each side of the stone with a pair of calipers. If the difference is slight, place some sheets of paper in gradated steps on the pressbed underneath the lower end of the stone to make it level with the motion of the scraper bar. A major difference in height should be corrected by grinding with carborundum.

Washing the Stone

Once the final graining has been completed, wash the stone thoroughly to remove all traces of ground stone and carborundum. This step is extremely important, because incomplete washing of the stone is often the real cause of failures that are later blamed on the etch, the ink, or the stone itself. The particles removed in the graining process actually create a kind of mortar, usually lodged in the surface grain. If these particles

are not removed, they settle quickly in the grain of the stone and harden upon drying. In the course of printing, they break up again and are removed in the dampening water. When a drawing is made on a stone that has not been cleaned thoroughly, all those parts of the drawing not attached to a solid piece of the

366. If the stone
is perfectly level after graining,
all the strips of paper
will be held under the straightedge
with equal pressure.

stone will eventually lift up and be lost. Delicate tusche washes are particularly vulnerable, because they settle in the crevices of the stone, often on top of these fine deposits of mortar.

To wash the stone well, hose the surface with plenty of water, rubbing with a clean cloth or strong paper towel at the same time. Never use a cloth that has held gum arabic, for even a minute trace of the

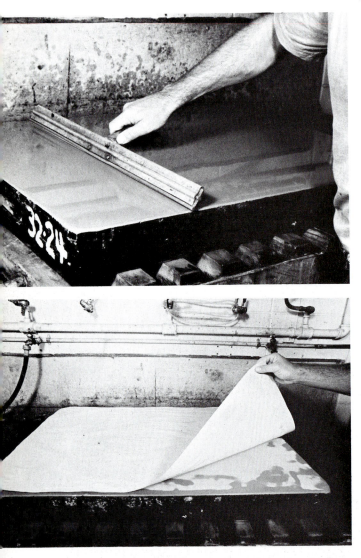

above: 368. Blotting with newsprint also helps to dry the stone.

below: 369. Fanning the stone dry
is the final step
after washing the carborundum
from the stone.

gum on the stone can prevent the drawing from "taking" properly. Remove the excess water from the stone by pulling a squeegee across the surface (Fig. 367), or blotting it with clean sheets of newsprint (Fig. 368). Fan dry (Fig. 369).

An excellent practice now is to counteretch the surface of the stone with a mild solution of acetic acid and water. A 5-percent concentration—about the strength of ordinary vinegar—is sufficient. Pour the solution over the stone and rub gently with a clean cloth. Wash immediately with running water, rinsing well, and fan dry. This counteretch has a complete cleansing action on the stone, removing any loose particles of carborundum or ground stone lodged in the surface grain.

Graining Zinc and Aluminum

Zinc and aluminum plates are grained commercially on a graining machine, a flat vibrating table on which the plates are clamped (Fig. 370). Aluminum oxide powder and water are sprinkled on the plate. A number of steel balls are set in the tray over the plate, and, as the table vibrates, the rolling motion of the steel balls forces the aluminum oxide to abrade the plate evenly. Sometimes a dilute solution of nitric acid is added to the aluminum oxide and water; the acid has a slight mordant action on the zinc and aids the process by imparting a microscopic grain of its own.

The grit size of the aluminum oxide powder determines the final plate grain. As with stone, a more detailed technique requires a finer graining. Medium plates are grained with aluminum oxide in the range of No. 150 to No. 180 grit; finer graining calls for No. 220 or even No. 250. Some commercial work can require as fine a grit as No. 600.

After the plate has been grained, it is flushed with clean water and dried quickly to prevent oxidation.

above: 370. A commercial graining machine for litho plates at N. Tietelbaum and Sons, New York.

below: 371. Large metal litho plates can be scored with a razor blade or mat knife.

top right: 372. The plate is broken at the score line to make two smaller plates.

center right: 373. The sharp corners of the metal plate should be cut off.

bottom right: 374. Use a file to remove sharp edges from the plate.

When it is ready to receive the drawing, counteretch with the appropriate solution. The same drawing materials can be used with plates and stone.

Metal litho plates can be easily scored with a razor blade or mat knife and broken (Figs. 371, 372). The edges should always be smoothed and the sharp corners cut off and filed (Figs. 373, 374). To protect the grain, make sure the plate remains face-up.

The Preliminary Drawing

After the lithographic surface has been grained, counteretched, and dried, it is ready for the preliminary drawing. Margins of at least an inch, and preferably more, should be left around the edges of the drawing. A thin coat of gum arabic applied to the

margins will help protect them from smudges and fingerprints while the drawing progresses (Fig. 375).

The materials used for making the guide drawing should be chemically inert and free of greasy or waxy substances. Conté crayon or pencil, carbon pencil, and charcoal pencil are suitable in this respect. Red conté is preferable to all these, however, because its color allows it to be differentiated more easily from the actual drawing.

The guide drawing should always be done with a light touch, since any buildup of conté will fill the grain, hampering greasy drawing materials from making good contact with the surface. Heavily drawn areas can be rubbled lightly with a piece of soft, absorbent cotton, to remove excess conté without changing the clarity of the drawing. Some artists prefer to work out the image directly on the stone, with only a light conté sketch as a guide (Figs. 376, 377).

Always take into consideration the fact that the final image will be reversed when printed. A large mirror is a big help in seeing it the other way around.

For a more accurate translation of the image, such as might be needed for a very detailed drawing or for the different stages of a multicolor print, it is best to

above left: 375. To protect the edges of the plate or stone from fingerprints, coat them lightly with gum arabic.

above right: 376. Sam Francis working on the lithographic stone at Gemini G.E.L. (See Pl. 23, p. 214.)

below: 377. Sam Francis working out a preliminary drawing at Gemini G.E.L. Los Angeles, in 1971.

offset the image onto the printing surface. Make a careful outline drawing of the image on thin paper, using either conté crayon or carbon pencil. Place the drawing face-down on the stone or metal plate, and run it through the press once with a fairly substantial pressure, or rub the back of it with a spoon. Make sure the paper does not move, particularly when off-

378. Twenty lithographic techniques
and combined techniques
were used to make
this test stone. They are,
from left to right, **top row:**
rubbing ink with gum arabic stop out,
manière noire technique using acid
on a base of 50% Harris Triple Ink and 50%
asphaltum, dry brush with liquid tusche wash,
manière noire using a sharp point,
and direct solvent transfer
with Hanco Kwiki press cleaner.
Second row: air brush on tusche
with a mark made by gum arabic,
tusche and water wash,
tusche and lithotine wash,
stone engraving, and textures
transferred to the stone.
Third row: spray paint
with a mark made by gum arabic,
seven grades of litho crayon
(Nos. 00 through 5) on their sides,
solid tusche with gum arabic stop out,
autographic ink drawing
made with a ruling pen,
and paper and gum arabic stop out stencil.
Bottom row: Prismacolor pencil,
No. 5 litho pencil,
litho pencils Nos. 1 through 4,
autographic ink, and partial reversal.

setting the drawing by hand. (See also color registration methods, p. 269.)

Drawing the Image

The uniquely versatile character of lithography comes from its ability to respond equally well to the finest whisper of tonality and the most intense area of color (Fig. 378). Unlimited novel effects and textures can be achieved through the careful use of a variety of drawing materials (Fig. 379), although the ease with which they are produced should not be allowed to result in a false sense of accomplishment. Techniques should be chosen to serve the purpose of the image.

379. Lithographic drawing
materials, left to right:
litho crayons, litho pencils,
stick tusche, brushes,
razor blades, ruling pens,
a bamboo drawing pen,
etching needles, and rubbing ink.

left: 380. Belliard (?).
S.A.R. Madame Adélaïde, detail enlarged 150%.
c. 1840. Crayon lithograph, printed by Delpech.
Collection Deli Sacilotto.

below left: 381. This detail of Figure 378
shows the textures of the
seven grades of litho crayons.

Lithographic Crayon and Pencil

Direct crayon drawings have an unmistakable lithographic quality. This technique for producing the lithographic image is one of the most easily identifiable of the many drawing methods and one of the most versatile as well.

Lithographic crayons come in $\frac{1}{4}$-inch-square sticks about 2 inches long. They can be broken into smaller, more convenient pieces, sharpened with a razor blade or sandpaper, and generally used in the same manner as conté is used on paper (Fig. 380). They can also be dissolved in distilled water or a solvent, such as kerosene or turpentine, for different effects and washes.

Litho crayons are available in seven grades of hardness, ranging from No. 00, the softest, to No. 5, the hardest. European-made crayons, such as Charbonnels, reverse the numbering system, using No. 5

382. David Hockney drawing
model Celia Clark at Gemini G.E.L.,
Los Angeles, in 1973.
(See Fig. 384).

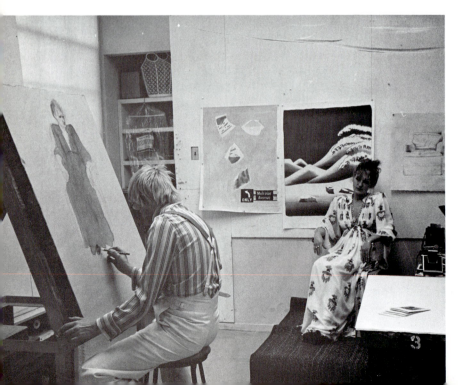

for the softer, greasier crayon. There is a considerable difference between the textures produced by the softest crayon and the hardest. The soft crayon produces a coarse-textured line; the harder crayon, by comparison, produces a sharper, brighter tone that reflects the grain of the stone more closely (Fig. 381). The crayon can also be turned on its side to create broad areas of tonality.

Litho pencils, made exclusively by William Korn, Incorporated, come only in the harder grades, Nos. 1 through 5. The core of each pencil is wrapped in paper that is peeled away from the tip for use. These pencils should not be mistaken for common black marking pencils. They are similar in appearance but vastly different in composition.

Litho pencils are convenient to use (Fig. 382) and can be sharpened with a razor blade or an ordinary coloring crayon sharpener. There is a distinct difference between the mark of a finely sharpened pencil and that of a blunt one. The blunt pencil, like an unsharpened crayon, will adhere mainly to the top of the grain, while the sharpened point will reach farther down into the grain and result in a much finer distribution of printing spots (Fig. 383).

It is not always easy to judge how middle tones will print, especially with subtle crayon and pencil drawings, because the stone or plate usually is a much darker shade of gray than the final printing paper. In order to compensate for this difference in tonality, make all tonal work stronger, on both stone and metal. This helps make the final print less stark in appearance (Fig. 384).

Lithographic Tusche

Lithographic tusche is available in solid or liquid form. Solid tusche is thinned with lithotine, turpentine, or distilled water before use. The liquid form,

above: **383.** These two details
of Figure 378 show
the No. 5 litho pencil (left),
and the Nos. 1, 2, 3, and 4 pencils (right).

below: **384. David Hockney.**
Celia. 1973.
Lithograph, 42½ x 28½".
Courtesy Gemini G.E.L., Los Angeles.

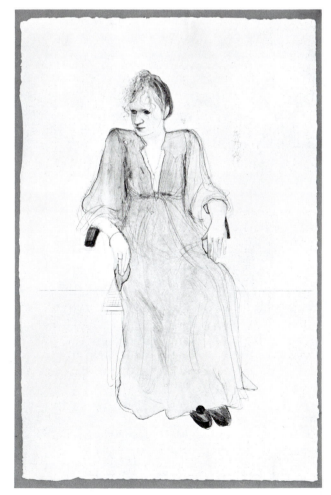

which already contains a little water, can be used as is
or diluted further with distilled water to varying con-
centrations for fine pen and brush work. Hard tap
water should not be used with tusche, because it can
cause the tusche to coagulate or create irregular and
unpredictable patterns. Once a dense, black layer of
tusche has been applied to the stone or metal surface,
its greasy and acid-resistant ingredients will with-
stand a strong etch solution and print as a rich, solid
area of ink (Fig. 385). Gum arabic can be used as a
stop out to create white areas.

Tusche Washes

The tusche wash, like the crayon drawing, produces
an effect that is unique to the lithographic printing
process (Fig. 386). It was designed originally as a me-
dium for making solids on the stone, and it was not
until many decades had passed that the possibilities
of making tonalities by diluting tusche with water
were first explored. The artist and printer Charles
Hullmandel used the technique successfully in 1840.
Because of its unpredictability, however, it was never
as widely used for a commercial lithographic tech-
nique as the crayon and pen-and-ink techniques.
Tusche washes are still among the most difficult of
lithographic images to etch and print accurately, par-
ticularly in large editions.

Stick tusche is better than bottled tusche for
washes, provided it is used immediately after being
mixed with water. It produces a smooth and uniform
dispersion of the greasy ingredients with the pigment,
so that the tonalities on the surface will be more in-
dicative of the tones that will finally print (Fig. 387).
Bottled liquid tusche, on the other hand, is not as
dependable for tonal work.

The mixing of the stick tusche and water and the
application of the wash both play an important role

left: 388. To make a tusche wash,
rub the stick tusche onto a dish
and mix it with distilled water.

below: 389. Tusche washes can also
be created with lithotine,
as in these two details of Figure 378.
The top detail shows the dry brush
technique.

in the final appearance of the print. Using a circular
motion, rub a substantial amount of the stick off onto
the center of a white ceramic dish or dry inking slab
(Fig. 388). Dissolve some of this tusche with a clean
brush and distilled water, mixing it well. Then apply
the dissolved tusche directly to the stone or metal
surface, with as little rubbing as possible. Rubbing
with the brush pushes grease particles into the sur-
face, creating a heavy grease layer that prints a much
darker tonality than intended.

Keep in mind that the amount of grease particles
is not always in direct proportion to the amount of
pigment visible on the surface. In other words, there
can be more or less grease on the surface than there
actually appears to be. The grease particles are trans-
parent, so their effect will not be seen until the image
is proofed. Some of the tonalities on the limestone
surface can be controlled in the etching process, but
when working with zinc or aluminum plates, most of
the tonalities depend on the way in which the tusche
washes are applied. For the most accurate tonal
gradations, use the brush judiciously and make as few
strokes as possible. It is a good idea to keep different
mixtures in separate containers, and if necessary, to
use separate brushes for each tonal mixture.

Turpentine or lithotine can also be used with the
stick tusche in place of distilled water (Fig. 389). This

390. Autographic ink
can create thin or heavy lines,
and smooth or varied textures,
as in these two details of Figure 378.
The top detail was done with a ruling pen,
the bottom with crowquill and speedball.

mixture produces some very fine gradations on stone when etched carefully, but it has a tendency to fill in the image badly on zinc or aluminum. Turpentine works well for tusche washes made on transfer paper, because it will not affect the paper's water-soluble coating. Corrections can be made easily on the paper simply by washing the surface with pure turpentine and adding new work.

Autographic Ink

Autographic (or zincographic) drawing ink, really a form of tusche, is a very smooth ink intended for fine linear work with the pen (Fig. 390). It flows easily on stone, metal plates, or transfer paper. Like tusche, it can be diluted for wash effects, but because of its transparent brown color, it produces an image that is difficult to read accurately.

Autographic ink is more effective than tusche on metal plates, because it has a higher grease content. It flows easily on ordinary uncoated papers (such as bond paper) and can be transferred to a stone or metal surface. To transfer an autographic ink drawing onto the printing surface, brush a thin layer of turpentine on the stone or metal, then fan it dry. (The turpentine makes it slightly more sensitive to grease, due to a minute trace of resin left after evaporation.) Meanwhile, place the completed drawing between damp blotters for 15 to 45 minutes, until it is slightly limp. The paper should not be wet, or else the drawing may dissolve from the surface. Tape the drawing, face-down, to the front edge of the plate or stone, and run

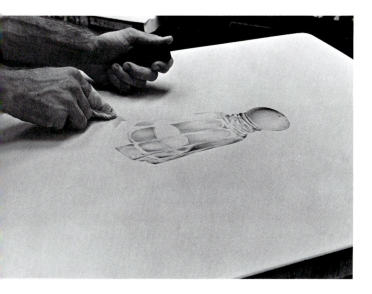

above: 391. Rubbing ink is applied
with a piece of soft cloth
wrapped around the finger.
It produces soft, cloudy effects.

it through the press once with a firm pressure. Sufficient grease will be transferred from paper to plate or stone to effect a good image. The image will be in reverse, and after etching, it will print in the same way as the original drawing.

Rubbing Ink

Rubbing ink comes in a slab $\frac{3}{4}$ by $\frac{5}{8}$ by 3 inches, in three grades—soft, medium, and hard. It is manufactured by William Korn, Incorporated, and is used primarily for extremely soft gradations and *sfumato* (cloudy, smoky) effects (Fig. 391). Apply rubbing ink by wrapping a finger in a piece of soft thin cloth, rubbing it first on the slab of ink, then on the stone or plate, building up tonalities slowly. More sharply defined edges can be made by stopping out with gum arabic and working from light to dark. Used as a crayon, the rubbing ink slab makes a heavy, greasy line similar in appearance to a crayon line but greatly magnified.

The particles of ink on the stone or plate have a very strong hold on the surface and can be given a much stronger etch than a comparable crayon-made tonal area.

Other Manners of Working on Stone or Metal

Airbrush Tusche diluted with distilled water to a workable consistency, or autographic ink or stick tusche dissolved in turpentine or lithotine can be used with an airbrush or spattered (Figs. 392, 393).

below: 392. In this detail of Figure 378
the white mark was made with gum arabic
stop out; the gradated tones were made
with tusche and an airbrush.

bottom: 393. **James Rosenquist.**
Water Spout. 1971.
Lithograph with toothbrush spatter,
29 x 21¼″. Courtesy Graphicstudio,
University of South Florida, Tampa.

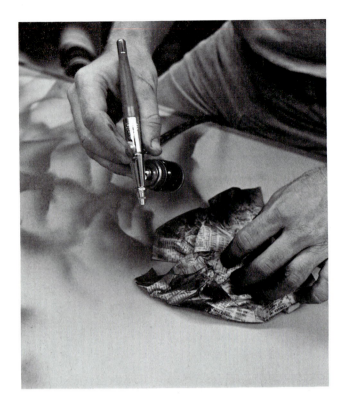

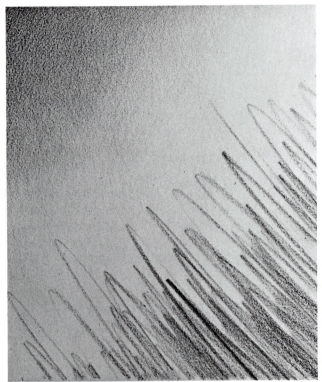

above: 394. Using an airbrush on a litho plate. The crumpled paper serves as a mask, giving the image a varied edge.

below: 395. Transfer ink diluted with turpentine helps make a convenient kind of "carbon" paper for direct use on a plate or stone.

right: 396. Prismacolor pencils make fine lines on the stone, as seen in this detail of Figure 378.

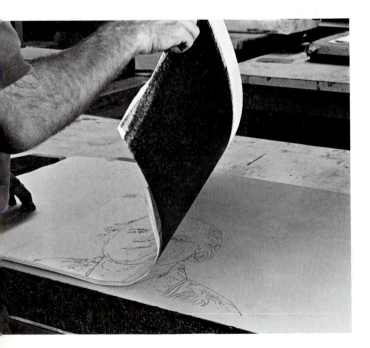

Gradated tones can be achieved on stones or plates (Fig. 394). Very fine work on stone should be treated carefully, so as not to destroy any of the small printing spots. On metal plates, especially zinc, the grease spots tend to spread slightly, making all work print somewhat more heavily than it appears.

A spray can of enamel or lacquer makes a useful substitute for an airbrush. The lacquer spray forms a permanent image on the plate or stone and is almost impossible to remove, so it should be used carefully to avoid overworking the tonalities. Lacquer and enamel are both receptive to grease and become the base to which the printing ink adheres.

"Carbon" Paper Quite beautiful effects can be achieved by using your own "carbon" paper (Fig. 395). This can be made easily by coating the back of a sheet of thin, smooth paper with some transfer ink diluted with turpentine. Use it directly on the stone or plate, just as you would an ordinary piece of carbon

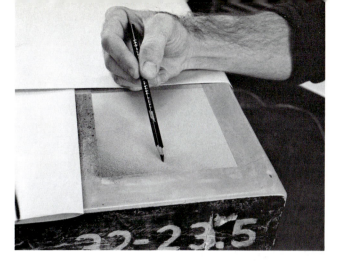

above: 397. Using a Prismacolor pencil.
The folded sheets of paper
protect the other work on the stone.

below: 398. A solid layer of tusche
is scratched with a sharp instrument
in one *manière noire* technique.

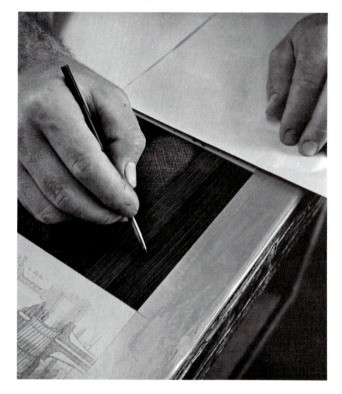

below: 399. The completed *manière noire*
section of the test stone
shown in Figure 378.

bottom: 400. This detail of Figure 378
shows the effect of using acid
to remove tusche in *manière noire* work.

paper. Its effects can be seen even more clearly when it is used on transfer paper.

Ultrafine Crayon Work Extremely fine detail can be obtained with a black Prismacolor pencil instead of a hard lithographic pencil (Figs. 396, 397). The stone or metal can be ground with a No. 300 or No. 400 carborundum, in order to give the surface an even finer tooth. The Prismacolor pencil has very little active grease content, but because it is a dense material, it resists the action of a light gum etch (about 4 drops of acid to 1 ounce of gum, or pure gum). The etch is left moist on the surface for about 15 minutes,

then blotted with newsprint, leaving a thin, even layer. Use a turpentine-asphaltum solution for the washout just before printing. This imparts grease to the image and helps to pick up minute detail.

Manière Noire *Manière noire* lithography can be used only on stone. The stone is first covered with a solid layer of tusche, with the image developed by scraping off varying amounts of the tusche (Fig. 398) or removing it with acid, after it is inked, in much the same way that a mezzotint artist would burnish tonalities from a solid black ground (Figs. 399, 400). This kind of work requires a quite strong

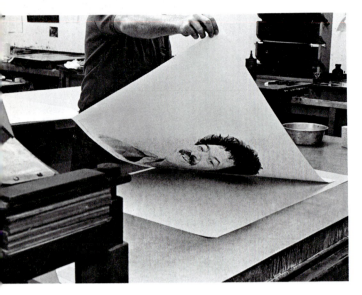

above: 401. A drawing made on transfer paper is positioned on the dampened plate before being run through the press.

right: 402. After being adhered to the plate under pressure, the paper is moistened with water.

below right: 403. The drawing is released onto the plate when the coating on the paper dissolves.

etch with gum arabic and nitric acid, in order to remove the grease that has penetrated the stone beneath the scraped areas. Once etched properly, however, it will withstand very long press runs with great image stability.

Transfer Paper

Transfer paper is as old as lithography itself. Early in the course of his experiments, Senefelder realized the advantages of using transfer papers, and he incorporated their use successfully into the techniques of his printing establishment.

Transfer paper is good-quality, dimensionally stable paper, with a water-soluble coating on one side. The drawing is made on the coated side, and the paper adhered under pressure to the surface of a damp stone or plate (Fig. 401). When the back of the paper is moistened (Fig. 402), the coating dissolves, releasing the drawing onto the printing surface (Fig. 403). Accurate transferring of images is a difficult art. In most printing workshops where stone is still used frequently, one person serves as the transfer specialist. To produce the sharpest possible image on a stone-to-stone transfer the printer must know just the right amount and consistency of transfer ink to apply. The technique can require considerable skill and experience for successful results.

Many other less critical techniques that would be difficult to use directly on the stone or plate are made possible with transfer paper (Fig. 404). For example, the paper can be placed over textured surfaces and rubbed with litho crayon or rubbing ink for an interesting effect in the style of a stone rubbing (Fig. 405). Collages can be made from small pieces of transfer paper imprinted with various textures; the assembled pieces are then transferred simultaneously to a stone or metal surface. Images can also be transferred from

below left: **404. Henri Matisse.** *Arabesque I.* 1924. Transfer lithograph, printed in black, 19$\frac{1}{16}$ x 12$\frac{5}{8}$". Museum of Modern Art, New York (Lillie P. Bliss Collection).

right: **405.** The textures of a leaf, a pen knife, and a button were produced on the stone by means of transfer paper in this detail of Figure 378. The inked pen knife was pressed into a rubber sheet and offset onto the transfer paper.

below right: **406. Edgar Degas.** *After the Bath.* 1885. Transfer lithograph, 7$\frac{1}{2}$ x 5$\frac{3}{4}$". British Museum, London.

one printing surface to another. Photoengravings or other relief images can be inked with transfer ink, printed on transfer paper, and transferred accurately to a stone or metal plate.

Transfer paper can be used for a number of special processes, among which is the *monotype*—in this case a print created by lithographic rather than intaglio methods (Fig. 406). To produce this effect, roll out a

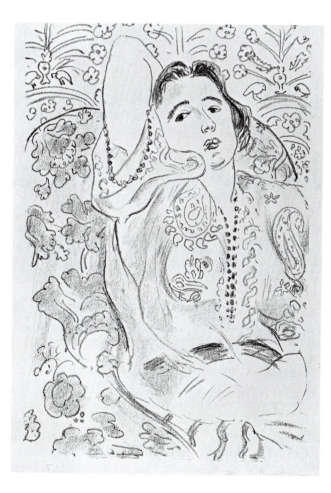

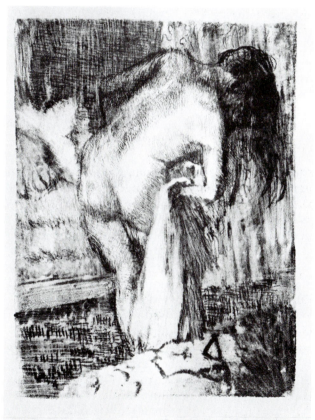

thin but stiff layer of transfer ink on an inking slab or a piece of glass. Place a sheet of transfer paper carefully on the layer of transfer ink, and make your drawing on the back, using a pencil, ball-point pen, or other instrument to apply pressure to the paper and pick up ink. When the desired image has been completed, it can be transferred to the printing surface in the same way as a drawing made on transfer paper.

Degas employed a unique variation of this technique. The artist would first draw onto a copper plate

with litho tusche and brush, then, after taking an impression in the monotype technique on transfer paper, would transfer the image to stone and in turn rework the image with brush, scraper, ink, and crayon. In this way he was able to retain the directness and fluidity of painting, and at the same time exert full control over the tonal structure.

There are also practical advantages to using transfer paper. The most obvious one is its light weight, which allows it to be worked on anywhere. The printing image also reverses itself when transferred, thus printing the same way as it was originally drawn. This is especially useful when typography or any form of writing is incorporated into a work.

Drawings can be made on transfer paper with any of the lithographic drawing materials: crayon, pencil, rubbing ink, diluted liquid tusche, and dissolved stick tusche. Care must be taken when using tusche diluted with water, because excessive scrubbing with the brush will remove the paper's water-soluble coating. The best results are obtained with tusche when it is used directly on the paper with relatively few strokes of the pen or brush. When dissolved in turpentine, stick tusche will not affect the coating. Corrections can be made simply by washing off the unwanted parts with benzine or clean turpentine and redrawing the image.

A variety of transfer papers are available from England, France, Germany, and Italy. There are also a few good methods for making your own (see below). Some commercially made transfer papers have lines ruled on the back, indicating the grain of the paper. These papers must always be run through the press in the direction of the grain and not against it, in order to minimize paper stretch.

Everdamp Paper Everdamp or yellow transfer paper is one of the most widely used transfer papers, and comes—as its name suggests—in a limp, slightly damp state. It should always be kept wrapped in plastic when not in use, and stored flat. Although this paper can be worked on directly with the usual lithographic materials, it gives the best results when used for making transfers from one stone or plate to another. It can also be used with transfer ink for transferring type to the stone or metal plate.

To transfer an image from one stone or plate to another, ink up the image with transfer ink, clean the margins, and dry the surface thoroughly. Next, lay the limp everdamp paper face-down on the image, cover it with a backing sheet, and run it through the press four or five times in both directions. Peel the paper carefully off the surface, and place it in position on another stone or plate. Run this through the press two or three times in both directions, using heavy pressure. Peel off one corner of the transfer paper and check the surface. If the image has not been transferred, increase the pressure on the press and run the stone or metal through twice more, again going in both directions. If even a ghost of the image appears, lift the rest of the paper and prepare the surface for printing, by dusting with rosin, then talc, and etching with a weak gum-acid solution.

White Transfer Paper White or opaque transfer paper generally comes with a smooth, shiny finish and lines ruled on the back to indicate the direction of the grain. The coating on this paper is often a mixture of ingredients such as starch, glue, gum arabic, and glycerine. All the usual drawing materials can be used on white transfer paper; as with everdamp, however, care must be exercised in using the tusche and water mixture to avoid dissolving too much of the coating.

The best way to transfer on white paper is to dampen very slightly the surface of the stone or plate

to receive the image. (There should be only enough moisture on the surface to make the paper adhere to it, and no more; in fact, the surface should appear almost dry.) Place the paper (face-down) and the backing sheet in position, then run them through the press in both directions two or three times, using light pressure. Once the paper is adhered, change the backing sheet, dampen the back of the paper slightly with water, and run it through the press four or five more times, increasing pressure as you go along. Repeat the procedure with more pressure, dampening the paper and changing the backing sheet again. After the paper has been run through the press about ten times, lift off the tympan and backing sheet, and sponge the back of the paper liberally with water. Let the water sit on the paper for about 5 minutes, then test a corner of the paper. If it lifts easily without sticking to the surface, then the coating has been dissolved completely and the image transferred to the printing surface. Blot any excess water and peel off the rest of the paper. Allow the stone or metal to dry, then process the image as usual.

Transparent Transfer Paper Transparent transfer paper, sometimes called *papier à rapport-pelure*, is available only from Europe, like most of the other commonly used transfer papers. It comes in a tissue-thin vellum stock without markings. To find the stickier coated side, test a corner of both surfaces with a moistened finger. Transparent paper can be used with the same drawing materials as the opaque white paper, and is transferred in the same way. Be sure no excess water is left on the surface before running the paper through the press; too much moisture will quickly cause the paper—especially the thinner variety—to wrinkle badly and crease under the press. Transparent papers are also useful for making overlays for color separations.

Making Your Own Transfer Paper Papers coated with the two formulas described below can be used in the same manner as white transfer papers.

An excellent and simple formula for making your own transfer paper is as follows. Mix 5 to 6 parts gum arabic (14° Baumé) and 1 part glycerine. (The glycerine prevents the paper from wrinkling and can be increased or decreased slightly for different papers. Too much will hinder drying, however.) Because it can be difficult to tell which is the coated side once the paper has dried, make light pencil marks on the back of each sheet. Place each sheet face-up on a smooth table top. Then, with a slightly dampened cellulose sponge, apply a thin coat of the solution to the unmarked side of the paper. Allow the first coat to dry, then apply a second coat. Use the sponge in different directions, taking care that the coatings are thinly and evenly applied. Dry the sheets face-up on the table top or in a rack.

The surface of the dry sheet of transfer paper should not be glossy, but it will have a slight sheen. (If it is glossy, the coating was probably applied too heavily, and the paper might slide off the stone or plate under pressure when moisture is applied in the transferring process.)

Although a considerable number of papers can be treated with this formula, one of the best and most stable papers is Basingwerk (light or heavy). Bond papers, drawing papers (both smooth and slightly textured), and many commercial offset papers can also be used successfully.

Another excellent formula for making transfer paper contains the following ingredients:

$1\frac{1}{2}$ ounces corn starch (dry powder)
1 liquid ounce glue (Franklin Hide Glue or Lepages Liquid Strength)
1 quart water

Kistler Etch Table
(Proportion of Acid
to 1 ounce gum arabic)

Drawing Strength	Yellow Stone			Light Gray Stone			Dark Gray Stone		
	drops nitric acid	drops phosphoric acid	grains tannic acid	drops nitric acid	drops phosphoric acid	grains tannic acid	drops nitric acid	drops phosphoric acid	grains tannic acid
very delicate	0	0	6	0	0	6	3	2	8
delicate	4	3	5	5	3	5	8	4	6
light	6	4	6	10	4	6	13	5	6
medium	12	5	6	15	5	6	18	5	6
heavy	15	5	6	18	5	6	20	5	6

Place all ingredients in a double boiler, and heat until the starch dissolves and thickens, becoming transparent. Again, mark the back of each sheet before coating, because the coated side dries to a mat finish that makes it indistinguishable from the uncoated side. Allow the mixture to cool *slightly,* and apply it to the unmarked surface of the paper with a cellulose sponge while still warm. Only one coat is necessary. Discard any leftover mixture, mixing fresh batches as needed.

Etching the Stone

Two factors determine the effectiveness of the etch on stone—the amount of acid in the solution, and the length of time it is allowed to react on the stone. In general, lightly drawn areas should receive a light etch and heavily drawn portions a stronger one. Images drawn with tusche require stronger etches than crayon work. Dark gray stones can withstand a stronger etch than softer yellow stones.

For most medium and delicate work, a weak etch left moist on the stone for a longer period of time will be preferable to a strong etch allowed to work briefly. The weaker etch promotes the development of a heavier layer of adsorbed gum and greatly increases desensitization of the nonimage areas without causing fine particles of the drawing to lift off. Stronger etches, however, are necessary in dark passages of the image where grease particles are close together. Because there is a tendency for grease to spread slightly from each particle, there is greater likelihood of filling in with a darker tonal area. The stronger etch, by its slight mordant action, removes any grease between close particles, and the adsorbed layer of gum more effectively contains the grease image.

Another important consideration in planning the strength of the etch is the manner in which the stone has been worked. If, for example, the artist used a soft crayon with light pressure, the particles of grease have only a tenuous hold on the stone, and too strong an etch can cause them to lift, destroying the tonality.

Because of the many variables involved, exact timings and proportions for the etch solution are difficult to determine. Only experience with a considerable number of different etches, stones, and

types of drawing will help in this regard, although the Kistler Etch Table opposite is a useful general guide to appropriate etch strengths. The beginner is advised to start with one or two types of stones and become thoroughly familiar with their characteristics under many different drawing and printing situations.

The use of phosphoric and tannic acid, as listed in the Kistler Etch Table, has a combined reaction, which creates different effects in the etch. The tannic, moreover, hardens the gum slightly upon drying, thus making the adsorbed gum layer more durable.

The phosphoric acid tempers the effect of the nitric acid, making it less harsh.

Many printers prefer an etch table that employs only nitric acid and gum arabic. The general etch table reproduced below, based on only these chemicals, provides a reliable guide for many situations.

Etching Techniques

Most professional printers have developed their own personal ways of determining the strength of the etch

General Etch Table for Stone
Drops of Nitric Acid per Ounce of Gum (14° Baumé)

Drawing Material	White/Yellow Stone				Yellow/Gray Stone				Gray Stone			
	delicate	light	medium	heavy	delicate	light	medium	heavy	delicate	light	medium	heavy
crayon & pencil #5			4	6–8		2	5	8	0–2	4	6	8–10
#4			4	6–8		2	5	8	0–2	4	6	8–10
#3		1	6–8	8–10	1	3	7	10–12	2–4	4–5	10	12–15
#2		2	6–8	10	1	3	8	10–12	2–4	6	10–12	12–15
#1	1	2	8–10	10–12	2	4	10	12–16	5	6	12–14	15–20
#0	1	3	8–10	10–12	2	4	10	12–16	5	6	12–15	15–20
tusche washes liquid or stick dissolved in water		2–3	8–10	10–12	5–8	8–12	12–15	18	8–10	10–12	18–20	20–25
tusche washes stick dissolved in lithotine	3–5	5	8–10	10–12	5	5–8	15	18	8	12	20	25
rubbing crayon	2	2–5	8–10	12–15	4	5–8	15	20	5–7	8–10	15–20	25
zincographic spray tusche spray		4–6				5–8	5–8			10–12	10–12	
autographic ink linear work or solid tones		5				5				5–8		

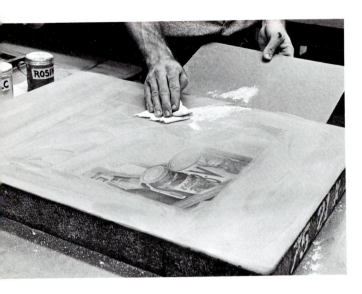

left: 407. Dust the stone
with rosin and talc before etching,
brushing off the excess.

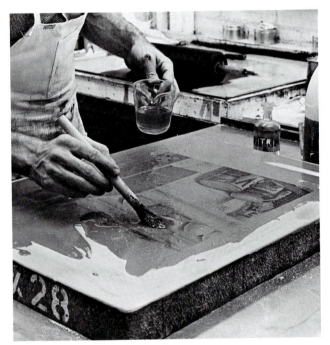

above: 408. Distribute the etch
over the stone with a brush.

below: 409. Etch darker tonalities
with a stronger solution,
applied with a bamboo brush.

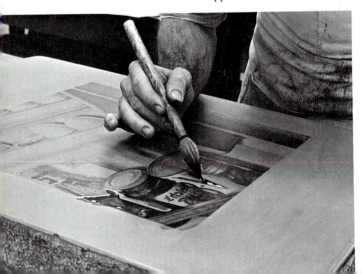

formula. Some prefer measuring each drop of acid carefully into a beaker; others might judge the amount of acid to use by watching the reaction on the surface. An old method for testing weak etches was to put a drop on one's tongue; the degree of tartness indicated its relative strength. This method is not recommended.

Since there is no visible reaction on the stone when using very weak etches, it makes sense to measure out the acid carefully when preparing a weak solution. An etch of medium strength begins to create a slight effervescence on the stone after a few seconds; a strong one shows an immediate, violent reaction.

Gum arabic, when used without any acid, will effectively desensitize most stones, with the exception of the darker gray ones. It can be used alone as a weak etch preparation for lightly drawn crayon work. For this purpose, however, a slightly more viscous solution of gum arabic (made from crystals or powder) is preferable.

Before etching the stone, dust the work lightly with rosin, then talc, brushing the excess off the stone (Fig. 407). (The rosin adheres to the greasy parts of the image, acting as an additional acid resist, and the talc helps remove the excess rosin.) Next, prepare a weak etch solution that will be about the right strength for the lightest parts of the drawing; pour this on the stone and brush generously over the entire surface (Fig. 408); or, *only* if the etch is very weak, spread with your hand. Leave the etch on the stone (brushing occasionally to distribute evenly) for 10 to 30 minutes or longer, as long as it does not dry. The thicker the application, the longer it can be left on the stone without danger of its drying out. Blot up excess etch with a sponge.

A slightly stronger etch can now be applied locally to the next darkest tonalities with a small brush (Fig. 409). (Stronger etches should *not* be applied with the

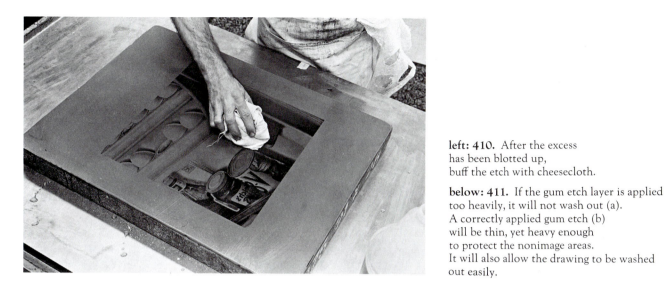

hand.) Japanese or Chinese brushes that have no metal parts are ideal for this purpose, because their sharp points can reach fine details on the stone. Depending on the nature of the drawing, several increasingly stronger etches may be necessary. These are applied to the darker tonalities in a similar manner. The stronger etches should be left on for only a few minutes, or until the visible effervescence on the stone stops.

After the etching is completed, the excess etch should be blotted up, then buffed with cheesecloth until only a thin layer remains (Fig. 410). It can then be allowed to dry. Never let a heavy layer of etch or gum dry on the stone, because it will crack and pull off parts of the drawing.

Buffing the gum or etch down properly is a very important step, on both stone and metal plates. The gum or etch layer must be thin enough to keep from cracking, yet completely protect the nonimage areas of the stone (Fig. 411). Special care must be taken with lightly drawn crayon work to avoid removing parts of the drawing while buffing. Separate sponges and pieces of cheesecloth should be reserved for use with gum only. These can be washed and used repeatedly. Another good way of smoothing out the gum or etch on the stone is to do the final buffing with the palm of the hand, smoothing gently until a slight drag is felt. (Once the etch has been buffed with cheesecloth, it is safe to use bare hands, even if the etch was strong.) Blotting with newsprint is also effective.

Etching Crayon Work

The etching of crayon work is relatively simple and direct. The lighter crayon tones bear special attention, however. Since very light pressure is used to make these tones, the particles of crayon have a very tenuous hold on the peaks of the grain. They can be

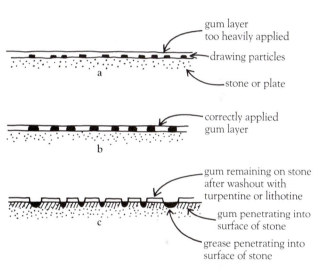

gum layer
too heavily applied

drawing particles

stone or plate

correctly applied
gum layer

gum remaining on stone
after washout with
turpentine or lithotine

gum penetrating into
surface of stone

grease penetrating into
surface of stone

removed inadvertently by using too strong an etch or by rubbing too hard when applying the etch or the gum. The best manner of treating these delicate tones is to apply a liberal amount of etch carefully over the stone, letting it sit undisturbed for at least 10 minutes (preferably longer). Blot up the etch with newsprint until only a very thin layer remains. This eliminates the rubbing or buffing that often destroys light tones.

The strength of the etch for light crayon work is important. It is almost impossible to use too weak an etch. Pure gum arabic or a solution of 1 to 3 drops of nitric acid per ounce of gum is usually sufficient, except on the blue-gray stones, which require from 4 to 6 drops per ounce. When gum arabic is used alone, a slightly thicker, heavier solution is often used.

Medium and dark crayon tones are best etched by using a carefully measured solution and estimating the amount of time it is to be left on the stone. An etch sufficient for the middle tones will usually consist of 5 to 10 drops of acid to an ounce of gum on the average stone but will vary on the yellow and darker

General Etch Table for Zinc

A = gum arabic, pH 4.0 to 4.5
B = Hanco Cellulose Gum, pH 5.5
C = Hanco Cellulose Gum (acidified), pH 2.9

Drawing Material	Drawing Strength		
	light	medium	heavy
crayon and pencil #5, #4	A—50% B—50%	A—25% B—75%	B—100%
#3, #2	B—100%	B—100%	B—90% C—10%
#1, #0, #00	B—75% C—25%	B—75% C—25%	B—50% C—50%
tusche washes liquid or stick dissolved in water	B—100%	B—75% C—25%	B—50% C—50%
tusche washes stick dissolved in lithotine	B—90% C—10%	B—50% C—50%	B—25% C—75%
rubbing crayon	B—75% C—25%	B—75% C—25%	B—50% C—50%
autographic, zincographic, or tusche spray	B—100%	B—90% C—10%	B—75% C—25%
autographic ink linear work or solid tones	B—75% C—25%	B—50% C—50%	B—50% C—50%

General Etch Table for Aluminum

A = pure gum arabic solution, pH 4.0 to 4.5
S = stock solution of 1½ ounces phosphoric acid and ½ gallon gum arabic (14° Baumé)

Drawing Material	Drawing Strength		
	light	medium	heavy
crayon and pencil #5, #4	A—75% S—25%	A—75% S—25%	A—50% S—50%
#3, #2	A—50% S—50%	A—50% S—50%	A—25% S—75%
#1, #0, #00	A—25% S—75%	A—25% S—75%	A—20% S—80%
tusche washes liquid or stick dissolved in water	A—25% S—75%	A—50% S—50%	A—10% S—90%
tusche washes stick dissolved in lithotine	A—50% S—50%	A—25% S—75%	S—100%
rubbing crayon	A—80% S—20%	A—50% S—50%	A—25% S—75%
autographic, zincographic, or tusche spray	A—75% S—25%	A—50% S—50%	A—40% S—60%
autographic ink linear work or solid tones	A—80% S—20%	A—60% S—40%	A—60% S—40%

gray stones. Dark crayon tones can stand an etch containing 8 to 16 drops of acid to an ounce of gum, and this greater concentration will produce a noticeable reaction on the surface.

Etching Tusche

Solid areas of tusche present few problems in etching. Once it has been laid down, tusche will print as a solid area whether etched strongly or weakly, since it is a heavy layer of greasy, acid-resisting substances.

In contrast, the etching of tusche washes is more complicated. The wash is by far one of the most difficult drawing techniques to etch and print successfully. The best guide to etching tusche washes (except the lightest tones, for which either the Kistler Etch Table or the general table on page 239 can be used), is by observing the reaction of the etch on the stone. Tusche always demands stronger etches than crayon work, and the proportion of acid to gum can go as high as 25 to 30 drops of acid to an ounce of gum. The acid in the gum should be increased until an effervescence can be seen within a tonal area, especially with the light-medium to medium-dark tones. When the reaction of the etch can be seen, this means it is working between the particles of grease. If no reaction is visible, even with a very strong etch, you can be

certain a solid layer of grease covers the area, and it will print as a solid tone even though it might appear as a middle or darker one.

Areas where tusche has been laid down solidly and scraped with a point or razor blade, such as in the *manière noire* technique, must always be etched very strongly. The stone in the exposed areas will have a slightly more yellowish cast than the areas on which tusche was not applied This is due to the fact that grease from the tusche has penetrated the image areas and still remains in the stone, even though most of the tusche has been scraped from the surface. The etch, therefore, must be strong enough to eat away the grease and desensitize the scraped parts.

After the etching has been completed, buff down the etch to a thin film and fan dry. The edges of the stone can now be rounded with a file (Fig. 365), then smoothed with snakeslip and water. Afterwards, a strong etch applied to these edges will help prevent them from taking ink during printing.

Etching Zinc

Although aluminum has almost entirely replaced zinc for lithography, zinc continues to be used in some commercial houses and private workshops.

Etches for zinc can have either a gum arabic or cellulose gum base. It has been found that cellulose gum etches have a greater capacity to desensitize zinc than aluminum, and that gum arabic reacts better and more efficiently on aluminum than on zinc. Either type of etch works well on zinc if applied correctly.

A good basic cellulose gum solution includes dry cellulose gum, water, and formaldehyde. The formaldehyde acts as a preservative, and has a slight hardening and tanning effect. This solution, which is available commercially, can be used alone as a mild etch, especially for delicate crayon work. Its pH value is about 5.5. For a wider variety of uses, an acidified cellulose gum solution, containing the basic solution plus phosphoric acid and magnesium nitrate, can be used. A commercially available preparation called Hanco Cellulose Gum (acidified) is good; its pH (about 2.9) makes it a good basic etch for metal.

Opposite is a table of suggested etch strengths for zinc. The etch should be applied with a wide brush or sponge, covering as much of the entire plate as possible with each stroke. It should be left on the plate for 1½ to 2½ minutes, then carefully buffed down to a very thin layer and fanned dry. A second coat applied in the same manner is recommended for all cellulose gum etches to ensure that a heavy enough coating of the cellulose gum is left on the plate. *Cellulose gum dries to about one-fifth the thickness of a similarly applied gum arabic solution.*

Tannic acid (or "green") etch, a gum arabic-containing etch for zinc, includes these ingredients:

1 quart water
2 ounces tannic acid (technical grade powder)
1 ounce phosphoric acid (85%)
3 avoir ounces potassium chrome alum
2 quarts gum arabic solution (14° Baumé)
additional water to make 1 gallon of solution

After a time, this etch will turn green, but this does not change its working qualities. It is a basic stock solution and can be diluted with gum for different work in the same proportion as the acidified cellulose gum above.

Etching Aluminum

All aluminum plate etches are made with gum arabic, and are basically simpler than those for zinc. A good formula consists of:

1½ ounces phosphoric acid
½ gallon gum arabic solution (14° Baumé)

This will make an aluminum etch stock solution with a pH value of about 1.8 to 2.2 It can be used full strength for dark crayon work and all tusche work (except for fine washes), or made weaker by adding pure gum arabic solution. There is no need to add a preservative unless the gum arabic is mixed from crystals or powder, in which case ½ ounce of formaldehyde to a gallon of solution will keep it from spoiling. See the table opposite.

The etch is usually applied for 1 to 5 minutes—sometimes up to 10 minutes—after which it is buffed down to a thin layer and left to dry. Remember that the longer it is left on, the stronger its effect will be. For darker images a second coat can be applied briefly before washing the etch from the plate. For very fine crayons or tusche washes, pure gum arabic works well. It should be applied carefully with a soft brush to avoid rubbing off fine tonalities. After 8 to 10 minutes, buff very gently and let dry for several hours.

Pro-Sol, a commercially prepared fountain solution, makes an excellent etch for aluminum when combined with gum arabic. For a strong etch, the chemicals are mixed in equal parts. A lighter etch consists of 25 percent Pro-Sol, 75 percent gum arabic.

Inks
and Papers

Lithographic Inks

Ink is characterized by two basic qualities: *length* and *tack*. A *long ink* has an elastic, rubbery quality; that is, it will stretch out in a long string when pulled away from a surface. A *short ink,* by comparison, breaks away much sooner and has a consistency almost like that of lard or butter.

The tack is really the measure of the ink's stickiness. A simple test can determine this characteristic. Put a small amount of ink on a piece of paper, then press one finger firmly into the ink and lift up. The more tightly the finger sticks to the paper and pulls up its surface, the greater the tack of the ink. An ink should have enough tack to print the image cleanly, yet it should release completely and easily from the stone or metal without pulling fiber from the paper's surface. A long ink will generally have more tack than a short ink.

For bold images that have very little detail, an ink with a great deal of tack is best. This tackier ink will adhere well enough to the image areas, yet keep the white areas clean. It can also be applied in a heavier layer without danger of spreading. The most difficult printing situation arises when the image has both extremely fine detail and large, flat areas. In this event, a balance must be reached between the ink's greasiness and its tackiness. Large, solid areas will require a heavy deposit of ink and lighter tonal work much less. Because of this, the rolling pattern may have to be altered to apply more ink to solid areas.

The only inks that should be used with leather nap rollers (see p. 253) are those without added chemical driers. Offset inks that contain driers cannot be used, because they would harden the leather in a very short time.

Some distinction should now be made between inks used for proofing up the image and those more suitable for printing an edition.

Proofing and Roll-Up Inks

Inks for proofing, such as the French *Noir à Monter* (Charbonnel) or other roll-up inks, have a high grease content and are used primarily for building up the image on the stone or metal before printing. These inks contain additional fatty ingredients (wax, tallow, or oleic acid) to increase their affinity for the greasy image. They are also completely nondrying, and can be used for inking up the image before putting the

stone or metal plate away. Even after years of storage, they will still dissolve easily in turpentine or lithotine. Roll-up inks also can be left on the leather nap roller for extended periods without ill effect.

Transfer Ink

Although transfer inks contain less black pigment than roll-up inks, the two are very similar in composition and are sometimes used interchangeably. Transfer black ink contains a large percentage of tallow and never dries on the roller. It is a good idea to keep a separate roller for transferring. This roller will need to be scraped only when the nap packs down. In cold weather, transfer ink can become too stiff for use. Should this happen, a small amount of medium varnish or heavier litho varnish (see below) can be added to improve its working qualities.

Inks for Printing the Edition

Inks for edition printing should have the right body and tack, not take on too much water, adhere well to the image, and print both solids and gradations of tone. Because of its excellent tack and body, crayon black (or chalk black) ink is ideal for hand-printing editions. Crayon black ink is a fully pigmented ink that contains no drier but varies considerably in its nondrying characteristics depending on the manufacturer. In the United States and France, crayon black inks are generally made with carbon black pigment and linseed oil varnish milled finely together. Because the varnish tends to act as a natural drier, these inks will form a rubbery skin in the can and should not be left on the roller for long periods of time. A small amount of transfer ink, roll-up ink, or tallow added to the ink will slow down its drying tendency and will often improve its affinity for the greasy image as well.

Crayon black inks are not as greasy as transfer inks, roll-up black, or other proofing inks, and they have a greater amount of tack, which helps to keep the image printing cleanly over an extended run.

Sinclair and Valentine Stone Neutral Black is one of the best proofing and printing inks available. In fact, it is the only one that can be used successfully for both purposes, and was formulated specifically for hand lithography. Other good crayon black inks are made by Graphic Chemical and Ink Company and by Charbonnel.

Ink Modifiers

For many print runs the crayon black inks can be used directly from the can. In special situations, however, they may require small amounts of modifiers in order to improve their printing qualities. For example, when printing fine crayon or airbrush work, the ink could be made slightly more greasy to increase its affinity for the fine tonal image, yet it must still be quite stiff to prevent it from spreading out under the pressure of printing. This can be accomplished by adding some light No. 00 varnish or a small amount of reducing oil or kerosene to the ink to reduce the tack, then some magnesium carbonate to increase the body. A small amount of tallow or transfer ink mixed with the crayon black ink will also produce good results and increase the ink's sensitivity to detail.

When adding any modifier to an ink, begin with a small quantity of each, and do not add the modifier to the rest of the printing ink until you are sure that it has produced the correct results.

Following is a description of the most commonly used ink modifiers.

Lithographic Varnishes The most common varnishes are those made from linseed oil. To make the

varnish, raw linseed oil is heated to approximately 600°F. The longer it is heated, the thicker or more viscous the varnish will be. No. 00 varnish, which is only slightly more viscous than raw oil, is heated for less than 1 hour, while No. 8 varnish (body gum) can be heated for as long as 24 hours. The lighter varnishes (00, 0, 1, 2, 3) thin the ink and reduce tack; the heavy varnishes (6, 7, 8) give a slight body to the ink and increase tack.

Alumina Hydrate When mixed with litho varnish, alumina hydrate makes one of the best transparent extenders available for lithographic ink. It increases the length and flow of the ink and is excellent for diluting color inks to make tints. Most transparent white inks are made from litho varnish and alumina hydrate.

Magnesium Carbonate If magnesium carbonate is added to ink, it becomes transparent and increases the body of the ink. It will also greatly reduce gloss, and for this reason it is a valuable addition to color inks. It accepts and holds succeeding colors well.

Magnesia Magnesia, a mixture of magnesium carbonate and magnesium hydroxide, is used interchangeably with magnesium carbonate.

Calcium Carbonate Calcium carbonate is a fine white powder that can be used in place of magnesium carbonate for stiffening an ink and reducing gloss. It does not hold succeeding colors quite as well as magnesium carbonate, however, and because of its semitransparent quality it will slightly reduce the brilliance of a color.

Setswell Reducing Compound A product of the Handschy Chemical Company, Setswell Reducing Compound is a wax compound that is also available under other trade names. This substance reduces shine when color inks are printed one over another, and helps to make the same amount of ink transfer to a previously printed area as to blank paper.

Oleic Acid Oleic acid, present in most animal and vegetable fats, as well as in soaps, tallows, and linseed oil, represents one of the most active elements in lithographic inks, crayons, and tusche. It will increase the ink's affinity for the greasy image whether it is mixed with the ink in small quantities or rubbed directly onto the image. It is therefore often used by printers to build up an image that has been printing too lightly. Oleic acid should be used sparingly, because too much of it will cause a scum to form over the entire plate or stone. A small amount added to the asphaltum washout solution will help to strengthen the grease base on zinc and aluminum plates in many cases.

Kerosene-Magnesium Carbonate Mixture Kerosene and magnesium carbonate mixed together to form a stiff paste, when added to an ink in small quantities, will reduce gloss and allow superimposed colors to sink into the printed surface, producing good trapping of the ink.

Driers Two of the most common driers for lithographic inks are cobalt and manganese, both of which speed up the drying of the ink. Inks already containing driers rarely need more than $\frac{1}{2}$ ounce of drier to 1 pound of ink. The cobalt drier tends to dry from the top of the ink layer down, while manganese dries simultaneously throughout the ink film. For this reason, they are often mixed together in equal amounts to produce a drier that exhibits the best characteristics of each one.

Plate 24. James Rosenquist.
Iris Lake. 1975.
Nine-color lithograph, 3′ × 62″.
Courtesy Graphicstudio,
University of South Florida, Tampa.

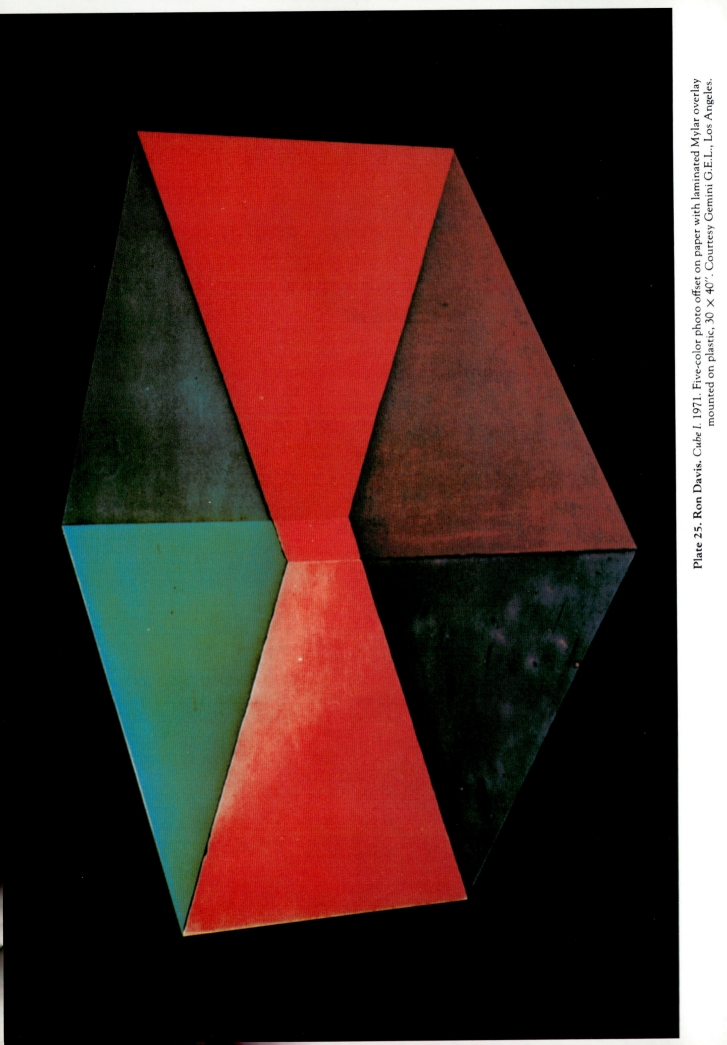

Plate 25. Ron Davis. *Cube I.* 1971. Five-color photo offset on paper with laminated Mylar overlay mounted on plastic, 30 × 40″. Courtesy Gemini G.E.L., Los Angeles.

Printing Papers

One of the most important considerations in printing a lithograph is the choice of paper. The paper can influence not only the manner in which a work is printed, but also the effectiveness and the beauty of the finished work itself.

Most fine papers are made with cotton fiber and occasionally linen fiber. The fiber is separated, chopped, and beaten before being made into paper. Each of these operations contributes to the characteristics of the finished paper. Chopping controls the length of the fiber, and beating controls its fineness. (Papermaking is described in detail in Chapter 10.) The addition of sizing (usually gelatin) controls the paper's ability to absorb water or ink. The more sizing, the less water or ink the paper will absorb. Sizing also acts as a binder, holding the fibers together and increasing considerably the paper's strength.

Although some efforts are being made to produce a paper suitable for hand-printing in the United States, most fine papers are still manufactured in Europe, where the art of papermaking has been practiced for centuries.

A paper should have certain basic characteristics in order to qualify for use in hand printing. Although these characteristics will vary from paper to paper, the following points are important general considerations to keep in mind.

1. The paper should be soft, yet not allow its fibers to be picked up easily from the surface by the ink.
2. It should have good dimensional stability, and not stretch uncontrollably under pressure.
3. It should be capable of absorbing several layers of ink without too much glossing.
4. It should be reasonably long-lasting and not become brittle or discolored with age.

Printing with Dry and Dampened Paper

If a paper makes good contact with all the minute traces of ink on an image, it will pick up more ink, and therefore the print will be more faithful to the original. The quality of the contact depends on the amount of pressure used, the basic texture and softness of the paper itself, and whether the paper is dry or damp.

A good paper can be printed either dry or damp, within certain limitations. There are definite advantages and disadvantages to using paper in either state.

Dry paper has one slight disadvantage—it requires very heavy pressure in order to push the fibers of the paper into close contact with the inked image. Dry paper also produces slightly harder-looking and more contrasting tonalities. Some artists prefer this crisp effect, even though the same image might pick up more detail and tonal nuance when printed on dampened paper. For color printing, however, dry paper has definite advantages. Registration is decidedly simpler and more accurate, due to the fact that there is less paper stretch. The problems of maintaining a constant and equal balance of moisture in each sheet throughout the entire edition are avoided. Dry paper is also easier to handle, and no drying or pressing is necessary once the printing of the edition has been completed.

The basic disadvantage of a dampened paper is its tendency to either expand or contract when wet, with the result that it becomes extremely difficult to produce close color registration. All papers, however, are made softer and more sensitive once they have been dampened. A dampened paper requires less pressure (making longer editions easier on the printer), picks up more detail from both stone and metal, and requires less ink to produce a fully intense image. An image printed on dampened paper is generally softer

in appearance than an image printed on dry paper. (This quality can be controlled somewhat by altering the stiffness of the ink; a stiffer ink makes an impression slightly more crisp.) For printing subtle crayon or tonal washes, dampened paper is far superior to dry paper, because of its ability to extract every tonal nuance the stone or plate is capable of producing. Since less ink is needed, as well as less pressure, there is less chance of the ink's spreading and filling in the image. Some heavily textured papers (such as Murillo, an imported heavy-weight paper) are too rough to use dry but will print beautifully when dampened. Many other rough or fully sized papers can be used to advantage if dampened, greatly increasing the list of good, edition-quality papers available for lithographic prints.

Dampening the Paper

If it is to be printed damp, the paper should be dampened until it is just limp, and not wet. Dampen the paper with a clean sponge, using distilled water to avoid discoloration. Use more water for heavier papers than for thin ones, and try to sponge evenly and quickly over the entire surface. Do not neglect the edges (Fig. 250). Heavy papers may have to be turned over and be dampened on the other side as well. Place the dampened sheets one on top of the other. If they begin to buckle as the lower sheets expand slowly, separate the bottom sheets and place the others as before. Once they have all been dampened, keep the sheets wrapped in plastic. Place them in a damp box (Fig. 412) or on a flat surface with a ¾-inch panel of plywood or other flat material on top. Set a weight on top so that the paper does not curl. Leave the paper wrapped in this manner for at least 4 or 5 hours (preferably overnight), so that the moisture has a chance to spread evenly throughout the paper.

412. The damp box is constructed of plywood and lined with plastic. The lid fits snugly into the box, so that when a weight is placed on top it helps flatten and distend the dampened sheets of paper inside. If the lid is made properly, moisture will not escape.

To dampen unsized or waterleaf papers, it is best simply to interleaf each sheet with a damp blotter and leave them wrapped in plastic overnight. You can also spray each sheet with water.

Never keep dampened paper wrapped in plastic for longer than five or six days, for mold can begin to form on the paper and create permanent stains. Although very small amounts of formaldehyde or carbolic acid can prevent—or at least retard—the formation of mold on the paper, it is not a good idea to add carbolic acid to the dampening water, because it can upset the paper's neutral acid-alkaline balance and could cause the paper to yellow in time.

Because dampened paper will pick up fingerprints even more easily than dry paper, some special clips for holding the paper by its edges are important for keeping the margins clean.

Paper Stretch

Paper stretch must be taken into consideration with all kinds of printing papers, although it is less of a problem with dry papers than with dampened ones. Most of the stretch occurs the first time a paper is run through the press under pressure, and becomes less each subsequent time. Whenever critical registration is needed, it is therefore recommended that a dry paper be used and that each sheet be run through the press once or twice with heavy pressure before any printing actually takes place. This will also smooth out some of the coarser papers, allowing for more consistent printing results. Unless the press bed is very clean, it is a good idea to lay the printing paper over a grained aluminum plate or litho stone to protect it. Paper stretches more when it is run through the press against the grain.

Suitable Papers

Following is a list of some of the finest papers available for lithography. A description of their characteristics will be found in Chapter 10, pp. 371–403.

- □ Arches Cover
- □ Basingwerk
- □ Copperplate Deluxe
- □ Crisbrook
- □ German Etching
- □ Inomachi (Nacre)
- □ Italia
- □ J. Barcham Green
- □ Rives BFK
- □ Roma
- □ Tovil
- □ Umbria

Printing

The Lithographic Press

Pressure of at least 8000 pounds per square inch is often needed for adequate printing of a lithograph. This is supplied by the lithographic press (Fig. 413). Unlike the etching press, which uses a heavy, rolling action to print, the lithographic press prints by means of a long, leather-covered scraper bar (Figs. 414, 415) that moves across a backing sheet (called a tympan) to press the paper against the ink on the stone or plate. Although lithographs from zinc or aluminum plates can be printed on an etching press with some success, the smooth, scraping pressure of the lithographic press produces superior results for the majority of images.

The Tympan

Several kinds of material can be used for the tympan—linen-grade phenolic G-10, glass epoxy, smooth fiberglass sheet, or Lexan, a newly developed plastic. Of all these, Lexan is superior in all respects.

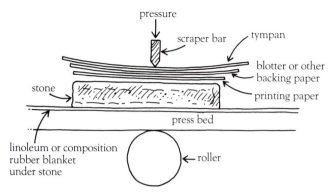

Diagram labels:

pressure

scraper bar — tympan

blotter or other
backing paper

stone — printing paper

press bed

linoleum or composition
rubber blanket
under stone — roller

left: 413. The lithographic press
and its parts. Pressure is exerted
by the scraper bar.

below left: 414. A strip of leather
being nailed to the scraper bar edge.
High-density polyethylene scraper bars
do not require leather strips.

below: 415. On the left, two typically shaped
scraper bar edges. Those on the right
are either too blunt or too sharp.

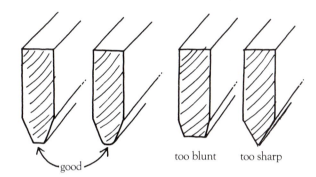

good too blunt too sharp

Rollers

The Leather Nap Roller

A good leather roller for inking the lithographic sur-
face must be soft and pliant, with a reasonably long
and dense nap (Fig. 416). In the inking process, it is
the nap that pulls out the fine detail and makes the
finished work sharp and crisp. The nap actually
reaches down into the grain of the stone or plate and

416. The leather nap roller
has a long, dense nap
that can ink the smallest detail.

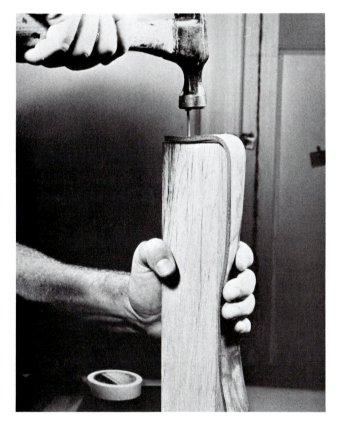

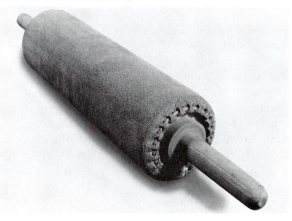

This material is clear, tough, dimensionally stable,
and not brittle. It is also available in sheets up to 8
feet long, enabling it to be attached to the press bed in
a special arrangement (Fig. 431). The tympan should
be about $\frac{3}{32}$ to $\frac{5}{32}$ inch thick.

Before use, the upper surface of the tympan
should be covered with a thin film of cup grease
wherever the scraper bar comes in contact with it. If
the tympan is a separate unit and placed in position
by hand, the grease should be kept away from the
edges so that the sheet can be handled easily.

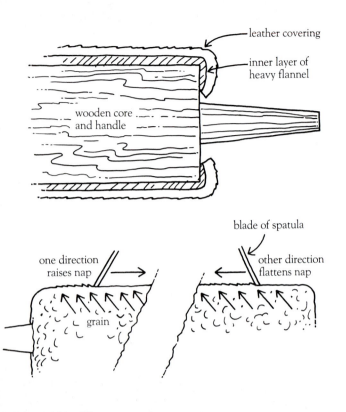

leather covering

inner layer of
heavy flannel

wooden core
and handle

blade of spatula

one direction
raises nap

other direction
flattens nap

grain

top: 417. The construction
of a leather nap roller.

above: 418. The nap is raised
when the leather is scraped
against the grain (left),
and smoothed flat when the leather
is scraped with the grain (right).

inks up every minute grease particle of the image. At one time it was common to have a set of these rollers, including one for each of the primary colors and black. Now, however, the leather nap roller is used almost exclusively with nondrying black inks for proofing, for hand-printing editions, or for making transfers from one stone to another.

Construction of the Leather Nap Roller The leather roller has a wooden core and handles made from a single piece of oak or maple (Fig. 417). The main cylinder of the roller is first covered with one or two layers of felt or flannel, over which calfskin or cowhide is carefully sewn. In the construction of nap rollers, the rough inner part of the hide remains on the outside. Smooth leather rollers have the other surface of the hide (the top grain) exposed. With either type of roller, it is best that the seam be sewn rather than glued, in spite of the expense and the difficulty of finding a skilled craftsman who does this type of work.

The combination of a good nap roller and properly dampened paper can produce an image whose quality and fidelity cannot be surpassed.

Breaking In a New Nap Roller It takes several weeks to break in a new roller, but it will take many months of continuous use and care before the roller reaches top condition. The following materials are necessary for breaking in the roller:

☐ neat's-foot oil or castor oil
☐ turpentine or kerosene
☐ No. 00 litho varnish
☐ No. 8 litho varnish (body gum)
☐ tallow
☐ roll-up ink or transfer ink

The most important step in breaking in a new roller is to saturate the leather with a nondrying oil and tallow. The oil and tallow keep the leather soft and help to prevent the total penetration of litho varnish and ink into the leather. Litho varnishes and most black printing inks have a base of heat-treated linseed oil, which in a relatively short time will oxidize and form a tough, rubbery skin. Without the protective barrier of tallow in the leather, the varnish and ink will penetrate and harden the leather.

One of the best procedures for breaking in a new roller is as follows:

1. Soak the leather in either neat's-foot oil or castor oil, allowing two or three days for the oil to penetrate completely into the leather. Add more oil each day until the leather will hold no more.
2. Determine the direction in which the nap lies. (This is called the *grain* of the leather.) Take a knife (a dull table knife will do) and scrape the leather in both directions. Scraping *against* the grain will raise the nap and give it a suedelike appearance. Scraping *with* the grain will lay the nap flat and smooth (Fig. 418). With the nap scraped in the direction of the grain, lying flat against the roller, mark one handle of the roller so

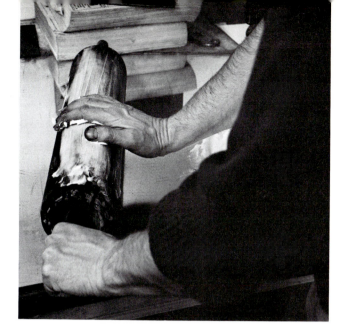

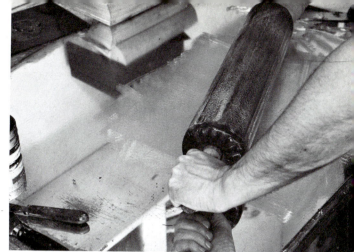

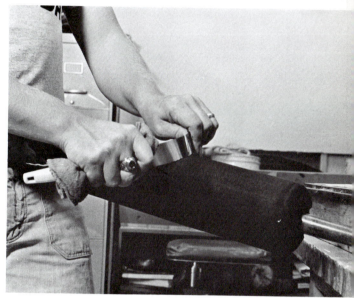

above: 419. Rubbing tallow into the leather.

above right: 420. Work the roller back and forth to spread the tallow evenly.

right: 421. Before storing the roller, scrape it clean of ink.

that it will always be easy to identify the way the grain of the nap runs. Moving the knife in the direction of the grain, scrape the neat's-foot oil or castor oil from the roller. Avoid scraping against the grain from now on, since this removes nap from the leather.

When most of the surface oil has been scraped off, rub mutton, deer, or beef tallow well into the leather (Fig. 419) and work the roller vigorously back and forth on the inking slab (Fig. 420). Scrape the roller in the direction of the grain, rub in more tallow, and work it in again. Repeat this procedure several times a day for at least two or three days, until the tallow has worked itself well into the leather.

3. Scrape the surface tallow off the roller and clean the inking slab with turpentine or kerosene. Pour a small amount of medium No. 4 litho varnish over the roller and work it in on the inking slab. Scrape the roller and work the varnish in at least half a dozen times. Next, scrape the leather and apply some No. 8 litho varnish (bodygum). Roll it out on the slab several times a day (scraping in between) for a day or two. The No. 8 varnish pulls up the nap of the leather and removes loose nap.

4. Finally, scrape off the No. 8 varnish, clean the slab, and roll out some stiff roll-up or transfer black ink. The roller is now ready to be used.

Care of the Leather Nap Roller It is not difficult to maintain a leather roller in good condition once it

has been broken in properly. If used regularly, it will give good service for many years. When in use it should be scraped daily. If it is not going to be needed for a few days or longer, it should be scraped of ink (Fig. 421) and smeared with tallow. Mutton and deer tallow are ideal for this purpose. Both are very dense animal fats and will keep the leather beautifully supple. Petroleum jelly, axle grease, and other petroleum products have a tendency to harden the leather and should not be used. Figure 422 shows stored rollers.

422. Stored rollers at Petersburg Press, New York; some are wrapped in foil.

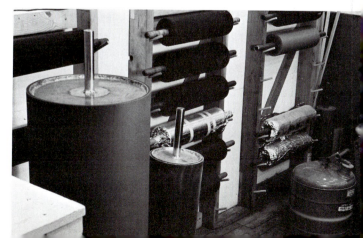

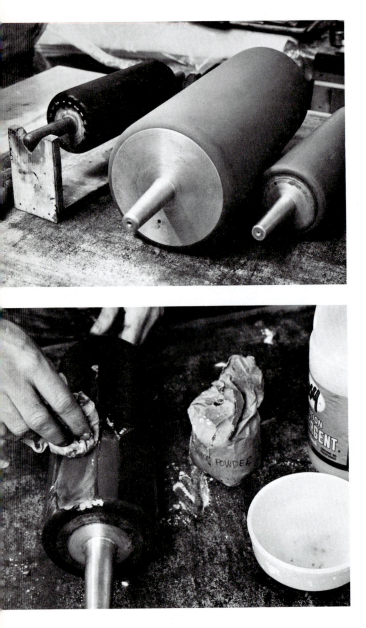

left: 423. A smooth leather roller (*left*) and two composition rubber rollers (*right*).

below left: 424. Cleaning a composition roller with powdered pumice, detergent, and water.

Composition Rubber Rollers

Most of the composition rubber rollers manufactured today are made completely of synthetic materials (Fig. 423). Although the exact nature of the materials is kept a carefully guarded secret by each manufacturer, the ingredients might include such exotic names as *chlorinated butadiene Neoprene* or *Buna-N*, which is a good synthetic rubber made from butadiene and acrylonitrile. Composition rollers are far superior to the rubber rollers of a decade or so ago in almost all respects. They have a greater life span, good dimensional stability, and resistance to most solvents.

The greatest advantage, for the hand printer as well as for the press operator, is that these rollers can be cleaned easily and used with any color ink. Previous colors can be washed out completely, allowing a yellow, for example, to be printed immediately following a black. One disadvantage of the composition rubber rollers is that they are not so sensitive to fine detail as the leather rollers. Because of their smoothness, they tend to make better contact with the top part of the grain on the stone or plate than with the crevices. This drawback is more apparent in hand printing, because the stones or plates generally have a coarser grain than commercial plates.

The relative hardness of a composition rubber roller is measured with the aid of a Shore hardness durometer. The Shore hardness scale goes from about 15 to 100. The higher the number, the harder the roller. Most hand rollers have a Shore hardness ranging from 25 to 30.

Care of Composition Rollers For cleaning composition rubber rollers, the safest and easiest solvents to use are kerosene and mineral spirits. These solvents do not dry so quickly as naphtha or gasoline but have a much higher *flash point*, making them safer to

Smooth Leather Rollers

Smooth leather rollers are made in the same way as leather nap rollers, except that the nap is on the inside and the top grain of the calfskin is exposed (Fig. 423). They are prepared in a way similar to the way in which the nap rollers are prepared, except that they are never scraped with a knife. These rollers give an additional tack to the ink, possibly due to the absorption of some of the ink's lighter oil into the leather. They are also useful in cleaning up an image that has become fuzzy. Ideally, a separate roller should be kept for each of the primary colors. Before being put away after use, smooth leather rollers are cleaned with turpentine or benzine and rubbed with tallow. To a large extent, composition rubber rollers have replaced the smooth leather rollers.

425. A convenient arrangement for the equipment needed in the litho workshop.

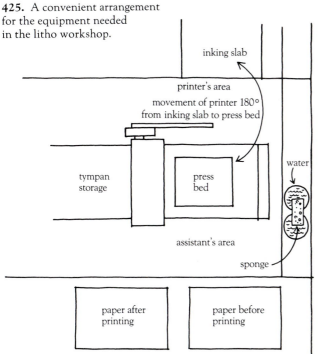

inking slab

printer's area

movement of printer 180° from inking slab to press bed

water

tympan storage

press bed

assistant's area

sponge

paper after printing

paper before printing

426. An excellent alternative layout for the workshop.

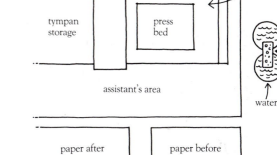

inking slab

printer's area

movement of printer 90° from inking slab to press bed

tympan storage

press bed

sponge

assistant's area

water

paper after printing

paper before printing

use. (The flash point indicates the temperature that must be reached before the vapors from the solvent become a fire hazard.) The flash point of kerosene is 130°F. By comparison, high-test gasoline has a flash point of minus 60°F, making it extremely dangerous to use. Naptha (benzine) has a flash point of 53°F, which means that it is considerably less volatile than gasoline, but much more volatile than kerosene.

After they have been in use for some time, composition rubber rollers can become glazed if they have not been washed thoroughly after each use. The surface begins to look smooth and shiny as particles of ink become embedded in the pores of the synthetic rubber. The safest method of cleaning these rollers is to use a mixture of some powdered pumice and either a solvent, such as kerosene, or a bit of detergent and water (Fig. 424). This cleaning will also restore the

texture of the rubber's surface and improve its inking qualities. Strong solvents such as lacquer thinner, acetone, toluol, xylol, or carbon tetrachloride should be avoided, since they cause the synthetic rubber to swell. If used sparingly and seldom, lacquer thinner or acetone can remove surface glaze on some composition rollers. It is best to follow the manufacturers' recommendations, however, to be safe.

Preparing to Print

Before you begin to print, the following preparations for setting up the workshop should be made (Figs. 425, 426):

1. Add grease to the tympan and scraper bar.
2. Make sure the roller is scraped in the direction of

the grain, put a small amount of roll-up black on the inking slab, and roll it out until you have a thin, even film.

3. Place some sheets of newsprint and printing paper on a table close at hand.

4. Prepare two sponges—one for dampening the image and another for use with gum. Do not interchange the two; either use sponges of different colors or trim one to a different shape.

5. If you are printing from a stone, place the stone on the pressbed and select a scraper bar of the proper size. The scraper bar should be wider than the printing image but narrower than the stone.

 Metal plates should be set on a larger stone or a panel of linen or canvas-grade phenolic, Benelux, or aluminum about 2½ inches thick. A small amount of water or gum arabic under the plate will create suction and make it adhere without slipping. (Gum arabic should not be used with Benelux, however.)

6. Check to see that the edges of the stone or plate are filed. If not, file them until they are round, then smooth them with some snakeslip and a little water. Apply a strong gum etch solution to the edges. After the etch has been allowed to sit for several minutes, rub it down to a thin, even layer and fan dry.

7. Set up start and stop marks on the press with masking tape.

The following equipment and materials will also be needed during the printing process.

- □ black proofing and roll-up inks
- □ printing inks (black, and color if desired)
- □ ink modifiers (litho varnish, alumina hydrate)
- □ prepared leather nap roller or rubber roller
- □ newsprint
- □ blotters
- □ proofing and printing papers
- □ sponges
- □ cheesecloth
- □ cotton or molleton
- □ clean rags
- □ gum arabic
- □ turpentine or lithotine
- □ asphaltum wash-out solution
- □ powdered rosin and talc (French chalk)
- □ acetic acid and nitric acid
- □ oxalic acid (optional)
- □ hydrochloric acid (optional)
- □ hydrofluoric acid
- □ razor blades or snakeslip
- □ fine-grained carborundum
- □ Kwik-Proof (optional)
- □ register needles (if printing in color)

The Wash-Out

The first important step before printing is to remove the greasy drawing material from the stone or plate. This procedure is called the *wash-out*.

Always check to be sure that the stone or plate has been gummed properly before washing the image out with turpentine or lithotine. If there is some doubt about the condition of the gum layer on the surface, wash the stone or metal with fresh water and recoat it with a thin, even layer of gum. Rub down the layer of gum with a piece of cheesecloth, and buff it down with your hand until it begins to dry. Then fan it dry and proceed to the wash-out. It is generally a good practice to do this with *all* images before wash-out.

Wash-Out Procedure

Pour a small amount of turpentine or lithotine onto the surface of the stone or plate, and rub the image lightly with a soft, dry cloth until the pigment and

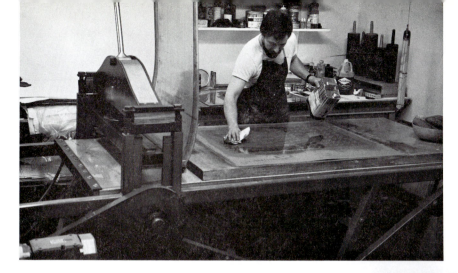

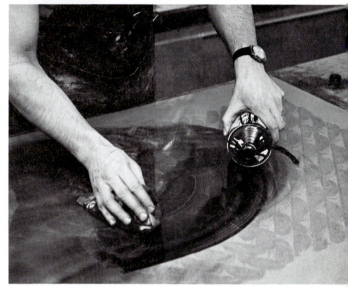

surface grease are gone (Fig. 427). The image seems to have disappeared completely, but actually a "ghost image" remains that is slightly different in tone from the nonimage areas.

The wash-out operation dissolves some of the greasy substances in the crayon and tusche and removes the pigment from the surface. On limestone, some of the remaining greasy substances will now penetrate more completely into the surface pores of the stone. With plates, even though there is no penetration into the metal, the wash-out allows the excess grease from the drawing material to be removed from the plate. The thin, dry gum layer on the nonprinting areas is unaffected by the solvent and protects these areas from contact with any greasy substances.

The image should wash out easily. Never rub hard (particularly on zinc or aluminum), because the image and nonimage areas are purely superficial and therefore especially vulnerable. When the excess solvent and the pigment have been removed from the surface and only the ghost image remains, apply a thin coat of asphaltum wash-out solution or some roll-up ink diluted with turpentine over the image (Fig. 428). Rub it down to a thin, even coat, and allow it to dry for a few minutes. Then wash the surface with water and a sponge and ink up immediately.

The asphaltum wash-out solution reinforces the thin and rather fragile printing base on stone, zinc, and aluminum. It makes the light tones stronger and allows the solid areas to pick up ink faster and more evenly. A few drops of oleic acid in the asphaltum solution will also help strengthen the grease base on zinc and aluminum plates.

The Wet Wash

If it is difficult to wash out the image with turpentine or lithotine, and streaks begin to appear, this indicates that the gum layer was applied too heavily and not buffed down thoroughly—a very common fault. To correct this condition, the image must be *wet washed*.

In this process, the gum is removed first with water. Then, while the surface is still wet, lithotine or turpentine is added quickly to remove the drawing; hence the term wet wash. The sequence of steps is important, and if it is not followed, any gum that remains on the surface could affect the ghost image once the surface pigment and grease have been removed. The surface should always remain wet during this procedure, because the washed plate is very vulnerable, and all traces of lithotine and greasy pigment should be removed from the surface with clean sponges and water. The surface, while still damp with water, is immediately inked up with roll-up ink. (The wet-wash technique is also useful for cleaning the printing surface in order to change to a different-colored ink.)

Cornelin, a mixture of solvent, gum arabic, and asphaltum, was designed as a one-step wash-out. Water is applied to the stone and a small pool of Cornelin is poured on top. A wet sponge is then used

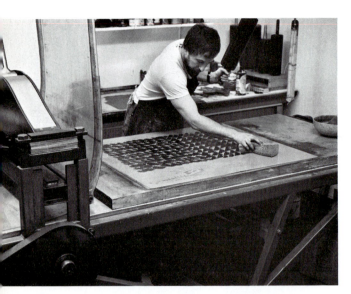

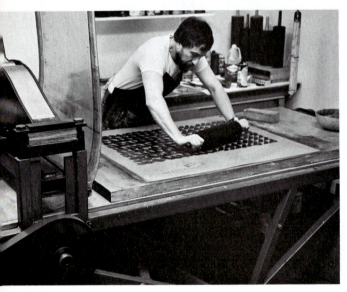

left: 429. Dampen the image
with a cellulose sponge and water.

below left: 430. Ink the image,
making sure the ink layer is even.

below: 431. Placing proofing paper
onto the inked plate in preparation
for the first proof. The tympan is attached
to a counterweight system.

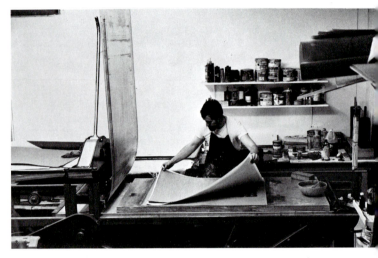

to wet wash the image. The solvent in the mixture dissolves any surface ink, while the gum is left on the nonimage areas and the asphaltum adheres to the image portions of the stone.

The Second Etch

The second etch is applied to the printing surface to stabilize the drawing, and to reinforce the chemical reactions that have taken place between the etch solution and the drawing material, and between the etch and the limestone or metal surface. This procedure is usually done before the first proof has been pulled.

In situations where only a few prints are required from a stone or plate, the second etch can be eliminated and printing carried out shortly after the first etch. The professional printing shop, however, requires the stability of the image over an entire edi-

tion, and so a second etch prior to printing is the standard procedure.

It is desirable to leave a period of time—from 1 to several hours—between the first and second etches. The same basic procedure applies to stone, zinc, or aluminum, except that different etches are suitable for different materials.

Wash out the image as in the normal preprinting sequence. Apply lithotine to the surface until the image is washed out, then apply a thin layer of asphaltum and dry the stone or plate. Next, dampen with a sponge and clean water and ink with roll-up ink until all aspects of the image appear satisfactory. This step need not be done on the press. A special table or area can be kept solely for this purpose and a leather roller maintained with roll-up black close by. When water from the dampening sponge has evaporated, dust the image with rosin, then talc. (Some printers prefer to dust zinc or aluminum with talc only, for fear of scratching the plate, but if the application is gentle, the rosin will cause no damage, and the two powders together give greater protection.) Remove excess powder, then etch with a light to medium etch for 2 to 5 minutes. Finally, buff down the etch and allow it to dry. Before printing, the image must be washed out again with lithotine.

For smaller editions, the second etch—if needed—can be given after the first proof is pulled. In this case, the procedures above should be followed.

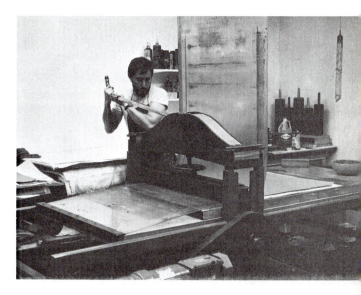

right: 432. Applying the pressure.
below right: 433. Pulling the first proof.

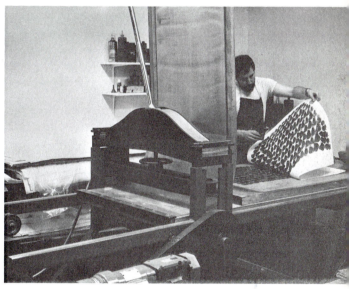

The First Proof

After the wash-out, continue to keep the surface damp with a clean sponge and fresh, cool water. Ink up the image, being careful not to favor any one area (Figs. 429, 430).

Once the image appears evenly inked, place a sheet of newsprint and a blotter on top. Lower the tympan and adjust for a firm but light pressure, then run the stone or plate through the press (Figs. 431–433). The first proof is normally light. Increase the pressure and ink up the image a second time without adding more ink to the slab. If the image is still too light after three or four prints, and yet the pressure feels adequate, then add more ink to the slab, a little at a time.

The balance between the right amount of ink and the right amount of pressure is one of the most important factors in good printing. Too much ink is perhaps the single most common reason for filling in of image detail. When proofing, therefore, increase the pressure first, then add ink afterwards. This is always a good rule to follow.

Remember that the printing surface must be kept continuously dampened with a thin film of water between inkings. The amount of water used is very important. If too little is applied, the surface will dry out and the ink will adhere to the dry spots; too much water will produce beading on the surface and interfere with the ink's adhering properly to the image. Try not to let the stone or plate dry out for extended periods while it is being printed. If the surface is left in an "open" state (that is, unprotected by a film of gum arabic or water) the process of oxidation will eventually cause the desensitized areas to pick up ink. This process is a slow one, however, and no anxiety need be felt if the stone or plate is left open for 10 minutes or so. If it must be left for longer than that, though, the image should be inked up and the surface protected with a thin film of gum arabic.

Once a proof has been made that appears satisfactory in every detail, ink up the image once more as if to make another print and clean the margins of the stone or plate carefully. Gum the image and fan dry.

Corrections and Alterations to the Stone

If you wish to change or alter the image after seeing the proofs, there are several different ways of doing so. It is possible to make changes at any point before the printing, if the image is processed properly.

Counteretching Stone

Before work can be added to the stone, the surface must be counteretched with a weak acetic acid and

water solution. This solution removes the adsorbed gum layer, calcium nitrate, and other substances from the nonimage areas of the stone, thus returning the surface in these places to its original condition. It will now accept greasy substances from the drawing materials once again.

Before counteretching, ink up the image fully and fan dry. Dust the ink first with rosin powder, then with talc. After washing the surface thoroughly to remove any excess powder, counteretch with a 5 to 10 percent solution of acetic acid and water, leaving it on the stone for 2 or 3 minutes. Small bubbles of carbonation will form on the surface, indicating that the process is working. Rinse well and repeat the process several times. Afterwards, wash the surface several times with clean water and fan dry. The stone is now ready to receive additions. Process the new work as you would an untreated stone.

If only a small portion of the stone needs to be counteretched, the solution can be put on the surface with a brush, then blotted up carefully and washed with clean water. To counteretch the whole stone, place it on the graining table and pour the solution over the surface. Brush the surface gently or rub lightly to remove the dissolved gum from the surface. Repeat several times, then wash the surface thoroughly with plenty of water and fan dry.

A stone may be counteretched many times, but it is important that the image always be well protected with ink, rosin, and talc. Otherwise, the action of the acetic acid—however slight—will gradually erode the image enough to make it perceptibly lighter.

Removing Part of the Image from the Stone

Small spots or fingerprints that show up in the proofing are removed easily with a razor blade or with a piece of snakeslip and a little water (Fig. 434). Etch these areas afterwards with a strong solution of nitric acid and gum arabic.

Another good way of removing unwanted work, and one which has the added advantage of not damaging the grain, is to apply a saturated solution of oxalic acid carefully to the area, leave it for a few minutes, then wash with clean water, being careful that none of the acid gets on the image. Then apply a thin layer of gum to the treated areas. Oxalic acid has strong grease-removing qualities, but it should also be handled with care because of its toxic effects. Do not allow it to come in direct contact with the skin. Apply it with a cotton swab or a rolled piece of felt.

Redrawing into an Area
Where the Image Has Been Removed

If the image is removed from an area that must be redrawn, it is important that the grain not be removed from the stone, in order for the new drawing to have a tooth. In this case, do not abrade the stone with either snakestone or a razor blade. Instead, ink up the image, apply a thin coat of gum, and fan dry. Remove the ink from the area to be redrawn with either benzene or high-test gasoline, then etch the area with a saturated solution of oxalic acid for 2 or 3 minutes. Wash the acid off carefully with water, then counteretch with the standard acetic acid and water solution for another 2 or 3 minutes, washing again with clean water. When the stone has dried, it is ready to receive the new drawing.

Corrections and Alterations to Metal Plates
Counteretching Zinc

As on limestone, the image on a zinc plate must be well protected with a layer of ink dusted with talc.

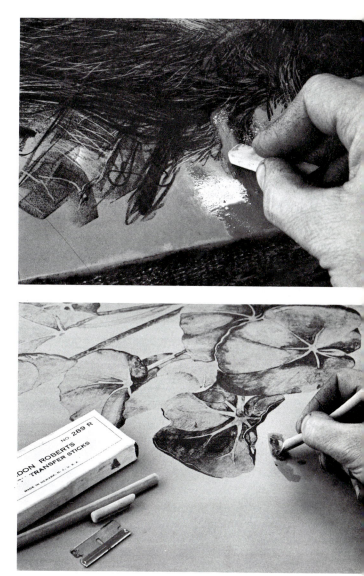

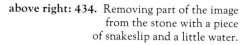

above right: 434. Removing part of the image from the stone with a piece of snakeslip and a little water.

right: 435. Using a plate eraser to remove part of the image from a metal plate.

Next, the entire plate or a portion of the plate must be counteretched before any changes can be made. A 5- or 6-percent solution of either acetic acid or hydrochloric acid and water makes an excellent counteretch for zinc. The counteretch solution is applied twice, for 2 to 3 minutes each time. The plate is then washed thoroughly and fanned dry. New work can now be added. (While washing the plate, rub the surface lightly with a wad of cotton or a piece of molleton to help remove sediment from the grain.)

Removing Work from Zinc and Aluminum Plates

Small spots on the plate are removed easily, either with a soft snakestone, plate eraser, or some powdered pumice and water (Fig. 435). These areas are then given an etch and fanned dry. The use of abrasive material on the plate removes some of the surface grain and should not be done when large areas are involved, since it could affect the plate's ability to hold water. For removing work over large areas without destroying the surface grain, the following procedure is effective.

First, gum the plate and fan dry, to prevent the ink and solvent from spreading from the image area. With a clean rag and some turpentine, remove the unwanted part of the drawing, following with some acetone or lacquer thinner applied in the same manner. Apply the acetone or lacquer thinner several times with a soft, dry cloth, until the ink is removed completely. Next—to remove residual grease—apply a strong plate etch for 2 to 3 minutes, rub down to a thin layer, and fan dry. To prepare the plate for receiving new work in this area, counteretch it, wash it with clean water, and dry.

To remove spots or parts of the image, an excellent solution is Polychrome Image Remover No. 229. This is a strong acid and solvent combination that effectively removes both grease and lacquered images.

Counteretching Aluminum

Aluminum is more difficult to counteretch effectively than zinc, because it is less affected by acids. The following solution, however, is recommended by the Graphic Arts Technical Foundation.

1 ounce ammonium alum
1 liquid ounce hydrofluoric acid (48%)
enough water to make 1 gallon of solution

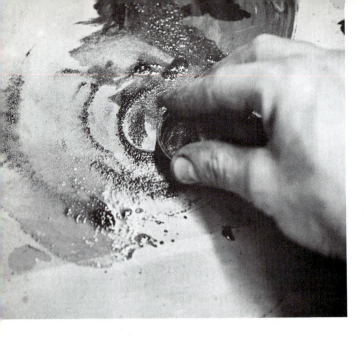

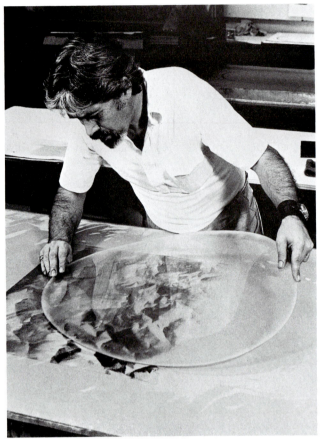

left: **436.** Regraining a small area of the stone with fine carborundum and a plastic bottle cap.

below: **437.** Laying a sheet of acrylic, in preparation for the air pressure deletion technique. (See Pl. 24, p. 247.)

The mixture is applied three times, blotted after each application, and washed well with water. New work can then be added to the counteretched areas. Because hydrofluoric acid is extremely dangerous, this solution must be used *with great caution.* Be sure to wear rubber or latex gloves, since this particular acid has the ability to penetrate the skin and attack bone marrow.

A safer counteretch can be made from hydrochloric acid, in the ratio of 3 ounces to 1 gallon of water.

Regraining a Portion of a Zinc or Aluminum Plate

Regraining a portion of a zinc or aluminum plate is a simple procedure that can save a plate from having to be redone for the sake of some small defect or change of mind. Not only is the grain restored, but also any remaining traces of the image are removed, creating a surface that is able to accept new work and hold water in an unbroken film. This is a good procedure to follow whenever a large area has been abraded with snakeslip and the smooth surface refuses to hold water evenly.

Sprinkle a small amount of fine-grained carborundum on the plate with a small amount of water, and rub with a small glass muller in a circular motion. A plastic bottle cap or glass stopper also works well (Fig. 436). Wash the plate often in order to check the grain, and—when it appears evenly grained—wash off the carborundum with water and counteretch the area before adding new work.

Air Pressure Deletion

Another method of eliminating unwanted image areas or spots involves an air eraser or airbrush with a carboloy tip, and No. 220 carborundum. This technique is particularly useful for small areas and close work near other image areas.

Ink up the image fully and dust with talc. Next, apply a layer of gum arabic and buff it down well. Talc the image again, and cover the parts of the image that are to be retained with cover stock or a sheet of acrylic (Fig. 437), using double-faced tape to hold it in place. Spray the area along the edge of the protective covering, using a sweeping motion and being careful to spray evenly (Figs. 438, 439). (If possible, this part of the process should be done in a clear area of the workshop or outdoors.) Once the edges of the unwanted areas have been sprayed, remove the remaining areas with Polychrome Image Remover No. 229, wiping off any excess with damp cloths. Sponge the treated area with acidified cellulose gum, wash out the entire plate, treat with asphaltum, and ink up with roll-up ink. The final step is to wash the treated area with a 5-to-1 solution of water and plate cleaner and apply Pro-Sol to the entire plate.

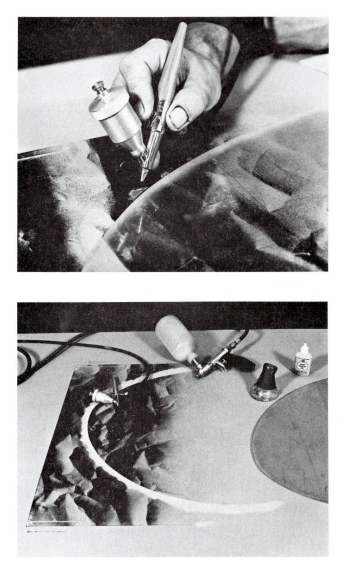

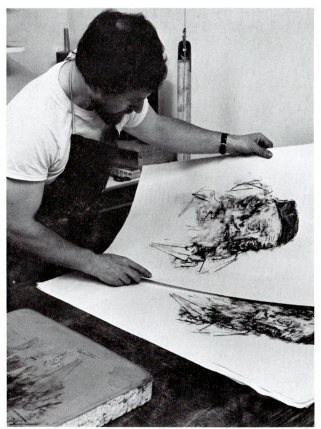

left: 438. Using the air eraser.

below left: 439. The finished deletion
(the white area on the plate)
and some of the materials used in the process.

below: 440. Each print in the edition
is checked against the *bon à tirer* proof.
This print is by Jack Levine.

The advantages of the air-pressure method are that it is fast and precise, and it will not damage the grain. It will remove image areas even after the plate has been lacquered as well (see p. 277).

The Printing Process

The skill and ability needed to print a large edition by hand is gained only after years of experience and familiarity with the medium. There is a considerable difference between pulling an edition of twenty or thirty prints and pulling a consistent edition of a hundred or more. Not only are special techniques required, but the printer must also have stamina and a temperament suited to this kind of production.

Each print must be checked against the *bon à tirer* proof, which is the final proof made before the printing of the edition begins. The *bon à tirer* proof shows the print as the artist wishes it to be and is the standard against which each subsequent print is judged (Fig. 440). The printer must inspect each print carefully as it comes off the press and be alert to any changes in the impression. Any necessary corrections must be made on the stone before these changes become a permanent part of the image.

Even atmospheric conditions can influence the printing routine and cause the printer to employ a different rhythm. Warm weather softens the ink, often necessitating the addition of a small amount of magnesia to increase its body. Cold weather has the opposite effect, stiffening the ink so that a small amount of light varnish is needed to make it workable. When humidity is low, the stone or plate will dry faster, making it necessary to dampen the surface more often. In high humidity, evaporation is slowed.

Printing Technique

The early stage of printing is the time during which many problems are likely to occur, since adjustments

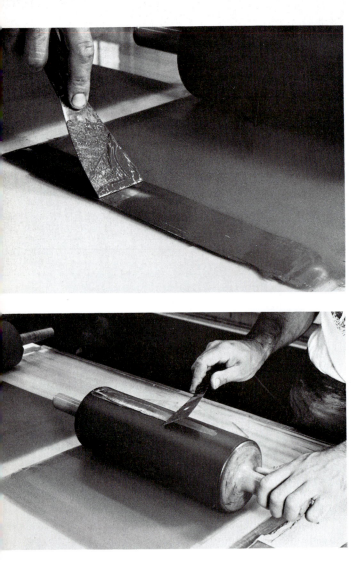

left: **441.** A strip of ink can be added to the top of the inking slab.

below left: **442.** Ink can also be applied directly to the roller.

below: **443.** To even out the ink on the slab, work the roller in a variety of directions, flipping it over occasionally.

Listen to the "sizzle" of the ink as you work the roller on the inking slab. When a small amount of water gets mixed in the ink, the sizzle will almost disappear. This happens each time the printing surface has been inked, because some water from the surface is picked up on the roller. Continue rolling the ink out on the slab until the sizzle returns, indicating that the water has evaporated. (A quite different condition occurs when water emulsifies with the ink, often after considerable printing has taken place. This is characterized by a gradual buildup of ink that is thick and gummy in consistency, without the tackiness or adhesion it had before. In this event, scrape both roller and slab, and add fresh ink.)

Proper handling of the roller is actually an art in itself. To a large extent, it controls the quality and consistency of the printing. There should be enough pressure exerted on the roller to make good contact with the image, yet the roller should not squeeze out the ink or push too much water away from the printing surface. Rolling the image slowly helps to deposit more ink, while a brisk inking with light pressure sharpens the image and helps pick up surface scum. If the stone or plate has dried out while being inked, do not run it through the press in this condition, because ink will be pushed into the surface where it has been picked up on the dry spots. Instead, dampen the surface and roll up the image again, quickly and with a light pressure. This brisk rolling will pick up the ink from the nonimage areas and restore the image.

The patterns of rolling are important. Do not always ink in the same direction. Vary the angle slightly each time so that a tendency to produce either dark or

are being made to the ink, and a pattern of rolling has not been established. Later, as the printing progresses, the difficulty comes in coordinating all the various elements in order to produce consistent results. For the single-color edition, use a good black ink such as Sinclair and Valentine Stone Neutral Black. This is less greasy than other inks and will keep the image cleaner and more open during the run. Do not use roll-up black or transfer ink for long runs, because these inks will cause the image to fill in.

One of the best ways to regulate the flow of ink is to add a strip of ink to the top of the slab (Fig. 441). Allow the roller to travel into the strip to pick up some fresh ink every three or four impressions. Another method is to apply the ink directly to the roller, and then work it back and forth on the slab (Fig. 442). When picking up ink from the slab, change the angle of the roller frequently, and allow it to spin at least a quarter-turn in the air after each stroke, so that when it comes down on the slab it will be in a different position each time (Fig. 443).

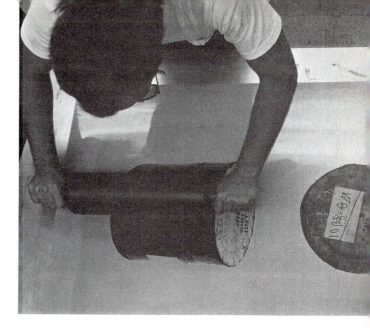

444. Dark areas of the image should receive an extra pass or two with the inked roller. It is helpful to feather the roller stroke from different directions.

light areas on the print will be minimized. Solid areas, however, will probably need an extra pass or two (Fig. 444). Adjust the pattern as you go along, until there is a perfect balance between the flow of ink, the number of passes, and the final results.

Try to regulate each procedure as much as possible. Count the number of passes it takes to ink up the image fully, as well as the number of passes needed to pick up the right amount of ink, keeping a constant bloom throughout the entire edition.

The final inking, just before running the stone or plate through the press, should be brisk to sharpen the image. Clean only the margins this time, and do not pass the sponge over the image, since this will blur the image slightly.

Enough pressure should be exerted by the press to enable the paper to make complete contact with all parts of the inked image. More pressure will be needed if the paper is printed dry or if the image is very large. Almost all the ink should come off onto the image after it is printed. If too much ink remains on the stone, it means either that the ink was applied too heavily or that the pressure exerted was too light. Remember, however, that to bring out every nuance and detail in the print, only just enough of both ink and pressure should be used.

As each print comes off the press, compare it carefully with the *bon à tirer* proof. After your eye becomes accustomed to the image, you will be able to tell immediately if any changes are taking place. If parts of the image are becoming lighter or darkening up, you can respectively "feed" or "starve" these areas by changing the rolling pattern. Again, over-inking is often the cause of filling in of the image. It is important to maintain a consistently paced rhythm in the dampening, inking, and printing cycle. Constant interruptions and breaks should be avoided, since they tend to promote inconsistent results.

Keep the dampening even over the surface by using as little water as possible. The sponging action also has a slight abrasive effect on the surface and will remove some of the adsorbed layer of gum in the desensitized areas in the course of printing. Regumming the plate or stone after every twenty or thirty prints will help restore gum to the surface.

If a gradual, slight darkening or filling in of the image occurs during the course of printing the edition, it is possible to correct it. The remedy *must* be applied as soon as a change is noticed in the print, to prevent the damage to the image from becoming permanently established.

One method is as follows. Ink up the image, and, using a continuous motion, quickly wipe a sponge with a small amount of weak to medium-strength etch over the surface. (If the sponge is not kept moving over the surface, it will "burn" the image.) Wash the stone or plate immediately with clean water, and continue to print as before. This technique will clean up the image and remove excess ink that may have spread from the image areas, before it has a chance to become part of the image itself.

Another technique, useful for stone, zinc, or aluminum, calls for printing the image several times on newsprint without inking it. This removes most of the ink from the surface. Next, roll a small amount of ink over the surface and etch with cellulose gum for plates or gum arabic for stone. Leave the etch for half an hour, then wash it off and print as before. If stronger measures are required, wet-wash the surface, moving very quickly, then roll-up and etch.

Scumming

Scumming occurs when grease forms on the non-image areas of the printing surface. It can be caused by three things: dirty dampening water or sponges, an

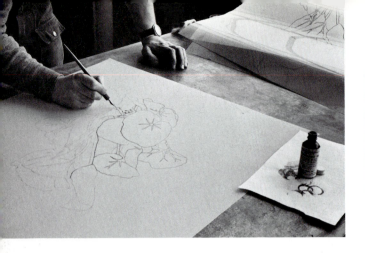

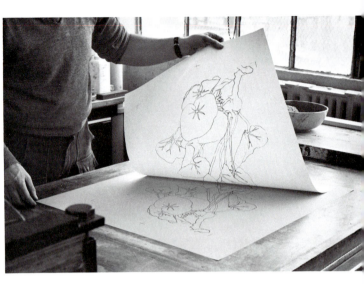

above: **445.** Drawing over the traced image
on the plate with autographic ink.

right: **446.** Pulling the key impression
on glossy stock.

ink that is either too liquid or too greasy, or a stone or plate that has not been adequately desensitized.

Scumming is often noticed in places where the roller comes down on the stone and where it changes direction. This is a normal problem and can be minimized by a final brisk inking over the entire stone. Scum in the margins also can be removed with a damp sponge or piece of foam rubber just before printing.

When printing from either stone or a metal plate, a weak fountain solution used as the dampening water sometimes can help to keep the image clear and reduce scumming. For stone, a few drops of phosphoric acid in the water will work well, although the image must be watched carefully to make sure there is no lightening of the image or mordant effect from the acid. For zinc and aluminum plates, a small amount of cellulose gum or gum arabic in the dampening water with a few drops of phosphoric or tannic acid will act as a good fountain solution.

Scumming can also be alleviated by the addition of magnesium carbonate and No. 7 or No. 8 varnish.

Color Printing

Color Inks

Color lithography presents untold creative possibilities (Pls. 22–25, pp. 214, 247, 248). Most color inks now being made are intended for offset lithography. This means that they are formulated for use with high-speed offset presses and have chemical driers added to their composition to speed up the drying time. The main problems in using these inks for hand printing are that they dry too quickly, and they are often too soft. These inks can, however, be ordered from the manufacturers without driers, or be modified successfully for hand printing. To use offset inks that contain driers, add a small amount of retarder.

Offset Inks and Hand Printing

An important consideration when using offset inks for hand printing is the relative thickness of the ink layer. The layer of ink deposited on the paper in hand printing is usually several times the thickness of that printed with offset machinery, although in both cases it is still microscopically thin. Offset inks, as a result, are designed to produce maximum luminosity and intensity when they are printed in an extremely thin layer. It is therefore necessary to *extend* offset inks with transparent white when printing by hand, in order to obtain an equivalent intensity of value. This is especially true when process colors are used to produce accurate full-color effects (for example, when blue and yellow overprint to make a brilliant green).

Transparent White One of the most useful inks in color lithography, transparent white is used for diluting colors and for making tints. It can be used in any quantity and makes colors lighter and more transparent. The only transparent whites suitable for hand printing are those without added driers. They will remain in the can for long periods without forming a skin. The viscosity of transparent white ink is often low, but this can be remedied easily by the addition of some magnesium carbonate or alumina hydrate.

Process Colors Process magenta, process yellow, and process blue-cyan, along with black, are the basic colors used in commercial offset lithography. They can also be used to advantage in hand printing, if their original function is understood. They are strong, intense, and very luminous colors designed for overprinting to give optimum full-color effects. With the three process colors and black, it is theoretically possible to create a complete spectrum. An understanding of the cumulative effects of one color printed over

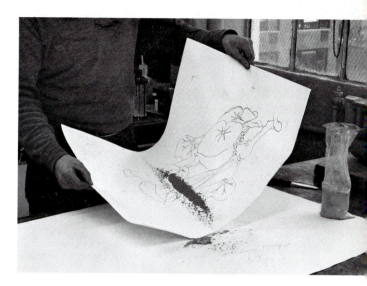

447. Dusting the key impression with iron oxide in preparation for transfer to other plates.

another will help the artist to create more effectively and with less effort.

If it is necessary, however, to use several shades of a color or a number of different colors to obtain the desired effects, then they should be used. The end results have the potential to produce a richness and quality that four-color halftone photo offset process work cannot match. In addition to the process inks, these basic colors are useful:

- ☐ ultramarine
- ☐ thalo blue
- ☐ thalo green
- ☐ lemon yellow
- ☐ vermillion
- ☐ primrose yellow
- ☐ violet magenta
- ☐ opaque white

These are standard colors, although it must be understood that different manufacturers may have different names for each one.

Registration of the Image on the Plate or Stone

As with any color printing technique, color lithography calls for accurate registration. It is necessary to have a basic plan regarding the size of the image, the number of colors, and the length of the edition. A major consideration when printing by hand will be the physical work involved. Since only one color can be printed at a time, it is best to consider carefully any steps that can cut down the number of colors without compromising the quality of the final result. There are several methods for ensuring accurate color registration. Some use key drawings, some other devices such as transferring and photographic techniques.

A Mylar impression should always be made of the key image (including registration marks) for checking all successive plates and impressions for accuracy. The dimensionally stable nature of Mylar makes the material ideal for this purpose.

Key Plate Transfer Method

One registration method uses a transfer technique and improvised carbon paper. Make a key line drawing of the image on tracing paper. Include two registration marks (small crosses or dots) away from the edges of the stone or plate and sufficiently close to the image to be reached by the scraper bar. Make a kind of carbon paper by rubbing one side of a piece of thin paper with either conté crayon or carbon pencil. Place this paper face down and the key drawing on top on a stone or plate. Tape the sheets down to prevent them from shifting, then trace the drawing onto the surface. After the first few strokes, check to see that the tracing has sufficient clarity, then proceed, making sure you include the registration marks as well.

Next, go over the traced drawing with a fine pen and autographic or zincographic writing ink (Fig. 445), then process the stone or plate in the usual way. Then make several prints of this key drawing on a smooth paper or Mylar sheet (Fig. 446). Make sure the stone or plate is completely dry before making the impression, so that moisture does not get on the paper and cause it to stretch or curl. (Moisture will not affect Mylar.) Use an ink that is quite tacky but reasonably stiff, so that each key impression will be as sharp as possible. Place some finely powdered iron oxide or other colored pigment on the printed sheet, and move the paper back and forth to make the pigment slide on the surface and adhere to the freshly inked drawing (Fig. 447). Slide the excess pigment back into its container, and tap the paper lightly on

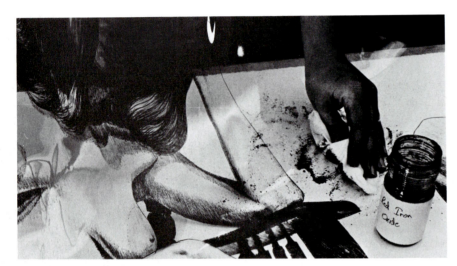

left: 448. The Mylar key impression
for Philip Pearlstein's *Two Female
Models on Rocker and Stool* is
dusted with iron oxide (see Figure 452).
This series of pictures
was photographed at Graphicstudio,
University of South Florida, Tampa.

below left: 449. The surface of the
plate is sensitized with Kwik-Proof.

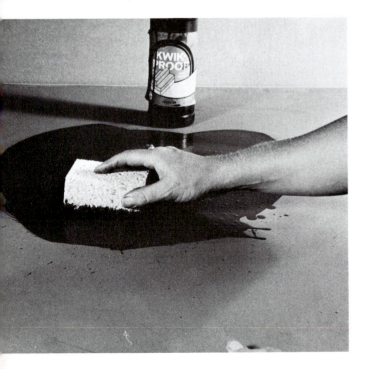

the back to remove loose powder. Lay the impression
in position face-down on another stone or plate and
run them through the press with a fairly substantial
pressure. This procedure can be repeated on addi-
tional stones or plates with freshly inked and pow-
dered key impressions for as many color printing sur-
faces as will be needed. This method of transferring
the key impression ensures that each image is identi-
cal and allows for close tolerances in registration.

Kwik-Proof Method

An alternative to the method described above em-
ploys Kwik-Proof, a light-sensitive material made by
Direct Reproduction Company. After the key image
and registration marks are made and processed, an
impression is pulled on a sheet of Mylar and dusted
sparingly with iron oxide (Fig. 448). The surface of a
zinc or aluminum plate is sensitized by being sponged
with Kwik-Proof (Fig. 449). After the solution has
been buffed down and allowed to dry in the manner

right: **450.** The sensitized plate and the Mylar are exposed in a vacuum frame.

below right: **451.** The Kwik-Proof is rinsed off the plate. The entire surface is now receptive to drawing materials.

bottom: **452.** Philip Pearlstein. *Two Female Models on Rocker and Stool.* 1975. Lithograph, 3′ x 6′2″. Courtesy Graphicstudio, University of South Florida, Tampa.

of an etch solution, place the stone or metal in a vacuum frame with the key image Mylar on top (Fig. 450). This will act as a negative. Close the frame and expose the sensitized surface to a 15-amp arc for about 2 minutes. The Kwik-Proof hardens on the exposed areas, becoming permanently affixed to the plate. On the unexposed areas, it simply will wash away. Remove the plate or stone, hose it with cold water (Fig. 451), and sponge it with a solution of 1½ ounces of ammonia and a gallon of water. The hardened Kwik-Proof that remains on the printing surface represents an exact negative image of the key drawing, and does not change the printing qualities of the surface in any way. The image is drawn with a greasy drawing material, then processed and printed like any other lithographic printing surface (Fig. 452).

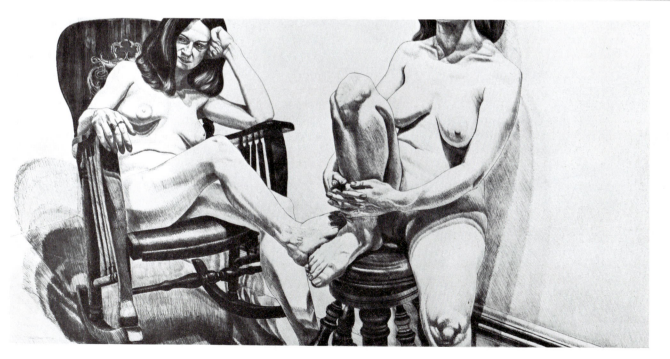

above: **453.** In the pin method
the register needle helps to align register marks
printed on the paper with marks drawn
or drilled on the stone or plate.

below: **454.** In the T-bar method mark the midpoint
of each of the short sides of the paper (a).
Align these edges with the T-mark
scratched on the plate or stone (b)
for registration (c).

Registration of the Paper on the Plate or Stone

Pin Method

When using the pin method of registration, it is necessary to print the registration marks (preferably dots or small crosses) on every sheet of paper with the first color. A pin or needle is then pushed through the paper at the center of each registration mark on every print, leaving a tiny hole. When registering the sheets onto the next stone or plate for the second color, a register needle is inserted into each small hole from the back of the paper. The point of the needle is then placed carefully at the center of the registration mark on the stone or plate, and the paper is eased down into position onto the surface (Fig. 453). Drilling a tiny hole at the center of the registration marks in which to fit the point of the needle will greatly facilitate finding the exact position. The visible registration mark can then be removed with snakeslip and etched, so that only the small hole remains.

Register needles can be made easily from pieces of wooden doweling about the length of an ordinary lead pencil. A needle or pin is pushed into the center of one end, so that only about $\frac{1}{2}$ inch of needle protrudes. Some fine etching needles are ideal.

T-Bar Method

Another very good registration method, and one that is actually easier to use than the pin method, involves marking the midpoints of the ends of each sheet of paper, using a sharp pencil on the back. The paper is then placed up against a T-mark scratched on one end of the plate or stone, and the opposite end laid down so that its mark lines up with a scratched mark on the stone or plate (Fig. 454). The only drawback to using this method is that the printing paper must always be

a window method

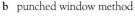

b punched window method line up cross on paper
 with cross on plate

c

the marks on either side of the hole on the back with a sharp pencil. Each subsequent color can be placed easily and accurately. The amount of paper stretch will also be seen readily in this method and can be compensated for by a slight movement.

Punched Holes Method

Another extremely accurate registration device incorporates a multiple hole-punching device that creates holes in both the plate and paper at the front end of the plate. Special metal register buttons are fitted from underneath the plate up through each hole. The holes in the paper are then fitted over the buttons for each impression. For stone, the register buttons can be attached to the leading edge of the stone surface, provided the stone is large enough and the buttons far enough away to avoid interference with the scraper bar and tympan. The buttons ($\frac{1}{4}$-inch round hole straighteners), adhesive tabs, and multiple hole punches are all available commercially.

Registering Large Prints

Special wooden rods raised from the surface of the plate, as shown in Figures 456 and 457, are a necessity

457. Pulling the proof being registered in Figure 456.

smaller than the plate or stone. A small part of the deckle on some papers will also have to be trimmed away to ensure accuracy.

Window Method

An often-used registration method is to print the first registration mark, then cut a triangle from the center of the point of registration (Fig. 455). This "window" allows the paper to be placed down into position quickly and eliminates peering under the paper to see the registration mark. Enough margin should be left on the paper to allow the window registration area to be trimmed off later.

A variation of this method involves printing a registration cross at each end in the first color, then—with a paper punch—making a hole about $\frac{1}{8}$ to $\frac{3}{16}$ of an inch in diameter in the center of the mark. Next, place each sheet on a light table and reinforce

when printing sheets of a very large size. These rods prevent the paper from dipping down and picking up ink before the sheet can be registered. The rods are left in position during printing, and are pushed out of the way as their ends touch the side of the press. In this way, the paper is lowered gradually to the surface just before the impression is made.

The Rainbow Roll and the Gradated Roll

Two special effects that can be achieved in color printing are the *rainbow roll* effect and the *gradated roll* effect. The same techniques are used for each; the difference between them is that the rainbow roll produces a consistent, rainbow-like effect using different colors, while the gradated roll uses different shades of the same color.

below left: 458. Laying strips of ink
on the slab for a gradated roll
being printed at Styria Studios, New York.

below right: 459. Also at Styria Studios,
an oversize roller covers
this gradated color area in one pass.

The inks used must be evened and smoothed out on the inking slab before they are applied to the stone or metal. Strips of each shade or color are applied to the top of the inking slab (Fig. 458), so that, as the roller travels back and forth on the slab, it can pick up more ink a little at a time to retain the same intensity of color. A very slight sideways motion of the roller when smoothing out the inks is usually necessary in order to blend them at the edges. When inking the image, however, only a back-and-forth motion should be used. This means that a roller large enough to cover the entire image in one pass is necessary (Fig. 459).

It is a good idea to mark the inking slab with masking tape at the point where the edge of the roller comes down, so that it always starts at the same place. The same applies to the plate or stone.

If the amount of printing to be done cannot be accomplished in one day or in one printing session, the width of each strip on the inking slab should be measured carefully so that the various shades or colors can be laid out again in the same way for the next day's work. All inks should be stored separately, of course, and carefully labelled for identification.

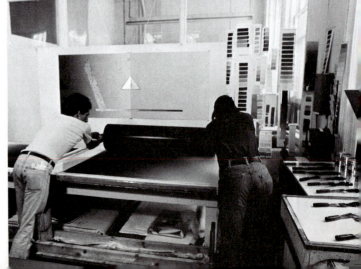

Special Lithographic Techniques

Reversing the Image

For single-color prints, there are special techniques that allow one to reverse the printing image; that is, to treat the stone or metal in such a way that the background areas become the printing surfaces, and the reverse (Fig. 378). Image reversal has untold applications and can be used to achieve a number of unique and different effects.

An older technique that is still very useful for work on stone involves a 1-to-5 solution of orange or white shellac and denatured or anhydrous alcohol. After inking up the image with roll-up ink, dusting with powdered asphaltum, and counteretching with a 5- to 10-percent solution of acetic acid, pour the shellac mixture evenly over the stone. While it is still slightly tacky but not completely dry, use benzine or turpentine to remove the ink and asphaltum from the image areas. Etch the stone repeatedly with a medium-strength etch. The image has now been etched away and will no longer print. The shellac, on the other hand, has resisted the action of the etch solution and has become the printing base.

This method can also be used for zinc, although it is best to replace the shellac with lacquer for long runs. (Shellac does not have the same tenacious hold on zinc that it has on stone.) After making sure that the plate is well gummed and dried, wash out the shellac with anhydrous alcohol. Apply a thin film of vinyl lacquer to the plate and fan it dry. Add some asphaltum wash-out solution on top of the lacquer, buff it down, and dry it.

Acrylic Polymer Method

A newer and more effective method for image reversal makes use of an acrylic polymer compound, such as Liquitex mat varnish or Aquatec varnish. This method has the advantage of reversing an image equally well on limestone, aluminum, and zinc. It also eliminates the necessity of counteretching the printing surface. If an image is to be reversed on a metal plate that has been lacquered, however (see below), the lacquer must first be removed with lacquer thinner. The steps for reversing the image are as follows.

1. Cover the plate or stone with a layer of gum and buff it down well.
2. Rub asphaltum into the surface and fan it dry.
3. Wash the gum off with water, and roll up the image with black ink. Talc the image, washing off the excess.
4. Gum the plate again, and apply strips of Contact paper to the edges of areas that are not to be reversed. Wash off the remaining gum with water, and dry the stone or metal surface.

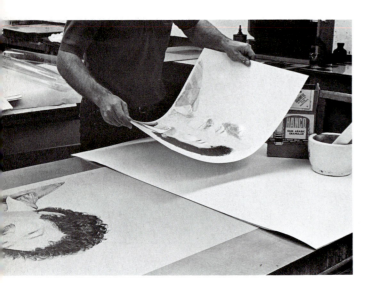

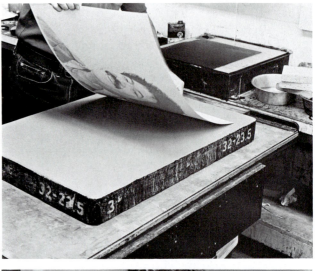

left: 460. A freshly printed impression is dusted with gum arabic powder.

below: 461. Place the paper face-down on a slightly dampened stone, and run it through the press.

5. Apply an acrylic compound to the entire plate, using a cotton pad, and buff it down gently with cheesecloth. Allow the coating to dry thoroughly. If you wish, apply a second coat after half an hour.
6. When the acrylic compound has dried, wash out the image areas within the strips of Contact paper with lithotine or benzine, being careful not to rub too hard. Make sure that these areas are free of any dirt or grease, and remove the Contact paper.
7. Etch the plate or stone, buffing the gum solution down well. When the etch has dried, wash out the acrylic compound with lacquer thinner or alcohol and dry the surface.
8. Rub asphaltum into the surface, wash off the gum with water, and roll up the new image.

If you wish to reverse an image and still retain a printing surface with the original image on it, so that changes can be made to either image, transfer the original to another stone or plate and reverse only one.

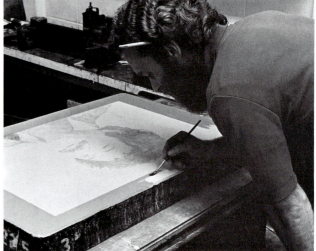

Gum Arabic Method

A method of image reversal using gum arabic preserves the original image and necessitates the use of a second printing surface on which the reversal actually takes place. This method works equally well on stone, zinc, and aluminum. In addition to the usual inks and supplies, you will need some finely powdered gum arabic and a sheet of good-quality smooth paper, such as Basingwerk parchment. The procedure is as follows.

1. Ink up the image fully, fan the stone dry, and pull an impression on smooth paper.
2. Lay the paper face-up on a table, and dust it with gum arabic powder, so that it adheres to all traces of the image (Fig. 460). Shake the paper and tap the back of it to remove any loose particles.

above: 462. After the image has been transferred, coat the margins with gum arabic.

below: 463. Ink up the image with transfer ink. When it is dry, dampen it with water. The image on the stone is now the reverse of the original positive image, to which it is compared in this photograph.

above left: 464. Before lacquering,
wash out the image with lithotine
and lacquer thinner, as shown here.

above right: 465. Buff the lacquer down
to a thin, even layer.

3. Place the clean stone or plate in position on the pressbed, and adjust the press to a light but firm pressure.
4. Moisten the surface of the stone or plate as evenly as possible with some water and a clean sponge. The surface should not be wet, but it should be slightly more than just damp.
5. Place the paper image side down on the stone or plate, and run it through the press (Fig. 461).
6. Remove the paper and fan it dry, then coat the margins of the stone or plate with gum arabic and fan dry (Fig. 462).
7. Cover the entire surface inside the margins with transfer ink diluted with lithotine or with litho-asphaltum to complete the reversal (Fig. 463).

In this process, the gum arabic adheres to the damp surface and forms a resist. The rest of the surface is made ink-receptive by the transfer ink or asphaltum. When the surface is dampened with water, therefore, the gum is dissolved and becomes the nonprinting part of the image.

Lacquering a Zinc or Aluminum Plate

Lacquering a plate involves replacing the grease image completely with a nonblinding vinyl lacquer, after the plate has been gummed carefully. Solvents that do not affect the gum in the nonimage areas are used to remove the greasy image. The lacquer then adheres to the image areas, replacing the grease.

Lacquering is one of the most important and useful techniques in plate lithography. It makes the image completely stable, so that it can be etched repeatedly without ill effects and remain extremely durable under all printing conditions. The usefulness of the process cannot be overemphasized, whether for long runs or short runs. When it is done carefully,

there is no loss of even the finest tones; in fact, they will become almost indestructible on the plate.

Since the lacquer is acid-resistant, it allows the plate to be wet-washed if any scumming or filling-in occurs for one reason or another during printing. An etch can be applied directly to the image area without destroying delicate tonalities.

Lacquering Technique

Before lacquering, the plate must be proofed and given a second etch to stabilize the image. Once the plate has been lacquered, very few changes in the image can be made. The steps are as follows.

1. Ink up the image fully and sharply with crayon black ink, dry it, and dust it lightly with talc. Apply a thin, even layer of gum. (For zinc, use two coats of cellulose gum or one coat of gum arabic; for aluminum, one coat of gum arabic.) It is important that the layer of gum be thin and even, in order to ensure that the image washes out easily.
2. After the gum is thoroughly dry, wash out the image first with lithotine, then with lacquer thinner and a soft cloth until all of the image is removed (Fig 464). Several applications of the lacquer thinner will be necessary. When no more of the image comes off onto the cloth, and the image appears much lighter than the background, it is sufficiently clean.
3. Pour a small amount of the nonblinding vinyl lacquer on the plate (Fig. 465), and with a soft, dry

466. Burning an image with the blowtorch.

467. Detail of a stone engraving for a diploma.

cloth, buff it down evenly and thinly. Allow at least 5 minutes for the lacquer to dry.

4. Apply a thin coat of asphaltum wash-out solution over the lacquer. Buff it down and fan dry. (The asphaltum helps attract ink.)

The plate is now ready for the press and need only be washed with water, sponged, and inked up. All traces of lacquer and asphaltum over the gummed, non-image areas will lift up and wash away when wet. If nonimage areas do not clean up quickly when sponged with water, roll briskly with ink, redampen, and roll again. The suction effect of the roller will clarify the image and lift lacquer and asphaltum from nonimage areas.

Burning the Image on Limestone With the Blowtorch

A technique used primarily in printing very large editions from limestone is to burn the image with a blowtorch. This method creates an extremely durable printing surface, capable in many cases of sustaining runs of many thousands of impressions. It has been used for decades in European print shops, particularly those with motorized, direct flatbed presses.

The image is first inked up thinly and sharply with crayon black ink, then dried. Next, it is dusted with finely powdered asphaltum. (Rosin powder can be used in place of asphaltum.) The excess powder should be removed with some talc or absorbent cotton. Wash the stone with water to remove any remaining loose particles, and dry it. Direct the flame of the blowtorch toward the image until the asphaltum melts and coalesces with the ink (Fig. 466). This forms a totally acid-resistant image. At the same time, the heat sends the grease farther into the stone. When using the blowtorch, be careful not to concentrate the

heat too long in one place, since uneven heating of the stone could crack it. The stone is then etched into slight relief by a strong gum-nitric solution, whose foaming action can be seen clearly on the surface. This relief creates certain advantages in printing. The slightly raised, inked areas press firmly into the paper with something of a letterpress effect, making each printing area sharp and clearly defined. The non-printing areas, on the other hand, are slightly lower and form a series of wells on the surface. These wells are capable of holding more water than the normally processed stone, without interfering with the rollers during inking. One disadvantage of the technique is that the strong etch has a tendency to erode image detail slightly, thus making the image starker.

Engraving on Stone

Until the time when stone was replaced by metal plates in commercial printing houses, engraving was an integral part of the lithographer's trade, even though it is more often thought of as an intaglio process than a lithographic process. The method became popular as a lithographic technique because an engraved stone could be reused many times, representing a considerable saving over the cost of engraving copper. Engraving on stone became the preferred technique for printing banknotes, stock certificates, and in particular for delicate work of all kinds, where precision and fineness of line were of major importance (Fig. 467).

It was often commercially advantageous to combine the qualities of engraving with those of lithography, and many engraved images on stone and copper were kept only for making transfers. The engraved stone or plate would be inked with transfer ink, wiped as an intaglio surface, and printed on an ever-damp-type paper. The printed image would then be

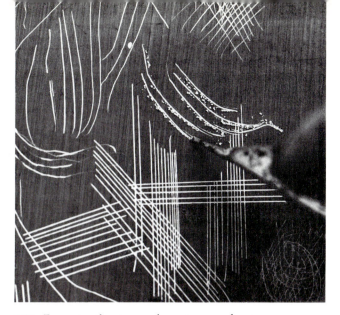

468. Engraving the stone makes crisp, even lines.

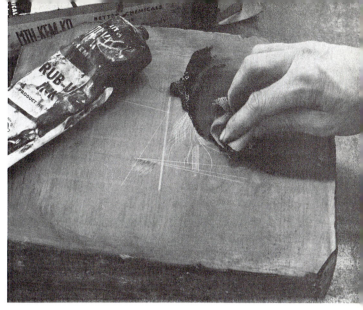

469. Rub-up ink makes a grease base on the stone.

transferred onto a larger stone, etched, and printed as a lithograph. Although some loss was apparent in the finished print due to transferring, a remarkable amount of detail was retained.

As a medium for serious expression, stone engraving has been largely overlooked in recent years, and few artists have utilized its remarkable qualities.

Preparing the Stone

The base for the engraving must be a smoothly polished limestone, preferably a harder, gray one. After being grained with No. 220 or finer grit, the stone should be washed carefully and the grain removed with a block of pumice stone or, preferably, with a sealing wax grinding stone.

The surface must be entirely free of scratches, since each scratch will ultimately print. Pour a small amount of gum arabic over the stone, and sprinkle it with some oxalic acid crystals. With a tightly rolled cylinder of felt, rub the gum and acid vigorously into the stone for 10 or 15 minutes, smoothing and polishing the surface.

A tough, durable glaze of calcium oxalate is formed by the action of the oxalic acid and calcium carbonate. In addition to polishing the stone, this desensitizes the surface and makes it hydrophilic. After polishing, wash the stone and apply a thin, even coat of gum arabic mixed with some lampblack or iron oxide. Fan dry.

Engraving Technique

A traced drawing can be made on the stone first, or the engraving can proceed directly on the surface. A very sharp steel point is used. There is no need to press heavily on the point, because only enough pressure to scratch the stone lightly is necessary. The line

has a tendency to be fine, crisp, and of even width (Fig. 468), although minor variations in thickness can be affected by varying the pressure on the point.

Once the engraving has been completed, rub some transfer ink, roll-up ink, tallow, or linseed oil into the lines to establish a grease base (Fig. 469).

Printing

Intaglio Method　The stone engraving can be printed in the same manner as any intaglio work. Wash the gum from the stone and dry it thoroughly. Rub some etching ink or litho ink (slightly thinned with a light linseed oil varnish) into the lines. As with an etching, the surface ink is then removed with tarlatan and sheets of paper, and finally wiped with the palm of the hand. The dampened paper is placed on top of the stone and run through the litho press with firm pressure. Use at least two blotters under the tympan to form a cushioning effect and help push the paper into the lines. The paper should be only slightly dampened, because any excess moisture will interfere with the ink's adhering to the paper. There are no felt blankets on the litho press to absorb moisture, and the blotters have only limited absorbency.

Lithographic Method　In the lithographic method of printing the engraving, the stone is dampened with water and the image inked with a leather nap roller. In other words, the stone is treated exactly like a normal lithographic surface. It is important to use a nap roller and an ink that is a little soft. Equally important, the initial drawing must not be scratched too deeply into the stone, for otherwise the nap from the roller may not be able to contact the incised lines. It is also possible to achieve excellent results using dry paper with this method, provided it is reasonably soft and a heavy pressure is used.

Lithoaquatint Technique

The lithoaquatint technique is a new process for the creation of fine tonalities and wash effects on aluminum or zinc plates (Fig. 470). The process calls for powdered Egyptian or Syrian asphaltum, anhydrous alcohol, and gum arabic.

Cover the margins of the plate and any areas where tones are not wanted with a thin coat of gum arabic. When the gum has dried, pour a little alcohol over the entire plate or wherever tones are desired. Some powdered asphaltum can then be either sprinkled or brushed into the alcohol. (The alcohol does not dissolve or otherwise affect the asphaltum, but acts only as a temporary vehicle, allowing the asphaltum particles to flow over the surface.) Smooth or highly varied textural effects can be formed and controlled with a brush or other tool. The solvent evaporates, leaving the fine asphaltum particles on the plate. A sponge and water can be used to remove or alter complete sections of the image at this point.

Next, the plate must be carefully heated on a hot plate until the asphaltum particles melt and adhere to the plate. Care must be taken to heat the plate evenly, for otherwise the metal may warp. After the metal has cooled, apply an appropriate plate-etching solution for either zinc or aluminum, and buff it down in the normal manner. Before printing, wash the asphaltum out with turpentine or lithotine, being careful to leave a thin film of dissolved particles over the entire image area.

The plate can then be dampened with a sponge and water and inked up. Since each of the dark asphaltum particles becomes a positive printing spot, the tonality—unlike the normal tusche wash—is completely visible at all times and serves as an accurate reflection of the printing image. For a more durable printing base, wash out the asphaltum with lacquer thinner during the solvent wash-out stage, and then lacquer the image (see p. 277).

A variation on this technique is to dust the powdered asphaltum onto the plate with a dust bag or in an aquatint dust box, in the manner one would use for applying rosin in the intaglio aquatint technique (see pp. 143–144). This produces a very even tonality.

470. A detail of a lithoaquatint image.

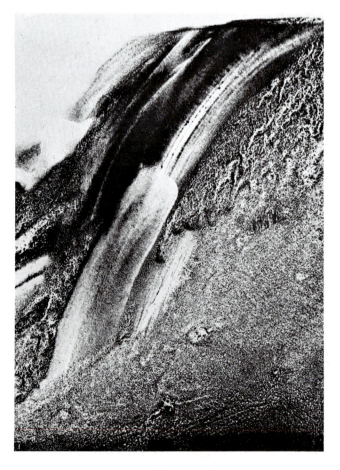

Photolithography

Photolithography is the process of creating an ink-receptive image on stone, zinc, or aluminum entirely by photographic means (Fig. 471). The surface of the stone or plate is first given a light-sensitive coating, then exposed to light through a negative image. The coating in the light-exposed areas hardens and accepts ink; the coating in the unexposed areas washes away, and the plate or stone is desensitized in these areas with a gum-etch preparation.

An albumin-bichromate sensitizing solution that had been in use for almost a century has recently been supplanted, to a large extent, by some of the newer diazo compounds. The diazo coatings require slightly longer exposure times than the bichromate-sensitized solutions. They remain unaffected by humidity, however, and have an extremely long shelf life. Most of the "wipe-on" solutions now in use employ diazo compounds.

The Albumin-Bichromate Process

The albumin-bichromate solution, still used occasionally, works equally well on stone, zinc, or aluminum. Once the coating has been applied to the surface and dried, it is important to have as close a contact as possible between the negative and the sensitized surface. This presents no problem with metal plates, since they can be placed in a vacuum frame where absolute contact is assured. With stone, however, the negative must be sandwiched between the stone and a sheet of glass. For good contact, the stone must be absolutely level.

The Light-Sensitive Coating

The formula for the coating consists of:

1 ounce albumin (powder or scales)
$\frac{1}{4}$ to $\frac{3}{4}$ ounce ammonium bichromate (crystals)
12 ounces distilled water
$\frac{1}{2}$ ounce ammonia water (household ammonia)

Dissolve the albumin in 6 ounces of water, and the ammonium bichromate in the remaining 6 ounces. Mix the two together, then add the ammonia. The solution will turn from a bright red-orange to yellow when the ammonia is added. Filter the solution by placing a piece of cotton at the neck of a funnel and pouring the solution through slowly. This will trap the undissolved residue from the albumin.

The ammonium bichromate in the solution is changed to ammonium chromate when made alkaline by the addition of the ammonia water. It has a shelf life of at least six months. The solution becomes fully light-sensitive only upon drying, when the ammonia evaporates and the ammonium chromate changes back to ammonium bichromate.

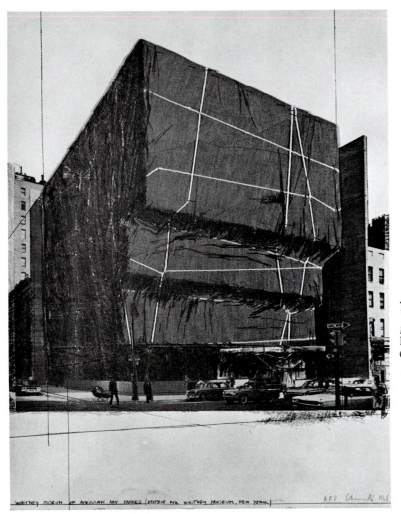

471. Christo.
Whitney Museum of American Art Packed,
project for Whitney Museum, 1968. 1971.
Photolithograph and collage, 28 x 22".
Courtesy Landfall Press, Inc., Chicago.

Applying the Coating

The surface of the stone should be very finely ground, preferably with grit finer than No. 220. A careful final graining with fine powdered pumice and a small stone will do. The stone is counteretched and washed thoroughly to remove any loose grinding particles, and then dried. In a dimly lit area, pour the solution slowly over the tilted stone from the top edge, and work the solution down with a lint-free litho wipe or cloth. Try to make the coating as even as possible, then let it dry in a darkened place.

The coating also can be applied to zinc or aluminum plates in much the same manner. The thickness and evenness of the coating can be controlled more accurately, however, when applied in a whirler. As with the stone, apply the coating in a subdued light, and let it dry in a dark place until ready for exposure.

Exposing the Image

To ensure a good, sharp image, there must be close contact between the negative and the coated surface during exposure. Cover all margins of the plate with opaque black or orange paper to prevent them from being exposed. Plates are placed in a vacuum frame for good contact, or, in the case of a stone, the negative is sandwiched between the coated surface and a clean sheet of glass.

The exposure time depends on several factors, such as the thickness of the coating, the length of time that has elapsed since the coating was applied, the relative humidity, and the intensity of the light source. Test exposures should be made. A good starting point would be a 5-minute exposure with a 15-amp carbon arc light source at a distance of 3 to 4 feet, or about 10 minutes with 2 photofloods at 4 feet.

Immediately after exposure, rub the entire surface with a solution of transfer ink and lithotine, or asphaltum-based wash-out solution. Rub this greasy mixture down to a thin, even layer, and allow about 5 minutes for the solvent to evaporate. Wash the surface with plenty of water. All the unexposed parts of the image will wash away, carrying the greasy coating as well. Apply the gum etch. To strengthen an image on a metal plate, lacquer it after proofing.

left: 472. The light-sensitive
diazo solution is applied evenly
under yellow light with a damp
cellulose sponge or lint-free wipe.

below: 473. After exposure, the developer
is sponged over the image.

Diazo Wipe-On Solutions

Diazo wipe-on solutions are relatively new in photo-lithography, but are already among the most widely used coatings for both presensitized and handcoated plates. Numerous companies supply diazo coatings; each has its own trade name for what is basically the same product. Some may also supply specially treated aluminum plates to be used with their coatings.

The sensitizer comes in two separate parts—the powdered diazo resin and a supporting liquid. When mixed together, they become the light-sensitive coating, which is applied to the surface with a slightly damp cloth in broad, even strokes (Fig. 472). The coating can be applied very easily by hand without the need of a whirler. Once dry, it can be exposed immediately or stored for later use.

The image is developed with the aid of a developer solution that is rubbed over the plate with a damp cellulose sponge until all parts of the image are clearly visible. The developer solution includes an emulsion of gum arabic and a synthetic lacquer resin dissolved in a compatible solvent, as well as a suitable dye. The developer removes the unexposed portions of the coating, while the lacquer in the emulsion adheres to the insoluble, light-exposed portions (Fig. 473). The developer is rinsed from the plate with water (Fig. 474). Finally, a solution of acidified gum and asphaltum is applied (Fig. 475). The solution is shaken well to improve suspension; then a small amount is poured on the middle of the plate and spread with a damp sponge. The gum acts as an etch, desensitizing the nonimage areas, while the asphaltum adheres only to the lacquered image and greatly increases its ink receptivity. This solution is buffed down to a thin layer and dried. The final step before printing is to wet the surface to remove the gum, dampen with a sponge, and ink up.

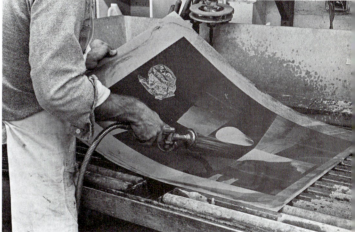

above: 474. Washing the developer solution from the plate with water.

below: 475. A solution of acidified gum and asphaltum is poured over the image.

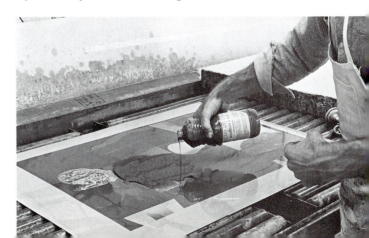

476. A process camera photographed at York University, Toronto. When the image has been positioned on the copy board, the board is tilted to a vertical position to face the lens of the camera. The lamps on the left are quartz iodine lamps.

Presensitized Plates

A considerable variety of presensitized metal plates are available commercially. Many of these plates are extremely fine-grained, however, and are more suitable for offset work than for hand printing. Only commercial plates at least .009 inch in thickness and with a coarse graining should be used for hand printing to obtain the best results.

Diazo-based solutions are employed for most currently available presensitized plates, but newer coatings, such as those made with photopolymers and light-sensitive polyvinyl alcohol (PVA), are gaining wider acceptance because of their extreme durability for long press runs.

Negative- and Positive-Working Plates

Most presensitized plates and wipe-on preparations are negative-working; that is, the image is produced on the surface by exposing the plate to light through a photographically produced negative. All of the processes described so far have been negative-working.

Positive-working plates create a positive image on the plate by exposing through a positive transparency. A special coating is used that requires special developers. These substances are not compatible with the other processes. Areas exposed to light on positive-working plates are dissolved with a developer that leaves the unexposed areas unaffected. (With these plates, it is possible to make your own positives on clear or frosted acetate without the aid of a camera, using India ink or black spray lacquer.) The method of exposure is the reverse of the more common, negative-working method. Instead of being increased for a darker, denser image, the exposure time is decreased, thus allowing more of the positive image on the plate to remain unaffected by the light.

Photolitho Transfer Paper

Photolitho transfer papers that can be used on both stone and metal plates eliminate the need to photosensitize the surface, as well as the problems associated with ensuring good contact between the negative and the sensitized surface. The coated and sensitized paper is exposed to a halftone or line negative and coated with a dilute solution of transfer ink. The paper is then immersed in water, and the unexposed areas dissolve, lifting the transfer ink coating. When the paper is run through the press, the transfer ink offsets onto the stone or plate.

Making Photolitho Transfer Paper

The steps for making photolitho transfer paper are:

1. Coat a hard, smooth rag paper with one of the following solutions: 3 ounces of gelatin dissolved in 3 ounces of warm water; or 3 ounces of cornstarch mixed with 6 ounces of warm water. (The second solution must be heated and stirred constantly until it is thick and translucent.)
2. Spread a thin, even coat of either solution on the paper with a fine-pore cellulose sponge and allow it to dry.
3. Prepare the sensitizing solution by dissolving 2 ounces of ammonium bichromate in 8 ounces of water, and adding 3 to 4 drops of ammonia water. Pour the sensitizing solution into a large tray.
4. Float the coated paper face-down in the sensitizing solution for about 1 minute, checking to see that no air pockets form and that the entire surface is covered by the solution.
5. Remove the paper, tape it face-up to a board, and allow it to dry in a dark place. When dry, it can be cut from the tape with a razor blade.

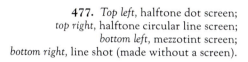

477. *Top left,* halftone dot screen; *top right,* halftone circular line screen; *bottom left,* mezzotint screen; *bottom right,* line shot (made without a screen).

6. Place the negative onto the sensitized paper, so that it appears the way it will ultimately print. Place them in a vacuum frame and expose them to a 15-amp arc lamp for about 4 minutes, at a distance of 3 to 4 feet.

7. After exposure, coat the entire surface of the paper with a thin, even layer of transfer ink diluted to a creamy consistency with some turpentine or lithotine.

8. Immerse the sheet in a tray of lukewarm water, and swab the surface gently with some soft cotton. The unexposed negative areas will dissolve, leaving the hardened positive coated with the transfer ink. When the positive image appears complete and sharp, place the paper face-down on a stone or plate, and run it through the press with a fairly heavy pressure.

The Process Camera

The process camera, or "copy" camera, is one of the mainstays of the photolithographic workshop and represents a considerable investment. It is basically similar to any other camera and is governed by the same general principles. Process cameras vary greatly in size, ranging from one that will take a 16-by-20-inch sheet of film to one that will take a 48-by-72-inch sheet. The most common size, for a 20-by-24-inch sheet, occupies a space about 12 feet long, from the extension of the copy board to the screen (Fig. 476).

Illumination is provided by carbon arc lamps, quartz iodine, pulsed zenon, or in some cases by photoflood lamps. Most process cameras are horizontal and mounted on the floor, although many of the very large format cameras are suspended from an overhead rack. Vertical cameras have gained a considerable amount of popularity, mainly because of their space-saving design.

The basic camera has three main units: the copy board, the lens, and the focusing screen and film-holding device. The copy board holds the material to be photographed by means of a suction device, or under glass in a pressure frame. The axis of the lens is maintained at right angles to the copy board and to the ground glass focusing area. Provision is made at the back of the camera for replacing the focal plane of the ground glass with a piece of film and for holding halftone screens. Both the copy board and the lens can move along a track to change the relationships among film, lens, and copy, thus enlarging or reducing the focused image.

The Photographic Negative

The most commonly used film for photolithography or photoengraving is a high-contrast *orthochromatic* film. This film is not sensitive to red light, so that a red light, such as Kodak Safelight Filter, Wratten Series 1A, can be used in the darkroom without danger to the film. Orthochromatic films, when used in combination with a prescribed developer, will produce negatives that are black and white only, without intermediate tonalities. In this respect they match the characteristics of the sensitized litho surface.

By comparison, films such as those used for snapshot photography are *panchromatic*—that is, sensitive to all colors. Negatives produced with this type of film are called *continuous tone negatives,* and have a full range of tonalities. When exposed onto sensitized paper and developed, they will produce the full-value photographic positive with which we are all familiar.

Line and Halftone Photography

A *line shot* is a photograph taken on orthochromatic film directly in the camera, without the use of a *half-*

478. Ron Davis checking proofs for an offset print at Graphic Press in 1971. (See Pl. 25, p. 248.) Courtesy Gemini G.E.L., Los Angeles.

tone screen. Line shots are generally used for type copy, linear work, and nontonal images. If an ordinary photograph, which has a continuous range of tonalities, were photographed as a line shot, the image would be reduced to stark black and white without intermediate tonalities.

In *halftone* photography, by comparison, tonal gradations in the image are simulated by placing a special contact (magenta) screen or glass halftone screen over the film before exposure. The screen is a grid of opaque vertical and horizontal lines that break up the tonalities of the image into dots on the film. Each minute opening in the grid creates a larger or smaller dot on the film, depending on whether more or less light is admitted. The total effect is that of a continuous range of tonalities.

The screens themselves are calibrated by the number of lines per inch. Two of the most common sizes for magazine or brochure work have 120 or 133 lines per inch. Newspaper halftones have about 85 lines per inch, while some specialty work on coated paper might use a screen as fine as 400. For hand lithography, a screen of about 150 lines per inch is usually the finest that can be printed.

Some other types of screens used to create halftones are the mezzotint screen, the elliptical dot screen, the parallel line screen, and the circular line screen. Each can be used to break up the tonal scale of the original image into a regular or irregular pattern of dots or lines. Three of these are compared with a line shot in Figure 477.

Exposures for Line and Halftone Photography

Since the sensitivity of different films varies, it is best to make test exposures according to each manufacturer's specifications. Kodak, for example, suggests a 10-second exposure at f/32 for same-size (1-to-1) line reproduction with Kodalith Ortho Film type 3; and when using a contact screen, the exposure should be 8 to 10 times longer. The greatest definition and resolution of most graphic-art lenses is found midway between the widest and the smallest apertures; f/16, f/22 or f/32 are therefore the apertures most commonly used whenever detailed work is to be reproduced. The light source is directed toward the copy from two sides at an angle of approximately 45 degrees, so that light is reflected away from the lens. This prevents "hot spots" on the image, which are caused by light bouncing back through the lens.

Mechanized Lithographic Printing

The offset press can print lithographs from zinc or aluminum plates wrapped around a cylinder. As the plate is dampened and inked, the impression is first offset onto another cylinder covered with a smooth composition rubber blanket. This impression is then transferred to the paper under pressure. The fidelity, sharpness, and detail made possible by offset lithography far exceeds the results obtained by all other ways of printing except the most scrupulous work done by hand on stone. A number of workshops have begun to make increasing use of offset printing for fine art applications (Fig. 478; Pl. 25, p. 248). As the fine qualities of offset become better known, the process will increasingly be used for fine art lithography.

part four
Serigraphy

7 The History of Serigraphy

Screen printing is among the newest of the graphic arts. Of the four major printmaking categories discussed here, it has by far the shortest history as a fine-art medium. Nevertheless, the origin of the technique itself is still quite obscure. There is little doubt that the process owes much to the ancient and simple stencil methods practiced throughout many parts of the world. Early stencils and pigments were made from organic materials and so have not survived.

More precisely documented are the applications of stenciling developed in China and Japan between A.D. 500 and 1000. The Chinese and Japanese found the process well suited for transferring images to fabric (Fig. 479), as a means of decoration as well as for making embroidery patterns. The cutout stencil allowed the heavy deposition of dye and pigments so necessary for textile printing. In addition to satisfying these practical needs, stenciling was also considered an art form in itself in the East.

The technique probably reached the West through the journeys of Marco Polo in the late 13th and early 14th centuries, when so many new ideas and materials were flooding Europe. It was still a relatively crude method at best, suitable only for bold shapes and patterns. One of the main drawbacks was that images could be produced only if the cut shapes remained attached to and supported by the stencil matrix itself. The difficulty of introducing floating shapes was apparent—a separate piece could not be used without changing its position or lifting off the surface. With the opening of Japan to westerners by the journeys of Commodore Matthew Perry in the mid-1850s, it was discovered that the Japanese had solved this problem long since.

The Japanese had perfected a method of using fine silk threads and strands of human hair to hold the floating shapes in place, allowing intricate patterns of almost unlimited complexity to be made. The strands of hair or silk were attached to the surface of the stencil matrix at intervals of about $\frac{1}{4}$ inch. They extended in many directions and served to support the delicate, floating shapes. An identical stencil was placed on top, sealing the fibers firmly in position. The entire stencil was then varnished and flattened,

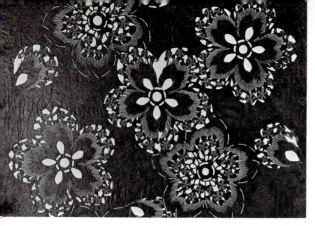

above: 479. Japanese stencil used to decorate silk. c. 1680–1750, Tokugawa period. Slater Memorial Museum, Norwich Free Academy, Norwich, Conn. (Vanderpoel Collection).

right: 480. Anthony Velonis. *Washington Square, New York City.* Before 1940. Serigraph. New York Public Library, Prints Division (Astor, Lenox, and Tilden Foundations).

forming the first direct precursor of the modern screen. Color was dabbed through the open areas with a stiff brush, yielding continuous patterns unimpeded by the thin threads and reproducing only the basic shapes.

Silk as a stencil carrier probably was used in France about 1870 for the printing of textiles. Screen printing, in fact, is still a major means of printing fabrics. England, which had very stringent and well-documented patent laws, recorded the use of a silk stencil in a patent awarded to Samuel Simson of Manchester in 1907. Printing through the stenciled silk was achieved with a stiff bristle brush. The squeegee later speeded up the process and also produced a more even layer of ink. It is not known for certain when the squeegee was introduced; however, by the early 20th century this tool was in common

use, and by the 1920s the first automatic screen printing machine had been invented.

The applications of the silkscreen technique in the early 20th century were largely commercial. The process was capable of meeting small runs on short notice and was relatively inexpensive. Silkscreen proved to be a perfect medium for the bold designs and colors that appealed to a burgeoning advertising industry. In particular, a new phenomenon—the billboard—owed its proliferation to silkscreen techniques. Cylindrical bottles, cans, and other oddly shaped items could be screen printed as well, and as time went on, new developments in electronics showed that silkscreen methods could be employed for printed circuitry of all kinds.

During the height of the Depression, a Works Progress Administration (WPA) silkscreen project

right: 481. Ben Shahn. *Where There is a Book There is No Sword.* 1950. Serigraph printed in black, 13⅞ x 11⅝". Museum of Modern Art, New York.

far right: 482. Marcel Duchamp. *Self-Portrait.* 1959. Serigraph printed in blue, 7⅞" square. Museum of Modern Art, New York (gift of Lang Charities, Inc.).

far left: 483. **R. B. Kitaj.**
Nancy and Jim Dine. 1970.
Serigraph and collage, 33½ x 23″.
Courtesy Marlborough Gallery, New York.

left: 484. **Eduardo Paolozzi.**
*A Formula That Can Shatter
into a Million Glass Bullets.*
1967. Serigraph.
Courtesy Pace Editions Inc., New York.

was begun under the direction of the artist and print-maker Anthony Velonis (Fig. 480). By 1935 Velonis and his group were able to bring the silkscreen process to the attention of serious artists for the first time. Many rejected the creative possibilities of silkscreen, largely because of the heavily commercial character it bore at that time. In order to differentiate creative silkscreen work from the more mundane purposes the process served, Carl Zigrosser, then curator of the Philadelphia Museum of Fine Arts, coined the term *serigraph,* from the Latin *seri,* meaning silk, and the Greek *graphos,* to write.

In the late 1920s, Louis D'Autremont in Dayton, Ohio, developed a knife-cut shellac stencil material called Profilm. The ease with which sharp-edge stencils could now be adhered to the screen changed the medium. Later, after Joseph Ulano improved the film and introduced both a lacquer stencil material and a gelatin photosensitive material, screen printing was able to keep pace with other graphic processes.

The National Serigraph Society was formed in 1940. This group exhibited screen prints throughout the world, emphasizing the creative aspects of the technique. Serigraphy soon became part of the vocabulary of graphic art, as museums added prints to their collections and in turn promoted the artistic legitimacy of the process. Initially, many of the WPA Art Project-sponsored prints imitated crayon drawings, watercolors, or oil paintings. During the period from 1935 to 1950, however, a considerable number of artists accepted the process for their own work and began to explore its particular characteristics. Harry Sternberg, Guy Maccoy, Hyman Worsager, Elizabeth Olds, Loris Bunce, Mervin Jules, Edward London, Ruth Gikow, Ben Shahn, and Velonis himself led the way (Fig. 481). In the 1950s the technique was further explored and adapted to more personal kinds of im-

agery, including that of the artist Marcel Duchamp (Fig. 482).

By the 1960s serigraphy had been adopted wholesale in the commercial printing industry. Its use for art prints was fostered by such influential figures as the English printer Christopher Prater. Prater began his career as a commercial printer, but he later produced works for such artists as Ron Kitaj and Eduardo Paolozzi (Figs. 483, 484).

Screen printing proved ideal for the aesthetic movements of the sixties. Possibly because of the close relationship to commercial printing methods, the medium lent itself naturally to the popular or "Pop" art imagery of such artists as Andy Warhol, Jasper Johns, and Roy Lichtenstein (Figs. 485–487), who transformed immediately recognizable symbols of American culture into new artistic statements.

One of the greatest advantages of the silkscreen technique is the relative ease of multiple-color printing. A silkscreen workshop is not expensive to set up and requires fewer skills on the part of the printer than other methods. Virtually any paper can be used for printing, making silkscreen more accessible than any other print medium. In addition, the colors are more predictable than in other types of printmaking, since the inks tend to be opaque and ride on the surface of the paper. Thus, when artists of the mid-20th century began to concentrate on color as the actual subject of their works—in the broad areas of Color Field painting or the vibrating harmonies of optical art—silkscreen again served as a natural medium for adaptation to prints (Figs. 488, 489). The flat colors and precise, ruler-sharp edges of "hard-edge" painting and Minimal Art also translated readily into silkscreen printing, since they are innate characteristics of the stencil process (Figs. 490, 491; Pl. 26, p. 297; Pl. 31, p. 334).

above: 485. Andy Warhol. *Campbell's.* 1964.
Serigraph on wood, 10 x 19 x 9½".
Courtesy Leo Castelli, Inc., New York.

below: 486. Jasper Johns. *Flags I.* 1973.
31-color serigraph, 27⅜ x 35⅜".
Courtesy Leo Castelli, Inc., New York.

above: 487. Roy Lichtenstein.
Untitled, from *Six Still Lifes.* 1974.
Serigraph and lithograph, 35⅞ x 44¾".
Courtesy Multiples, Inc., New York.

Indicative of the combined and expanded methods that many artists have investigated are Robert Rauschenberg's *Star Quarters* (Fig. 578); James Rosenquist's *Earth and Moon* (Fig. 585); Roy Lichtenstein's *Moonscape,* printed on metallic plastic (Pl. 27, p. 298); Brice Marden's *Painting Study II,* printed with heated encaustics (Fig. 492); and Joe Tilson's *Diapositive: Clip-O-Matic Lips,* on acetate film with metallized acetate film (Pl. 28, p. 315). Silkscreen lends itself especially well to combination with other media, including painting and collage.

The reappearance of the figure in 20th-century art coincided in time with the trend toward increasing numbers of colors in silkscreen work, and these two elements complement each other (Fig. 493). With the advent of Photorealism, works in ten, twenty, or more colors can reproduce with photographic accuracy the figurative imagery of this style (Fig. 494). It should be clear that this medium has become an indispensible part of the artistic vocabulary of the times.

above: 488. Richard Anuszkiewicz.
No. VI, from *Sequential.* 1972.
Serigraph. Courtesy the artist.

below: 489. Ellsworth Kelly. *Black and Red.* 1970.
Serigraph, 24⅞ x 30".
Courtesy Leo Castelli Inc., New York.

left: 490. **Ernest Trova.**
Print #4, from *Series Seventy-Five*. 1975.
Serigraph, 42 x 35".
Courtesy Pace Editions, Inc., New York.

above: 491. **Will Barnet.** *Aurora.*
1977. Serigraph, 17½ x 40".
Courtesy the artist.

far left: 492. **Brice Marden.**
Painting Study II. 1974.
Serigraph with wax
and graphite applications.
Courtesy Multiples, Inc., New York.

left: 493. **Alex Katz.**
Good Morning. 1975.
9-color serigraph, 37½ x 28½".
Courtesy Brooke Alexander, Inc., New York.

494. **Audrey Flack.**
Royal Flush. 1973.
Serigraph, 4' x 5'6".
Courtesy Louis K. Meisel Gallery, New York.

8 Serigraphy Techniques

Since the revitalization of serigraphy (or screen process printing) by the Pop Art and Op Art movements of the early 1960s, the process has continued to gain in popularity. Bright, sharply defined edges and large-scale photographic imagery are more vividly realized in the screen printing process than in the more demanding, more complicated lithographic and intaglio processes. Serigraphy is also easy to learn and simple to do. Colors and screens can be changed readily, and the printing itself is fast and effortless. One of the most versatile of printmaking techniques, serigraphy is suitable for both sharp, crisp images and fluid, painterly effects (Fig. 495; Pl. 29, p. 316). Since almost every technique used in screen printing reproduces the image in positive form (as opposed to a reversed or negative image), the method offers great advantages in allowing the artist to see the work in various stages during the printing.

Although there is a considerable difference between the beginner and the professional screen printer, the image-making and printing procedures remain simple. The necessary materials are inexpensive. No heavy machinery is needed. Much can be done with just a sturdy table, a few screens, a squeegee, inks, and a simple drying arrangement for the prints. If the image-making procedures become more exacting and involved, however, more sophisticated equipment (such as a vacuum table) is needed.

Screen printing is a variation of the stencil process. In stenciling, a shape cut from a piece of dense paper is recreated on another surface by dabbing ink or paint through the cut-out. In screen printing, fab-

294

495. James Rosenquist.
Miles. 1975.
Serigraph with airbrushed
rainbow, 30 x 22″.
Courtesy Graphicstudio,
University of South Florida, Tampa.

ric stretched tightly on a rigid frame becomes the screen, or support, for the stencil. A stencil is made either by painting a substance (such as glue) onto the fabric, or by adhering a special film to the screen that prevents ink from passing through. One controls the areas that print by controlling the parts of the screen that remain open to the free passage of ink.

Screen ink is highly viscous and will not flow through the screen by itself. The rubber or plastic blade of a squeegee must be pulled across the fabric to force the ink through the open areas.

The term *silkscreening* is sometimes used because silk is the traditional support fabric, although other materials such as nylon and polyester are now more common. The word serigraphy is derived from the Latin word *seri*, silk, and the Greek *graphos*, to write.

Materials and Equipment

The Basic Frame

The following materials are needed for constructing and preparing the frame and the screen:

- ☐ wood or aluminum frame, handmade or ready-made
- ☐ screen fabric (silk, nylon, or polyester)
- ☐ nylon or polyester tape
- ☐ staple gun
- ☐ stretching pliers (optional)
- ☐ powdered cleanser, powdered pumice, or No. 400 carborundum
- ☐ nylon scrub brush
- ☐ Screen Prep or Mesh Prep (optional)
- ☐ gummed brown paper tape, 2½ to 3 inches wide
- ☐ epoxy resin (optional)
- ☐ drop stick or other lifting device
- ☐ baseboard of plywood, Novaply, or Formica

Joining the Frame

The first step in preparing to make a serigraph is to obtain the frame that holds the screen. Although in-expensive ready-made frames can be purchased, it is a simple job to make your own. The most common material for the frame is wood, usually pine or spruce. (Aluminum frames, considerably more expensive than their wooden counterparts, are available commercially. Although some have built-in devices for stretching the fabric, they offer few advantages in either weight or performance, except that they can be immersed with the screen in special cleaning tanks unsuitable for wooden frames.)

The wood used for the frame must be straight, smooth and free of knots, and thoroughly dry. The thickness of the wood will depend on the size of the screen. For example, a small frame measuring 12 by 16 inches could be made from 1-by-2-inch stock. A larger, 36-by-48-inch frame requires wood at least 1½ inches square or even larger. For bigger frames, 2-by-2-inch lumber is usually adequate.

Before you actually construct the frame, consider the size of the printing area. The frame should be at least 1½ inches larger on the sides than the printing area, and at least 3 inches larger at either end. This allows room for the squeegee to travel and permits printing ink to be deposited at either end of the

Plate 26. Robert Indiana.
Hexagon, from *Polygons* suite. 1976.
Serigraph, image 24 × 22″.
Courtesy Editions Denise René, New York.

Plate 27. Roy Lichtenstein.
Moonscape, from *11 Pop Artists,* Volume I. 1967.
Serigraph, 12 × 18$\frac{1}{16}$″.
Museum of Modern Art, New York
(gift of Original Editions).

496. Before constructing the frame,
determine the size of the image
and leave room for the squeegee and the ink.

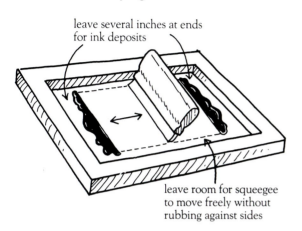

leave several inches at ends
for ink deposits

leave room for squeegee
to move freely without
rubbing against sides

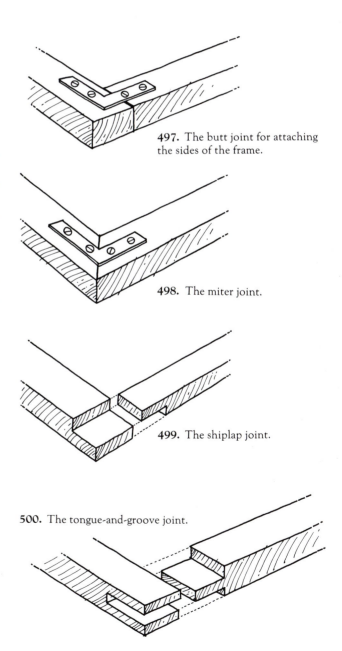

497. The butt joint for attaching
the sides of the frame.

498. The miter joint.

499. The shiplap joint.

500. The tongue-and-groove joint.

screen (Fig. 496). It is sometimes a good idea to leave margins of 3 to 3½ inches between the inside of the frame and the beginning of the image on all four sides, particularly on screens larger than 24 by 30 inches. This will allow the image to be printed either horizontally or vertically, and the squeegee to be drawn in either direction.

Any one of several types of joints can be used for securing the corners of the frame, such as the *butt joint, miter joint, shiplap joint,* and *tongue-and-groove joint* (Figs. 497–500). Whichever joint is used, it is most important that the pieces of wood meet *exactly*. There must be no twisting and no uneven surfaces. The entire frame—especially the side on which the fabric is to be stretched—should be smooth and should lie perfectly flat. Bumps in the wood, jagged edges, and rough surfaces should be sanded down before the fabric is stretched, to prevent tearing it. The frame should also be rigid enough to withstand the tension of a tightly stretched screen without warping or bending.

Screen Fabrics and Their Characteristics

The traditional screen fabric, silk, has been used much less in the last decade than formerly. This is due in part to the tremendous improvement in the quality of synthetic fabrics. Nylon and polyester fabrics are ideal for use with direct photo emulsions, which are now more frequently employed in screen printing than ever before. For some techniques, such as direct tusche or litho crayon, silk is preferred.

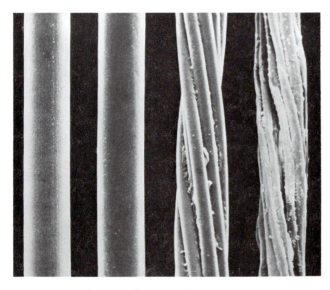

501. *Left to right:* monofilament nylon, monofilament polyester, multifilament polyester, and multifilament silk.

Silk Silk for screen printing is a *multifilament* fabric; that is, each strand is composed of innumerable, finer strands (Fig. 501). This allows great adhesion of all kinds of stencils to the screen, including photographic film and handcut film. Silk has excellent dimensional stability and good wearing qualities, and is available in a variety of types. The finest grade is Swiss-made, although domestic and Japanese silk are adequate for most of the techniques in which silk is preferred. Silk is unaffected by solvents such as lacquer thinner, alcohol, benzine, mineral spirits, and turpentine. Once stretched, it will remain tight on the frame, being only slightly affected by humidity. (It will loosen slightly when wet, but tightens again when dry.)

Silk is excellent for drawings made directly on the screen and for indirect photo emulsions (such as Ulano Hi-Fi Green or Blue). The latter can be removed easily from the silk by spraying with hot water, and/or by soaking in an enzyme cleaner. Since silk is an organic material, it can be destroyed by strong acids and alkalies. For this reason, it is unsuitable for repeated use with direct photo emulsions, which are removed with bleach.

Nylon Nylon is a most durable material capable of withstanding great punishment and extremely hard use. The nylon used in screen printing is a *monofilament* fabric, whose horizontal and vertical threads are made of a single strand of nylon (Fig. 501). The greatest drawback of nylon is its elasticity—it stretches considerably when wet, and tightens again as it dries. It is even affected by humid weather. This tendency must be taken into consideration whenever close color registration is needed, especially on large screens where even the slightest misalignment becomes more apparent.

Nylon fabric can be used safely with most solvents, such as lacquer thinner, benzine, mineral spirits, alcohol, and turpentine, but not with strong acids.

Polyester Polyester fabrics are among the newest and most versatile of the synthetics. They are available in both multifilament and monofilament form and are excellent for all techniques. Polyesters have excellent dimensional stability and high tensile strength, allowing them to be stretched tightly even on very large screens and to be used in situations that require critical registration. Polyester is much less easily affected by humidity than either silk or nylon and combines some of the best features of both. It is impervious to strong alkalies and acids and can be used safely with lacquer thinner, alcohol, benzine, mineral spirits, and turpentine. Like silk, multifilament polyester is ideal for hand-drawn images.

Comparison of Mesh Sizes

Natural Silk

number	mesh count per inch	mesh opening in inches
6XX	74	.0096
8XX	86	.0076
10XX	105	.0063
12XX	124	.0047
14XX	139	.0039
16XX	157	.0035
18XX	171	.0032
25XX	195	.0025

Multifilament Polyester

number	mesh count per inch	mesh opening in inches	open area %	fabric thickness in inches
6XX	74	.0092	44	.0061
8XX	86	.0071	36	.0059
10XX	110	.0051	30	.0051
12XX	125	.0045	27	.0047
14XX	137	.0042	26	.0047
16XX	158	.0035	27	.0039
20XX	175	.0033	36	.0035
25XX	196	.0028	31	.0033

Monofilament Nylon

mesh count per inch	mesh opening in inches	open area %	fabric thickness in inches
74	.0077	34	.0106
86	.0076	44	.0072
109	.0055	37	.0071
124	.0050	42	.0055
140	.0044	38	.0049
160	.0035	32	.0052
180	.0032	31	.0042
200	.0030	36	.0033
235	.0024	31	.0033
260	.0021	31	.0030
285	.0021	31	.0030
306	.0018	29	.0027
330	.0017	34	.0024
355	.0016	33	.0024
380	.0014	30	.0023
420	.0010	18	.0026
457	.0010	21	.0023

Monofilament Polyester

mesh count per inch	mesh opening in inches	open area %	fabric thickness in inches
54	.0124	44	.0118
64	.0106	42	.0094
74	.0087	42	.0094
86	.0075	46	.0073
110	.0059	43	.0057
125	.0051	42	.0049
140	.0047	42	.0045
160	.0038	35	.0047
180	.0035	38	.0039
200	.0028	29	.0045
235	.0024	31	.0039
260	.0022	31	.0030
285	.0020	32	.0029
306	.0017	27	.0029
335	.0016	25	.0022
350	.0012	19	.0029
380	.0013	24	.0026
420	.0010	18	.0026

Classification of Screen Fabrics

The weight and fineness of silk and multifilament polyester is expressed in terms of a number followed by an X, XX, or XXX. A single X indicates standard weight. The weight most often used for screen printing is XX, or double extra weight. An XXX size indicates that there is an extra strand in both the lengthwise threads (the *warp*) and the crosswise threads (the *woof*), giving added strength and wearing ability.

Mesh sizes range from 6XX to 25XX, and the higher the number, the finer the mesh. An 8XX fabric has 86 strands of fabric per inch; a 20XX fabric, 175 threads per inch. The average mesh size for most work is about 12XX to 14XX. For textile printing, however, the fabric most often used has a rating of about 8XX or 10XX. These screens have a great percentage of open area in the fabric and allow the passage of the heavy layer of ink necessary for this kind of printing.

The percentage of open area is, in effect, an efficiency rating for the fabric. The greater the open area, the greater the ink flow through the fabric. When a very fine mesh is employed that also has a comparatively high percentage of open area, the diameter of each strand of fabric is necessarily finer. This is important in halftone printing, in which maximum detail and a minimum of interference from the screen fabric are required. See the table above.

Screen fabrics are sold by the yard in bolts ranging from 40 inches to over 6 feet in width. When calculating the amount of fabric to buy, allow for 2 to 3 extra inches beyond the dimensions of the frame.

Stretching the Fabric

Whether the screen will be silk, polyester, or nylon is determined by the techniques to be used in the image-making process.

One of the most important factors in good printing is the tightness of the fabric on the frame. Any slack in the screen will cause blurred images and make close registration impossible. The larger the image, the more important it is to have a taut screen, since any degree of slack becomes magnified over a greater distance. In multicolor printing requiring several different screens, it is important to have the tensions of all the screens as close to one another as possible.

The groove-and-cord method of stretching the fabric on the screen is used on many commercially made frames. The frame has a groove all around the bottom, over which the fabric is placed. The grooves must be smoothed with sandpaper to avoid catching the fabric. A cord pushed into the groove holds the fabric firmly in place. The fabric can be tightened by forcing the cord farther into the groove. To change the fabric, simply remove the cord.

One of the finest methods for stretching the fabric involves the M & M Fabric Stretcher, with a series of pneumatically operated stretching units. In this technique, utilized by many professional printers for fine detail and process printing, the fabric is stretched over the frame simultaneously from all sides by the stretcher. The tension is equalized all around and the degree of tension is monitored by a dialed pressure gauge. This allows for the maximum tension for a given type of fabric and also ensures an identical degree of tension on two or more screens. After the fabric has been stretched, it is adhered to the frame with epoxy. The tension is maintained until the epoxy has hardened. This method of stretching has proven ideal for situations in which consistency and close tolerances are demanded, particularly when used with polyester screens.

All the stretching can be done by hand. On very large screens, however, stretching pliers will help give the necessary tension to the fabric if your grip is weak.

Because of its unique characteristics, nylon is best stretched in stages. It should be wet with water and stretched until taut. The process should be repeated several times until a maximum point of tension has been reached. Polyester needs to be stretched only once. Silk should be scrubbed with detergent and water, then rinsed well. This removes the sizing and results in a tighter screen. New wooden frames should be weighted or clamped to prevent warping as they dry.

Stapling the Fabric to the Frame

If you are stretching your fabric by hand, cut the fabric, if possible, so that it is at least 2 inches larger than the outside dimensions of the frame. Lay it over the frame, making sure that the threads run parallel to the sides of the frame. Next, staple the edge of the fabric to the bottom of the frame, pulling it evenly in the direction of the stapling (Fig. 502).

A special strong fabric tape made of polyester or nylon is available for use with this method. The tape is placed over the fabric so that both it and the fabric are stapled simultaneously. When the fabric is to be removed from the frame, the tape is stripped from the edge, pulling all the staples with it.

Staple at an angle rather than parallel to the frame; this prevents tearing of the fabric when the tension is increased. When the first side has been completed, pull the fabric to the opposite side and put three or four staples about an inch or so apart in the center of the frame (Fig. 503). Next, staple the other two sides at the center, being careful to pull the fabric tightly and evenly all around. Pull and staple each

above left: 502. Staple the first side of the fabric to the bottom of the frame.

above right: 503. Place a few staples in the center of the opposite side.

right: 504. After tacking down the centers of the other two sides, staple all the way around. Extra staples can be added to tighten the fabric.

side in rotation, working from the center, and placing a few staples at a time until all sides have been completed (Fig. 504). A space of about ¾ inch should be left between staples the first time around the frame. Further tightening can be done by pulling the fabric and stapling between the staples already on the frame. Finally, hammer the staples into the frame so that they are flush with the surface.

Cleaning the Stretched Fabric

After it has been stretched, the fabric should be given a "tooth," so that all types of stencils will adhere to the smooth strands of fabric. There are a few ways of doing this. Special preparations for nylon are available, such as Screen Prep or Mesh Prep, which are scrubbed onto the surface with water. Another method that also can be used for monofilament and multifilament polyester fabrics is to scrub both sides of the fabric with powdered cleanser, powdered pum-

ice, or No. 400 carborundum and a little detergent, using water and a nylon brush. The fabric should always be rinsed thoroughly with clean water afterwards, particularly if it is multifilament polyester. This removes all traces of powder or detergent from the strands. It is a good idea to prepare the screen in this way the first two or three times it is used to ensure that the fabric will hold the stencil.

Taping the Screen

Once you have stretched and cleaned the fabric, the next step is to tape the edges of the screen. This prevents ink from seeping through the ends of the fabric and getting on the margins of the print. It also eliminates the problem of ink being pushed in between the frame and the end of the fabric, only to appear during the printing of another color. Taping also facilitates the process of cleaning up once the printing has been completed.

The most convenient tape is ordinary gummed, brown paper tape, between $2\frac{1}{2}$ and 3 inches wide. Cut four strips of tape, equal in length to the four sides of the frame. Moisten the gummed side with water and apply the tape to the underside of the frame, so that it covers the tacks or staples and extends $\frac{3}{4}$ inch or so onto the screen. Press the moistened tape down firmly (Fig. 505). Cut four more strips, then turn the frame over and adhere these to the inside of the frame, so that the tape covers both the fabric and the inside of the wood (Fig. 506). There should be a margin of about $1\frac{1}{2}$ inches of tape on the sides and at least 3 inches on the ends, where the squeegee starts and stops and the ink is placed. Be sure that the tape on the inside of the screen extends $\frac{1}{4}$ to $\frac{1}{2}$ inch beyond the tape on the bottom, to avoid creating a buildup of tape in the margin. When such a buildup is allowed to occur, it can interfere with the action of the squeegee.

After taping has been completed, apply a coating of either shellac or lacquer to the taped areas on both sides of the screen. The coating should extend about $\frac{3}{8}$ inch onto the fabric itself. This helps seal the tape and prevent leakage of water and ink. (Lacquer thinner will dissolve lacquer, and alcohol will dissolve the shellac.)

A special tape available from screen printing supply houses adheres with water and is lacquer resistant. It is much thicker than regular gummed tape, however, and this may present a problem in printing.

An alternative to taping the screen is to cover the wood and margins of the screen with epoxy resin. On the inside of the screen, where the fabric and inside edge of the wood meet, place enough epoxy to form a well. Epoxy is unaffected by the solvents and solutions used in normal printing and makes a very permanent sealing agent for the frame and margins of the screen when it is applied properly.

above left: 505. Press the gummed tape firmly over the staples so that it extends about $\frac{3}{4}$ inch onto the screen.

above right: 506. Turn the frame over and tape the inside, covering both wood and fabric.

below: 507. The drop stick device holds up the screen, leaving both hands free to prepare for the next print.

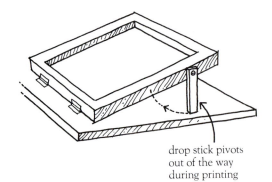

drop stick pivots out of the way during printing

below: 508. The spring-loaded prop automatically lifts the screen when pressure from the squeegee is removed after each print.

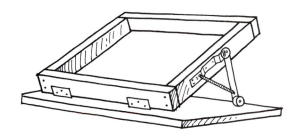

509. The counterbalance lift
raises the screen by means
of an adjustable weight.
This arrangement
was photographed
at Fine Creations, Inc., New York.

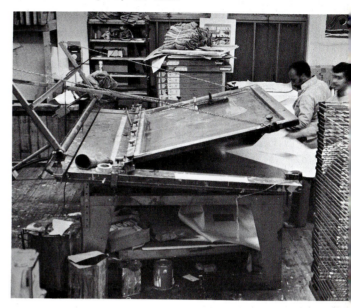

Devices for Raising the Screen

The screen must be raised after each stroke of the squeegee, so that the finished print can be removed and a new sheet of paper placed underneath. The simplest device for keeping the screen raised is a *drop stick*, a thin strip of wood about $\frac{3}{8}$ inch wide, $\frac{3}{4}$ inch high, and about 8 inches long. The drop stick is attached to one side of the frame so that it pivots freely. When the screen is lifted, the strip of wood drops down, propping the screen up at an angle (Fig. 507). This enables you to have both hands free to remove the paper and repeat the printing operation.

A spring-loaded *side kick* device can be clamped to the side of the screen frame to raise the screen automatically after printing. To print, press down on the squeegee and the screen will be lowered to the surface (Fig. 508).

Other lifting arrangements include the *counterbalance lift,* in which an arm extending back beyond the edge of the printing table is attached to the side of the frame. An adjustable weight that can be clamped at varying distances from the screen to regulate the lifting capacity is attached to the arm (Fig. 509). The *door spring lift* involves a raised support near the back of the frame. A door spring is attached to the top of the raised support at one end, while the other end is attached to the front of the screen frame. A *pulley lift* is convenient on large screens. It allows for the exact regulation of the lifting capacity in relation to the weight of the screen itself.

The Screen Printing Unit

A completely portable and very convenient screen printing unit can be made by attaching the screen to a baseboard with hinges. The baseboard not only protects the screen, but also eliminates the need to find a flat surface for the printing paper (Figs. 507, 508). The baseboard should be made of $\frac{1}{2}$- or $\frac{3}{4}$-inch smooth and absolutely flat plywood or Novaply. Formica adhered to a piece of plywood with epoxy also makes an excellent baseboard.

The hinges for attaching the screen frame to the baseboard can be of several types. The most common is the brass door hinge, made in two parts and held together by a pin. If the baseboard is to be used for more than one frame, as in a multicolor print, the position of the hinges must be identical on each frame so that the frames will be in register. Special clamp hinges available from screen printing supply houses can be either screwed into the baseboard or clamped onto one edge. The screen is held to the hinge by clamps. Screens can be changed without difficulty when using the clamp-type hinges.

Blocks of wood should be placed on either side of the open screen area so that they just touch the frame when it is in the printing position. This will prevent any sideways movement of the screen due to looseness in the hinges and also will aid in close registration, particularly on large screens.

The Squeegee

The squeegee is the device that pulls the screen printing ink across the surface of the screen, pushing it through the open areas onto the paper beneath. It consists of a wooden or metal casing that holds a rub-

Hardness of Squeegee Blades

Types of Blades	Durometer Readings
soft	40–45
medium	50–55
hard	60–65
extra hard	70–80

510. Various types of squeegee blades:
square-edged (a), square-edged
with rounded corners (b), single-sided bevel edge (c),
double-sided bevel edge (d), round edged (e),
and doubled-sided bevel edge with flat point (f).

ber or plastic blade. Because the blade is the most critical element of the squeegee, its condition and flexibility help determine the final results. It must be kept clean and adequately sharpened. Different blade shapes are available for different kinds of screen printing (Fig. 510).

For printing on flat objects, such as paper and cardboard, the square-edged blade is the one most commonly used. A square-edged blade with rounded corners is best to place heavy deposits of ink on any flat surface and to print fluorescent colors or light colors over dark. The single-sided bevel edge is used for printing on glass or name plates, and the double-sided bevel edge serves for printing on round or uneven surfaces, such as bottles and other containers. It is also convenient for printing fine detail on textiles. The round-edged squeegee blade is used mainly for textile printing. It allows for the necessary heavy deposits of ink. For ceramic printing, use a double-sided bevel edge with a flat point. The ceramic glazes are mixed with a vehicle, printed on decal paper, and then transferred to the ceramic ware and fired.

Squeegee casings and blades can be purchased as separate units or already assembled. The assembled squeegee and the individual blade are both sold by the inch. The squeegee should be at least an inch larger than the image on either side, and at the same time be 1 to 2 inches shorter than the inside dimensions of the frame. This will allow for free movement of the squeegee during the printing stroke. The well-equipped shop should have a good variety of squeegees of different lengths, for the smallest to the largest images. A one-hand squeegee with a handle attached in the center works well for small and medium-size images, since it frees the other hand for removing the prints and placing blank paper under the frame.

Squeegee Blade Composition

All squeegee blades are available in three basic degrees of hardness—soft, medium, and hard. For the vast majority of work on all types of surfaces, the medium blade is best. See the table above. Blades are made of several different types of materials, having different characteristics. Three common types are neoprene, rubber, and polyurethane.

right: **511.** Sharpen the squeegee blade by drawing it back and forth along a strip of garnet paper.

below right: **512.** A one-person squeegee unit at Gemini G.E.L., Los Angeles.

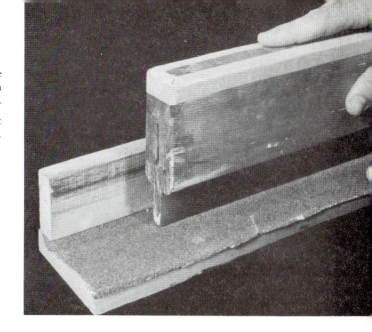

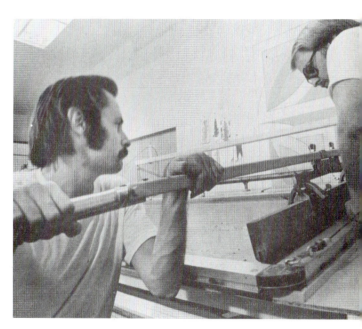

Neoprene A black neoprene blade can be used with all types of oil-base inks and all synthetic colors. It wears sooner than other blades, however, and requires more frequent sharpenings. Fine particles of the blade may show up occasionally in very light or transparent colors as the blade is worn down during printing.

Rubber Rubber blades are actually composed of a synthetic rubber called *buna* and are a grayish-tan color. These blades have excellent resiliency and good wearing ability. They outlast neoprene blades and do not produce streaks. Rubber blades can be used with all inks, oils, lacquers, and water-base colors. They resist lacquer thinners, alcohol, and other solvents.

Polyurethane Polyurethane plastic, usually a transparent amber color, is the most durable of all blade materials. It requires less maintenance than any other material and remains sharp for longer periods of time, even with hard usage. It resists all solvents and is compatible with all printing inks.

Sharpening the Squeegee

A sharp squeegee is essential for clear and even printing. A simple sharpening device can be made by gluing strips of medium sandpaper or garnet paper onto a flat surface. Garnet paper is available at all screen printing supply sources, in strips 6 inches wide and any length. Sheets of sandpaper can also be pieced together to make a sharpening device of any length. The sharpening device should be as long as the longest squeegee in the shop. To use it, hold the squeegee in a vertical position, with the flat part of the blade against the garnet paper or sandpaper, and saw the blade back and forth until the edges are sharp (Fig. 511). For large squeegees, two people—one at either

end—perform this operation. Automatic sharpeners with motorized sanding devices will do the job in seconds. For a small shop, however, the expense of such a unit is rarely justified.

The One-Person Squeegee Unit

A one-person squeegee unit enables one person to print large images with relatively little effort (Fig. 512). The main part of the unit is a counterbalanced arm on which the squeegee is attached. After the angle of the squeegee has been adjusted to the best printing angle, pressure is applied to the single arm as the squeegee is pulled across the screen. The opposite side of the arm runs across a bar on bearings or rollers parallel to the direction in which the squeegee travels. These units are available for printing images ranging

513. A screen printing unit
with vacuum table, made by
M & M Research Engineering.

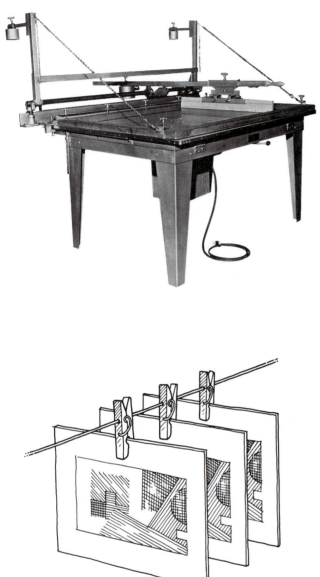

516. Another drying device
uses clothespins nailed to a fixed rack
to hold the prints (a).
A fixed rack can also be constructed
to hold prints vertically where space
is not a consideration (b).

above: 514. Finished prints
can be hung on a clothesline.

below: 515. A screen print
by Roy Lichtenstein is dried
in a hinged metal rack at Styria Studios, New York.

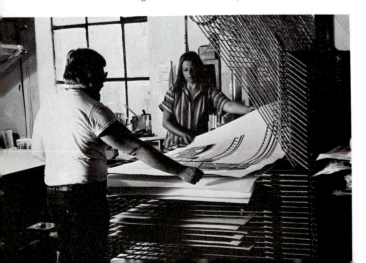

in size from 24 by 30 inches to over 5 by 10 feet. The
one-person unit in combination with a vacuum table
is ideal for both small and large runs.

A vacuum table is a printing table with hundreds
of small holes drilled into the surface. Suction is cre-
ated when the vacuum is on, drawing air through the
holes and holding the paper firmly against the surface
during printing. Once the paper has been printed, the
vacuum is turned off so that the paper can be re-
moved. A vacuum unit is essential for all critical reg-
istration (Fig. 513).

Drying Facilities

The drying arrangement for the finished prints is one
of the most important aspects of serigraphy. It should
be considered well in advance of the actual printing.
Screen printing is a fast, efficient process, and it is
important to provide for a way of stacking or racking
the prints so that the printing can continue uninter-
rupted for the length of the run. A number of differ-
ent drying arrangements can be devised, such as a
clothesline arrangement, a metal or wooden drying
rack, a rack device with clothespins, a fixed tray rack,
or a strip rack (Figs. 514–516). The area in which both
printing and drying take place should be well venti-
lated to enable the evaporating solvents to escape.

Stencil-Making Techniques

In serigraphy, the basis for any image is the substance or material used to fill openings in the screen corresponding to nonprinting areas. Many ordinary substances—such as water-soluble glue, lacquer, and shellac—can be applied directly to the fabric on all nonprinting areas to form the *blockout*. This is perhaps the simplest means of making a stencil, and it is well suited for bold images in which detail and perfect edges are not required.

In a more positive method of working, two substances whose solvents are incompatible with each other can be used in making the stencil. For example, an image can be created directly on the fabric with a water-soluble glue. When this has dried, a thin coating of lacquer is applied over the entire screen. When the lacquer in turn has dried, the glue is dissolved with water, lifting the lacquer on top of it and leaving the screen open in the positive, image areas. The lacquer remaining on the screen blocks the passage of ink in the nonprinting areas. A wide variety of substances can serve in similar ways to create images. It is important, therefore, to understand the nature of stencil-making materials and their solvents. In the following techniques, these materials will be needed:

- □ glue (Lepages Original or Franklin Hide Glue)
- □ shellac
- □ denatured or anhydrous alcohol
- □ lacquer blockout
- □ water-soluble blockout
- □ lithographic crayon or tusche
- □ rubber cement
- □ lacquer thinner
- □ turpentine, lithotine or kerosene
- □ paint thinner
- □ phosphoric, hydrochloric, or glacial acetic acid
- □ glycerine
- □ Maskoid or E-Z Liquid Frisket
- □ tracing paper, layout paper, or bond paper
- □ clean rags, sponges, and newspaper
- □ scoop coater

Characteristics of Basic Blockout Solutions

Glue Lepages Original Glue and Franklin Hide Glue are two of the best kinds of glue to use for screen printing. Both are quite viscous and can be thinned with water up to a 50-percent solution for easier application to the screen. This is especially necessary when the glue is used as a coating over the entire screen. Two thinned coats of solution applied separately are better than one heavy coat in this case.

Since glue is transparent, the addition of a small amount of watercolor paint or poster paint will help

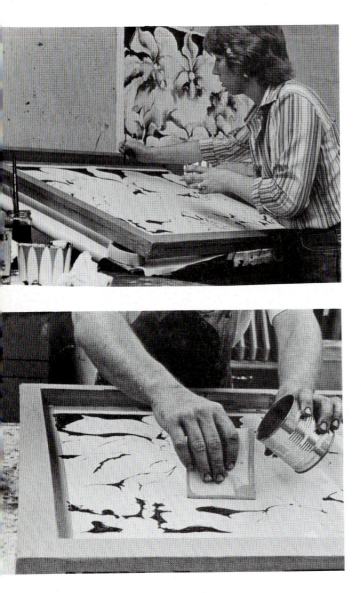

Drawing Materials, Screen Fillers, and their Solvents

Substance	Solvent
glue (Lepages Original Glue, Franklin Hide Glue) **and water-soluble blockout**	water
shellac (white or orange)	alcohol, acetone (dissolves slowly in lacquer thinner)
lacquer blockout	lacquer thinner, acetone,
litho crayon, tusche	turpentine, lithotine, kerosene, paint thinner, lacquer thinner, acetone, benzine, mineral spirits
rubber cement, Maskoid	rubber cement thinner (also can be removed from the screen with a rubber cement eraser)

dreds of impressions and can be seen and retouched easily because of its color. It washes out of the screen with warm or cold water but cannot be used with a water-base ink, or the blockout will be dissolved. Water-soluble blockout is good for oil-base inks, lacquers, enamels, and any textile inks that do not contain water. See the table above.

Glue-Shellac Method

A stencil-making technique that uses glue and shellac can create a positive image. A guide drawing can be placed beneath the screen first to make a more accurate stencil. The glue, which can be made more visible with watercolor paint or poster paint, is then applied directly to the image areas (Fig. 517). When it is dry, the entire surface is covered with a thin coat of shellac, applied with a small squeegee or a piece of cardboard (Fig. 518). In applying shellac, be careful not to leave too much on the image areas, for otherwise it will be difficult to wash out the glue. Once the shellac has dried, wash the glue out with a spray of cold water and check the screen for pinholes against a light source. Touch up if necessary by applying shellac over the holes. Water-soluble blockout can be used in place of glue for this method. It has the advantage of being easier to see on the screen and is less brittle than glue when dry. When this method is used on silk

to make it visible on the screen. The addition of 2 to 4 percent glycerine will help to make the glue more flexible and easier to work with.

Shellac Both orange shellac and white shellac are suitable for the stencil-making process. *Five-pound cut shellac* is preferable, since it has a heavy consistency and will go further. It can be thinned when necessary with common denatured or anhydrous alcohol.

Lacquer Blockout A tough, flexible lacquer called *lacquer blockout* can be used as a screen filler and for touching up handcut lacquer film and photo stencils. It works with all oil-, enamel-, cellulose-, and water-base inks but cannot be used with lacquer or vinyl inks.

Water-Soluble Blockout *Water-soluble blockout* can serve in place of glue for any of the screen-printing techniques discussed below. This substance creates a strong, flexible film that can produce hun-

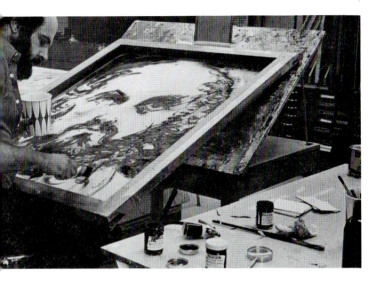

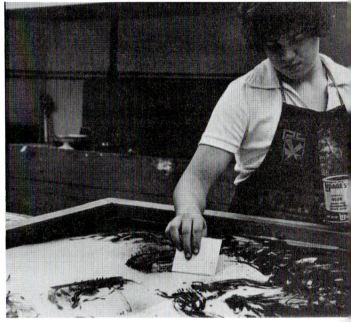

left: 519. Harry Hurwitz applying liquid Toosh (a superior brand of tusche for the tusche-glue technique).

below: 520. Applying glue to the image with a piece of mat board.

fabric, it may be difficult to remove the shellac from the silk after printing. Alcohol alone does not always work and it may be necessary to alternate alcohol with acetone and lacquer thinner.

Glue-Lacquer Method

In the glue-lacquer method, as in the glue-shellac method, the positive image is drawn onto the screen with glue. Again, a drawing can be placed underneath to serve as a guide for the work, or a pencil drawing can be made directly on the screen. Watercolor or poster paint can also be added to the glue. After the completed glue image has dried, apply a thin, even coating of lacquer or lacquer blockout over the screen with a small squeegee or a piece of cardboard. Once the lacquer coating has dried, wash the glue from the screen with warm water. The image areas can be cleaned further by rubbing them lightly with a sponge and water to remove both the glue and the lacquer.

This method can also be reversed by using lacquer blockout as the positive drawing medium and glue as the overall filler. Remove the lacquer from the screen with lacquer thinner; the glue will remain on the screen in the nonimage areas. All types of inks except water-base inks can be used with this method.

Tusche-Glue Method

The use of liquid tusche (see p. 227) to form the stencil allows for painterly effects that imitate the fluidity and immediacy of direct brushwork. Screens of silk or multifilament polyester work best for this technique. The screen must be thoroughly clean of any soap, sizing, or grease.

Make a pencil drawing directly on the screen to serve as a guide for the tusche drawing. Shake the bottled tusche well, and pour it out into a shallow dish. It should be about the consistency of heavy cream. Then apply the tusche directly to the top of the screen with a brush, so that the image will read correctly when the screen is in the printing position (Fig. 519). Allow the tusche to dry, then check the screen by holding it up to the light. Parts of the image that are to print as solid areas should be completely opaque. If necessary, touch up with additional tusche. Once the tusche has dried, the screen is ready for the application of the glue mixture.

The glue mixture, which serves as the blockout, consists of:

4 ounces Lepages Original Glue or Franklin Hide Glue
$2\frac{1}{2}$ ounces water
5–15 drops acid (phosphoric, hydrochloric, or glacial acetic)
10 drops glycerine

Apply this mixture over the top surface of the entire screen with a small squeegee or a piece of cardboard. Since the mixture is thin, apply two light coats. If small pinholes of light appear, touch them up afterwards. The glue should be applied on the same side of the screen as the tusche, or it will seal the tusche in and prevent complete washout (Fig. 520).

When the glue has dried, wash the tusche out with kerosene, working on the bottom side of the

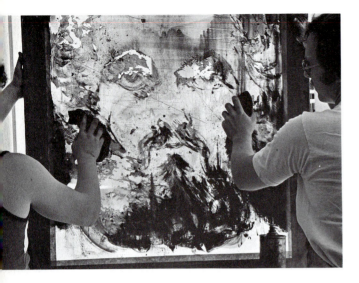

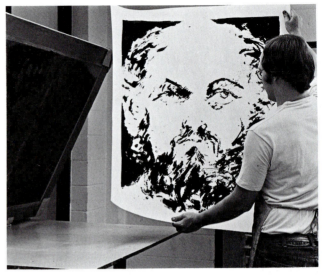

left: 521. Washing the Toosh
from the screen with kerosene.

below: 522. A proof of the finished print.
The image retains
all of the original brush work.

screen (Fig. 521). In this way, the tusche will dissolve readily and lift off any glue that has adhered to it. Scrub the screen lightly with a nylon brush to help dislodge particles of tusche from the edges of the image and to bring out the subtle brushstroke effects that can be achieved by this technique (Fig. 522).

Because tusche is a mixture of wax, shellac, soap, and black pigment, it is soluble in water and in petroleum solvents such as kerosene, turpentine, mineral spirits, and lacquer thinner. Glue thinned with water might therefore begin to dissolve the tusche when it is applied over it. This is the reason for the presence of acid in the glue solution. The acid reacts with the tusche and hardens it, still leaving it vulnerable to kerosene or other solvents. A small percentage of glycerine in the glue makes it more flexible and less brittle. Coloring matter, such as watercolor or gouache, can make the mixture more visible.

Water-soluble blockout can substitute for glue. The formula should be modified as follows:

4 ounces water-soluble blockout
3 ounces water
5 drops acid (phosphoric, hydrochloric, or glacial acetic)

Just before printing, check the screen for pinholes again. Completely white areas and margins can be given an additional coat of glue or blockout solution to make the stencil more ink-resistant.

Litho Crayon-Glue Method

The litho crayon-glue method is technically the same as the tusche-glue method, except that litho crayons (or rubbing ink) are used in place of, or in combination with, tusche (Fig. 523). This method provides another positive means of working on the screen, with results similar in appearance to a crayon drawing.

Any of the three grades of rubbing ink (soft, medium, and hard) will perform well, although with litho crayons the softer grades (Nos. 00, 0, 1, 2, and 3) are best. When using litho crayon, make the drawing stronger than the final image is to be, to compensate for the slight visual loss that results in this process. A guide drawing or sketch can be placed directly under the screen. Both the drawing and the screen should be held firmly so that they do not shift. The technique of placing the screen over textured objects or surfaces and rubbing it with litho crayon (as if you were making a stone rubbing) affords an almost inexhaustible source for new effects.

When the image is complete, treat the stencil in the same manner as the tusche stencil, applying the glue or blockout on the drawing side of the screen, then washing the crayon image out (Fig. 524).

Other Solutions for Making Stencils

Maskoid and E-Z Liquid Frisket are opaque latex solutions that congeal when dry. They can be applied directly to the screen with a brush or other drawing instrument and are fluid enough to be used in a ruling pen for fine linear work. When the screen is dry, glue or water-soluble blockout is applied over the entire screen on one side only, as in the preceding methods, in two (or possibly three) thin coats. Let the screen dry thoroughly, then remove the Maskoid or E-Z Frisket by rubbing with a rubber cement eraser to pick up all the dried latex. The image areas are now open and ready for printing.

below: 523. Harrison Covington working directly on the screen with litho crayon.

right: 524. After coating the drawing side of the screen, wash out the crayon image with lithotine.

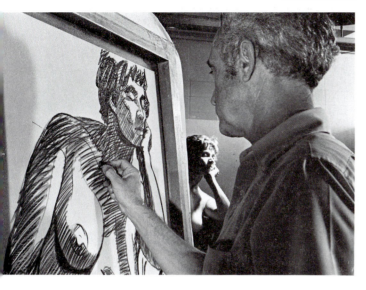

The Paper Stencil

Making a stencil with paper is one of the easiest methods to undertake, and although the stencil will not withstand prolonged printing, many good impressions can be produced this way. The technique is best suited for large, bold images.

The deposit of ink depends on the thickness of the paper used. The heavier the paper, the heavier the deposit of ink will be—particularly at the edges of the image, which tend to be sharply defined. Tracing paper, layout paper, and even ordinary bond paper can be used for cutting the stencil. Cut openings in the paper to represent the image, and place the cutout underneath the screen. The paper should extend as far as the frame, so that ink does not seep beyond the stencil area. The stencil will be adhered to the screen

with the first pass of the squeegee. The outer edges can be taped to the frame; floating parts of the image can be held in place with a spot of glue.

Disadvantages of this method are that it is difficult to make corrections once printing has begun, and each stencil can be used with only one color. Clean-up is simplified greatly, however. Peel the stencil paper away from the screen and clean the ink from the screen with a solvent, rags, and newspapers.

Pochoir

The simplicity of the *pochoir* technique often causes it to be underrated as a means for adding color or new images to a print (Pl. 30, p. 333). *Pochoir* is a stencil technique in which shapes are cut out of a thin plastic such as Mylar or acetate, thin brass or copper plates, or oiled stencil paper. The color is dabbed onto the print through the opening with a stencil brush or sometimes with a roller. A fairly soft roller and thin stencil will produce the sharpest possible image.

Extremely fine results are possible with this technique (Fig. 525), and the consistency in quality for

525. Oshaweetuk.
Four Musk Oxen. 1959.
Eskimo stencil print, image $5\frac{1}{8}$ x 17″.
Brooklyn Museum, New York.

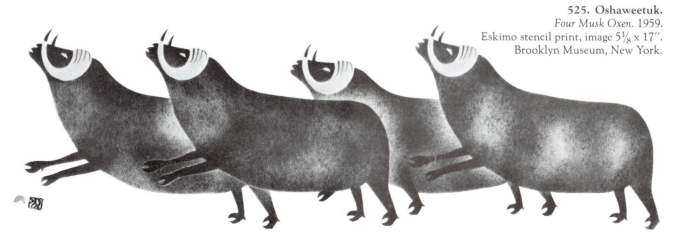

above left: **526.** Lacquer stencil film can be taped to a light box during the cutting. Note the angle of the knife.

above right: **527.** Lift the film with the point of the knife.

any size edition can be maintained very accurately, both for heavy deposits of ink and for thin transparencies of color. *Pochoir* is easy to use as a means of applying carefully controlled color areas to a black-and-white etching or lithograph.

Lacquer Stencil Film

Handcut lacquer stencil film creates sharp, hard-edged images. It is used commercially for large type and images, as well as for fine art applications in which bold, solid areas or crisp detail are necessary. Designs that are cut into stencil film can be infinitely more detailed than those made with a paper stencil, and they are strong enough to yield thousands of impressions. The required materials for making a stencil from lacquer film are:

- ☐ lacquer film
- ☐ a small stencil knife or X-acto knife with a pointed blade
- ☐ lacquer adhering liquid
- ☐ clean, soft rags or cloths
- ☐ a well-prepared screen

Lacquer stencil film consists of a thin sheet of lacquer adhered to a paper or plastic backing. It is available in rolls 36, 40, or 44 inches wide, and up to 300 inches long. The lacquer film is cut with a sharp pointed knife and peeled away from the backing. The areas that are removed are those that will print. The film remaining on the backing paper is adhered to the screen, and then its backing is removed. Lacquer stencil film can be used with all inks, except those that are lacquer- or vinyl-based.

Cutting the Film

Lacquer film comes in a number of different colors, all transparent so that a drawing can be placed underneath to guide the cutting. The lacquer (emulsion) side should be up. The design is cut piece by piece, with the knife held in a vertical position (Fig. 526), and the lacquer film is peeled away from the backing sheet by using the point of the knife (Fig. 527). Exert enough pressure on the knife to cut through the film only, and not through the paper or plastic backing. It takes some practice to find the proper touch.

A special cutting knife is made by the Ulano Company expressly for stencil cutting. It has a swivel blade of surgical steel mounted in a ball-bearing socket, making it ideal for cutting both intricate, curved shapes and large, geometric images. The blade can be made stable by tightening a knob on the handle. Other good and less expensive knives are available, some with swivel blades and some without. The X-acto knife is a good, all-purpose knife for cutting paper stencils and film stencils. Special compass cutters are also available for cutting circles. There are bicutters with twin blades that cut parallel lines simultaneously. Some bicutters are adjustable and can cut lines of varying widths. Film line cutters are used for cutting fine lines with a single stroke. These come in a set of three tools that cut and peel the film simultaneously in lines of differing widths.

Adhering the Film to the Screen

Good adhesion of the film to the screen fabric depends upon having a clean, properly prepared screen.

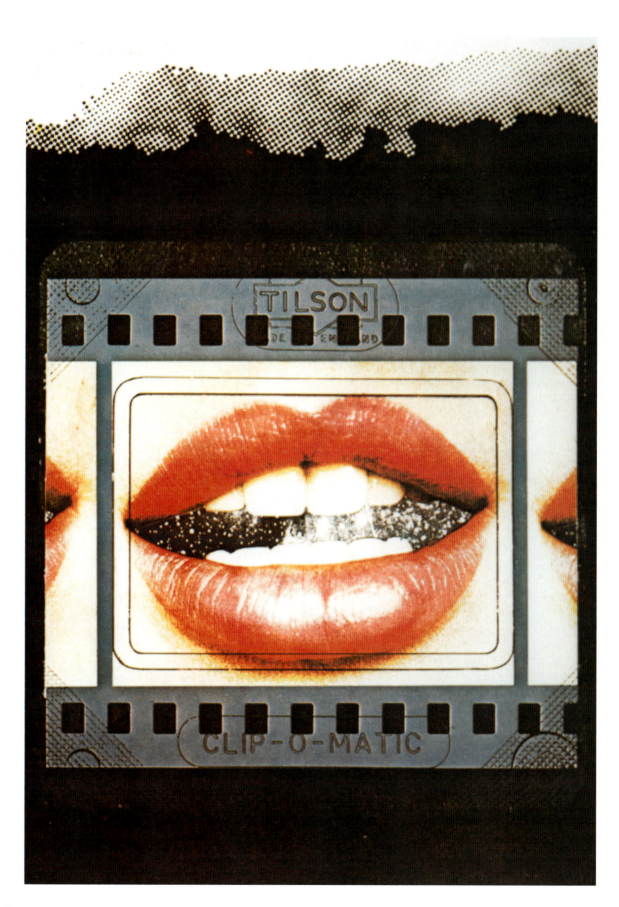

Plate 28. Joe Tilson. *Transparency, Clip-O-Matic Lips 2.* 1967–68.
Serigraph on acetate film with metalized acetate film, 34¾ × 25⅞″. Tate Gallery, London.

Plate 29. Michael Heizer.
Untitled, from *Lashonda* series. 1975.
Painting through screen
over a black silkscreened element, 42″ square.
Courtesy Gemini G.E.L., Los Angeles.

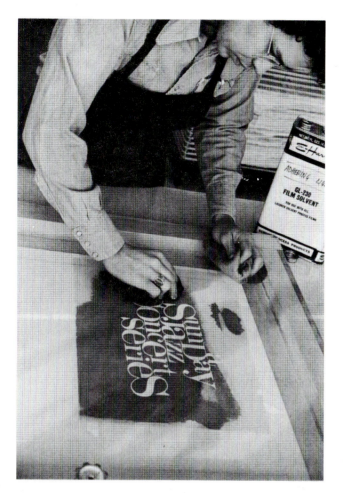

There should be no trace of oil, grease, sizing, or any other foreign material on its surface. Monofilament fabric screens, especially if they are new, should be given a "tooth" to ensure better adhesion of the film to the fabric. The adhering process is as follows:

1. Make sure the film has been removed from all image areas. Set the remaining film on a smooth, flat table with the lacquer side up, and place a few small tabs of masking tape on each corner, so that as the screen is lowered, the film will be held lightly to the bottom. Lower the screen to the film. A piece of cardboard or Masonite placed under the film will raise it slightly from the table, allowing more pressure to be applied.

2. Pour enough lacquer adhering liquid on a cotton rag to make it thoroughly wet, but not dripping. Working outward from the center, apply the liquid to the screen, and wipe the area immediately with a dry pad, rubbing with light but even pressure to push the softened stencil into the fabric (Fig. 528). The areas that have adhered well will begin to appear darker. Work on only a small area at a time, and do not allow the adhering liquid to remain on the film, for it could dissolve the film.

3. When the film appears to be adhered evenly without bubbles or light spots, allow it to dry for 15 or 20 minutes. A fan will speed up the drying. When the film has dried, remove the tabs of masking tape from the corners and peel off the backing sheet slowly, starting from a corner (Fig. 529). If pieces of film begin to lift off with the backing sheet, reapply them with the solvent and allow another, longer period for drying.

4. Check the screen against the light and touch up any pinhole spots with lacquer blockout solution

above left: 528. Adhere the film to the screen with adhering liquid, using light, even pressure.

below: 529. Starting from a corner, carefully peel the backing away from the adhered film.

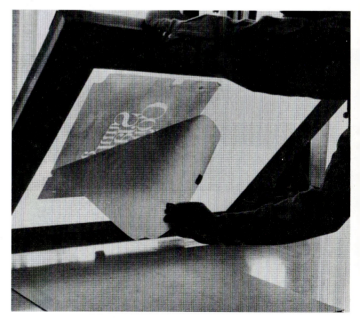

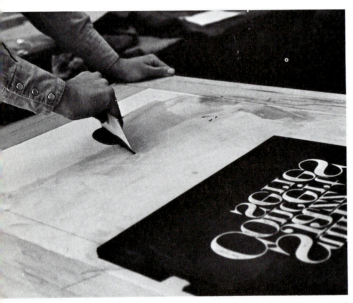

above: **530.** Blockout solution is applied to the margins before printing.

below: **531.** A proof of the complete image.

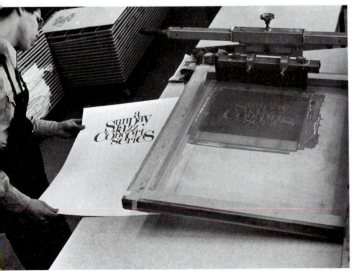

and a brush on both the top and the bottom of the screen. Use blockout solution for the margins beyond the edges of the film as well (Fig. 530). The screen is now ready for printing (Fig. 531).

Water-Soluble Film

Water-soluble film, such as Ulano Aquafilm, is similar in appearance to lacquer film. It is unaffected by lacquer-, oil-, vinyl-, and petroleum-base solvents and inks, but can be softened and dissolved by water and by any solutions containing water. Water-soluble film should be cut in the same way as lacquer film; again cut through the emulsion only and not the backing.

Aquafilm is adhered to the screen in a slightly different manner than lacquer film. The adhering liquid recommended by the manufacturer is:

1 part isopropyl alcohol (90 percent)
2 parts acetic acid and water (5 percent acidity)

Ordinary white vinegar can take the place of acetic acid. Another formula calls for 3 parts water instead of acetic acid or vinegar.

To adhere the water-soluble film, wet a piece of cloth with adhering solution, and apply it generously to the top of the screen, working on only a small area at a time. Blot quickly with clean newsprint, kimwipes, or tissues, pressing firmly on the surface. Pressure helps to push the softened film into the screen fabric. The areas that have adhered well will appear darker. Continue to apply adhering liquid, blotting it immediately afterwards, until the entire film appears firmly attached to the screen. Allow 45 to 60 minutes for the film to dry, more in humid conditions.

When the film is dry, peel off the backing sheet carefully, and touch up any pinholes or imperfections, as well as all marginal areas of the screen up to the frame, with water-soluble blockout on both sides.

Photographic Techniques

Most contemporary workshops are equipped with facilities for using photographic images in etching, screen printing, and lithographic techniques. The popularity of this manner of creating images has grown considerably in the last decade (Fig. 532). Photographic techniques need not be costly, for a great deal can be accomplished with a minimum of equipment. If you plan to employ photographic means to make your stencil, you will need all or some of the following materials:

☐ photographic positive or handmade positive
☐ Azoclean, Nylon Mesh Prep, Silk Mesh Prep, or powdered cleanser
☐ stiff nylon scrub brush
☐ acetic acid or vinegar (optional)
☐ direct screen emulsion (diazo compound or ammonium bichromate)
☐ presensitized film and developer
☐ scoop coater
☐ ultraviolet light source (carbon arc lamp, pulsed zenon, fluorescent light, or black light)
☐ sheet of clear glass
☐ water-soluble blockout, glue, or Kodak Red Photo Opaque
☐ newsprint
☐ vacuum table

The basis of all screen photographic processes is the *positive*, such as a photographic positive image or a hand-drawn, opaque image on transparent acetate (or other translucent material). This positive is placed either on a special sensitized film or against a screen coated with sensitized emulsion. Wherever light travels through the positive, the sensitized coating hardens, while the unexposed areas dissolve and become the open, printing areas.

There are two basic techniques: the *direct screen emulsion technique*, in which a light-sensitive coating is applied directly to the screen fabric; and the *indirect film technique*, in which a separate sensitized sheet of gelatinized film on a plastic support is adhered to the screen after being exposed and developed.

In order for the photo emulsion to adhere completely to the screen, the screen must be thoroughly clean and free of any foreign matter. Grease, ink, and other substances must be removed. Commercial preparations are excellent. These include Azoclean, a degreasing concentrate; Nylon Mesh Prep, which cleans and roughens nylon and monofilament polyes-

532. Andy Warhol. *Vote McGovern.* 1972.
Serigraph, 42″ square. Courtesy Gemini G.E.L., Los Angeles.

ter; and Silk Mesh Prep, for silk and multifilament polyester. Commercial household cleaning powders are also effective. All of these preparations are scrubbed on both sides of the screen with a stiff nylon brush and some warm water. A 5-percent solution of acetic acid or vinegar can be poured over the screen to neutralize any traces of chlorine from household cleaners. The screen always should be rinsed thoroughly with clean, hot water after scrubbing, and be allowed to dry. Special attention should be given to cleaning and rinsing procedures when using multifilament fabrics, since particles of cleanser or detergent can remain lodged in the strands of the fabric.

The Direct Screen Emulsion Technique

Screen Fabrics

Monofilament polyester and nylon are ideal for use with direct photo emulsions. Special "anti-halo" fabrics designed for this purpose are dyed yellow or orange to prevent light from passing through the fabric at the edges of the image. Thus, no ragged edges are formed during exposure.

Although multifilament polyester can be used for direct emulsion work, monofilament nylon and polyester are preferred, because they are easier to clean. Monofilament fabrics also have a high percentage of open area, and ink flows freely through the strands of fabric. The most versatile fabrics for photo emulsion work have thread counts of 175 to 285. Since the photo emulsion surrounds the fabric, adhesion is excellent for long runs.

Solutions

Direct photo emulsions have been improved continually in the past decade. They are convenient, simple to apply, and easy to remove from the screen once the printing has been completed. Although they are more common in the commercial field, they have many artistic applications, both for photographic images and for direct drawing techniques. When used in combination with the "anti-halo" nylon or monofilament polyester, they make possible exquisite detail and sharpness. Ironically, it is possible to achieve even greater sharpness and more accurately rendered detail with a brush or an airbrush on translucent Mylar or acetate, than with tusche or litho crayon applied directly to the screen. There is little doubt that, as familiarity with direct photo emulsions grows and their exciting creative possibilities are realized, they will replace many older, less efficient techniques.

There are two types of direct screen emulsions. In one, the sensitizing base is a diazo compound; in the other, it is ammonium bichromate.

Diazo-Sensitized Photo Emulsion The diazo sensitizing compound is the newest sensitizer to come onto the market. Although it requires a longer exposure time, it is superior to the bichromate emulsion in many ways. The diazo emulsion screen produces images that are slightly sharper, cleaner, and less affected by light bounce or the "halo" sometimes associated with bichromate emulsions. Screens treated with this emulsion can be stored for more than three months without *dark reaction*, change in exposure, or loss of detail. Dark reaction is the hardening of film stored for long periods in the dark. Even though no light has reached the emulsion, it becomes insoluble.

There are a number of manufacturers who make basically the same product. Although there are slight

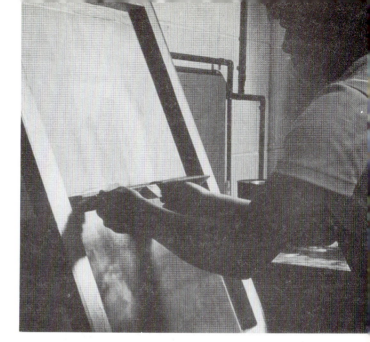

533. Coating the screen with direct emulsion, using a scoop coater under subdued light.

differences, the results should be equally good and consistent if the manufacturer's specifications are followed carefully.

The Naz-Dar Company makes a product called Encosol-1. This consists of the liquid emulsion, the diazo sensitizer, and a blue dye concentrate, all of which come in separate containers. The sensitizer and emulsion form the basic transparent coating. The dye is added to allow close visual inspection at all stages of the process.

To mix the ingredients, first fill the bottle containing the sensitizer with distilled water and shake it well, until all the sensitizer is dissolved. Pour the sensitizer into the Encosol-1 emulsion, and stir with a wooden or plastic spoon until the fluids are thoroughly blended. Add the dye solution, if desired, and mix thoroughly. Once mixed, the emulsion will last about 3 months at room temperature, and about 6 months if kept under refrigeration.

Raysol Universal Sensitizer, made by the Advance Process Company, is a diazo-based sensitizer that can substitute for ammonium bichromate with regular screen emulsions. When used according to directions, it exhibits the same characteristics as other diazo-sensitized emulsions.

Bichromate-Sensitized Photo Emulsion Bichromate-sensitized photo emulsions consist of an emulsion base (a heavy, blue, gluelike solution) and the sensitizing solution of ammonium bichromate and water. Ammonium bichromate (dichromate) is sold as dry, orange crystals that must be dissolved in water before being blended with the emulsion base. To make the solution, mix 4 ounces of crystals with 1 quart of lukewarm water. When stored in an amber or light-proof container, this solution will keep for many months without refrigeration until it is mixed with the base.

The solution of dissolved crystals and the emulsion base should be mixed together in a 1 to 5 ratio. The resulting bright green solution should be used within 6 hours. It is therefore a good idea to mix only enough to coat the screen or screens you plan to work on right away. Discard any leftover solution, and mix a fresh supply when it is needed.

Applying Direct Photo Emulsion to the Screen

Since photo emulsions make the screen sensitive to light, they should be applied to the screen in a dimly lit space and dried in complete darkness or in a darkroom with a yellow or red safelight only.

The most efficient way to apply the emulsion to the screen is to use a scoop coater. The coater has a trough that holds a quantity of emulsion and deposits a thin, even layer of it on the fabric. If you are working with a variety of screen sizes, you will need several scoop coaters of different sizes. The scoop coaters should fit conveniently within the frame and be able to coat each side of the screen in one pass.

Place the cleaned screen against a wall or table at a slight angle. Fill the scoop coater to about three-quarters of its capacity, and, starting at the lower edge, tilt the coating edge toward the fabric so that the emulsion begins to pour onto the screen (Fig. 533). Move the coater up toward the top edge of the screen. When you reach the top, tilt the coater downward, so that the extra emulsion flows back into it. Repeat the operation, then turn the screen over and coat the other side. Allow the screen to dry in a dark place, then apply two additional coats to the bottom, letting each coat dry in between, and one more on top. If possible, apply each coat at right angles to the previous coat.

Five or more coats of the emulsion produce sharper, crisper stencils than two or three coats. If the

534. A photographic image by Romare Bearden is exposed in a vacuum frame to a carbon arc lamp.

final coating is too thin, the exposure will be influenced by the fabric mesh, resulting in saw-toothed edges. Since the exposure is made through the bottom of the screen (that is, the side that will come in contact with the printing paper), two extra coats of emulsion on that side ensure that the stencil will be unaffected by the screen mesh.

The thickness in the ink deposit also can be controlled by the thickness of the coating on the bottom of the screen. The thicker the coating, the heavier will be the ink layer that is printed. It must also be remembered that the thicker the coating, the longer the exposure time needed to burn in the image.

The Photographic Positive

Exposure for all types of photo emulsions—both direct and indirect—is always made with a positive image. A copy camera, although certainly a great asset to any workshop, is not a prerequisite to producing creative work with photographic images. Much can be accomplished with a photographic enlarger, a good lens, and a little ingenuity.

The object of darkroom work is to obtain a photographic positive the same size as the final image on the screen. For example, when a 35mm negative is placed in an enlarger and an exposure is made on another sheet of film (such as Kodalith Orthochromatic film), the result is an extremely high-contrast black-and-white positive enlargement without gray values. This is called a *line shot.* Type, lettering, and all black and white line illustrations are line shots.

When a tonal image is to be reproduced photographically, it must be made into a halftone positive. In this case, the light passing through the negative in the enlarger must then shine through a halftone screen that has been placed in contact with the Kodalith film. The tonal values of the 35mm negative

are broken up by the lines of the screen into a series of black and white dots of varying sizes. These simulate the tonal values of the original negative. The fineness or coarseness of the screen is determined by the number of lines per inch. Until fairly recently, a 65-line screen was used for most screen process halftone work. Today, however, with new screens and emulsions available, halftones of 133 lines and more per inch have been printed successfully. The recent development of the *mezzotint screen* has opened up great possibilities for color separation work, without the disadvantage of the *moiré* pattern that can appear when two or more screens are combined (see p. 335).

The Handmade Positive

A hand-drawn positive on a transparent or translucent material allows you to achieve excellent results with direct or indirect photo emulsions, even if you do not have access to a copy camera or other expensive darkroom equipment.

The drawing should be made with an opaque substance. Kodak Photo Opaquing solution is ideal and can be applied with a brush or thinned with water for use in a ruling pen. Other substances—such as black poster color, India ink, ordinary graphite pencil, litho pencils and crayon—also serve for a variety of textural effects. Prestype letters on an acetate backing form an excellent positive for poster work and lettering of all sizes and styles.

Several kinds of materials make good drawing supports for handmade positives. Three of the best are transparent frosted acetate, translucent vellum, and frosted Mylar. Although more expensive, frosted Mylar is ideal for hand-drawn images. It is dimensionally stable, does not wrinkle, and transmits light exceptionally well. India ink will not "crawl" on its surface. With register guides, a series of Mylar sheets

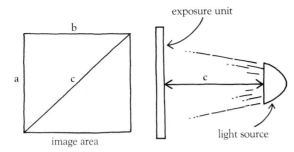

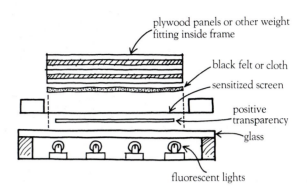

above: 535. The optimum distance between the exposure unit and a single light source is the same as the diagonal measurement of the image area (the length of c).

right: 536. An exposure unit can be made easily.

Exposure

Exposure takes place with the sensitized screen and the photographic positive in the closest possible contact. Exposure time is governed by several factors: the sensitivity of the emulsion, the thickness of the coating on the screen, the strength of the light source, and its distance from the screen. The ultraviolet end of the light spectrum has the greatest effect on photo emulsions, and any light source that is high in ultraviolet light will work. Carbon arc lamps, pulsed zenon, cool fluorescent lights, and black lights all have high outputs of ultraviolet light (Fig. 534).

If a single-point light source is used, such as a single carbon arc lamp, it is important that all parts of the image be illuminated equally. The optimum distance from light source to emulsion is the same as the diagonal of the image. This diagonal can be determined simply by measuring. For example, if an image measures 18 by 24 inches, the diagonal is 30 inches. The light source, therefore, should be 30 inches from the positive and the emulsion-covered screen for maximum yet even illumination (Fig. 535). If the light source is closer, the exposure will be uneven and a "hot spot" will result; if farther away, illumination will be distributed evenly, but—since less light will reach the screen—exposure time must be longer.

A screen given six coats of emulsion needs twice the exposure time of a screen coated only three times. The exposure must be sufficient to harden the emulsion to the fabric, for otherwise the entire emulsion—including the nonimage areas—will dissolve from the screen during the washout procedure.

If a single 30-amp carbon arc lamp is placed at a distance of 30 inches from a screen with five coats of emulsion, the ideal exposure time would be about 5 to 8 minutes.

An exposure unit (Fig. 536) made from a series of black-light or cool-white fluorescent lights, in rows 3 to 4 inches apart and about 4 inches below a plate glass support, will provide a good exposure source. An even simpler arrangement can be made using a flat surface, such as a table top, that is smaller than the frame. Set the frame, bottom side up, on the table, so that the screen rests directly on the surface and the frame extends beyond the table's edge. Place the positive transparency on top of the sensitized screen, and cover it with a sheet of glass. The glass provides enough weight to ensure good contact between the screen and the positive. Use two photofloods at 45-degree angles to each other and at least 3 feet from the glass to provide good illumination. Since these lamps will produce heat, direct a fan at the glass to keep it cool and prevent it from cracking. A fairly long exposure will be necessary, because the photofloods have considerably less ultraviolet output than either the fluorescents or the arc lamps. With the two 250-watt bulbs placed about 4 feet from the screen, exposure time should be in the range of 10 to 15 minutes.

The best type of exposure unit is one with a vacuum frame to ensure close contact between the positive and the emulsion-coated screen. Two basic kinds are available. The Polycot vacuum unit holds the entire screen and frame and tilts up for exposure to a separate light source. The Polylite vacuum unit has fluorescents in a light table arrangement on which the positive and screen are placed and covered with a rubber-backed frame.

Washout

Exposure to ultraviolet light hardens the emulsion and renders it insoluble in water. The unexposed

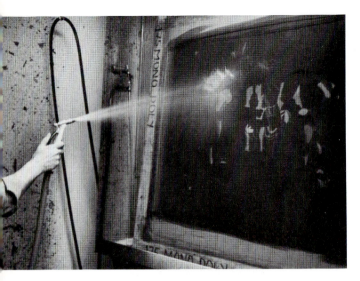

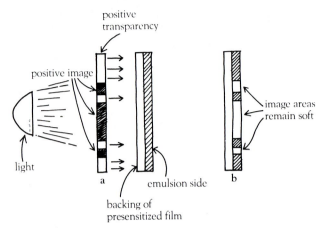

left: 537. Washing the unexposed areas
from the screen shown in Figure 534.

below: 538. Light travels
through the positive transparency,
then through the backing sheet
to the emulsion side of the film (a).
After exposure, the image areas
remain soft to permit washout (b).

parts of the image, which represent the positive printing areas, are then washed from the screen with a spray of warm water, about 110°F (Fig. 537). Special spray pumps fitted with high-pressure nozzles remove soft, unexposed emulsion quickly from the screen. An ordinary garden hose with an adjustable spray nozzle can be used safely for most work, but to remove the emulsion from fine airbrush-like images, a high-pressure unit is necessary. If the unexposed emulsion is not removed completely by the spray, the image will have ragged edges. After the washout, a cold-water spray will harden the remaining emulsion.

After inspecting the screen closely to ensure that the washout was thorough and complete, blot it with clean newsprint or blotting paper, then place it directly in front of a fan and dry it quickly with a stream of cool air. Check the dry screen by holding it against a light source. Touch up any pinholes with water-soluble blockout, glue, or Kodak Red Photo Opaque.

Indirect Film Technique

Presensitized films—such as Ulano Hi-Fi Green, Hi-Fi Blue, Colonial Five Star, and McGraw Pre-Sensitized Film—are excellent for the indirect photo screen printing method. They are composed of a thin, sensitized gelatin layer, adhered to a clear polyester or vinyl backing sheet. Exposure is made directly and through the backing sheet, using a photographic positive or hand-drawn positive image. Exposure, development, and washout are all done in the darkroom, and the film is then adhered to the screen. It is especially important that the screen fabric (preferably silk or multifilament polyester) be clean and properly roughened for good adhesion. Monofilament fabrics, if used, should be scoured thoroughly with abrasive and detergent. The indirect film and the transparent positive can be placed in an ordinary vacuum frame.

Presensitized films should be opened only under very subdued light, such as red or yellow safelights, and never should be left open in daylight or under fluorescents. Cut a piece of film an inch or so larger than the positive image, and replace the rest of the film in its original container.

Exposure

Exposure is not emulsion-to-emulsion, as it is with most other contact procedures, but must be made through the transparent backing. Light must travel first through the photographic or hand-drawn positive, and then through the backing sheet to reach the gelatin emulsion (Fig. 538). The light coming through the backing sheet hardens the gelatin as it makes contact with the backing, causing the gelatin to adhere to the backing temporarily. Exposure from the emulsion side will leave the emulsion soft where it contacts the backing, and it will separate from the backing during development. If you are unsure which side is the emulsion side, scrape a corner of each side with a knife. On the emulsion side, some of the gelatin will be scraped off.

The basic exposure time for presensitized film is approximately 3 minutes when using a single 30-amp carbon arc lamp at a distance of 30 inches. Exposure time is always governed by the strength of the light source and its distance from the film. If you are unsure of exposure times, make a step-wedge series of exposures on a test image to find the best image resolution. Good contact between positive and film is essential. A vacuum unit is an ideal aid (Fig. 539).

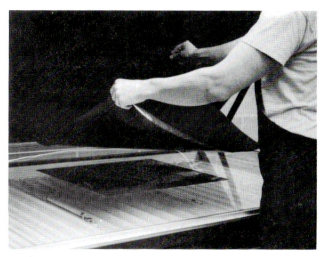

539. Using a Polylite vacuum exposure unit.

540. The film is developed emulsion side up.

Development

A special two-part developer for these films can be purchased in convenient premeasured envelopes. The contents of each envelope are dissolved in 16 ounces of water at 68 to 70°F. The mixture is poured into a tray large enough to accommodate an entire sheet of exposed film. Immerse the film in the developer with the emulsion side up for 1½ to 2½ minutes (Fig. 540). Remove the film from the tray carefully, since the emulsion is soft at this point and can be scratched easily with a fingernail. Spray the surface with a gentle current of warm water, 110 to 115°F, until the image areas appear clearly defined and all the softened emulsion has been washed away. Spray briefly with cold water to make the film a little more firm.

Adhering the Film to the Screen

Immediately after spraying with cold water, place the film emulsion side up on a smooth, level surface. Lower the screen gently onto the film. Blot the screen immediately with clean newsprint, maintaining a light, even pressure (Fig. 541). This will blot excess moisture from the surface and push the softened emulsion into the screen. Change the newsprint several times, using each sheet only once on each side, so that any emulsion that might come off onto the newsprint will not be deposited back on the screen. Areas that have adhered well will immediately appear darker.

Place the screen in an upright position, and dry it with a fan. When it is dry, peel the backing slowly from the screen; the gelatin film will remain adhered to the screen. Hold the screen up to the light, and check for any imperfections. Touch up, if necessary, with water-soluble blockout. The screen is now ready for the next stage—the printing process.

Other Photographic Techniques
Duotone Printing

An overall color cast, as well as added richness and depth, can be given to a normal black-and-white image by means of the *duotone* process. This involves printing the image first in a color, then in black or a second color. The first halftone positive is placed on the screen and rotated against the light until the *moiré* pattern disappears (usually when the halftone is at an angle of about 22½ degrees to the threads of the fabric). The second halftone positive should be made so that its halftone pattern is about 20 to 30 degrees from that of the first. Your eye is the best guide.

Continuous-Tone Screen Printing

The recently-developed *continuous-tone* screen printing technique considerably expands the possibilities of the screen printed image. A continuous-tone negative (one that has not been screened) is placed in the enlarger and exposed through a *mezzotint* screen onto sheets of ortho film, using a step exposure system like the posterization technique.

541. The presensitized film is gently adhered to the screen after development and washout.

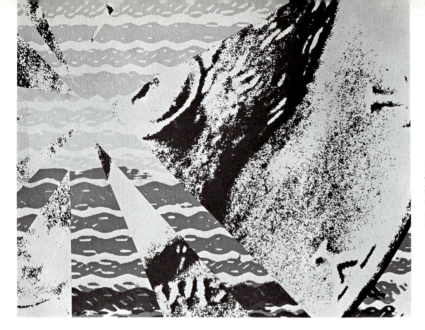

542. James Rosenquist.
Starfish, detail. 1974.
Serigraph poster
with mezzotint screen.
Courtesy Graphicstudio,
University of South Florida, Tampa.

The Mezzotint Screen Although it was only lately introduced, the mezzotint screen is becoming increasingly popular for screen printing. It can be used for making black-and-white halftones, as well as for color separations. Its great advantage over the halftone screen is that it has a random dot pattern, instead of a regular dot pattern, eliminating the need to angle screens in color process work (Fig. 542). The finest mezzotint screen suitable for screen printing is a 150-line (equivalent rating) grid.

Continuous-Tone Technique All image planning should take place at the camera stage, when the greatest control is possible. Therefore, the number of step exposures to be made should be decided in advance. With a 150-line mezzotint screen, a very smooth tonal gradation can be achieved in three steps. Printing conditions must be optimum to reproduce fine detail faithfully. If five steps and a 75-line screen are used, it is possible to produce the continuous tone effect with even softer transitions.

The ink employed for the continuous tone is important. Each step printing must use a transparent film of ink that prints cleanly and thinly. (The thin-film ethyl cellulose inks are excellent.) Even more important is the choice of transparent base, which must be absolutely clear and colorless. Most extender bases have too much opacity to be successful. A very small percentage of ink is added to the transparent base, because the tone produced will depend on the number of steps in the series. In three-step printing, the overprinting of the three tones should produce accurately the darkest tone desired. With more steps, the transition between the deep tones and highlights will be smoother. From the point of view of production, it would be convenient to use the same ink tone for each printing step; the ink may be intensified or lightened at any stage to control the tonal range.

Posterization

Posterization is a photographic technique utilizing variable exposures and a continuous-tone negative to reproduce the positive images in a series of steps. The step positives are then exposed onto different screens and printed in a selected range of colors or tones, producing highly dramatic images with sharp, delineated areas of color. Posterization techniques require some darkroom experience, since the work depends on successful photographic manipulation of the image.

The first requirement in a multistep posterization is a good-quality continuous-tone negative with an extensive range of middle tones. The negative can be 35mm, 2¼ by 2¼ inches, or 4 by 5 inches. It is placed in an enlarger, which is then focused to the exact size desired. The image is exposed onto orthochromatic film such as Kodalith, Dupont Ortho-Litho, or Ansco litho film. This reduces the gradated tones of the negative into a high-contrast black-and-white positive. In a simplified three-step procedure, for example, three exposures can be made—one underexposed, one with normal exposure, and one overexposed. The three resulting positives will be considerably different from one another in tone and contour (Fig. 543). They are used to produce images on three different screens, with either the direct or the indirect photo technique (Fig. 544). The screens are then printed with a selection of colors in careful register (Fig. 545). In addition to using variable exposures, the development time can be increased or decreased to add further variance to the images. Orthochromatic films have considerable latitude in both exposure and development times.

A greater range and subtlety can be produced in the image by increasing the number of steps in the procedure, and by working with a positive as well as a negative image to produce the step exposures.

above left: 543. Three Kodalith positives, *top to bottom:* one underexposed, one normally exposed, and one overexposed.

above right: 544. The three positives shown in Figure 543 were placed on the screens with presensitized film.

right: 545. This completed posterized image was made by printing the screens in Figure 544. Exact registration is critical to the success of such a print.

Printing

Screen Printing Inks

A wide variety of inks have been formulated in recent years to meet the needs of the growing field of serigraphy. In addition to the usual oil- or cellulose-base inks for printing on paper and similar materials, inks have been designed for printing on glass, plastics, metal, and textiles (Fig. 546). The printing surface need not be flat—it is possible to screen an image onto glassware, plastic containers, and ceramic ware (with the aid of decal paper). In the electronics industry, printed circuits often are screened onto copper-clad phenolic with acid-resistant ink, and then etched in acid. Epoxy resins, which form some of the strongest and most durable bonds between two surfaces, have been formulated into inks that can be printed on almost any surface, including metal, glass, and wood,

and are completely weather-resistant. Vinyl inks also have been used more and more to screen patterns and designs on vinyl products. The ink dissolves the supporting vinyl material slightly, and as it dries it becomes an integral part of the item itself.

Paper, however, remains the supporting material for most of the creative screen printing work done today. Poster inks (both mat and glossy) are used more often than any other type of ink for artistic work of all kinds, although other types of inks (such as enamels, lacquers, and fluorescent inks) are sometimes introduced for special effects.

Characteristics of Screen Printing Inks

An ink must have certain characteristics in order to be suitable for screen printing. It must be nonoily,

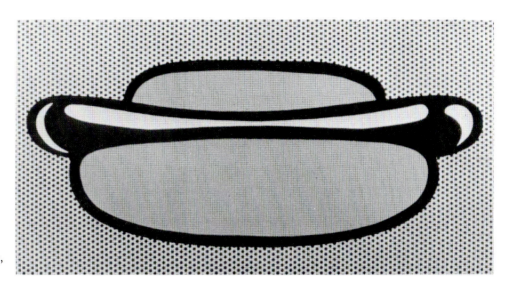

546. Roy Lichtenstein.
Hot Dog. 1964.
Baked enamel on steel,
2 x 4'.
Courtesy Leo Castelli Gallery,
New York.

short and buttery in consistency, and have sufficient body for sharp, even printing. Shortness is the quality that prevents drag on the squeegee and makes the ink break from the screen without leaving "strings." An oily ink will leave oil rings or "halos" around images.

If you modify an ink for any reason, keep these basic characteristics in mind so that the proper printing qualities will be maintained. If, for example, a small amount of lithographic ink is added to some screen ink or to a transparent base, there will be little change in the printing characteristics. As more is added, however, the tackiness of the litho ink will make it more difficult to print and will produce considerable drag on the squeegee. If a dry powder—such as aluminum stearate, magnesium carbonate, or cornstarch—is added to the ink, its body will be increased. If the quantity is great, however, the ink will be too thick for proper printing, the final image brittle, and the colors dull. In most cases, it is best to stay within the manufacturer's specific recommendations when making modifications to the ink.

All screen inks consist of a vehicle (also called the binder) and pigment (or other coloring matter). The vehicle generally determines the drying time of the ink. Cellulose poster inks and lacquers dry very quickly—usually in 15 to 30 minutes. Enamels may take from 4 to 12 hours or more, depending on the specific ink and the humidity of the air.

The drying itself takes place in a different way for each particular ink. Ink can dry by evaporation, oxidation, polymerization, penetration, or a combination of these.

The inks that dry by evaporation include poster inks, lacquers, vinyls, and water-base inks. As the solvents evaporate, the pigment and a resinous binder are left on the printed surface.

Enamels and other oil-base inks dry primarily by means of oxidation, with some evaporation and po-

lymerization. Oxidation is a process in which oxygen from the atmosphere unites with the ingredients of the ink, slowly transforming the liquid ink into a solid. Drying agents, made from the metallic salts of cobalt, lead, manganese, or zinc, speed up the drying of enamel inks.

Polymerization occurs when certain substances unite to form a molecular crosslinking system. This takes place simultaneously throughout all the molecules of ink. Epoxy inks, which dry in this way, usually contain epoxy resin with pigment and a catalyst. When these are mixed together, polymerization begins. These inks dry much faster than enamels, and heat speeds the drying even more. (One type of epoxy ink dries only when heated.)

Some inks are formulated to dry primarily by penetration. This method of drying relies on a highly absorbent paper or fabric to retain the bulk of the vehicle and pigment. Some water-containing textile inks appear dry to the touch immediately after printing because the ink is absorbed into the fabric so quickly. The water actually evaporates at a rate that depends on the humidity of the surrounding area.

Types of Screen Printing Inks

Poster Inks Poster inks usually are formulated from a base of nitrocellulose or ethyl cellulose. Under normal conditions they dry in 15 to 20 minutes, primarily by means of solvent evaporation. Printing, therefore, always should take place in a well-ventilated place. Poster inks are available in mat and gloss finishes and are used widely for printing on paper or cardboard. They are heavy, intense, and for the most part opaque, although it is now easy to control the ink's thickness and light-reflecting qualities. If mixed with transparent base (see below) the colors will become increasingly lighter and more transparent.

When more than 50 percent base is mixed with the ink, it is a good idea to add a small amount of binding varnish to improve adhesion and increase the flexibility of the printed surface.

Mat poster inks on large flat areas of color are particularly susceptible to scuff marks. A little glossy ink or varnish will help to alleviate this problem. Mat and glossy inks also can be mixed to achieve a semi-gloss finish.

Paper has a considerable influence on the finish and durability of the ink. Glossy ink printed on a highly absorbent surface will dry to a dull finish; on a nonabsorbent stock it will dry to a high sheen. This can present problems in color printing, because the first color may dry to a dull finish, and any over-printed colors may dry to a higher gloss. To overcome this difficulty, a sealer coat composed of 60 percent transparent base, 30 percent opaque white, and 10 percent binding varnish can be printed first over the entire image area. Another solution is to cover the entire image with clear varnish after printing.

Enamel Inks Enamel inks are characterized by their toughness, their ability to adhere to a variety of surfaces (including glass and metal), and their brilliance and flexibility. They dry very slowly, however, often taking up to 12 hours or more depending on temperature and humidity conditions. Although mat-finish enamels are available, enamel inks usually are associated with high-gloss surfaces. They are bright and luminous when mixed with an enamel transparent base. A heavy buildup of ink is also possible in color printing, creating a surface tactility.

Fluorescent Inks Fluorescent inks reflect light. They also convert wavelengths of light to the wavelength of their particular color, thus producing their characteristic glow. Unlike phosphorescent paint,

which glows in complete darkness, fluorescents are activated by a black (ultraviolet) light or other light source. Since they are semitransparent, they achieve maximum effectiveness only when printed on white stock. For a print made on black or dark paper, screen white opaque ink on the image areas first. Fluorescent inks have limited permanence but can be made to last longer if protected from sunlight.

Lacquer Inks Lacquer inks dry very quickly and work with all types of photo stencils, water-base blockout, and glue solutions. They should not be used with lacquer stencils, lacquer blockout, or shellac, however. (Lacquer slowly dissolves shellac.) Good ventilation is important when using lacquer inks, because of their odor and the volatility of their solvents. Lacquers are characterized by their high gloss, acid resistance, and rugged durability.

Vinyl Inks Developed expressly for printing on vinyl, vinyl inks come in both mat and glossy finishes and can be mixed for any degree of finish in between. A special vinyl base is available to reduce the ink to any degree of transparency.

Vinyl inks dry by evaporation in about 15 minutes after printing (or slightly longer in humid conditions). It is imperative to have good ventilation, not only to speed the drying, but also to disperse toxic fumes from the evaporating solvents. Use lacquer thinner as the solvent for cleaning up after printing. Strict fire precautions should be observed, since the inks and their solvents are highly flammable. One excellent characteristic of these inks is that they do not dry in the screen, so they can be left for long periods without drying and clogging the screen.

Inks Made with Oil Colors Oil colors can be mixed with transparent base to produce brilliantly

colored improvised inks. The more oil color used, the longer the drying time of the ink.

Ink Modifiers

There are a number of additives that modify the qualities of ink. Most modern inks have been formulated to be used directly from the can. A modifier is sometimes necessary, however, to obtain certain printing qualities.

Transparent Base The most common modifying agent is transparent base, which acts as an extender for ink and, in any quantity, as an agent for making ink transparent. It is heavy-bodied and adds "shortness" to the ink. The natural lubricating character of transparent base often improves the printing qualities of the ink. Each type of ink—whether lacquer, vinyl, enamel, or poster ink—has its own particular transparent base.

Extender Base A neutral bulking medium, extender base increases the working quantity of a given amount of ink without changing its color. This base imparts a certain opacity to an ink, which means that it is unsuitable for use as a transparent medium where absolute clarity of the transparencies is wanted. If extender is added to an ink in more than a 1 to 3 ratio, it has a tendency to become brittle and chalky. A little binding varnish will improve the ink's flexibility and adhesion.

Binding Varnish An additive that is especially effective with poster inks is clear binding varnish, which increases the flexibility of an ink. Binding varnish improves the ink's adhesion to the printing surface and helps prevent chalking of the ink, especially on very absorbent surfaces. If transparent base or ex-

tender base comprises 50 percent or more of an ink, it is a good idea to add approximately 5 to 10 percent of binding varnish.

Toners Toners are highly concentrated colors useful for intensifying or tinting an image. A small quantity of toner added to a transparent base produces rich yet transparent colors. Toners cannot be used alone but are formulated strictly as additives to other colors or bases.

Gloss Varnish Gloss varnish is used either as an additive or as an overall varnish to increase the glossiness of flat ink. When printed over the entire image, it gives it an even gloss and intensifies flat colors.

Flattening Powders A number of powders help to flatten an ink and increase its body. Cornstarch, magnesium carbonate, aluminum hydrate, and aluminum stearate all can be added to inks in small quantities for this purpose. If too much powder is included, however, the surface may become chalky and the screen clogged.

Reducers The most common form of reducer for any particular ink is its solvent. A small amount of mineral spirits or paint thinner, for example, will dilute poster inks, making them more fluid and increasing their tendency to be absorbed into the surface of the paper stock. Some reducers, such as kerosene, also will slow the drying of the ink and lessen its tendency to clog the screen. Each manufacturer makes a reducer for each of its inks.

Retarders Retarders slow the drying of the ink, reducing the viscosity and promoting greater ink flow at the same time. They help prevent clogging of the screen and are invaluable for hand printing.

The Color Palette

Every manufacturer offers a wide range of colors for each type of screen printing ink. For a small serigraphy workshop, it is wise to limit the purchase of inks to the type or types most frequently needed. If the bulk of the work is fine art printing on paper, for example, 90 percent of the printing probably will be done with flat poster inks. In a student workshop, where many different people will print, limiting the types of ink available may help to eliminate the danger of someone's accidentally mixing incompatible inks. In any event, keep the printing area well organized and all equipment properly stored and labeled (Fig. 547).

Since poster inks are used more than any other type of ink for printing on paper or board, it is a good idea to acquaint yourself with the color charts put out by each manufacturer. Flat and glossy poster inks can be mixed in equal parts to produce semigloss colors. When mixing inks, it is best to stay with one brand.

Gallon containers of flat poster inks and quarts of glossy inks in the same color range are the most convenient initial investment. It is also advisable to have several gallon containers of transparent base to extend individual colors and make them transparent.

All colors theoretically can be produced with the three primary colors—red, yellow, and blue. In practice, however, this is only partially true. The choice of primaries determines the brilliance of the secondary colors. To obtain a brilliant green, for example, the yellow must be cool and not tend to orange, and the blue also should be cool and not tend to purple. Peacock blue and primrose yellow make a crisp, brilliant green. Ultramarine blue, which has a purple tinge, will yield a dull green, and if it is mixed with a warm, slightly orange shade of yellow, it will give a considerably more muddy green. On the other hand, ultramarine blue mixed with cerise will result in a clean, brilliant purple. Peacock mixed with fiery red, however, will produce a muddy purplish color.

Because of these characteristics, it is necessary to have a range of colors in addition to the primaries. This range should include a warm and cool variant of each of the primaries, black, opaque white, a good transparent white, and an extender. A basic inventory of colors might be:

☐ lemon yellow (warm)
☐ primrose yellow (cool)
☐ yellow ochre (warm earth color)
☐ fire red (warm red-orange)
☐ cerise (cool alizarin red)
☐ peacock blue (cool blue, slightly greenish)
☐ ultramarine blue (warm blue, slightly purple)
☐ opaque white
☐ black
☐ transparent base (modifier)
☐ extender base (modifier)
☐ binding varnish (modifier)

Color Mixing and Matching

Before beginning the actual printing, premix the exact color you desire in sufficient quantity for the whole job. Nothing is more annoying than having to interrupt the printing because enough ink was not mixed initially. This would not be a problem if all colors were used directly from the container, of

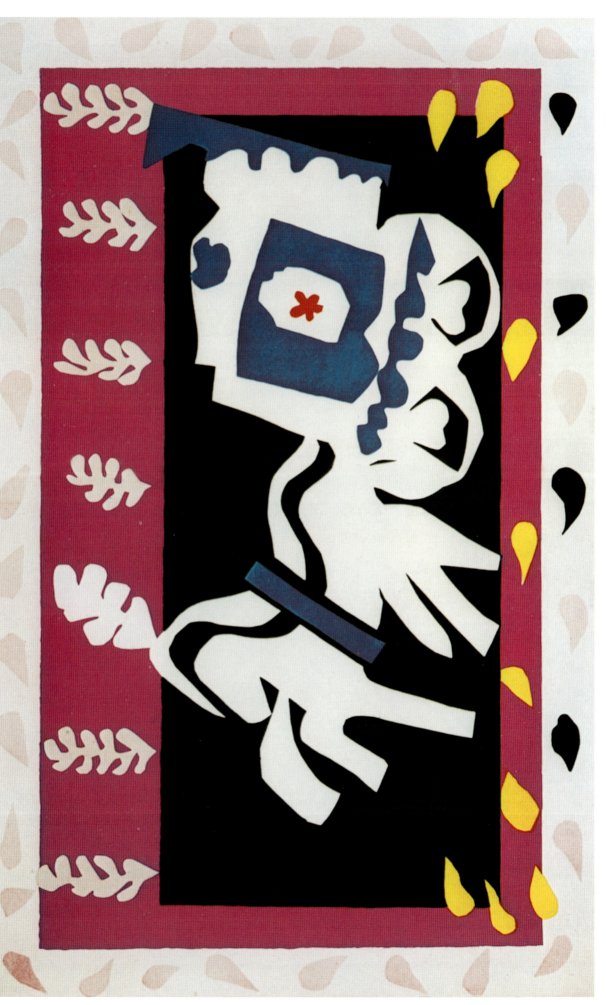

Plate 30. Henri Matisse. *The Burial of Pierrot,* Plate VIII from *Jazz.* 1947. Pochoir, 16¼ × 25⅛".
Grunewald Graphic Arts Foundation, University of California, Los Angeles.

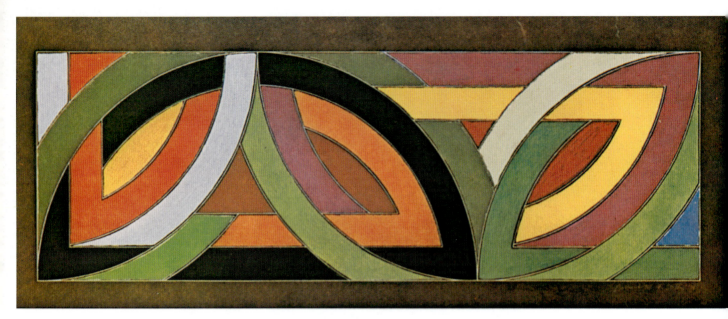

Plate 31. Frank Stella. *York Factory II.* 1973.
Fifty-three-color serigraph, $18\frac{7}{16} \times 44\frac{7}{16}''$.
Courtesy Gemini G.E.L., Los Angeles.

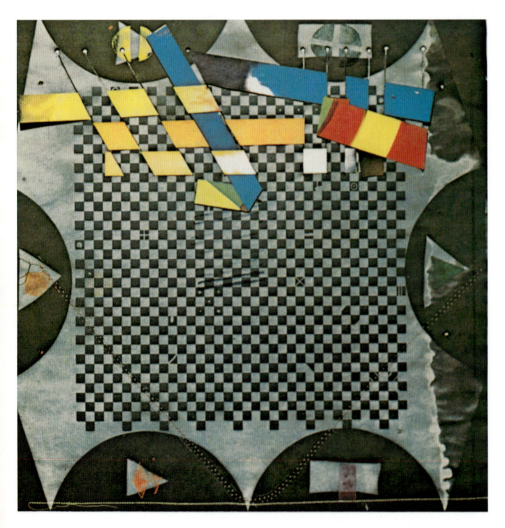

Plate 32. Alan Shields.
Sun, Moon, Title Page. 1971.
Dye, silkscreen on paper,
and thread, 26″ square.
Courtesy Paula Cooper Gallery, New York

548. A *moiré* pattern results from the misalignment of two screens.

course. But with most color serigraphy, each individual color is unique (Pl. 31, opposite). Each one must be mixed separately and matched to a color sample.

Color matching involves good visual perception. The screen print relies ultimately on the *appearance* of the mixed color, rather than on any scientific device for determining a correct match. A 3-by-4-inch piece of black paper or showcard board with two small openings about an inch apart serves as an excellent aid in matching two colors. Place each color under one of the openings. The card isolates them from surrounding colors and allows you to make a close comparison of the match. When using opaque colors, a dab of the mixed color on a piece of printing paper gives a fair indication of the color as it will print. Wait for the ink to dry before judging the match. This method is inaccurate for transparent colors, however, because the final color will be influenced by the thickness of the ink layer. It is important to proof transparent colors under the same conditions that will be encountered in the final printing. This means using the same stencil thickness, the same screen fabric, the same paper, and so forth, so that the ink deposit will be identical. The mixing procedure itself is also of great importance when mixing transparent colors. The inks must be blended thoroughly, for otherwise streaks will show up in the printing. (This defect is less noticeable when using opaque inks.)

A number of clean metal cans, nonporous paper containers, or jars should be kept on hand for mixing and storing inks. Storage containers should have tight covers to prevent the ink from drying. A color sample taped to the outside serves as a useful color reference.

Process Colors

Process colors have a finely ground concentration of pigment and are designed to give the cleanest possible transparent colors when overprinted. The colors are process red (magenta), process blue (cyan), and process yellow. For the best results in clarity and sharpness, these inks should be mixed with a heavy-bodied halftone base.

Four-Color Process Work

In normal process work, the areas where each of the three basic colors (red, yellow, and blue) and black appear in the original art work or color transparency must be separated by special filters in a process camera or enlarger. In halftone separations, each color is separated into a series of dots representing its tonal range. The halftone screen must be placed at specific angles for each color in order to prevent the dot patterns of the different colors from printing on top of each other, and to avoid *moiré* patterns.

A *moiré* pattern is an optical effect that results when two regularly patterned surfaces are placed together in such a way that both patterns can be seen simultaneously, yielding a third strong pattern (Fig. 548). The pattern changes with the relationship of one screen or fabric to the other. *Moiré* effects have been used for centuries to produce decorative textiles in which two independent fabrics have been woven together. Except when created intentionally, however, a *moiré* pattern is objectionable to the screen printer and usually is eliminated in multicolor halftone work. Screen printers have a special problem, because—in addition to the halftone screens—the fabric itself can produce a *moiré* pattern. As a result, even when a single-color halftone image is to be placed on the screen, it must be angled carefully. The halftone positive and the screen are placed together and held up to the light, and the positive is rotated slowly until the pattern disappears. The screen is then marked so that the exposure of the positive takes place in exactly

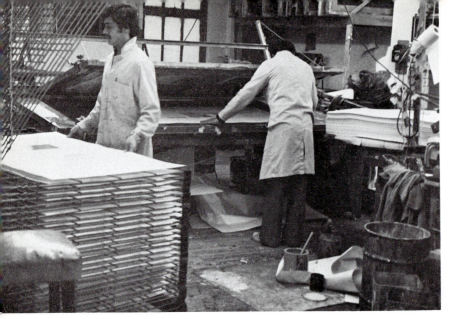

549. In this workshop
at Fine Creations, Inc., New York,
prints are removed
from the squeegee unit
and placed in a drying rack
a few steps away.

the same position. (When using direct photo emulsion, position marks for the positive should be made before the emulsion is put on the screen.) Some printers avoid *moiré* patterns by stretching the screen in such a way that the strands of fabric are diagonal to the sides of the frame.

In three-color process work, the halftone screens used to make the separation positives are placed at the following angles to the horizontal axis:

yellow	105°
blue	45°
red	75°

In four-color process work, the angles are as follows:

yellow	90°
blue	105°
black	45°
red	75°

Papers

A great variety of papers produce excellent results in screen printing. Smooth finishes yield the sharpest possible prints and reproduce the finest detail, although textured sheets are suitable for some applications and can be smoothed somewhat by being run through a litho press between sheets of newsprint. Many types of bristol board, cover stock, and other heavy papers can be used for proofing as well as for printing posters and limited editions. When quality and permanency are desired, heavy Oriental papers and etching and lithography papers serve quite well. Arches 88, a special 100-percent cotton fiber paper, has a smooth finish designed for quality screen printing. It is available in sheets and in rolls. Rives BFK yields excellent luminosity in transparent overlays of color because of its brightness.

Experimental uses of paper in serigraphy include Alan Shields' *Sun, Moon, Title Page* (Pl. 32, p. 334), a two-sided work on dyed, stitched, and woven paper.

Printing Technique

The mechanics of screen printing are refreshingly simple when compared to other graphic arts processes. The first thing to consider in printing is the convenience of the printing setup. Everything necessary for the printing operation must be easily accessible and arranged to allow the printing to proceed swiftly and without interruption (Fig. 549). Make sure your working space has adequate ventilation to allow the solvents in the ink to evaporate and to speed drying. The supplies you will need include:

- poster, enamel, fluorescent, lacquer, or vinyl ink
- ink modifiers
- cans or jars for storing mixed colors
- soft, clean rags
- paint thinner
- waste printing paper and good printing paper
- squeegees, several different sizes
- drying rack or other drying arrangement
- dowel sticks
- register tabs made of plastic or heavy paper
- a sheet of clear Mylar or acetate
- solvent appropriate to your ink
- sheets of newsprint
- a nylon scrub brush
- acetic acid or vinegar (optional)

Short runs can be handled by a single person, who positions the paper, squeegees the ink, and racks each sheet for drying. Long runs are managed best by at least two persons—one who squeegees, and one, or even two, "take-off" assistants to register the paper

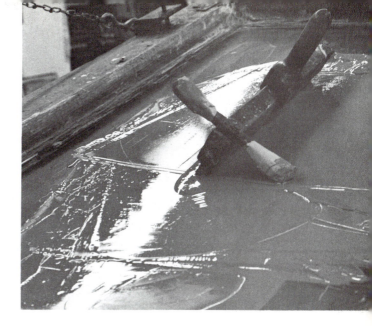

and rack it after printing. There must be sufficient room for the assistant to register the paper freely and remove each sheet without getting in the way of the printer. The drying racks also should be placed so that each sheet can be racked immediately after it is printed and a steady rhythm maintained.

Select a squeegee larger than the image by at least an inch on either side and smaller than the sides of the frame to glide freely during the printing stroke. Place dowel sticks into holes on either side of the squeegee so that they extend over the frame. These will act as a stop to prevent the squeegee from falling into the ink (Fig. 550). For a one-handed squeegee, nail a short stick to the handle (Fig. 551). Masking tape on the stick can be changed when it becomes covered with ink.

Check to see that all equipment is laid out in a logical way, and begin by registering a sheet of trial paper. Go through all the motions of printing and racking the paper, to see if any obstruction or impediment exists in the even flow of the work. If so, adjust your setup or procedures to allow the printing to proceed smoothly and rapidly.

Holding the Paper to the Table

Although a vacuum table is certainly the most efficient instrument for holding the paper firmly during printing, another very useful technique that can be used in the absence of a vacuum table is to spray a table top with an adhesive. Blot the adhesive two or three times with clean sheets of cover stock to reduce the tack. The adhesive should now have sufficient tack left to hold the paper down, but not enough to damage it when it is removed after printing. Fresh adhesive should be sprayed on the table after every ten or fifteen prints. It is also a good idea to mask any areas of the table you do not wish to spray.

above left: 550. Dowel sticks inserted in the squeegee handle hold the two-handed squeegee out of the ink.

above right: 551. A one-handed squeegee can be kept out of the ink reservoir by a stick nailed to the handle.

Estimating the Amount of Ink Needed

Screen printing ink manufacturers give a general estimation of the coverage of each of their inks, expressed in square feet per gallon for a particular mesh size. This makes a good guide for estimating the amount of ink needed for a particular job.

The total area to be covered is determined by the size of the printing area, the number of prints to be made, the size of the screen mesh, the thickness of the stencil, the condition and hardness of the squeegee, and the amount of pressure exerted on the squeegee during printing. A coarse screen mesh allows more ink to flow through the screen, and a dull or rounded squeegee deposits a heavier ink layer. Greater pressure on the squeegee results in a thinner layer of ink.

After estimating the coverage needed for a given run, add an additional 10 to 15 percent to avoid the frustrating and time-consuming task of rematching a color in the middle of a job.

The Flood Stroke

The *flood stroke*, one of the most useful techniques in screen printing, is utilized in almost all screen printing jobs. Immediately before each printing stroke, the screen is lifted away from the paper, and ink is distributed over the screen by pulling the squeegee in the opposite direction from the printing stroke. (Before the first flood stroke, pour a quantity of ink across the top or the side of the screen, depending on

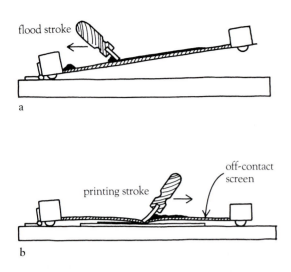

a

b

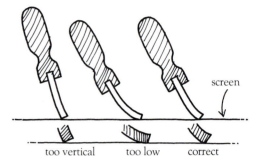

left: 552. Before each print,
the screen must be flood coated
by pulling the squeegee across the screen
to distribute the ink (a).
The printing stroke forces the ink
through the screen as the squeegee travels
back in the other direction (b).

below: 553. The angle of the squeegee
should be 45 degrees.
The two squeegees to the left
are too vertical or too low;
the one at right is correct.

too vertical too low correct

the direction the squeegee will follow.) Do not apply any pressure in the flood stroke (Fig. 552), since the weight of the squeegee itself is usually sufficient. The flood stroke fills the mesh with ink and prevents the screen from drying. It also prepares the screen for the next stroke. Replenish the ink as necessary while printing.

Squeegee Manipulation

Lower the screen into position. Without turning it around, grasp the squeegee firmly with both hands and pull it across the screen. The squeegee should be held at an angle of about 45 degrees from the vertical, in the direction of the stroke (Fig. 553). It makes a slight rasping sound if it is pulled across the screen correctly. Lift the screen immediately, remove the paper, flood coat the screen, and insert another sheet. This sequence should be followed for each print. All screen printing is actually "off-contact"; that is, the screen rests at least $\frac{1}{8}$ to $\frac{3}{8}$ inch above the paper (depending on the image size) until the moment of printing. Small pieces of cardboard or thumbtacks under the corners of the frame hold the frame off the table. The pressure of the squeegee pulls the screen down to the paper, and after the squeegee has passed, the tension of the screen lifts it up again. If the entire screen rested on the paper during printing, the pull from the squeegee would make it drag across the paper and blur the image slightly.

Except where a heavy buildup of ink is desired, the characteristics of a good screen print are low buildup of ink, sharp, crisp outlines, and faithful printing of every open detail. This can be achieved only with a sharp squeegee, proper squeegee angle and pressure, taut screens, and good ink. The angle and pressure of the blade are of paramount importance. Whether the squeegee blade is soft, medium,

or hard, the optimum angle at which it contacts the screen is 45 degrees. Because the blade bends under pressure, the angle must be watched carefully.

Excessive pressure is unnecessary; it creates too much friction and could lead to a slight distortion of the screen. If the squeegee is too soft, if it is held at the wrong angle or used with too much pressure, the blade may flatten out, causing fuzzy edges and heavy, uneven deposits of ink.

With extremely sharp, hard-edged images, a slight underplay of ink may occur on some edges and cause a slight roughness to appear. After every dozen or so prints, wipe the underside of the screen lightly in that area with a soft, clean cloth.

If printing must be interrupted for any length of time, squeegee the ink left on the screen onto some waste paper to clear the screen; if oil or enamel ink was used, spray both sides with Ink-O-Saver (a light, nondrying oil used to prevent skimming of litho inks). Before resuming the printing, wipe both sides of the screen with a clean rag and make several prints on waste paper until the image begins to print perfectly again.

Register Guides

Several types of register guides are available commercially. For the vast majority of prints, however, simple register stops made of heavy-weight paper or plastic slightly thicker than the printing stock perform quite well. Cut three tabs approximately $\frac{3}{4}$ by 2

inches, and adhere two to the long side of the base-board or vacuum table and one to the short side (Fig. 554). Use a little water-soluble glue or spray adhesive. (Do not use a permanent bonding glue). When in perfect register, the paper will butt up against all three stops. Allow for some extra prints to be made in every edition, because there are always a few prints that will be spoiled due to misregistration or some other cause.

Very large prints can be registered easily by using two metal buttons (commercially available) that are taped to the table top, outside the area covered by the frame. Two small pieces of film or cardboard with a hole punched in each are taped to the back of the printing paper, extending past the edge. (A large margin is needed, for the paper must be trimmed after printing.) The holes in the tabs slip over the buttons on the table top.

A simple method of registration, also suitable for deckle-edged paper, uses the principle described in the T-bar method mentioned on page 272. T-marks are placed on the table or baseboard, and lightly—with pencil—on the face of each sheet.

Another helpful guide in color work is a clear sheet of Mylar or acetate a few inches larger all around than the printing paper. Once the position for the first color has been established and the register tabs have been set on the baseboard, place the sheet of plastic in position over the image area and the tabs, taping it to prevent it from moving. Print the image onto the plastic sheet, and mark the position of the registration guides accurately on it with tape. Remove the plastic, and print with the first color.

When the second screen is ready for printing, tape a sheet of paper to the baseboard and pull a proof. Then position the clear plastic with the first color and registration points accurately on top. New register tabs for the second color, seen through the clear plas-

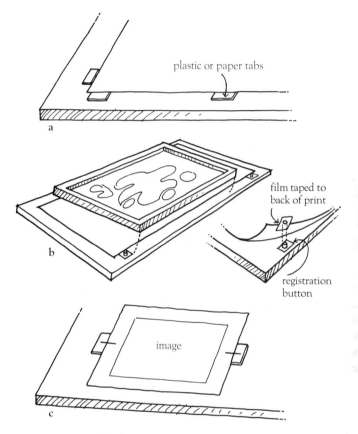

554. Register guides for screen printing include three-point register tabs (a), register buttons (b), and the T-bar method (c).

tic, are then attached to the baseboard. The plastic is removed before printing. This method allows very close registration, and if it is done carefully, little adjustment of the tabs will be necessary.

Registration marks are burned into photographically made color screens along with the image. Rolls of transparent cellophane register marks can be purchased in negative or positive form from any lithographic supply house and are well worth their small cost. After five or ten trial sheets have been printed with the register marks showing, a tab of masking tape can be placed over these marks on the bottom side of the screen to prevent their appearing in the finished prints of the edition.

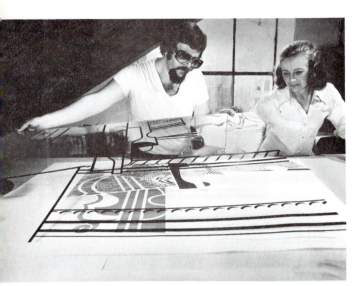

left: 555. A print by Roy Lichtenstein
is registered with a Mylar sheet
at Styria Studios, New York.

below left: 556. **Larry Bell.** *Untitled #3.* 1974.
Five-color serigraph
with tinted varnish
and white rayon flocking, 6' x 2'6".
Courtesy Graphicstudio,
University of South Florida, Tampa.

Registering on Fully Deckled Paper

Registering against cardboard or plastic tabs is accurate only when the paper has straight edges. The following technique allows close registration on deckled or irregular paper, without registration stops.

Cut a sheet of acetate, or preferably transparent Mylar, several inches larger all around than the printing paper, and hinge one edge to the side or front of the printing baseboard or table with tape. Print the first color onto each sheet of paper, and allow the ink to dry. Print the second color onto the Mylar, position the paper under it, then lift the Mylar and print the second color (Fig. 555). Because the Mylar remains hinged to the printing baseboard or table, the process can be repeated for every sheet of paper and every subsequent color.

This method is more time-consuming than using register stops, but when care is taken not to move the paper once it has been positioned, it is extremely accurate. A vacuum table is a great help in holding the paper firmly in place.

Flocked Prints

A *flocked* print is made by printing with an adhesive varnish. While it is still tacky, finely cut fibers, tinsel, pearl flakes, or other materials can be applied to give the print a glittery, suedelike, velvety, or textured effect. The technique has been used commercially for decades. Some artists have made use of its tactile and sensory qualities to great advantage in contemporary printmaking (Fig. 556).

Before it can be flocked, the area must first be screen printed with adhesive, which dries to a slightly yellow tint. (This adhesive also can be purchased in a variety of colors or can be tinted with inks.) Flocking material is available in different colors and should be

applied to the image shortly after the adhesive has been screened on. Place each print in a cardboard box slightly larger than the paper, and dust handfuls of flock onto the image areas. Leave the prints in a drying rack for a minimum of 8 hours, making sure that nothing touches the surfaces.

When the adhesive has dried, there are two methods for removing any remaining excess flock. A soft wallpaper brush with long bristles can gently sweep it off, but this should be done only once. Another technique, helpful for rayon flocking, is to pass an electrostatic gun or wand over the flock, which causes it to stand straight up and results in a softer-looking print. (Electrostatic guns can be purchased from most screen printing supply sources.) Use extreme care in storing flocked prints, for the flocking can be damaged quite easily.

Cleaning the Screen

After all printing has been completed, the screen and the other equipment must be cleaned thoroughly. Place several sheets of newspaper onto the printing surface, and lower the screen on top. Scrape excess ink from the edges of the screen, and store it in a container for future use. Scrape the excess ink from the squeegee blade, and clean it with solvent. Make sure the blade and the wooden handle are spotless.

Pour a small amount of appropriate solvent (kerosene, mineral spirits, paint thinner, or turpentine) directly onto the screen. Clean the ink from the screen by wiping the solvent around the inside of the frame and over the image with rags (Fig. 557). Replace the newsprint often with fresh sheets until most of the ink has been removed. Lift up the screen, and with two clean rags and some additional solvent, rub both sides of the screen simultaneously, working until the printing areas appear immaculate when held

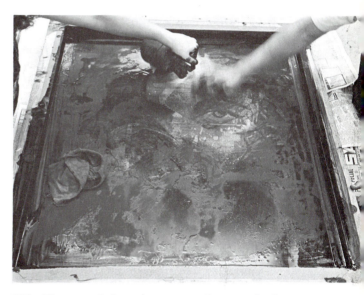

557. Cleaning ink from the screen with rags and solvent.

up to the light. If the screen is to be reused, be careful not to damage the stencil on the bottom. Place all used rags in a fireproof metal container. Never leave them lying about, because they create a fire hazard

Removing Direct Emulsion

After printing, the ink is cleaned from the screen with solvent, then the direct photo emulsion can be removed easily from the screen with a solution of equal parts of water and ordinary household bleach. (Silk cannot be reclaimed in this way, because the bleach destroys the fabric, but nylon and polyester are unaffected by bleach and can be reclaimed many times.)

Apply the solution to both sides of the screen to soften the emulsion. Next, scrub the emulsion off with a nylon bristle brush, and spray the screen with hot water. A high-pressure spray unit will help.

Removing Presensitized Film

If you have used the indirect photo method for making the stencil, remove as much of the printing ink from the screen as possible, using lacquer thinner to remove stubborn particles of oil, cellulose, or enamel inks. Spray the presensitized film with hot water from both sides of the screen, then scrub with a nylon brush on both sides of the fabric (Figs. 558, 559). If it is difficult to remove the film completely, use an enzyme stencil remover. (Any screen printing supply source will carry one.) Finally, the screen should be rinsed with a 5-percent solution of acetic acid or with vinegar to kill any active enzymes remaining in the fabric. Rinse with clean water afterwards.

below left: 558. Presensitized film is removed with hot water.

below right: 559. The screen should then be scrubbed with a nylon brush.

Removing Lacquer Film

After printing, wash the ink thoroughly from the screen. Then remove the film and blockout solution with lacquer thinner. Make sure that your work space is well ventilated, because lacquer thinner fumes are noxious and highly flammable.

A good procedure for cleaning is to place several thicknesses of newspaper under the screen on a flat table and pour some thinner on the screen, allowing it to set for a minute or so. Rub the top of the screen lightly with a cloth or paper towels, then lift the screen. A good portion of the film and the blockout solution will be left on the newspaper. Change the papers and repeat until the screen is clean.

For a final cleaning, hold the screen vertically, and rub both sides of it simultaneously with two cloths wet with lacquer thinner. Check frequently to see if any ink or blockout still remains in the screen by holding it up to a light, and repeat if necessary.

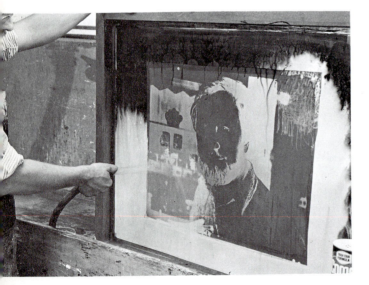

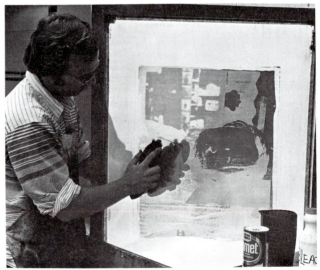

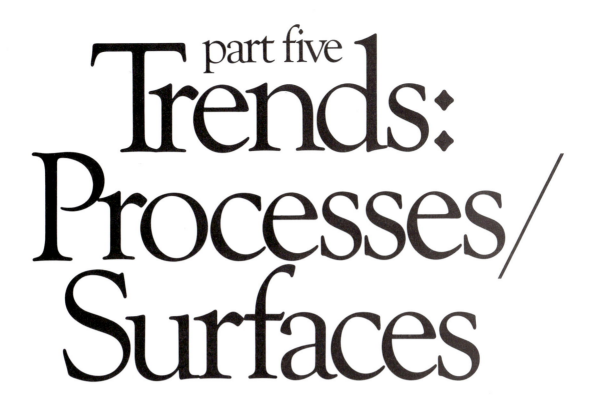

part five

Trends: Processes/Surfaces

9 Expanded and Applied Techniques

Through the centuries art has proved endlessly flexible in its ability to adapt to changing conditions of life. Continuing this tradition, many artists today have accepted the challenge presented by an accelerated development of technology. The result is an astonishing variety of unique and exciting innovations that make new use of paper, plastics, and photography, as well as employing such typically inartistic methods as the duplicating process to explore previously undiscovered means of expression.

Some of these novel techniques are being applied in conventional ways; by contrast, some artists handle traditional means with wonderful freshness. The etchings in Jim Dine's *Eight Sheets from an Undefined Novel* (Fig. 259) were colored by hand for a unique effect of color and brush stroke. In many cases the barriers separating prints, painting, multiple objects, and sculpture have been dissolved. The technique of

screen printing on large canvas works has been used by Robert Rauschenberg and Andy Warhol since the 1950s (Fig. 560). On a smaller scale, Lucas Samaras has mixed a variety of media to create his 98-color, ten-page *Book* (Fig. 561), including offset lithography, silkscreen, thermography, embossing, and diecutting.

In Claes Oldenburg's *Soft Drum Set* (Fig. 562), print techniques were applied to fabrics that were in turn sewn onto a three-dimensional object. The three-dimensional print *Gertrude* by Red Grooms (Pl. 33, p. 351) was made from two lithographs printed from aluminum plates. The prints were cut, folded, and adhered to form the whimsical figure and chair that were then mounted in an acrylic box. On the *Calyx Krater Trash Can* (Pl. 34, p. 352), James Rosenquist used Kodak KTFR photosensitive resist with *aqua regia* to etch Greek warriors on 18k gold. The first step was preparation of a scale drawing, after

right: **562. Claes Oldenburg.**
Soft Drum Set. 1969.
Soft sculpture with silkscreened
canvas and wood,
10 x 19 x 14″.
Courtesy Multiples, Inc., New York.

below: **560. Andy Warhol.**
American Indian Series. 1976.
Serigraph on canvas, 3′6″ x 4′2″.
Courtesy Leo Castelli, Inc., New York.

bottom: **561. Lucas Samaras.** *Book.* 1968.
98-color multimedia work, 10 x 10 x 2″.
Courtesy Pace Editions, Inc., New York.

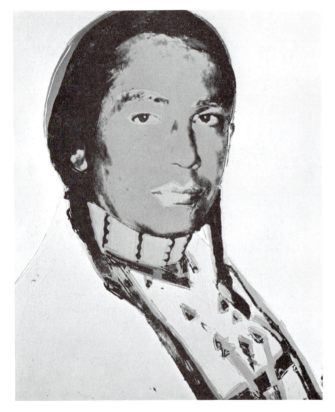

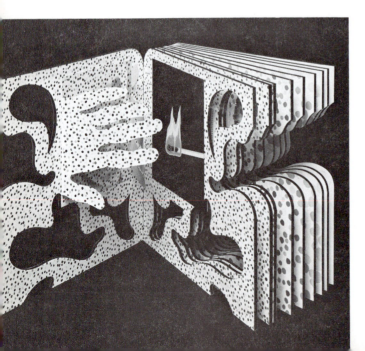

which a Kodalith transparency was made. The gold sheet was cleaned (degreased) with 1 part ammonium persulfate to 10 parts water by weight. The sensitized plate and the transparency were exposed to an arc lamp for 2 minutes. The plate was backed with asphaltum applied with an airbrush, then etched in a solution of 1 part hydrochloric acid, 3 parts nitric acid, and 3 parts water by volume. (The etching was done outdoors to avoid inhalation of the fumes.) The plate was then fashioned into a three-dimensional form, arc welded, painted, and polished.

Coins in Space for Daniel Ellsberg (Fig. 563), also by Rosenquist and produced on fabric at Styria Studios, employed a large-scale gradated or rainbow roll, a technique usually associated with smaller-scale works on paper. The large squeegee was fitted with a partitioned ink reservoir that maintained the proximity and integrity of the colors.

Ignoring the limitations of the paper surface, Jasper Johns added die-cut letters to his print *No* (Fig. 564), and in an exploration of the roles paper can play, Frank Stella formed paper and image simultaneously (Pl. 37, p. 362). Ed Moses printed lithographic washes on four sheets of silk tissue and one sheet of Arches that were overlaid and attached. The result is a rich, delicate, and diaphanous image (Pl. 35, p. 352). Ed Ruscha dispensed with commercially prepared ink and used Metrecal with grape and apricot jam to print his silkscreened *Fruit-Metrecal Hollywood* (Fig. 565), physically uniting content and material. The prints have remained colorfast.

These remarkable works represent just a few of the many uniquely creative trends in printmaking today. More and more artists are searching for freedom of expression through whatever means seem appropriate to them (Pl. 36, p. 361). Uncharted avenues of expression are limited only by the confines of one's imagination.

below: **563. James Rosenquist.**
Coins in Space for Daniel Ellsberg. 1972.
Silkscreen on fabric and vinyl, 8'2" x 5'5".
Courtesy Multiples, Inc., New York.

right: **564. Jasper Johns.** *No.* 1969.
Lithograph with lead letters, 4'8" x 2'11".
Courtesy Gemini G.E.L., Los Angeles.

below: **565. Ed Ruscha.**
Fruit-Metrecal Hollywood. 1971.
Serigraph, 10 x 37½".
Courtesy Cirrus Editions, Ltd., Los Angeles.

Monotypes

First used by the Italian artist Giovanni Castiglione (1600?–1665?) in the 17th century (Fig. 566), the monotype technique has continued to fascinate later artists. The process produces a single print by using pressure to transfer an image drawn or painted on one surface to another surface. The image is drawn on a smooth surface—such as a sheet of glass, a litho stone, or an etching plate—usually in oil colors diluted with turpentine. A sheet of paper, often dampened, is placed over the completed image and burnished by hand or run through an etching or lithographic press. Watercolors and litho inks also work well.

Both Gauguin and Degas employed the technique many times. Degas made over three hundred monotypes with oil colors and lithographic ink (Fig. 180). He also developed a method of making a monotype on transfer paper with lithographic transfer ink. This

image was then transferred to a grained litho stone, etched, and printed. In this way, Degas was able to combine the spontaneity of the monotype with the means for producing a consistent edition (Fig. 406).

If a sheet of glass or Plexiglas is used as the drawing surface, a guide drawing for the image can be placed underneath. Thus, a number of very similar monotype images can be made.

A method of combining drypoint with the monotype technique was used by Jim Dine in his *Portrait of Rimbaud* (Figs. 567–569). The drypoint was inked in black in the normal manner and color was brushed onto the plate prior to printing. Ten unique prints were made in this way, each numbered 1/1.

A method of printing a monotype that allows colors to be overprinted is to tape one edge of the printing paper to the plate. Take the first impression, lift the paper, redraw the necessary areas, and print again. The stable position of the paper will allow for accu-

567. Jim Dine.
Portrait of Rimbaud. 1975.
Drypoint and monotype, 6 x 4$^{15}/_{16}$".
Collection Mr. and Mrs. Donald Saff.

566. Giovanni Benedetto Castiglione
*The Angel Announces the Birth of Christ
to the Shepherds.* 17th century.
Monotype, 14$^1/_2$ x 9$^5/_8$".
Albertina Graphische Sammlung, Vienna.

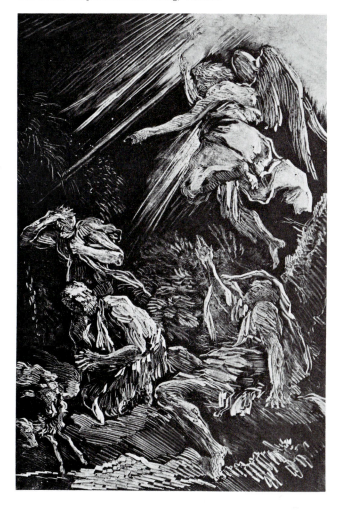

above: 568. The plate is prepared with a drypoint needle.

below: 569. Color is brushed over the plate before each print.

rate registration with each subsequent printing. The registration guides in Chapter 4 are also effective.

Pieces of cut paper for hard, sharp edges, inked shapes for adding color or variety, and textured objects for embossing can also be combined with the basic techniques if the image is printed on dampened paper using an etching press.

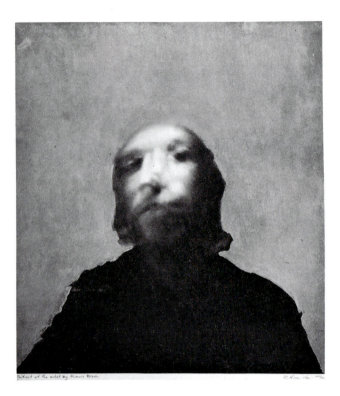

570. Richard Hamilton.
Portrait of the Artist
by Francis Bacon. 1970–71.
Serigraph and collotype, 21⅝ x 19½".
Courtesy Petersburg Press, Ltd., London.

Collotypes

The collotype or photogelatin process is a means of obtaining high-quality photo reproduction related to lithography. This process requires no halftone screens, however, and because of its infinite range of screenless tones (Fig. 570), it is sometimes confused with photogravure.

Collotype dates back to 1876, when Joseph Albert experimented with sensitized gelatin on glass plates. Today grained zinc or aluminum plates are used; these can be wrapped around offset cylinders for rotary printing.

Gelatin is sensitized with potassium bichromate or ammonium bichromate to form the basic emulsion. This mixture hardens when exposed to light; the unexposed areas remain soft and will swell when wet. In the process of swelling, these areas also become slightly higher than the exposed parts of the image. A film of the bichromated gelatin is allowed to flow onto the plate and dry. The plate is exposed to a continuous-tone photographic negative. The parts exposed to the greatest amount of light will become the hardest, while the other areas will retain water in proportion to the degree of exposure.

More ink adheres to the harder parts of the image and less to the softer, moist areas dampened with a mixture of water and glycerin. Because of the fragility of the image, very long runs are not possible. For this reason, collotype has never achieved great popularity as a commercial process. The lithographic hand press or flatbed press is often used in printing, although the process has recently been adapted for offset equipment with excellent results. It remains a highly specialized and temperamental technique, however. This process is also known as *heliotype.*

Formed and Cast Paper Prints

The expansion of the roles that paper can play in the graphic arts processes has led to the development in recent years of many fascinating and innovative techniques. Working at the Richard de Bas papermill in Ambert, France, Robert Rauschenberg poured rag pulp by hand onto a wire mesh, sometimes laminating pieces of cloth or images printed on very delicate paper into the wet paper pulp at the same time (Fig. 571). The unique pieces of paper were left to dry naturally. Each was then displayed in such a way that

571. Pigmented pulp was poured onto a mold by Robert Rauschenberg for his *Pages and Fuses—Bit.* Here two mill workers couch the finished print.

Plate 33. Red Grooms. *Gertrude.* 1975.
Six-color lithograph, cut out,
mounted, and boxed in acrylic, 19¼ × 22 × 10½″.
Courtesy Brooke Alexander, Inc., New York.

left: **Plate 34. James Rosenquist.**
Calyx Krater Trash Can. 1977.
Etched 18-carat gold with oil paint;
height 4½″, diameter 2⅞″.
Collection Sydney Singer, New York.

below: **Plate 35. Ed Moses.**
Broken Wedge Series No. 6. 1973.
Lithograph on silk tissue, 24 × 18½″.
Courtesy Cirrus Editions, Ltd., Los Angeles.

572. Louise Nevelson.
Dawnscape. 1975.
Cast paper relief produced
from a rubber mold, 27 x 31″.
Courtesy Pace Editions, Inc., New York.

the luminous qualities of the paper image could be viewed from both sides.

In India, Rauschenberg sandwiched grids of split and tied bamboo between layers of poured paper pulp, often including fabric in the paper layers as well. The luminosity of the thin paper combined with the bamboo grid and the color of the fabric produced an unusual and striking new view of paper as image.

Rag pulp has also been used for casting images in relief (Fig. 572). Molds are made from plaster or from a new rubberlike plastic called RTV (made by Dow-Corning Corporation). RTV is a two-part system, consisting of a base and a curing agent with virtually no shrinkage factor. When one part of catalyst and ten parts of base (by weight) are mixed thoroughly and left at 77°F for 24 hours, the mixture will cure by means of polymerization. The resulting material is a white rubber of great strength and flexibility that allows undercuts to be cast accurately. Silastic E RTV and Silastic G RTV are ideal for making molds with intricate detail.

Using either a plaster mold or one made of RTV, the rag pulp is formed by being pushed into the crevices of the mold by hand and left until it is dry enough to be removed without falling apart. Because plaster absorbs water, paper in a plaster cast will dry in about one day. Paper pressed into nonabsorbent RTV can take several days to dry. The thickness of the layer of paper depends on the overall size of the cast. The larger the cast, the heavier the paper relief must be to support itself. During the process of drying, more molding can be done by hand.

Colored pigments or dyes (such as Dr. Martin's Colors) also can be added to the pulp before it is placed in the mold. Dyed cotton pulp and colored paper collage were used by Frank Stella to produce images with clearly delineated areas of color. Working with John and Kathleen Koller of Hand Made Papers in Connecticut, Stella employed a technique developed by Kenneth Tyler in collaboration with the Kollers. The images were made by forming the pulp on a segmented, shaped screen mold. The relief print was colored by hand (Pl. 37, p. 362). The prints were published by Tyler Graphics, Ltd.

Gum Printing

In the gum printing technique, a sheet of paper is coated with a solution of gum arabic, ammonium dichromate, and a pigment. The paper is then taped to a board and allowed to dry in a dark place. When it has dried, the paper can be covered with a handmade or camera-produced negative or positive and placed in a vacuum frame for exposure to a light source. The unexposed areas are washed off the paper with lukewarm water. The resulting image areas are permanent and fixed firmly to the paper.

The ingredients for the sensitizer solution are as follows:

½ ounce ammonium dichromate crystals
5 ounces water
5½ ounces gum arabic (14° Baumé)
pigment as needed

573. James Rosenquist,
Mirrored Flag. 1971.
Lithograph with metallic Mylar foil, 29 x 22″.
Courtesy Graphicstudio,
University of South Florida, Tampa.

Dissolve the ammonium dichromate crystals in water, then mix the resulting solution with the gum arabic and add pigment to the desired intensity.

Cliché Verre

To produce a *cliché verre* print, an opaque coating such as poster ink or even oil paint is placed on a clear sheet of glass or plastic. Wherever the glass or plastic is drawn upon, the coating will be removed, and light will shine through. This actually produces a hand-made negative, which can be exposed onto various types of photographic papers in the usual manner. The resulting black-and-white positive image can be reproduced in editions of any size (Fig. 178).

To obtain a color *cliché verre* print, you can make your own photographic paper by employing the gum printing process (see above) on such papers as Arches or Rives. The image appears in the color of the pigment used in the coating. Photographic emulsions can also be obtained commercially from Rockland Colloid Corporation, and should be sprayed or brushed onto the paper in a darkroom.

Prints Made with Plastics

The first plastics—developed in 1868—were made from cellulose nitrate. The term "plastic" now en-compasses a wide range of materials, made up of various combinations of carbon, oxygen, hydrogen, chlorine, fluorine, and nitrogen. First employed for artistic purposes in unique works by Naum Gabo, Antoine Pevsner, and the Bauhaus artists László Moholy-Nagy and Gyorgy Kepes, plastics—particularly acrylic—soon became popular art materials. By the end of World War II, plastics technology had become readily available to artists through the use of plastics in advertising and industry.

Plastics fall into two groups—*thermoplastics,* which become soft and malleable in the presence of sufficient heat, and *thermal-setting plastics,* which change irreversibly from liquid to solid when a thermo reaction takes place. Plastics can be reflective, transparent, translucent, or opaque and are castable.

Mylar Film

James Rosenquist set adhesive-backed reflective Mylar film on his 1971 lithograph *Mirrored Flag* (Fig. 573). The Mylar was placed carefully on the surface to ensure proper registration. Before it was rubbed to adhere it to the lithograph, a sheet of paper was laid on the surface to avoid fingerprints or scratches on the soft surface of the Mylar. Clear Mylar also can be screen printed, and because it does not stretch, it often serves for lithographic registration procedures.

Acrylic

Because of its dimensional stability, light weight, and ease of fabrication, acrylic sheet offers a great range of potential uses. Working with acrylic is no more complex than working with wood, provided that certain minor modifications are taken into account to accommodate the intrinsic properties of the material (Figs. 574, 575).

above left: 574. The edge of an acrylic sheet can be polished by a controlled flame. The protective backing has been rolled back here.

above right: 575. A shaped piece of acrylic is laminated to a rectangular acrylic sheet by means of solvent applied with a hypodermic needle.

Cutting Acrylic sheets up to approximately $\frac{1}{16}$ inch thick can be scored with a razor blade and snapped apart. Acrylic film for edition printing can be die-cut on a stamp press. For cutting thicker sheets with a table, radial, or panel saw, a standard wood veneer blade usually will suffice. This type of blade reduces chipping and cracking. Do not set blade height more than $\frac{1}{4}$ inch above the material. Because of its thermoplastic properties, acrylic should be cut slowly to avoid melting. When smooth cuts are desired in thick acrylic sheet, a 10-percent solution of soluble oil and water should be applied to the blade during cutting. With a band saw, use a skip-tooth or buttress blade, which has extra gullet capac-ity and allows for large chips. (Six teeth per inch of blade is the recommended size.) When cutting with a saber saw, use a nonferrous metal blade of fourteen to sixteen teeth per inch. A Cutawl with a #22 blade can cut intricate shapes, provided it is moved slowly across the surface of the plastic (Fig. 291).

Drilling Acrylic can be drilled in the same manner as wood and metal. The tip of the bit, however, should have a 60-degree bevel, with a dubbed-off area at the cutting point. These drill bits are easy to obtain. Drilling should be done at the highest possible speed (approximately 5000 RPM). For large holes (greater than $\frac{1}{2}$ inch), reduce the speed to 1000 RPM. In *Mirage Morning* (Fig. 576) James Rosenquist drilled through acrylic sheet and riveted window shade hardware to its surface.

Sanding and Polishing Machined surfaces can be restored to their original smooth and highly polished state by a progressive-step sanding procedure, beginning with No. 120 grit and advancing to 240, 320, and

576. James Rosenquist.
Mirage Morning. 1975.
Lithograph with Plexiglas face
and window shades,
paper size 3' x 6'2".
Courtesy Graphicstudio,
University of South Florida,
Tampa.

below: **577. Larry Rivers.**
French Money. 1965.
Serigraph on acrylic
with acrylic collage, 32 x 30".
Courtesy Multiples, Inc., New York.

right: **578. Robert Rauschenberg.**
Third panel from *Star Quarters.* 1971.
Silkscreened mirrored Plexiglas, 4' square.
Courtesy Multiples, Inc., New York.

finally 400. It is preferable to wet the acrylic while sanding. After the sanding has been completed, the acrylic can be restored to its original surface by polishing with a polishing wheel and alumina abrasive. A final polishing should be done on a clean, soft buffing wheel without compound. Sanding and buffing are recommended as preliminary steps to solvent cementing and gluing. An edge-polishing technique is flame polishing, in which an oxygen-hydrogen flame is passed quickly over the edge. (Carbon-based fuel should not be used.)

Gluing Commercially available methylene chloride generally is used for solvent-cementing of acrylic sheet, either by direct application or through capillary action. This solvent cement is applied with a hypodermic needle or a fine brush along the seam.

This was done for the box in *Gertrude* (Pl. 33, p. 351). Other adhesives, such as epoxy, also can be used, but these do not fuse the material together, and they require a rough surface to be effective.

Care and Cleaning Acrylic sheet normally has a negative polarity, which makes it attract particles in the air. To neutralize this electrostatic effect, the surface should be cleaned with isopropyl alcohol and a soft cloth. To remove minute scratches, buff with a surface finish polish such as Mirror-glaze compound.

Placing Images on Acrylic Sheet The most common ways of placing an image on acrylic are brushing, spraying, and screening. Before screening an image, clean the acrylic with isopropyl alcohol in the manner described above. Screening should take place at 70 percent humidity or below, to guarantee permanent adhesion of the paint. If *vacuum forming* (see below) is to take place, a flexible paint product (such as Grip-Flex FR-1) should be used for screening. Larry Rivers' *French Money* (Fig. 577) is an example of a screened image on acrylic, with the addition of smaller, shaped acrylic forms that have been solvent-cemented to the surface. In Robert Rauschenberg's *Star Quarters* (Fig. 578), produced at Styria Studios in New York, acrylic sheet was screened on both sides and then vacuum-plated with a mirror surface on the back. The fact that the sheet could be printed on both sides provided a physical space to juxtapose the images, which in turn were compounded by the reflective surface of the mirror.

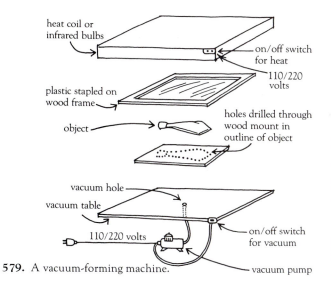

579. A vacuum-forming machine.

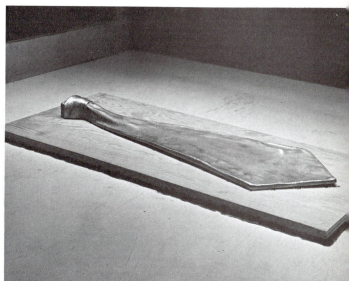

above: **580.** The object is set on a piece of wood with holes drilled along the outline. The wood is wax-sealed to the vacuum table.

below: **581.** The completed vacuum-formed image of styrene plastic should be removed from the original as it begins to cool.

Forming Thermoplastics

The technique of forming thermoplastics is fundamentally the same for acrylic, vinyl, urethane, styrene, and polyethylene. The two processes that offer the greatest potential for expanding the range of graphic images are *vacuum forming* and *press molding*. In both cases, the material must be brought to its moldable temperature by infrared lamps, heating coils, or a commercially available oven.

Vacuum Forming Plastic sheeting can be vacuum-formed over any object—within its stretching limitations—to produce high-fidelity reproductions of that object. This is accomplished by placing the object on a vacuum table, draping plastic over it, heating the plastic, and withdrawing the air so that the plastic is sucked down toward the table and around the object. Commercially available machines, like those manufactured by Plasti-Vac, Incorporated, are ideal. One also can build a vacuum-forming machine with a vacuum cleaner or a vacuum pump connected to a drilled Formica-on-plywood table top (Fig. 579). Infrared bulbs should be placed overhead to heat the material. To ensure the sealing effect necessary to draw a vacuum, the plastic sheet can be mounted to a plywood frame with an interior window cut to the desired dimensions of the finished piece. Screws or staples can be used to secure the plastic to the frame. (Drill plastic before using screws to avoid cracking or splitting.)

If the object over which the plastic is being formed extends over the holes in the vacuum table, a small spacer should be used between the object and the table. If the object is placed on a piece of wood (Fig. 580), cut ridges in the back of the wood from the vacuum hole to the holes under the edge of the object. Since the plastic shrinks while cooling, it should be

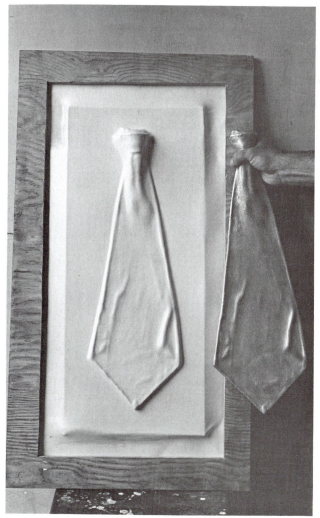

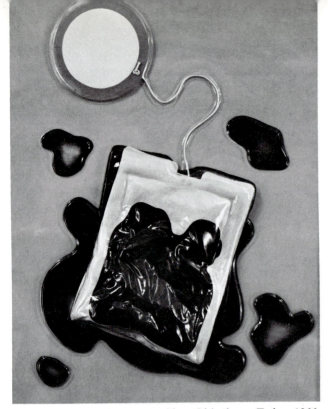

582. Claes Oldenburg. *Teabag.* 1966.
Serigraph on felt, Plexiglas, and plastic,
with felt bag and rayon cord attached;
$39\frac{5}{16}$ x $28\frac{1}{16}$ x $3''$.
Museum of Modern Art, New York (gift of Lester Avnet).

583. Tom Wesselmann. *Cut Out Nude.* 1965.
Serigraph on vacuum-formed plastic, $7\frac{7}{8}$ x $16\frac{1}{4}''$.
Museum of Modern Art, New York (gift of Original Editions).

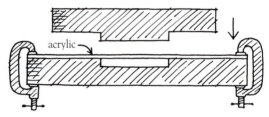

acrylic

above: 584. A sheet of plastic is clamped
to a negative mold, heated, and press molded
by the positive mold.

below: 585. James Rosenquist. *Earth and Moon.* 1971.
Lithograph with Plexiglas hourglass face, $18\frac{1}{2}$ x $17\frac{1}{2}''$.
Courtesy Graphicstudio,
University of South Florida, Tampa.

removed from the object as soon as it falls below the
thermal-forming temperature (Fig. 581). (To check
the draw of the vacuum, pass a lighted match over the
vacuum holes. The flame should be sucked down to
the holes if the vacuum is working properly.) Claes
Oldenburg's *Teabag* is an example of a vacuum-
formed object (Fig. 582). Color was screened onto the
acrylic backing sheet and the felt teabag. The bag was
then sandwiched between the formed sheet and the
backing sheet.

A variation of vacuum forming can be seen in Tom
Wesselmann's *Cut Out Nude*, in which *blow forming*
was used (Fig. 583). After the images were screened
with flexible ink, the plastic was placed over a nega-
tive mold and blown down by air pressure.

Press Molding Press molding is done by heating
the plastic until it is pliable, clamping it to a negative
mold and pressing a positive mold into it (Fig. 584).
James Rosenquist employed this technique for *Earth
and Moon* in order to form the outer sheet of the
hourglass, which then was trimmed and glued to a
backing sheet (Fig. 585). The backing sheet was
drilled and the hourglass filled with beads.

Liquid to Solid Systems

Thermal setting and chemical curing processes for
image production undoubtedly will see even greater

586. Richard Hamilton.
Relief from *Five Tyres Remoulded*. 1972.
Relief cast in white synthetic rubber, 24 x 34".
Courtesy Petersburg Press, Ltd., London.

top right: 587. The mold for Claes Oldenburg's
Profile Airflow is prepared
at Gemini G.E.L., Los Angeles.
(See Fig. 590.)

center right: 588. The finished mold is examined.

bottom right: 589. Oldenburg setting the flexible
polyurethane relief form
over the finished lithograph.

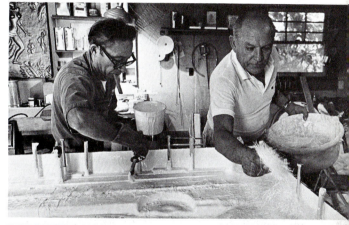

use in the near future. In 1972, Richard Hamilton produced a suite entitled *Five Tyres Remoulded*. It included computer-plotted perspective drawings that were screen-printed on clear Mylar, and a relief-cast white synthetic rubber impression that set out the history of the rubber tire (Fig. 586). The relief impression was made of Silastic RTV.

In *Profile Airflow* Claes Oldenburg overlaid a two-color lithograph with a transparent molded polyurethane relief, which was produced in an edition of seventy-five prints by Gemini G.E.L. (Figs. 587–590). Like RTV, polyurethane is a flexible elastomer with a high tear strength. Unlike RTV, however, polyurethane resin can be colored. Because it is not self-releasing from a mold like RTV, a barrier coat of silicone oil should be used as a releasing agent.

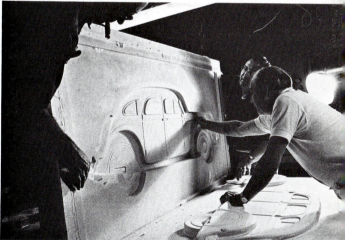

Polyurethanes TU 60 and TU 75, manufactured by Conap Corporation, are excellent materials for casting or moldmaking. Polyurethanes should be mixed in very well-ventilated areas, because once the moisture-sensitive liquid urethane is exposed to air, it gives off both carbon dioxide and free diisocyanate (TDI), which is odorous and toxic. Do not allow the material to come in contact with the skin.

Intaglio on Plastics

Plexiglas, Phenolic (G-10), and Lexan (from $\frac{1}{16}$ to $\frac{1}{8}$ inch thick) can serve in a variety of ways to create

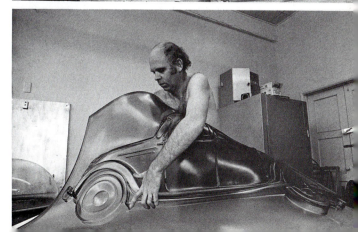

590. Claes Oldenburg.
Profile Airflow. 1969.
Molded polyurethane relief
over two-color lithograph,
2'9½" x 6'5½".
Courtesy Gemini G.E.L., Los Angeles.

relief and intaglio plates. These plastics can be cut in much the same way as wood blocks or metal plates, and offer some specific advantages.

They come in large sheets, making them relatively economical. While their surfaces are hard, smooth, and easy to ink or wipe, they still yield beautifully to engraving, woodcut, and drypoint tools. Making an engraving in Plexiglas would not be a formidable task for an inexperienced engraver. Guide drawings can be placed under the plastic sheet to aid in the cutting, or the surface can be covered with black water-base ink that protects the plastic and provides helpful contrast while it is being cut. When the image has been completed, the ink is simply washed off. Registration procedures discussed in Chapter 4 can be used, and consecutive plates in a multicolor print can also be placed over one another to check the progress, appearance, and registration of the image.

A variety of textural effects can be fashioned with the help of a flexible shaft tool. Wire brushes, felt and cloth wheels, and a wide range of bits will cut and abrade the surface with an almost infinite variety of rich textures. An air-driven dental drill makes lines in Phenolic (G-10) that are as delicate as the finest etched lines on a copper plate. The action of solvents such as methylene chloride can be controlled on acrylic sheet to yield an image with the appearance and delicacy of an aquatint or lithographic wash. Collograph plates can also be made by gluing objects to the surface with polymer or epoxy, in combination with any of the above procedures as well.

Transfer Techniques

Solvent Transfer

Robert Rauschenberg perfected his solvent transfer drawing technique when working on his suite of drawings for Dante's *Inferno*. Since that time, he has also utilized the method for edition printing. The fabric or paper to which the newspaper or magazine images are applied is placed face-up on a litho stone or aluminum block covered with glassine paper to avoid stains. The images are then placed face-down and sprayed generously with solvent. (Hanco Press Cleaner and Bingham Roller Cleaner are good solvents for this purpose.) The damp images are covered with glassine paper, a sheet of cover stock, and the tympan, and run through the litho press. It is sometimes necessary to run the image through the press a number of times, depending on the age and type of the paper and ink used in producing the newspaper or magazine. If large surfaces are being sprayed, a gas mask should be used to avoid inhalation of the fumes from the solvent.

Rauschenberg has used this process on silk chiffon and silk taffetas, and other fabrics in his *Hoarfrost*

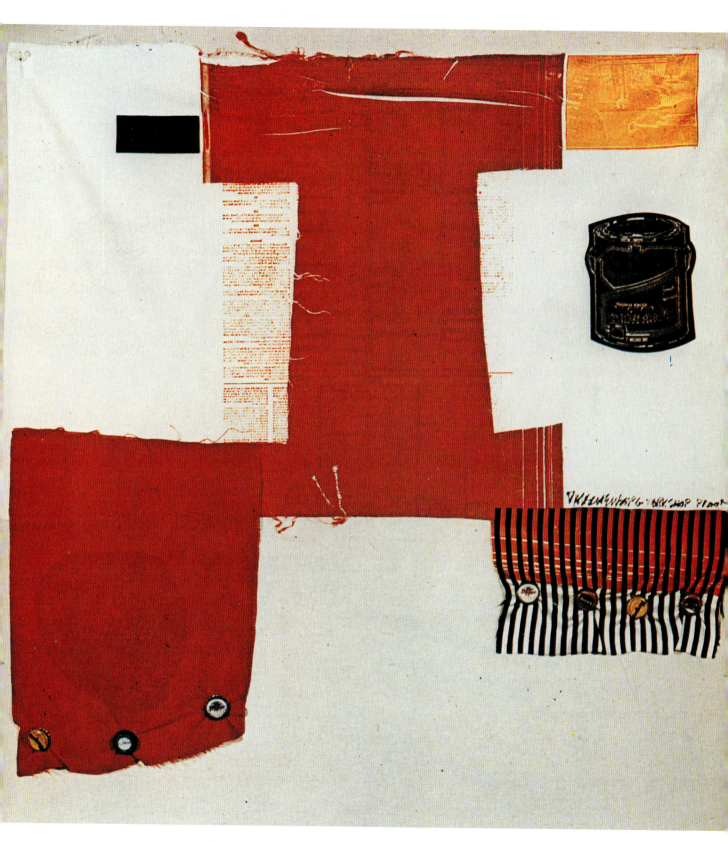

Plate 36. Robert Rauschenberg.
Cat Paws, from *Airport* series. 1974.
Intaglio on sewn cotton, muslin,
and satin with bottle caps, 34 × 35½".
Courtesy Graphicstudio,
University of South Florida, Tampa.

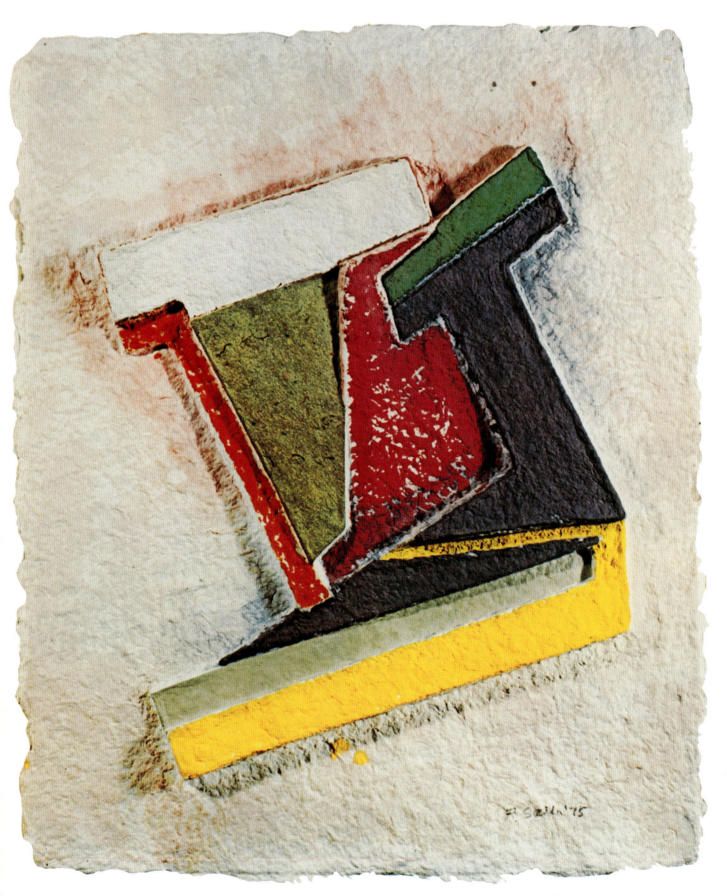

Plate 37. Frank Stella. *Olyka III.* 1975. Paper relief print, 26 × 21½ × 1¾".
Courtesy Getler-Pall Gallery, New York.

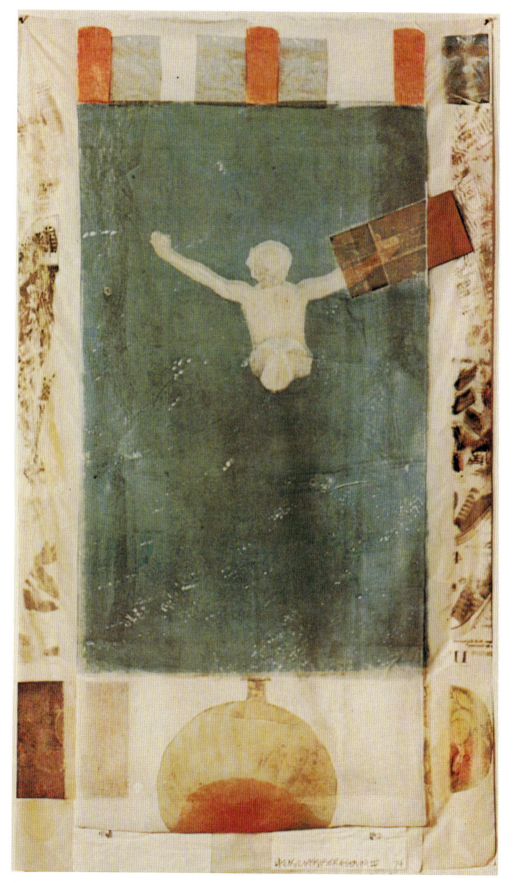

Plate 38. Robert Rauschenberg. *Pull,* from *Hoarfrost* suite. 1974.
Transfer and collage, 7′1″ × 4′. Courtesy Gemini G.E.L., Los Angeles.

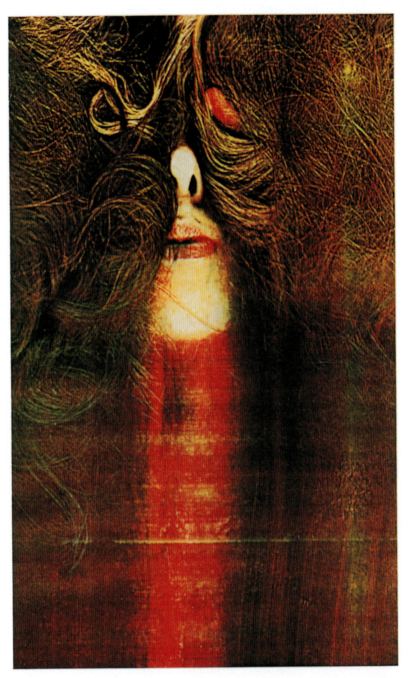

above: **Plate 39. Susan Kaprov.** *Self-Portrait.* 1975.
Xerox color print, five overlays of color, 14 × 8½″.
Courtesy the artist.
below: **Plate 40. Sonia Sheridan.** *Mary Jane.* 1977.
3M color-in-color matrix transfer to fabric, 1′5″ × 8′3″.
Courtesy the artist.

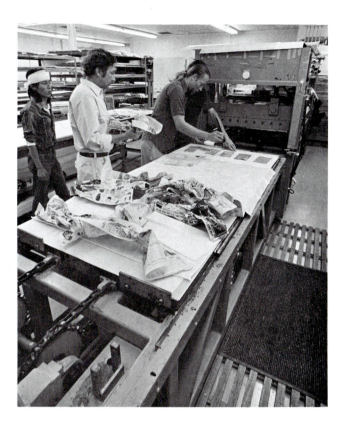

591. Robert Rauschenberg's
Hoarfrost Editions
project in progress
in 1974 at Gemini G.E.L.,
Los Angeles.
(See Pl. 38, p. 363.)

for acetone has a solvent effect on plastic.) Because the paper will stretch, the back should be scraped only once to avoid double images. An edition of prints can be made easily with this process. This technique can also be used on the lithographic stone or plate. The image is then processed in the normal manner.

suite, created at Gemini G.E.L. in Los Angeles (Fig. 591; Pl. 38, p. 363).

Contact Paper Transfer

Magazine transfers on clear contact paper can be used to make photo positives or finished images to be applied to other surfaces. The image is set face-down on clear Contact paper and rubbed with a burnisher. The Contact paper and image are placed in lukewarm water until the paper is soft enough to be removed easily by gentle rubbing. The ink from the image remains on the Contact paper, which then can be used as a photo positive capable of reproducing the original with surprising fidelity. Laminating film made by the Douglas Stewart Company is a good material for this purpose.

Xerox Transfer

Black-and-white Xerox copy images can be transferred to other surfaces, including paper, fabric, and glass. Though a Xerox machine uses an electrostatic transfer system that works on any type of paper, paper made by Nekoosa seems to work best for transferring purposes. The Xerox copy image is placed face-down on the receiving surface and rubbed with a wad of cotton dampened with acetone. Once the image has been dampened evenly, the back of it is scraped with a straightedge. (Wood or metal is best,

Color Xerox Images and Transfers Robert Whitman recently completed a suite of color Xerox images. By placing a variety of objects on the exposure window of a Xerox copier and altering the color controls, he has produced images rich in color and texture. Because it uses an electrostatic system, the machine yields colors with a tactile quality that further enhances the work. These color Xerox copies can be transferred in the same manner as black-and-white images.

Because of the techniques she employs, Susan Kaprov uses the Xerox machine as a monoprinting device. Placing photographs, found objects, fabrics, acetate drawings, and even her face on the exposure window, she builds her images with overlays of color as the same sheet of paper is passed through the copier a number of times. *Self Portrait* (Pl. 39, opposite) contains five such overlays. The yellow, cyan, and magenta controls were manipulated to obtain the rich and varied hues, values, and intensities. The unpredictability of the results poses a formidable challenge, as does the occasional streaking and unevenness of the colors.

3M Color Transfers

The 3M Company has developed a thermographic "color-in-color" copying system. It produces a dry, nonsilver, color copy measuring $8\frac{1}{2}$ by 11 inches. The "color-in-color" process is also capable of copy-

ing images from color slides and has enlargement capacities of 5X, 7X, and 11X. In addition to the normal color positive, prints can be made on a transfer matrix available from the manufacturer. Full-color images can be transferred from the matrix onto paper, cloth, wood, metal, and other surfaces. The transfer can be completed in 2 minutes at 280°F, with an iron or dry mounting press. The receiving surface must be sprayed with sizing transfer solution, also available from the manufacturer. In addition to producing high-fidelity color prints, one also can manipulate the color controls for unique results. Sonia Sheridan has made large figurative images by exposing a model's body one section at a time over the machine's copying face (Pl. 40, p. 364). The figure then was reconstructed on a large piece of fabric by means of heat transfer.

Transferring to Epoxy

Magazine images can be transferred to epoxy resins from clay-coated paper. Tape the image face-up on a flat surface. Mix epoxy resin 502 and curing agent RC 303 in a 1-to-1 ratio. After stirring them for about 1 minute, spread a thin coat (about 1/16 inch) over the surface of the image. The image then should be sprayed with a small amount of acetone to release any air bubbles on the surface. As soon as the resin mixture has jelled, spray it with mold release. After about 15 minutes, place the resin and paper under warm water until the paper is soft enough to be removed by very gentle rubbing. Once the resin has dried, a thin coat of 502 and RC 303 should be painted over the residual ink, safeguarding it against damage. Now totally cured, the surface should be polished with mirror glaze. This process, perfected by Harry Hollander, can produce editions and photo positives.

Other epoxy resin mixtures can be employed for varied effects, such as color images, colorless images,

bubble-free images and so on. Manufacturers' specification sheets should be consulted.

Magazine Image Transfer for Lithography

A new process perfected at Gemini G.E.L. makes it relatively easy to transfer directly from magazines to litho stones or plates without photographic work.

Spray the stone or plate with two or three good layers of Celusolve acetate solvent. Place the magazine image face-down and quickly cover it with four sheets of newsprint. Run it through the press seven times with medium pressure, then again three times using two clean sheets of newsprint dampened on the back. Remove the newsprint and image, fan dry, and wait 1 hour. Carefully talc and sponge the image with gum. Do not buff down. After 20 minutes, wash off the gum and ink up slowly with a composition roller. Pull one print on newsprint, then etch with a 3- or 4-drop etch solution.

Decal Transfer for Ceramics

In collaboration with Alan Eaker, Rauschenberg created a series of press-molded ceramic sculptures at Graphicstudio. These works, editioned by Julio Juristo, utilized silkscreen decal transfers that were fired onto the clay surface. The decal transfer was made in the following way.

A clay piece made from a plaster mold was fired (Fig. 592). Then a piece of decal paper was flood-coated with underglaze varnish through an open silk screen. Color glazing oxides then were mixed with underglaze varnish and squeegeed through the image screen onto the flood-coated paper. When it had dried, the decal paper was immersed in warm water. In the meantime, the area of the ceramic that was to receive the decal was painted with cellulose gum. The

opposite left: 592. Clay object for Robert Rauschenberg's *Tampa Clay Piece 3* is removed from the mold at Graphicstudio, University of South Florida, Tampa. (See Fig. 594.)

opposite right: 593. The serigraph decal image is slipped from its backing paper and adhered to the clay.

right: 594. Robert Rauschenberg. *Tampa Clay Piece 3.* 1972–73. Press molded clay with silkscreened ceramic glaze decal, platinum luster glaze, patina, and tape; 19½ x 24 x 5½″. Courtesy Graphicstudio, University of South Florida, Tampa.

decal, which had been loosened from its backing paper by the water, was slipped off the paper onto the wet cellulose gum and allowed to dry (Fig. 593). The clay, already fired to cone 9, was then fired to cone 06, permanently fixing the decal image to the surface (Fig. 594). Firing the luster glazes at a lower temperature (cone 018) did not alter the decal transfer image. The use of cellulose gum was critical, since other adhesives that were tested bubbled through the image, permanently destroying the work. (For information on coloring oxides and firing procedures, a ceramics manual should be consulted.)

Blueprints and Brown Sepiaprints

At Graphicstudio (University of South Florida, Tampa), Paul Clinton developed a technique for blueprinting and brown sepiaprinting on roll Rives B.F.K. The process can be controlled to yield a permanent image on fine paper. Rauschenberg's *Tampa 2* (Fig. 595) was produced in the following way.

1. A transparency was made from Kodalith film and a 133-dot screen. The pieces of cardboard were placed in the copy camera to be photographed.
2. One ounce of distilled water was used to dissolve 3.3 grams of green granular ferric ammonium citrate. When this had dissolved completely, 1.5 grams of potassium ferricyanide crystals (reagent A.C.S. $KaFe[CN]_6$) was added and the mixture placed in a brown bottle. (Blueprint sensitizer must be mixed fresh each day, in order to control value, hue, and intensity. If left on the shelf for a longer period of time, it will tend to darken, making it impossible to produce a consistent edition.) To prevent staining beyond the image, a Mylar stencil was cut to the size of the image. (The piece of Mylar also aided in registration.) The sensitizer then was sponged onto a piece of unsized paper, which was allowed to dry in a darkroom for approximately 12 hours.
3. The Kodalith transparency was placed over the sensitized paper in a vacuum frame and exposed for 20 minutes with a 17-amp carbon arc lamp.

595. Robert Rauschenberg. *Tampa 2.* 1973. Three-color lithograph and blueprint, 2′5½″ x 6′2½″. Courtesy Graphicstudio, University of South Florida, Tampa.

above: 596. The positive mold for Jasper Johns' *High School Days* is placed over the lead sheet and negative mold.

right: 597. The formed lead sheet results from the pressure of the Hoe press. The mold can be seen on the press bed.

4. The exposed paper was placed in an epoxy-coated wooden tray filled with developer. The developer was a $\frac{1}{2}$- to 1-percent solution (by weight) of granular potassium dichromate ($K_2Cr_2O_7$) and water. When the print had developed, it was rolled onto a 4-inch PVC pipe, carried to the rinse tray, and unrolled. (The developer tray and chemicals must be cleaned regularly, to avoid staining the unsized paper with the contaminated developer.)

5. After the excess developer was washed out in the rinse tray, the print was hosed with water for 10 minutes and then allowed to soak in water for another 15 minutes. (Insufficient washing creates an imbalance of color; overwashing changes the rich, blue color of the print to a very pale blue-green.)

6. The print was placed between two blotters and allowed to sit for a week. Slow drying in this way ensured retention of the rich, blue color.

The production of *Tampa 12*, a later series, combined brown sepiaprinting and lithography on unsized, roll Rives B.F.K. The procedure was as follows.

1. Sensitizer solution was made by mixing 45 grams ferric ammonium citrate, 7.5 grams tartaric acid, 19 grams silver nitrate, and 500 milliliters dis-

tilled water. (This sensitizer must be mixed fresh each day. Allow 24 hours to elapse before using.)

2. The sensitizer was sponged onto the paper and allowed to dry in the same manner as that used for blueprinting (see above).

3. After being placed in a vacuum frame with the Kodalith image, the paper was exposed with a 17-amp carbon arc lamp for 4 minutes.

4. The exposed paper was placed in a developer tray containing a solution of 21 grams hydroquinone, 112 grams sodium sulfite, and 30 drops of acetic acid in 30 quarts of water. (This developer lasts for 3 prints, after which it is usually too dirty and too weak to be effective. The tray should be washed when changing the developer to remove any contaminants.)

5. The print was removed in a roll, as the blueprint had been, and placed in a rinse tray of water, then in a fixative bath. Unlike blueprinting, brown sepiaprinting required the use of a fixative bath because of the presence of silver nitrate in the sensitizer. The fixative solution was a mixture of

below left: 598. The lead is tooled to press it more securely against the polystyrene backing.

below right: 599. The lead sheet is adhered to a wooden board.

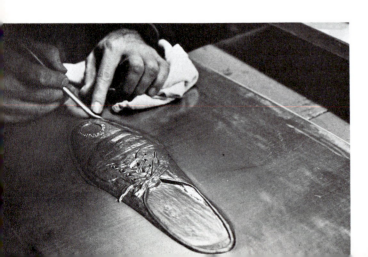

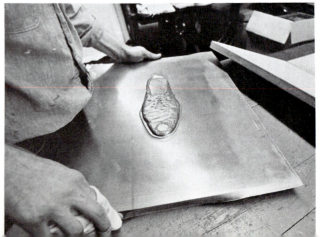

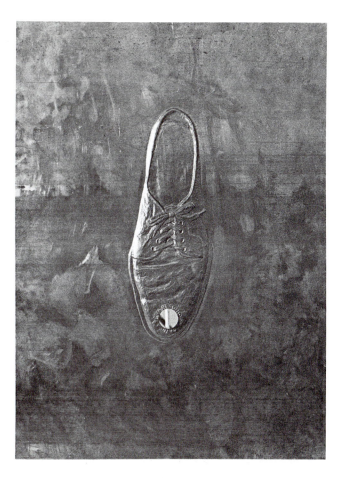

750 grams sodium thiosulfate, 28 capfuls household ammonia, and 8 gallons water.

6. The print was removed from the fix solution, placed in a clean tray, and hosed with water for 20 minutes.
7. The drying procedure was the same as that employed for blueprinting.

Making a blueprint and a brown sepiaprint on the same sheet of paper presents a problem, because of the incompatibility of the blueprint with brown sepia developer, and of the brown sepiaprint with potassium dichromate. To produce a combined print, the brown sepiaprint must be completed first and allowed to dry completely. When the blueprint area has been sensitized and exposed, it must be developed by brushing the potassium dichromate developer over the sensitized area by hand, without the convenience of immersing the print in a tray.

Embossed Lead Images

Jasper Johns and Robert Morris utilized soft lead to edition images that bridge graphics and bas-relief sculpture. In *High School Days* by Johns (Figs. 596–600), .015 soft cold rolled lead sheet was formed by a negative and positive mold in a hydraulic Hoe press.

600. Jasper Johns.
High School Days. 1969.
Lead relief with mirror, 23 x 17″.
Courtesy Gemini G.E.L., Los Angeles.

The molds were made from the original created by the artist in wax and plaster. Once formed, the lead was adhered to a rigid polystyrene backing that was in turn supported by wood. The surface was then scrubbed to an even finish so that it would oxidize naturally in a consistent manner. A small mirror was added to the surface.

Memory Drawings by Robert Morris (Fig. 601) was created by placing soft sheet lead over a photomechanically etched plate produced from the artist's original lettering. The plate and lead sheet were rolled through an etching press, employing a thick, flexible rubber blanket and substantial pressure. Once embossed, the borders of the image were folded over a wood-supporting frame.

Cast Plate Intaglio

Intaglio plates can be made in cast nonferrous metal (bronze, copper, or zinc) or in cast plastic, then printed by the same techniques employed for engraved, etched, or collagraph plates.

601. Robert Morris.
Memory Drawings.
Embossed lead relief
printed on an etching press.
Courtesy Styria Studios, New York.

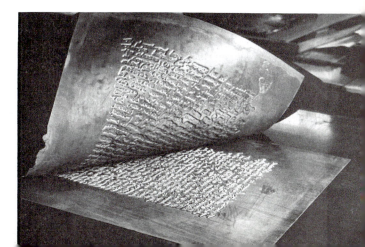

left: **602.** Rufino Tamayo inking
a cast bronze plate
made from a wax original.

below: **603. Rufino Tamayo.**
Mano Negra.
Cast plate intaglio, 4 x 2'.
Courtesy Grafica Artistica, S.A.,
Mexico City.

Nonferrous Metal and Plastic

Metal plates can be made from an original in wax, taking advantage of this material's unique characteristics (Figs. 602, 603). Undercuts should be avoided. The wax can then be invested and a metal plate cast, utilizing the *lost wax method.* If grit, metal, fabric, paper, string, or other objects are placed on the wax, a mold must first be made from Silastic RTV-G or plaster and a wax impression of this must be formed before the lost wax procedure can be followed. (The mold and second wax impression are necessary because the objects placed on the wax original would not melt away in the casting process.)

If RTV is to be used for the mold, a wall of clay should be constructed approximately 1/4 inch from the border and 1/4 inch higher than the highest point of the original. (Avoid using linseed oil-based plasticene.) Make sure that the clay adheres firmly to the surface. The RTV is then mixed thoroughly in a 10-to-1 ratio by weight with its curing agent, and poured slowly over the surface of the original until the entire area is filled to the height of the clay wall. The RTV will cure in 24 hours and can then be removed readily from the original and hosed with water. Once it has dried, the mold is ready to receive the wax that will in turn be used for investment and casting.

When making a plaster mold, construct a wood frame approximately 1 inch from the border and 1 inch higher than the highest point of the original. (Large-size works should be made of thicker plaster and reinforced with hardware cloth.) Seal the frame with clay at its corners and along its base where it meets the surface in order to avoid leaks. The original is covered with a thin barrier coat of coconut oil-base soap (green soap), and a mixture of 60 percent plaster and 40 percent water by weight is poured in until it reaches the top of the frame. Once the plaster

has set, the wood frame and original are removed, and a wax positive is made from the plaster mold. The plaster mold must be damp to prevent the wax from penetrating and sticking to the mold.

The plate made from the final wax should not exceed 3/16 inch in thickness, nor should the height of the relief on the surface (from peak to valley) exceed 1/8 inch. Thick blankets and heavy pressure are required in printing a cast metal plate.

If a plastic plate is made, the matrix is fashioned and molded in RTV-G or plaster as outlined above. Epoxy resin is poured into the mold, and fiberglass cloth is used as a backing to add strength. Once cured, the plate is ready for printing in the normal intaglio technique (see Chap. 4).

10 Papers, Papermaking, Curating of Prints

A natural phenomenon occurs in the life cycle of the paper wasp (of the *Vespidae* family). This insect builds its remarkably well-engineered dwelling by masticating vegetable fibers, combining them with a viscous binder, and exuding a paper pulp. The same principle eventually came to be used in the manufacture of paper, although it was some time before the technique was adapted for human purposes.

Before the invention of paper, early peoples treated such materials as brick, stone, metal, leaves, bark, animal skins and bones, and even the skin of fish in various ways to produce writing surfaces. Although these all served their purposes, none was ideal, and in almost every culture, ingenious substitutes came gradually into use.

Papyrus was the "paper" of the early Egyptians, Greeks, and later the Romans (Fig. 604). It is from the Latin word *papyrus* that our word paper comes. Papyrus was made from the *pellicle,* or outer stem, of an aquatic sedge found in abundance along the banks of the Nile River. The pellicle was cut from the plant with a sharp mussel shell to form strips that were dried flat and glued together in a crisscross pattern. The surface was polished with an animal tooth or piece of ivory. This material, in use during the 2nd century B.C. when Alexandria was being built, was employed in the library of Ptolemy.

Thousands of miles away, fragments of a yellow vegetable fiber paper were placed in a tomb in Siam that has been dated as early as 202 B.C.

In Cathay, a type of paper was being made from silk fragments and vegetable fibers, which were chopped, beaten, and mixed with water to form a pulp. When the pulp was poured over a screen, the water drained through, leaving the fibers on top to mat down and dry. The Chinese character for paper

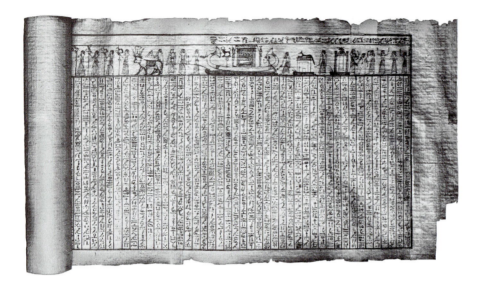

604. *Book of the Dead.* Egyptian. Hieroglyphic papyrus of the Ptolemaic period. Oriental Institute, University of Chicago.

includes the symbol for silk, which argues strongly for the early existence of this type of paper. By A.D. 105, however, a substitute was formed from linen rags, mulberry bark, hemp, and fishnet. This invention generally is credited to Ts'ai Lun, a privy councillor to the Emperor Ho-ti, and legend reports that Ts'ai Lun was motivated to find this substitute by the high cost of silk. The role he played was probably that of a popularizer and not an inventor, however, since it is evident that paper like this had been in existence for some time. (Oriental paper is sometimes incorrectly referred to as "rice paper." No paper can be made from rice, and even the original material to which the term referred was more closely related to papyrus. This was a white writing surface produced in Formosa by cutting the pith of the *Fatsia papyrifera* tree in a spiral fashion.)

The Romans improved upon the process of making papyrus but eventually replaced this completely with vellum, or parchment. Parchment had been used in the city of Pergamus, which gave this type of paper its name. Pergamus parchment was yellow, but the Romans were able to produce parchment in white and various colors. It was made from the skin of sheep, goats, or hogs and was used for centuries because of its great durability.

Improvements were soon made in the paper "invented" by Ts'ai Lun as well. Ts'ai Lun's contemporary, Tso Po, developed paper for a variety of purposes in different sizes and colors. Among the applications for Tso Po's product were writing paper, toilet paper, and "spirit paper," which served as a funeral offering for the dead and replaced the precious metal coins that had previously been put in tombs. The pulp for these papers was beaten by hand, and at first it was formed into sheets by being poured over a cloth screen on a bamboo frame. But paper soon was being made from a rigid mold with bamboo

stringers that could be dipped into a vat of pulp, producing a more consistent thickness and evenness. The process quickly made its way to Korea, probably in the 2nd century A.D. Beginning about the year 700, paper was either coated with gypsum or rubbed with starch or rice flour, so that ink would not penetrate the fibers. In 751 a *dharani* (or *sutra* charm scroll) was printed upon with wooden blocks, making it one of the earliest existing examples of wood block printing.

A Buddhist monk named Tamjing brought an understanding of papermaking to Japan in 610. In 770 the Empress Shotoku made a million paper *dharani* by printing with copper blocks. Paper and paper charms, as well as image-making techniques such as surface rubbing and stenciling, made their way west along the silk trade route, arriving in Samarkand in the 6th or 7th century. When Moslems captured some Chinese mill workers, papermaking began in Samarkand in 751. The paper made there—of especially high quality—was composed of flax and hemp. By 795 a papermill opened in Baghdad, and soon there was one in almost every Arabic city from Samarkand to Fès. The Moslem conquest spread the technique westward.

605. A centuries-old system of wooden stamping hammers at the Fabriano paper mill in Italy. These hammers are no longer in use.

<h1>Papers and Papermaking</h1>

The History of Western Paper

When the Moors invaded Spain in the 12th century, they brought knowledge of papermaking with them. For the maceration of rags they set up a stamping mill in Xātiva (now S. Felipe de Játiva). Wooden hammers attached to a water-driven central cam pounded the pulp in troughs (Fig. 605). The Arabs had perfected a technique of wire drawing by this time, providing a substitute for split bamboo, and so rigid molds were made from brass wire.

Fabriano, a mill that opened in 1276, made major contributions to the new technique of papermaking. Whether knowledge of papermaking came to Fabriano from Spain, Cairo, Damascus, or Tripoli through Sicily and Naples is still a matter for speculation. In 1337, the mill began exporting rag paper sized with gelatin. This had a smooth surface that was favored throughout Europe, and at once it replaced parchment and many of the Arab imports. Soon after opening, Fabriano had begun to make paper with watermarks, the original purpose of which is still unclear. These designs result from minute variations in pulp thickness, produced by wires sewn onto the mold screen. They may have been used as trademarks, as indications of paper size, as symbols of secret organizations, or as mold identification marks. In England, for example, paper sizes began to be referred to by the watermark. The smallest-size sheet had a jug watermark, and thereby came to be known as *pot*; paper with a cap-and-bells mark was called *foolscap*. The first marks employed at Fabriano (in 1282), were circles and crosses; in 1285 the *fleur-de-lis* appeared, and almost immediately after that came a variety of designs that sometimes included the papermaker's initials.

Just before Marco Polo arrived from the East in 1295 with stores of paper money, a mill was begun in

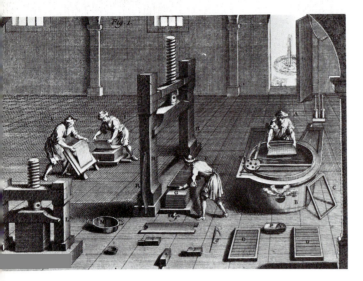

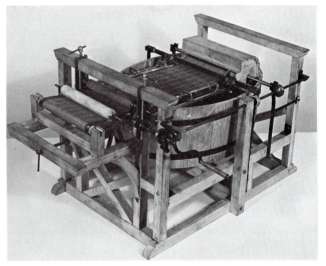

Bologna. Mills opened in France and Germany within a few years of each other (Fig. 606). The Nuremberg mill founded by Ulman Stromer is shown in a woodcut illustration for the *Nuremberg Chronicle* of 1493.

The Hollander Beater

Another mill opened later in the Netherlands, where, by the end of the 17th century, the Hollander beater had been invented. The Eighty Years War had separated the Netherlands from the rest of Europe, cutting off its supply of paper. The Dutch thus were forced to manufacture their own paper. Because they depended on wind to drive their machinery, it was the windmill that powered the first Hollander beater in 1673. Nine years later, Johann Joachim Becher wrote a description of the Hollander he had seen in Serndamm. It appears to have been a variation of a grinding mill, which operated by means of stone wheels rolling over a stone bed. The Hollander, however, employed either a stone or a metal bed, as well as a wheel with dull blades that broke up cotton and linen fibers in a water-filled tub and separated them as they were pounded by the blades. Far more efficient than the stamper, the Hollander altered the way in which cotton and linen were prepared before maceration. They had been soaked, wadded into balls, and allowed to sit for months so that fungi and bacteria would break down the material in a process called *retting*, making it easier for the stamper to separate the fibers. The amount of waste was high and the practice therefore costly. The Hollander saved material because it did away with the fermenting process. It also reduced *foxing*, or stains caused by a chemical reaction of bacteria on iron salts. Although its relative merits were debated for some time, the use of the Hollander eventually became a standard process in the paper-making industry (Fig. 611).

The Calender Roll

Through the invention of the calender roll in the early 18th century, the Dutch made another important advance—this time in the way paper was finished. Burnishing paper to obtain a smooth surface had been done by hand, until this arduous process was superseded by the water-driven glazing hammer, with mallets that pounded the surface smooth. The calender roll consisted simply of large wooden rollers through which the dry paper was fed, producing a superior surface.

Early Mills

The first papermill in England was begun by John Tate before 1495, and by 1588 the Spilman's mill was operating in Dartford, Kent. It was also in Kent that James Whatman started his Turkey Mill, as he named it, in 1731. In 1757, the English printer John Baskerville printed his *Virgil*, on *wove paper* that probably was produced for him at Whatman's mill. Except for early papers made in China, paper had been made on *laid molds*. The laid ribs and thin wire chain of this type of mold left a slight impression in the paper. The *wove mold*, made from woven screen, produced a smooth paper that was better suited to Baskerville's delicate type design.

Choice paper was made from clean rags, since whiteness was the characteristic most desirable for printing papers. Rags that were not clean were either sun- or alkaline-bleached, until after the discovery of chlorine when a bleached wood pulp paper was made in England. By 1804 Joshua Gilpin was bleaching pulp in the Brandywine Creek mill in Delaware. Bleaching expanded the range of fibers that could be made into pulp, but it also hastened the eventual deterioration of the paper, due to residual acid that

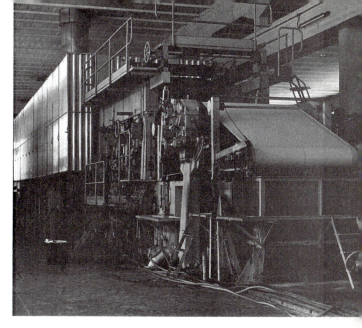

opposite left: 606. An early French papermill is shown in this illustration from *Art de Faire le Papier* by J. J. Le Français de Lalande, 1761.

opposite right: 607. A Fourdrinier machine of 1798. Science Museum, London.

608. A section of the contemporary pulp mill at Fabriano.

could not be washed out or neutralized with any process known at that time.

The Continuous Web

While working for Leger Didot in the late 18th century in Paris, Nicholas-Louis Robert devised a method of making a continuous roll of paper by pouring pulp on a continuous wire screen. Henry and Sealy Fourdrinier financed additional research and employed the engineer Bryan Donkin to work on the project. Donkin was able to perfect the process, and by 1807 the Fourdrinier machine was on the market, producing continuous rolls of wove paper (Fig. 607). An almost endless variety of papers—from rag printing papers to banknote papers and offset stock—are still made on descendants of the Fourdrinier machine. These papers are referred to as *moldmade* papers or *machine-mold* papers.

Within two years of the marketing of the Fourdrinier, John Dickinson in England had built a machine that lifted pulp from the vat onto a cylinder. The pulp adhered by means of suction and was then transferred to rollers. He later added heated rollers to his machine for machine-sizing. Heated rollers eventually were used to manufacture a dry roll of paper. His other inventions include a process for cutting paper into sheets.

The fundamentals of papermaking have not changed greatly since the invention of the continuous web machine, though industrial sophistication has speeded up the process and expanded the range of usable fibers (Fig. 608). Quality paper now can be produced from purified wood pulp, because methods have been found to neutralize the acid and produce paper with great longevity. Rosin sizing, which had deleterious effects on paper, has been replaced by alkaline sizing that protects the paper from contami-

nants in the air. These and other new chemical processes and fibers will have ever-increasing uses in printmaking.

Papermaking

Within the last few years, many large mills that made paper by hand have closed, and material and labor costs have more than doubled. In spite of this, growing interest in the graphic arts has spawned an interest in hand papermaking.

The making of paper involves a number of separate operations, whether it is done by hand or by machine. The pulp, or basic stock, must be made from cotton or linen fibers that have been cut, immersed in water, and beaten to create uniformity in the length of the fibers and to separate the individual fibers and draw them out. Water is just as important a material in the papermaking process as the fibers, because it is forced into the intermolecular spaces of the fibers, thereby uniting the fibers by means of hydrogen bonding. (If the fibers were beaten without water, the result would be cotton felt, not paper.)

The beaten, hydrated fibers, now called pulp, are placed in a water-filled vat. This is continually agitated so that the fibers remain suspended in the liquid.

In the next operation, the pulp is transferred from the vat to a mold that forms rolls or sheets of paper of uniform size and thickness. When paper is made by hand, the mold consists of a wove or laid screen attached to a wooden frame, and the *deckle*, a thin, wooden framelike device fitting over the outer edges of the mold and onto the screen. The mold and deckle are dipped into the vat, so that the fibrous liquid is dispersed evenly over the screen and held in by the deckle. As the mold is lifted upward, the water drains through the screen, leaving the fibers intertwined (or *felted*) on the screen. The deckle is removed and the

609. Robert Motherwell.
The Stoneness of the Stone. 1974.
Lithograph on laminated
handmade paper, 40 × 29″.
Courtesy Brooke Alexander, Inc., New York.

layer of paper pressed face-down with a rocking motion onto a pile of alternating layers of paper and woven felt. This operation is called *couching the sheet.* When the desired number of sheets has been made, excess moisture is squeezed from the felt and paper and each sheet is dried.

Although it also adds strength to the sheet, sizing is used principally to limit the paper's absorbency. This is essential for papers intended for writing and for certain kinds of printing. Papers that have no sizing are called *waterleaf papers.*

Paper made by hand has a rough edge on all four sides, where some fibers slip under the wooden deckle of the mold. This rough edge is also called a deckle.

The same basic procedures are utilized for machine-made papers, except that instead of lying flat, the screen is wrapped around a revolving cylinder or drum. This is partially submerged in the vat containing the fibers and water. As the fibers cling to the screen, a continuous web of paper forms. The paper moves through drying, sizing, and pressing operations on a conveyor belt system. A natural deckle is formed only on the two outer edges of the web of paper. Sheets are either cut or torn across the direction of the web to simulate a natural deckle.

Although many machine-made papers are produced from the same high-quality, pure cotton or linen fibers as handmade papers and have the same qualities of permanence and durability, there are some essential differences between the two. The fibers of handmade paper are intertwined equally over the entire surface in the felting process, thereby creating identical tension and strength in any direction. In machine-made papers, on the other hand, the movement of the cylinder mold creates an alignment of fibers favoring the direction of the movement of the mold. This creates a lengthwise grain along the paper. Machine-made paper has greater strength in

the direction of the grain than at right angles to it. This type of paper also will stretch more when pressure is applied across the grain than when it is applied along the grain, and it can be made with extremely low tolerances in thickness. In commercial papers, the variation in thickness across the sheet can be kept within a thousandth of an inch.

A number of independent papermakers have collaborated to make special papers for such artists as Robert Motherwell, Robert Rauschenberg, and Frank Stella, and some have begun the production of significant new papers on a limited basis (Fig. 609).

The Raw Material

Because raw cotton and linen rags cannot be obtained in sufficient quantities for the production of quality papers, commercial and private papermakers rely on other sources for their raw material. Many commercial machine-made papers being used increasingly by printmakers are composed of wood cellulose fibers. The quality of these papers has been improved vastly over the last quarter century, and their stability and permanence often match those of better-grade rag papers. This was not always so; papers made from wood pulp during the years from 1900 to 1939 in particular have proven highly vulnerable to deterio-

610. *Left to right:* flax fibers magnified 100 times; cotton fibers, 120 times; and wood cellulose fibers, 90 times.

ration. This is due to the alum-rosin sizing and moisture from the air, which combine to produce the continuous formation of acid in the paper fibers. Although similar basic processes are still used widely in the making of wood pulp, newer procedures for washing, isolating, and sizing the cellulose fibers are now favored, yielding less acidic, more stable paper.

A new process for breaking down the wood pulp and isolating the cellulose fibers from the resinous substances of the wood has been introduced recently. The result, called *alpha pulp*, is made up of cellulose fibers with a neutral pH balance and a longer fibrous structure than other pulp. Alpha paper promises to be comparable to most rag papers in its longevity. Certainly, the newer alpha papers have a potential life many times that of earlier pulp papers.

Paper made from linen is relatively rare, since cotton is much more readily available from various sources and is easier to prepare (Fig. 610). Fabrics with even a small percentage of synthetic fibers are unsuitable for making paper, because synthetic fibers cannot be fibrillated or hydrated, and therefore cannot bond properly with the fibers surrounding them. They remain separate, causing lumps.

Cotton suitable for making paper by hand can be obtained from a number of sources, depending on the quantity needed and on whether the papermaker intends to make a few experimental sheets or produce paper in quantity. A mixture of dyed cotton fabrics often can produce magnificently toned papers, but the color will vary from batch to batch. It is almost impossible to maintain consistency in the color and the amounts of each type of rag used. To produce a white or off-white sheet from dyed rags, boil the pulp first, then bleach it. Ordinary chlorite bleach can be used, but care must be taken not to overbleach the pulp, or the fibers will be weakened considerably. The pulp must be washed thoroughly to remove all bleach.

Limited Production of Pulp If you wish to make paper on a limited basis, the raw material can be obtained from old pure cotton shirts, cheesecloth, sheets, or the trimmed ends of other sheets of paper. Old rags must be of pure cotton and be cut or chopped into very small pieces, shredded, and pounded to break up and separate the fibers. It is a good idea to boil the chopped rags in water for several hours, to soften the fibers and to destroy any bacteria that could grow in the pulp, causing putrefaction or fermentation.

If new cotton is used, boiling will not be necessary, and the fibers need only be beaten. *Cotton linters*, for example, are short cotton fibers unsuitable for spinning and the making of fabrics. They are gathered from the cotton seed in the ginning operation and supplied to the chemical industry in large quantities, as an inexpensive source of raw cellulose. Linters come in blotter-like sheets that can be broken up easily, beaten, and made into a pulp suitable for hand papermaking. These fibers have already been boiled, washed, and bleached, and need only be beaten.

Quantity Production of Pulp The serious papermaker needs a supply of cotton that is consistent and predictable in order to shred and beat the fibers for uniform results. For this kind of production, end cuttings of cotton fabrics such as cheesecloth (supplied by mills) or cotton linters are recommended.

Beating the Fibers

Pulp made from paper scraps can be cut into very small pieces and beaten in a blender, providing that it is done in small quantities. Cotton rags cannot be beaten in this way, because the blender does not fibrillate or hydrate the cotton fibers. Cotton rags also will break the blender.

611. A laboratory Hollander beater.

The Laboratory Hollander Beater

Laboratory Hollander beaters are commercially available machines in which the fibers are crushed and fibrillated in a controlled, efficient manner. The stock is placed in the Hollander (which is filled with water), and as it moves through the machine, a heavy metal cylinder rotates above a metal plate. Metal bars on the surface of the cylinder "roll" grind the fibers between themselves and the bedplate. This fibrillates and hydrates the fibers and causes the ends of each fiber to be spread out, improving the bonding of one fiber to another.

Small beaters that can be installed onto a heavy table are available in 1½- and 5-pound sizes (weighing 600 and 1800 pounds) from Voith-Allis, Incorporated (Fig. 611). These two sizes are designed for laboratory use. Larger semicommercial beaters are also available from the same company in 25-, 50-, and 150-pound sizes weighing several tons each.

612. The basic frame, with wooden ribs, wire screen held down by copper stripping, and wooden deckle.

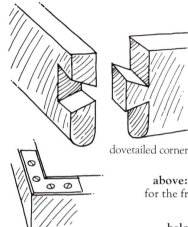

dovetailed corner

mitered corner

above: 613. A dove-tailed corner for the frame with rounded bottom, and a mitered corner.

below: 614. The frame viewed from the top, with heavy brass wire running through the ribs (a). The ribs are attached to the sides of the frame by dowel sticks (b). When the screen is in place and the mold is lifted from the pulp-filled vat, the wedge shape of the ribs creates suction (indicated by the arrows) to hold the fibers to the screen (c).

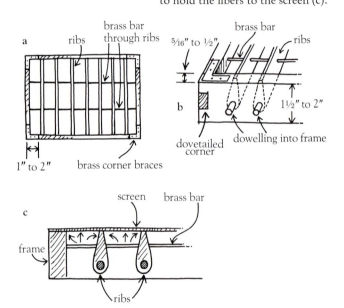

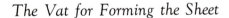

a ribs brass bar through ribs 5/16" to 1/2" brass bar ribs

1" to 2" brass corner braces

b dovetailed corner dowelling into frame 1½" to 2"

c screen brass bar

frame ribs

The Vat for Forming the Sheet

The vat is a large rectangular or round tub filled with warm water in which the beaten pulp is placed. The fibers are kept agitated so that they will be suspended evenly throughout the liquid. A small diameter paddle wheel device placed lengthwise along the bottom of the tank agitates the fibers. Its upward movement helps push them to the top.

The Mold

The Frame The wooden frame of the mold is generally made of mahogany, although occasionally

below: 615. A thin strip of brass is nailed over the edges of the laid or wove screen.

right: 616. A laid screen, with the laid wires running horizontally and the chain wires intersecting them.

maple or oak is used. Mahogany from Honduras, Santo Domingo, or Cuba is considered superior to that from Mexico or the Philippines. The wood must be well seasoned, and often is boiled and dried repeatedly beforehand. This enables it to withstand extended dipping in the warm water of the pulp vat without warping.

The basic frame for the mold measures somewhat less than $\frac{1}{2}$ inch in thickness by about $1\frac{1}{2}$ to 2 inches in depth, depending on the final size of the mold (Fig. 612). The wood is dovetailed or mitered at the corners, and brass corner braces are screwed to the wood for strength (Fig. 613). A series of wedge-shaped wooden ribs are attached to the long sides of the inner frame, spaced 1 to 2 inches apart. The wedge shape of the ribs is important for several reasons. It supports the screen, gives strength to the mold, and allows for equal drainage over the surface of the screen. The ribs also create a slight suction effect as the mold is lifted, causing the fibers to cling tightly to the screen (Fig. 614).

The Screen　Since the late 18th century two screens have been used for each mold. A coarse one is first placed over the frame and ribs, with a finer one set on top. This allows better drainage and a more even distribution of the pulp on the surface. The screens—always of brass—are attached to the top edge of the frame with brass wire. A thin strip of brass, placed along the top edge of the frame to cover the ends of the screen, is nailed down with small brass or copper brads (Fig. 615).

The *laid screen* consists of a series of parallel brass wires crossed by finer brass wires woven at equally spaced intervals (Fig. 616). The heavier parallel wires produce the characteristic *laid marks* on the paper, and the finer wires keeping them equidistant produce *chain marks*. A coarse screen of about eight or ten laid

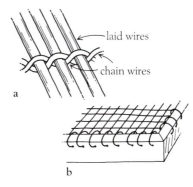

above: 617. A close-up of the construction of a laid screen (a), and the laid screen stitched to the frame (b).

right: 618. A close-up of the wove screen construction, with intersecting wires of equal thickness.

wires per inch is attached to the frame on top of the ribs. Next, a finer laid screen of 18 to 26 laid wires per inch is placed on top. The two are then stitched with very fine brass wires to the ribs and the frame (Fig. 617). Small holes are drilled in the wood every half inch or so for this purpose.

The *wove screen* resembles a finer version of the common window screen in construction (Fig. 618). This produces a smooth, even sheet of paper with little or no surface texture. As with the laid mold, a coarse screen is attached to the frame first, then a finer wove screen is placed on top and stretched so that it lies flat. It is held down with fine sewing wire in the same manner as the laid screen, and thin strips of

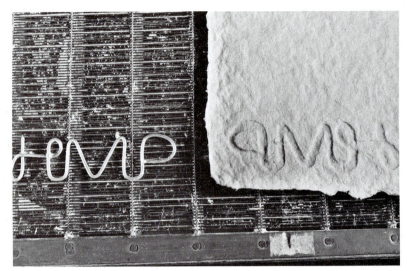

below: **619.** The deckle raised over the mold, and a close-up of a corner of the frame with the deckle in place.

right: **620.** A watermark on a laid screen, and a sheet of watermarked paper made on the same screen.

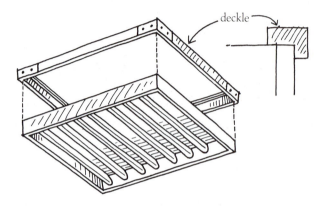

deckle

brass or copper are tacked down all around to cover the ends of the mesh.

The Deckle The deckle, made from mahogany (or sometimes another wood), is a light frame that fits over the edge of the screen mold and holds in the pulp while the sheet is being formed. It is often mitered at the corners and reinforced with strips of brass or copper. The deckle determines the size of the sheet and must fit perfectly all around the screen mold (Fig. 619).

A single deckle is sometimes made to fit two separate screen molds, so that as one sheet is being couched on the felt, the deckle can be placed on the other mold to form another sheet without interrupting the rhythm of the work.

The Watermark

The *watermark* is a variation in thickness made on a sheet of paper as it is being formed by raised designs or letters attached to the wove or laid screen. In its simplest form, it consists of an image made of thin brass wire (approximately 20 gauge) placed on top of the screen. This is attached to the screen either with fine brass wires or by soldering. When the mold is immersed in the vat, the pulp settles onto the surface of the screen. Because the mold is manipulated in such a way that the fibers move horizontally across the screen before settling, fewer fibers remain on top of the raised wire surfaces of the watermark image than on the basic screen. As light shows through the completed sheet, the watermark (a mirror image of the wire pattern) can be seen clearly, because the paper in that area is actually thinner, and more light passes through it (Fig. 620).

Complex watermarks can be made not only by adding wire to the screen, but also by indenting the screen so that heavier deposits of pulp are created, producing darker areas when illuminated. Only the wove screen is used for this particular purpose, although fine pieces of woven screen can be sewn to a laid screen for textural and tonal variations that are not true watermarks.

Chiaroscuro Watermarks The realization that raised or indented areas on the mold screen could produce lighter or darker watermarks led to the development of a technique for producing *chiaroscuro*, or tonal, watermarks, with a complete range of tones from light to dark (Fig. 621). The technique was a process of trial and error at first. The surface of the screen was raised and indented in much the same manner as one might use to beat a sheet of copper in low relief, but the tonalities could not be seen until a sheet of paper actually had been made. Thus the technique was somewhat unpredictable.

A much more accurate method of making the *chiaroscuro* watermark was developed some time later. This method is still in use today, notably at the Cartiere Miliani mill in Fabriano. The watermark is first sculpted in relief on a sheet of beeswax about $\frac{3}{8}$ to $\frac{1}{2}$ inch thick. The lighter tones are made by re-

Dr. h.c. C.M. BRIQUET 1839-1918
créateur de la science des filigranes

above left: 621. This *chiaroscuro* watermark
appears on a sheet of paper
from the Cartiere Miliani mill in Fabriano, Italy.

above right: 622. The wax relief from which
the screen for the watermark
in Figure 621 was ultimately made.
A light has been placed behind
the upper part of the image.

moving more wax; the darker tones by removing less.
As light shines through the wax from behind, the
image appears with all its details and tonalities (Fig.
622). Considerable skill is needed for this work. At
the Cartiere Miliani mill it is done by a special de-
partment, and a portrait measuring 8 by 10 inches
takes an experienced craftsman about 2 weeks to re-
produce in wax.

In the next step a plaster cast is made from the
wax, and from the plaster another cast is made, so
that the relief has been reproduced in one negative
and one positive form. These two molds are then used
to form the negative and positive in a stronger sup-
port material, such as brass castings or copper elec-
trotypes. (If a copper electrotype is made, the copper
shell must be filled with lead or other material in
order to make a rigid die.) The woven screen is then
sandwiched between the negative and positive dies,
being compressed in the form of the original wax re-
lief (Fig. 623).

When this relief screen is lowered into the vat,
more pulp settles in the recesses than in the raised
portions, resulting in a sheet of paper with slight var-
iations in thickness. The most exquisite and detailed
tonalities can be made with this technique.

Color Watermarks To make a color watermark,
tinted paper pulp is sandwiched between two thin
watermarked sheets by couching the first water-
marked sheet, couching the tinted pulp on the water-
marked area through an open stencil, then placing
another watermarked sheet identical to the first on

623. A close-up of
the wove screen used for
the watermark shown in Figure 621.

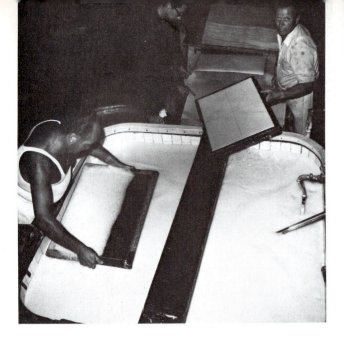

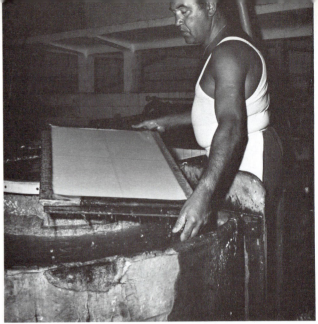

top in careful registration. The color is visible only when the sheet is held up to the light.

Another technique employs two separate molds with different watermarks. Each is made in a different color, and one is couched upon the other. When they have dried, each watermarked area will show the color of the other sheet.

Colored Paper

Dye or pigment for tinting paper is introduced while the fibers are being beaten in the Hollander. The most permanent type of coloring matter is in a pigment form, such as burnt sienna or other earth pigments. A great deal of pigment is needed, since most of it falls to the bottom of the vat and only the finer particles remain in the fibers.

To separate color areas on the same sheet of paper, a method employing an internal deckle bar separate from the main deckle is used. Dyed pulp is poured into each separate unit while the mold rests barely submerged in the vat. The mold is shaken slightly to distribute the pulp and is then lifted from the vat. The internal deckle bar is removed so that the edges of the colored fibers intertwine. The paper is then drained and couched in the normal manner.

Forming the Sheet

The deckle is placed in position on top of the screen and the mold dipped into the vat at a shallow angle. Only about one-half to three-quarters of the screen is actually submerged in the vat; otherwise, the suction caused by lifting it would be too great. With a light, sweeping motion the mold is brought close to the surface of the liquid in the tank (Fig. 624).

The quantity of pulp distributed on the screen is determined by the density of the pulp in the solution,

above left: 624. Lifting the mold from the vat of pulp at the mill in Fabriano, where the following series of photographs was taken.

above right: 625. The water is allowed to drain from the mold.

the depth to which the mold is dipped, and the skill of the operator. The operator in fact controls the weight, thickness, and evenness of each sheet. The technique requires years to perfect, and the number of mills that have closed in recent years accounts—at least in part—for the lack of trained vat technicians.

The pulp is scooped onto the mold with a slight rocking motion, causing the pulp to move in a wave from one side of the screen to the other and thus settle evenly over the surface. A slight sideways shake in lifting the mold from the vat forces some of the fibers to align themselves in a cross direction as the water drains through. A ridge or bar across a corner of the tank acts as a resting place for the mold as the water drains (Fig. 625). Most of the water drains from

626. The deckle bar is removed from the mold.

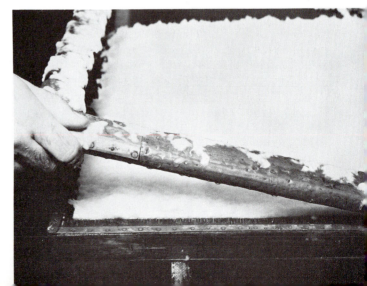

right: **627.** The mold is turned over, and the new sheet of paper is pressed to the pile of felts.

below: **628.** A rocking motion is needed to release the sheet.

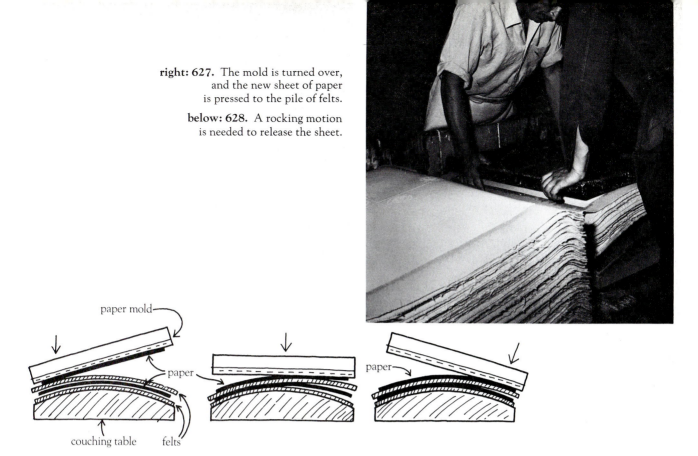

paper mold

paper

paper

couching table felts

the mold, and the fibers settle within a few seconds after the mold has been lifted from the vat. The deckle is then removed and the mold held at an angle to promote further draining (Fig. 626). The sheet is now ready to be couched.

Couching the Sheet

Before the couching begins, several sheets of felt should be draped over a slightly curved surface to start out the pile (or *post*, as it is called). The felt is made from thin sheets of tightly woven wool, cut several inches larger than the paper to be couched. When the deckle has been removed, the mold is turned over onto the pile (Fig. 627). One side is pressed onto the felt, and the mold is rocked over the curved surface to the other side, pressing the paper onto the felt. This lifts the paper from the mold and leaves it deposited on the felt (Fig. 628). Another felt is placed on top immediately in preparation for the next sheet. The felt must not drag or pull, for otherwise the sheet underneath it will be ruined.

The two sides of a sheet of paper are known by different names. The side that makes direct contact with the wire mold is called the *wire side*; the side that touches the felt in the couching process is called the *felt side*. Most printing is done on the felt side, although many papers (particularly handmade ones) can be printed equally well on either side.

Squeezing Excess Water from the Post

When the required number of sheets have been made, pressure is applied to the post of felt and paper. No matter how carefully the pulp has been beaten, the paper will be weak if it is not pressed sufficiently while still wet. In the modern papermill, hydraulic pressure or a heavy screwtype device accomplishes this (Fig. 629). The amount of pressure exerted is

629. A screwlike paper press at the Richard de Bas paper mill in Ambert, France. The work in progress is Robert Rauschenberg's *Pages and Fuses—Bit.* (See Fig. 571.)

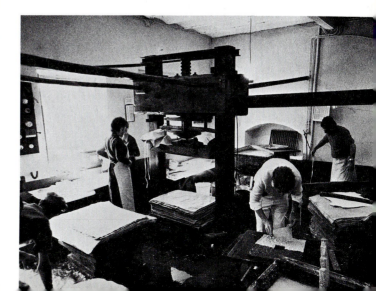

usually at least 40 tons. In a small shop, where only a few dozen sheets are made at a time, individual felts with a sheet of paper on top can be placed in a rack or on a table top for partial drying. As the paper dries, it becomes stronger. Later it can be lifted carefully from the felt and stacked or hung up to dry.

A method of stacking the paper while it is drying is called *exchanging* or *parting*. The sheets are taken from the post and stacked one over the other without overlapping. A light pressure is applied, and the stack is left overnight. The next morning, the sheets are restacked in a different order and again placed under pressure. This method produces a smoother, more even surface and eliminates the texture left by the felt in the couching process.

Drying

After the exchanging or parting of the paper (which may be done several times) the pile of paper is finally removed from pressure. In spurs of four or five sheets at a time, the paper is hung over ropes or round wooden sticks about 3/4 inch in diameter (Fig. 630). It is traditional in many mills to use ropes fashioned from horsehair, since this does not stain the paper. No attempt is made to separate the spurs of paper until they are completely dry. Drying time depends on the humidity and the circulation of air in the drying loft. When they are thoroughly dry, the sheets will be stuck together, but they can be stripped from each other easily in preparation for a final pressing or for sizing if necessary.

Sizing

Many handmade papers need not be sized. Sizing is necessary only if the absorbency of the paper must be reduced for certain writing or printing applications, or if a firmer and stronger sheet is desired. An unsized (waterleaf) paper or one with a minimum of sizing is preferable for printing etchings or lithographs, because the fibers can be compressed or molded to the plate image more easily. A fully sized sheet of paper would also tend to transfer some of the sizing to the etching press blankets when it is dampened, necessitating frequent cleaning of the blankets.

The most commonly used material for sizing is an animal size made from hide cuttings or the bones and hooves of livestock. The principal ingredient is gelatin. Pure gelatin is perfectly suitable, although it is more expensive than commercial sizing. The cake of size or gelatin is first soaked in cold water until it swells and then heated slowly until it has dissolved completely. The temperature should be brought to about 95°F and kept there, for the sizing penetrates into the paper better when it is warm. The basic sizing solution must not be boiled under any circumstances, and should be about 5° Baumé.

An old method of sizing paper was to immerse each sheet in the sizing solution by hand, seeing that each sheet was well covered, and then to remove the sheets and place them in a pile, squeezing out the excess size under pressure. A newer method employs two continuous rolls of felt that dip into a tub filled with warm sizing. A sheet of paper is placed on the lower roll, and as this roll moves forward, the upper roll of felt moves on top of the sheet. The paper and rolls of felt are dipped into the sizing bath, and as they emerge they are pressed tightly between two other cylinders to squeeze out excess sizing. The sized paper is then hung up or placed in racks to dry. For small shops, a method of hanging the paper by clothespins is sufficient. If racks are used, care must be taken that the ribbing does not emboss the sheet, especially with heavy-weight papers. To avoid this, the racks can be made from wire or plastic screening material, which

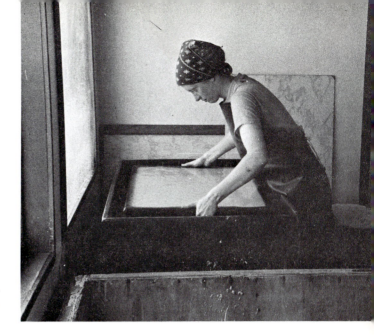

631. Kathryn Clark forming a sheet of paper at Twinrocker Handmade Paper in Brookston, Indiana.

will hold the paper flat but still allow plenty of air to circulate over the entire surface.

To size a very small quantity of paper, dip each sheet into a tray filled with warm size. Place each sheet on a larger piece of glass or Formica, and squeeze the excess size out by rolling a hard composition rubber roller or a plastic roller across the paper several times.

Soft-sized papers are dipped into the sizing solution once; *hard-sized* papers are dipped once, dried, and dipped again.

Finishing

Handmade paper can have a rough or smooth surface, depending on the quality of the beaten pulp, the texture of the felt, and the fineness of the screen. For a smoother finish, the paper is run through a series of polished metal rollers that compress it in varying degrees, depending on the number of times it passes between the rollers and the amount of pressure used. For *hot-pressed papers*, characterized by very smooth surfaces, the polished rollers are heated before the paper is run through. *Cold-pressed papers* can vary in finish from rough to smooth.

Calendered paper serves for certain commercial applications. Calendering is used only for machine-made papers, and produces an extremely smooth, sometimes glossy surface. The web of paper passes through a vertical stack of polished cast iron rollers that crush the fibers to minute tolerances in thickness and smooth the paper's surface.

Printmaking Papers

Since the early 13th century Europe has always been a leading supplier of rag papers suitable for printmaking. Although the greatest quantities and varieties of handmade and moldmade papers are still being manufactured by mills in Italy, Germany, Great Britain, and Holland, printmaking papers can now be purchased from mills in the United States. The European techniques of making paper by hand were brought to the United States early, with the establishment of the Rittenhouse Mill in Germantown, Pennsylvania, in 1690, and again much later by Dard Hunter at Limerock, Connecticut, in 1928. More recently, and largely through the persistent efforts of Douglas Howell, a resurgence in the art of hand papermaking has contributed to the development and success of several new operations. In addition to Howell, Aris Koutroulis, Laurence Barker, Kathryn and Howard Clark, and John and Kathleen Koller have helped keep the tradition alive.

Twinrocker, a small mill begun by the Clarks in Indiana, and Handmade Papers, operated by the Kollers in Connecticut, make papers of excellent quality that are used increasingly by printmakers (Fig. 631). Through these independent sources, paper of almost any weight, color, and size can be purchased in small or large quantities. The standard papers from large European or American mills are available in specific weights and formats.

The weights of European papers are always given in grams per square meter. Arches Cover and Rives BFK in the most popular sizes, for example, each weigh 250 grams per square meter. The weight of American-made papers is usually but not always indicated by pounds per ream (five hundred sheets). A cover stock similar in weight to Arches or Rives BFK would weigh approximately 140 pounds per ream. Weight is sometimes expressed in terms of pounds per one thousand sheets—for example, 250 M means 250 pounds per thousand sheets. These weights are not based on standard-size sheets, but on the particular size of the sheet being weighed.

Following is a descriptive list of some of the best papers available from the large commercial mills. Along with the large variety of handmade papers available from small mills, these provide an almost inexhaustible source of good printing papers.

Acta Paper Fabric A heavyweight paper (approximately 140-pound) of pure alpha cellulose fibers, Acta Paper Fabric is suitable for any technique, and can be embossed, formed, shaped, drawn on, or printed on with excellent results. It has a medium-smooth, cold-pressed surface and is available in sheets 18 by 24 inches and 24 by 36 inches.

American Etching Machine-made from 100 percent rag fibers, American Etching is a relatively soft, off-white, 360-gram paper excellent for etching. This paper also serves well for lithography if printed with heavy pressure. It is available in 38-by-50-inch sheets.

Apta A beautiful 100 percent rag sheet with a character of its own, Apta is handmade at the Richard de Bas mill in Ambert (Puy-de-Dôme), France. This heavyweight (240 grams), white paper has two watermarks—the words *Auvergne à la main* in one corner, and *1326*, a heart, and *Richard de Bas* in the other. It is excellent for etchings and lithographs when dampened, and comes in sheets 20 by 26 inches.

Aquabee Another 100 percent rag paper is the American-made Aquabee. Its white, very smooth surface is excellent for lithography, screen printing, and drawing. Aquabee is machine-made in sheets 18 by 24 inches and 24 by 36 inches, as well as in rolls 42 inches wide.

Arches Cover Arches Cover is a beautiful, mold-made, watermarked French paper available in off-white and a warm buff color. This paper has natural deckles on its long edges; the short edges are torn to simulate a deckle. It is 100 percent rag and versatile enough to print both etchings and lithographs exceptionally well. Arches Cover gives very good results when dampened and also takes embossing, making it suitable for intaglio work. It holds color well with heavy pressure and is better suited for color printing than many other papers. In addition, it erases well, making corrections easier. Available in France in perhaps a dozen varying sizes, it can be obtained readily in the United States and Canada in these sizes: 19 by 26 inches, 22 by 30 inches, and 29 by 41 inches. Other sheet sizes and rolls are available on special order from the Arjomari mill in France. Arches Cover weighs 250 grams per square meter.

Arches En-Tout-Cas A 25-percent rag paper excellent for proofing most types of prints, Arches En-Tout-Cas is also a good student paper for drawing and watercolor work. It weighs 280 grams, is fairly inexpensive, and comes in rolls 52 inches wide by 10 yards long.

Arches Silkscreen Also known as Arches 88, Arches Silkscreen is 100 percent rag with a very smooth finish. Designed for quality printing in silkscreen work, this paper also prints lithographs and etchings equally well. It is available from Arjomari in rolls, and from domestic suppliers in sheets 22 by 30 inches. Arches Silkscreen is made in two weights, 300 grams and 350 grams.

Arches Text A fine paper with a laid or wove finish, Arches Text stretches when dampened, and can wrinkle easily unless covered quickly with a blotter and a weight. This paper prints with better results when damp, however, particularly if it is to be used

for lithography. It is also excellent for drawing, calligraphy, and etching. Arches Text is available in sheets 20 by 25½ inches and 25½ by 40 inches, the latter weighing 80 pounds per ream.

Arches Watercolor Handmade from 100 percent rag fibers, Arches Watercolor is available in many weights, from 90 to 400 pounds, in cold-pressed and hot-pressed finishes. In addition to watercolor paintings, intaglio and collagraph prints also can be made with this paper, because it can be embossed deeply. It is necessary to print with very heavy pressure, however, and to soak the paper adequately, sometimes for several days. Most of the weights come in 20-by-30-inch sheets; some are also available in 25½-by-40-inch sheets. A special 555-pound paper with rough finish comes in sheets 29½ by 41 inches.

Basingwerk Basingwerk is a dense, very smooth, and comparatively thin English paper made from Esparto grass. Although capable of picking up the most minute detail whether printed dry or damp, this paper prints with best results when damp. Inexpensive, stable, and permanent, it makes an excellent printing and proofing paper for etchings, lithographs, and relief prints. Basingwerk is off-white and comes in two weights, heavy (155 grams) and light (120 grams). Sheets are 26 by 40 inches.

Bodleian Bodleian is a printing paper excellent for limited edition fine arts books. It is handmade in England of 100 percent rag fibers, weighs 55 grams per square meter, and can be obtained in sheets 20 by 28 inches.

Charter Oak A beautiful, 100 percent rag paper from the Barcham Green mill in England, Charter Oak is excellent for drawing, etching, and—when dampened—for lithography. It is sized and watermarked, weighs 100 grams per square meter, and is made by hand in sheets 20 by 25 inches.

Classico Watercolor A heavy paper suitable for watercolor painting and intaglio, Classico Watercolor is made by the Fabriano mill in Italy. This paper is composed of 25 percent rag and 75 percent high alpha, and comes in rough, medium, and smooth finishes in 22-by-30-inch sheets. It comes in several weights, ranging from 160 grams to 600 grams per square meter.

Copperplate Copperplate, a moldmade paper from Germany, contains little or no sizing. This paper is soft and white and prints etchings and lithographs especially well. It is 34 percent rag and 66 percent high alpha, and has two natural deckles, two torn deckles, and no watermark. Dampening is difficult to control, because the sheets are extremely absorbent. Copperplate is available in sizes 22 by 30 inches and 30 by 42½ inches, and weighs 250 grams per square meter.

Copperplate Deluxe Similar to Copperplate in weight and appearance, Copperplate Deluxe is composed of 75 percent rag and 25 percent high alpha. Its absorbent surface is excellent for multiple overlays of color, althouth its curled edges create a problem in registration. Heavy pressure and heavy inking yield the best results on Copperplate Deluxe. If it is to be printed damp, the paper must be interleaved with damp blotters, then sprayed with water and left under a weight overnight. It is best for etching, lithography, collagraph prints, and embossing, and comes in sheets 22 by 30 inches and 30 by 42½ inches, the latter size weighing 220 pounds per ream. Copperplate Deluxe is produced by Papierfabrik Zerkall, Germany.

Cosmos Blotting An essential accessory for the printmaker is blotting paper. It is used in every printing technique that requires dampened paper. Cosmos Blotting paper weighs 360 grams per square meter and is available in 24-by-38-inch sheets.

Crisbrook Crisbrook is a fine, 100 percent rag, white waterleaf paper from the Barcham Green mill in England. It is 140-pound, unsized, hot-pressed, and watermarked. Excellent for detailed work of all kinds, Crisbrook has good luminosity for color work, although the ink may have to be modified in order to prevent glossing when overprinting. The sheets are 22 by 30 inches.

De Wint Another Barcham Green paper, De Wint is tinted brown and made of 100 percent rag. It is sized but useful for all techniques, and is made in a 22½-by-30½-inch sheet. This paper is usually available on special order only and weighs 90 pounds per ream.

Dutch Etching An excellent paper for all techniques, Dutch Etching is made by the Van Gelder mill in the Netherlands. This paper is composed of 50 percent rag and 50 percent alpha and comes in 22-by-30-inch and 30-by-44-inch sheets. Its weight per square meter is 300 grams.

Fabriano Watercolor Made of 100 percent rag fibers, Fabriano Watercolor is available from the Fabriano mill as both handmade and moldmade sheets in 44- to 300-pound weights. It can be used for intaglio techniques as well as for watercolor work, but only after prolonged soaking in water. Sheets are 19 by 24 inches and 22 by 30 inches.

German Etching German Etching paper is similar in many respects to Copperplate Deluxe. This high-quality, 300-gram off-white paper is suitable for all techniques, although it requires heavy pressure and heavy inkings when used for lithography. German Etching is composed of 100 percent rag. The paper is unsized, and must be dampened by being sprayed with water, covered with plastic, and pressed. It has two natural deckles and two torn deckles, and comes in 22-by-30-inch and 30-by-42-inch sheets. The 30-by-42-inch sheet also is available in black. German Etching is made by Buettenpapierfabrik, Germany.

Hayle A handmade, 110-gram paper from the Barcham Green mill, Hayle is useful for small deluxe editions. This 100-percent rag paper is excellent for all techniques, although for best results it should be printed damp. Hayle is made on a laid screen and watermarked, with four natural deckles, and is available in a 15½-by-20½-inch sheet.

Ingres Antique Ingres Antique is an Italian laid paper available in white and eight colors. It is suitable for most printmaking techniques, as well as for calligraphy and drawing. The weight of this paper is 95 grams per square meter; sheets are 18¾ by 24¾ inches.

Italia A beautiful, bright white paper, Italia is heavy, dense, quite soft, and an ideal choice for single-color work of all kinds. Composed of 50 percent rag and 50 percent high alpha, this paper absorbs very little ink, but the ink can be modified with flattening agents when overlays of color are used, in order to prevent glossing. Italia can be printed both dry and damp and is also excellent for intaglio work in which fine detail is required. It occasionally has surface imperfections, and the texture is variable. The paper is watermarked and available in 20-by-28-inch and 28-by-40-inch sizes. The largest size has two natural

deckles on the long sides and torn deckles on the short sides; the smaller sheets are torn from the larger ones. Italia is made by Cartiere Enrico Magnani Mill, Pescia, Italy. Large sheets weigh 260 pounds per ream.

J. Barcham Green A moldmade, 100 percent rag paper available in rough, cold-pressed, or hot-pressed finishes, J. Barcham Green is made by the English mill of the same name. This warm white paper is unsized, smooth, and 140-pound. In addition to watercolor work—for which it was designed—J. Barcham Green is excellent for etching, lithography, and serigraphy, although for best results in etching and lithography it must be dampened thoroughly. It takes detail and color quite well and is available in 22-by-30-inch sheets. Another weight, 133-pound, is also available in sheets 26 by 40 inches.

Johannot A product of the Arjomari mill in France, Johannot is a watermarked paper with two natural and two torn deckles. Moldmade of 100 percent rag, with a slightly textured finish, this paper is well suited for etching, lithography, and drawing. Sheets are 22 by 30 inches and 20 by 41 inches. Johannot is made in two weights, 125 grams and 240 grams.

Lenox 100 Lenox 100, or Lenox Cover, is an excellent American paper suitable for all techniques. It is white, 100 percent rag with a neutral pH and comes in 115-, 180-, and 330-pound weights. Mold-made, with two natural and two torn deckles, Lenox 100 is also available in several sizes: 17½ by 23 inches, 22 by 30 inches, 26 by 40 inches, and 38 by 50 inches.

Lenox 25 A proofing paper most helpful for any printing technique, Lenox 25 is very similar to Lenox 100 in color and texture, although it is only 25 per-cent rag. Its weight is 190 grams per square meter, and the sheets are 25 by 38 inches.

Murillo A heavy (360 grams), cream-colored paper with a textured surface, Murillo is excellent for etching and embossed work, and is also suitable for lithography (particularly single-color work) when dampened. This paper is 25 percent rag. It is available from the Fabriano mill in Italy and also comes in black. The sheets are 27½ by 39½ inches.

Opaline Parchment An extremely smooth-textured and translucent Swiss paper, Opaline Parchment is particularly useful for calligraphy as well as for printmaking of all kinds. Its weight is 160 grams; the sheets are 22 by 28½ inches.

Rives BFK A very white, moldmade paper of 100 percent rag fibers, Rives BFK is made by the Arjomari mill in France. This paper is normally very lightly sized, but on special orders the sizing can be increased. It is an excellent choice for lithography, etching, and serigraphy, because it is versatile, stable, and prints well dry and damp. Rives BFK is watermarked, with two natural and two torn deckles, and is available in sheets 19 by 26 inches, 22 by 30 inches (weighing 240 grams per square meter), and 29 by 41 inches (weighing 260 grams per square meter). This paper also can be found unsized in rolls 42 inches by 100 yards.

Rives Velin Cuve Teinte Papier (BFK Gray) A beautifully toned, gray-buff paper similar in color to newsprint, Rives Velin Cuve Teinte Papier is 100 percent rag, available in sheets 30 by 40 inches. It weighs 260 grams per square meter.

Rives BFK Papier de Lin A new Rives paper made of 25 percent linen rag and 75 percent cotton,

Papier de Lin is heavyweight (270 grams per square meter) with either a rough or a cold-pressed finish. With proper dampening, it is suitable for all printing techniques and is highly stable and durable. The sheets are 22 by 30 inches.

Rives Lightweight and Rives Heavyweight Two 100 percent rag papers, Rives Lightweight (115 grams) and Rives Heavyweight (175 grams) are both lighter than Rives BFK. They are moldmade in buff and off-white, and watermarked, with two natural and two torn deckles. These papers serve beautifully for intaglio, lithography, silkscreening, and—if dampened slightly—for relief printing on a press.

Roma Roma is a beautiful, 100 percent rag, handmade Italian paper. Light to medium in weight, with medium sizing, this paper can be printed either dry or damp. It has limited absorbency for color printing, however, and if an image is printed to the edge of the sheet the watermark may show. (This sometimes can be alleviated by dampening.) Roma is available in eight colors and is easy to obtain in 19-by-26-inch sheets. Other sizes for large quantity orders can be supplied by the Fabriano mill. This paper weighs 130 grams per square meter.

Strathmore Artist Bristol An American-made paper of 100 percent cotton rag, Strathmore Artist Bristol is available in smooth or shiny finishes, and in 1-, 2-, 3-, 4-, or 5-ply weights. (Multiple-ply weights will separate if dampened.) This paper is not watermarked, but it has an embossed chop on one corner and is most useful for screen printing. It is available in 23-by-29-inch sheets and 30-by-40-inch sheets.

Tableau A white paper with a strong, long-fibered texture, Tableau is a vegetable parchment made from hemp, and serves well for all relief printing techniques. It resembles certain Japanese papers and can also be used for interleaving. This paper is made in 18-by-24-inch and 24-by-36-inch sheets, and in 40-inch rolls 60 and 160 feet long. The 24-by-36-inch sheets weigh 21 pounds per ream.

Tovil A beautiful, fully deckled, cream-colored sheet, Tovil is handmade of 100 percent rag in a medium weight (110 grams). It has two strong watermarks and fairly hard sizing, and is excellent for one-color or two-color etchings and lithographs (when dampened). Each sheet is 15½ by 20½ inches.

Umbria Umbria shares many of the characteristics of Roma and is made by the same mill. This soft, handmade paper of 100 percent rag fibers serves well for all techniques. It is a watermarked, slightly sized, 60-pound paper available in 20-by-26-inch sheets.

Wood Pulp Papers

Contemporary production of paper from wood pulp has been vastly improved since the first large-scale utilization of wood for pulp in the mid-1800s. The 19th-century method employed sodium hydroxide, which broke down the cellulose fibers of the wood and separated them from the lignin, pectins, and carbohydrates. This resulted in a relatively weak, short-fibered paper. In 1884, a new process in which calcium or magnesium bisulphite was the active ingredient resulted in a longer and therefore stronger fiber. This became known as the *sulphite process*. Sodium sulphate was later added in the course of what is essentially the earlier soda method, resulting in a strong sulphate pulp. This came to be called *kraft* pulp (from the German word meaning strong) and is used in wrapping papers, adhesive tapes, and so on.

Alpha Cellulose More recently, the production of *alpha cellulose* has had many applications in the paper industry. The alpha cellulose is that portion of the pulp or cellulosic material in the wood that resists solution by sodium hydroxide at ordinary temperatures. It is produced by briefly treating pulp with a 17.5-percent solution of sodium hydroxide at 20°C. Following the initial mercerization and softening of the fibers, the solution is diluted to about 9.5 percent sodium hydroxide, filtered, and washed with 10 percent acetic acid and water to neutralize the alkali. Finally, it is washed again to free the fibers of acid. Alpha fibers are stronger and of greater length than any produced by previous methods. Their neutral pH factor also ensures an extremely durable paper—perhaps as durable as the best rag papers.

With improved techniques in methods of making paper from wood cellulose—in particular the development of alpha cellulose fibers—there is no doubt that many better-grade commercial papers will be used increasingly for limited fine art editions.

Better-Quality Wood Pulp Papers

The commercial offset papers in the following list are excellent long-lasting wood pulp papers for proofing. Most have cut edges, no deckle, and very smooth or slightly textured surfaces. They are also ideal for serigraphy. Most come in white and various colors.

- Carrara Cover (23 by 29 inches, 26 by 40 inches)
- Index (26 by 40 inches)
- Mohawk Superfine Cover (20 by 26 inches, 26 by 40 inches)
- Mohawk Text (26 by 40 inches)
- Weyerhauser Starwhite Cover (20 by 26 inches)
- Tuscan Cover (26 by 40 inches)
- Pericles Cover, partial rag (26 by 40 inches)

632. *Kozo* fibers magnified 50 times.

Japanese Papermaking Techniques

The number and variety of Japanese papers are endless. Perhaps in no other country is the art of hand papermaking still a widespread, respected, and important industry. The art is practiced as it has been for centuries, with admirable skill, patience, and attention to quality. The endurance and strength of Oriental papers is remarkable, and many types are able to exist for centuries with little or no deterioration in quality.

Although wood pulp papers are produced in modern Japan and throughout the Orient, the papers most often employed for fine art prints are made in the ancient manner, with the same basic materials that have been used for centuries. The strong fibers from three plants are used—*gampi*, *mitzumata*, and *kozo*. *Kozo* fiber is long, tough, and dimensionally stable, while *mitzumata* is finer and somewhat shorter. *Gampi* fibers usually are mixed with one of the other types, for they shrink badly when used alone. Cheaper, lesser-grade papers are produced by adding wood pulp to some of the vegetable fibers. When prefixed by the word *kizuki* ("genuinely made"), the paper is 100 percent *kozo* or *mitzumata*; the prefix *hankusa* ("half grass") indicates a 50-percent fiber and 50-percent wood pulp content.

Beating the fibers by hand is considered to produce the longest fibers and bring out their best characteristics, thus yielding the finest papers (Fig. 632). The production of these papers is a cottage industry that has existed for hundreds of years in many fami-

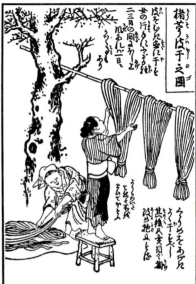

above and opposite: 633. This series of woodcuts
by Tokei Niwa was made in 1798 to illustrate
Kamisuki Chohoki by Kunihigashi.
The prints show (*left to right*) Japanese papermakers peeling
the bark from branches of the paper mulberry tree,
soaking the bark,
hanging the bark to dry,
beating the fibers made from the bark,
and forming sheets of paper from the pulp.

lies (Fig. 633); one hopes that it will not be replaced entirely by modern, more efficient methods.

After the pulp has been prepared, two main methods are used to form the paper. The first method involves pouring the pulp directly onto the partially submerged laid or wove mold. This sometimes is done alongside a stream; the mold and pulp float on the surface, while the papermaker forms the sheet in the running water. The other method is similar to the Western technique, using a vat and dipping the mold into the fibrous pulp solution.

Developed from the Chinese mold, the Japanese mold is constructed from approximately twenty-six finely split strips of bamboo per inch (the laid structure), tied together at 1-inch intervals with silk thread (the chain part of the screen). In ancient Chinese and Japanese molds, horsehair replaced silk thread.

A Japanese innovation for the forming of paper is the hinged mold and separate, flexible screen made of split bamboo (Fig. 634). The screen is placed in the mold, the hinged deckle drops down, and a measured amount of pulp is either poured on top or scooped up from the solution in the vat. As it is being lifted and drained, the deckle is raised, and the new sheet of paper is rolled or couched onto a post of wet paper.

The screen is replaced in the frame, and another sheet is formed.

The system of stacking paper between wool felts has never been used in the Orient. Traditionally, papers were stacked one on top of the other and placed in a pressure device consisting of a cantilevered wooden pole weighted with a number of heavy stones. Some mills today use newer methods.

Paper is dried differently in different regions. A common method is to leave the newly formed paper (still in the mold) to dry in the sun. The paper is later stripped from the mold and the mold is reused. This method necessitates having a large number of molds, of course, and is highly dependent on the vicissitudes of the weather.

Another method, often used in China and India, is to adhere the damp sheets of paper to a clean, dry, plaster wall, using a brush. As moisture is absorbed into the plaster and evaporated by the sun, the dry sheets fall to the ground.

A third method of drying is simply to lay the papers on hillsides or on the tops of bushes to dry. They are also draped over horsehair ropes in a way similar to that used in many Western drying lofts.

Most of the handmade Oriental papers are unsized. Some may be lightly sized, however. Early Chinese papermakers used rice or wheat starch as a sizing material, while sizes today usually are made with gelatin and alum. For the *sumi* pen-and-ink technique—in which it is important for the ink to be absorbed into the fibers—unsized paper is used; for traditional wood block printing with rice paste and pigments, the paper (made of tough *kozo* fibers to withstand the strain and tension of the rubbing) should be fully sized.

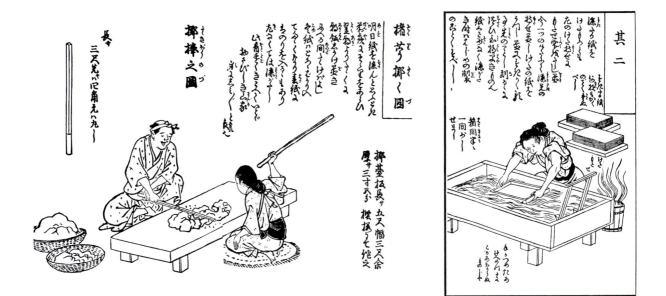

An ancient method of finishing the sized sheet of paper for certain writing or printing applications was to burnish the sheet by hand with a polished agate or other stone. Although this method still exists in parts of the Orient, glazing of the paper now is done by glazing rollers.

Japanese Papers

Following is a descriptive list of some of the most widely used Japanese woodcut printing papers. Most are available from the larger suppliers in the United States. All have four deckled edges, except where noted otherwise.

Chiri A handmade, 100 percent *kozo* fiber paper, Chiri is excellent for interleaving and making flyleafs. The paper is beige, weighs 15 pounds per ream, and is available in sheets 23 by 35½ inches.

Gasenshi Echizen Another handmade paper is Gasenshi Echizen, a white sheet made of 10 percent *mitzumata* fibers. In addition to printmaking and interleaving, this paper can be used for making rubbings. It weighs 10½ pounds per ream, and comes in 17½-by-25½-inch sheets.

Goyu Goyu is a white handmade paper of 90 percent *kozo* fiber. A fine paper for wood block printing, it weighs 20 pounds to the ream in 21-by-29-inch sheets.

Inomachi (Nacre) Handmade of 100 percent *kozo* fiber, Inomachi is somewhat expensive, but very durable and beautiful. An excellent choice for all sin-gle-color work in woodcut and lithography, this paper stretches considerably under pressure, which is the reason it is not recommended for color work in which close registration is required. It is available in two weights (44- and 85-pound), two sizes (20 by 26 inches and 22 by 30 inches), and two colors (white and cream).

Japanese Etching A 120-pound paper of 40 percent *mitzumata* fibers, Japanese Etching is suitable for etching, lithography, and woodcut. The sheets are available in white only, and are 24½ by 36 inches.

Kitakata Kitakata is a toned paper made of 100 percent *mitzumata* fibers. Because of its light weight (8 pounds per ream), it is well suited for repairing and hinging prints, as well as for wood block printing. The sheets are 16 by 20 inches.

634. The flexible bamboo screen.

Kochi A 44-pound white paper of 60 percent *kozo* fibers, Kochi can be used for book printing and Sumi painting as well as for wood block printing. It comes in 20-by-26-inch sheets.

Mending Tissue Another light (8-pound) paper suitable for hinging and other applications in print care and conservation, Mending Tissue is handmade of 80 percent *mitzumata* fibers and has no deckled edges. It is available in white only, in 22-by-31½-inch sheets.

Moriki Moriki, 100 percent *kozo* paper, comes in white and three colors, in 25-by-36-inch sheets weighing 25 pounds per ream.

Mulberry Mulberry paper has many applications, including book printing, wood block printing, hinging, interleaving, and others. It is handmade of 50 percent *kozo* fibers, weighs 31 pounds per ream, and comes in sheets 24 by 33½ inches, in white only.

Natsume 4002 and Natsume 4007 Two printing and decorative papers, Natsume 4002 and 4007 are both white and handmade in 24-by-36-inch sheets. Natsume 4002 is 100 percent *kozo* fiber and weighs 50 pounds; 4007 is only 10 percent *kozo* and weighs 40 pounds.

Okawara Okawara is a 100 percent *kozo* paper, handmade in white only in both 6½- and 16-pound weights. The sheets are 12 by 16 inches or 14 by 35 inches. (A machine-made variety of Okawara is also available; this weighs 90 pounds in 36-by-72-inch sheets).

Okawara Student Okawara Student, like Okawara, is a handmade, white paper, but it is only 40 percent *kozo*, and the 18-by-25-inch sheets weigh 15 pounds per ream.

Sekishu Sekishu is an 80 percent *kozo* fiber paper with a wide variety of uses. This paper lends itself well to wood block printing, hinging, making rubbings, and applications in print conservation. It is available in white and natural, weighing 21 pounds per ream in 24-by-39-inch sheets.

Silk Tissue Although it seldom is used for printmaking, Silk Tissue has many applications in the area of print conservation, including interleaving, hinging, and making flyleafs. It is machine-made of 100 percent *gampi* fibers and has no deckles. The sheets are white, measure 18 by 24 inches, and weigh 26 pounds per ream.

Suzuki A heavy (120-pound) white paper made of 40 percent *kozo* fibers, Suzuki is well-suited for wood blocks. It is handmade in 36-by-72-inch sheets.

Tairei Another paper without deckles, Tairei is a machine-made printing and decorative sheet that contains 20 percent *kozo* fibers. Tairei #105 is white with gold specks; Tairei #108 is orange with gold specks. Both are available in 24-by-36-inch sheets and weigh 52½ pounds.

Torinoko A good choice for block printing as well as for Sumi painting, Torinoko is a 58-pound white paper made of 20 percent *kozo* fibers. The sheets are 21 by 31 inches.

Unryu Unryu is suitable for decorative rather than printmaking purposes. It is 18-pound white handmade paper, composed of 30 percent *kozo* fibers and having two deckles on each 24-by-39-inch sheet.

The Curating of Prints

Paper is a durable yet fragile material. It can last for hundreds of years if it is made carefully with selected materials and cared for properly, but it also can be destroyed easily if made with poor materials or improperly handled, stored, or framed.

Newsprint, made from ground wood pulp, is a paper designed to be short-lived. It becomes brown and brittle within a few years. Other papers of better quality than newsprint often can have extremely limited life spans due to the action of acids or other chemicals left in the fibers; these cause a rapid breakdown in the paper and greatly reduce its longevity. During the period when wood pulp was manufactured on a large scale, particularly from 1900 to about 1940, papermaking methods were employed that left a considerable amount of free acid and other impurities in the paper as a result of chemical reactions between the alum-rosin sizing and moisture in the air. The millions of books and documents printed on this inferior material are now a nightmare to librarians and paper restorers throughout the world. Worse yet is the fact that these inferior papers will contaminate better ones when they are placed in contact with them.

Apart from selecting quality papers whose long life span can be anticipated, the proper care and conservation of paper and valuable works of art on paper is a task that benefits the artist, the museum curator, and the collector alike. Attention must be paid not only to the quality of the paper, but to the way in which it is handled, the conditions and manner in which it is stored, and the other materials with which it comes in contact. With these precautions, prints can remain in excellent condition for many years.

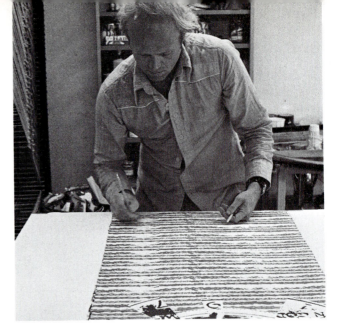

above: **635.** A razor blade is used to remove a spot of ink.

right: **636.** James Rosenquist signing the edition of *Miles*. (See Fig. 495.)

The Completed Edition

Cleaning the Prints

Completed edition prints are first reviewed carefully to remove those that are defective or inconsistent with the *bon à tirer* proof. The artist and the printer often do this together. All rejected prints are destroyed. Some of the accepted prints may have to be cleaned of specks, fingerprints, or other marks, however. For simple smudges and fingerprints, a soft white eraser or art gum eraser can be used. Erasing must be done with caution, because the fibers of some papers are easily disturbed. Specks of ink or other small imperfections can be picked out with a razor blade (Fig. 635).

Signing the Edition

Since the 1930s, numbering and signing an edition has become a standard practice. There are no fixed rules regarding the placement of the signature and the numbers; rather, this is usually left to the artist's discretion and aesthetic judgement. The signature is most often placed in the lower right corner, however, and the number in the lower left corner.

The number is a fraction—the denominator represents the full number of the edition, and the numerator the number of the print. The first three prints of an edition of one hundred, for example, would by numbered $\frac{1}{100}$, $\frac{2}{100}$, and $\frac{3}{100}$.

One of the best ways to sign the edition is to stagger the sheets, perhaps a dozen at a time, leaving enough space at the bottom of each for the numbering and signing to be done. In this way, the artist can go through the procedure quickly, rather than having to flip over one print at a time (Fig. 636).

With some techniques, such as lithography or silkscreen, there is seldom any difference between the first and the last print pulled, so that sequential numbering is not a great consideration. With drypoints, mezzotints, and aquatints, however, there may be a slight deterioration in quality as the edition is pulled. In a case such as this, it is important for the sequence of numbering to be accurate.

The Chop Mark

The printer's mark, the publisher's mark, or the workshop mark (Fig. 637), and sometimes a copyright seal are placed on prints by means of *blindstamping* (also called *inkless embossing* or *debossing*) on the front and/or by *wet stamping* on the back. These *chop marks* not only serve to identify the origin of a particular

637. Chop marks of printer Maurice Sanchez, below, and Graphicstudio, University of South Florida, Tampa, bottom.

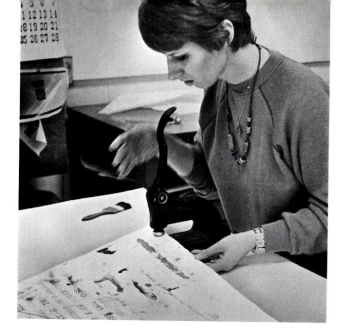

print and the collaborators, if any, but they also aid in designating authorized prints. The chop is therefore placed on the print immediately after the signing session. Although the location of the mark or marks is always determined by the artist, most chops are placed on the lower border of the print near the signature (Fig. 638). On bled prints, they can appear within the design (Fig. 639). If the artist does not wish to have the surface of the print altered, wet stamps are employed on the verso only.

Blindstamping The chop should be tested on the printing paper first, to determine the degree of pressure that must be applied. The paper is then placed in the blindstamper, and the locations of both paper and blindstamper are marked on the table top to ensure proper alignment through the edition. If the blindstamp is to be placed on an inked area, a fresh strip of tissue should be inserted between the inked surface and the blindstamper for each print. If a copyright mark (©) is used, it should be located in an area unlikely to be covered by a mat. Some large workshops have their own print identification numbering system. The print identification number (if any) is placed on the back near the debossed workshop mark.

Wet Stamping The wet stamp is a commercially made rubber stamp, generally printed with a very light gray litho ink made from white and Sinclair and Valentine Stone Neutral Black. The prints are placed face-down and staggered to allow enough room for stamping. The stamp is usually placed along the lower edge of the print. After being stamped, the prints should remain undisturbed for 24 to 48 hours before being stacked with interleaving sheets. If the print is copyrighted, it should be wet-stamped with the copyright holder's name (the artist, workshop, or publisher), the word "copyright," the date, and the copy-

above left: 638. Affixing the chop mark on an Arakawa print at Graphicstudio.

above right: 639. When an image bleeds to the edge of the sheet, the chop mark (if desired) must be placed within the image area.

right mark. In addition, copyright applications must be forwarded to the Copyright Office in Washington, D.C., with two photographs of the work.

Types of Proofs

Trial Proofs *Trial proofs* are black-and-white or color proofs with minor variations in the image, pulled as the artist refines the work just before arriving at the *bon à tirer* proof.

State Proofs There may be any number of *state proofs*. These involve substantial changes made before the final edition is pulled, and often show major stages in the development of the image. The difference between states is sometimes so great that separate editions are pulled from individual state proofs.

Progressive Proofs *Progressive proofs* are a series of impressions made for a multicolor print, showing each color separately and in combination with each of the other colors (Pls. 9–14, pp. 77, 78).

Bon à Tirer Proof The *bon à tirer* or "right to print" proof is the first impression that meets the aesthetic and technical standards of the artist and the printer. It is used as a guide against which each print in the edition is compared and becomes the property of the master printer at the end of the run (Fig. 440).

Artist's Proofs It is a common practice to reserve approximately 10 percent of the edition for *artist's*

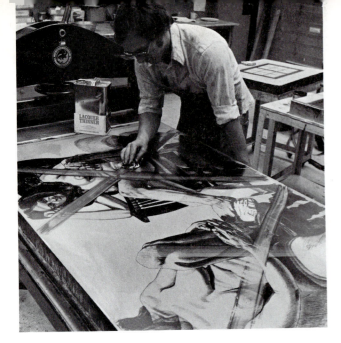

7710 NEBRASKA AVENUE, TAMPA, FLORIDA 33604
PHONE 813/231-7111

```
ARTIST:     Jim Dine
TITLE:      A Nurse
DATE:       11/6/75 - Bon-A-Tirer    1/21/76 - Edition signing
PYRAMID I.D. NO.:  JD76221
PAPER SIZE :   31" x 42"  (natural deckle edges)
IMAGE SIZE:    20" x 24"
OBJECT SIZE:   Not applicable
WORK WAS PRODUCED BY
THE ARTIST IN COLLABORATION WITH:  Mitchell Friedman for Trial
    Proofing, Donald Saff for the Bon-A-Tirer and Tom Kettner,
    with the assistance of Ralph Durham, for Editioning.
EDITION RECORD:

    30 Edition (numbered 1/30 through 30/30)
    10 Artist's Proofs
     1 Bon-A-Tirer
     1 Printer's Proof
     3 Pyramid Proofs

PROCESS DESCRIPTION:
The images were etched on roofer's copper and all plates
were steel-faced.  All impressions were printed on white
German Etching paper with lefranc & bourgeois Black.
Titles were impressed into each print with Sinclair and
Valentine Stone Neutral Black.

The publisher's chop, printer's chop and copyright seal
are located at the lower left hand corner of the paper.
The print identification number is located on the reverse
side of the paper above the publisher's chop.

Each print was hand colored by the artist.

ARTIST _____  DATE _January 23, 1926_
PYRAMID_____   DATE _January 23, 1926_
```

All works are copyrighted and reproductions must have a credit
which reads ©Courtesy of Pyramid Arts Ltd., Tampa, Florida

above: 640. After the printing of Philip Pearlstein's lithograph *Two Female Models on Rocker and Stool*, the plate is cancelled. (See Fig. 452.) Courtesy Graphicstudio, University of South Florida, Tampa.

right: 641. The documentation sheet for Jim Dine's etching *A Nurse*. (See Fig. 259.)

proofs, although this figure can be higher. These prints are intended for the artist's personal use and are normally identical to the edition prints. The artist's proof is sometimes known by its French name, *épreuve d'artiste*.

Presentation Proofs *Presentation proofs* are usually equal in quality to the prints of the edition and are dedicated to an individual. They are normally *hors commerce* ("not for sale"), although they occasionally find their way onto the market.

Printer's Proof *Printer's proofs* are given to the printer who collaborated with the master printer and with the artist. They may be dedicated personally or simply marked "Printer's Proof."

Cancellation Proof An impression taken from a stone, block, or plate after it has been effaced at the end of the run is called a *cancellation proof* (Fig. 640). This indicates that no further prints can be made.

Documentation

Another common practice is to make a documentation sheet, listing all the pertinent data concerning a published edition of prints. This is a useful legal document signed by both the artist and the printer, or

the publisher in some cases, and it indicates exactly how many prints were pulled in every category, the techniques employed in printing, the type and colors of ink that were used, the kind of paper, and the materials used in drawing (Fig. 641). The documentation often includes a reproduction of the print.

The Care of Prints

Handling Paper

There are special ways to handle paper. Any type of paper can be bruised, creased, wrinkled, or soiled easily. Museum curators and print dealers take many elaborate precautions to prevent improper handling of a print, from placing each work in a plastic envelope to instructing and observing the handler care-

642. The correct way to handle a sheet of paper.

398 Trends: Processes/Surfaces

left: 643. Creases can be caused by improper handling.

above: 644. Tearing paper with a metal straightedge.

fully. Yet, in spite of considerable literature on the subject, countless works are wrinkled, creased, stained, discolored, or otherwise mutilated by careless handling or the use of inferior mounting or framing materials.

The following guidelines will help to ensure that proper care is taken of valuable prints.

1. Paper should always be held so that it flows in an even, unbroken wave. It should be grasped carefully between the thumb and fingers at opposite edges or corners in a way that will not cause the paper to buckle (Fig. 642). Faulty handling causes a kink in the paper, and the creases produced are often irreparable (Fig. 643).
2. Prints should be touched only with clean hands or with paper tabs, to protect the edges.
3. Loose prints never should be rolled up for prolonged storage, but should be stored flat in metal or wooden print cabinets, solander boxes, or other flat storage cabinets. Each print should be interleaved with an acid-free tissue, such as tableau tissue, glassine, Japanese mulberry paper, or other inexpensive fine and soft material. Tinted paper, newsprint, or cardboard should not be used for this purpose. If tubes are used for mailing or carrying prints, a large-diameter tube is best, so that the prints will not be rolled tightly. Remove and flatten the prints as soon as possible.
4. Prints should come in contact only with quality rag mounting board with neutral pH or other special papers used for mounting. Cardboard or chipboard, for example, will stain and make the paper brittle in time.
5. Special tapes, such as gummed linen tape (Holland tape) or gummed transparent hinging tape, or adhesives, such as wheat paste or rice starch paste, should be used for mounting or matting.

Trimming Paper

Tearing It is best to maintain the natural deckle of a sheet of paper whenever possible; however, trimming the paper to size is sometimes unavoidable. Most papers can be torn with a heavy metal straightedge or a tearing bar (Fig. 644). The latter device can be constructed from a piece of steel, 18 gauge or thicker, loosely bolted to a table top. For convenience, the front end of the table should have a long ruler or tape permanently fixed to it, though the table itself can be marked for efficient measurement of a given paper size. Place the paper face-down under the tearing bar, because the bar leaves a visible straight line along the deckle on the side of the paper that it contacts. Pull the section to be trimmed up and toward the bar, holding the bar firmly in place with the other hand.

Another way of trimming paper to retain a decklelike edge is to fold it and burnish the fold lightly with a piece of ivory or other smooth tool. Insert a long knife into the fold, and draw the blade slowly against it, making sure that the long blade remains parallel to the paper surface. (It is helpful to work along the end of a table top.)

If a decklelike edge is desired on a quantity of machine-cut or razor-cut paper, the stock should be placed on a workbench, overlapping the end of the bench top by about $1/4$ inch. A piece of wood 1 by 3 inches and longer than the edge being trimmed should be placed on the top of the stack $1/4$ inch back from the edge, and held in place by another person or clamped in place with moderate pressure. A wood rasp is then drawn against the end of the stack of paper, creating a consistent rough edge on each individual sheet. If a natural deckle is to be feigned on only a few sheets, place the paper face-down and scrape the edge with a razor. Working at a slight angle

645. A moist sponge is run along the folded edge of a sheet of Japanese paper before tearing.

will feather the paper toward the edge and create the most natural-looking deckle, although it is a tedious and time-consuming job.

Razor Cutting If a single edge is to be razor cut, the tearing bar or a straightedge will do. A board at least ⅛ inch thick should be placed on the table top to protect it. When all four edges must be razor cut, as is more often the case, it is most efficient to make a template, preferably of metal, to the desired format. Formica, Masonite, or Plexiglas will also serve the purpose, but greater care must be taken to avoid cutting into the template.

Japanese Papers Japanese papers present a particular problem in trimming. Because they have very long fibers, they cannot be trimmed by means of the tearing technique above. The paper must first be folded, and the fold burnished with a piece of ivory or a burnisher. Open the paper, refold it, and score it again. The fold is then placed along the edge of a table top, overlapping the table by a fraction of an inch. A moist elephant-ear sponge (similar to the type used in ceramics) is then run along the edge of the folded paper (Fig. 645). Open the sheet again and separate it along the damp scored line. This technique creates a natural-looking edge with fibers of varying lengths extending from the paper border.

Print Storage

Wooden or metal print file cabinets, solander boxes, or other flat storage cabinets are best for the storage of prints (Figs. 646, 647). The solander box is an ideal way to store and display prints. When closed, the box seals out dust and moisture and keeps the prints flat. When opened, it lies flat, allowing each print to be removed and inspected with complete freedom. Extra care must be taken with etchings, mezzotints, and silkscreens having large flat areas of color, for they are particularly vulnerable to damage from a paper edge or fingernail scratching the surface. Solander boxes are rigid and can be stacked one on top of the other.

Environmental Conditions Wherever prints and paper are stored, the humidity is of the greatest importance. If it is too high, the humidity will promote the growth of molds, which discolor the paper and cause foxing by feeding on the iron salts in the paper (Fig. 648). Ideally, the moisture content of the air should be about 50 percent. If the air is too dry, the paper may become brittle; this does not damage the paper, however, and is preferable to foxing. (The papyrus documents preserved in the dry pyramids in the Sahara certainly would have deteriorated centuries earlier if moisture had been present to promote the growth of mold or bacteria.) Because mold spores are always present in the atmosphere, particular caution must be observed in humid climates or during prolonged rainy spells.

Dust and pollution are urban problems that affect not only prints, but also other works of art. Sulphur dioxide, nitrogen oxide, and nitrogen dioxide are a particular threat in highly populated areas. These gases mix with water or moisture in the air and are converted to acids that are particularly harmful to exposed surfaces of all kinds.

Dust alone can do inestimable damage if allowed to settle onto a print for a prolonged period. Not only do the particles get into the fibers of the paper, producing smudges and discoloration, but chemical or abrasive actions by different substances in the dust can stain or abrade the fibers of the paper.

Effects of Light Strong light, and sunlight in particular, has a number of serious effects on the printed

646. Several flat storage cases are used in the curating studio at Gemini G.E.L., Los Angeles.

above: 647. Rigid solander boxes lie flat when opened and are ideal for print storage.

below: 648. A sheet of paper with foxing stains caused by bacteria.

image and on the paper itself. Few colors or dyes are completely immune to strong sunlight or prolonged exposure to other bright lights. Ultraviolet light is the wavelength that is most dangerous to printed works. It fades colors and causes some papers to darken, some to yellow, and others to bleach out to a lighter shade. Plexiglas UF 3, if used in place of glass for framing, will greatly reduce the amount of damaging ultraviolet light that reaches the print.

The Japanese custom of storing prints or paintings and bringing them out only when they are to be viewed is contrary to the Western tradition of framing and hanging them. It is nonetheless an excellent way of protecting the images from deterioration.

Matting the Print

Because the damage done to a framed print is concealed, it often goes unnoticed for years. Cheap varieties of cardboard, chipboard, corrugated board, and other backing materials can be extremely harmful to the print when placed in direct contact with it, and should be used for temporary support only. These wood pulp cardboards contain noticeable amounts of acid, which stain the fibers of the print in time. The acidic content also weakens the cellulose fibers in the paper, changing their color and making them brittle.

The best mat boards are the all-rag mounting boards (often called museum mounting boards), available in several different weights and sizes. They are usually a white or yellowish buff color and display the same color throughout when cut. For large prints, the heavier weight rag mat board will be necessary. Hot-pressed, heavy-weight watercolor paper also will make an excellent substitute matting or backing material. Cheaper mat boards have wood pulp centers and surfaces of better grade paper. Although these are commonly used for much of the framing done in the

649. Thin mat board can be cut with a single stroke of the knife.

United States and are available in a wide range of tones and colors, museums and institutions always avoid them because of their tendency to discolor paper. Some recommended types of museum mounting boards include W & A (Cream), Gemini (White), Lenox (Bright White), and Bainbridge All-Rag Museum Mounting Board (White or Ivory). All come in 2-ply and 4-ply weights, in sheets measuring 22 by 32 inches, 32 by 40 inches, and 40 by 60 inches. An excellent barrier paper that can be put between the print and the backing board if necessary is A/N/W Drawing-Framing Paper. This is a single-ply (cream) stock, available in rolls 60 inches by 29 yards.

Cutting the mat requires skill. The equipment needed includes a sturdy table, a heavy-weight metal straightedge, a mat knife or utility knife, and a compass. Learn to sharpen the blade of the knife and keep the cutting edge well honed during the cutting. This will improve the results and make the job easier. Cutting through the board should be done with a single stroke if possible, to produce the cleanest edge. For a straight cut on extra heavy board, hold the metal straightedge firmly against a lightly penciled line, and cut the board with a light stroke, then with a heavier one to cut through completely. Thin boards should be cut in a single stroke (Fig. 649).

The beveled mat is a little more difficult to cut. Some mat cutters prefer to cut from the back of the mat, others from the face. Both methods are good, although there are advantages to cutting from the back. Pencil lines made on the back to indicate the mat opening can be erased afterwards, and the corners do not show the slight overcutting made by the knife.

To cut a beveled mat from the back, measure the size of the opening and subtract this from the width of the mat. Divide the remainder in half to find the margin width, and—with this measurement set on the compass—run the metal point of the compass along the outside edges of the mat, making parallel pencil lines on opposite sides. The margins on the top and sides are usually equal, with the bottom slightly wider, although the proportions will depend on the size and character of the individual print. Normal margin widths are between 2 and 6 inches.

The ordinary mat knife can become the simplest and most practical device for cutting mats, after a little practice. Mat-cutting units, like the Keeton Kutter made by Bainbridge, facilitate the cutting procedure. They can cut straight or beveled edges and lessen the need for pencil lines on the mat.

Two boards of equal size are used for each mat—one for the backing board and one for the open window. The front window mat is hinged to the backing board along the top or on the left side, whichever is longer (Fig. 650). Use either a special linen tape with a water-soluble, nonstaining, nonacidic adhesive, or a strip of mulberry or other strong Oriental paper with wheat or rice paste.

The print can then be positioned under the opening and hinged at the top with additional strips of linen tape or Oriental paper, such as *hosho*, mulberry, or *kozo* paper. Scotch tape, masking tape, rubber cement, gummed tape, and heat-sealing tissues should be avoided. They discolor the paper, often irreparably, and most lose their adhesive quality within a year or so. Hinges can be made in various ways, as shown in Figure 650. If a buildup in the combined thicknesses of the layers of tape becomes a problem, method *a* should be used. Once the hinge has been attached, the print and backing board are placed under a heavy weight to ensure flatness. A sheet of blotter paper should be placed between the weight and the print.

Making a French mat is an expensive procedure aesthetically suited to a more decorative approach to matting and framing. It consists of accurately ruled

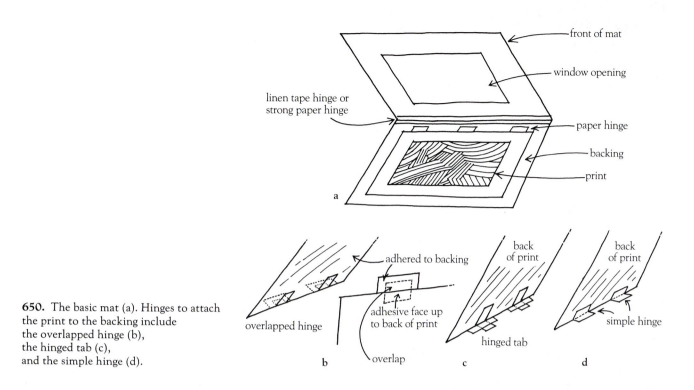

650. The basic mat (a). Hinges to attach the print to the backing include the overlapped hinge (b), the hinged tab (c), and the simple hinge (d).

lines of differing widths on the face of the mat, forming a decorative color border along the edge of the opening. The area between two lines is often filled with a subtle watercolor wash in a tone coordinated with the colors of the print.

Framing the Print

The selection of a frame is an aesthetic and economic consideration ultimately dependent upon the object to be framed. Three basic ways of framing are shown in Figure 651. Method *b* is ideal for making the print impervious to moisture, because the matted unit is sandwiched between Plexiglas on the front and Mylar or acetate on the back and sealed with strong plastic or cloth tape on all four edges.

Metal frames can be purchased readymade or in sections that can be put together at home. They are excellent for framing contemporary prints, and are best used in conjunction with Plexiglas, because this eliminates the danger of breakage. Always a problem with a glass-covered frame, breakage is particularly likely in metal frames in which the metal contacts the glass directly.

The print never should be placed in direct contact with glass or Plexiglas. If the print is very large, making matting difficult, a small spacer or fillet should be used. If contact is unavoidable, use Plexiglas instead of glass. Because glass reacts to atmospheric conditions, it allows moisture to condense on the inside and stain the print.

Print Restoration

The art of restoring works of art on paper is a delicate task requiring considerable skill and knowledge. The procedures outlined here should be undertaken only if you are completely familiar with the substances and materials of the print, and should be weighed against the value of the print as well. When working with an unfamiliar paper, it is best to proceed with caution and make tests before treating the entire sheet. The better the quality of the paper, the more it can be subjected to bleaching or immersion procedures.

Cleaning the Surface

Dust should be removed from the surface of a print with a soft, dry cloth, always using light, circular motions. Cleaning pads such as those used by draughtsmen work well, particularly on the margins of a print, although pencil signatures should not be touched with the pad for they might be erased. Compressed gas cans like Dustmaster, which contains dichlorodifluoromethane (CCl_2F_2), are sold by photographic suppliers for ridding negatives of lint and make excellent tools for cleaning dust and eraser residue from the print surface.

More heavily soiled prints that do not respond to dusting or erasing can be immersed in a water bath. Apply a small amount of mild detergent to the stained area and rinse well with clean water. This method alone will often eliminate weak stains or light

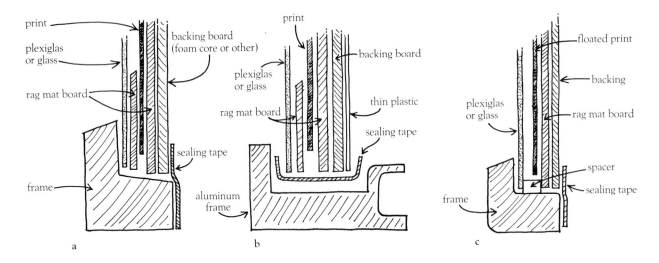

print
plexiglas or glass
rag mat board
frame

backing board (foam core or other)
sealing tape

a

print
plexiglas or glass
rag mat board
aluminum frame

backing board
thin plastic
sealing tape

b

plexiglas or glass
frame

floated print
backing
rag mat board
spacer
sealing tape

c

651. The traditional framing arrangement (a);
a recommended framing method
for use with aluminum section frames
to produce a moisture-proof unit (b);
and a method of framing a floated print (c).

foxing, and is one of the safest methods for cleaning certain types of prints. Stains that do not respond to this method must be bleached, however. It is important to remember that prints made with water-soluble inks or watercolors cannot be cleaned by immersion.

Bleaching the Print

Bleaching can be resorted to when all else fails. The greatest precautions should be taken with delicately colored prints and pencil signatures, of course. In these cases, the bleaching solution should be tested on similar material first to ensure that no fugitive action or loss of image results. Carbon-base inks (such as black lithographic or etching ink) and earth pigments (such as burnt sienna or umber) present no problem because they are unaffected by bleach. The technique must be used with caution in all instances, however, so that overbleaching does not occur. This weakens the cellulose fibers and gives the paper an artificial chalky-white appearance.

Three bleaching methods can be used for different situations. The first employs sodium hypochlorite and requires total immersion of the print in the solution. The second method uses chlorine dioxide gas as the bleaching agent, without immersion, and in the third, chloramine-T is applied only to the stained spot.

Sodium Hypochlorite Method The following solution is used to remove foxing stains, mildew, and other discolorations.

4 ounces sodium hypochlorite bleach
2 quarts water

Mix the solution and pour it into a tray large enough to accommodate the print. Rock the print gently in the solution and remove it as soon as the stain has disappeared. Rinse it in water, then place it in a bath of the following solution:

1 teaspoon sodium thiosulphate crystals
1 quart warm water

This solution is commonly used as a fixer for photographic prints. Because it is acidic, it neutralizes the alkaline action of the bleaching solution. The print should be left in this solution for a few minutes, and then washed thoroughly under running water. A hypo clearing agent can be added in the early stages of washing to remove any further traces of the fixer.

Chlorine Dioxide Gas Method Chlorine dioxide gas must be used either outdoors or in a specially constructed chamber, so that none of the vapors will be inhaled. The following method is suitable for fragile prints or drawings that cannot withstand immersion. In a special enclosed construction, place several wire racks or screen shelves to hold the prints. Place a tray underneath, containing approximately 1 teaspoonful of technical-grade sodium chlorite and one quart of water. The addition of a few drops of formaldehyde causes the immediate release of chlorine dioxide gas, which bleaches the paper above.

The same solution can also be used for bleaching prints by immersion. Twenty minutes is usually sufficient time to bleach out foxing or other stains, after which the prints should be rinsed thoroughly in clean, running water. This is a relatively mild bleach and one of the safest to use on prints, although care must be taken not to inhale its fumes.

Chloramine-T Method For direct application to a spot or stain on the paper, mix 1 teaspoonful of chloramine-T crystals with 1 quart of warm water. Apply it with a brush, or spray it onto the paper from the front or the back. Application from the back is recommended for thin, fragile papers. The solution can be applied repeatedly, after which the print can be blotted dry. No other treatment is necessary, for no harmful residue is left.

Reducing the Acidity of a Sheet of Paper or Print

The acidity of a sheet of paper or a print can be reduced by mixing $\frac{1}{2}$ teaspoonful of magnesium carbonate with 1 quart of water, then discharging a carbon dioxide cartridge into the solution. This changes the solution to magnesium bicarbonate, which should be left to stand for about an hour. It can then be sprayed on the paper, several times if necessary. A reading can be taken with special pH testers applied to a portion of the paper that has been dampened with clean water. The pH range is from 0 to 14. The highest acidic level is 0; the highest alkaline level is 14. A neutral pH value is 7.

Mending Tears, Folds, and Creases

Small rips and tears in a print can be mended with rice or wheat flour mixed with water to form a paste. This is applied in a thin layer to a piece of Japanese mulberry or *kozo* paper, which is pressed to the back of the torn area. Tear the edges of the mending paper, rather than cutting them, so that sharp edges will not be formed.

Some creases can be removed by dampening the print lightly and pressing the creased areas against a smooth surface. Ironing with a warm (*not* hot) iron can also remove a crease from a dampened print, if a protective cloth is put over the paper to prevent scorching.

Sterilization of Paper or Prints

Sterilization is a useful technique to prevent or stop the growth of mildew and other mold spores in papers, books, and prints. It is also beneficial in humid climates for prints or other works of art on paper before they are sealed into a frame. An airtight compartment is made to accommodate the papers or prints to be fumigated. These should be placed on a shelf in the compartment, allowing free circulation of the inner air. Underneath, some thymol crystals are placed in a small Pyrex glass or enamel tray propped up a few inches above a 40-watt lamp. The heat from the bulb releases thymol vapors that efficiently sterilize the paper. A treatment of 2 to 3 hours' duration is usually sufficient.

Formaldehyde vapors are also effective for sterilization. A 40-percent formaldehyde solution can be placed in a dish below the paper in a tightly sealed compartment and left overnight so that the vapor penetrates the paper fibers.

Insects can do an enormous amount of damage to prints and paper if conditions favorable to them are allowed to exist. Silverfish, termites, cockroaches, and woodworms are the most common types of destructive vermin.

The starch and sizing in paper, as well as the cellulose fibers, make paper of all kinds particularly attractive sources of nourishment for these insects. Treatment with thymol or formaldehyde will discourage them, although the best method of preventing infestation is to look for it frequently by moving works from cabinets and by cleaning storage areas. If infestation occurs, use insecticide sprays or powders.

Appendix A
The Chemistry of Etching

The corrosive effects of oxidation or rusting on metal were well known in the ancient world. For centuries alchemists attempted to change objects from one state to another with these phenomena, often emphasizing effect rather than practicality. Experimentation with strong oxidizing and reducing agents to alter the forms of metals assumed purpose in the early 15th century, however. Armorers in this period began to decorate their swords by scratching through a wax ground and etching the metal underneath with a corrosive liquid. This corrosive etch was made from sal ammoniac (ammonium chloride), vinegar (acetic acid), and vitriol (iron sulfate or sulfuric acid). Although the action of the mixture on iron was slow (often requiring immersion for several days to effect a reasonable bite), the mordant was used for more than a century to etch iron and steel.

In 1500 Daniel Hopfer, an armor decorator in Augsberg, began etching on flat iron. Within the next two decades, Urs Graf in Switzerland, Albrecht Altdorfer in Germany, Francesco Mazzuoli (Parmigiano) in Italy, and Albrecht Dürer in Nuremberg were using flat iron for etching plates. The iron etched crudely, however, and not until about 1520, when Lucas van Leyden began using copper for etching, did the technique allow the precise control and freedom so important to the artists—such as Jacques Callot and Rembrandt—who were to follow.

As copper became a more popular material for etching, artists sought the ideal etching agent for it. A mixture of vitriol, saltpeter (sodium nitrite, $NaNO_2$), and alum was commonly used by metal refiners at that time, but because of the noxious fumes it produced, experimenters began to look for a more compatible mordant.

In his 1643 treatise on etching and engraving, Abraham Bosse mentions an etching solution composed of the following ingredients:

3 pints white vinegar (acetic acid)
6 ounces sal ammoniac (ammonium chloride)
6 ounces common salt (sodium chloride)
4 ounces verdigris (made by the reaction of the lees of wine on copper)

The reaction of this solution on copper was slow but accurate, and it is highly probable that it is the one used by Rembrandt for his etchings. In making the solution, the sal ammoniac and salt were crushed to a fine powder, placed in a large, enamel pot with the other ingredients, and boiled. The mixture was allowed to come to a boil three times, cooled, and poured into glass containers. After two to three days, it was ready for use. The lees of wine reacted to form a tartrate complex that effectively removed copper chloride as it formed, slowly dissolving the metal.

The plate was etched by either scooping the mordant up in an earthenware pot and pouring it over the almost upright plate several times; or forming a tight wall around the edges of the plate with bordering wax and pouring the acid in. From the results that Rembrandt, Callot, and other etchers achieved, there is no doubt that the possibilities for control and accuracy were considerable

Nitric acid, a strong, corrosive substance, was first discovered in 1787 by Raymond Lully, and was later used increasingly as a mordant for copper and other metals. Some artists were dissatisfied, however, with the coarseness of its bite and its tendency to undercut delicate work. A new mixture appeared in the 1850s and has been attributed to Seymour Hayden. This consisted of hydrochloric acid, potassium chlorate, and water, and became known as the Dutch mordant. It attacked copper without forming bubbles and practically eliminated undercutting, producing a fine, accurate bite similar to that achieved by Rembrandt more than two centuries earlier.

In addition to the Dutch mordant and nitric acid, ferric chloride (iron perchloride) is increasingly being used for etching copper today. The etched line it makes is similar to that of the Dutch mordant.

Reaction of Nitric Acid and Zinc

When a weak solution of nitric acid and water comes in contact with zinc, a process of *simultaneous reduction and oxidation* takes place. In this type of reaction, one molecule loses an electron (oxidation), and the other gains an electron (reduction). When zinc and nitric acid react, the positively charged hydrogen ion in the acid solution oxidizes the zinc and is, in turn, reduced. The zinc, in other words, loses an electron to the hydrogen ion. As zinc oxide is formed, a molecule of hydrogen escapes in the form of a gas:

$$\underset{\text{(zinc)}}{Zn} + \underset{\text{(nitric acid)}}{2HNO_3} \longrightarrow \underset{\text{(zinc nitrate)}}{Zn(NO_3)_2} + \underset{\text{(hydrogen)}}{H_2\uparrow}$$

If a greater concentration of nitric acid is used, however, a yellow-orange gas called nitrogen dioxide is produced, along with a smaller amount of a colorless gas, nitrogen oxide. Both are extremely dangerous, and neither should be inhaled. The reaction is:

$$\underset{\text{(zinc)}}{Zn} + \underset{\text{(nitric acid)}}{4HNO_3} \longrightarrow$$

$$\underset{\text{(zinc nitrate)}}{Zn(NO_3)_2} + \underset{\substack{\text{(nitrogen} \\ \text{dioxide)}}}{2NO_2\uparrow} + \underset{\text{(water)}}{2H_2O}$$

As the reaction continues, an added danger is the formation of dinitrogen tetroxide, a deadly poison, in the following reversible reaction:

$$\underset{\text{(nitrogen dioxide)}}{2NO_2} \longleftrightarrow \underset{\text{(dinitrogen tetroxide)}}{N_2O_4}$$

One must also be aware of the continual formation of free hydrogen in all solutions. This gas is potentially explosive when mixed with oxygen. (H_2O is so stable that tremendous energy is released when it is produced from H_2 and O_2). Not only should all acids be vented to the outside, but also the use of an explosion-proof fan should be considered.

$$\underset{\text{(free hydrogen)}}{2H_2\uparrow} + \underset{\text{(oxygen)}}{O_2\uparrow} \longrightarrow \underset{\text{(water)}}{2H_2O}$$

Reaction of Nitric Acid and Copper

Because copper is considerably less reactive than zinc, nitric acid must be used in greater concentration to oxidize metal effectively. The reactions, however, are analogous to those for zinc; that is:

$$\underset{\text{(copper)}}{Cu} + \underset{\text{(nitric acid)}}{4HNO_3} \longrightarrow$$

$$\underset{\text{(copper nitrate)}}{Cu(NO_3)_2} + \underset{\substack{\text{(nitrogen} \\ \text{dioxide)}}}{2NO_2\uparrow} + \underset{\text{(water)}}{2H_2O}$$

The blue color of copper in solution results from the presence of the hexaquo-copper (II) ion, $[Cu(H_2O)_6]^{2+}$, a complex ion formed from the copper ion, Cu^{2+}, and water as shown below.

The formation of dangerous nitrogen dioxide is possible if the solution contains too much nitric acid.

Reaction of Ferric Chloride (Iron Perchloride) and Copper

The reaction of ferric chloride and copper is represented by the following equation:

$$\underset{\substack{\text{(ferric} \\ \text{chloride)}}}{2FeCl_3} + \underset{\text{(copper)}}{Cu} \longrightarrow \underset{\substack{\text{(cupric} \\ \text{chloride)}}}{CuCl_2} + \underset{\substack{\text{(ferrous} \\ \text{chloride}}}{2FeCl_2}$$

Iron (II) may precipitate on the surface of the plate as iron (II) hydroxide (ferrous hydroxide). In solution,

$$\underset{\substack{\text{(ferrous} \\ \text{chloride)}}}{FeCl_2} \xrightarrow{\underset{\text{(water)}}{H_2O}} \underset{\substack{\text{(ferrous} \\ \text{ion)}}}{Fe^{2+}} + \underset{\substack{\text{(chloride} \\ \text{ion)}}}{2Cl^-}$$

and

$$\underset{\text{(iron)}}{Fe^{2+}} + \underset{\text{(water)}}{H_2O} \longrightarrow \underset{\substack{\text{(ferrous} \\ \text{hydroxide)}}}{Fe(OH)_2\downarrow} + \underset{\substack{\text{(hydrogen} \\ \text{ion)}}}{2H^+}$$

The adverse equilibrium can be averted by the addition of H^+ (as in hydrochloric acid), and the iron hydroxide ion is thus kept soluble. A 7- to 10-percent solution of hydrochloric acid is necessary to maintain the precipitate, $Fe(OH)_2$, in solution. This does not interfere with or react with the metal to any degree.

Reaction of Dutch Mordant and Copper

Dutch mordant is a mixture of hydrochloric acid, potassium chlorate, and water. These must be combined either outdoors or under a ventilating hood, because when first mixed together, they produce chlorine gas, a dangerous substance that escapes into the air. The gas must not be inhaled.

$$KClO_3 \; + \; 6HCl \; \longrightarrow$$

(potassium (hydrochloric
chlorate) acid)

$$3Cl_2\uparrow \; + \; KCl \; + 3H_2O$$

(chlorine (potassium (water)
gas) chloride)

When copper is introduced into the solution, the following reaction takes place:

$$5Cu \; + \; 12HCl \; + \; 2KClO_3 \; \longrightarrow$$

(copper) (hydrochloric (potassium
 acid) chlorate)

$$5CuCl_2 \; + \; Cl_2\uparrow \; + \; 2KCl \; + 6H_2O$$

(cupric (chlorine (potassium (water)
chloride) gas) chloride)

Reaction of Hydrochloric Acid and Iron

Iron is dissolved in the same manner as zinc—that is, by the action of the acid alone. In this case, the lower oxidation state alone is formed:

$$Fe \; + \; 2HCl \; \longrightarrow \; FeCl_2 \; + \; H_2\uparrow$$

(iron) (weak solution of (iron (II) (hydrogen)
 hydrochloric acid) oxide or
 ferrous
 chloride)

Reaction of Nitric Acid and Iron

In the presence of a more potent oxidizing agent, such as a strong solution of nitric acid, iron (III) nitrate is formed by the action of the nitric acid on the iron. Either of the following reactions can occur:

$$Fe \; + \; 6HNO_3 \; \longrightarrow$$

(iron) (nitric acid)

$$Fe(NO_3)_3 \; + \; 3NO_2\uparrow \; + \; 3H_2O$$

(iron (III) (nitrogen (water)
nitrate) dioxide)

$$Fe \; + \; 4HNO_3 \; \longrightarrow$$

(iron) (nitric acid)

$$Fe(NO_3)_3 \; + \; NO\uparrow \; + \; 2H_2O$$

(iron (III) (nitrogen (water)
nitrate) oxide)

Reaction of a Solution of Cupric Chloride and Aluminum

Cupric chloride, a copper salt, forms a good etching solution for aluminum. Because aluminum has such a granular texture, the bite produced by a strong solution will be coarse. The cupric chloride is crushed in a mortar and pestle, and a saturated solution of it is made in water. Mix with 3 parts water for a strong solution, or with up to 10 parts water for a more slowly acting solution. The following reaction then takes place when aluminum is introduced:

$$2Al \; + \; 3CuCl_2 \; \longrightarrow \; 2AlCl_3 \; + \; 3Cu\downarrow$$

(aluminum) (cupric (aluminum (copper)
 chloride) chloride)

Dichromate Oxidation

Other formulas have been used for the etching of aluminum, zinc, and copper in which potassium dichromate in sulfuric acid and/or hydrochloric acid is used. The oxidizing quality of this mixture is extremely potent. Since it will dissolve almost anything, it is commonly used by chemists for scrupulous cleansing of glass laboratory apparatus. Potassium dichromate is a poison and must be handled with the utmost care. By itself, it can cause strong allergic reactions, and the danger of dermatitis exists as well from prolonged contact with the skin. When in solution with acid, this substance must not come in contact with the skin.

Other Etchants

Materials	Etchants
aluminum (non-anodized)	20% solution sodium or potassium hydroxide (alkaline etching), or 15% solution hydrochloric acid
copper	cupric chloride (saturated solution)
glass, ceramic	hydrofluoric acid. Extreme caution should be exercised, since this acid is highly corrosive to skin and mucous membranes. Check with a chemist for safe handling procedures.
gold	solution of nitric acid (1 part by volume), hydrochloric acid (3 parts), and water (3 parts). This solution is often referred to as *aqua regia*.
magnesium	5% solution nitric acid (by weight)
silver	55% solution ferric nitrate (by weight)
stainless steel	solution of 50% ferric chloride (42° Baumé), and 50% hydrochloric acid, or solution of 37% hydrochloric acid (1 part by volume), 70% nitric acid (1 part), and water (3 parts)

Appendix B
Steel Facing

The process of steel facing was invented in France about 1857, and by the latter part of the 19th century it was in use throughout the world. In this technique, a microscopically thin layer of pure iron is deposited onto a copper plate by means of electrodeposition. Because it is much harder than the copper, the iron increases the wearing qualities of the plate. This provides a tremendous advantage not only to the etcher or engraver, who can thus pull hundreds and often thousands of impressions from a single plate, but also to the mezzotint or drypoint artist, whose fragile work normally withstands relatively few impressions.

Steel facing requires the immersion of the copper plate and a sheet of iron in an electrolyte solution. (The term "steel facing" is actually a misnomer, since steel—an alloy of carbon, iron, and other metals—cannot be faced onto copper.) The copper becomes the *cathode* or negatively charged element; the iron, the *anode* or positively charged element. The electrolyte allows a direct current (supplied by a power source such as a battery or rectifier) to flow from the iron to the copper. When the current is turned on, ions of iron are removed from the anode, pass into the solution, and are then deposited onto the copper.

The Vat

The vat in which the process takes place must be large enough to accommodate the largest plate to be faced and should be sturdily constructed of fiberglass and wood, plastic material, or some other nonconductive, waterproof material (Fig. 652). Two long brass or copper rods are placed on top of the vat. The iron plate is suspended from one rod by iron hooks. The copper plate hangs from the other rod, attached by copper strips that are either soldered to the back of the plate or connected in such a way that good contact with the plate is ensured. Heavy copper cables are then connected from the positive terminals of the battery or rectifier to the iron plate (anode) or the rod from which it hangs, and from the negative terminal to the copper plate (cathode) or its rod.

The most common electrolyte solution consists of $1\frac{1}{2}$ to 2 pounds of ammonium chloride (sal ammoniac) to 1 gallon of distilled water. (Use distilled water to prevent impurities from being introduced.)

The iron used for steel facing should be as pure as possible, with little or no carbon. Swedish wrought iron and Armco iron are the best, although they are difficult to obtain except through special sources.

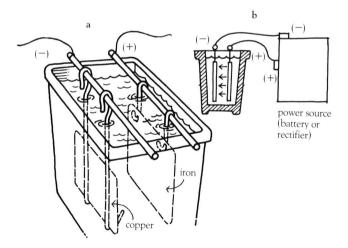

652. The vat containing the copper and iron plates is filled with electrolyte solution (a). Copper cables connect the plates to the power source (b).

The Power Source

The power source for steel facing must be a direct current, such as that produced by a battery. A car battery can be used, although it does not allow precise

timing or control of the deposition due to its diminishing strength. A 25 or 50 amp rectifier (6 volt) that changes an alternating current to a direct current is ideal, and can be obtained from any steel-facing supply outlet. The rectifier provides variation in both the amperage and the voltage of the current. The current density should be about .03 amperes per square inch of cathode surface. Too great a current density will plate the metal too quickly and create a roughness in the deposit, particularly on the edges of the plate.

Preparing the Plate

Before being immersed, the copper must be immaculately clean, without the slightest trace of grease or oil. Clean the plate with hot potash or a 5-percent solution of caustic soda and whiting. All ink must be removed from the lines of the image. After cleaning, the plate should be protected with paper towels or handled with clean gloves, to avoid putting fingerprints on the surface. Even the lightest fingerprint will interfere with proper adhesion of the iron. The clean plate can then be placed in the bath and the current switched on.

The Steel-Faced Plate

It is best to electroplate slowly, taking the copper plate out of solution every 5 to 7 minutes and scrubbing it with a bristle brush and some very fine pumice or whiting before reinserting it in the bath. The average plate will take no longer than 15 to 20 minutes, although the exact time depends on the strength of the current and the size of the area being plated.

After a plate has been steel faced, it must be rinsed with clean water and dried quickly. A thin coat of oil or wax ground should then be applied. The iron on the surface can rust very easily, so it must be protected at all times when the plate is not in use.

The number of impressions that can be made from a steel-faced plate depends on several factors. A heavily engraved or etched plate can produce more than five thousand impressions; a finely or coarsely ground aquatint plate, from several hundred to several thousand; a drypoint plate, several hundred at most. Of course, this is a rough guide that will vary with the strength of the initial burr, the thickness of

the iron deposit, and the grittiness of the printing ink, all of which affect the life of the facing.

If a long run is needed from a steel-faced plate, the plate must be continually checked for the slightest signs of wear, indicated by a trace of copper showing on any sharp ridges of the lines. On a deeply aquatinted plate the peaks of the metal in the dark areas of the image show the copper first. When copper shows, the plate must be cleaned immediately, the iron removed (see below), and the plate refaced.

A heavier deposit of iron will allow many more prints to be made from a plate than a thin plating will. But in order to preserve the finest subtlety on the plate, it is preferable to plate thinly, repeating the operation as needed.

Chromium can also be faced onto copper, providing a most durable printing surface. A single chromium plating can withstand many more impressions than a single iron plating. Chromium, however, is not as sensitive to detail as iron, nor is it suitable for all techniques.

Removing the Facing

To remove iron from the plate, make sure that any ink or oil has been removed from the surface. A thorough scrubbing with ammonia and whiting followed by a rinsing with clear water will usually suffice. Immerse the plate in a tray filled with a 5-percent solution of nitric acid and water. This will remove the iron without affecting the copper. (A very weak solution of sulphuric acid and water can also be used.) Rock the tray slightly and remove the plate when copper shows over the entire surface. The plate can then be rinsed with water and refaced if necessary.

Steel Facing Zinc

Zinc cannot be steel faced directly. It must be plated with copper first, then faced with iron. Because of the double facing, there is usually a slight loss of detail in the image. Zinc can be nickel faced directly, however, providing an ultrahard surface from which hundreds of impressions can be made. Special plating equipment and solutions are necessary, but the major disadvantage of nickel facing zinc is that the nickel is difficult to remove afterwards.

Appendix C
Presses

Presses for printmaking exist in varying degrees of sophistication. In addition to the necessary service they perform in facilitating the contact between image surface and paper, many printmakers find them fascinating specimens of machinery. By studying the principles and designs of early commercial presses and those currently on the market, printmakers have begun—often in consultation with machinists—to construct presses that suit their particular needs. Most of the mechanical principles involved are relatively simple and can be adapted to a range of printmaking situations. Readymade presses for each printmaking technique are available from commercial suppliers in many sizes and prices. A list of manufacturers begins on page 419.

Basic Principles of Press Design

In the mid-15th century two distinct forms of printing existed: relief and intaglio. Relief printing of books and similar works required that the printing surface of both the woodblock and the type be exactly the same height, especially if they were to be printed together. Direct downward pressure from a flat platen onto a sheet of paper placed on the inked surface gave the best and sharpest impressions. A press that performed this function allowed the entire surface to be printed at once, with a consistency impossible in hand burnishing.

For intaglio printing a different kind of press was necessary. Tremendous pressure was required to push the dampened paper into the finely inked crevices to make an impression. This pressure was provided by a roller press with a movable bed. The plate was first placed on the pressbed, with the dampened paper arranged on top and several soft felt blankets placed over the paper. As the roller passed over the surface, a heavy downward pressure through felts and paper

gave the right cushioning action for the paper to make contact with the image below the surface. This principle of intaglio printing has remained unchanged to the present day.

With the advent of lithography at the end of the 18th century yet a third type of press became necessary. Lithography requires a relatively uncushioned pressure. A greased scraper bar provides a smooth, scraping pressure—often in excess of 10,000 pounds per square inch—along a thin edge. This action has proven far superior for impressing the paper fibers against the thinly inked planographic surface.

Relief Presses

Until the early 15th century relief printing was strictly a hand process, which at every stage functioned without the aid of any mechanical contrivance. However, at that time Gutenberg began his experiments in printing, and by 1438 he had a joiner, Konrad Sarpoch, construct a wooden press that applied pressure to the paper over the entire area of inked type. The raised type was first inked by hand with leather ink balls, then the dampened paper was placed on top. Pressure applied by a handle and a wooden screw arrangement lowered the upper platen to make the impression (Fig. 653). This device al-

653. A working model of Gutenberg's wooden press of about 1438, in the Gutenberg Museum, Mainz.

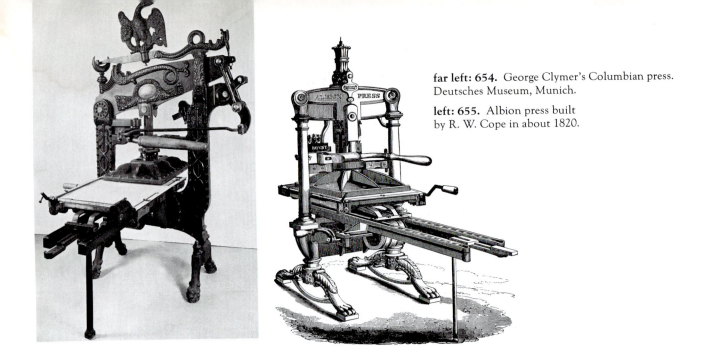

lowed for a uniformity of impression and greatly increased the speed of printing. Presses similar to Gutenberg's remained the workhorses of the printing industry throughout the Renaissance and into the beginning of the 19th century.

In the first few years of the 19th century Earl Stanhope in England constructed the first iron hand press. Although smaller and more compact than earlier wooden presses, this machine still relied on principles that Gutenberg had copied from the Rheingau wine presses. The first real development came in 1813, when George Clymer built the Columbian press (Fig. 654). Introduced into England in 1817, this press incorporated a compound set of levers, rather than a screw device, for applying pressure. The lever mechanism was connected to a counterweight in the form of a cast-iron American Eagle. Although its ornate design inspired many jokes, the Columbian press far surpassed any yet constructed in ease of operation and in the amount of pressure it could exert.

A new press called the Albion was built by R. W. Cope in England about 1820, seemingly as a challenge to the rival American press (Fig. 655). A simplified, efficient machine, the Albion press (along with the Columbian) remained the backbone of all book and handbill printing during the 19th century. Many of these presses are still in use today in art schools or private workshops for printing woodblocks, wood engravings, posters, and hand-set type.

Mechanical relief printing—or letterpress—became practical with the introduction of the steam-driven cylinder printing machine, first built by Friedrich Koenig in 1811 and put into operation two years later at the *Times* of London (Fig. 656). The cylinder press could turn out impressions at the rate of 1100 per hour, more than four times the speed of contemporary hand presses. By 1827 an improved version of

Koenig's machine was printing between 4000 and 5000 impressions per hour, and about 1868 the *Times* installed the first rotary web-fed press, which was capable of more than 20,000 impressions per hour, even though the type was still being set by hand. This vastly increased production satisfied the growing demand for daily news publication.

From the introduction of Koenig's press it was apparent that speed really could not be increased as long as traditional inking methods remained in force. Leather rollers on the cylinder machine paved the way for a new method of inking in letterpress—and in lithography as well. By 1819 the old leather ink rollers had been replaced by rollers made from glue, molasses, gelatin, or a combination of these materials.

Today, web-fed letterpress machines yield in excess of 100,000 impressions per hour for newspaper and magazine work. This rate of production, coupled with newly developed photocomposition operations, helps to fill the astonishing demand for printed material of all kinds. Limited jobs and proofing, however, may still be done on small machines such as the Vandercook proof press (Fig. 115) or one of the older platen presses introduced in the late 1800s. These

656. The first steam-driven letterpress machine with fully automatic operation, built by Friedrich Koenig in 1811.

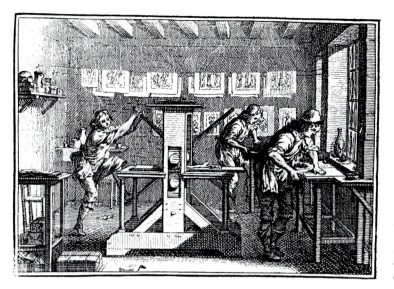

657. An early wooden etching press is shown in this illustration from *De la Manière de Graver à l'Eau Forte et au Burin, et de la Gravure en Manière Noire* by Abraham Bosse, 1758.

machines, which are fed by hand, often have automatic inking rollers and will accept not only type but any type-high wood block or wood engraving.

Etching Presses

Early etching presses differed very little from those in use today. In order for the dampened paper to be impressed into the engraved or etched lines, tremendous pressure has to be produced.

Early etching presses were made almost entirely of wood, including the cylinders and bed (Fig. 657). This situation did not change until the early 1800s, when metal began to replace wood as the major material in press design. Many of these 19th-century presses have heavy cast-iron frames and multiple reduction gears, which create maximum pressure with minimum effort. The gear ratio of earlier metal presses and small contemporary models is about 8-to-1. Larger machines can have gear ratios in excess of 20-to-1. It is not uncommon, however, to find some smaller presses without gearing, in which the drive is made directly to the upper cylinder by means of spokes, just as in the older wooden presses.

On most European and English etching presses, a stack of cardboard pieces placed above the upper cylinder bearing gives a slight cushioning action under pressure and helps to equalize any minute differences in elevation between one side of the cylinder and the other (Fig. 658). Figure 659 shows a practical device—adjustable metal arms with small rollers around which the main felts are attached, so that the printer need not handle the blankets before and after each impression.

The basic idea of a roller traveling over the plate and exerting downward pressure of felts and paper has never been improved upon for most ordinary

above: **658.** A stack of cardboard provides a cushioning effect under pressure. This press is at the Istituto Statale, Urbino, Italy.

below: **659.** An arrangement with adjustable arms and rollers for holding the felts, at the Istituto Statale.

above: 660. The basic etching press. This is one of the first models built by Charles Brand in New York.

below: 661. A sturdy and well-designed press by American French Tool Company, Coventry, Rhode Island.

662. The Connecticut Press, a recently developed hydraulic press capable of exerting great pressure for conventional intaglio work or for heavily embossed images.

sure. Over the past few decades great improvements in gravure printing have made this superb form competitive with lithography for very large runs.

Lithographic Presses

Senefelder's first press was a wooden etching press that he adapted for printing from stone (Fig. 663). In this arrangement the upper cylinder could be raised or lowered by means of a foot pedal. Later, Senefelder

forms of intaglio printing (Figs. 660, 661). Some printers have experimented, to a limited degree, with hydraulic pressure in special presses that differ radically from the conventional roller press (Fig. 662). These machines help to satisfy the demands of many contemporary printmakers, whose imagery requires deep, embossed shapes or heavily bitten lines.

No way has been found to print the individual etching plate mechanically, but special presses have been designed for the high-speed printing of engraved letterheads and other commercial work from flat metal plates. These presses emboss the edges of paper in a separate operation to simulate the hand-pulled impression.

Rotogravure is a commercial intaglio form of printing that gives extremely high-quality reproduction. The name comes from the fact that the image is etched onto metal cylinders that rotate at high speed. In the printing cycle, a relatively fluid ink contacts the cylinder and is immediately removed from the surface with a metal "doctor blade," but remains in the etched wells comprising the image. The ink is then transferred to the paper under pres-

663. Senefelder's first lithographic press, an adaptation of a wooden etching press of about 1796. This is an illustration from Senefelder's manual, published in 1818.

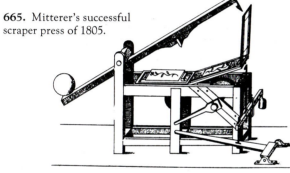

665. Mitterer's successful scraper press of 1805.

664. Senefelder's pole press, utilizing the scraper principle. This is an actual press built in 1797. Deutsches Museum, Munich.

First made in 1796, the pole press applied pressure through a system of foot-operated levers to a pole directly above the fixed stone (Fig. 664). Paper was placed on the inked stone, with a leather tympan on top. The scraper at the end of the pole was then pulled across the stone by hand under pressure. Obviously, the arc made by the pole created a difference in pressure throughout the stroke of the scraper bar, but this was somewhat minimized by the height of the pole—often 10 feet or more. Compensation for any slight changes in pressure could be made by raising or lowering the foot pedal slightly over the length of the stroke.

Senefelder's pole press demanded considerable skill in its manipulation and remained in use for less than ten years. In 1805 Hermann Joseph Mitterer, director of the Feiertagschule in Munich, developed a press that differed radically from Senefelder's designs. Mitterer's invention was the forerunner of most presses built from that time on. The press had a movable bed on which the stone was placed. A hinged scraper bar could be pivoted into position over the stone. Pressure was applied through a series of levers operated by a foot pedal to the scraper bar. The bed and stone would then be pulled under the scraper bar under pressure by a belt connected by a handle to a shaft (Fig. 665). The single handle was shortly replaced with a wooden star-wheel. This press, for the first time, provided both sufficient pressure and ease of operation necessary for printing fine detail, as well as equal pressure over the entire printing area.

About 1818 Senefelder invented an ingenious portable press. However, other than the documentation of the fact and a sample of the press that survives (Fig. 666), there is little evidence to suggest that it ever achieved any degree of popularity.

constructed a similar press in which the upper cylinder was made of stone, but this proved inferior to his modified etching press.

Senefelder's pole press, which incorporated the scraper principle, was the first major change since his first attempts at printing and pointed the way for future developments in lithographic hand printing.

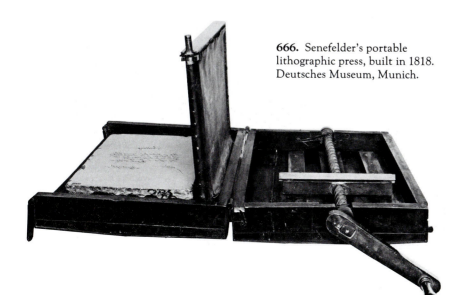

666. Senefelder's portable lithographic press, built in 1818. Deutsches Museum, Munich.

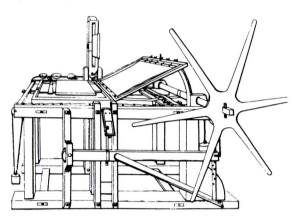

667. Star-wheel press illustrated in *Théorie Lithographique* by Houbloup (1825).

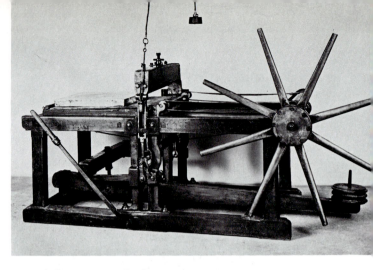

670. A German star-wheel press incorporating many refinements. This press was built by Johann Mannhardt in 1850 and was in operation until 1939. Deutsches Museum, Munich.

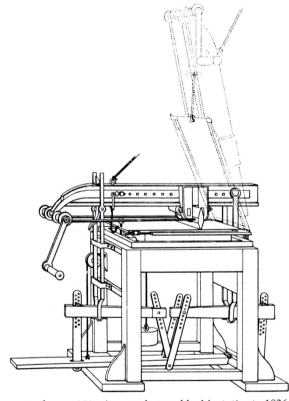

above: 668. A press designed by Morinière in 1826.

below: 669. An improved star-wheel press built by Brisset in 1833.

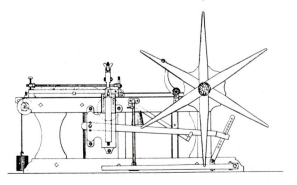

During the next few decades other press designs emerged (Figs. 667, 668). A star-wheel press invented by Brisset in 1833, based on principles that Mitterer had developed, became the most popular machine for hand lithography throughout Europe (Fig. 669). Many variations and refinements were made to Brisset's press (Fig. 670), but the fact that many of these same presses are still in use today proves their sound and practical design.

In 1817 the Count de Lasteyrie ordered some of the first leather rollers for lithography from Schmautz and Cie., a firm that is still in operation. After the invention of the mechanized lithographic press in about 1850, in which the stone was inked and dampened automatically by steam power, the hand press was relegated increasingly to proofing and short-run specialty printing (Fig. 671).

In the United States and England the geared metal press of the Fuchs and Lang type assumed dominance as a proofing press, while in Europe presses of the Brisset type—mostly of wooden construction—remained the most popular of hand presses. By the early 1900s a metal press with a unique top lever pressure adjustment was used extensively in Germany for proofing and transferring (Fig. 672).

One of the greatest advances in press design came about in 1860, when Henri Voirin patented a new automatic lithography press powered by steam. Although similar in many respects to a press developed almost a decade earlier, the Voirin press incorporated refinements that proved so efficient that few changes were made in the next half century. Many of these same presses are still in use in workshops specializing in the printing of fine art editions.

Senefelder had anticipated the automatic lithographic press, as well as many other developments never achieved during his lifetime. However, he

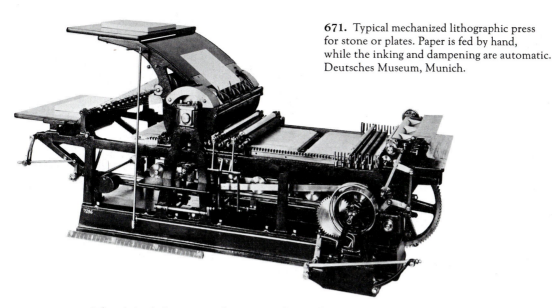

671. Typical mechanized lithographic press for stone or plates. Paper is fed by hand, while the inking and dampening are automatic. Deutsches Museum, Munich.

right: 672. A German top-lever press, designed primarily for proofing and built by Karl Krause of Leipzig in 1906. Deutsches Museum, Munich.

below right: 673. A contemporary four-color offset press in use at Graphic Press, Los Angeles, for the production of Robert Rauschenberg's *Horsefeathers Thirteen*. Courtesy Gemini G.E.L., Los Angeles.

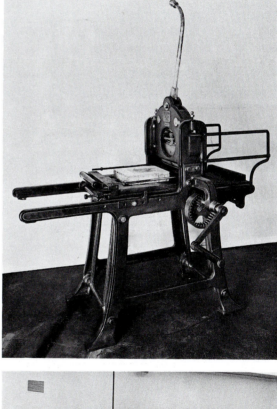

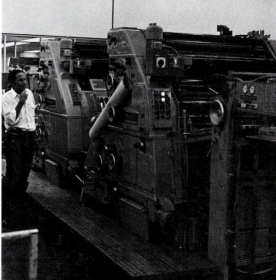

never foresaw the introduction of the offset principle in lithography. Offset was first employed by Henri Voirin in 1878 on a modified flat-bed press for printing on tin. But the first successful application came with the construction of a rotary offset press by Ira Rubel at Rutherford, New Jersey, in about 1903. In this press, built by the Potter Printing Press Company, the printing plate, either zinc or aluminum, is wrapped around one cylinder. As it rotates, the plate is dampened and inked by a cluster of inking and dampening rollers. The inked image is then transferred to a second cylinder, which has a special composition rubber blanket pulled tightly around it. The paper, in the printing cycle, picks up the impression from the rubber blanket as it is squeezed between the blanket cylinder and a third cylinder (the impression cylinder). ·

Normal speed for the modern offset press (Fig. 673) is between 4000 and 6000 impressions per hour and considerably faster on web-fed offset machines. Offset proof presses are sometimes used to proof jobs before they are put on the production press (Fig. 674).

Although the offset press is generally thought of in terms of commercial printing, there is a growing interest in offset lithography for creative work. The fidelity, sharpness, and detail possible with this type of press far exceeds all other kinds of lithography, except for the most scrupulous work done on stone. As artists begin to explore the infinite ways images

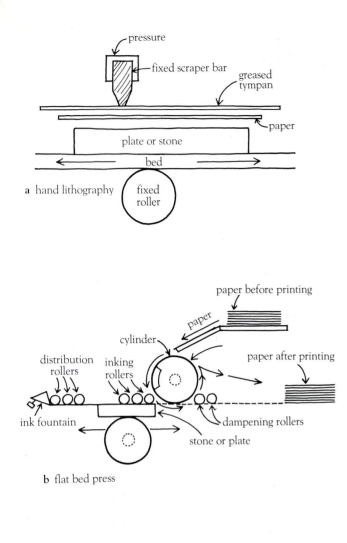

pressure

fixed scraper bar

greased tympan

paper

plate or stone

bed

a hand lithography **fixed roller**

paper before printing

paper

cylinder

paper after printing

distribution rollers **inking rollers**

ink fountain **dampening rollers**

stone or plate

b flat bed press

cylinder with rubber blanket

plate or stone **paper**

c offset proof press

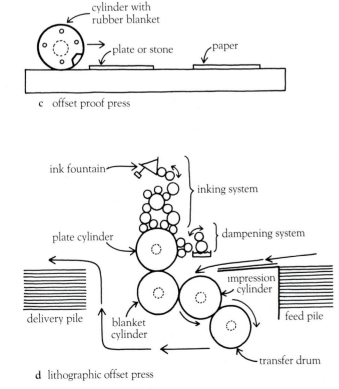

ink fountain **inking system**

plate cylinder **dampening system**

delivery pile **impression cylinder**

blanket cylinder **feed pile**

transfer drum

d lithographic offset press

left: 674. The basic lithographic press principles, illustrated by the hand proofing press (a); the operating principles of the mechanized flat-bed press, such as that shown in Figure 671 (b); the simple hand-operated offset proofing press principle, in which the cylinder picks up the inked impression and deposits it onto the paper (c); and the single-color offset press operation (d).

can be created directly on plates and how accurately their intentions are realized, offset will no doubt assume a respectability long denied it.

Screen Printing Equipment

Screen printing has always been associated with the short-run, inexpensively produced work. In recent years both the quality and the speed of screen printing have been improved immeasurably. New presses equipped with feeding and take-off devices, as well as automatic drying and stacking arrangements, can automatically print more than 3000 impressions per hour. Three- and four-color process work are also becoming commonplace in screen printing. For limited edition printing, however, it is still most practical to use the hand-printing method or to work with a one-person squeegee unit (Fig. 675).

675. The one-person squeegee unit is a self-contained unit excellent for short- to medium-run production work. Courtesy M & M Research Engineering.

List of Suppliers

Many materials—such as solvents, brushes, paper, and tools—can be obtained from a well-stocked hardware or art supplies store. Consult the Yellow Pages for local commercial printing, chemical, and plastics suppliers.

SUPPLY DEALERS

General Supplies

Aiko's Art Materials Import
Arthur Brown and Bro., Inc.
F. Charbonnel
L. Cornellisen & Son
The Craftool Co.
David Davis
M. Flax
Sam Flax
Graphic Chemical and Ink Co.
Handschy Chemical Co.
Hunter-Penrose, Ltd.
Joy J. Industries
Lith Kem Co.
New York Central Supply Co.
Polychrome Corp.
Rembrandt Graphic Arts Co.
Roberts & Porter
Sander Wood Engraving Co., Inc.
Sinclair & Valentine

Woodcutting Supplies

Wood for Wood Engraving

The Craftool Co.
Graphic Chemical and Ink Co.
J. Johnson Co.
H. L. Wild

Wood for Wood Cutting

American Wood Type Co.

Intaglio Supplies

Plates

Graphic Chemical and Ink Co.
National Steel and Copper Plate Co.
Harold Pitman Co.

Steel Facing

Andersen & Lamb
Armco Steel Corp. (iron)

Grounds and Stopouts

David Davis
Graphic Chemical and Ink Co.
New York Central Supply Co.

Tools

Broadhead-Garrett Co. (general)
F. Charbonnel
The Craftool Co.
Foredom Electric Co., Inc. (flexible shaft)
Graphic Chemical and Ink Co.
Hunter Penrose, Ltd.
E. C. Lyons

Tarlatan

Beckmann Felt Co.
Graphic Chemical and Ink Co.

Felt

Continental Felt Co.
Graphic Chemical and Ink Co.

Lithographic Supplies

Stones

Graphic Chemical and Ink Co.
Rembrandt Graphic Arts Co.

Plates

Capitol Plate & Supply Co. (aluminum)
City Litho Plate Co. (zinc)
Phillips and Jacobs, Inc. (aluminum)
N. Teitelbaum Sons, Inc. (zinc and aluminum)

Litho Crayons and Pencils

Graphic Chemical and Ink Co.
William Korn, Inc.

Tusche

F. Charbonnel
L. Cornellisen & Son
Sam Flax
Graphic Chemical and Ink Co.
William Korn, Inc.
Edward Owens Assoc. (Toosh)

Carborundum

King and Malcolm

Silkscreen Supplies

Advance Process Supply Co.
Arthur Brown and Bro., Inc.
Colonial Printing Ink Co.
Naz-Dar Co.
Standard Screen Supply Co.

Papers

Printing Papers, Imported and Domestic

Andrews/Nelson/Whitehead
Laurence Barker
David Davis
Farnsworth & Serpa Handmade Paper Mill
HMP Papers
Guy T. Kuhn
New York Central Supply Co.
Special Papers, Inc.
Twinrocker Handmade Paper
Upper U.S. Papermill

Japanese Papers

Aiko's Art Materials Import
Andrews/Nelson/Whitehead
KYO Trading Co., Ltd.
Talas
Zellerbach Paper Co.

Blotting Papers

Andrews/Nelson/Whitehead
Crestwood Paper Corp.
Graphic Chemical and Ink Co.
Lindenmeyer Paper Corp.
Saxon Paper Corp.

Matting Board

Andrews/Nelson/Whitehead
Charles T. Bainbridge's Sons

Zellerbach Paper Co.

Tableau Papers

Sam Flax
Technical Paper Corp.

Transparent Hinging Tape

Talas

Starch for Paste

KYO Trading Co., Ltd.

Paper Acidity Test Kit

W. J. Barrow Research Laboratory, Inc.

Cover Stock and Proofing Papers

Andrews/Nelson/Whitehead
David Davis
New York Central Supply Co.
Saxon Paper Corp.
Zellerbach Paper Co.

Lithographic Transfer Paper

F. Charbonnel
L. Cornellisen & Son
Sam Flax

Laboratory Hollander Beaters

Voith-Allis, Inc.

Acid-Free Storage Folders

Hollinger Corp.
Spink & Gaborc, Inc. (portfolios and solander boxes)
Talas (solander boxes)

Inks

Pigments

Fezandie & Sperrle, Inc.
Inmont Corp.

Letterpress for Woodcut

IPI (Interchem Corp.)
Siebold Ink Co.

Intaglio

F. Charbonnel
Cronite Co.
David Davis
Rudolph Faust, Inc.
Graphic Ink and Chemical Co.
T. N. Lawrence & Son, Ltd.
Lorilleux-LeFranc

Lithography

F. Charbonnel
Graphic Chemical and Ink Co.
Handschy Chemical Co.
Sinclair & Valentine
Superior Printing Ink Co.
Van Son Holland Inks

Silkscreen

Advance Process Supply Co.
Colonial Printing Ink Co.
Naz-Dar Co.

Rollers and Brayers

Apex Printers Roller Co.

Dick Blick
Ideal Rollers Co.

Leather Rollers

L. Cornellisen and Son
Ets. Charles Schmautz
Roberts & Porter, Inc.

Rubber Rollers

Samuel Bingham Co.
Charles Brand (large diameter)
Canal Rubber
L. Cornellisen and Son

Presses

Intaglio

American French Tool Co.
Oliviero Bendini
Charles Brand
The Craftool Co.
Craftsmen Machinery Co.
Glen Alps
Graphic Chemical and Ink Co.
Griffin Co.
Hunter-Penrose, Ltd.
Martech
M & M of Madison
A. Paolini
Reinhold Breisch
Rembrandt Graphic Arts Co.
Sakura Color Products Corp.

Lithography

Charles Brand
The Craftool Co.
Griffin Co.
Rembrandt Graphic Arts Co.
Takach-Garfield Press Co.
Tamarind Institute

Silkscreen

M & M Research Engineering
Naz-Dar Co.

Offset

Consult *Printing News*

Flat-bed Hydraulic Press

Product Design Corp.

Miscellaneous Supplies

Vacuum Forming

AAA Plastic Equipment, Inc.
Plasti-Vac, Inc.

Plastics

Conap, Inc.
Dow Chemical Co.
Polyproducts Corp.

Photographic Supplies

Autotype USA
Harold Pitman Co.
Rockland-Colloid Corp. (Print-E-Mulsion)
Sander Wood Engraving Co. (emulsion for woodblocks)
Treck Photographic, Inc.
McGraw Colorgraph (carbon tissue)

Laminating Film

Douglas Stewart Co.

Foundries

Joel Meisner, Inc.
Taller de Grafica Mexicana

3M Color-in-Color Printing

3M Company

Xerox Color Printing

Xerox Corp.

Vacuum Frames, Reproduction Cameras

Littlejohn Graphic Systems, Ltd.
Nu Arc Co. Ltd.

Metal Powders

Alcan Metal Powders

ADDRESSES OF LISTED DEALERS

AAA Plastic Equipment
 2617 N. Ayers
 Fort Worth, TX 76103
Advance Process Supply Co.
 6900 River Rd.
 Pennsauken, NJ 08110
 400 W. Noble St.
 Chicago, IL 60622
 3101 San Jacinto
 Houston, TX 77004
 570 McDonald Ave.
 Brooklyn, NY 11218
 268 Eddystone Rd.
 Downsview, Toronto
 Ontario, Canada
Aiko's Art Materials Import
 714 N. Wabash Ave.
 Chicago, IL 60611
Alcan Metal Powders
 P.O. Box 290
 Elizabeth, NJ 07207
Glen Alps
 6523 40th Ave.
 Northeast Seattle, WA 98115
American French Tool Co.
 Route 117
 Coventry, RI 02816
American Wood Type Co.
 42-25 9th St.
 Long Island City, NY 11101
Andersen & Lamb
 28 Fulton St.
 Brooklyn, NY 11201
Andrews/Nelson/Whitehead
 31-10 48th Ave.
 Long Island City, NY 11101
Apex Printers Roller Co.
 1541 N. 16th St.
 St. Louis, MO 63106
Armco Steel Corp.
 International Division
 270 Park Ave.
 New York, NY 10017
Autotype USA
 P. O. Box 267
 Parkchester Station
 Bronx, NY 10462
Charles T. Bainbridge's Sons
 20 Cumberland St.
 Brooklyn, NY 11205
Laurence Barker
 Ganduxer, 5
 1-7, B
 Barcelona 6, Spain
W. J. Barrow Research Laboratory, Inc.
 428 North Blvd.
 Richmond, VA 23221
Beckmann Felt Co.
 120 Baxter St.
 New York, NY 10002
Oliviero Bendini
 Via Modigliani, 31
 40133 Bologna
 Italy
Samuel Bingham Co.
 201 N. Wells St.
 Chicago, IL 60606

Dick Blick
 P.O. Box 1267
 Galesburg, IL 61401
Charles Brand
 84 E. 10th St.
 New York, NY 10003
Broadhead-Garrett Co.
 4560 E. 71st St.
 Cleveland, OH 44105
Arthur Brown and Bro., Inc.
 2 W. 46th St.
 New York, NY 10036
Canal Rubber
 329 Canal St.
 New York, NY 10013
Capitol Plate & Supply Co.
 476 Plasamour Dr. N.E.
 Atlanta, GA 30324
F. Charbonnel
 13, Quai de Montebello Court
 Rue de l'Hotel Colbert
 Paris 5e
 France
City Litho Plate Co.
 429 Vandervoort Ave.
 Brooklyn, NY 11222
Colonial Printing Ink Co.
 180 E. Union Ave.
 East Rutherford, NJ 07073
Conap, Inc.
 E. Union St.
 Allegheny, NY 14706
Continental Felt Co.
 22 W. 15th St.
 New York, NY 10011
L. Cornellisen & Son
 22 Great Queen St.
 London WC 2
 England
The Craftool Co.
 1 Industrial Rd.
 Woodridge, NJ 07075
Craftsmen Machinery Co.
 1073 Main St.
 Millis, MA 02054
Crestwood Paper Corp.
 263 Ninth Ave.
 New York, NY 10001
Cronite Co.
 88th St. and Kennedy Blvd.
 North Bergen, NJ 07047
David Davis
 (Fine Arts Materials Co.)
 531 La Guardia Pl.
 New York, NY 10012
Dow Chemical Co.
 45 Rockefeller Plaza
 New York, NY 10020
Ets. Charles Schmautz
 219 Rue Raymond Losserand
 Paris 14
 France 75
Farnsworth & Serpa Handmade
 Paper Mill
 1333 Wood St.
 Oakland, CA 94607
Rudolph Faust, Inc.
 542 South Ave. East
 Cranford, NJ 07016
Fezandie & Sperrle, Inc.
 111 Eighth Ave.
 New York, NY 10011
M. Flax
 10852 Lindbrook Dr.
 Los Angeles, CA 90024
Sam Flax
 25 E. 28th St.
 New York, NY 10016
Foredom Electric Co., Inc.
 Bethel, CT 06801

Graphic Chemical and Ink Co.
 P.O. Box 27
 Villa Park, IL 60181
Griffin Co.
 2241 Sixth St.
 Berkeley, CA 94710
HMP Papers
 Barlow Cemetery Rd.
 Woodstock Valley, CT 06282
Handschy Chemical Co.
 528 N. Fulton Street
 Indianapolis, IN 46202
Hollinger Corp.
 P.O. Box 6185
 Arlington, VA 22206
Hunter-Penrose, Ltd.
 7 Spa Rd.
 London SE16 3QS
 England
Ideal Rollers Co.
 2124 39th Ave.
 Long Island City, NY 11101
Inmont Corp.
 Printing Ink Division
 St. Mark St.
 Auburn, MA 01501
IPI (Interchem Corp.)
 636 Eleventh Ave.
 New York, NY 10036
J. Johnson Co.
 33 Matinecock Ave.
 Port Washington, NY 11050
Joy J. Industries, Inc.
 Box 36
 Northport, NY 11768
KYO Trading Co., Ltd.
 Sanjodori, East Jingumichi
 Kyoto, Japan
King and Malcolm
 57-10 Grand Ave.
 Maspeth, NY 11378
William Korn, Inc.
 260 West St.
 New York, NY 10013
Guy T. Kuhn
 Box 166
 Keedysville, MD 21756
T. N. Lawrence & Son, Ltd.
 2 Bleeding Heart Yard
 Greville St.
 Hatton Garden, London EC1N 8SI
 England
Lindenmeyer Paper Corp.
 11-12 53rd Ave.
 Long Island City, NY 11101
Lith Kem Co.
 46 Harriet Pl.
 Lynbrook, NY 11563
 335 S. Pasadena Ave.
 Pasadena, CA 91105
Littlejohn Graphic Systems, Ltd.
 16-24 Brewery Rd.
 London N1
 England
Lorilleux-LeFranc
 161 rue de Republique
 Puteaux, Seine
 France
E. C. Lyons
 16 W. 22nd St.
 New York, NY 10010
M & M Research Engineering
 13111 W. Silver Spring Dr.
 Butler, WI 53007
M & M of Madison
 402 Hilldale Ct.
 Madison, WI 53705
Martech, Ltd.
 P.O. Box 504
 Bayside, NY 11361

McGraw Colorgraph
 99 Hawthorne Ave.
 Valley Stream, NY 11580
Joel Meisner, Inc.
 120 Fairchild Ave.
 Plainview, NY 11803
National Steel and Copper Plate Co.
 543 West 43rd St.
 New York, NY 10036
Naz-Dar Co. of New York
 33 Lafayette Ave.
 Brooklyn, NY 11217
Nax-Dar Co.
 1087 N. Branch St.
 Chicago, IL 60622
Naz-Dar Co. of Michigan
 12800 Woodrow Wilson
 Detroit, MI 48238
Naz-Dar of California
 2832 S. Alameda
 Los Angeles, CA 90058
Naz-Dar Canada, Ltd.
 925 Roselawn Ave.
 Toronto 19
 Ontario, Canada
New York Central Supply Co.
 82 Third Ave.
 New York, NY 10003
Nu Arc Co., Ltd.
 175 Varick St.
 New York, NY 10014
Edward Owens Assoc.
 8 Sycamore Rd.
 Orinda, CA 94563
A. Paolini
 Via Sasso 51
 61029 Urbino
 Italy
Phillips & Jacobs, Inc.
 P.O. Box 77049
 Atlanta, GA 30309
Harold Pitman Co.
 515 Secaucus Rd.
 Secaucus, NJ 07094
Plasti-Vac, Inc.
 214 Dalton Ave.
 Charlotte, NC 28205
Polychrome Corp.
 Yonkers, NY 10702
 3313 Sunset Blvd.
 Los Angeles, CA 90026
Polyproducts Corp.
 Order Dept., Room 25
 13810 Nelson Ave.
 Detroit, MI 48227
Printing News
 468 Park Ave. South
 New York, NY 10016
Product Design Corp.
 18 Marshall St.
 Norwalk, CT 06856
Reinhold Breisch
 Maschinen und Pressenbau
 7441 Neckartenzlingen
 Württemberg, Germany
Rembrandt Graphic Arts Co.
 Stockton, NJ 08559
Roberts & Porter, Inc.
 26-25 123rd St.
 Flushing, NY 11354
Rockland-Colloid Corp.
 599 River Rd.
 Piermont, NY 10968
Sakura Color Products Corp.
 1 chome, 10-17 Nakamichi
 Higashinari, Osaka 537
 Japan
Sander Wood Engraving Co., Inc.
 212 Lincoln St.
 Porter, IN 46304

Saxon Paper Corp.
 240 W. 18th St.
 New York, NY 10011
Siebold Ink Co.
 150 Varick St.
 New York, NY 10013
Sinclair & Valentine
 (Div. of Martin Marietta)
 14930 Marquandt Ave.
 Santa Fe Springs, CA 90670
 4101 S. Pulaski Rd.
 Chicago, IL 60632
Special Papers, Inc.
 West Redding, CT 06896
Spink & Gaborc, Inc.
 32 W. 18th St.
 New York, NY 10003
Standard Screen Supply Co.
 15 W. 20th St.
 New York, NY 10011
Douglas Stewart Co.
 11150 O'Neill Ave.
 Madison, WI 53704
Superior Printing Ink Co.
 295 Lafayette St.
 New York, NY 10012
Takach-Garfield Press Co.
 3207 Morningside Dr. N.E.
 Albuquerque, NM 87110
Talas
 104 Fifth Ave.
 New York, NY 10011
Taller de Grafica Mexicana S.A.
 Portal de Santo Domingo #4
 Mexico 1, D.F.
Tamarind Institute, Clinton Adams, Dir.
 University of New Mexico
 Albuquerque, NM 87106
Technical Paper Corp.
 729 Boylston St.
 Boston, MA 02116
N. Teitelbaum Sons, Inc.
 1080 Brook Ave.
 P.O. Box 444
 Bronx, NY 10451
3M Company
 3M Center, Duplicating
 220-10 East
 St. Paul, MN 55110
Treck Photographic, Inc.
 1 W. 39th St.
 New York, NY 10018
Twinrocker Handmade Paper
 Brookston, IN 47923
Upper U.S. Papermill
 999 Glenway Rd.
 Oregon, WI 53575
Van Son Holland Inks
 92 Union St.
 Mineola, NY 11581
Voith-Allis, Inc.
 P.O. Box 2337
 Appleton, WI 54911
H. L. Wild
 510 E. 11th St.
 New York, NY 10009
Xerox Corp.
 Desco Printing
 10923 Indian Trail
 Dallas, TX 75230
Xerox Reproduction Center
 5046 Biscayne Blvd.
 Miami, FL 33137
 3255 Wilshire Blvd.
 Los Angeles, CA 90057
 295 Madison Ave.
 New York, NY 10017
Zellerbach Paper Co.
 4000 E. Union Pacific Ave.
 Los Angeles, CA 90054

Bibliography

General Works

Adhémar, Jean. *Graphic Art of the 18th Century.* New York: McGraw-Hill, 1964.

————. *Twentieth-Century Graphics.* New York and Washington, D.C.: Praeger, 1971.

Allen, Bryan. *Print Collecting.* London: Frederick Muller, 1970.

Arber, A. *Herbals.* Cambridge: 1925.

Baro, Gene. *Thirty Years of American Printmaking.* New York: Brooklyn Museum, Universe Press, 1976.

Beall, Karen F., et al. *American Prints in the Library of Congress.* Baltimore: Johns Hopkins Press, 1970.

Bennett, Paul A. *Books and Printing.* New York: World Publishing Company, 1963.

Bland, David. *A History of Book Illustration: The Illuminated Manuscript and the Printed Book.* London: Faber, 1969.

Bloy, C. H. *A History of Printing Ink: 1440–1850.* London: Wynkyn de Worde Society, 1967.

Blum, André. *The Origins of Printing and Engraving.* New York: Scribner, 1940.

Breitenbach, Edgar, and Margaret Cogswell. *The American Poster.* New York: The American Federation of Arts and October House, 1968.

Brooks, Alfred M. *From Holbein to Whistler: Notes on Drawing and Engraving.* London: Oxford; New Haven: Yale, 1920.

Buchheim, Lothar-Gunther. *The Graphic Art of German Expressionism.* New York: Universe Books, 1960.

Buhler, Albert. *The Fifteenth Century Book.* Philadelphia: University of Pennsylvania Press, 1960.

Cahn, Joshua Binion. *What is an Original Print?* New York: Print Council of America, 1964.

Carter, Thomas F. *The Invention of Printing in China and Its Spread Westward.* 2nd ed. Revised by L. Carrington Goodrich. New York: 1955.

Castleman, Riva. *Modern Art in Prints.* New York: Museum of Modern Art, 1973.

————. *Prints of the Twentieth Century: A History.* New York: Museum of Modern Art, 1976.

————. *Technics and Creativity.* New York: Museum of Modern Art, 1971.

Cleaver, James. *A History of Graphic Art.* New York: Philosophical Library, 1963.

Craven, Thomas. *Treasury of American Prints.* New York: Simon and Schuster, 1943.

Eichenberg, Fritz, ed. *Artist's Proof Annual.* New York: Pratt Institute, Barre Publishers, and New York Graphic Society, 1961–present. Collector's Edition (reprint of first eight issues), 1972.

————. *The Art of the Print.* New York: Abrams, 1976.

Getlein, Frank, and Dorothy Getlein. *The Bite of the Print.* New York: Clarkson O. Potter, 1963.

Gilmour, Pat. *Modern Prints.* London: Studio Vista/Dutton, 1970.

Hallstein, F. W. H. *German Engravings, Etchings & Woodcuts, 1400–1700.* 7 Vols. Amsterdam: Menno Hertzberger.

Hargrave, Catherine Perry. *A History of Playing Cards.* New York: Dover, 1966.

Hogben, Lancelot. *From Cave Painting to Comic Strip.* New York: Chanticleer Press, 1949.

Ivins, William M., Jr. *How Prints Look.* New York: Metropolitan Museum of Art, 1943.

————. *Notes on Prints.* New York: Metropolitan Museum of Art, 1930.

————. *Prints and Visual Communication.* New York, 1953. Reprint. New York: Da Capo, 1969.

Joachim, Harold. *Prints: 1400–1800.* Minneapolis: Minneapolis Institute of Arts, 1956.

Johnson, Elaine L. *Contemporary Painters and Sculptors as Printmakers.* New York: Museum of Modern Art, 1966.

Johnson, Una E. *Ten Years of American Prints.* New York: Brooklyn Museum, 1956.

Karshan, Donald. *American Printmaking.* Washington, D.C.: Smithsonian Institution, 1969.

Levarie, Norma. *The Art and History of Books.* New York: James H. Heineman, Inc., 1968.

Levenson, Jay. *Prints of the Italian Renaissance.* Washington, D.C.: National Gallery of Art, 1973.

Lieberman, William. "Master Prints from the Museum Collection," *Museum of Modern Art Bulletin,* Vol. XVI, No. 4. New York: 1949.

Lindemann, Gottfried. *Prints and Drawings, A Pictorial History.* New York and Washington, D.C.: Praeger, 1970.

Longstreet, Stephen. *A Treasury of the World's Great Prints.* New York: Simon & Schuster, 1961.

Mayor, A. Hyatt. *Guide to the Print Collection.* New York: Metropolitan Museum of Art, 1964.

————. *Prints and People.* New York: Metropolitan Museum of Art, 1971.

McMurtrie, Douglas C. *The Book: The Story of Printing and Bookmaking.* New York: Oxford, 1943.

Mongan, Elizabeth. *Selections from the Rosenwald Collection.* Washington, D.C.: National Gallery of Art, 1943.

————, and Carl O. Schniewind. *The First Century of Printmaking, 1400–1500.* Chicago: R. R. Donnelly, 1941.

Museum of Graphic Art and Finch College Museum of Art. *Five Centuries of Graphic Art.* New York: Museum of Graphic Art, 1966.

Passeron, Roger. *French Prints of the 20th Century.* New York: Praeger, 1970.

Pennell, Joseph. *The Graphic Arts.* Chicago: University of Chicago Press, 1921.

Printing Historical Society Journal. London: Printing Historical Society, St. Bride Institute, 1964–76.

Roger-Marx, Claude. *Graphic Art of the 19th Century.* New York: Mc-Graw Hill, 1962.

Sachs, Paul J. *Modern Prints and Drawings.* New York: Knopf, 1954.

Salamon, Fernando. *The History of Prints and Printmaking from Dürer to Picasso: A Guide to Collecting.* New York: American Heritage Press, 1972.

Shadwell, Wendy. *American Printmaking: The First 150 Years.* New York: Museum of Graphic Art, 1969.

Siblik, Jiri. *Twentieth-Century Prints.* New York: Hamlyn, 1970.

Sotriffer, Kristian. *Printmaking: History and Technique.* New York: McGraw-Hill, 1968.

Stasik, Andrew, ed. *The Print Review.* New York: Pratt Graphic Art Center.

Steinberg, Saul H. *Five Hundred Years of Printing.* Baltimore: Penguin, 1966.

Strachan, W. J. *The Artist and the Book in France.* New York: Wittenborn, 1970.

Stubbe, Wolf. *Graphic Arts in the Twentieth Century.* New York: Praeger, 1963.

Van Gelder, J. G. *Dutch Drawings and Prints.* New York: Abrams, 1959.

Wechsler, Herman J. *Great Prints and Printmakers.* New York: Abrams, 1967.

Wingler, Hans M., ed. *Graphic Work from the Bauhaus.* Translated by Gerald Onn. Greenwich, Conn.: New York Graphic Society, 1969.

Zigrosser, Carl. *Multum in Parvo.* New York: Braziller, 1965.

————. *Six Centuries of Fine Prints.* New York: Covici-Friede, 1937.

————. *The Appeal of Prints.* Philadelphia: Leary's Co., 1970.

————. *The Book of Fine Prints.* Revised ed. New York: Crown, 1956.

————. *Thirteen illustrated Essays on the Art of the Print.* Print Council of America and Holt, Rinehart and Winston, 1962.

————, and Christa M. Gaehde. *A Guide to the Collecting and Care of Original Prints.* New York: Crown, 1966.

General Works: Technique

Brunner, Felix. *A Handbook of Graphic Reproduction Processes.* Taufen: Arthur Niggli Ltd.

Heller, Jules. *Printmaking Today.* New York: Holt, Rinehart and Winston, 1972.

Hollander, Harry B. *Plastics for Artists and Craftsmen.* New York: Watson-Guptill, 1972.

Mayer, Ralph. *The Artist's Handbook of Materials and Techniques.* 3rd revised ed. New York: Viking, 1972.

Newman, Thelma R. *Plastics as an Art Form.* Philadelphia and New York: Chilton, 1964.

Peterdi, Gabor. *Printmaking.* New York: Macmillan, 1959.

————. *Printmaking Methods Old and New.* New York: Macmillan, 1971.

Rasmusen, H. *Printmaking with Monotype.* Philadelphia: Chilton, 1960.

Ross, John, and Clare Romano. *The Complete Printmaker.* New York: The Free Press, 1972.

Relief

Bliss, Douglas P. *A History of Wood Engraving.* London: Spring Books, 1964. (Originally published 1928.)

Bodor, John J. *Rubbings and Textures: A Graphic Technique.* New York: Reinhold, 1968.

Dobson, Austin. *English Wood Engravers.* (Series including books on Bewick, Stone, Gill, O'Connor, Hassall, Gibbings) 1951.

Farleigh, John. *Engraving on Wood.* Leicester: Dryad, 1954.

Field, Richard S. *Fifteenth Century Woodcuts and Metalcuts from the National Gallery of Art.* Washington, D.C.: National Gallery of Art, 1965.

Green, Peter. *Introducing Surface Printing.* New York: Watson-Guptill, 1967.

Hind, Arthur M. *Introduction to a History of Woodcut.* 2 Vols. New York: Dover, 1963. (Originally published 1935.)

Kafka, Francis J. *Linoleum Block Printing.* New York: Taplinger Publishing Co., 1958.

Leighton, Clare. *Wood-Engraving and Woodcuts.* London: Studio, 1932; New York: Studio, 1944.

O'Connor, John. *The Technique of Wood Engraving.* London: B. T. Batsford, Ltd., 1971.

Phillips, Walter J. *The Technique of the Color Woodcut.* New York: Brown-Robertson, 1926.

Platt, John. *Colour Woodcut.* New York: Pitman, 1938.

Rothenstein, Michael. *Frontiers of Printmaking: New Aspects of Relief Printing.* New York: Reinhold, 1966.

———. *Relief Printing.* New York: Watson-Guptill, 1970.

Rumpel, Heinrich. *Wood Engraving.* Geneva: Bonvent, 1972.

Relief: China and Japan

Amsden, D. *Impressions of Ukiyo-e.* New York: 1905.

———, and J. S. Happer. *The Heritage of Hiroshige.* San Francisco: 1912.

Azechi, Umetaro. *Japanese Woodblock Prints: Their Technique and Appreciation.* Tokyo: Toto Shuppan Co., 1963.

Blunt, W. *Japanese Colour Prints from Harunobu to Utamaro.* London: 1952.

Boller, W. *Masterpieces of the Japanese Color Woodcut.* Boston: n.d.; London: 1957.

Chiba, Reiko. *The Making of a Japanese Print.* Tokyo: 1963.

Crighton, R. A. *The Floating World: Japanese Popular Prints, 1700-1900.* London: Victoria & Albert Museum, 1973.

Hayashi, Y. *A Study of Erotic Books Illustrated by Harunobu.* Tokyo: 1964.

Hillier, Jack R. *Japanese Masters of the Colour Print.* London: Phaidon, 1954.

———. *The Japanese Print: A New Approach.* London: G. Bell, 1960.

Ives, Colta Feller. *The Great Wave: The Influence of Japanese Woodcuts on French Prints.* New York: Metropolitan Museum of Art, 1974.

Kondo, L. *Japanese Genre Painting.* Rutland, Vt.: Tuttle, 1961.

Lane, Richard. *Masters of the Japanese Print.* Garden City, N.Y.: Doubleday, 1962.

Laufer, Berthold. *Paper and Printing in Ancient China.* Chicago: Caxton Club, 1931.

Michener, James. *Japanese Prints: From the Early Masters to the Modern.* Rutland, Vt.: Tuttle, 1959.

Mody, N. H. N. *A Collection of Nagasaki Colour Prints and Paintings: Showing the Influence of Chinese and European Art on That of Japan.* Rutland, Vt.: Tuttle, 1969.

Rhys, Hedley H. "Afterword on Japanese Art and Influence," *Paris and the Arts from the Goncourt Journals.* Translated and edited by G. Becker and E. Phillips. Ithaca, N.Y.: Cornell University Press, 1971.

Robertson, Ronald. *Contemporary Printmaking in Japan.* New York: Crown, 1965.

Robinson, B. W. *Japanese Landscape Prints of the Nineteenth Century.* London: 1957.

Statler, Oliver. *Modern Japanese Prints: An Art Reborn.* Rutland, Vt.: Tuttle, 1956.

Takahashi, S. *The Japanese Wood-Block Print Through Two Hundred and Fifty Years.* Tokyo: 1965.

Turk, F. A. *The Prints of Japan.* New York: October House, 1966.

Warner, L. W. *The Enduring Art of Japan.* Cambridge: Harvard, 1953.

Yoshida, Toshi, and Rei Yuki. *Japanese Print Making: A Handbook of Traditional & Modern Techniques.* Rutland, Vt. and Tokyo: Tuttle, 1966.

Intaglio

Banister, Manly. *Etching and Other Intaglio Techniques.* New York: Sterling, 1970.

Brunsdon, John. *The Technique of Etching and Engraving.* New York: Reinhold, 1967.

Buckland-Wright, John. *Etching and Engraving.* London: Studio, 1953.

Chamberlain, Walter. *The Thames & Hudson Manual of Etching and Engraving.* London: Thames & Hudson, 1972.

Eastman Kodak Company. *Photofabrication Methods with Kodak Photosensitive Resists* Rochester, N.Y.: Kodak Corporation.

Edmondson, Leonard. *Etching.* New York: Reinhold, 1973.

Faithorne, W. *The Art of Graving and Etching.* 2nd ed. London: 1702. Reprint. New York: Da Capo, 1968.

Gross, Anthony. *Etching, Engraving, and Intaglio Printing.* London: Oxford, 1970.

Hayter, Stanley William. *New Ways of Gravure.* New York: Pantheon, 1949.

Hind, Arthur. *A History of Engraving and Etching.* New York: Dover, 1963. (Originally published 1908, Houghton Mifflin Co.)

———. *Early Italian Engraving.* 7 Vols. New York: Knoedler, 1938-48.

———. *Guide to the Processes and Schools of Engraving.* London: British Museum, 1933.

Leaf, Ruth. *Intaglio Printmaking Techniques.* New York: Watson-Guptill, 1976.

Lehrs, Max. *Historical and Critical Catalog of German, Netherlandish, and French Copper Engravings in the 15th Century.* 10 Vols. Vienna: 1908-34. Reprint with five supplementary volumes. New York: Collectors Editions, 1969-70.

———. *Late Gothic Engravings of Germany and the Netherlands.* New York: Dover, 1969.

Levenson, Jay A., Konrad Oberhuber, and Jacquelyn L. Sheehan. *Early Italian Engravings.* Washington, D.C.: National Gallery of Art, 1973.

Lumsden, E. S. *The Art of Etching.* New York: Dover, 1962.

Phillips, John Goldsmith. *Early Florentine Designers and Engravers.* Cambridge: Harvard University Press, 1955.

Pyle, Clifford. *Etching Principles and Methods.* New York: Harper & Row, 1941.

Reed, Earl H. *Etching: a Practical Treatise.* New York: Putnam, 1914.

Roger-Marx, Claude. *French Original Engravings from Manet to the Present Time.* London: Hyperion, 1939.

Shestack, Alan. *Fifteenth Century Engravings of Northern Europe from the National Gallery of Art.* Washington, D.C.: National Gallery of Art, 1968.

Sternberg, Harry. *Modern Methods and Materials of Etching.* New York: McGraw-Hill, 1949.

Trevelyan, Julian. *Etching: Modern Methods of Intaglio Printmaking.* New York: Watson-Guptill, 1964.

Wenninger, Mary Ann. *Collagraph Printmaking.* New York: Watson-Guptill, 1975.

Wright, J. B. *Etching and Engraving.* London: Studio, 1953.

Zerner, Henri. *The School of Fontainbleau: Etchings and Engravings.* New York: Abrams, 1970.

Lithography

Antreasian, Garo Z., and Clinton Adams. *The Tamarind Book of Lithography: Art and Techniques.* New York: Abrams, 1971.

Arnold, Grant. *Creative Lithography and How To Do It.* New York: Harper & Row, 1941.

Banister, Manly. *Lithographic Prints from Stone and Plate.* New York: Sterling, 1972.

Cleveland Museum of Art. *Catalogue of an Exhibition of Lithography (1798-1948).* Cleveland: 1948.

Cumming, David. *A Handbook of Lithography.* 3rd ed. London: A. & C. Black, 1948.

Drepperd, Carl W. "Beginning of American Lithography," *Early American Prints.* New York: 1930.

Halbmeier, Carl. *Senefelder: the History of Lithography.* New York: Senefelder Publishing, 1926.

Hartsuch, Paul J. *Chemistry of Lithography.* Pittsburgh: Graphic Arts Technical Foundation, 1961.

Jones, S. *Lithography for Artists.* London: 1967.

Kistler, Lynton R. *How to Make a Lithograph.* Los Angeles: 1950.

Knigin, Michael, and Murray Zimiles. *The Contemporary Lithographic Workshop Around the World.* New York: Reinhold, 1974.

———. *The Techniques of Fine Art Lithography.* New York: Reinhold, 1970.

Man, Felix. *Artist's Lithographs.* New York: Putnam, 1971.

Peters, Harry T. *America on Stone.* Garden City, N.Y.: Doubleday, 1931.

Reed, Robert F. *Offset Lithographic Platemaking.* Pittsburgh: Graphic Arts Technical Foundation, 1967.

———. *What the Lithographer Should Know About Ink.* Pittsburgh: Graphic Arts Technical Foundation, 1967.

———. *What the Lithographer Should Know About Paper.* New York: Lithographic Technical Foundation, 1961.

Sansom, W. B. *Lithography: Principles and Practices.* London: Pitman, 1960.

Soderstrom, Walter. *The Lithographer's Manual.* New York: Waltwin Publishing, 1937.

Tory, Bruce E. *Photolithography.* Sydney: Associated General Publications Printing, 1953.

Trivick, Henry H. *Autolithography.* London: Faber, 1960.

Twyman, Michael. *Lithography: 1800-1850.* London: Oxford, 1970.

Weaver, Peter. *The Technique of Lithography.* New York: Reinhold, 1964.

Weber, Wilhelm. *A History of Lithography.* London: Thames & Hudson, 1966.

Weddige, Emil. *Lithography.* Scranton: International Textbook, 1966.

Silkscreen

Auvil, Kenneth W. *Serigraphy: Silk Screen Techniques for the Artist.* Englewood Cliffs, N.J.: Prentice-Hall, 1965.

Biegeleisen, J. I. *Screen Printing: A Contemporary Guide.* New York: Watson-Guptill, 1971.

Carr, Francis. *A Guide to Screen Process Printing.* London: Vista, 1961.

Chieffo, Clifford T. *Silk Screen as a Fine Art: A Handbook of Contemporary Silk Screen Printing.* New York: Reinhold, 1967.

Fossett, Robert O. *Techniques in Photography for the Silk Screen Printer.* Cincinnati: Signs of the Times, 1959.

Kinsey, Anthony. *Introducing Screen Printing.* New York: Watson-Guptill, 1968.

Kosloff, Albert. *Ceramic Screen Printing.* Cincinnati: Signs of the Times, 1962.

———. *Photographic Screen Process Printing.* Cincinnati: Signs of the Times, 1968.

———. *Screen Printing Techniques.* Cincinnati: Signs of the Times, 1972.

Marsh, Roger. *Silk Screen Printing for the Artist.* London: Tiranti, 1968.

Middleton, H. K. *Silk Screen Process: A Volume of Technical References.* London: Blandford, 1949.

Reinke, William A. *Silk Screen Printing.* Oil Color Litho Co.

Russ, Stephen. *Practical Screen Printing.* London: Studio Vista, 1969.

Schwalback, M. V., and J. A. Schwalback. *Screen Process Printing.* New York: Reinhold, 1970.

Shokler, Harry. *Artist's Manual for Silk Screen Printmaking.* New York: American Artists Group, 1946.

Steffen, Bernard. *Silk Screen.* London: Pitman, 1963.

Stephenson, Jessie B. *From Old Stencils to Silk Screening: A Practical Guide.* New York: Scribner, 1953.

Sternberg, Harry. *Silk Screen Color Printing.* New York: McGraw-Hill, 1942.

Paper

American Pulp and Paper Association. *The Dictionary of Paper.* New York: 1951.

Clapperton, Robert H. *Modern Paper-Making.* 3rd ed. London: Oxford, 1952.

———. *The Paper-Making Machine.* New York: Pergamon Press, 1967.

Doloff, Francis W., and Roy L. Perkinson. *How to Care for Works of Art on Paper.* Boston: Museum of Fine Arts, 1971.

Grant, Julius. *Cellulose Pulp and Allied Products.* New York: Interscience Publishers, Inc., 1969.

Green, John. *Papermaking by Hand.* Maidstone: 1967.

Hunter, Dard. *Papermaking: The History and Technique of an Ancient Craft.* 2nd ed. 1957. Reprint. New York: Knopf, 1967.

Kelly, Francis. *Art Restoration.* New York: McGraw-Hill, 1972.

Kunihigashi, Hihyoe (or Kunisaki, Jihei). *Kamisuki Choho-Ki (Papermaker's Treasury).* Reprint. Berkeley: University of California, 1948.

Langwell, W. H. *The Conservation of Books and Documents.* London: Pitman, 1957.

Library of Congress. *Papermaking: Art and Craft.* Washington, D.C.: Library of Congress, 1968.

Norris, F. H. *Paper and Paper Making.* New York: 1952.

Monographs

Adhémar, Jean. *The Caprices of Goya.* Paris: Fernand Hazan, 1951.

———. *Toulouse-Lautrec: His Complete Lithographs and Drypoints.* New York: Abrams.

Bechtel, Edwin de T. *Jacques Callot.* New York: Braziller, 1965.

Benesch, O. *Edvard Munch.* London: Phaidon, 1960.

Binyon, Laurence. *The Engraved Designs of William Blake.* London: 1926. Reprint. New York: Da Capo, 1968.

Bloch, Georges. *Pablo Picasso: Catalogue of the Printed Graphic Work, 1904–1967.* Berne: Editions Kornfeld & Klipstein, 1968.

Boeck, Wilhelm. *Picasso Linoleum Cuts Bacchanals, Women, Bulls and Bullfighters.* New York: Abrams, 1962.

Boon, Karel G. *Rembrandt: The Complete Etchings.* New York: Abrams, 1963.

Brion, Marcel. *Dürer: His Life and Work.* New York: Tudor, 1960.

Burke, Joseph, and Colin Caldwell. *Hogarth: The Complete Engravings.* New York: Abrams.

Clark, J. M. *Dance of Death by Hans Holbein.* London: Phaidon, 1947.

Collins, Leo C. *Hercules Seghers.* Chicago: University of Chicago Press, 1953.

Crouse, Russell. *Mr. Currier and Mr. Ives.* Garden City: Doubleday, 1930.

Davis, Burke, and Ray King. *The World of Currier and Ives.* New York: Random House, 1968.

Dodgson, Campbell. *Albrecht Dürer: Engravings and Etchings.* New York: Da Capo, 1967.

Field, Richard S. *Albrecht Dürer: A Study Exhibition of Print Connoisseurship.* Philadelphia: Philadelphia Museum of Art, 1970.

———. *Paul Gauguin: Monotypes.* Philadelphia: Philadelphia Museum of Art, 1973.

Ferrari, Enrique Lafuente. *Goya: His Complete Etchings, Aquatints and Lithographs.* New York: Abrams, 1962.

Geisberg, Max. *Martin Schongauer.* New York: Knoedler, 1928.

Geiser, Bernhard, and Hans Bolliger. *Picasso: Fifty-Five Years of His Graphic Works.* New York: Abrams, 1955.

Gelman, B. *Wood Engravings of Winslow Homer.* New York: Crown, 1969.

Harris, Jean C. *Edouard Manet: Graphic Works.* New York: Collectors Editions, 1970.

Harris, T. *Goya: Engravings and Lithographs.* 2 Vols. London: Oxford, 1964.

Hillier, Jack R. *Hokusai.* London: Phaidon, 1956.

———. *Suzuki Harunobu.* Philadelphia: Philadelphia Museum of Art, 1970.

———. *Utamaro: Color Prints and Paintings.* London: Phaidon, 1961.

Hirano, Chie. *Kiyonaga: A Study of His Life and Works.* Cambridge: Harvard University Press, 1939.

Horodisch, Abraham. *Picasso as a Book Artist.* Cleveland: World Publishing, 1962.

Hunter, Sam. *Joan Miró: His Graphic Work.* New York: Abrams.

Karshan, Donald. *Picasso Linocuts: 1958–1963.* New York: Tudor, 1968.

———. *The Graphic Art of Mary Cassatt.* Washington, D.C.: Smithsonian Institution, 1967.

Klein, H. Arthur, ed. *Graphic Works of Peter Bruegel the Elder.* New York: Dover, 1963.

Knappe, Karl Adolf. *Dürer: The Complete Engravings, Etchings, and Woodcuts.* New York: Abrams, 1965.

Larkin, Oliver W. *Daumier: Man of His Time.* Boston: Beacon Press, 1968.

Lavalleye, Jacques. *Pieter Bruegel the Elder and Lucas van Leyden: The Complete Engravings, Etchings, and Woodcuts.* New York: Abrams, 1967.

Leiris, Michel, and Fernand Mourlot. *Joan Miró: Lithographs.* New York: Tudor, 1972.

Leonhard, Kurt. *Picasso: Recent Etchings, Lithographs and Linoleum Cuts.* New York: Abrams.

Leusden, Willem van. *The Etchings of Hercules Seghers and the Problem of his Graphic Technique.* Utrecht: A. W. Bruna & Son, 1961.

Lieure, Jules. *Jacques Callot: La Vie Artistique et Catalogue Raisonné.* 9 Vols. Paris: 1734. Revised ed. New York: Collectors Editions, 1969.

Los Angeles County Museum. *Edgar Hilaire Germain Degas.* Los Angeles: Los Angeles County Museum of Art.

———. *Picasso: Sixty Years of Graphic Works.* Los Angeles: Los Angeles County Museum of Art, 1966.

Mayor, A. Hyatt. *Giovanni Battista Piranesi.* New York: H. Bittner & Co., 1952.

McNulty, Kneeland. *The Collected Prints of Ben Shahn.* Philadelphia: Philadelphia Museum of Art, 1967.

Meyer, Franz. *Marc Chagall: His Graphic Work.* New York: Abrams, 1957.

Minott, Charles I. *The Engravings of Martin Schongauer: Studies and Illustrated Catalogue.* Reprint. New York: Collectors Editions, 1970.

Mourlot, Fernand. *Picasso: Lithographs.* Boston: Boston Book & Art Publ., 1970.

Museum of Fine Arts. *Albrecht Dürer: Master Printmaker.* Boston: Museum of Fine Arts, 1971.

———. *Rembrandt: Experimental Etcher.* Greenwich: New York Graphic Society, 1969.

Museum of Modern Art. *Hayter and Studio 17.* Vol. XII #1. New York: 1944.

Novotny, F. *Toulouse-Lautrec.* London: Phaidon, 1969.

Panofsky, Erwin. *Albrecht Dürer.* 2 Vols. Princeton: Princeton University Press, 1948.

Roger-Marx, Claude. *Bonnard Lithographs.* Monte Carlo: Editions du Livre, 1950.

———. *The Lithographs of Toulouse-Lautrec.* London: 1948.

Shestack, Alan, ed. *The Complete Engravings of Martin Schongauer.* New York: Dover, 1969.

———. *The Master E. S.: Five Hundredth Anniversary Exhibition.* Philadelphia: Philadelphia Museum of Art, 1967.

Sorlier, Charles. *The Lithographs of Chagall.* New York: Crown, 1974.

Talbot, Charles W., Gaillard F. Ravenel, and Jay A. Levenson. *Dürer in America.* New York: Macmillan, 1971.

Timm, Werner. *The Graphic Art of Edvard Munch.* New York: New York Graphic Society, Ltd., 1961.

Vincent, Howard P. *Daumier and His World.* Evanston, Ill.: Northwestern University Press, 1968.

Werner, Alfred. *The Graphic Works of Odilon Redon.* New York: Dover, 1969.

White, Christopher. *Rembrandt as an Etcher: A Study of the Artist at Work.* 2 Vols. University Park, Pa.: Pennsylvania State University Press, 1969.

———, and Karel G. Boon. *Rembrandt's Etchings: An Illustrated Critical Catalogue.* 2 Vols. Hollstein Series. Amsterdam: 1971.

Zigrosser, Carl, ed. *Prints and Drawings of Käthe Kollwitz.* New York: Dover, 1969.

———. *The Complete Etchings of John Marin.* Philadelphia: Philadelphia Museum of Art, 1969.

Glossary

à la poupée An *intaglio* printing technique for applying several colors simultaneously to a single plate with small pads or rolls of felt.

acetic acid (CH₃COOH) A mild acid used for cleaning *intaglio* plates and screens for *silkscreen*, among other applications.

acidulate In *lithography*, to make a *gum arabic* solution acidic.

adsorption The adhesion of a thin film of molecules on the surface of an impermeable material.

adsorption gum film A tough, elastic film formed by *gum arabic* on metal and limestone.

airbrush *Lithographic* image-making technique in which *tusche* is blown onto a plate or stone instead of being brushed or penned on.

algraphy See *aluminography*.

alpha pulp A wood *pulp* composed of pure cellulose fibers.

aluminography *Lithography* on aluminum plates, as opposed to zinc plates or limestone. Also called *algraphy*.

animal sized A term referring to paper *sized* with a gelatin solution.

aqua regia *Etching* solution consisting of 1 part nitric acid, 3 parts hydrochloric acid, and 3 parts water by volume. It is suitable for etching gold.

aquatint *Intaglio* process in which *rosin* or *asphaltum* powder is used to produce a tonal or textural surface on a metal plate.

artist's proof One of a small group of *prints* set aside from the *edition* for the artist's use. Also called *épreuve d'artiste*.

Arkansas stone A hard stone used with oil to sharpen tempered steel tools in *woodcut* and *intaglio* techniques.

asphaltum Acid-resistant ingredient of *etching grounds* also used as a *stop-out*; sometimes replaces *tusche* in *lithography*. Also called *bitumen*.

autographic ink A smooth *lithographic* drawing ink, similar in composition to *tusche*. Also called *zincographic ink*.

autographie French term for a *lithographic* image first drawn on *transfer paper*.

autolithography In *lithography*, an original image made directly on the stone or plate. Compare *chromolithography* and *photolithography*.

baren Japanese tool for applying pressure in the printing of *woodcuts*. It consists of a flat spiral of bamboo sheathing about 5 inches in diameter and a backing disc, wrapped in a bamboo sheath.

bath The mixture of acid and water in which *intaglio* plates are etched.

beater Machine used in paper-making processes to separate the fibers of the raw material and mix them with water, forming *pulp*.

Ben Day tint Mechanical tint composed of dots or lines that can be added to drawings, type, or *prints* for textural and tonal purposes. The name is taken from that of its inventor, Benjamin Day.

bench hook In *relief* printing, a device for holding a wood block in place on the table top during cutting.

bevel To file or round off the edges of a stone or metal plate. Also, the sloping edge thus formed.

bimetal plate A *lithographic* plate employing a top layer of copper over aluminum or stainless steel.

binder Substance that holds together the particles of *pigment* in an *ink* or paint.

bite The *mordant*, or corrosive, effects of an acid on a metal plate.

bitumen See *asphaltum*.

black method See *mezzotint*.

blanket Pressed or woven wool felts used on an etching press to apply a cushioning pressure to the paper.

bled print A *print* in which the image extends to one or more of the edges of the paper.

bleeding *Ink* seepage around a printed image, caused by excessive use of ink, oil, or pressure.

Blinddruck German term for *embossed print*.

blind embossing See *embossed print*.

blinding In *lithography*, the inability of an image area to accept *ink*.

block book Early printed book in which the text and images were often cut from the same wood block.

blockout Any material applied to a plate, block, stone, or screen to prevent certain areas from accepting *ink*.

blotting paper Highly absorbent paper without *sizing*, used to aid in the drying of dampened *prints* and to equalize moisture in printing papers that are dampened before use.

body The density or *viscosity* of an *ink*.

body gum Lithographic varnish No. 8.

bon à tirer proof The "right to print" *proof*, designated by the artist as the standard against which every *print* in the *edition* is to be judged for its aesthetic and technical merits.

bordering wax A soft wax used to form a wall around an *etching* plate before it is treated with acid.

brayer Hand roller for applying *ink* to a stone, plate, or block.

bridge Device used to protect image areas of a plate or stone from contact with the hand during drawing. Also, in *silkscreen*, a band to prevent floating parts of a solid *stencil* from falling off the screen.

broadside Originally, sheets of paper containing printed satire or commentary on one side only. Now refers to any large printed and folded sheet.

bronzing Dusting metallic powder onto a freshly printed image. Metallic *inks* now available may replace this technique.

burin *Engraving* tool for metal or wood with a square or lozenge-shaped steel shaft attached to a wooden handle. Also called a *graver*.

burn In *lithography*, to damage delicate work by using too strong an etch solution.

burnisher In *intaglio*, an oval-shaped tool used for polishing and smoothing the plate. In *relief* printing, any device for pushing the paper against an inked block in order to pick up *ink* and produce the *print*.

burnt plate oil Raw linseed oil that has been ignited to burn off lighter oils contained in it.

burr In *intaglio*, the ridge of metal cast up on either or both sides of a line by the *engraving* or *drypoint* tool. In engraving, the burr is usually removed, while in drypoint it remains on the plate, creating the characteristic fuzzy edges of the lines.

calcium carbonate (CaCO₃) A filler and coating agent obtained from the reaction of lime and carbon dioxide or as a by-product in the manufacture of caustic soda (lye). Also called *whiting* and the main constituent of lithographic stone.

calender System of large horizontal rollers for smoothing out the surface of a finished sheet of paper.

cancellation proof *Print* taken from a plate, block, or stone after the image has been effaced at the end of the *edition*. This is done to ensure that no further prints can be made.

carbon tissue Gelatin-coated paper that can be made *light-sensitive* for use in the *photogravure* process.

carborundum Solid or powdered abrasive used for sharpening *woodcut* tools and for graining stones for *lithography*. Its technical name is silicon carbide.

cardboard relief print A *print* made in the *relief* manner from inked pieces of mat board that have been glued to a base plate.

catalogue raisonné Classified and numbered list of *prints* by a particular artist, listing the titles, dates, *editions*, and conditions of all known prints (or paintings).

cellocut *Relief* or *intaglio print* made from a surface built up on a base with liquid plastics (such as celluloid dissolved in acetone).

cellulose gum Synthetic gum used to etch zinc plates for *lithography*.

chalk manner Any technique that imitates the effect of crayon on paper, particularly in *lithography* and *intaglio*.

chalking In printing, the flaking or rubbing off of dry *pigment*, caused by insufficient *binder* in the *ink*.

charge To cover with *ink*.

chemical printing Early name for *lithography*.

chiaroscuro Italian term for extreme gradations of tone from light to dark.

chiaroscuro watermark A *watermark* with a complete range of tonal values.

chiaroscuro woodcut Type of *woodcut* developed in the early 16th century that used two or more blocks to obtain differences in tone and sometimes differences in color.

chine collé Technique for pressing a thin sheet of *sized* Oriental paper to a heavier backing sheet and printing it at the same time. This can be accomplished by both *lithographic* and *intaglio* printing methods.

chop Identifying mark impressed on a *print* by the printer or workshop, or in some cases by the artist or a collector. Also called *dry stamp*.

chromolithography Term coined in the 19th century for a color *lithography* technique that was used almost exclusively for reproducing paintings and watercolors. Compare *autolithography* and *photolithography*.

cliché verre French term for glass *print*, or print made by photographic means from an image scratched through a light-resistant *emulsion* on a sheet of clear glass.

cold-pressed finish Rough or smooth texture made on a sheet of paper by running it through a series of cooled metal cylinders. Compare *hot-pressed finish*.

collagraph *Print* made from an image built up with glue and sometimes other materials.

collector's mark Inked or embossed stamp made in the margin of a *print* by the owner.

collotype High-quality reproduction process using a gelatin-coated glass plate to hold the image. Also known as *heliotype* and *photogelatin printing*.

colophon Inscription including the printer's name and other bibliographical information, found at the end of a book or on the back of the title page.

color separation The process of making a separate plate, block, or stone for each color to be printed.

composite print *Print* made from a number of individual plates, blocks, stones, or *stencils*, combining different techniques in the same work.

conté Brown, red, or black semihard chalk or crayon with a fine texture.

continuous-tone image Photographic image—either positive or negative—that contains a full gradation of tonalities.

copy camera See *process camera*.

cotton linters Cotton fiber remnants that are available in blotter-like sheets for hand papermaking.

couching The process of pressing freshly made sheets of paper onto a woven felt blanket to transfer the sheet from the mold.

counteretch In *lithography*, to remove the etch solution from the stone or metal in order to make changes in the image. Also called *resensitizing*.

counterproof Printed image identical to the image on the block or plate and made by taking an *impression* of a wet *proof*.

crayon manner *Etching* and *engraving* technique popular in the late 16th century. It made use of *roulettes* and *needles* to achieve the effect of a crayon drawing. Later, another technique of drawing on a thin paper over a *soft-grounded* metal plate became known by this name.

creeping bite *Etching* technique for producing a subtle transition of tone by submerging the plate in the acid in stages.

crevé In *etching*, an area in which the metal surface between closely spaced lines has been eaten away by the acid.

criblé A *relief* technique in which shaped punches are used to hammer indentations in the plate. Also called *dotting*.

cross-hatching Sets of parallel lines drawn at various angles to produce shading and tonal effects. Compare *hatching*.

cure To change the physical properties of a substance by means of a chemical reaction, usually with heat. Also called to *set*.

cut block print Type of *relief print* in which a single block is cut into pieces that are inked separately, reassembled, and printed.

cylinder machine Papermaking machine consisting of wire-covered cylinders on which the *pulp* is formed into a web of paper.

dabber Cotton pad covered with silk or smooth leather and used for spreading *ink* over a printing surface or for distributing melted *ground* over an *etching* plate.

damp box Covered box lined with oilcloth, plastic, or zinc in which dampened paper for printing is put while the water disperses throughout the fibers.

dandy roll On a *Fourdrinier machine*, a roll carrying a wire design or *watermark* that is transmitted to each fresh sheet of paper.

dark reaction Hardening of film or *light-sensitive screens* that are stored in the dark for a long period of time.

deckle Wooden frame that holds the paper *pulp* on the screen while the sheet of paper is being formed. Also, the naturally ragged edge of a handmade sheet of paper.

die stamping *Intaglio* printing method in which an inked copper or steel plate (the die) is printed under heavy pressure, resulting in a partially embossed image.

dimensional stability The tendency of a sheet of paper or a metal plate not to shrink or stretch under pressure or other stress.

doctor blade In *rotogravure*, a metal blade that scrapes excess *ink* from the surface of the cylindrical image before printing.

documentation sheet Form identifying the technique employed in making a *print*, as well as the *inks*, paper, drawing materials, and the size of the *edition*.

dotting See *criblé*.

dragon's blood A bright red rosin from the Dracocalamus tree used in some *etching* procedures.

dry stamp See *chop*.

drypoint *Intaglio* technique in which a sharp needle scratches the plate, creating a *burr* that yields a characteristically soft and velvety line in the final *print*.

duotone *Halftone* image printed first in a color, then in black.

dust bag In *aquatint*, a small silk or nylon bag used to dust the plate with powdered *rosin*.

dust box In *aquatint*, an airtight box in which a metal *etching* plate is placed to allow *rosin* or *asphaltum* particles to settle on it.

Dutch mordant An *acid bath* for *etching* copper, consisting of water, hydrochloric acid, and potassium chlorate.

échoppe *Etching* tool designed by the 17th-century artist Jacques Callot for producing lines that thin and swell like *engraved* work.

edition Set of identical *prints*, sometimes numbered and signed, that have been *pulled* by or under the supervision of the artist and are authorized for distribution.

electrodeposition To deposit particles of a metal on another surface by means of electricity.

electrotype A duplicate printing surface made by taking a wax or lead mold of the original surface and coating it with a thin layer of copper by means of electroplating. The copper is removed and reinforced with metal to produce the electrotype.

embossed print *Intaglio print* in which

the image is raised slightly, producing a three-dimensional effect. Also called *inkless intaglio* or *blind embossing* (when printed without *ink*), *gauffrage* (French), *Blinddruck* (German), and *karazuri* or *kimekomi* (Japanese).

emulsion Mixture of two incompatible liquids.

end grain The side of a block of wood that does not show the grain, perpendicular to the *plank side* and used for *wood engraving*.

engraving *Intaglio* technique in which the image is produced by cutting a metal plate directly with a sharp engraving tool. The incised lines are inked and printed with heavy pressure.

épreuve d'artiste French term for *artist's proof*.

épreuve d'état French term for *state proof*.

etching *Intaglio* technique in which a metal plate is first covered with an acid-resistant *ground*, then worked with an etching needle. The metal thus exposed is "eaten" in an acid *bath*, creating depressed lines that are later inked and printed.

etching press *Intaglio* printing press consisting of two large cylinders and a sliding bed. The bottom cylinder supports the bed, on which the inked plate and the paper are placed, while the top cylinder presses the paper against the plate.

exchanging Method of stacking freshly *couched* and pressed sheets of paper in small piles to dry.

false biting In *etching*, the accidental pitting by acid of areas on the plate that were covered with *ground*. Also called *foul biting*.

feathering Removing with a feather or a small brush the bubbles produced on an *etching* plate by the corrosive effect of acid. Also a means of etching limited areas of the plate with acid, controlling its action by means of a feather.

felt side The side of a sheet of paper that first contacts the felt in the *couching* process. Compare *wire side*.

felting In papermaking, the intertwining of fibers on the screen as water drains from the *pulp*.

fibrillation In papermaking, the beating and separating of the fibers to make *pulp*.

flash point Temperature at which a liquid will ignite in the air.

flat bed press Type of printing press consisting of a flat, moving surface on which the inked plate and paper are placed, and a smooth cylinder above that provides the pressure for printing.

flocked print *Serigraph* made with an adhesive varnish over which wool or rayon flakes can be sprinkled.

flood stroke In *serigraphy*, a technique for filling the *screen* with *ink* before each *print* to prevent it from drying out. The *squeegee* distributes *ink* across the *screen*

in the opposite direction of the printing stroke.

flower-of-sulphur aquatint *Aquatint* technique using olive oil and sulphur powder to produce a textured surface on the plate.

foul biting See *false biting*.

fountain solution Slightly acidic solution used in place of water for dampening a *lithographic stone* or plate.

Fourdrinier machine Machine invented in 1807 for making continuous rolls of paper.

foxing Brown stains produced by the chemical reaction of bacteria on the iron salts in a sheet of paper.

French chalk See *talc*.

gauffrage French term for *embossed print*.

gelatin Albuminous substance used in *sizing* paper.

gesso Mixture of gypsum and glue that is used to prepare surfaces for painting and to coat collages before inking and printing them.

ghost image In lithography, traces of the image remaining on the stone or plate after the *washout*.

glacial acetic acid Concentrated pure *acetic acid* (CH_3COOH).

gouge In *relief* printing, a tool for clearing nonimage areas from a block of wood or linoleum.

gradated roll Specialized technique in which a plate or stone is inked with strips of different shades of the same color, which are blended at the edges and printed simultaneously.

grain In *lithography*, to roughen the surface of a stone or plate before making the image. Also, the natural direction of the nap on a leather nap *roller*. In *relief* printing, the natural texture of the wood block.

graver See *burin*.

"green" etch In *lithography*, a solution containing tannic acid and phosphoric acid, and used for preparing zinc plates.

ground In *etching* and *aquatint*, an acid-resistant substance used to protect nonimage areas of the plate from the action of the acid. *Hard grounds* contain asphaltum, beeswax, and rosin; *soft grounds* contain the same ingredients plus tallow. In *mezzotint*, the deep background produced by roughening the plate surface with *roulettes* and *rockers*.

gum acacia See *gum arabic*.

gum arabic Natural gum produced by the acacia tree, and the main ingredient of *lithographic* etch preparations. Also called *gum acacia*.

halftone Photographic image that has been broken up into dots of varying sizes to achieve the effect of a full range of tonalities.

halftone screen Grid of opaque lines that break up tonalities on a photographic image into dots of varying sizes.

halo Oil ring sometimes left around an image printed with an oil-base *ink*.

hammering up See *repoussage*.

hand wiping The technique of removing surface *ink* from an *intaglio* plate with the palm of the hand just before printing. Compare *rag wiping*.

hard ground See *ground*.

hard sizing Method of *sizing* paper in which the paper is dipped into the *size* solution, dried, and dipped in again. Compare *soft sizing*.

hatching Sets of close parallel lines to produce shading and tonal effects. Compare *cross-hatching*.

heliogravure Photomechanical intaglio printing process. See *photogravure*.

heliotype See *collotype*.

hickey On a *print*, an unwanted spot of *ink* with a white ring around it, caused by dirt in the ink.

Hollander beater Machine invented in 1673 for separating and beating cotton and linen fibers, producing *pulp* for paper faster than previous methods.

hot-pressed finish Smooth surface produced on a sheet of paper by running it through a series of heated metal cylinders. Compare *cold-pressed finish*.

hydrophilic Water-loving.

hygroscopic Water-retentive.

impasto On a *print*, a raised area produced by a very heavy layer of *ink*.

impression See *print*.

impression number The number of a *print* in an *edition*. The first three prints in an edition of one hundred would be numbered $\frac{1}{100}$, $\frac{2}{100}$, $\frac{3}{100}$.

India paper Thin paper sometimes used for proofing.

India stone Round sharpening stone used for *burins*, knives, *scrapers*, and other tools.

ink Coloring matter composed of *pigment*, a *binder*, and a *vehicle*.

inkless intaglio See *embossed print*.

intaglio Printing technique in which paper is pushed into depressed or recessed lines made in a metal plate and filled with *ink*. The image can be made on the plate by acid or a sharp tool, using one of the following techniques: *etching, engraving, aquatint, mezzotint,* or *drypoint*.

island In *silkscreen*, a floating part of a paper *stencil* that will fall away if not attached by a *bridge*.

Japan paper General name for Oriental papers.

karazuri Japanese term for *embossed print*. Also called *kimekomi*.

key block In color *relief* printing, a block containing the complete image and used to position partial images on other blocks for each individual color.

kiss impression In *relief* printing, a light *print* made when a sheet of paper is laid over an inked block and rubbed lightly with the hand.

kozo Plant fibers from the mulberry tree from which many Japanese papers are made.

lacquering Special *lithographic* technique in which the greasy image is re-

placed with vinyl lacquer, creating a completely stable and durable printing base.

laid screen A screen for hand paper-making composed of intersecting brass wires of two different weights; the heavier ones are laid wires, the lighter ones chain wires. Paper made on this type of screen is called laid paper and shows the distinct marks of the laid wires. Compare *wove screen*.

length Description of the consistency of an ink. A long ink is elastic and rubbery. Compare *shortness*.

letterpress Commercial *relief printing* process.

levigator Heavy steel or iron disc with a handle, used for *graining lithographic stones*.

lift ground *Aquatint* technique in which the image is drawn on the plate with a water-soluble solution (usually containing sugar). The plate is covered with a *ground* and submerged in water, which dissolves the sugar solution, lifting the ground and exposing the image areas so the plate can be *etched*. Also called *sugar-lift aquatint*.

lightfastness The ability of a dyed paper or an ink to resist changing color when exposed to light.

light-sensitivity The ability of a substance or surface to change chemically when exposed to light.

line engraving *Intaglio* technique in which the image is made by scored lines of varying width in a metal plate. The *burr* thrown up by the *engraving* tool is removed with the *scraper*.

line shot Black-and-white photographic *negative* or *positive* made on high-contrast film without a *halftone screen* and used for black-and-white copy only or for special effects.

linoleum print Type of *relief* print in which the image is cut into a piece of linoleum.

lithoaquatint Recently developed *lithographic* technique for creating fine tonalities and wash effects on metal plates.

lithographic crayon Greasy drawing substance used for drawing images on a *lithographic* stone or plate.

lithographic press Printing press that prints by means of a *scraper bar*, using heavy pressure.

lithography Printing technique in which the image areas on a lithographic stone or metal plate are chemically treated to accept *ink* and repel water, while the nonimage areas are treated to repel ink and retain water. Because the printing surface remains flat, lithography is sometimes referred to as a *planographic* technique.

lithotine Substitute for turpentine.

lithotint Process developed by Charles Hullmandel and patented by him in 1840, for imitating a wash drawing by using *tusche* washes in *lithography*.

livering Thickening of *ink* caused by oxidation of the oil *vehicle*.

macehead *Stipple engraving* tool, having an irregular pattern of points.

machine-mold paper See *moldmade paper*.

maculature *Intaglio* technique for cleaning *ink* from the plate by pulling two *proofs* without inking in between.

makeready Printing technique in which a lower part of a plate or block is built up from beneath with sheets of paper.

manière noire See *mezzotint*.

manière noire lithography *Lithographic* technique for stone. The surface is covered with a solid layer of *tusche*, and the image is produced by scraping parts of the *tusche* layer away.

mask stencil In *silkscreen*, a *stencil* in which *ink* is applied to the background, around the outer margins of the image.

mass tone The color of an *ink* on the ink slab. This sometimes differs from the color after printing.

mesh size Means of measuring the fineness of a fabric, usually expressed as a number followed by one or more ×'s.

metal graphics Technique invented by Rolf Nesch for making printing plates by adding copper wire and other materials to a metal base.

metal relief print *Relief print* made from a metal collage or etched metal plate.

mezzotint *Intaglio* image-making technique in which the plate is worked from dark tones to light. The surface is first roughened with a mezzotint *rocker* or *roulette* so that, if inked, it would print a rich, solid black. The areas that are not to print are then burnished and flattened to produce various grays and white. Also called *manière noire*, or the *black method*.

mezzotint screen Tonal screen for *halftone* photography, employing a random pattern of dots.

mitography Synonym for *serigraphy*, proposed by Albert Kosloff but never widely adopted.

mitzumata Low shrub grown in Japan for its bark, whose fibers are much used in papermaking.

moiré pattern Optical effect caused by the misalignment of two strongly patterned surfaces so that a third distinctive pattern is formed.

moldmade paper Continuous roll of paper made on a *Fourdrinier machine*. Also called *machine-mold* paper.

monotype Technically, a *print* pulled in an *edition* of one, from a painting made on a sheet of metal or glass. The method has been successfully adapted in special *lithography* techniques.

mordant An acid. Also, the corrosive effect of an acid.

muller Knob-shaped tool of marble or glass with a roughened base, used for grinding dry *pigment* with plate oil in order to make *ink*.

multiple tint tool *Engraving* tool that produces several parallel lines in one stroke.

negative Photographic image in which the areas of light and shade are the reverse of their appearance in the original. Compare *positive*.

negative stencil In *serigraphy*, a *stencil* on which the background is the actual printing area. Compare *positive stencil*.

niello Early metal *engraving* technique developed in Italy in which the *engraved* lines on a silver plate are filled with a black enamel-like substance.

nitric acid (HNO₂) Corrosive substance used in *etching*.

offset printing Method of printing that involves the transfer of an inked image to an intermediary, such as the rubber cylinder on an offset press, then to paper.

oil stone Smooth stone used with oil for sharpening steel tools.

oleomanganate of lime In *lithography*, the base for the printing *ink*. It is formed by the reaction of the fatty acids in lithographic drawing materials and the alkaline limestone.

opacity coverage In *serigraphy*, the area that can be covered by a given amount of *ink*, expressed in gallons per square foot.

open biting In *etching*, exposing large areas of the plate to acid.

overprint varnish Permanent varnish applied to poster *inks* for *silkscreen* work intended for outdoor use.

papier à rapport-pelure Thin, transparent transfer paper for special *lithographic* techniques.

parchment See *vellum*.

paste print *Intaglio* print made on paper covered with a doughlike substance. The technique was used in the late 15th century.

pH scale In chemistry, a scale of values from 0 to 14, measuring the acidity or alkalinity of a substance. A pH value of 7 is neutral. Numbers less than 7 indicate more acidity; those greater than 7 indicate more alkalinity.

photogelatin printing See *collotype*.

photogravure An *intaglio* printing process in which the image has been placed on the plate by photographic means using *carbon tissue*.

photolithography Technique for producing an image on a *lithographic* plate by photographic means. Compare *autolithography* and *chromolithography*.

photosilkscreen Technique for the transfer of photographic images to a *stencil* for screen printing.

pigment Coloring matter in *ink* or paint, usually in powder form.

pigtail In *engraving*, a rough curl of metal pushed up by the *burin* when an engraved line ends abruptly.

plank side The side of a wood block on which a *woodcut* is made. The *grain* of

the wood runs parallel to the length of the block.

planography Printing from a flat surface. Usually refers to *lithography*.

plate mark Imprint of the edge of the plate on an *intaglio print* produced by the heavy pressure needed for printing.

plate tone Visible trace of color in non-image areas of an *intaglio print*, produced by leaving a thin film of *ink* on the plate after wiping.

platen Type of printing press, named for the iron or steel plate that pushes the paper against the inked image.

pochoir Printmaking technique using a *stencil* made of plastic, brass, copper, or oiled paper, originally for applying small areas of color.

positive Photographic image in which the areas of light and shade correspond to the original image. Compare *negative*.

positive stencil Stencil in which the image is the printing area. Compare *negative stencil*.

post A pile of alternating sheets of freshly *couched* paper and felts.

posterization In *serigraphy*, a photographic technique for producing sharp and dramatic images by making variable exposures of a *continuous-tone image*.

presentation proofs Prints outside the *edition*, generally intended as gifts.

print Image produced on paper or another material by placing it in contact with an inked block, plate, collage or stone and applying pressure; or by pressing *ink* onto a sheet of paper through a *stencil*. Also called an *impression*.

printer's proofs Prints outside the *edition*, given to the master printer and the printer-collaborator, if any.

process camera Large camera unit used for photo-printmaking techniques. Also called a *copy camera*.

progressive proofs Series of *proofs* for a multicolor *print*, showing each of the colors individually and with the other colors.

proof Trial *print pulled* to test the progress of the image.

pull To print an image.

pulp The basic ingredient of paper, consisting of cotton or vegetable fibers that have been chopped and beaten with water so that the fibers are properly hydrated and *fibrillated*.

quire Twenty-four sheets of paper.

rag paper Fine paper for printing, made from 100 percent cotton or linen rags and not containing any wood *pulp*.

rag wiping Technique for removing *ink* from the surface of an *intaglio* plate with a soft rag just before printing. Compare *hand wiping*.

rainbow roll Specialized technique in which a plate or stone is inked with strips of several different colors at once. They are blended at the edges to produce a rainbowlike effect.

ream Five hundred sheets of paper. For wrapping tissues a ream is 480 sheets.

reduction block print Type of *relief* print made by alternately cutting and printing the same block, working from light colors through to darker ones.

register marks Marks drawn or engraved on a plate or stone to aid in *registration*. They are usually in the form of a small cross or triangle.

registration Adjustment of separate plates, blocks, or screens in color printing to ensure correct alignment of the colors.

relief Printmaking technique in which the image is printed from a raised surface, usually produced by cutting away nonimage areas.

relief etching Metal *relief* plate produced by *intaglio* techniques.

repoussage Technique for removing unwanted indentations from a metal plate by hammering them gently forward from the other side.

resensitize See *counteretch*.

resist Any material applied to a surface to prevent the passage or adhesion of a substance, such as *ink*.

restrike A reprinting of a plate, usually neither signed nor numbered and, in most cases, reworked after the *edition* is completed.

retroussage In *intaglio*, a technique for producing slightly darker areas on an *etching* or *aquatint* by dabbing a soft cloth lightly over the inked plate.

retting Deteriorative action of fungi and bacteria on water-soaked cotton and linen.

rice paper Term sometimes applied, incorrectly, to certain Oriental papers.

rocker In *mezzotint*, a serrated cutting tool with a wide, curved edge that roughens the surface of the plate.

roll up To *ink* the image on a plate, stone, or block.

rosin Organic substance in lump or powder form that melts when heated. It is mainly used in printmaking for *aquatint grounds*.

rotten lines In etching, broken lines caused by unequal pressure of the needle working through the *ground*.

roulette In *mezzotint*, a textured wheel drawn across the plate to roughen the surface and produce tonalities.

rub up In *lithography*, to rub the image areas with a greasy substance in order to make them more *ink*-receptive.

rubbing Print made by rubbing *ink* or a pencil over a sheet of paper placed on a raised surface.

rubbing ink Lithographic drawing material used for producing soft and smoky effects. It comes in slabs and is applied with the finger or a soft cloth.

sandpaper aquatint Aquatint produced by running the plate through the press with a piece of sandpaper face-down on it.

scorper Wood engraving tool for clearing large areas or making heavy, textured lines.

scraper In *intaglio*, a steel tool with three sharp edges coming to a point, used in many techniques for removing metal from plates.

scraper bar In *lithography*, the leather-covered blade of the *lithographic* printing press, which exerts the necessary pressure on the plate or stone.

scum Unwanted *ink* tonalities forming on the surface or edges of a *lithographic* stone or plate.

serigraphy Printing technique that makes use of a *squeegee* to force *ink* directly onto a piece of paper or canvas through a *stencil* containing the image. The term was coined by Carl Zigrosser. The process is also called *silk-screen* or (seldom) *mitography*.

set See *cure*.

set-off Impression made on the back of a sheet of paper by a wet *print* underneath it.

shortness Description of the consistency of an *ink*. A short ink is buttery and stiff, breaking away from the printing surface easily and without forming strings. Compare *length*.

silkscreen See *serigraphy*.

sizing Gelatinous substance that reduces the absorbency of a sheet of paper. Compare *hard sizing; soft sizing*.

sizing catchers Thin, smooth *etching* press *blankets* that are placed next to the dampened printing paper.

slipsheet Sheet of tissue or newsprint placed over a wet *print* to prevent offsetting of wet ink onto other prints placed on top.

snakeslip Finely compressed pumice sticks for removing small image areas from a *lithographic* stone or plate.

snakestone Abrasive stone quarried in Scotland and used for erasing and polishing work on *lithographic stones*. Also called *water-of-Ayr stone*.

soft ground See *ground*.

soft sizing Method of *sizing* paper by dipping it into the size solution once. Compare *hard sizing*.

solander box Flat box for storing *prints*.

smoking the ground In *etching*, a technique for darkening the *ground*, using the flame of a candle or a wax taper.

spit biting Aquatint technique for achieving gradated tonal effects by applying acid to the plate with a brush containing saliva or water.

spitsticker Wood engraving tool for making curved lines.

squeegee Silkscreen tool for pushing the *ink* through the screen. It consists of a handle and a wooden or metal casing holding a hard rubber or plastic blade.

starve To roll less *ink* than usual on an image.

state proof Series of *proofs* taken after each of the steps in the completion of a

print. Also called *épreuve d'état.*

steel engraving 19th-century technique for *engraving* on steel, producing larger editions than were possible from copper plates.

steel facing Process for adding pure iron to a metal *intaglio* plate by *electrodeposition.*

stencil In *serigraphy,* a means of blocking the passage of *ink* through the nonimage areas of the *screen.* A stencil can be made of paper, glue, *tusche,* shellac, and a variety of other materials.

stereotype Metal cast made from a mold of a *relief* printing surface.

stipple *Etching* and *engraving* technique that produces tonal effects by means of fine, closely spaced dots.

stone engraving Specialized *lithographic* technique in which the image is produced by lightly scratching the surface of the stone with a sharp point and filling the resulting lines with *ink.*

stone paper Heavy paper coated with a mixture of grained stone. It was invented by Alois Senefelder as a possible substitute for *lithographic* stone.

stop-out Substance (such as stop-out varnish or *ground*) that prevents acid from attacking certain areas on an *etching* plate.

struck off *Printed, pulled.*

sugar-lift aquatint See *lift-ground.*

suite Related group of original *prints.*

sumi Chinese black *ink.*

surface rolling Inking an image (other than a *lithographic* one) on the surface and not in the grooves.

tack Stickiness of an *ink.*

talc Powder made from magnesium silicate and used to dust *lithographic* plates and stones. Also called *French chalk.*

Tam o'shanter Good-quality *snakestone.*

tap-out Test of *ink* color in which a little of the ink is spread on paper with the finger.

tarlatan Sheer cotton fabric, heavily sized and used for *rag wiping* of *intaglio* plates.

thixotropy The property of an *ink* that renders it more flexible when worked and less flexible after standing.

thread count Number of threads per inch in a fabric.

tint tool Tool for producing lines of various widths in *intaglio* and *wood engraving* techniques.

toner Highly concentrated *silkscreen ink.*

tooth In *serigraphy,* the roughness of the screen fabric, produced by means of special abrasives. In *lithography,* the roughness on the stone, produced by *graining.*

transfer lithograph Lithograph made on *transfer paper.*

transfer paper Paper with a water-soluble coating on one side. When the paper is dampened, any image drawn on the coated side will be released from the paper onto the printing surface.

trap The slight overlapping of two areas of color on a *print.*

trial proof *Proof* pulled from a block, plate, or stone to check the appearance of the image.

trimetal plate Plate made of three layers of metal, usually copper and chromium, with steel or aluminum.

tusche Grease-based drawing material used for *lithographic* images and some types of *stencils.* It contains wax, tallow, soap, shellac, and lampblack, and comes in solid and liquid form.

tympan Greased sheet on a *lithographic* press along which the *scraper bar* moves applying pressure to the paper underneath.

type height Approximately $7/8$ inch, or 0.918 inch.

ukiyo-e The classic period of Japanese *woodcutting,* lasting from the first half of the 17th century to the middle of the 19th century.

underbiting In *etching* or *aquatint,* insufficient *biting* in an acid *bath.*

undercutting In *etching* or *aquatint,* the lateral *biting* of the acid in areas that were covered with *ground.*

vehicle Liquid ingredient of an *ink* or paint that allows the *pigment* to be applied easily to a surface.

veiner Small U- or V-shaped gouge for wood block cutting.

vellum Early type of paper made from the skin of sheep, goats, or hogs. Also called *parchment.*

viscosity In an *ink,* the resistance of the liquid to flow or movement.

washout In *lithography,* the process of removing the greasy drawing material from the completed image on stone or plate.

water-in-ink emulsion Fine water droplets surrounded by *ink.*

water-of-Ayr stone See *snakestone.*

waterleaf paper Paper without *sizing.*

watermark Image made within a sheet of paper by variations in *pulp* thickness.

wet wash In *lithography,* a corrective procedure for removing greasy drawing materials from the plate or stone.

whetstone Abrasive stone for sharpening steel or metal tools with water.

white line *Print* in which the image appears in white on a dark background.

whiting See *calcium carbonate.*

wire side The side of a sheet of paper that was in direct contact with the wire screen during the papermaking process. Compare *felt side.*

wood engraving *Relief print* made on the end grain of a block of wood. The relief areas are inked and printed. Also called *xylography.*

wood pulp paper Paper made of cellulose wood fibers.

woodcut *Relief print* made on the *plank side* of a block of wood.

wove screen Screen for hand papermaking composed of fine brass wires, all of the same weight and woven to produce a smooth and even surface. Paper made on this type of *screen* is called wove paper and does not show the marks of the wires. Compare *laid screen.*

xylography See *wood engraving.*

zincographic ink See *autographic ink.*

zincography 19th-century term for *lithography* on zinc plates.

Index

Photographic Sources

American French Tool Company, Coventry, R.I. (661); Jörg P. Anders, West Berlin (25); Oscar Bailey (592, 594); Charles Brand, New York (660); Brooklyn Museum, N.Y. (492); Rudolph Burckhardt, New York (485, 489); Cincinnati Art Museum, Ohio (6); Geoffrey Clements, Staten Island, N.Y. (104); Bevan Davies, New York (191, 560); Deste, London (484); Deutsches Museum, Munich (298, 653); Eeva-Inkeri, New York (471, Pl. 32); Dan Freeman (382, 591); Gemini G.E.L., Los Angeles (571); Giraudon, Paris (152); Grafica Artistica, S.A., Mexico City (602–603); Helga Photo Studio, Inc., New York (491); Institute of Paper Chemistry, Appleton, Wisc. (610, 630, 632, 634); George Jennings, Jr. (479); Jones-Gessling Studio, Huntington, N.Y. (494); Kulicke Frames, Inc., New York (649); Galerie Louise Leiris, Paris (344); Lichtbildwerkstätte "Alpenland", Vienna (4, 51); Malcolm Lubliner, Los Angeles (55, 358, 376, 512, 587–590, 596–600); M & M Research Engineering, Butler, Wisc. (513, 675); Michael Marton, Buskirk, N.Y. (356); Alexander A. Mirzaoff, Tampa, Fla. (Pls. 6, 24, 34, 36); Modern Photography Magazine, New York (Pl. 40); Seong Moy, New York (130–133, Pls. 9–13); Albert L. Mozell, New York (271, 490); Peck, Stow & Wilcox (202); Hans Petersen, Copenhagen (180); Eric Pollitzer, Hempstead, N.Y. (486, 493, 572, Pls. 3, 5, 14, 37, 39); James Robie (673); Nick Scheidy, New York (487, 562–563, Pl. 18); Spink & Gaborc, Inc., New York (647); Walter Steinkopf, West Berlin (8, 23, 27–28, 134–135, 147); Tetko, Inc., Elmsford, N.Y. (501); Rodney Todd-White & Son, London (Pl. 8); University of Connecticut, Storrs (662); John Webb, Cheam, Surrey (Pl. 28).

Fig. 665 from *Vollständiges Lehrbuch der Steindruckerey* by Senefelder, 1818. Fig. 668 from *Traité théorique et pratique de lithographie* by Engelmann, 1839. Fig. 669 from *Journal für Buchdruckerkunst*, 1842.

Works by Braque, Cassatt, Chagall, Miró, Villon: Permission © A.D.A.G.P., Paris, 1977. Works by Bonnard, Cezanne, Degas, Denis, Klee, Matisse, Picasso, Redon, Renoir, Vuillard: Permission © S.P.A.D.E.M., Paris, 1977.